NEO-IMPRESSIONIST PAINTERS

**Recent Titles in
the Art Reference Collection**

NEO-IMPRESSIONIST
ᙉ PAINTERS ᙓ

A Sourcebook on Georges Seurat, Camille Pissarro, Paul Signac, Théo Van Rysselberghe, Henri Edmond Cross, Charles Angrand, Maximilien Luce, and Albert Dubois-Pillet

Russell T. Clement and Annick Houzé

Art Reference Collection, Number 23

GREENWOOD PRESS
Westport, Connecticut • London

Library of Congress Cataloging-in-Publication Data

Clement, Russell T.
 Neo-impressionist painters : a sourcebook on Georges Seurat,
 Camille Pissarro, Paul Signac, Théo Van Rysselberghe, Henri Edmond
 Cross, Charles Angrand, Maximilien Luce, and Albert Dubois-Pillet /
 Russell T. Clement and Annick Houzé.
 p. cm.—(Art reference collection, ISSN 0193–6867 ; 23)
 Includes bibliographical references and indexes.
 ISBN 0–313–30382–7 (alk. paper)
 1. Neo-impressionism (Art)—France Bibliography. 2. Neo-
 impressionism (Art)—Belgium Bibliography. 3. Painting,
 Modern—19th century—France Bibliography. 4. Painting,
 Modern—19th century—Belgium Bibliography. I. Houzé, Annick.
 II. Title. III. Series: Art reference collection ; no. 23.
 ND547.C54 1999
 759.05'5—dc21 99–36377

British Library Cataloguing in Publication Data is available.

Library of Congress Catalog Card Number: 99–36377
ISBN: 0–313–30382–7
ISSN: 0193–6867

First published in 1999

Greenwood Press, 88 Post Road West, Westport, CT 06881
An imprint of Greenwood Publishing Group, Inc.
www.greenwood.com

Printed in the United States of America

The paper used in this book complies with the
Permanent Paper Standard issued by the National
Information Standards Organization (Z39.48–1984).

10 9 8 7 6 5 4 3 2

A la mémoire de Jean Reese Clement

1920-1998

une rose florissante, une mère sans pareille

Contents

Preface

Standing before any of Seurat's half-dozen monumental canvasses such as *Bathers at Asnières* or *La Grande Jatte*, the defining achievements of a single-minded eight-year color experiment that ended with the artist's death in 1891 at age 31, one is mystified at the theoretical and technical wizardry behind marshalling tiny, measured doses of contrasting and harmonious colors into such vibrant, poised surfaces. As Paul Signac memorialized at Seurat's deathbed: "Above the bed in which poor Seurat died hangs *Cirque*, his last work . . . I was reminded of certain primitive paintings in which the departed has a vision, a luminous apotheosis, of the happy souls awaiting him in paradise." Of equal if not greater aesthetic pleasure are Seurat's exceptionally eloquent and expressive black *conté* crayon drawings, forms rendered as exquisitely as folds of soft cloth. In convincing ourselves and Greenwood Press of the value of a Neo-Impressionist research guide, viewed from the onset as a logical addition to other Greenwood bio-bibliographies and sourcebooks on late 19th and early 20th century French avant-garde colorists–*Paul Gauguin* (1991), *Henri Matisse* (1993), *Georges Braque* (1994), *Les Fauves* (1994), and the *French Symbolists* (1996)—over time we came to appreciate the accomplishments and originality of the other Neo-Impressionists represented here.

This sourcebook compiles and organizes the literature on Neo-Impressionism in general as well as sources on eight individual French and Belgian Neo-Impressionist artists. Each individual section includes a biographical sketch, chronology, primary and secondary bibliographies, and exhibition lists (individual and group). Entire careers are covered in the sourcebook, not just their Neo-Impressionist periods.

To produce the sourcebook, from 1995 to 1998 relevant literature was gleaned from computer and card catalogues and from printed indexes and guides to the library and archival collections of major art museums, universities, and scholarly and artistic institutes in the United States and Western Europe. Standard art indexes and abstracting services, such as the *Bibliography of the History of Art; Art Index, ARTbibliographies MODERN; International Repertory of the Literature of Art; Répertoire d'art et d'archéologie;* Chicago Art Institute, Ryerson Library's *Index to Art Periodicals; Frick Art Reference Library Original Index to Art Periodicals; Arts and Humanities Citation Index; Humanities Index; Religion Index; MLA Bibliography; Worldwide Art Catalogue Bulletin;* and *Répertoire des catalogues de ventes* were consulted, along with pertinent bibliographic databases such as RLIN, SCIPIO, WorldCat, UnCover, FirstSearch, OCLC, and Internet sites. The sourcebook attempts to be as comprehensive as possible within time, travel, budget, and length

constraints. It should not, however, be construed as exhaustive.

This guide is intended as a briefly and partially annotated bibliography, not as a critical one. Annotations are provided sporadically for entries where titles give incomplete or unclear information about works and their content. Monographs and dissertations are annotated with more regularity than periodical articles. When they appear, annotations are of necessity brief and are intended only to note the subject matter discussed, the general orientation, or the conclusion of the study. Obviously, a few sentences can hardly hope to represent fairly and adequately describe even a short article, to say nothing of a major book. Our apologies to authors who may feel that the annotations have misrepresented, misconstrued, misunderstood, or even distorted their work in this process of radical condensation. Our own opinions and critical judgements have in no case been conscious criteria for inclusion or exclusion. Foreign-language titles abound, particularly in French. Since a reading knowledge of French is essential for serious Neo-Impressionist research, with a few exceptions only titles in other foreign languages are occasionally translated.

How to Use the Primary and Secondary Bibliographies

The bibliographies are divided into sections, accessible by the Contents. Entries are numbered consecutively throughout. In every section, books are listed first, followed by periodical articles. Within each section, citations are listed alphabetically by author or chronologically, when noted. Anonymous works are alphabetized by title. When several entries are credited to the same author, they are arranged chronologically. Authors whose surnames have changed and those who have rearranged their given names or initial are generally listed as they appear in print. They may, therefore, be found in the Personal Names Index in more than one location. The Exhibitions sections contain information and publications about exhibitions, including a few sales catalogues and reviews, arranged chronologically into individual and group exhibition categories.

The most effective use of the secondary bibliographies is by means of the Contents and Art Works and the Art Works and Personal Names Indexes. Entries are indexed with reference to their citation numbers. Particular publications may be located in the Personal Names Index under the author or any other persons associated with the work.

Acknowledgments

Many enlightened minds and capable hands assisted in the creation of this sourcebook. Library colleagues, art and cultural historians, curators, and Neo-Impressionist specialists provided generous encouragement and invaluable aid in identifying, correcting, and organizing sources. Staff members at Brigham Young University's Harold B. Lee Library were exceptionally diligent and supportive in inputting, formatting, correcting entries, and issuing a seemingly endless series of drafts – arduous tasks assiduously directed by Erva Rieske. Kayla Willey provided special assistance in the final formatting of the manuscript. Among others, incalculable credit and special thanks to Emily Fluckiger, Wendy Stevenson, Kimberly Cory and Amy Jensen for data entry and formatting. Also a special thanks to Deborah Hatch for working on the arduous task of proofreading the indexes. Richard Hacken, European Studies Librarian and Humanities Coordinator at BYU, proofread and edited the German, Italian, and Scandinavian entries. Christiane Erbolato-Ramsey, BYU's Fine Arts Librarian, performed the same careful proofing of Spanish and Portuguese. Also at BYU, Kathleen Hansen's able Interlibrary Loan staff procured important books and journals essential to the project; appreciation is likewise expressed to James Hammons' Interlibrary Services staff at the John C. Hodges Library, The University of Tennessee, Knoxville. Supervisors whose unstinting support enabled timely completion of the sourcebook include Lori Goetsch, Linda Phillips, and Rita Smith at The University of Tennessee Libraries and Carla Kupitz at BYU. Research travel to France was supported by the Lee Library's Professional Development Committee. We're mindful of taxing family and personal relations through preoccupation with the work and gratefully acknowledge their indulgence and endorsement, particularly Rebecca S. Clement who endured intense editing bouts with customary graciousness.

Over the course of the project, we came to share critic Téodor de Wyzewa's 1891 appreciation of the Neo-Impressionist painters themselves:

> *Et ma joie était grande de trouver dans un coin de Montmartre un si admirable exemplaire d'une race de peintres-théoriciens réunissant la pratique à l'Idée.*

> *Great was my joy in discovering, in a corner of Montmartre, such an estimable group of painter-theoreticians who fused practice with theory.*

"Georges Seurat," *L'Art dans les deux mondes* (18 April 1891):263.

Introduction

The young avant-garde art critic and champion Félix Fénéon (1861-1944) coined the term "Neo-Impressionism" in a review of the Eighth and last Impressionist exhibition in the spring of 1886. Camille Pissarro, an ardent Neo-Impressionist since earlier that year after encountering Georges Seurat's radical new "optical painting" in late 1885, had persuaded Impressionist colleagues to allow paintings by himself, Seurat, Paul Signac, and his son Lucien Pissarro to hang together in the same room. Pissarro, at age 56 a generation older than his new colleagues, proudly referred to the new style as "scientific Impressionism" to distinguish it from the "romantic Impressionism" of Monet, Renoir, Sisley, and other Impressionists. Seurat's *La Grande Jatte* (1884-86) stole the show as the largest and most controversial picture on view.

The novelty of these oddly luminescent, "mechanical" paintings comprised of tiny dots of pure colors startled audiences, critics, and the older Impressionists. Instead of random, variable brush strokes meant to express the sensations and optics of nature, there were uniform touches of pure hues (called *points* in French, hence "pointillism"), supposedly applied according to scientific principles and chromatic theories. Instead of colors mixed on the palette, areas of harmonious and contrasting colors were mixed optically by viewers, creating dazzling effects of heightened luminosity, even vibration that the Neo-Impressionists called "divisionism."

Similar to the Impressionists, however, the Neos adhered to basic tenets of French modernism: rejection of traditional academic methods of pictorial composition, preference for landscapes and scenes of everyday life instead of historical and religious subjects, and paintings that conveyed a sense of disillusionment with urbanization and capitalism. Small dots allowed the Neos to paint on dry areas of the canvas, in contrast to the Impressionists' technique of layered wet strokes designed to capture changing conditions of light and atmosphere. The new procedure was painstaking and tedious for some Neo-Impressionists. For Seurat and a few others in the group, the passion for color dots even extended to the borders around the canvasses. Seurat's unwieldy name for the style was "chromo-luminarism."

Neo-Impressionism was developed by Seurat in the early 1880s through study and experimentation with 19th-century scientific theories of color and light. Towards the end of his life, Seurat detailed his search for an "optical formula" of painting in a letter dated June 20, 1890 to the critic Félix Fénéon. In the letter, he cites the influence of the aestheticians Charles Blanc and David Sutter, the chemist Michel-Eugène Chevreul, the American

physicist Ogden Rood (Seurat purchased and annotated the French translation of Rood's *Modern Chromatics* shortly after it appeared in 1881), the mathematician and aesthetician Charles Henry (whose experiments he learned about in 1886 and whose later works included illustrations by Signac), the color disks of James Maxwell, and the chromatic theories of Heinrich-Wilhelm Dove. Blanc's *Grammaire des arts du dessin* (Paris: Renouard, 1867); Charles Henry's article "Introduction à une esthétique scientifique" (*La Revue contemporaine*, Aug. 1885, pp. 441-69); Chevreul's exploration of physiological responses to color and line; and Rood's treatise on color harmonies and contrasts that affirmed that optical mixture was superior to palette mixture provided Seurat with the intellectual and theoretical underpinnings of his Neo-Impressionist synthesis.

Between 1886 and Seurat's death in 1891, Neo-Impressionism emerged as the leading avant-garde movement, complete with, in the words of Martha Ward, "a theory-based manifesto and creed; a quick notoriety; a claim to historical legitimacy and advance based on models from science; a negation or transgression of conventional measures of artistic value; a defense of aesthetic purity in the name of social amelioration; an assertion of progress as a prerogative of youth." (*Pissarro, Neo-Impressionism, and the Spaces of the Avant-Garde*, Chicago & London: University of Chicago Press, 1996, p. 1).

Camille Pissarro (1830-1903) was Seurat's first convert in late 1885. He influenced his son Lucien (1863-1944) to adopt the new style. They were soon joined by Paul Signac (1863-1935), who became Seurat's principal disciple and successor. These four artists were the original Neo-Impressionists. Following the final Impressionist exhibition in the spring of 1886, other artists treated in this sourcebook entered the movement, including Albert Dubois-Pillet (1846-90), Maximilien Luce (1855-1941), the Belgian Théo Van Rysselberghe (1862-1926), Charles Angrand (1854-1926), and Henri Edmond Cross (1856-1910). Dozens of painters not included in this guide exhibited at various times with the Neo-Impressionists and experimented with Neo-Impressionist techniques and color theories. The 1968 Neo-Impressionism exhibition held at the Solomon R. Guggenheim Museum, New York, for example, included Neo-Impressionist paintings by 14 French artists (and another 9 "Contemporaries in France"), 5 Belgian artists, and 5 Danish artists, and Neo-inspired works by 18 Fauves and Cubists.

Nearly all of the Neo-Impressionist painters were active members of the political left during the 1880s and 1890s. Most maintained close connections with the literary intelligentsia of the period, who were deeply enamored with Symbolism. In many studies, Neo-Impressionism is viewed in light of contemporary political and social issues, counterbalanced by a strong belief in science as the solution to everything from social ills to the technical problems of painting. Neo-Impressionist anarchism primarily took the form of magazine illustrations and posters to bolster socialist propaganda, although Luce was imprisoned in the government's roundup of socialist sympathizers following the assassination of President Sadi Carnot in 1894.

Neo-Impressionist pictures shown at the final Impressionist show in 1886, especially Seurat's *La Grande Jatte*, garnered sufficient critical and public attention for the movement to blossom. Besides Fénéon, leading Symbolist critics and writers such as Gustave Kahn, Paul Adam, Emile Verhaeren, and Jean Ajalbert championed this radical departure from Impressionism and became friends with Seurat, Signac, and the others. In varying degrees

of intensity and duration, major artists beyond the core group who briefly embraced or experimented with Neo-Impressionism included van Gogh, Gauguin, Toulouse-Lautrec, Emile Bernard, Emile Schuffenecker, Henri Delavallée, and many others.

In Belgium, the new style made such inroads that by 1889 it was the dominant avant-garde movement. Les XX, since 1884 Belgium's leading exhibition society for modern art, welcomed the Neos in February, 1887. Both Seurat and Signac attended the show that year in Brussels. Octave Maus, Les XX's secretary and spokesman, proclaimed Seurat "the Messiah of a new art" in an article published in *L'Art moderne* on June 27, 1886. Seurat exhibited with Les XX in 1887, 1889, and 1891 and received a memorial show in 1892. In 1888, Signac showed 12 paintings and Dubois-Pillet 13. Belgian Vingtistes attracted to the Neo technique included Théo Van Rysselberghe, Henry Van de Velde, Alfred William Finch, Anna Boch, and Jan Toorop. Neo-Impressionism spread to Holland in 1892 and later attracted German and Italian artists.

Neo-Impressionism's first and most productive phase lasted from 1885 to about 1894. Group shows were held regularly in Paris, notably an exhibition in early 1893 at l'Hôtel Brébant and four shows at rue Laffitte in 1893-94. The movement suffered a serious setback from which it never fully recovered with Seurat's sudden death in 1891. Dubois-Pillet had died the year before, when Angrand gave up painting for drawing and retired to Normandy. In a much-publicized defection, Pissarro rejected what he came to regard as a tedious formula and returned to his earlier Impressionist style. Lucien Pissarro moved to London and Signac to Saint-Tropez.

Although never as puissant in its second phase, Neo-Impressionism was revived by articles written by Signac serialized in *La Revue blanche* in 1898. His defense of Neo-Impressionism, commonly referred to as the movement's manifesto, appeared in book form as *D'Eugène Delacroix au néo-impressionnisme* (Paris: Editions de la Revue blanche, 1899). The work was read by artists throughout Europe and was responsible for renewed interest in divisionism between 1900 and 1910, initially by the Fauve artists (especially Matisse and Derain) and later by German and Italian artists (especially the Futurists). In the 20th century, Robert Delaunay, Jean Metzinger, Gino Severini, Roy Lichtenstein, and others have experimented with pointillist luminosity.

Neo-Impressionism Chronology, 1881–1905

Information for this chronology was gathered from Robert L. Herbert, *Neo-Impressionism* (exh. cat., NY, Solomon R. Guggenheim Museum, 1968):240-47; Anne Distel, "Chronology" in *Georges Seurat, 1859-1891* (exh. cat., NY, Metropolitan Museum of Art, 1991):399-412; John Rewald, *Post-Impressionism: From van Gogh to Gauguin* (NY: Museum of Modern Art, 1978); Ellen Wardwell Lee, *The Aura of Neo-Impressionism: The W. J. Holliday Collection* (exh. cat., Indianapolis Museum of Art, 1983); Mary Martha Ward, *Pissarro, Neo-Impressionism, and the Spaces of the Avant-Garde* (Chicago & London: University of Chicago Press, 1996); and John G. Hutton, *Neo-Impressionism and the Search for Solid Ground* (Baton Rouge & London: Louisiana State University Press, 1994), among other sources. The following brief chronology includes highlights only; please refer to works cited above and to chronologies of individual Neo-Impressionist artists for more information.

1881

Publication of the French translation of the American physicist Ogden Rood's *Students' Textbook of Colour: or, Modern Chromatics, with Applications to Art and Industry* which, along with other newly published experimental studies on light and color including the color discs of James Maxwell and the theories of Heinrich-Wilhelm Dove, becomes the fundamental scientific Neo-Impressionist treatise on color theory and application for Seurat. A previously published work that greatly influenced Seurat is Michel-Eugène Chevreul's *De la loi du contraste simultané des couleurs et de l'assortiment des objets colorés considérés d'après cette loi dans ses rapports avec la peinture, les tapisseries...* (Paris: Pitois-Levrault, 1839).

1884

February
First exhibition of *Les XX*, founded in the previous year by Octave Maus, James Ensor, Théo Van Rysselberghe, and other Belgians. No contact with future Neo-Impressionist in Paris until 1886.
15 May-1 July
Salon des Artistes Indépendants, Paris includes works by Charles Angrand, Henri Edmond

Cross, Albert Dubois-Pillet, Paul Signac, and Seurat (*Une Baignade, Asnières*). Many Neo-Impressionists meet each other for the first time at this exhibition and show together again in December at the inaugural Société des Artistes Indépendants.

1885

Charles Henry publishes *Introduction à une esthétique scientifique*, a key Neo-Impressionist text. Seurat meets Pissarro, forms close relationships with Signac and Pissarro, and introduces both to color theories and dotted brush strokes. Pyotr Kropotkin's socialistic *Paroles d'un révolté* is published in Paris and attracts the attention of both Neo-Impressionists and Symbolists.

1886

Pissarro and Signac experiment with pointillism. Durand-Ruel's New York *Impressionists of Paris* exhibition includes Seurat's *Une Baignade, Asnières* and works by Pissarro and Signac.
May-June
Eighth and final Impressionist exhibition pits "scientific Impressionists" (Seurat, Signac, and Pissarro) against "romantic" Impressionists (Monet, Renoir, and others). Seurat's *Sunday Afternoon on the Island of the Grande Jatte* creates a sensation. Seurat and Signac meet Charles Henry, the young scientist whose writings on color theory and aesthetics influence them profoundly.
August-September
Angrand, Cross, Dubois-Pillet, Seurat, and Signac show at the Indépendants. In a review published in the Belgian journal *L'Art moderne* (19 Sept. 1886):300-2, critic Félix Fénéon coins the term "Neo-Impressionism" in proclaiming the new style as the successor to Impressionism. At the end of October, *La Vogue* publishes Fénéon's pamphlet *Les Impressionnistes en 1886*, which delineates Seurat's role as the originator of Neo-Impressionism. Neo-Impressionist and Symbolist writers who defend their style in reviews meet at banquets and informal dinner meetings sponsored by La Société des Artistes Indépendants and *La Revue indépendante*.

1887

February
Seurat causes a sensation with *La Grande Jatte* at *Les XX*, Brussels and begins friendships with Belgian painters and writers. A group of Vingtistes Neo-Impressionists emerges led by Alfred William Finch, Anna Boch, Henry Van de Velde, Théo Van Rysselberghe, Jan Toorop, and later Georges Lemmen.
March-May
Les Indépendants is dominated by Angrand, Cross, Dubois-Pillet, Luce, Seurat, Signac, and others, who show together in the same rooms. Signac meets van Gogh, who experiments with Neo-Impressionism; for a short time Gauguin and his circle also try the new style.

1888

Neo-Impressionists show at *Les XX* (Signac with 12 paintings, Dubois-Pillet with 13), Brussels. *La Revue indépendante* holds successive individual-artist shows for Seurat, Signac, Dubois-Pillet, Luce, and other Neo-Impressionists throughout the year. Charles

Henry publishes *Cercle chromatique* (Paris: Charles Verdin, 1888), for which Signac produces the advertising graphics, and *Rapporteur esthétique* (Paris: G. Séguin, 1888).

1889

Neo-Impressionists show at *Les XX*, Brussels, joined by new Belgian members, and at *Les Indépendants*, Paris. Camille Pissarro begins to modify his pointillist technique and returns to an earlier Impressionist style.

1890

Neo-Impressionism dominates *Les XX* and *Les Indépendants*. Dubois-Pillet dies in August. Pissarro continues his much-publicized defection from the movement, citing tedium with formulae. Angrand is also disenchanted.

1891

French and Belgian Neo-Impressionists participate in *Les XX* and in *Les Indépendants*, during which Seurat dies of diphtheria at age 31. Pissarro leaves Neo-Impressionism behind and the Nabis, led by Gauguin and championed by the Symbolists, displace the Neo-Impressionists as the dominant avant-garde artists of the early 1890s. Le Barc de Boutteville, Paris, holds the first of several joint Nabis and Neo-Impressionist exhibitions. Cross produces his first mature Neo-Impressionist works and settles on the Mediterranean.

1892

Belgian Neo-Impressionists dominate the movement as Van de Velde and Toorop organize exhibitions in The Hague and in Antwerp. Seurat memorial retrospectives are held at *Les XX*, *La Revue Blanche*, and *Les Indépendants*. Signac paints in Saint-Tropez, where he later builds a villa. Le Barc de Boutteville holds two Nabis Neo-Impressionist shows and at the end of the year the first exhibition devoted solely to Neo-Impressionism takes place at l'Hôtel Brébant, Paris.

1893

Les XX continues to show Neo-Impressionist works while Belgian artists are attracted to art nouveau and Arts and Crafts. Galerie Laffitte, Paris, with help at first from Antoine de la Rochefoucauld and later Léonce Moline, holds single and group Neo-Impressionist shows over the next three years.

1894

La Libre Esthétique succeeds *Les XX* in Brussels, where Neo-Impressionism wanes. Galerie Laffitte, Paris, holds three *Groupe des peintres néo-impressionnistes* exhibitions.

1895

Galerie Laffitte shows 24 paintings and 13 drawings by Seurat and holds an individual-artist exhibition for Van Rysselberghe. Samuel Bing opens his Salon de l'Art nouveau, Paris, in December with a Neo-Impressionist/Nabi exhibition.

1896

Signac publishes articles about Neo-Impressionism in *La Revue blanche* and other journals, reviving interest in the movement by younger artists including Matisse and future Fauves.

1897

Julius Meier-Graefe, a German art critic and historian, buys Seurat's *Chahut* and commissions Van de Velde to prepare a special frame and matching furniture. Cross and Luce show at *La Libre Esthétique*, joined by Signac at *Les Indépendants.*

1898

Van Rysselberghe moves to Paris and later to the Mediterranean to work near Cross and Signac. Neo-Impressionism loses its impact in Belgium. Signac publishes *D'Eugène Delacroix au néo-impressionnisme* first in installments in *La Revue blanche* and the following year as a book. Dedicated to Seurat, it becomes the seminal text on the movement. In Germany, Count Harry Kessler acquires Seurat's *Poseuses*. With Van de Velde's assistance, Kessler organizes the first Neo-Impressionist exhibition in Germany at Keller and Reiner, Berlin and arranges for excerpts of Signac's articles to appear in the German magazine *Pan*. Van Rysselberghe shows in the Vienna *Secession*.

1899

Publication in book form of Signac's *D'Eugène Delacroix au néo-impressionnisme* (Paris: Editions de la Revue Blanche, 1899). Durand-Ruel, Paris devotes three rooms to the Neo-Impressionists and Nabis and gives Luce a single-artist show.

1900

Major Seurat retrospective by *La Revue blanche*.

1901

Keller and Reiner, Berlin regularly shows Neo-Impressionism.

1902

Neo-Impressionism shows in Germany; collections form in Hagen, Weimar, and Berlin.

1903

Druet's new Parisian gallery specializes in Neo-Impressionist work until 1914. Neo-Impressionist shows in Berlin, Weimar, Hamburg, and other German cities. Signac's *D'Eugène Delacroix au néo-impressionnisme* is translated into German; he receives a single-artist exhibition at Cassirer, Berlin.

1904

Early Fauvism is characterized by a strong Neo-Impressionist influence. Cross and Signac

host many Fauves in their Mediterranean villas. Matisse paints with Signac and enters a Neo-Impressionist phase; André Derain is similarly affected. Signac and Luce exhibit at Galerie Druet, Paris. *La Libre Esthétique* holds a major retrospective of Impressionism and Neo-Impressionism.

1905

Cross and Van Rysselberghe hold shows at Druet's. Fauvism, led by Matisse, reigns at the Salon d'Automne, Paris.

Common Abbreviations

cat.	catalogue
col.	color
diss.	dissertation
dist.	distributed
ed(s.)	edition(s) or editor(s)
exh.	exhibition
illus.	illustrations
min.	minutes
no. or nos.	numbers
p. or pp.	page(s)
pl.	plate(s)
rev.	revised
ser.	series
supp.	supplement
vol(s).	volumes

Neo-Impressionism
in General

I. Manuscripts

1. Brussels, Archives de l'art contemporain, Musées royaux. *Les XX, La Libre Esthétique, Octave Maus.* Holographs.

Maus (1856-1919) was secretary of Les XX and La Libre Esthétique exhibition societies and co-founder of Belgium's leading avant-garde art journal, *L'Art moderne.* Includes letters from Seurat and other Neo-Impressionists as well as documentation for the Brussels exhibitions, 1884-1914.

2. Brussels, Bibliothèque de Belgique. *Henry Van de Velde.* Holographs.

Henry Van de Velde (1863-1957), a Belgian designer, painter, architect and writer, was a leading figure in the creation of Art nouveau in the 1890's. Archive includes thousands of letters from Neo-Impressionists and other artists and personal manuscripts of Van de Velde.

3. Brussels, Bibliothèque royale de Belgique. *Emile Verhaeren.* Holographs.

Verhaeren (1855-1916) was a Belgian symbolist, poet, and critic who defended Les XX and La Libre Esthétique avant-garde art societies as well as Neo-Impressionism. Archive includes Verhaeren's literary estate and letters from Seurat, Signac, and other Neo-Impressionists.

4. Paris, Bibliothèque Doucet. *Félix Fénéon.* Holographs.

Miscellaneous documents and letters concerning Fénéon (1861-1944), critic and champion of the Neo-Impressionists. Fénéon, a friend and admirer of Seurat and Signac, published a

collection of Neo-Impressionist criticism in *Les Impressionnistes en 1886*(Paris: Publications de la Vogue, 1886).

5. VAN DE VELDE, HENRY. *Peinture moderne.* Unpublished manuscript, written before 1930. Van de Velde Archive, Brussels, Bibliothèque royale, Musée de la littérature, FSX/79.

6. VAN DE VELDE, HENRY. *Autobiography.* Typewritten manuscript. Van de Velde Archive, Brussels, Bibliothèque royale, Musée de la littérature, FSX/4.

II. Books

7. AJALBERT, JEAN. *Mémoires en Vrac au temps du symbolisme, 1880-1890.* Paris: A. Michel, 1938. 413 p., illus., pl.

Mentions Neo-Impressionists and Symbolism.

8. ALEXANDRE, ARSÈNE. *La Collection Canonne.* Paris: Editions Bernheim-Jeune et Renaissance de l'Art, 1930. 129 p., illus., pl.

9. AMAN-JEAN, FRANÇOIS. *Souvenir d'Aman-Jean.* Paris: Musée des Arts décoratifs, 1970. 58 p., illus.

Catalogue of an exhibition organized by the Union Centrale des arts décoratifs, held at the Musée des Arts décoratifs, 4 April-4 May 1970. Aman-Jean (1858-1936) was a friend of Seurat and a fellow pupil in Justin Lequier's drawing courses.

10. ANDRY-BOURGEOIS, C. *L'Oeuvre de Charles Henry et le problème de la survie.* Paris: Meyer, 1931. 60 p., illus.

11. ANGRAND, PIERRE. *Naissance des Artistes Indépendants, 1884.* Paris: Nouvelles Editions Debresse, 1965. 127 p.

History of Les Indépendants, the exhibition society that fostered Neo-Impressionism.

12. APOLLINAIRE, GUILLAUME. *Chroniques d'art, 1902-1918.* Textes réunis avec préf. et notes par L.C. Breunig. Paris: Gallimard, 1960. 524 p.

Collection of art criticism that includes many references to Neo-Impressionism.
a. Other eds.: 1981; 1993.
b. U.S. eds.: *Apollinaire on Art: Essays and Reviews, 1902-1918.* Trans. by Susan Suleiman. NY: Viking, 1972; NY: Da Capo, 1988.
c. English ed.: London, Thames & Hudson, 1972. 546 p., illus.
d. Italian ed.: *Cronache d'arte 1902-1918.* Edizione Italiana a cura di Vittorio Fagone; traduzione di Maria Croci Gulì. Palermo: Novecento, 1989. 472 p.

13. ARGÜELLES, JOSE A. *Charles Henry and the Formation of a Psychophysical Aesthetic.* Ph.D. Thesis, University of Chicago, 1969. 193 p.

Bibliography, pp. 182-94.

a. Printed version: Chicago: University of Chicago Press, 1972. 200 p.

14. AURIER, GABRIEL-ALBERT. *Oeuvres posthumes*. Avec un autographe de l'auteur et un portrait gravé à l'eau-forte par A.-M. Lauzet. Notice de Remy de Gourmont. Dessins et croquis de G.-Albert Aurier, Vincent van Gogh, Paul Sérusier, Emile Bernard, Jeanne Jacquemin, Paul Vogler. Paris: Mercure de France, 1893. 480 p. illus.

15. BARROWS, SUSANNA. *Distorting Mirrors: Visions of the Crowd in Late Nineteenth-Century France*. New Haven: Yale University Press, 1981. 221 p. (Yale Historical Publications. Miscellany, no. 127)

16. BASLER, ADOLPHE and CHARLES KUNSTLER. *La Peinture indépendante en France*. Paris: G. Crès, 1928. 2 vols.

For information on the Neo-Impressionists, see vol. 1, *De Monet à Bonnard*.

17. BAZIN, GERMAIN. *L'Epoque impressionniste*. Avec notices biographiques et bibliographiques. Paris: P. Tisné, 1947. 93 p., 95 pl.

a. Other eds.: 1953; Paris: Somogy, 1982.

18. BAZIN, GERMAIN. *Les Impressionnistes au Musée d'Orsay*. Paris: Somogy, 1990. 280 p., 222 illus., 212 col.

Introduction to the Impressionists that examines the work of 24 prominent Impressionist artists held in the collection of the Musée d'Orsay in Paris, including Camille Pissarro, Seurat, and Signac.

19. BERGER, KLAUS. *Japonismus in der westlichen Malerei, 1860-1920*. Munich: Prestel-Verlag, 1980. 368 p., illus. (Studien zur Kunst des neunzehnten Jahrhunderts, no. 41)

a. English ed.: *Japonisme in Western Painting from Whistler to Matisse*. Trans. by David Britt. Cambridge: Cambridge University Press, 1992. 397 p., illus.

20. BERNHEIM DE VILLERS, GASTON. *Petites histoires sur de grands artistes*. Paris: Bernheim-Jeune, 1940. 180 p., illus.

a. U.S. ed.: *Little Tales of Great Artists*. Trans. and edited by Denys Sutton. NY: E. Weyhe, 1949. 105 p., illus., 32 pl.

21. BESSON, GEORGE. *Le Musée chez soi; les maîtres de la peinture française, 1850-1950*. Paris: Braun, 1958. 158 p., illus.

22. BILLY, ANDRE. *L'Epoque 1900; 1885-1905*. Paris: Jules Tallandier, 1951. 484 p. (Histoire de la vie littéraire)

23. BLANC, CHARLES. *Grammaire des arts du dessin. Architecture, sculpture, peinture*. Paris: Renouard, 1867. 720 p., illus.

Seminal treatise on color theory and luminosity that influenced Seurat's development of Neo-Impressionism in the early 1880s, first published in *Gazette des Beaux-arts* (1860-66).
a. 2nd ed.: Paris: Renouard, 1870.
b. 3rd ed.: Paris: Renouard, 1876.

24. BLANCHE, JACQUES-EMILE. *Les Arts plastiques.* Préface de Maurice Denis. Paris: Editions de France, 1901. 529 p. (La Troisième République, 1870 à nos jours, no. 8)

25. BLANCHE, JACQUES-EMILE. *La Pêche aux souvenirs.* Paris: Flammarion, 1949. 457 p.

26. BLOCK, JANE. *Les XX and the Belgian Avant-Gardism 1868-1894.* Ph.D. thesis, University of Michigan, 1980. 436 p.

a. Printed version: Ann Arbor, Michigan: UMI Press, 1984. 185 p., illus. (Studies in the Fine Arts. Avant-garde, no. 41)

27. BLOCK, JANE, ed. *Belgium, the Golden Decades, 1880-1914.* NY: P. Lang, 1997. 264 p., 64 illus. (Belgian Francophone Library, no. 3)

Includes references to the Neo-Impressionists and Les XX and La Libre Esthétique exhibition societies.

28. BOCK, CATHERINE CECELIA. *Henri Matisse and Neo-Impressionism, 1898-1908.* Ph.D. thesis, University of California at Los Angeles, 1977. 447 p., 143 illus.

Details Matisse's exposure to and study of Neo-Impressionism and its formative influence.
a. Printed ed.: Ann Arbor, Michigan: UMI Press, 1981. 216 p., illus. (Studies in the Fine Arts: the Avant Garde, no. 13)

29. BOIGEY, MAURICE. *La Science des couleurs et l'art du peintre.* Préface de J.-F. Bouchor. Paris: Librairie Félix Alcan, 1923. 176 p., illus. (Art et esthétique).

30. BOIME, ALBERT. *The Academy and French Painting in the Nineteenth Century.* London; NY; Phaidon; dist. in the U.S. by Praeger, 1971. 330 p., 161 illus., pl.

a. Another ed.: New Haven; London; Yale University Press, 1986. 330 p., illus.

31. BOURGEOIS, CHARLES GUILLAUME ALEXANDRE. *Mémoire sur les lois que suivent dans leurs combinaisons entre elles, les couleurs produites par la réfraction de la lumière, ainsi que celles transmises ou réfléchies par les corps dits naturellement colorés. Lu à la classe des sciences physiques et mathématiques de l'Institut impérial de France, le 22 juin 1812.* Paris, Chez l'auteur. 80 p.

32. BOURGEOIS, CHARLES GUILLAUME ALEXANDRE. *Leçons expérimentales d'optique sur la lumière et les couleurs.* Paris, 1816-17.

33. BOURGEOIS, CHARLES GUILLAUME ALEXANDRE. *Manuel d'optique expérimentale, à l'usage des artistes et des physiciens.* Paris: L'Auteur, 1821. 196 diagrams on 40 pl.

34. BRACQUEMOND, FELIX. *Du dessin et de la couleur.* Paris: G. Charpentier, 1885.

35. BRETTELL, RICHARD R. and CAROLINE B. BRETTELL. *Les Peintres et le paysan au XIX^e siècle.* Geneva: Skira, 1983. 167 illus.

Bibliography, p. 153.

36. BRIDGMAN, FREDERICK ARTHUR. *L'Anarchie dans l'art.* Traduit de l'anglais. Paris: Société française d'éditions d'art, 1898. 248 p.

37. BRÜCKE, ERNST RITTER VON. *Principes scientifiques des beaux-arts; essais et fragments de théorie; suivis de l'optique et la peinture par Hermann Helmholtz.* Paris: Librairie G. Ballière, 1878. (Bibliothèque scientifique internationale, no. 26)

Includes a contribution by Hermann von Helmholtz, "L'Optique et la peinture."
a. Another ed.: Paris: F. Alcan, 1885.

38. CALLEN, ANTHEA. *Artists' Materials and Techniques in Nineteenth-Century France.* Ph.D. thesis, London University, Courtland Institute of Art, 1980. 513 p.

Analyzes artistic techniques of 30 individual paintings in detail, dating 1860-1905. Includes works by Pissarro, Signac, and Seurat.
a. English eds.: *Techniques of the Impressionists.* London: Orbis, 1982. 192 p., illus.; London: New Burlington Books, 1985; 1987.
b. U.S. ed.: Secaucus, NJ: Chartwell Books, 1982.
c. French ed.: *Les Peintres impressionnistes et leur technique.* Paris, 1983.

39. CANNING, SUSAN MARIE. *A Preliminary Study and Catalogue of Expositions of the Belgian Group Les Vingt, 1883-1893.* M.A. thesis, Pennsylvania State University, 1973. 204 p.

40. CANNING, SUSAN MARIE. *A History and Critical Review of the Salon of 'Les Vingt,' 1884-1893.* Ph.D. diss., Pennsylvania State University, 1980. 529 p.

41. CARR, REGINALD P. *Anarchism in France: The Case of Octave Mirbeau.* Montréal: McGill/Queen's University Press; Manchester: Manchester University Press, 1977. 190 p.

42. CASSOU, JEAN. *Panorama des arts plastiques contemporains.* Paris: Gallimard, 1960. 796 p., 117 illus. (Le Point du jour)

43. CHAMPA, KERMIT SWILER. *Studies in Early Impressionism.* New Haven and London: Yale University Press, 1973. 106 p., illus.

a. Another ed.: NY: Hacker Art Books, 1985. 106 p., illus., 105 pl.

44. CHARPENTIER, AUGUSTIN. *La Lumière et les couleurs au point de vue physiologique.* Paris: J. B. Baillière et fils, 1888. 352 p., 22 illus. (Bibliothèque scientifique contemporaine)

45. CHASSE, CHARLES. *Le Mouvement Symboliste dans l'art du XIXᵉ siècle: Gustave Moreau – Redon – Carrière; Gauguin et le groupe de Pont-Aven; Maurice Denis.* Paris: Floury, 1947. 215 p., illus.

46. CHENNEVIERES, PHILIPPE DE. *Souvenirs d'un directeur des Beaux-arts.* Paris: Aux bureaux de l'artiste, 1883-89. 5 vols.

a. Another ed.: Paris: Arthena, 1979. 671 p., illus., 56 pl.

47. CHEVREUL, MICHEL-EUGENE. *De la loi du contraste simultané des couleurs et de l'assortiment des objects colorés.* Paris: Pîtois-Levrault, 1839. 735 p., illus., atlas.

French chemist whose experiments and writings on color contrasts and harmonies influenced Neo-Impressionism. Seurat, who probably learned of Chevreul's theoretical discussion of the law of simultaneous contrast of colors from reading Charles Blanc's *Grammaire des arts du dessin* (Paris: Renouard, 1867), copied out sections regarding how adjacent complementary colors affected each other, indicative of Seurat's attraction to this aspect of Chevreul's numerous color theories.
a. Other eds.: Paris: Imprimerie Nationale, 1889; Paris: L. Laget, 1969.
b. English eds.: *The Principles of Harmony and Contrast of Colours.* Trans. by Charles Martel. London: Longman, Brown, Green and Longmans, 1854, 1855, 1857, 1859, 1860, 1868, 1872, 1881, 1887, 1889, 1890, 1903, 1910.
c. U.S. eds.: NY: Reinhold Publications, 1967; NY: Garland, 1980; NY: Von Nostrand Reinhold, 1981; Westchester, Pennnsylvania: Schiffer Publications, 1987.

48. CHEVREUL, MICHEL-EUGENE. *Des couleurs et de leurs applications aux arts industriels. A l'aide des cercles chromatiques.* Paris: J. B. Ballière et fils, 1864. 26 p., 27 col. pl.

a. Another ed.: 1888.

49. CHEVREUL, MICHEL-EUGENE. *Des arts qui parlent aux yeux au moyen de solides colorés d'une étendue sensible et en particulier des arts du tapissier des Gobelins et du tapissier de La Savonnerie.* Paris, 1867.

Excerpted from an article first published in *Journal des savants* (1866).

50. CLARK, TIMOTHY J. *The Painting of Modern Life: Paris in the Art of Manet and his Followers.* Princeton, NJ: Princeton University Press, 1984. 338 p., illus., 32 pl.

a. Other eds.: NY: Knopf, 1985; 1986; 1989.
b. English ed.: London: Thames and Hudson, 1985.
Review: J. House, *Burlington Magazine* 128:997(April 1986):296-7.

51. COGNIAT, RAYMOND. *Le Salon entre 1880 et 1900.* Catalogue par Raymond Cogniat; préface de Paul Chabas. Paris: Expositions de Beaux-arts de la Gazette des Beaux-arts, 1934. 34 p., illus. (Les Etapes de l'art contemporain)
Printed catalogue of an exhibition held April-May 1934 in Paris at *La Gazette des Beaux-arts.*

52. COGNIAT, RAYMOND. *Le Siècle des Impressionnistes.* Paris: Flammarion, 1959. 207 p., illus., pl.

53. COQUIOT, GUSTAVE. *Cubistes, futuristes, passéistes, essai sur la jeune peinture et la jeune sculpture, avec 48 reproductions.* Paris: Librairie Ollendorf, 1914. 277 p., pl.

a. Rev. ed.: 1923.

54. COQUIOT, GUSTAVE. *Les Indépendants, 1884-1920.* Paris: Librairie Ollendorf, 1920. 239 p., illus., 40 pl.

55. COQUIOT, GUSTAVE. *Des peintres maudits.* Paris: A. Delpeuch, 1924. 218 p., illus.

56. COUYBA, CHARLES-MAURICE. *L'Art et la démocratie: les écoles, les théâtres, les manufactures, les musées, les monuments.* Paris: E. Flammarion, 1900. 363 p.

a. Another ed.: 1902.

57. DARDEL, ALINE. *Catalogue des dessins et publications illustrées du journal anarchiste 'Les Temps nouveaux,' 1894-1914.* Ph.D. thesis, Université de Paris (IV), 1980. 2 vols.

58. DENIS, MAURICE. *Les Théories, 1890-1910, du Symbolisme et de Gauguin vers un nouvel ordre classique.* Paris: Bibliothèque de l'Occident, 1912. 270 p.

a. Other eds.: Paris: Rouart et Watelin, 1913; 1920; 1960.
Reviews: H. Ghéon, *Nouvelle revue française* 45(1 Sept. 1912):537-43; *Le Temps* (22 Oct. 1912):4; L. Vauxcelles, *Gil blas* (2 Aug. 1913); A. Soffici, *La Voce* 3(1913):1003.

59. DESTREE, JULES. *Art et socialisme.* Brussels: Journal le Peuple, 1896. 32 p. (Bibliothèque de propagande socialiste)

60. DORIVAL, BERNARD. *Les Etapes de la peinture française contemporaine.* Paris: Gallimard, 1943-48. 4 vols.

See vol. 1, *De l'impressionnisme au fauvisme, 1883-1905.* "Notice bibliographique," vol. 1, pp. 275-84.

61. DORIVAL, BERNARD. *L'Ecole de Paris au Musée National d'Art moderne.* Paris: Somogy, 1961. 324 p., col. pl.

a. U.S. ed.: *The School of Paris in the Musée d'Art moderne.* Trans. by Cornelia Brookfield and Ellen Hart. NY: Abrams, 1962. 316 p., illus.

62. DORRA, HENRI, ed. *Symbolist Art Theories: A Critical Anthology.* Berkeley: University of California Press, 1994. 396 p., 50 illus.
Compilation of 60 essays and writings by artists and critics that includes texts by Seurat and Signac in "The Post Impressionists" section.

63. DUMAS, HORACE. *La Physique des couleurs et la peinture*. Paris: Les Presses Universitaires de France, 1930. 171 p., diagrs.

64. DUNSTAN, BERNARD. *Painting Methods of the Impressionists.* NY: Watson-Guptill Publications, 1976. 184 p., illus.

a. Rev. ed.: 1983. 160 p., illus.

65. DUVAL, ELGA LIVERMAN. *Téodor de Wyzewa: A Critic Without a Country*. Ph.D. thesis, Columbia University, 1980. 304 p.

a. Printed ed.: Geneva; Paris: Droz, 1961. 173 p., illus.

66. EGBERT, DONALD DREW. *Social Radicalism and the Arts: Western Europe; a Cultural History from the French Revolution to 1968.* NY: A. A. Knopf, 1970. 821 p., 53 illus.

67. ESCHOLIER, RAYMOND. *La Peinture française, XXe siècle.* Paris: Floury, 1937. 144 p., illus., col. pl.

68. EVENSON, NORMA. *Paris: A Century of Change, 1878-1978.* New Haven and London: Yale University Press, 1979. 382 p., illus.

69. FAURE, ELIE. *Histoire de l'art: l'art moderne*. Paris: G. Crès, 1921. 468 p., illus.

a. Revised eds.: Paris : Le Livre de Poche, 1964. 2 vols.; Paris: Pauvert, 1984. 548 p., illus.

70. FENEON, FELIX. *Les Impressionnistes en 1886.* Paris: Publications de la Vogue, 1886. 42 p.

Anthology of criticism that includes Neo-Impressionist texts, including reference to Seurat's role in the development of Neo-Impressionism.

71. FENEON, FELIX, ed. *L'Art moderne et quelques aspects de l'art d'autrefois*. Paris: Bernheim-Jeune, 1919. 2 vols.

For information on Seurat, see vol. 1, pp. 55-60.

72. FENEON, FELIX. *Oeuvres*. Introduction de Jean Paulhan. Paris: Gallimard, 1948. 478 p.

a. Another ed.: 1991.

73. FENEON, FELIX. *Au-delà de l'impressionnisme*. Textes réunis et présentés par Françoise Cachin. Paris: Hermann, 1966. 187 p., illus. (Miroirs de l'art)

Selection of texts from Neo-Impressionism's principal critic and defender.

74. FENEON, FELIX. *Oeuvres plus que complètes*. Textes réunis et présentés par Joan U.

Halperin. Genève: Librairie Droz, 1970. 2 vols. (1087 p.), illus., 23 pl. (Histoire des idées et critique littéraire, no. 107)

Collection of critical writings by the influential art critic Félix Fénéon (1861-1944), who championed numerous Impressionist and Neo-Impressionist artists and was Seurat's most important critic. Volume 1, *Chroniques d'art*; volume 2, *Les Lettres, les mœurs.*

75. FEVRE, HENRY. *Etude sur le Salon de 1886 et sur l'Exposition des impressionnistes.* Paris: Tresse et Stock, 1886. 50 p.

"Extrait de la *Revue de demain.*"

76. FIORI, TERESA. *Archivi del divisionismo.* Raccolti e ordinati da Teresa Fiori. Rome: Officina edizioni, 1968. 2 vols., pl. (Archivi dell'arte contemporanea)

Bibliography, vol. 1, pp. 459-537.

77. FLAGG, PETER S. *The Neo-Impressionist Landscape.* Ph.D. diss., Princeton University, 1988. 511 p., illus. (vol. 1, text; vol. 2, illustrations)

Examines Neo-Impressionist landscapes by Seurat, Paul Signac, Henri Edmond Cross, and Camille and Lucien Pissarro. First used in Seurat's *Un Dimanche après-midi sur l'Ile de la Grande-Jatte*, divisionism became increasingly decorative with Signac and Cross. Bibliography, pp. 325-80; Figures, pp. 381-460.

78. FOCILLON, HENRI. *La Peinture aux XIX^e et XX^e siècles; du réalisme à nos jours.* Ouvrage illustré de 210 gravures. Paris: Librairie Renouard, 1928. 524 p., illus. (Manuels d'histoire de l'art)

a. Another ed.: Paris: Flammarion, 1991. 2 vols.

79. FONTAINAS, ANDRE and LOUIS VAUXCELLES. *Histoire générale de l'art français de la Révolution à nos jours.* Paris: Librairie de France, 1922. 3 vols. 120 pl. See vol. 1, *La Peinture, la gravure, le dessin*, pp. 159-68. Vol. 2 also by Georges Gromort; vol. 3 by Gabriel Mourey.

80. FRANCASTEL, PIERRE. *L'Impressionnisme; les origines de la peinture moderne de Monet à Gauguin.* Paris: La Librairie "Les Belles Lettres," 1937. 271 p., 12 pl. (Publications de la Faculté des lettres de Strasbourg, 2 ser., no. 16)

81. GACHET, PAUL. *Deux amis des impressionnistes: le Dr. Gauchet et Murer.* Paris: Editions des Musées Nationaux, 1956. 232 p., illus., 96 pl.

82. GAGE, JOHN. *Colour and Culture.* London: Thames and Hudson, 1993. 335p., illus.

a. U. S. ed.: Boston: Little, Brown and Co., 1993.

83. GAUSS, CHARLES EDWARD. *The Aesthetic Theories of French Artists, 1965 to the Present.* Baltimore: John Hopkins Press, 1949. 111 p.

a. Other eds.: 1966, 1973.

84. GEFFROY, GUSTAVE. *La Vie artistique 1892 à 1903.* Paris: E. Dentu, 1892-1903. 8 vols., illus.

85. GEORGE, WALDEMAR. *Le Dessin français de David à Cézanne et l'esprit de la tradition baroque.* Paris: Editions des Chroniques du Jour, 1929. 89 p., 97 pl.

86. GEORGE, WALDEMAR. *Profits et pertes de l'art contemporain.* Paris: Editions des Chroniques du Jour, 1932. 150 p., illus., pl. (Vers un nouvel humanisme)

a. Italian ed.: *Profitti e perdite dell'arte contemporanea.* Traduzione di A. Soffici. Florence: Vallechi, 1933. 193 p.

87. GORDON, JAN. *Modern French Painters.* London: J. Lane, The Bodley Head, 1923. 188 p., illus., col. pl.

a. Other eds.: 1926; 1929; 1936; Freeport, NY: Books for Libraries Press, 1970.

88. GREENSPAN, TAUBE G. *'Les Nostalgiques' Re-examined: The Idyllic Landscape in France, 1890-1905.* Ph.D. diss., City University of New York, 1981. 539 p., illus.

Examines various interpretations of the idyllic theme in French symbolism. Cross, Signac, and Van Rysselberghe are cited for contributions to the pastoral iconography of the 1890s. Bibliography, pp. 423-47.

89. GUILLEMIN, AMEDEE VICTOR. *La Lumière et les couleurs.* Ouvrage illustré de 71 figures gravées sur bois. Paris: Hachette, 1874. illus. (Petite encyclopédie populaire)

90. HALBERTSMA, KLAAS TJALLING AGNUS. *A History of the Theory of Colour.* Amsterdam: Swets Zeilinger, 1949. 267 p., illus.

General history of the 19th century color theory.

91. HALPERIN, JOAN UNGERSMA. *Félix Fénéon and the Language of Art Criticism.* Ann Arbor, Michigan: UMI Research Press, 1980. 243 p., 22 pl. (Studies in Fine Arts; Criticism, no. 6)

92. HALPERIN, JOAN UNGERSMA. *Félix Fénéon, Aesthete and Anarchist in Fin-de-Siècle Paris.* With a forward by Germaine Brée. New Haven and London: Yale University Press, 1988. 425 p., illus.

Bibliography, pp. 401-11.

93. HAMANN, RICHARD. *Der Impressionismus in Leben und Kunst.* Cologne: M. Dumont-Schauberg, 1907. 319 p., pl.

a. 2nd ed.: Marburg: Verlag des Kunstgeschichtlichen Seminars, 1923.

94. HAMMACHER, ABRAHAM MARIE. *Le Monde de Henry Van de Velde.* Anvers:

Editions Fonds Mercator; Traduction française par Claudine Lemaire. Paris: Hachette, 1967. 356 p., illus.

95. HEMMINGS, FREDERICK WILLIAM JOHN. *Culture and Society in France, 1848-1895. Dissidents and Philistines.* NY: Charles Scribner's Sons; London: Batsford, 1971. 280 p., illus., 24 pl. (Studies in Cultural History)

Bibliography, pp. 264-8.

96. HENKELS, HERBERT. *La Vibration des couleurs. Mondriaan-Sluijters-Gestel.* The Hague,: Haags Gemeentemuseum, 1985. 31 p.

97. HENNEQUIN, EMILE. *La Critique scientifique.* Paris: Perrin, 1888. 246 p.

a. Other eds.: 1890; 1894; NY: Johnson Reprint Corp., 1970; Heidelberg: C. Winter, 1982.
b. Italian ed.: *La Critica scientifica.* Traduzione di Gianpiero Ghini. Florence: Alinea, 1983. 137 p., illus.

98. HENRY, CHARLES. *Cercle chromatique présentant tous les compléments et toutes les harmonies de couleurs avec une introduction sur la théorie générale de la dynamogénie, autrement dit: du contraste, du rhythme et de la mesure.* Paris: Charles Verdin, 1888. 168 p., illus.

Important text on color harmonies and contrasts utilized by the Neo-Impressionists. Illustrations designed by Paul Signac.
Review: G. Lechalas, *Revue philosophique* 28(Dec. 1889):635-45.

99. HENRY, CHARLES. *Rapporteur esthétique. Notice sur ses applications à l'art industriel, à l'histoire de l'art, à l'interprétation de la méthode graphique en général, à l'étude et à la rectification esthétique de toutes formes.* Paris: Séguin 1888. 22 p.

Review: G. Lechalas, *Revue philosophique* 28(Dec. 1889):635-45.

100. HENRY, CHARLES. *Eléments d'une théorie générale de la dynamogénie autrement dit du contraste, du rythme et de la mesure avec applications spéciales aux sensations visuelle et auditive.* Bruges: Imprimé par Desclée, de Brouwer et Cie, 1889. 56 p., pl., diagrs.

101. HENRY, CHARLES and PAUL SIGNAC. *Application de nouveaux instruments de précision (cercle chromatique, rapporteur et triple-décimètre) à l'archéologie.* Paris: Leroux, 1890.

102. HENRY, CHARLES. *Harmonies de formes et de couleurs: démonstrations pratiques avec le rapporteur esthétique et le cercle chromatique.* Paris: Librairie Scientifique A. Hermann, 1891. 65 p.

Account of a conference session held 27 March 1890.

103. HENRY, CHARLES. *Quelques aperçus sur l'esthétique des formes.* Dessins et calculs de Paul Signac. Paris: La Revue Blanche, 1895.

104. HERBERT, EUGENIA W. *The Artist and Social Reform; France and Belgium,*

1885-1898. New Haven, CT: Yale University Press, 1961. 236 p., illus. (Yale Historical Publications. Miscellany, no. 74)

Concentrates on links between social ideals and art of French and Belgian Neo-Impressionists.
a. Other eds.: Freeport, NY: Books for Libraries Press, 1971, 1980.

105. HERBERT, ROBERT L. *Impressionism: Art, Leisure and Parisian Society.* New Haven, CT; London: Yale University Press, 1988. 324 p., illus.

Bibliography, pp. 314-5.
a. Reprint: 1991.
b. French ed.: *Les Plaisirs et les jours, l'impressionnisme.* Paris, 1988.

106. HESS, WALTER. *Die Farbe in der modernen Malerei: Selbstzeugnisse französischer und deutscher Maler zum Problem der Farbe seit Cézanne.* Ph.D. thesis, Munich, 1949. 292 p.

Examines 19th and 20th century color theories, mostly in the words of artist-practitioners. Includes statements by Signac and Seurat.
a. Printed eds.: *Das Problem der Farbe in den Selbstzeugnissen moderner Maler.* Munich: Prestel-Verlag, 1953. 194 p., illus; *Das Problem der Farbe in den Selbstzeugnissen der Maler von Cézanne bis Mondrian.* Mittenwald: Mäander, 1981. 203 p. 3, illus.
Review: H. Matile, *Pantheon* 41:1(Jan.-March 1983):88-9.

107. HILDEBRANDT, HANS. Die Kunst des 19. und 20. Jahrhunderts. Potsdam: Akademische Verlagsgesellschaft Athenaion, 1931. 458 p., illus., pl. (Handbuch der Kunstwissenschaft)

108. HOLL, J.-C. *Après l'impressionnisme.* Paris: Librairie du XXe Siècle, 1910. 74 p.

109. HOLL, J.-C. *La Jeune peinture contemporaine: Maurice Denis, Georges d'Espagnat, Albert André, Maximilien Luce, Paul Signac, Charles Guérin, Pierre Laprade, Henri Déziré, Albert Marquet, Louis Charlot, Claude Rameau, Charles Lacoste.* Paris: Editions de la Renaissance Contemporaine, 1912.

110. HOMER, WILLIAM INNES. *Seurat and the Science of Painting.* Cambridge, MA: MIT Press, 1964. 327 p., illus.

Comprehensive discussion of Seurat's scientific and aesthetic art theory sources, including Chevreul, Rood, Henry and other color theorists and scientists that Seurat consulted.
a. 2nd ed.: 1970.
b. Reprint: NY: Hacker Art Books, 1985. 326 p., illus., 2 pl.
Reviews: L. D. Steefel, *Art Journal* 24:3(1964-65):306; 308; J. Russell, *Apollo* 81 (May 1965):413-5; J. Killham, *British Journal of Aesthetics* (1965):309-10; H. Dorra, *Burlington Magazine* 108(1966):209; J. Hodkinson, *Journal of the Optical Society of America* 56:2(February 1966):262-3; R. Weale, *Palette* 40(1972):16-23.

111. HUMBERT DE SUPERVILLE, DAVID PIERRE GIOTTINO. *Essai sur les signes inconditionnels dans l'art*. Leyden: C. C. Van der Hoek, 1827-32. 3 vols., illus.

112. HUTTON, JOHN GARY. *A Blow of the Pick: Science, Anarchism, and the Neo-Impressionist Movement*. Ph.D. diss., Northwestern University, 1987. 599 p., illus.

Analyzes of Neo-Impressionism within the context of anarchism and capitalism and the ways in which the artists attempted to create "social art."

113. HUTTON, JOHN GARY. *Neo-impressionism and the Search for Solid Ground: Art, Science and Anarchism in fin-de-siècle France*. Baton Rouge, Louisiana; London: Louisiana State University Press, 1994. 276 p., 65 illus. (Modernist Studies)

Cultural history that examines the theoretical basis of French Neo-Impressionist painting and the social milieu out of which it emerged by focusing on the work of Georges Seurat, Paul Signac, Maximilien Luce, Camille Pissarro, and Charles Angrand. Hutton examines how they embraced recent scientific theories and the use of the word "science" within anarchist discourse as a means for constructing a new social order. Hutton explains how their original intention to highlight social injustice was superceded by a call for a more overtly political and didactic art, which eventually helped to cause the dissipation of the group. Selected Bibliography, pp. 253-70.
Review: J. Crary, *Journal of Interdisciplinary History* 28(Summer 1947):115-6.

114. HUYGHE, RENE, ed. *Histoire de l'art contemporain: la peinture*. Publiée sous la direction de René Huyghe, avec le concours de Germain Bazin. Préface de Jean Mistler, introduction par Henri Focillon. Paris: F. Alcan, 1933-34. 2 vols., illus. (Amour de l'art)

Includes Robert Rey's essay "Le Néo-impressionnisme," vol. 1, pp. 33-5.
a. Reprint: NY: Arno Press, 1968. 536 p., illus. (Arno Series of Contemporary Art, no. 5)

115. HUYGHE, RENE. *Les Contemporains*. Notices biographiques par G. Bazin. Paris: Tisné, 1939., pl.

116. HUYSMANS, JORIS-KARL. *L'Art moderne*. Paris: G. Charpentier, 1883. 277 p.

a. Other eds.: 1902, 1908, 1911, 1919, 1923, 1969, 1975, 1986.

117. IMDAHL, MAX. *Farbe. Kunsttheoretische Reflexionen in Frankreich*. Munich: W. Fink, 1987. 191 p. In German and French.

Bibliography, pp. 155-87.
a. French ed.: *Couleur: les écrits des peintres français de Poussin à Delaunay;* traduit de l'allemand par François Laroche. Paris: Editions de la Maison des Sciences de l'homme, 1996.

118. JACKSON, A. B. *La Revue blanche, 1889-1903: origine, influence, bibliographie*. Paris: M. J. Minard, 1960. 327 p., illus. (Bibliothèque des lettres modernes, no. 2)

119. JAY, ROBERT ALLEN. *Art and Nationalism in France, 1870-1914*. Ph.D. diss., University of Minnesota, 1979. 235 p., illus., 48 pl.

120. JENSEN, ROBERT. *Marketing Modernism in Fin-de Siècle Europe*. Princeton, NJ: Princeton University Press. 367 p.

Includes lengthy sections on Neo-Impressionist group and individual exhibitions.

121. JOHNSON, UNA E. *Ambroise Vollard, Editor*. NY: Wittenborn and Co., 1944. 214 p., illus., 24 pl.

122. JONES, LOUISA E. *Sad Clowns and Pale Pierrots: Literature and the Popular Comic Arts in 19th-Century France*. Lexington, KY: French Forum, 1984. 296 p.

123. JOURDAIN, FRANTZ. *Les Décorés, ceux qui ne le sont pas*. Paris: H. Simonis Empis, 1895. 278 p.

124. JOURDAIN, FRANTZ. *Propos d'un isolé en faveur de son temps*. Paris: E. Figuière, 1904.

125. JOURDAIN, FRANTZ. *Né en 1876*. Paris: Ed. du Pavillon, 1951.

126. KAHN, GUSTAVE. *Symbolistes et décadents*. Paris: L. Vanier, 1902. 404 p.

a. Reprints: Geneva: Slatkine Reprints, 1977; NY: AMS Press, 1980.

127. KEMP, MARTIN. *The Science of Art: Optical Themes in Western Art from Brunelleschi to Seurat*. New Haven and London: Yale University Press, 1990. 374 p., 553 illus.

See index for sections on Seurat and other Neo-Impressionists. Select Bibliography, pp. 363-4.
Review: P. Hills, *Art History* 4:4(1991):617-9.

128. KLINGSOR, TRISTAN L. *La Peinture*. Paris: F. Rieder, 1921. 124 p., illus. (L'Art français depuis vingt ans, no. 3)

129. KRÖLLER-MÜLLER, HELENE EMMA LAURA JULIANE. *Die Entwicklung der modernen Malerei; ein Wegweiser für Laien*. Leipzig: Klinkhardt & Biermann, 1927. 251 p., illus.

130. LAPPARENT, PAUL DE. *La Logique des procédés impressionnistes*. Paris: Société Française d'Imprimerie d'Angers, 1926. 164 p.

131. LAPRADE, JACQUES DE. *L'Impressionnisme*. Paris: Améry Somogy, 1956. 83 p., col. illus. (Panorama des arts)

132. LASSAIGNE, JACQUES. *L'Impressionnisme, sources et dépassement, 1850-1900*. Geneva: Albert Skira, 1974. 96 p., 58 illus. (La Grande histoire de la peinture, no. 14)

Surveys Impressionism's flowering and aftermath; illustrated with works by Seurat and Signac.

133. LAVER, JAMES. *French Painting and the Nineteenth Century.* With notes on artists and pictures by Michael Sevier and a postscript by Alfred Flechtheim. London: Batsford; NY: C. Scribner's, 1937. 119 p., illus., pl.

134. LEE, ELLEN WARDWELL. *The Aura of Neo-Impressionism: The W. J. Holliday Collection.* Artists' biography by Tracy E. Smith. Indianapolis: Indiana Museum of Art; Indiana University Press, 1983. 214 p., illus.
Bibliography, pp. 202-8.

135. LEHEL, FRANZ. *Notre art dément; quatre études sur l'art pathologique. Les Chercheurs. Notre art dément. L'Impressionnisme pathologique. La Démence de Cézanne.* Paris: H. Jonquières, 1926. 122 p., illus.

136. LETHEVE, JACQUES. *Impressionnistes et symbolistes devant la presse.* Paris: A. Colin, 1959. 302 p., illus. (Collection Kiosque, no. 1)

137. LEVEQUE, CHARLES. *La Science du beau, ses principes, ses applications et son histoire.* Paris: A. Durand, 1861. 2 vols.

a. 2nd ed.: 1872.

138. LEVIN, MIRIAM R. *Republican Art and Ideology in Late Nineteenth-Century France.* Ph.D. thesis, University of Massachusetts, 1980.

a. Printed ed: Ann Arbor: UMI Press, 1986. 339 p., illus. (Studies in the Fine Arts. Art Theory, no. 11)

139. LHOTE, ANDRE. *La Peinture: le cœur et l'esprit, suivi de Parlons peinture; essais.* Paris: Denoël et Steele, 1933. 234 p., 6 pl.

140. LHOTE, ANDRE. *Peinture d'abord, essais.* Paris: Denoël et Steele, 1942. 178 p.

141. *Liste des travaux de M. Charles Henry.* Rome, 1880.

142. LOOSJES-TERPSTRA, ALEIDA BETSY. *Moderne Kunst in Nederland, 1900-1914.* Ph.D. thesis, Rijksuniversiteit te Utrecht, 1958. 2 vols. in 1, illus.

Important survey of Dutch New-Impressionism that includes bibliographies for individual artists.
a. Printed eds.: Utrecht: Haentjens, Dekker & Gumbert, 1959. 352 p., 191 illus; Utrecht: Veen Reflex, 1987.

143. LÖVGREN, SVEN. *The Genesis of Modernism: Seurat, Gauguin, van Gogh & French Symbolism in the 1880's.* Ph.D. diss., University of Uppsala, 1959. Stockholm: Almqvist & Wiksell, 1959. 178 p., illus. Bloomington: Indiana University Press, 1971. 241 p., 28 illus.

Interpretative survey of the intellectual currents leading to Symbolism and the development of Post-Impressionism. Examines Symbolism in literature and painting with an analysis of key works by Seurat and others.

a. Revised ed.: New York: Hacker Art Books, 1983. 241 p., 28 illus.
Review: L. Steefel, *Art Journal* 21:2(Winter 1961-2):97-100.

144. MABILLE, PIERRE. *Conscience lumineuse*. Paris: A. Skira, 1938. 78 p., illus., 8 pl.

a. Another ed.: *Conscience lumineuse, conscience picturale*. Textes établis et présentés par Jacqueline Chénieux-Gendron et Rémy Laville. Paris: J. Corti, 1989. 196 p., illus., 16 pl.

145. MAINARDI, PATRICIA. *The End of the Salon: Art and the State in the Early Third Republic*. NY: Cambridge University Press, 1993. 210 p., illus.

146. MAITRON, JEAN. *Histoire du mouvement anarchiste en France (1880-1914)*. Paris: Société Universitaire d'Editions et de Librairie, 1951. 744 p.

a. 2nd ed.: 1955. 502 p., 9 pl.

147. MAITRON, JEAN. *Le Mouvement anarchiste en France*. Paris: Maspero, 1975. 2 vols.

"Bibliographie du mouvement anarchiste en France, 1880-fin 1972," vol. 2, pp. 209-414.
a. Another ed.: 1983.

148. MALPEL, CHARLES. *Notes sur l'art d'aujourd'hui et peut-être de demain*. Paris: Editions Grasset, 1910. 2 vols.

149. MARET, FRANÇOIS [Pseud. of Franz van Ermengen]. *Les Peintres luministes*. Brussels: Editions du Cercle d'Art, 1944. 45 p., 32 pl. (L'Art en Belgique)

Summary of Neo-Impressionist color theory, with particular attention to pigments used in Seurat's work.

150. MARLAIS, MICHAEL ANDREW. *Conservative Echoes in Fin-de-Siècle Parisian Art Criticism*. University Park: University of Pennsylvania Press, 1992.

151. MARLAIS, MICHAEL ANDREW. *Anti-Naturalism, Idealism and Symbolism in French Art Criticism, 1880-1895*. Ph.D. diss., University of Michigan, 1985. 398 p., illus.

Bibliography, pp. 377-98.

152. MARTIN, ELISABETH PUCKETT. *The Symbolist Criticism of Painting in France: 1880-95*. Ph.D. diss., Bryn Mawr College, 1948. 230 p.

Bibliography, pp. 218-30.
a. Printed ed.: Ann Arbor, MI: University Microfilms, 1952.

153. MASSARANI, TULLO. *Charles Blanc et son œuvre; critique, histoire et théorie des arts du dessin: architecture, sculpture, peinture, ornement*. Avec une introd. par Eugène Guillaume. Paris: J. Rothschild, 1885. 242 p.

Includes an introduction by Eugène Guillaume, "Charles Blanc et l'esthétique."

154. MATHER, FRANK JEWETT. *Modern Painting.* NY: H. Holt; Garden City, NY: Garden City Pub. Co., 1927. 385 p., illus.

155. MATHEWS, PATRICIA TOWNLEY. *G.-Albert Aurier's Symbolist Art Theory and Criticism.* Ph.D. diss., University of North Carolina at Chapel Hill, 1984. 503 p., illus., 28 pl.

Bibliography, pp. 466-88.

156. MATHEY, FRANÇOIS. *Les Impressionnistes et leur temps.* Paris: Hazan, 1959.

157. MAUCLAIR, CAMILLE. *The French Impressionists (1860-1900).* London: Duckworth; NY: E. P. Dutton, 1903. 211 p., illus. (The Popular Library of Art)

158. MAUCLAIR, CAMILLE. *L'Impressionnisme, son histoire, son esthétique, ses maîtres.* Paris: G. Baranger, 1904.

159. MAUCLAIR, CAMILLE. *L'Art indépendant français sous la III^e République: (peinture, lettres, musique).* Paris: La Renaissance du Livre, 1919. 170 p. (Bibliothèque internationale de critique. Lettres et arts)

160. MAUCLAIR, CAMILLE. *Jules Chéret.* Paris: M. Le Garrec, 1930. 133 p., illus., pl. 730 copies.

Bibliography, pp. 127-9.

161. MAUCLAIR, CAMILLE. *Un siècle de peinture française, 1820-1920.* Avec 16 héliogravures hors texte. Paris: Payot, 1930. 209 p., illus., 16 pl.

162. MAUS, OCTAVE. *Trente années de lutte pour l'art. Les XX. La Libre esthétique. 1884-1914.* Bruxelles: Librairie de L'Oiseau Bleu, 1926. 508 p., illus., 42 pl.

Documents the Belgian Neo-Impressionist exhibition societies for which Octave Maus (1856-1919) served as secretary. Account of his career written by his wife.
a. Reprint: Brussels: Lebeer Hossmann, 1980.

163. MEIER-GRAEFE, JULIUS. *Der moderne Impressionismus.* Berlin: J. Bard, 1903. 60 p., illus. (Die Kunst, no. 11)

a. Another ed.: 1904.

164. MEIER-GRAEFE, JULIUS. *Entwicklungsgeschichte der modernen Kunst.* Stuttgart: J. Hofmann, 1904. 3 vols.

a. 2nd ed.: Munich: Piper, 1927.
b. English ed.: *Modern Art.* Trans. by Florence Simmonds and George W. Chrystal. London: W. Heinemann, 1908. 2 vols.
c. U.S. ed.: NY: G. P. Putnam's Sons, 1908. 2 vols.

165. MELLERIO, ANDRE. *Le Mouvement idéaliste en peinture.* Paris: H. Floury, 1896.

74 p., illus. (Petite bibliothèque d'art moderne)

166. MELLERIO, ANDRE. *La Lithographie originale en couleurs.* Paris: Publication de L'Estampe et L'Affiche, 1898.

167. MIRABAUD, ROBERT. *Charles Henry et l'idéalisme scientifique.* Postface de Charles Henry: appendice: note sur les travaux de Charles Henry par Victor Delfino. Paris: Fischbacher, 1926. 108 p.

168. MIRBEAU, OCTAVE. *Des artistes. 1 série, 1885-1896.* Paris: E. Flammarion, 1922. 294 p.

a. Another ed.: Paris: Union Générale d'Editions, 1986. 438 p.

169. MIRBEAU, OCTAVE. *Combats esthétiques.* Paris: Nouvelles Editions Séguier, 1990. 2 vols.

170. MIRBEAU, OCTAVE. *Notes sur l'art.* Edition établie, annotée et présentée par Jean-François Nivet et Pierre Michel. Paris: L'Echoppe, 1990. 83 p.

171. MOFFETT, CHARLES S., ed. *The New Painting: Impressionism 1874-1886.* An exhibition organized by the Fine Arts Museums of San Francisco with the National Gallery of Art, Washington, D. C. Geneva: Richard Burton Publishers, dist. in the U.S. by the University of Washington Press, Seattle, 1986. 507 p., illus.

Catalogue of an exhibition held 17 Jan.-6 April 1986 at the National Gallery, Washington D.C., and from 19 April-6 July 1986 at the M. H. de Young Memorial Museum, San Francisco. Bibliography, pp. 497-505.
a. Another ed.: 1986. 509 p., illus.

172. MONNERET, SOPHIE. *L'Impressionnisme et son époque: dictionnaire international illustré.* Présentation de René Huyghe. Paris: Denoël, 1978-81. 4 vols., illus.

173. MOORE, GEORGE. *Modern Painting.* London: Walter Scott, Ltd., 1893. 248 p.

a. Other eds.: London: Walter Scott, 1898, 1900, 1913, 1923.
b. U.S. eds.: NY: C. Scribner's Sons, 1893, 1923.

174. MOORE, GEORGE. *Confessions of a Young Man (1886).* Introduction by Robert M. Coates. London: S. Sonnenschein, Lowrey 1888. 357 p.

a. Other eds.: 1889, 1904, 1916, 1923.
b. U.S. eds.: NY: Boni and Liveright, 1923. NY: G. P. Putnam's Sons; Capricorn Books, 1959.

175. MORIN, LOUIS. *Quelques artistes de ce temps.* Paris, 1898.

176. MORISOT, BERTHE. *Correspondance de Berthe Morisot: avec sa famille et ses amis Manet, Puvis de Chavannes, Degas, Monet, Renoir et Mallarmé.* Documents réunis et présentés par Denis Rouart. Paris: Quatre Chemins, 1950. 184 p., illus., some col.

See index for Neo-Impressionist references.
a. U.S. eds.: *The Correspondence of Berthe Morisot, with her Family and her Friends.* Trans. by Betty W. Hubbard. NY: G. Wittenborn, 1957. 187 p., illus., some col.; NY: Weyhe, 1959; with a new introduction and notes by Kathleen Adler and Tamar Garb. Mt. Kisco, NY: Moyer Bell, 1987.
b. English eds.: London: Lund, Humphries, 1957. 187 p., illus., some col.; London: Camden Press, 1986. 246 p., illus.
Reviews: *Burlington Magazine* 93(May 1951):173; C. Brightman, *New York Times Book Review* (March 1989):39, J. McKenzie, *Studio International* 201(April 1988):64-7; N. Mathews, *Women's Art Journal* 10:1(Spring-Summer 1989):46-9.

177. MOTOKAWA, KOITI. *Physiology of Color and Pattern Vision.* Tokyo: Igaku Shoin; Berlin; New York: Springer, 1970. 283 p.

178. MULLER, JOSEPH-EMILE. *L'Impressionnisme.* Paris: Fernand Hazan, 1974. 31 p., col. Illus., 40 pl.

Presents a selection of paintings by 12 Impressionists, including Pissarro and Seurat, and a short description of Impressionism and Neo-Impressionism.
a. English eds.: *Impressionism.* Bourne Fend, Bucks.: Spurbooks, 1976. 31 p., col. illus., 79 pl.; London: Eyre Metheun, 1980. 112 p., 91 illus.
b. U.S. ed.: NY: L. Amiel, 1974. 31p., col. illus., 80 pl.

179. MUTHER, RICHARD. *The History of Modern Painting.* London: Henry & Co., 1895-96. 3 vols., illus., pl.

a. Another ed.: London: J. M. Dent, 1907.
b. U.S. eds.: NY: Macmillan, 1896; NY: E. P. Dutton, 1907.

180. NATANSON, THADEE. *Peints à leur tour.* Paris: Albin-Michel, 1948. 388 p., pl.

181. NEEDHAM, H. A. *Le Développement de l'esthétique sociologique en France et en Angleterre au XIXe siècle.* Paris: H. Champion, 1926. 323 p. (Bibliothèque de la Revue de littérature comparée, no. 28)

182. NIEMEYER, WILHELM. *Malerische Impression und koloristischer Rhythmus.* Düsseldorf: A. Bagel, 1911.

Examination of German Neo-Impressionism that treats minor German artists.

183. NOCHLIN, LINDA, ed. *Impressionism and Post-Impressionism 1974-1904. Sources and Documents.* Englewood Cliffs, NJ: Prentice-Hall, 1966. 222 p. (Sources and Documents in the History of Art)

184. NOCHLIN, LINDA. *The Politics of Vision: Essays on Nineteenth-Century Art and Society.* NY: Harper & Row, 1989. 200 p., illus. (Icon Editions)

Nine essays on French avant-garde art, including references to the Neo-Impressionists and an essay on Seurat's *La Grande Jatte.*

185. *Notice sur les travaux scientifiques de M. Charles Henry.* Rome: Imprimerie des Sciences Mathématiques et Physiques, 1891. 61 p.

186. NOVOTNY, FRITZ. *Cézanne und das Ende der wissenschaftlichen Perspektive.* Vienna: A. Schroll, 1938. 214 p., pl.

Investigates Seurat's formal structure and objective or spatial description in comparison to Cézanne (see pp. 145-52).
a. Another ed.: 1970.

187. OSBORN, MAX. *Geschichte der Kunst.* Eine kurzgefasste Darstellung ihrer Hauptepochen. Berlin: Ullstein, 1909. 499 p.

a. Other eds.: 1912, 1920, 1924, 1929.

188. OZENFANT, AMEDEE and CHARLES EDOUARD JEANNERET. *La Peinture moderne.* Paris: G. Crès, 1925. 172 p., illus., 33 pl. (Collection de 'L'Esprit nouveau')

a. Another ed.: 1927.

189. PACH, WALTER. *The Masters of Modern Art.* NY: Viking Press; B. W. Huebsch, 1924. 118 p., illus., 36 pl.

a. Another ed.: 1929.
b. Reprint: NY: Books for Libraries Press, 1972.

190. PADGHAM, C. A. and J. E. SAUNDERS. *The Perception of Light and Colour.* London: Bell, 1975. 192 p., illus., 10 pl.

Bibliography, p. 179.
a. U.S. ed.: NY: Academic Press, 1975.

191. PARADISE, JOANNE. *Gustave Geffroy and the Criticism of Painting.* Ph.D. diss., Stanford University, 1982. 539 p., illus.

a. Printed ed.: NY: Garland, 1985. 491 p., illus.

192. PELADAN, JOSEPHIN. *Introduction à l'esthétique.* Paris: E. Sansot, 1907. 102 p. (Les Idées et les formes)

193. PELLOUTIER, FERNAND. *L'Art et la révolte.* Paris: L'Art Social, 1896.

194. *Petit bottin des lettres et des arts.* Paris: E. Giraud, 1886. 180 p., illus.

Includes contributions by Paul Adam, Félix Fénéon, Jean Moréas, Oscar Méténier, and other critics.

195. PICA, VITTORIO. *Gl'impressionisti francesi.* Bergamo: Istituto Italiano d'Arti Grafiche, 1908. 212 p., pl. (Collezione di monografie illustrate. Serie artiste moderni, no. 3)

196. PIERROT, JEAN. *L'Imaginaire décadent, 1880-1900.* Paris: Presses Universitaires de France, 1977. 340 p. (Publications de l'Université de Rouen, no. 38)

a. U.S. eds.: *The Decadent Imagination, 1880-1900.* Trans. by Derek Coltman. Chicago: University of Chicago Press, 1981. 309 p.; 1984.

197. PISSARRO, CAMILLE. *Camille Pissarro: Letters to his Son Lucien.* Edited with the assistance of Lucien Pissarro by John Rewald. Trans. by Lionel Abel. NY: Pantheon; London: K. Paul, Trench, Trubner, 1943. 367 p., illus.

a. Rev. ed.: Mamaroneck, NY: Paul P. Appel, 1972.
b. Reprint: Santa Barbara and Salt Lake City: Peregrine Smith, 1981.

198. POGU, GUY. *Néo-impressionnistes: étrangers et influences néo-impressionnistes*; *exemples.* 1963. 29 p., illus.

On cover: "Fascicule no. II." Dans le cadre des recherches techniques et psycho-sociales des causes de l'art, mai 1963.

199. POISSON, GEORGES. *La Femme dans la peinture française moderne.* Paris: Plon, 1955. 95 p., illus.

200. POLLOCK, GRISELDA. *Avant-Garde Gambits, 1888-1893: Gender and the Colour of Art History.* London: Thames and Hudson, 1992. 80 p., illus. (Walter Neuran Memorial Lectures, no. 24)

a. U.S. ed.: NY: Thames and Hudson, 1993

201. PREVIATI, GAETANO. *I Principii scientifici del divisionismo.* Torino: Fratelli Bocca, 1906. 266 p., illus.

a. 2nd ed.: Torino: Fratelli Bocca, 1929. 243 p., illus.
b. French ed.: *Les Principes scientifiques du divisionnisme (la technique de la peinture).* Trans. by V. Rossi-Sacchetti. Paris Grubicy, 1910. 329 p., illus.

202. *Principales publications de M. Charles Henry.* Paris, 1884.

203. *La Promenade du critique influent: anthologie de la critique d'art en France, 1850-1900.* Textes réunis et présentés par Jean-Paul Bouillon [et al.]. Paris: Hazan, 1990. 443 p., illus.

204. PUY, MICHEL. *L'Effort des peintres modernes.* Paris: A. Messein, 1933. 158 p. (Collection La Phalange)

205. QUINSAC, ANNIE-PAULE. *La Peinture divisionniste italienne; origines et premiers développements, 1880-1895.* Paris: Editions Klincksieck, 1972. 295 p., 47 plates.

206. RAPHAEL, MAX. *Von Monet zu Picasso.* Munich-Leipzig: Delphin Verlag, 1913. 130 p., illus.

a. Other eds.: 1919; Frankfurt am Main: Qumran, 1983. 219 p., illus.; Frankfurt am Main; New York: Edition Qumran in Campus Verlag, 1985. 219 p., illus.; Frankfurt am Main: Suhrkamp, 1989. 227 p., illus.

207. RATLIFF, FLOYD, ed. *Paul Signac and Color in Neo-Impressionism.* With an English translation of *From Eugène Delacroix to Neo-Impressionism* by Paul Signac, translated by Willa Sherman, edited by Floyd Ratliff. Berkeley: University of California Press, 1990. 317 p., illus.

Detailed scientific and psychophysiological study of Neo-Impressionism's divisionist color theory and technique. Includes an English translation of Signac's *D'Eugène Delacroix au néo-impressionnisme* (Paris: Editions de la Revue Blanche, 1899). 104 p.
a. Another ed.: NY: Rockefeller University Press, 1992.

208. RAYNAL, MAURICE, JEAN LEYMARIE and HERBERT EDWARD READ. *Histoire de la peinture moderne de Baudelaire à Bonnard.* Geneva: Skira, 1949. 152 p.

a. Another ed.: Genève: Skira; 1949-51. 3 vols., col. pl., col. illus.

209. REARICK, CHARLES. *Pleasures of the Belle Epoque. Entertainment and Festivity in Turn-of-the-Century France.* New Haven; London: Yale University Press, 1985. 239 p., illus., 10 pl.

a. Reprint: New Haven: Yale University Press, 1986. 240 p., illus.

210. REGNIER, HENRI DE. *Vestigia flammae.* Paris: Editions du Mercure de France, 1921. 260 p.
Reprints: Paris: Editions du Mercure de France, 1922. 260 p.

211. RESZLER, ANDRE. *L'Esthétique anarchiste.* Paris: Presses Universitaires de France, 1973. 113 p.

212. REWALD, JOHN. *The History of Impressionism.* NY: Museum of Modern Art, 1946. 474 p., illus., col. pl.

a. Other eds.: 1955, 1961, 1973, 1980.

213. REWALD, JOHN. *Post-Impressionism: From van Gogh to Gauguin.* NY: Museum of Modern Art, 1956. 619 p., illus., col. pl.

Monumental history of the critical years of Neo-Impressionism, 1886-91. Includes indispensable critical bibliographies of the movement and major artists.
a. Other eds.: 1962, 1978, 1982. NY: Doubleday, 1962. 619 p., illus.
b. French ed.: *Le Post-impressionnisme: de van Gogh à Gauguin.* Paris: A. Michel, 1961. 2 vol., illus.
c. German eds.: *Von van Gogh bis Gauguin. Die Geschichte des Nachimpressionismus.* Cologne: M. DuMont Schauberg, 1967; rev. ed. 1987. 412 p., illus.
d. Italian ed.: *Il postimpressionismo da van Gogh a Gauguin.* Firenze: Sansoni, 1967. 639 p.
e. Russian ed.: [Post-Impressionism from van Gogh to Gauguin] [title in Russian]

Leningrad: Iskusstvo, 1962. 434 p., illus., col. pl.
f. English ed.: London: Secker & Warbuck, 1978. 540 p., illus.

214. REWALD, JOHN. *Studies in Post-Impressionism.* London: Thames & Hudson; New York: H. N. Abrams, 1986. 295 p., illus.

215. REY, ROBERT. *La Renaissance du sentiment classique dans la peinture française à la fin du XIXe siècle. Degas-Renoir-Gauguin-Cézanne-Seurat.* Paris: Les Beaux-Arts; G. van Oest, 1931. 162 p., illus.

216. RICHARDSON, EDGAR PRESTON. *The Way of Western Art, 1776-1914.* Cambridge: Harvard University Press, 1939. 204 p., illus.

a. Other eds.: New York: Cooper Square Publishers, 1967, 1969, 1970. 204 p., illus.

217. RICHARDSON, JOHN ADKINS, ed. *Modern Art and Scientific Thought.* Urbana: University of Illinois Press, 1971. 191 p., illus.

218. ROBERTS, KEITH. *The Impressionists and Post Impressionists: 105 Reproductions.* Selected and introduced by Keith Roberts. London: Phaidon, 1975. 96 p., 105 illus.

Selection of 105 color reproductions chosen to represent major artists and sub-styles with Impressionism and Post-Impressionism. Includes examples by Seurat and Pissarro.

219. ROBIN, MAURICE. *L'Art et le peuple.* Paris: Hommes du Jour, 1910.

220. ROGER-MARX, CLAUDE. *La Gravure originale en France de Manet à nos jours* Paris: Editions Hyperion, 1939. 128 p., illus.
a. English ed.: *French Original Engravings from Manet to the Present Time.* London: Hyperion Press, 1939. 128 p., illus.

221. ROGER-MARX, CLAUDE. *Le Paysage français de Corot à nos jours, ou le dialogue de l'homme et du ciel.* Paris: Librairie Plon, 1952. 112 p., illus.

222. ROGER-MARX, CLAUDE. *Maîtres du XIXe siècle et XXe siècle.* Genève: P. Cailler, 1954. 327 p., illus.

223. ROOD, OGDEN NICHOLAS. *Modern Chromatics. Students' Text-Book of Color with Applications to Art and Industries.* New York: D. Appleton and Co., 1879. 329 p., illus. (International Scientific series, no. 26)

Treatise on color harmonies by the American physicist that influenced Seurat in 1881.
a. Other eds.: NY: D. Appleton and Co., 1881, 1899, 1913, 1916. 239 p., illus.; NY: Van Nostrand Reinhold, 1973; London: C. Kegan Paul, Trench, Trübner, 1879, 1883, 1890, 1904, 1910, 1980. 330 p.
b. French ed.: *Théorie scientifique des couleurs.* Paris: Baillière et cie, 1881. 279 p., illus.
c. Facsimile ed.: Introduced and annotated by Faber Birren. NY: Van Nostrand Reinhold Co., 1973. 257 p., illus.

224. ROOKMAAKER, HENDRICK R. *Synthetist Art Theories: Genesis and Nature of the*

Ideas on Art of Gauguin and his Circle. Amsterdam: Swets & Zeitlinger, 1959. 284p.

a. New ed.: *Gauguin and the 19ᵗʰ Century Art Theory.* Amsterdam: Swets & Zeitlinger, 1972. 362 p.

225. ROSENSTIEHL, M. AUGUSTE. *Les Premiers éléments de la science de la couleur.* Mulhouse: Impr. Veuve Bader et cie, 1884. 53 p., illus.

226. ROSKILL, MARK W. *Van Gogh, Gauguin, and the Impressionist Circle.* Greenwich, CT: New York Graphic Society, 1970. 310 p., 8 col.

a. Another ed.: London: Thames and Hudson, 1970. 310 p., illus.

227. ROSLAK, ROBYN SUE. *Scientific Aesthetics and the Aestheticized Earth: The Parallel Vision of the Neo-Impressionist Landscape and Anarcho-Communist Social Theory.* Ph.D. diss., University of California at Los Angeles, 1987. 366p.

Relates Neo-Impressionist pointillist technique and landscape subject matter to the group's scientifically based anarchist model of physical and social worlds. Focusses on how the late 19ᵗʰ century French scientific climate helped to shape the Neo-Impressionist aesthetic.

228. ROSSEL, ANDRE. *La Belle époque (1898-1914).* Paris: L'Arbre Verdoyant, 1982. 318 p.

229. SALMON, ANDRE. *Peindre.* Paris: Editions de La Sirène, 1921. 56 p., illus.

230. SALMON, ANDRE. *Propos d'atelier.* Paris: G. Crès, 1922. 275 p., illus.

a. Another ed.: Paris: Nouvelles Editions Excelsior, 1938. 275 p.

231. SANCHEZ VASQUES, ADOLFO. *Art and Society: Essays in Marxist Aesthetics.* Trans. by Mario Riofrancos. NY: Monthly Review Press, 1973. 287 p.

232. SCHAPIRO, MEYER. *Modern Art: 19ᵗʰ and 20ᵗʰ Centuries. Selected Papers.* NY: Braziller, 1979. 277 p., illus.

a. Other eds.: NY: Braziller, 1978, 1994.
b. English ed.: London: Chatto & Windus, 1978. 277 p., illus.
c. Italian ed.: *L'Arte Moderna,* Torino: G. Einaudi, 1986. 300 p., illus.

233. SCHURR, GERALD. *Les Petits maîtres de la peinture, valeur de demain, 1820-1920.* Paris: Editions de la Gazette, 1969-89. 7 vols.

a. Another ed.: Paris: Editions de l'Amateur, 1972-79. 4 vols.

234. SCHWARZ, MARTIN. *Octave Mirbeau: vie et œuvre.* The Hague: Mouton, 1966. 205 p.

235. SEIGEL, JERROLD. *Bohemian Paris: Culture, Politics, and the Boundaries of Bourgeois Life, 1830-1930.* NY: Viking, 1986. 453 p., illus.

a. Another ed.: NY: Penguin Books, 1987. 453 p., illus.

236. SERULLAZ, MAURICE. *Les Peintres impressionnistes.* Paris: Tisné, 1959. 185 p., col. illus.

a. Another ed.: Paris: Société Française du Livre, 1973. 187 p., col. illus.
b. U.S. ed.: *The Impressionist Painters; French Painting.* Trans. by W. J. Strachan. NY: Universe Books, 1960. 186 p., illus.

237. SHAPIRO, THEDA. *Painters and Politics: The European Avant-Garde and Society, 1900-1925.* NY: Elsevier, 1976. 341 p., illus.

238. SHERMAN, PAUL D. *Colour Vision in the Nineteenth Century: The-Young-Helmholtz-Maxwell Theory.* Foreword by W. D. Wright. Bristol: A. Hilger; Philadelphia: dist. by Heyden, 1981. 233 p., illus., 4 pl.

239. SHIFF, RICHARD. *Cézanne and the End of Impressionism.* Chicago: University of Chicago Press, 1984. 318 p., illus.

240. SHIKES, RALPH E. *The Indignant Eye: The Artist as Social Critic in Prints and Drawings from the 18th Century to Picasso.* Boston: Beacon, 1969. 439 p., illus.

241. SIGNAC, PAUL. *D'Eugène Delacroix au néo-impressionnisme.* Paris: Editions de La Revue Blanche, 1899. 104 p.

Manifesto and defense of Neo-Impressionism. The text concentrates on pointillist technique instead of subject matter. Original version appeared in *La Revue blanche* (1898).
a. Other eds.: Paris: H. Floury, 1911; 1921; 1939; Françoise Cachin, ed., Paris: Hermann, 1964; Paris: Hermann, 1978.
b. English trans.: *Paul Signac and Color in Neo-Impressionism.* Trans. by Willa Silverman, ed. by Floyd Ratliff. Berkeley: University of California Press, 1990. 104 p.
c. Italian ed.: *Da Eugène Delacroix al neoimpressionismo.* Napoli: Liguori editore, 1993. 171 p.

242. SILVER, KENNETH ERIC. *Esprit de corps: the art of the Parisian avant-garde and the First World War, 1914-1925.* Princeton, N.J.: Princeton University Press, 1989; London: Thames and Hudson, 1989. 504 p., illus.

a. Another ed.: 1991.
b. French ed.: *Vers le retour à l'ordre; l'avant-garde parisienne et la Première Guerre mondiale.* Paris: Flammarion, 1989.

243. SILVERMAN, DEBORA L. *Art Nouveau in Fin-de-Siècle France: Politics, Psychology, and Style.* Berkeley and Los Angeles: University of California Press, 1989. 415 p., illus.

a. Another ed.: 1992.

244. SONG, MISOOK. *Art Theories of Charles Blanc (1813-1882).* Ph.D. diss., Pennsylvania State University, 1981. 195 p., illus.

a. Another ed.: Ann Arbor, Michigan: UMI Research Press, 1984. 145 p., illus.

245. SONN, RICHARD DAVID. *French Anarchism as Cultural Politics in the 1890s.* Ph.D. diss., University of California at Berkeley, 1981. 593 p., illus.

Examines 1890s French anarchism as a wide-ranging cultural phenomenon that merged heterogeneous social and ideological groups into a fragile alliance that did not survive the decade. Discusses anarchism's appeal to both Neo-Impressionist and Symbolist artists.
a. Printed ed.: *Anarchism and Cultural Politics in fin-de-siècle France.* Lincoln: University of Nebraska Press, 1989. 365 p., illus.

246. SOURIAU, PAUL. *L'Esthétique de la lumière.* Paris: Hachette, 1913. 439 p., illus.

247. STOCK, PIERRE-VICTOR. *Memorandum d'un éditeur.* Préface de Jean Ajalbert. Paris: Stock (Delamain et Boutelleau), 1935. 329 p., 1 pl.

248. SUTTER, DAVID. *Philosophie des beaux-arts appliquée à la peinture.* Ouvrage approuvé par l'Académie Impériale des Beaux-arts. Paris: J. Tardieu, 1858. 355 p.

a. Another ed.: Paris: Morel, 1870.

249. SUTTER, DAVID. *Science du rythme suivant les belles traditions de l'école italienne.* Paris, 1878.

250. SUTTER, JEAN, ed. *The Neo-Impressionists.* With contributions by Robert L. Herbert, Isabelle Compin, Pierre Angrand, Lily Bazalgette, Alan Fern, Pierre Eberhart, Francine-Claire Legrand, Henri Thérinen, Marie-Jeanne Chartrain-Hebbelinck. Translated from the French by Chantal Deliss. Greenwich, Conn.: New York Graphic Society, 1970. 232 p., illus.

Biographical summaries of major and minor Neo-Impressionists.
a. English ed.: London: Thames & Hudson, 1970. 232 p., illus.
b. French ed.: *Les Néo-impressionnistes.* Lausanne and Neuchâtel: Paris: Bibliothèque des Arts; 1979. Ides et Calendes, 1970. 232 p., illus.

251. SWART, KOENRAAD WOLTER. *The Sense of Decadence in Nineteenth-Century France.* The Hague: Nijhoff, 1964. 272 p.

252. SWEENEY, JAMES JOHNSON. *Plastic Redirections in 20th Century Painting.* Chicago: University of Chicago Press, 1934. 103 p., illus.
a. Another ed.: New York: Arno Press, 1972. 102 p., illus.

253. THOMSON, BELINDA. *The Post-Impressionists.* Oxford & Phaidon, 1983. 192 p., illus.

a. Reprint: 1983.

254. THOMSON, RICHARD. *Monet to Matisse: Landscape Painting in France, 1874-1914.* With an essay by Michael Clarke. Edinburgh: Trustees of the National Galleries, 1994. 199 p., illus., some col.

255. THOMSON, RICHARD, ed. *Framing France: The Representations of Landscape in France, 1870-1914.* Manchester, England; NY: Manchester University Press, 1998. 226 p., illus.

256. THOROLD, ANNE, ed. *Artists, Writers, Politics: Camille Pissarro and his Friends.* Oxford: Ashmolean Museum Oxford University Press, 1980. 78 p., illus.

257. TRUDGIAN, HELEN. *L'Esthétique de J.-K. Huysmans.* Paris: L. Conrad, 1934. 389 p.

a. Reprint: Genève: Slatkine Reprints, 1970. 389 p.

258. VAISSE, PIERRE. *La Troisième République et les peintres. Recherches sur les rapports des pouvoirs publiques et la peinture en France de 1870 à 1914.* Unpublished typescript. Paris, 1980.

a. Printed ed.: Paris: Flammarion, 1995. 476 p.

259. VAN DE VELDE, HENRY. *Du paysan en peinture.* Brussels: Editions de l'Avenir Social, 1891.

260. VAN DE VELDE, HENRY. *Die Renaissance im modernen Kunstgewerbe.* Berlin: Bruno und Paul Cassirer, 1901. 147 p.

a. Rev. ed.: Berlin: Verlag von Bruno Cassirer, 1903. 147 p.

261. VAN DE VELDE, HENRY. *Geschichte meines Lebens.* Hans Curjel, ed. Munich: R. Piper, 1962. 544 p., illus.

a. Reprint ed.: 1986.
b. French ed.: *Récit de ma vie: Anvers, Bruxelles, Paris, Berlin.* Texte établi et commenté par Anne van Loo, avec la collaboration de Fabrice van de Kerckhove. Paris: Flammarion, Bruxelles: Versa, 1992-

262. VAN SPEYBROECK, MARIA THERESIA. *Franse invloeden op het Belgisch impressionnisme en neo-impressionnisme.* Ph.D. diss., Université de Gand, 1976. 2 vols.

263. VENTURI, LIONELLO. *Les Archives de l'impressionnisme. Lettres de Renoir, Monet, Pissarro, Sisley et autres. Mémoires de Paul Durand-Ruel. Documents.* Paris; NY: Durand-Ruel, 1939. 2 vols., illus.

a. Reprint: New York: Franklin, 1968. 2 vols., illus.

264. VENTURI, LIONELLO. *Impressionists and Symbolists.* NY: C. Scribner, 1950. 244 p., illus.

Discusses Seurat and Neo-Impressionism on pages 189-210.
a. Reprint: NY: Cooper Square Publishers, 1973.
b. French ed.: *De Manet à Lautrec.* Paris: Albin Michel, 1953. 313 p., illus.

265. VERHAEREN, EMILE. *Sensations.* Paris: G. Crès & cie, 1927. 252 p., illus.

Includes the Belgian poet's observations of several Neo-Impressionists.
a. Reprint: 1928.

266. VIBERT, JEHAN-GEORGES. *La Science de la peinture.* Paris: Paul Ollendorff, 1891. 332 p.

a. Other eds.: Paris: Paul Ollendorff, 1900; Paris: Société d'éditions littéraires et artistiques. 1902. 32 p.; Paris: Gutenberg Reprint, 1981. 332 p.
b. English ed.: *The Science of Painting.* London: P. Young, 1892.

267. VINCENT, MADELEINE. *La Danse dans la peinture française contemporaine (de Degas à Matisse).* Lyon: Bosc frères et L. Riou, 1944. 79 p., illus.

268. *Les XX Bruxelles: catalogue des dix expositions annuelles.* Brussels: Centre International pour l'Etude du XIXᵉ Siècle, 1981. 310 p., illus.

Includes facsimiles of the annual exhibition catalogues of Les XX, originally issued 1884-93.

269. VOLAVKA, VOJTECH. *Malirsky rukopis ve francouzskem obraze nové doby.* Prague: Statni graficka skola, 1934. 23 p., illus.

270. VOLLARD, AMBROISE. *En écoutant Cézanne, Degas, Renoir.* Paris: B. Grasset, 1938. 300 p.

271. WALDMANN, EMIL. *Die Kunst des Realismus und des Impressionismus im 19.Jahrhundert.* Berlin: Propyläen Verlag, 1927. 652 p., illus.

a. Spanish ed.: *Arte dell realismo e impresionismo en el siglo XIX.* Barcelona: Editorial Labor, 1944. 789 p., pl.

272. WARD, MARY MARTHA. *Pissarro, Neo-Impressionism, and the Spaces of the Avant-Garde.* Chicago: Chicago University Press, 1995. 353 p., illus., 4 pl.
Examines how 1880s French art, criticism, and marketing shaped Neo-Impressionism into the first modern avant-garde movement in painting. Bibliography, pp. 331-7.

273. WARRAIN, FRANCIS. *L'Oeuvre psychobiophysique de Charles Henry.* Paris: Gallimard, 1931. 551 p., illus.

a. 2ⁿᵈ ed.: Paris: Hermann, 1938. 551 p., illus.

274. WECHSLER, JUDITH. *A Human Comedy. Physiognomy and Caricature in 19ᵗʰ Century Paris.* Introduction by R. Sennett. London: Thames and Hudson; Chicago: University of Chicago Press, 1982. 208 p., illus.

a. English ed.: London: Thames and Hudson, 1982. 268 p., illus.

275. WEISBERG, GABRIEL P. *Social Concern and the Worker: French Prints from 1830-1910.* Salt Lake City: University of Utah Press, 1974. 138 p., illus.

Exhibition catalogue that includes references to Neo-Impressionism's social agenda.

276. WHITE, BARBARA EHRLICH, ed. *Impressionism in Perspective.* Englewood Cliffs, NJ: Prentice-Hall, 1978. 165 p., 26 illus. (Artists in Perspective)
Collection of essays, some of which mention various Neo-Impressionists.

277. WHITE, HARRISON C. and CYNTHIA A. WHITE. *Canvases and Careers: Institutional Change in the French Painting World.* NY: Wiley, 1965. 167 p.

a. 2nd ed.: Chicago: University of Chicago Press, 1993. 173 p., illus.
b. French ed.: *La Carrière des peintres au XIXe siècle: du système académique au marché des impressionnistes.* Traduit de l'anglais par Antoine Jaccottet. Paris: Flammarion, 1991. 166p., illus. (Série Histoire, art, Société)

278. WILENSKI, REGINALD HOWARD. *Modern French Painters.* NY: Reynal & Hitchcock, 1940. 424 p.

a. Other eds.: NY: Harcourt, Brace and World, 1949, 1954, 1963; NY: Vintage Books, 1960.
b. English eds.: London: Faber & Faber, 1940, 1944, 1945, 1947, 1954.

279. WRIGHT, WILLARD HUNTINGTON. *Modern Painting: Its Tendency and Meaning.* NY: J. Lane, 1915. 352 p.

a. Another ed.: NY: Dodd, Mead, & Co., 1926. 352 p., illus.

280. ZIEGLER, J. *Traité de la couleur et de la lumière.* Paris, 1852.

III. Articles

281. ADHEMAR, HELENE. "Galerie du Jeu de Paume: dernières acquisitions." *Revue du Louvre* 23:4-5(1973):285-98. 16 illus.

Works by Pissarro and Seurat recently acquired by the Jeu de Paume, Paris.

282. ALBERT, CHARLES. "L'Art et la société." *L'Art social* (Dec. 1896):161-73. Conférence faite le 27 juin 1896.

a. Reprint: Paris: Bibliothèque de l'art social et bureaux des *Temps nouveaux*, 1896.

283. ALEXANDRE, ARSENE. "Les Peintres indépendants." *L'Evénement* (23 Aug. 1886).

284. ALEXANDRE, ARSENE. "L'Art de demain." *La Révolte*, supplément littéraire (1892):250-1.

285. AMARAL, CIS. "Chevreul: From Soap to Color." *Art and Artists* 10:6 (Sept. 1975):34-9. 3 illus.

Biographical article on Michel-Eugène Chevreul, the mid-19th century French chemist

whose color theories profoundly influenced Impressionism and Neo-Impressionism.

286. ANTOINE, JULES. "Les Peintres néo-impressionnistes." *L'Art et critique* 63(9 Aug.1890):509-10; (16 Aug. 1890):524-6.

287. APOLLINAIRE, GUILLAUME. "Les Indépendants, Cross, Signac, Luce, etc." *L'Intransigeant* 22(April 1911).

288. AQUILINO, MARIE-JEANNINE. "Painted Promises: The Politics of Public Art in Late Nineteenth-Century France." *Art Bulletin* 75:4(Dec. 1993):697-712.

289. ARNOLD, MATTHIAS. "Die Postimpressionisten als Zeichner." *WeltKunst* 53:2(15 Jan. 1983):120-4. 9 illus., 4 col.

Mentions drawings and watercolors by Seurat, Signac, and other Neo-Impressionists.

290. "L'Art japonais et le néo-impressionnisme." *L'Art moderne* 7:17(Feb. 1889):50-2.

291. "Aspects of Post Impressionism." *Art and Artists* 226(July 1985):32.

292. BAES, EDGAR. "L'Art anarchiste." *La Libre critique* 3(30 Oct. 1892):91.

Part 2 of an article on anarchist art.

293. BAUDOÜIN, PAUL. "Mes souvenirs." *Gazette des Beaux-arts* ser. 6, 13(May 1935):295-314.

294. BAZALGETTE, LILY. "Documents. Le Néo-impressionnisme." *L'Information artistique* 36(Jan. 1957):66-73.

295. BESSON, GEORGE. "Un poète turc a-t-il inspiré les néo-impressionnistes?" *Les Lettres françaises* (7 Jan. 1954).

296. BIRREN, FABER. "Neo-Impressionism: The Most Scientific of all Schools of Color in Art." *Color Research and Application* 4:4(Winter 1979):200-7. 8 illus.

Discusses Neo-Impressionism's color theories and technique derived from Delacroix and the scientific study of color by Michel-Eugène Chevreul (1786-1889), Odgen Rood (1831-1902), and Charles Henry (1859-1926). Rood's influence on Seurat is elaborated.

297. BLOCK, JANE. "A Study in Belgrade Neo-Impressionist Portraiture." *Art Institute of Chicago Museum Studies* 13:1 (1987):37-51. 16 illus., 1 col.

Profiles the Belge Neo-Impressionist Georges Lemmen (1865-1916), with an emphasis on the series of portraits he painted of his sister. Detects Seurat's and Van Rysselberghe's strong influence on Lemmen and traces Lemmen's involvement with Les XX.

298. BONNET, PAUL. "Seurat et le Néo-impressionnisme." *Le Crocodile* (Lyon) (Nov.-Dec. 1957):6-22.

299. BREITBART, MYRNA. "Impressions of an Anarchist Landscape." *Antipode* (Sept. 1975):44-9.

300. BRETTELL, RICHARD R. and SCOTT SCHAEFER. "Impressionism in Context." in *A Day in the Country: Impressionism and the French landscape*, ed. by A.P.A. Belloli (Los Angeles: Los Angeles County Museum of Art, 1984):17-23. 1 illus.

Discusses the rationale behind the decision to include paintings by Seurat, Cross, and Signac in this exhibition on French Impressionist landscape.

301. BROWN, RICHARD A. "Impressionist Technique: Pissarro's Optical Mixture." *Magazine of Art* 43(Jan. 1950):12-5.

302. CACHIN, FRANÇOISE. "The Neo-Impressionist Avant-garde." in *Avant Garde Art*, ed. by Thomas B. Hess and John Ashbery (NY: Macmillan, 1967). Reprinted in *ARTnews Annual* 34(1968):54-65.

303. CACHIN, FRANÇOISE. "Les Néo-impressionnistes et le Japonisme, 1885-1893" in *Japonisme in Art, An International Symposium*, ed. by Yamada Chisaburō. (Tokyo: Committee for the Year 2001, 1980):225-37.

Discusses the influence of Japanese art on the paintings of Seurat, Signac, and Cross .

304. CACHIN-SIGNAC, GINETTE. "Autour de la correspondance de Signac." *Arts* (7 Sept. 1951):8. Also published as "Documenti inediti sul neo-impressionismo" *La Biennale di Venezia* 6(Oct. 1951):20-3.

Contains letters from Seurat and Pissarro to Signac.

305. CANNING, SUSAN MARIE. "The Symbolist Landscapes of Henry Van de Velde." *Art Journal* 45:2(Summer 1985):130-6. 10 illus.

Examination of Van de Velde's stylistic experiments with symbolism, influenced in part by Neo-Impressionism, in particular by Seurat.

306. CATHELIN, JEAN and GABRIELLE GRAY. "La Vie artistique et intellectuelle à Montmartre du second empire à l'expo de '89." *La Rue* 21(1976):79-88.

307. CHESNEAU, ERNEST. "Les Peintres impressionnistes." *Paris-Journal* (7 March 1882).

308. CHEVREUL, MICHEL-EUGENE. "Mémoire sur l'influence que deux couleurs peuvent avoir l'une sur l'autre quand on les voit simultanément." *Mémoires de l'Académie royale des sciences de l'Institut de France* 11(1832):447-520.

309. CHINAYE, HECTOR. "L'Art au dessus des révolutions." *La Jeune Belgique* (1885-86):339-49.

310. CHRISTOPHE, JULES. "Les Néo-impressionnistes au Pavillon de la ville de Paris." *Journal des artistes* 19(6 May 1888):147-8.

311. CHRISTOPHE, JULES. "Symbolisme." *La Cravache* (16 June 1888).

312. CHRISTOPHE, JULES. "Certains chromatistes au Cours-la-Reine." *Journal des artistes* 13(3 April 1892):101-2.

313. CIVALE, GIOVANNI B. "Socialism and Art." *The International Socialist Review* (Jan. 1908):385-91.

314. CORK, RICHARD. "A Postmortem on Post-Impressionism." *Art in America* 68:151(Oct. 1980):82-94, 149-53.

315. COUGNAC, PAUL DE. "Louise Dussault: l'artiste à la rose." *Magazin'Art* 7:4(Summer 1995):52-4. 7 col. illus.

Explores the work and artistic formation of the Canadian flower painter Louise Dussault that comments on her pointillist technique similar to Seurat and Signac.

316. COUSTURIER, EDMOND. "L'Art dans la société future." *La Révolte, supplément littéraire* 14(1891):354-5.

317. COUSTURIER, EDMOND. "Notes d'art." *Les Entretiens politiques et littéraires* 6(10 April 1893):331-3; 6(10 May 1893):429-30.

318. CREPIN, GEORGES. "L'Art et le socialisme." *Le Socialiste* (27 Jan. 1894):2.

319. CURNOW, BEN. "Forma Functions: Nike Savvas and Stephen Little." *Art and Text* 49(Sept. 1994):38-9. 2 col. illus.

Article on two contemporary Australian artists, with references to Savvas' pointillist technique.

320. DARDEL, ALINE. "Illustrations et satiristes, V: La Révolte, ou le drapeau noir — Luce, Camille et Lucien Pissarro." *Gazette de l'Hôtel Drouot* (11 Dec. 1981):50-1. See also (30 Oct. 1981):30-1; (18 Dec. 1981):28-9.

321. DAULTE, FRANÇOIS. "Cinquante ans d'art français dans les collections romandes: de Cézanne à Picasso." *L'Oeil* 359(June 1985):24-31. 8 illus.

Survey of French paintings in the Fondation de l'Hermitage in Lausanne that mentions Neo-Impressionism.

322. DE DREUZY, M. "La Couleur chez Jacques Villon." *Information d'histoire de l'art* 19:5(Nov.-Dec. 1974):221-4. 2 illus.

Discusses Villon's reliance on Neo-Impressionist color theory, as espoused by Seurat and Ogden Rood.

323. DELEVOY, ROBERT. "Van de Velde avant Van de Velde" in *Henry Van de Velde, 1863-1957* (Brussels: Palais des Beaux-arts, 1963).

324. DELVILLE, JEAN. "Art et socialisme." *La Jeune Belgique* (31 Oct. 1896):339-41.

325. DESHAIRS, LEON. "Art et socialisme." *Le Mouvement socialiste* (1899):355-60.

326. DESHMUKH, MARION F. "Art and Politics in Turn-of-the-Century Berlin: The Berlin Secession and Kaiser Wilhelm II" in *Turn of the Century: German Literature and Art, 1890-1915.* Ed. by Gerald Chapple and Hans H. Schulte. Bonn: Bouvier Verlag H. Grundmann, 1981.
Examines the Berlin Secession artists, organized in 1898, and notes foreign artists such as Pissarro and other Neo-Impressionists who exhibited with them.

327. DORRA, HENRI. "Charles Henry's 'Scientific' Aesthetic." *Gazette des Beaux-arts* 74:1211(Dec. 1969):345-56.

328. DORRA, HENRI. "Valenciennes' Theories: From Newton, Buffon and Diderot to Corot, Chevreul, Delacroix, Monet and Seurat." *Gazette des Beaux-arts* (124:1510) (Nov. 1994):185-94.
Discusses the influence of Valenciennes' early 19th century theories of perspective and landscape in later artists such as Pissarro, Seurat, and Monet.

329. ELDERFIELD, JOHN. "The Garden and the City: Allegorical Painting and Early Modernism." *Houston Museum of Fine Arts Bulletin* 7:1(Summer 1979):3-21. 25 illus.
Study of allegorical paintings by modern French painters, including examples by Signac and Seurat.

330. ELLIOT, EUGENE CLINTON. "On the Understanding of Color in Painting." *Journal of Aesthetics and Art Criticism* 16(June 1958):453-70.

331. "Une esthétique scientifique." *L'Art moderne* (10 Feb. 1889):46.

332. FENEON, FELIX. "Le Néo-Impressionnisme: correspondance particulière de *L'Art moderne.*" *L'Art moderne* 7:18(1 May 1887):138-40.

333. FENEON, FELIX. "L'Impressionnisme aux Tuileries." *L'Art moderne* 6(19 Sept. 1886):30-2.

First use of the term "Neo-Impressionism" by art critic Félix Fénéon in describing Seurat's paintings in Fénéon's review of the 8th Impressionist Exhibition, Paris.

334. FENEON, FELIX. "Le Néo-impressionnisme." *L'Art moderne* 7(1 May 1887):138-40; 8:16(15 April 1888):121-3.

335. FENEON, FELIX. "Notes inédites de Seurat sur Delacroix." *Bulletin de la vie artistique* (1 April 1922):154-8.

336. FENEON, FELIX. "Les Disparus, Charles Henry." *Bulletin de la vie artistique* 7(15 Nov. 1926):350.

337. FER, EDOUARD. "Les Principes scientifiques du néo-impressionnisme." *Pages d'art* (Dec. 1917):501-12; (May 1918):181-94.

338. FINCH, CHRISTOPHER. "Art: Neo-Impressionist Paintings." *Architectural Digest* 50(Oct. 1993):196-9.

339. FLAX, NEIL M. "Charles Blanc, le moderniste malgré lui" in *La Critique d'art en France 1850-1900*. Actes du colloque de Clermont-Ferrand 25, 26 et 27 mai 1987, réunis et présentés par Jean-Paul Bouillon.
Proceedings of a colloquium, Clermont-Ferrand, 25-27 May 1987 (Saint-Etienne: Université de Saint-Etienne, 1989): 95-104.

340. FOSCA, FRANÇOIS. "La Méthode picturale des impressionnistes et les historiens de l'art." *Werk* 6(June 1952):198-200.

341. FRECHES-THORY, CLAIRE. "La Donation Ginette Signac." *Revue du Louvre et des musées de France* 28:2(1978):107-12. 8 illus.

Discussion of works donated by Madame Ginette Signac to the Louvre: *Sous la Lampe* and *Venise, La Voile Verte* by Signac, *L'Air du Soir* and *Le Naufrage* by Cross, *L'Homme à La Barre* by Van Rysselberghe and a work by Maximilien Luce.

342. GAGE, JOHN. "Colour in History: Relative or Absolute." *Art History* 1:1(March 1978):104-30.

343. GEFFROY, GUSTAVE. "Chronique, pointillé-cloisonnisme." *La Justice* (11 April 1888):1.

344. GEFFROY, GUSTAVE. "Néo-impressionnistes, l'art d'aujourd'hui." *Le Journal* (28 Jan. 1894):3.

345. GERMAIN, ALPHONSE. "Les Néo-impressionnistes et leur théorie." *Art et critique* (15 Sept. 1889):250-2.

346. GERMAIN, ALPHONSE. "Du symbolisme dans la peinture." *Art et critique* 58(5 July 1890):417-20.

347. GERMAIN, ALPHONSE. "Delacroix théoricien." *Art et critique* (25 Oct. 1890):683-5.

348. GERMAIN, ALPHONSE. "Le Modernisme et le beau." *La Plume* 2(15 March 1891):115-6.

349. GERMAIN, ALPHONSE. "Théorie des néo-luminaristes et néo-traditionnistes." *Moniteur des arts* 20(27 March 1891):534-5, 543-4.

350. GERMAIN, ALPHONSE. "Sur un tableau refusé: théorie du symbolisme des teintes." *La Plume* 2(15 May 1891):171-2.

351. GERMAIN, ALPHONSE. "Théorie des déformateurs." *La Plume* 2(1891):289-90.

352. GERMAIN, ALPHONSE. "Théorie des néo-luminaristes (Néo-impressionnistes)." *L'Art moderne* 11:28(12 July 1891):221-2; 30(26 July 1891):239-40.

353. GERMAIN, ALPHONSE. "Théorie chromo-luminariste, exposé et critique." *La Plume* 3:57(1 Sept. 1891):285-7.

354. GERMAIN, ALPHONSE. "Essai de Kallistique: pour le beau." *Essais d'art libre* 3(Feb. 1893).

355. GERMAIN, ALPHONSE. "Le Chromo-luminarisme." *Essais d'art libre* (Feb.-March 1893):13-20.
Special issue.

356. GHEZ, OSCAR. "Impressionism and After: The Petit Palais, Geneva." *Connoisseur* 192: 773(July 1976):216-23. 11 illus.

Description of Impressionist and Neo-Impressionist paintings in the Petit Palais, Geneva, including examples by Cross and other pointillists.

357. GOTTMANN, C. "Malerei und Naturwissenschaft." *Kultur und Technik* 3:3(Sept. 1979):17-32. 24 illus.

Discusses the application of science to art in the 19th century, including Seurat's and Signac's restrictive pointillist technique.

358. GREEN, NICHOLAS. "Dealing in Temperaments: Economic Transformation of the Artistic Field in France During the Second Half of the Nineteenth Century." *Art History* 10(March 1987):59-75.

359. GUYOT, YVES. "L'Art et la science." *Revue scientifique* (July 1887):138-46.

360. HABASQUE, GUY. "Le Contraste simultané des couleurs et son emploi en peinture depuis un siècle" in *Problèmes de la couleur*, edited by Ignace Meyerson (Paris: S.E.V.P.E.N., 1957):239-53.

Paper delivered at a colloquium held at the Centre de la Recherche de psychologie comparative, Paris (18-20 May 1954). Pages 248-53 ("Discussion") includes extensive remarks by Meyer Schapiro.

361. HANOTELLE, MICHELINE. "Le Néo-Impressionnisme dans l'œuvre de Léo Gausson." *Gazette des Beaux-arts* 114:1450(Nov. 1989):216-26.

362. HARTRIDGE, HAMILTON. "The Visual Perception of Fine Detail." *Philosophical Transactions of the Royal Society of London.* Ser. B, 232(15 May 1967):519-671.

363. HENRY, CHARLES. "Variétés: loi d'évolution de la sensation musicale." *Revue philosophique de la France et de l'étranger* 22:(1886):81-7.

364. HENRY, CHARLES. "Introduction à une esthétique scientifique." *La Revue contemporaine* 2(Aug. 1885):441-69.

Exploration of physiological responses to lines and colors that influenced Seurat's Neo-Impressionist color theory.

365. HENRY, CHARLES. "Sur la dynamogénie et l'inhibition." *Comptes rendus de l'Académie des sciences* 108(7 Jan. 1889):70-1.

366. HENRY, CHARLES. "Le Contraste, le rythme, et la mesure." *Revue philosophique de la France et de l'étranger* 28(Oct. 1889):356-81.

367. HENRY, CHARLES. "Lettre au directeur de la 'Revue': esthétique et psychophysique." *Revue philosphique de la France et de l'étranger* 29(March 1890):332-6.

368. HENRY, CHARLES. "L'Esthétique des formes." *La Revue blanche* 7:34(Aug. 1894):118-29; 7:36(Oct. 1894):308-22; 7:38(Dec. 1894):511-25; 8:40(Feb. 1895):116-20.

369. HENRY, CHARLES. "La Lumière, la couleur, la forme." *L'Esprit nouveau* 6(1921):605-23; 7:729-36; 8:948-58; 9:1068-75.

370. HENRY, CHARLES. "Le Rapporteur esthétique et sensation de forme." *Revue indépendante* ser. 3, 7:18(April-June 1888):73-90.

371. HENRY, CHARLES. "Cercle chromatique et sensation de couleur." *Revue indépendante* ser. 3, 5:19(May 1888):73-90.

372. HENRY, CHARLES. "Harmonies de couleurs." *Revue indépendante* ser. 3, 7(June 1888):458-78.

373. HERBERT, ROBERT L. and EUGENIA W. HERBERT. "Artists and Anarchism: Unpublished Letters of Pissarro, Signac and Others." *Burlington Magazine* 102:692-3(Nov. and Dec. 1960):473-82; 517-22.

a. French trans.: *Le Mouvement social* 36(July-Sept. 1961):2-19.

374. HERBERT, ROBERT L. "Industry in the Changing Landscape from Daubigny to Monet" in *French Cities in the Nineteenth Century*, ed. by John M. Merriman (London: Hutchinson, 1982):139-64.

375. HERBERT, ROBERT L. "Impressionism, Originality and Laissez-Faire." *Radical History Review* 38(Summer 1987):7-15.

376. HERICOURT, J. "Une Théorie mathématique de l'expression: le contraste, le rythme, et la mesure, d'après les travaux de M. Charles Henry." *Revue scientifique* 44(9 Nov. 1889):586-93.

377. HERRMANN, LUKE. "Painter of Light & Colour." *Antique Collector* 58:9(Sept. 1987):76-83. 9 col. illus.

Traces the career of the German Neo-Impressionist painter Curt Hermann (1854-1929). Under the influence of Henry Van de Velde, Paul Signac, Henri Edmond Cross and Théo Van Rysselberghe, Hermann developed an early pointillist style, later abandoning it in favor of a broader, more colorful style.

378. HILDEBRANDT, HANS. "Neo-Impressionisten." *Aussaat. Zeischrift für Kunst und*

Wissenschaft 2:1-2(May-July 1947); 2:3-4(Aug.-Oct. 1947).

379. "Hommage à Charles Henry." *Cahiers de l'étoile* 13(Jan.-Feb. 1930).

Special issue includes contributions by Paul Signac, Paul Valéry, Gustave Kahn, René-Louis Doyon, J. Roche, F. Divoire, E. Gautier, G. Jameau, R. Jean, Léouzon-Le-Duc, G. Pillement, G. Pimienta, G. Bohn, Andry-Bourgeois, J. de Casa-Fuente, E. Caslant, R. Fleury, L. Génevais, A. Gleizes, R. Lutembacher, F. Warrain, and V. Delfino.

380. HOOG, MICHEL. "La Direction des beaux-arts et les Fauves (1903-1905)." *Art de France* 3(1963):363-6.

381. HUTTON, JOHN GARY. "'*Les Prolos Vagabondent*': Neo-Impressionism and the Anarchist Image of the *Trimardeur*." *Art Bulletin* 72(June 1990):296-309. 19 illus.

Discussion of Neo-Impressionism's concept of "integral image" that conveys meaning without titles or conventional allegories, with reference to the anarchist icon of the tramp, identified here as nonconformist hero and prototypical social victim. Reproduces examples by Pissarro, Luce, Cross, and Van Rysselberghe, among other artists.

382. HUYGHE, RENE. "L'Impressionnisme et la pensée de son temps." *Prométhée* (Feb. 1939):6-16.

383. IMDAHL, MAX. "Die Rohe der Farbe in der neueren französischen Malerei. Abstraktion und Konkretion" in *Poetik und Hermeneutik. Immanente Asthetik ästhetische Reflexion. Lyrik als Paradigma der Moderne.* (Munich: W. Fink, 1966):195-225.

384. ISLER DE JONGH, ARIANE. "The Origins of Colour Photography: Scientific, Technical and Artistic Interactions." *History of Photography* 18:2(Summer 1994):111-9. 9 illus., 8 col.

Traces the history of the autochrome, the first successful indirect method of color photography. Compares the autochrome technique to the effects of pointillism employed by Seurat and other Neo-Impressionists.

385. IVES, COLTA FELLER. "The Application of Charles Henry's Chromatic Circle." *The Metropolitan Museum of Art Bulletin* 48(Fall 90):48.

386. JULLIAN, RENE. "Un Néo-impressionniste ignoré: Antoine Muguet." *Bulletin de la Société de l'histoire de l'art français* (1972):349-52. 6 illus.

Presents the life and career of Neo-Impressionist Antoine Muguet (b. 1873), an admirer of Seurat and Signac.

387. KAHN, GUSTAVE. "De l'esthétique du verre polychrome." *La Vogue* (18 April 1886):54-65.

388. KAHN, GUSTAVE. "La Vie mentale: l'art social et l'art pour l'art." *La Revue blanche* 11:82(1896):416-23.

389. KAHN, GUSTAVE. "Au temps du pointillisme." *Mercure de France* 171:691(1 April 1924):5-23.

Important text that relates Seurat and the Neo-Impressionists to Symbolism by a supportive critic and personal friend.

390. KELLER, HENRY G. and J. J. R. MACLEOD. "The Application of the Physiology of Color Vision in Modern Art." *Popular Science Monthly* 83(Nov. 1913):450-65.

391. KOZLOFF, MAX. "Neo-Impressionism and the Dream of Analysis." *ArtForum* 6:8(April 1968):40-5.

392. KUNKEL, PAUL. "For Collectors: The Rediscovered Neo-Impressionists." *Architectural Digest* 40:4(April 1983):68-76.

Argues for collecting Neo-Impressionist works as investments.

393. LANT, ANTONIA. "Purpose and Practice in French Avant-Garde Print-Making of the 1880s." *Oxford Art Journal* (Jan. 1983):18-29.

394. LECOMTE, GEORGES CHARLES. "L'Exposition des Néo-impressionnistes." *Art et critique* (29 March 1890):203.

Reprinted in *L'Art moderne* (30 March 1890):101.

395. LEVY-GUTMANN, ANNY. "Seurat et ses amis." *Art et décoration* (1934):36.

396. LÖVGREN, SVEN. "Symbolismens genombrott i det franska 1880-talsmålriet." *Konstrevy* 3(1956):105-7, 124.

397. MALATO, CHARLES. "Some Anarchist Portraits." *Fortnightly Review* (1 Sept. 1894):315-33.

398. MALTESE, CORRADO. "Tra Leonardo e Land: qualche interazione tra arte e scienza." *Storia dell'arte* 38-40 (Jan.-Dec. 1980):419-23.

Relates Edwin Land's theory of color vision to work by Seurat, Signac, and other Neo-Impressionists, along with artists from the Renaissance to the Fauves.

399. MAUCLAIR, CAMILLE. "L'Oeuvre sociale et l'art moderne: les beaux-arts." *La Revue socialiste* (Oct. 1901):421-35.

400. MAUGIS, M. T. "Néo-impressionnistes." *Arts* (5-11 March 1958).

401. MAUS, OCTAVE. "Les Vingtistes parisiens." *L'Art moderne* 6(27 June 1886):201-4.

Laudatory article on Neo-Impressionism that proclaimed Seurat "the Messiah of a new art."

402. MAUS, OCTAVE. "La Recherche de la lumière dans la peinture." *L'Art moderne* 7(26 June 1887):201-2. See also *Catalogue de la V^e exposition des XX*, Brussels, 1888.

403. MAUS, OCTAVE. "Le Salon des XX, à Brussels. *La Cravache parisienne* 9(16 Feb. and 2 March 1889).

404. MEYERSON, EMILE. "Les Travaux de M. Charles Henry sur une théorie mathématique de l'expression." *Bulletin scientifique* (20 Dec. 1889):98-100.

405. MICHEL, ALBERT. "Le Néo-impressionnisme." *La Flandre libérale* (Feb.-March 1888). Reprinted in *L'Art moderne* 8:1(10 March 1888):83-5.

406. MIRBEAU, OCTAVE. "Néo-impressionnistes." *L'Echo de Paris* 3529(23 Jan. 1894):1.

407. MOFERIER, JACQUES. "Symbolisme et anarchie." *Revue d'histoire littéraire de la France* 65:2(April-June 1965):223-8.

408. MORNAS, ANTOINE. "L'Anarchie et les artistes." *Les Temps nouveaux* 1(14-20 March 1896):2-3.

409. MULLALY, T. "Pointillists." *Apollo* 63 (June 1956):185-89.

410. NEMECZEK, ALFRED. "Vincent van Gogh in Paris: das Fest der Farben." *Art: das Kunstmagazin* 11(November 1994): 14-34. 42 col. illus.

Describes van Gogh's career, styllistic changes, and pointillist influences of Pissarro, Signac, and other Neo-Impressionists.

411. "Néo-impressionnisme." *L'Art moderne* 8:46(11 Nov. 1888):365-7.

412. "Le Neo-impressionnisme." *Gazette des Beaux arts* ser. 6, 11(Jan. 1934):49-59.

413. "Les Neo-impressionnistes." *L'Escarmouche* (7 Jan. 1894).

414. PICARD, EDMOND. "La Socialisation de l'art." *L'Art moderne* 16(31 March 1895):73-5.

Part 1 of a multi-part article.

415. RAPP, BIRGITTA. "Alfred William Finch's debut som neoimpressionist." *Taidehistoriallisia Tutkimuksia* (Finland) 12(1991):7-17. 5 illus. Summary in English.

Describes the career of the painter and ceramic artist Alfred William Finch (1854-1930), including Neo-Impressionist influences.

416. REARICK, CHARLES. "Festivals in Modern France: The Experience of the Third Republic." *Journal of Contemporary History* (July 1977):435-60.

417. "Recherche de la lumière dans la peinture." *L'Art moderne* 7(26 June 1887):201-2.

418. RETTE, ADOLPHE. "L'Art et l'anarchie." *La Plume* 5:91(1 Feb. 1893):45-6.

419. REVEL, JEAN-FRANÇOIS. "Charles Henry et la science des arts." *L'Oeil* (Nov. 1964):20-7, 44, 58. illus.: *Portrait de Fénéon, La Jetée de Cassis, Saint Briac, Les Balises.*

420. REWALD, JOHN. "Camille Pissarro and Some of his Friends." *Gazette des Beaux-arts* 23:916(June 1943):363-76.

421. REWALD, JOHN. "Félix Fénéon." *Gazette des Beaux-arts* ser. 6, 32:965-6(July-August 1947):45-62; 33:972(Feb. 1948):107-26.

422. REWALD, JOHN. "French Paintings in the Collection of Mr. And Mrs. John Hay Whitney." *The Connoisseur* 137:552(March 1956):134-40.

423. REY, ROBERT. "Le Néo-impressionnisme" in *Histoire de l'art contemporain*, ed. by René Huyghe (Paris: L'Amour de l'Art, 1933):33-5.

424. RIOPELLE, CHRISTOPHER. "Renoir, the Great Bathers." *Philadelphia Museum of Art Bulletin* 86:367-68 (Fall 1990):5-40. 43 illus (12 col.)

Examines, in part, Renoir's opposition to Pointillism's formation and monumentalism.

425. ROOD, OGDEN NICHOLAS. "Modern Optics and Painting." *Popular Science Monthly* 22(Feb. 1874):415-21; (March 1874):572-81.

426. ROSLAK, ROBYN SUE. "Neo-Impressionism, Organicism, and the Construction of a Utopian Geography: The Role of the Landscape in Anarcho-Communism and Neo-Impressionism." *Utopian Studies* new ser., 1(1990):96-113.

427. ROSLAK, ROBYN SUE. "The Politics of Aesthetic Harmony: Neo-Impressionism, Science, and Anarchism." *Art Bulletin* 73(Sept. 1991):381-90.

428. ROSTRUP, HAARVARD. "Pointillisme" in *Meddeleser frà Ny Carlsberg Glyptotek* (Copenhagen: Carlsberg Glyptotek, 1947).

429. RUHMER, EBERHARD. "Wilhelm Leibl et ses amis, pour et contre l'Impressionnisme." *Gazette des Beaux-arts* 95(May-June 1980):187-97. 8 illus.

Examines Paris and the German avant-garde, 1850-80, and German acceptance of Impressionism, particularly Seurat, Signac, Monet, and Manet, among other topics.

430. SABBRIN, CELEN. "La Science et la philosophie en art." *La Vogue* 11:12(4-11 Oct. 1886):410-8.

431. SAUVAGE, CLAUDE. "L'impressionnisme (2)." *Magazin'Art* 3:1(Sept. 1990):90-2. 2 col. illus.

As part of a series on Impressionism, Sauvage identifies three distinct periods. Between 1886 and 1900, a second generation of Impressionist artists prolonged the movement, introducing techniques such as pointillism.

432. SCHAPIRO, MEYER. "The Nature of Abstract Art." *Marxist Quarterly* (Jan.-March

1937):77-98.

Reprinted in *Modern Art, 19th and 20th Centuries: Selected Papers* (NY: George Braziller, 1978):193.

433. SCHARF, AARON. "Painting, Photography, and the Image of Movement." *Burlington Magazine* 104(May 1962):186-95.

434. SERULLAZ, MAURICE. "Ainsi est né l'impressionnisme." *Galerie Jardin des arts* 139(July-August 1974):26-33. 28 illus.

Serullaz discusses the introduction to his *Encyclopédie de l'impressionnisme,* which also discusses Pointillism.

435. SERULLAZ, MAURICE. "Autour de Seurat: dessins néo-impressionnistes." *Revue du Louvre et des musées de France* 41(May 1991):109-10.

436. SHIFF, RICHARD. "The End of Impressionism: A Study in Theories of Artistic Expression." *Art Quarterly* (Autumn 1978):338-77.

437. SHIKES, RALPH E. and STEVEN HELLER. "The Art of Satire: Painters as Caricaturists and Cartoonists." *Print Review* 19(1984):8-125.

438. SIEBELHOFF, ROBERT. "Jan Toorop's Early Pointillist Paintings." *Oud Holland* 89:2(1975):86-97. 13 illus.

Analyzes Toorop's career and influences, including his Neo-Impressionist period (1888-91).

439. SIGNAC, PAUL. "Un camarade impressionniste: Impressionnistes et révolutionnaires." *La Révolte* 4(13-19 June 1891):3-4.

Tribute to Seurat, shortly after his death.

440. SIGNAC, PAUL. "Néoimpressionnismus." *Pan* 4:1(1898):55-62.
German version of Signac's *D'Eugène Delacroix au néo-impressionnisme* essay, originally printed in *La Revue blanche* (1898).

441. SIGNAC, PAUL. "Fondation de la Société des artistes Indépendants." *Partisans* 3(Jan. 1927):3-7.

442. SIGNAC, PAUL. "Charles Henry" in "Hommage à Charles Henry," special number of *Cahiers de l'étoile* 13(Jan.-Feb. 1930):7-2.

443. SIGNAC, PAUL. "L'Art des néo-impressionnistes" in *Le Néo-impressionnisme*, exh. cat., Paris, Galerie d'Art Braun (Feb.-March 1932).

444. SIGNAC, PAUL. "Le Néo-impressionnisme. Documents." *Gazette des Beaux-arts* 11:852(Jan. 1934):49-59.

Introduction to *Seurat et ses amis-la suite de l'impressionnisme*, exh. cat., Paris, Galerie

Wildenstein (Dec. 1933-Jan. 1934). English translation in *ARTnews* 52:8(Dec. 1953):28-31, 55-7. Reprinted in Paul Signac, *D'Eugène Delacroix au néo-impressionnisme*, ed. by Françoise Cachin (Paris: Hermann, 1964).

445. SIGNAC, PAUL. "What Neo-Impressionism Means." *ARTnews* 52:8(Dec. 1953):28-31, 55-7.

English translation of Signac's preface to *Seurat et ses amis-la suite de l'impressionnisme*, exh. cat., Paris, Galerie Wildenstein (Dec. 1933- Jan. 1934).

446. SILVERMAN, DEBORAH L. "The 1889 Exhibition: The Crisis of Bourgeois Individualism." *Oppositions* (Spring 1977):71-91.

447. SITWELL, OSBERT. "The Courtauld Collection." *Apollo* 2:7(July 1925):63-9.

448. SKIPWITH, PEYTON. "What is Post-Impressionism?" *Connoisseur* 202:814(Dec. 1979):242-7. 6 illus.

Examines pros and cons of different definitions of Post-Impressionism. Mentions Seurat, Cross, and Dubois-Pillet.

449. SLUYTS, CHARLES. "L'Association pour l'art." *Les Entretiens politiques et littéraires* 7(10 July 1893):7-15.

450. SMITH, PAUL GERALD. "Paul Adam, Soi et 'Les Peintres impressionnistes': la genèse d'un discours moderniste." *Revue de l'art* 82(1988):39-50. 1 illus.

Analyzes two texts by critic Paul Adam on Impressionism and Neo-Impressionism, specifically *Soi* (Paris: Tress & Stock, 1886) and "Les Peintres impressionnistes." *La Revue contemporaine* (May 1886):541-51.

451. SMITH, PAUL GERALD. "Seurat: The Natural Scientist." *Apollo* 132:346(Dec. 1990): 381-5. 4 illus. 3 col.

In reference to three paintings by Seurat in the Berggruen collection on loan to the National Gallery, London, Smith demonstrates how Seurat's color theory follows the ideas of Charles Blanc's *Grammaire des arts du dessin* (Paris: Renouard, 1867).

452. SOREL, GEORGES. "Sur les application de la psycho-physique." *Revue philosophique de la France et de l'étranger* 22:1(1886):363-75.

453. SOREL, GEORGES. "Contributions psycho-physiques à l'étude esthétique." *Revue philosophique de la France et de l'étranger* 29:1(1890):561-79; 30(1890):22-41.

454. SPRINGER, ANNEMARIE. "Terrorism and Anarchy: Late 19th Century Images of a Political Phenomenon in France." *Art Journal* 38:4(Summer 1979):261-6. 8 illus.

Documents anarchist illustrations by Signac, Pissarro, Luce, and others.

455. STEEFEL, LAWRENCE D. "Historical Method and Post-Impressionist Art. A

Review Article." *Art Journal* 21:2(Winter 1961-2):97-100.

In part, reviews Sven Lövgren's *The Genesis of Modernism: Seurat, Gauguin, van Gogh & French Symbolism in the 1880's* (Stockholm: Almquist & Wiksell, 1959).

456. SUTTER, DAVID. "Les Phénomènes de la vision." *L'Art* 20:6(1880):74-6, 124-5, 147-9, 195-7, 216-20, 268-9.

457. "La Théorie des néo-impressionnistes en 1834." *L'Art moderne* (2 Sept. 1888):284-5.

458. THIEBAUT, PHILIPPE. "Art nouveau et néo-impressionnisme: les ateliers de Signac." *Revue de l'art* 92(1991):72-8. 13 illus.

Describes the relationship of Signac to Art nouveau and Neo-Impressionism as revealed through his living arrangements, beginning with the artist's residence in 1897 at the Castel Béranger built and maintained by Hector Guimard. Thiébaut argues that Signac's journals from this period show that Art nouveau was not an homogenous movement and discusses his friendship with fellow pointillist Théo Van Rysselberghe.

459. TIPHERETH [pseud.]. "Néo-impressionnistes." *Le Cœur* 8(July 1894):8-9.

460. TIPHERETH [pseud.]. "Regard en arrière et simples reflexions sur l'art en 1884." *Le Cœur* 9(Dec. 1894):6-7.

461. VAISSE, PIERRE. "Charles Blanc und das Musée des Copies." *Zeitschrift für Kunstgeschichte* 39(1976):54-66.

462. VAN DE VELDE, HENRY. "Die Belebung des Stoffes als Schönheitsprincip." *Kunst und Künstler* 1:12(Dec. 1903):453-63.

463. VIATTE, GUY. "Nouvelles acquisitions des musées de province depuis 1960: peintures et dessins du XIXe siècle." *Revue du Louvre et des musées de France* 14:4-5(1964):294.

464. VILLATTE, LOUIS. "L'Art social." *Le Décadent* (15-30 Sept. 1888):8-11.

465. WALKER, JOHN A. "Art and Anarchism." *Art and Artists* 13(May 1978):16-9.

466. WALKER, JOHN A. "Post-Impressionism." *Marxism Today* 24(March 1980):19-21.

467. WARD, MARY MARTHA. "The Eighth Exhibition: The Rhetoric of Independence and Innovation" in *The New Painting: Impressionism, 1874-1886,* ed. by Charles S. Moffett (San Francisco: Fine Arts Museums of San Francisco; Washington, D.C.: National Gallery of Art, 1986):421-42.

468. WARD, MARY MARTHA. "Impressionist Installations and Private Exhibitions." *Art Bulletin* 73:4(Dec. 1991):599-622.

469. WEBER, KLAUS. "Der Dämon der Linie': frühe Arbeiten von Henry van de Velde zwischen Bild und Ornament" in *Henry van de Velde: ein europäischer Künstler seiner Zeit,*

ed. by Klaus-Jürgen Sembach and Birgit Schulte (Cologne: Wienand Verlag, 1992):118-31. 19 illus., 2 col.

Discusses the strong influence of Georges Seurat, with the result that at the end of the decade his paintings show a mixture of Neo-Impressionist and Symbolist forms. This combination can also be seen in his first applied art works and book designs in the early 1880s. During the 1890s he refined and developed Seurat's theory of line.

470. WEBSTER, J. CARSON. "The Technique of Impressionism: A Reappraisal." *College Art Journal* 4:4(Nov. 1944):3-22.

Deals in part with 19th century color theory and Neo-Impressionist application.

471. "What Neo-Impressionism Means; Seurat and his Friends." *ARTnews* 52(1953)28-31

472. WHELAN, RICHARD. "'Le Roi' Fénéon and the Neo-Impressionists." *Portfolio* 3:2(March-April 1981):46-55. 13 illus., 7 col.

Discusses critic Félix Fénéon's championship of Seurat's pointillist painting, *La Grande Jatte* (1884-86), which launched him on his career as the most perceptive and articulate critic and spokesman for the Neo-Impressionists from the 1880s to the 1920s. Also concerns Fénéon's treatment of Bonnard, Vuillard, Toulouse-Lautrec, Vallotton, and fellow critic Thadée Natanson.

473. ZERVOS, CHRISTIAN. "Idéalisme et naturalisme dans la peinture moderne." *Cahiers d'art* 2(1927):293-8.

474. ZEVAES, ALEXANDER. "Art et socialisme." *Le Socialiste* (19 Jan. 1896):3.

475. ZIMMERMANN, MICHAEL F. "Die Utopie einer wissenschaftlichen, sozialen Kunst. Zur Theorie des Neo-Impressionismus und ihrer Aufnahme in Deutschland" in *Curt Herrmann 1854-1929; Ein Maler der Moderne in Berlin*, ed. by Rolf Bothe (Berlin: Berlin Museum; Verlag Willmuth Arenhövel, 1989):264-83.

Exhibition catalogue, Museum of Berlin.

476. ZUPNICK, IRVING L. "The Social Conflict of the Impressionists." *College Art Journal* 19(Winter 1959-60):146-53.

IV. Exhibitions

Note: For detailed Neo-Impressionist exhibitions chronology and history especially prior to 1892, see Robert L. Herbert, *Neo-Impressionism* (exh. cat., NY, Solomon R. Guggenheim Museum, 1968):240-9 and "Chronology" by Anne Distel in *Seurat* (exh. cat., Paris, Grand Palais; NY, Metropolitan Museum of Art, 1991):399-442.

1892-93, 2 December-8 January	Paris, Hôtel Brébant. *Exposition des peintres néo-impressionnistes.*
	Reviews: A. Alexandre, *Paris* (8 Dec. 1892); H. Durand-Tahier, *La Plume* (15 Dec. 1892):531; C. Saunier, *L'Art moderne* (25 Dec. 1892):412-3; R. Sertat, *La Revue encyclopédique* (1 Feb. 1893):73.
1893-94, December-January	Paris, 20 rue Laffitte. *Groupe des peintres néo-impressionnistes.* First rue Laffitte exhibition, organized by Signac, Van Rysselberghe, and others.
	Reviews: A. Alexandre, *Paris* (1 Jan. 1894); G. Geffroy, *Le Journal* (28 Jan. 1894).
1894, February	Paris, 20 rue Laffitte. *Groupe des peintres néo-impressionnistes.* Second rue Laffitte Neo-Impressionist exhibition.
1894, March	Paris, 20 rue Laffitte. *Groupe des peintres néo-impressionnistes.*
	Reviews: C. Mauclair, *Mercure de France* (March 1894):284; Tiphereth, *Le Cœur* (July 1894):8-9.
1894, 22 November	Paris, 20 rue Laffitte. *Groupe des peintres néo-impressionnistes, tableaux de Luce, aquarelles de Signac.* First special exhibition of the Groupe des peintres néo-impressionnistes, featuring paintings by Luce and watercolors by Signac.
1894-95, 15 December-5 January	Paris, 20 rue Laffitte. *Cross et Petitjean.* Second special exhibition of the Groupe des peintres néo-impressionnistes, featuring paintings from 1884-94.
1895, 22 February-14 March	Paris, Galerie Laffitte (Léonce Moline). *Exposition de quelques peintures, aquarelles, dessins et eaux-fortes de Ch. Agard, Eug. Delâtre, J. H. Lebasque, feu Georges Seurat.*
1895, 23 February-1 April	Brussels, La Libre Esthétique.
1898, March -April	Brussels, La Libre Esthétique.
	Review: Colleville, *La Plume* (1 April 1898):222.
1898, November	Berlin, Harry Kessler (Keller und Reiner). *Peintres néo-impressionnistes.*

1899, 10-31 March	Paris, Galerie Durand-Ruel.

Included a Neo-Impressionism room.
Reviews: G. Coquoit, *Gil Blas* (18 March 1899) and *La Vogue* 2(1899):56; A. Fontainas, *Mercure de France* (March 1899):247; F. Fagus, *La Revue blanche* (1 Nov. 1899):3872; T. Natanson, *La Revue blanche* (1 April 1899):508; Y. Rambosson, *La Plume* (1 June 1899):382; J. Leclercq, *Chronique des arts et de la curiosité* (18 March 1899):94.

1903, January	Hamburg, Galerie P. Cassirer. *Neo-impressionisten*. Also shown Berlin.
1903, Summer	Weimar. *Exposition de tableaux de M. Denis, Cross, Luce, Signac, Van Rysselberghe, Vuillard, Bonnard, etc.*
1909, January	Paris, Galerie Druet. *Aquarelles et dessins de Cross, Luce, Seurat, Signac, etc.*
1909, May	Paris, Galerie Bernheim-Jeune. *Aquarelles et pastels de Cézanne, Cross, Degas, Jongkind, C. Pissarro, Roussel, Signac, Vuillard.*
1911, 19 June-3 July	Paris, Galerie Druet. *Exposition de peintures et aquarelles de H. E. Cross et P. Signac.*
1918, November	Paris, Galerie du Luxembourg. *Exposition permanente des néo-impressionnistes.*
1926	Paris, Société des Artistes Indépendants. *Trente ans d'art indépendant 1884 à 1914.*

Memorial catalogue with appendices that featured Neo-Impressionist paintings exhibited at Les Indépendants.

1927	Lyon, Salon du Sud-est. *Rétrospective de l'époque néo-impressionniste.*
1928, 3 December	Paris, Galerie Georges Petit. *Catalogue des œuvres importantes de Camille Pissarro, et de tableaux, pastels, aquarelles, dessins, gouaches par Mary Cassatt, Cézanne, Dufeu, Delacroix, Guillaumin, Blanche Hoschedé, Jongkind, Le Bail, Luce, Manet, Claude Monet, Piette, Seurat, Signac, Sisley, Van Rysselberghe, etc.*, composant la Collection Camille Pissarro dont la première vente aux enchères publiques aura lieu à Paris, Galerie Georges Petit, le lundi 3 décembre 1928.
1929, February	Lucerne. *L'Ecole impressionniste et néo-impressionniste.*
1932, 25 February-17 March	Paris, Galerie d'art Braun. *Le Néo-impressionnisme*. Préface par Paul Signac. 18 p., 13 illus.

1933-34, November-
January

NY, Wildenstein Galleries. *Seurat and his Friends.* Also shown Paris, Galerie Wildenstein (Dec. 1933-Jan. 1934) as *Seurat et ses amis-la suite de l'impressionnisme.* Introduction by Paul Signac, reprinted in *Gazette des Beaux-arts* ser. 6, 11:76 (Jan. 1934):49-59; translated into English as "What Neo-Impressionism Means," *ARTnews* 52:8(Dec. 1953):28-31, 55-7.

Reviews: A. Lévy-Gutmann, *Art et décoration* (1934):36-7; L. Vauxcelles, *L'Art vivant* (Feb. 1934):58-9.

1936 - 37, 23 December-
25 January

Rotterdam, Museum Boymans van Boiningen. *Schilderijen uit de Divisionistische School van Georges Seurat tot Jan Toorop.*

1937, 20 January-27
February

London, Wildenstein Galleries *Seurat and his Contemporaries.* Organized in collaboration with the *Gazette des Beaux-arts.* Preface by Paul Signac (1933) translated into English. 38 p., 7 illus.

Review: *Apollo* (March 1937):164.

1937, November

Zurich, Galerie Alktuaryus. *Le Néo-impressionnisme.*

1942-43, 12 December-
15 January

Paris, Galerie de France. *Les Néo-impressionnistes.* Catalogue includes excerpts from Signac's *D'Eugène Delacroix au néo-impressionnisme* (Paris: Editions de La Revue Blanche, 1899) 14 p.

Review: P. du Colombier, *Beaux-arts* (20 Dec. 1942):7.

1950, 2 November-2
December

London, Redfern Galleries. *Pointillists and their Period.*

1952

Venice, XXVIᵉ Biennale. *Il Divisionismo.* Text ("Il divisionismo in Francia") by Raymond Cogniat.

1953, 18 November-26
December

NY, Wildenstein & Co. *A Loan Exhibition of Seurat and his friends: for the Benefit of the Scholarship Fund of l'Alliance française de New York.* Catalogue by John Rewald.

1953-54, 4 December-17
January

Los Angeles, Los Angeles County Museum. *Watercolors by Paul Signac, with Two of his Paintings, and Works by Georges Seurat and Henri Edmond Cross.* 20 p., illus.

1954, June

Paris, Galerie Baugin. *Autour de Seurat.*

1955

The Hague, Haags Gemeentemuseum. *Nieuwe Beweging. Nederlandse schilderkunst om 1910.* K. E. Schuurman W.A. L. Beeren.

1955, 15 April-8 May	Paris, Grand Palais, Société des Artistes Indépendants. *Hommage à P. Signac et ses amis.* Texte de George Besson.
1956, 10 June-22 July	Douai, Bibliothéque municipale. *Exposition Henri Edmond Cross et ses amis: Seurat, Signac, Angrand, Luce, Lucie Cousturier, Van Rysselberghe (centenaire de H. E. Cross).* 16 p.
	Paris, Bibliothèque nationale. *Gustave Geffroy et l'art moderne.*
1958, 25 February-15 March	Paris, Galerie André Maurice. *Les Néo-impressionnistes.* No catalogue.
1958, 31 May-8 July	Saint-Denis, Musée Municipal. *M. Luce et son milieu, les Néo-impressionnistes.*
	Review: *Revue des arts* 8(July 1958):199-200.
1958, 27 June-October	Paris, Musée National d'Art moderne. *De l'Impressionnisme à nos jours.*
1958, 15 November-14 December	Luxembourg, Musée des Beaux-arts. *Du Néo-impressionnisme à nos jours.*
1959	Belgrad, Museum. *P. Signac i njegovi prijatelji.*
1959, 31 March-9 April	Los Angeles, Municipal Art Gallery. *The Collection of Mr. and Mrs. J. Rewald.*
1960	Paris, Galerie André Maurice. *Les Néo-impressionnistes.*
1960, 6-30 May	Paris, Galerie du XXᵉ siècle. *E. Fer, Valtat, Cross, Nessi, Seyssaud, Signac, Luce.*
1960, 23 July-31 August	Honfleur, Grenier à sel, société des Artistes honfleurais. *Le Paysage normand. Les Peintres pointillistes.*
1960-61, 4 November-23 January	Paris, Musée National d'Art moderne. *Les Sources du XXᵉ siècle.*
1961	Paris, Galerie J.-C. et J. Bellier. *Les Néo-impressionnistes.*
1961, 2 May-10 June	Paris, Galerie de Paris. *Les Amis de Saint-Tropez.*
1962, 17 February-17 June	Brussels, Musées Royaux des Beaux-arts de Belgique. *Le Groupe des XX et leurs contemporains.* Also shown Otterlo, Rijksmuseum Kröller-Müller (15 April-17 June 1962). Préface par Francine-Claire Legrand. Introduction par Philippe Roberts-Jones et Abraham-Marie Hammacher.

Exhibition of Belgian Neo-Impressionism. Includes capsule biographies and bibliographies of major Les XX artists.

1962, 30 October-17 November

NY, Hammer Galleries. *Seurat and his Friends.*

1963, 19 November-14 December

NY, Hirschl & Adler Galleries. *Neo-Impressionism.*

1965, 20 January-14 March

New Haven, Connecticut, Yale University Art Gallery. *Neo-Impressionists and Nabis in the Collection of Arthur G. Altschul.* Catalogue by Robert L. Herbert.

Includes exhibition lists and bibliographies.

1965, 23 April-16 May

Paris, Société des Artistes Indépendants. *Les Premiers indépendants 1884-1894.* Texte de R. Charmet.

1966, 29 April-10 July

Brussels, Musées Royaux des Beaux-arts de Belgique. *Evocation des 'XX' et de 'La Libre esthétique'.* Introduction par Philippe Roberts-Jones.

1966, 7-25 June

London, Arthur Tooth & Sons. *Pointillisme: A Loan Exhibition of Paintings by Angrand, Cross, Dubois-Pillet* [et al.]. 10 p., 26 pl.

1967, 24 May-27 June

Paris, Galerie Hervé. *Quelques tableaux de maîtres néo-impressionnistes.*

1968, February-April

NY, Solomon R. Guggenheim Museum. *Neo-Impressionnism.* Catalogue by Robert L. Herbert. 175 works shown..

Includes an introductory essay, short artist biographies, exhibitions and chronology, and bibliography.

Reviews: F. Cachin, *ARTnews* 66(Feb. 1968):35[+]; *Arts Magazine* 42 (March 1968):54; W. Kane, *Burlington Magazine* 110(July 1968):426

1968

Genève, Musée du Petit Palais. *L'Aube du XXe siècle, de Renoir à Chagall.*

1969, 17 January-13 April

Brussels, Musée Royaux des Beaux-arts de Belgique. *Peintres belges -- lumières françaises.* Introduction par Marie-Jeanne Chartrain-Hebbelinck.

1971, 18-30 February

NY, Hammer Galleries. *Neo-Impressionism.*

1974, 15 January-15 March

Paris, Galerie Durand-Ruel. *Hommage à Paul Durand-Ruel, 1874-1974: cent ans d'impressionnisme.* Catalogue par Germain Bazin et Claude Roger-Marx. 102 p., 82 illus.

Memorial exhibition that emphasizes gallery owner Paul Durand-Ruel's devotion to Impressionist and Neo-Impressionist works.

1977, 28 March-29 May Paris, Musée National du Louvre, Cabinet des dessins. *De Burne-Jones à Bonnard; dessins provenant du Musée National d'art moderne.* Avant-propos par Maurice Serullaz; préface par Pierre Georgel; catalogue par Jacqueline LaFargue. 63 p., 113 illus. 113 works shown.

Included works by Neo-Impressionists such as Signac and Cross.

Reviews: B. Scott, *Apollo* 105:184(June 1977):490; M. Serullaz, *Revue du Louvre et des musées de France* 27:2(1977):103.

1977, 27 May-10 July Düsseldorf, Städtische Kunsthalle. *Vom Licht zur Farbe, Nach-impressionistische Malerei zwischen 1886 und 1912.* Jürgen Harten, Robert L. Herbert, John Matheson.

1977, 2 July-23 October Copenhagen, Statens Museum for Kunst, kobberstiksamlingen. *Hebert Melbye's Samling; en illustreret oversight.* Text by Erik Fischer. 79 p., 69 illus. In Danish and English.

Catalogue of the Herbert Melbye Collection, bequeathed to the Museum for Kunst in 1976 and permanently housed in the Kobberstiksamling. Includes works by Cross and Signac, among other artists.

1977 The Hague, Dienst voor Schone Kunsten. *Haagse Kunstkring. Werk verzameld.*

1977 The Hague, Haags Gemeentemuseum. *Licht door Kleur.*

1979, 20 January-11 March Ghent, Musée des Beaux-arts. *Veertig Kunstenaars rond Karel Van de Woestijne.* Introduction by Robert Hoozee.

1979-80, 2 November-6 January Ann Arbor, University of Michigan, Museum of Art. *The Crisis of Impressionism 1878-1882.* Catalogue by Joel Isaacson, with the collaboration of Jean-Paul Bouillon [et al.]. Ann Arbor: University of Michigan Museum of Art, 1979. 220 p., illus.

Includes a chronology, bibliography and "Catalogues of the Impressionist Exhibitions, 1879-1882," pp. 207-20.

1979-80, 17 November-16 March London, Royal Academy of Arts. *Post Impressionism, Cross-Currents in European Painting.* Catalogue text by John House.

1980	Utrecht, Centraal Museum. *Van Gogh tot Cobra. Nederlandse schilderkunst 1880-1950.* Catalogue by G. Imanse
1980-81, 1 November-4 January	Oxford, Ashmolean Museum. *Artists, Writers, Politics: Camille Pissarro and his Friends.* Catalogue by Anne Thorold.
1982-83, 13 October-16 January	Saint-Germain-en-Laye, Musée Départemental du Prieuré. *L'Eclatement de l'impressionnisme.* Jeanine Warnod, Marie Amélie Anquetil, avec la collaboration de Marianne Barbey et d'Olivier Michel. 139 p. 138 works shown.

Exhibition divided into four sections, including one on Neo-Impressionism with works by Seurat, Signac, and Pissarro.

1983, 26 January-13 March	Indianapolis, Indiana Museum of Art. *The Aura of Neo-Impressionism: The W. J. Holliday.* Catalogue by Ellen Wardwell Lee. Annotations by Tracy E. Smith. Bloomington: Indiana University Press, 1983. 214 p., 127 illus.

Exhibition of Neo-Impressionist paintings from the collection of Mr. and Mrs. W. J. Holliday, formed between 1957 and 1971, containing 96 pictures by 85 artists. Included works by Seurat, Signac, Luce, Van Rysselberghe, Jean Metzinger, and August Herbin, among others. Lee describes Neo-Impressionism's development; Smith's annotations include notes on each painter's career and exhibition histories of works shown.

1984-85, 28 June-22 April	Los Angeles, Los Angeles County Museum of Art. *A Day in the Country, Impressionism and the French Landscape.* Also shown in Chicago, Art Institute of Chicago (23 Oct. 1984-6 Jan. 1985); Paris, Grand Palais (8 Feb.-22 April 1985). Sponsored by the IBM Corporation, the National Endowment for the Arts, and the Federal Council on the Arts and Humanities, Washington, D.C. Catalogue texts by Richard Brettell, Sylvie Gache-Patin, Scott Schaefer, Françoise Heilbrun; edited by A. P. A. Belloi. 375 p., 233 illus. 90 works shown.

Exhibition of landscapes and cityscapes by 16 artists, including Cross, Pissarro, Seurat, and Signac. Catalogue includes five essays.
a. French ed.: Paris: Réunion des Musées Nationaux, 1985.

1985, 6 April-14 July	Tokyo, National Museum of Western Art. *Exposition du pointillisme.* Also shown Kyoto, Municipal Museum of Art. Catalogue by Françoise Cachin.

1985, 8 June-22 September	Pontoise, Musée Pissarro. *Peintures néo-impressionnistes.* 15 p., illus.
1986, 17 January-6 July	San Francisco, San Francisco Fine Arts Museums. *The New Painting, Impressionism 1874-1886.* Also shown Washington, D.C., National Gallery of Art (19 April-6 July 1986). Catalogue by Charles S. Moffett.
1986-87 December-May	Naples, Museo di Capodimonte. *Capolavori impressionisti dei musei americani.* Also shown Milan, Pinacoteca di Brera (March-May 1987). Catalogue by Gary Tinterow. 113 p., 47 col. Illus.
	Exhibition of Impressionist paintings from American museums that included works by Pissarro, Seurat, and Signac, among others.
1987, 15 January-13 September	NY, Jewish Museum. *The Dreyfus Affair: Art, Truth and Justice.* Catalogue by Norman L. Kleeblatt. 316 p., 341 illus.
	Exhibition of paintings, posters, prints, cartoons, and photographs that document the Alfred Dreyfus Affair, a Jewish officer in the French Army who was accused in 1894 of passing state secrets to the Germans. Notes the involvement of the artistic and literary avant-garde, including supporters Pissarro and Signac.
1988, 17 May-11 December	Paris, Galeries Nationales du Grand Palais. *Le Japonisme.* Also shown Tokyo, National Museum of Western Art (23 Sept.-11 Dec. 1988).
1988, 28 May-7 August	Amsterdam, Rijksmuseum Vincent van Gogh. *Neo-impressionisten, Seurat tot Struycken.* Catalogue by Ellen Wardwell Lee. Met bijdragen van Connie Homburg, Ronald de Leeuw en Ronald Pickvance. In cooperation with the Indianapolis Museum of Art. Zwolle: Waanders, 1988. 224 p., illus. Bibliography, pp. 217-22.
1988-89, 23 November-27 January	London, JPL Fine Arts. *A Selection of Impressionist and Neo-Impressionist Drawings, Watercolours, Pastels, and Paintings, Nineteenth and Twentieth Century French Sculpture.* 82 p., 52 illus., 32 col. No text.
	Exhibition of works by Pissarro, Cross, Luce, Van Rysselberghe, and Signac, among others.
1989	Salzburg, Galerie Salis. *Seurat und sein Kreis.*
1989, 23 May-14 July	London, JPL Fine Arts. *Private View.* 60 p., 49 illus., 36 col. No text.

	Exhibition of works by Cross, Luce, Van Rysselberghe, Signac and Pissarro, among others.
1989	Pittsburgh, Carnegie Museum of Art. *Impressionism: Selection from Five American Museums.* Introduction by Richard R. Brettell. Catalogue by Marc S. Gerstein. 202 p., illus., 84 col.

Traveling exhibition of paintings from the Carnegie Museum, the Minneapolis Institute of Arts, the Nelson-Atkins Museum of Art (Kansas City), the St. Louis Museum of Art, and the Toledo Museum of Art. Included works by Luce, Pissarro, Seurat, and Signac.

1990, 17 March-17 June Pontoise, Musée de Pontoise, Tavet et Pissarro. *Néo et post-impressionnistes belges dans les collections privées de Belgique.* Also shown Charleroi, Musée des Beaux-arts (18 May-17 June 1990). Commissaire de l'exposition: Christophe Duvivier. 60 p., illus.

1990 Tokyo, Bridgestone Museum of Art. *Masterworks from the Bridgestone Museum of Art.* Catalogue by Yasuo Kamon. 102 p., illus.

Included works by Pissarro and Signac, among many other artists.

1992-93, 31 October-5 September Ghent, Museum voor Schone Kunsten. *Les XX and the Belgian Avant-Garde: Prints, Drawings and Books, ca. 1890.* Also shown Lawrence, Kansas, Spencer Museum of Art (24 Jan.-21 March 1993); Williamstown, Massachusetts, Sterling and Francine Clark Art Institute (12 April-13 June 1993); Cleveland, Cleveland Museum of Art (13 July-5 Sept. 1993).

Catalogue essays by Jane Block, Susan M. Canning, Donald Friedman, Sura Levihe, Alexander Murphy, Carl Strikwerda. Edited by Stephen H. Goddard. Lawrence: Spencer Museum of Art, 1992. 400 p., 234 illus., 19 col.

Exhibition of prints, drawings, pastels, posters, books, and journals of Les XX, a Symbolist Belgian group of artists who included James Ensor, Théo Van Rysselberghe, Fernand Rops, and Jan Toorop. Catalogue includes six essays about Les XX.

1994, 9 June-6 September NY, Museum of Modern Art. *Masterpieces from the David and Peggy Rockefeller Collection: Manet to Picasso.* Catalogue by Kirk Varne

Exhibition of 21 paintings, including works by Pissarro, Seurat, and Signac.

1995, 31 March-19
November

Amsterdam, Rijksmuseum Vincent van Gogh. *In Perfect Harmony: Picture + Frame.* Also shown Vienna, Kunstforum Wien (24 Aug.-19 Nov. 1995). Texts by Edwin Becker, Isabelle Cahn, et al. 277 p., illus., some col.

Exhibition of paintings with artist-designed frames dating 1850-1920. Includes individual chapters on Pissarro and Seurat, among other artists.

Georges Pierre Seurat

Biography

Seurat was the inventor and acknowledged leader of Neo-Impressionism. During his brief life and career (1882-91), he also produced highly sophisticated line and *conté* crayon drawings renowned for subtle tonal variations. He considered his large-figure, programmatic Neo-Impressionist compositions such as *Bathers at Asnières* (1883), *La Grande Jatte* (1884-85), *Models* (1886-88), *Circus Sideshow* (1887-88), *Le Chahut* (1889-90), and *Circus* (1890-91) his masterworks and the fullest expressions of the new aesthetic.

Born into a Parisian middle-class family, he was more attached to his mother than his distant and eccentric father and dined at the family apartment his entire life. He was a full-time art student at age 15 and entered l'Ecole des Beaux-arts in 1878 as a pupil of Henri Lehmann (1814-82), a disciple of Ingres. He gravitated towards more progressive instruction under Pierre Puvis de Chavannes and pursued overarching interests in the expressive values of line and color, color theory, and the science of optical effects that became the central tenets of Neo-Impressionism.

Seurat's earliest oil paintings of rural landscapes and peasants (1881-82) owed much to Corot, Millet, and other painters of the Barbizon School. About this time his search for a scientific "optical painting" led him to the writings and work of Delacroix and contemporary theorists and aestheticians such as Chevreul, Blanc, Helmholtz, Maxwell, Sutter, Rood, and others. Ogden Rood's *Modern Chromatics*, which Seurat purchased soon after it was translated into French in 1881, had a major impact. Seurat copied out Rood's color wheel, made notes on experimental sections of the book, and likely adopted Rood's system of color harmonies and contrasts for his first monumental Neo-Impressionist canvas, *Bathers at Asnières* (1883). Although *Bathers* was rejected by the official Salon of 1884, it attracted attention at the Salon des Indépendants in mid-1884, where Paul Signac first encountered Seurat's work.

Seurat experimented with pointillist techniques in a second large canvas, *La Grande Jatte*, in 1884 and 1885 by heightening his palette further and using finely divided color-patch brushwork that he called "chromo-luminarism," known later as divisionism. The Impressionist Camille Pissarro converted to Neo-Impressionism after meeting Seurat in October, 1885. By the following spring, Signac and Pissarro's son Lucien joined to form the nucleus of the new group. The four Neos exhibited side by side in the last Impressionist show in May, 1886. Seurat's *La Grande Jatte* was the most controversial painting in the exhibition and brought him instant notoriety. The fledging Neo-Impressionist movement was adopted by Félix Fénéon, Paul Adam, Gustave Kahn, and other Symbolist art critics and writers who promoted it as the leading avant-garde style in the aftermath of Impressionism.

Seurat exhibited every year with Les Indépendants and biennially with Les XX in Brussels from 1887. He belonged to elite Symbolist literary and artistic circles and cultivated the friendship of scientists such as Charles Henry. From 1886, he painted on the Normandy coast in the summers and spend winters creating monumental figure paintings. He also completed stunning tenebrist crayon drawings that he exhibited with his paintings. At the time of his sudden death of acute diphtheria at age 31 in March, 1891, Seurat had produced over 240 oil paintings and several hundred drawings.

Contemporaries described Seurat as reserved, methodical, firm in opinions, and protective of his role as Neo-Impressionism's instigator and aesthetician. He was hostile towards Gauguin and voiced concerns that his technique was being corrupted by others. Near the end of his short life the Symbolists' support declined and Fénéon criticized the increasingly anti-naturalistic quality of his work. Few of his closest friends were aware of his mistress Madeleine Knobloch or of the son born to them in February, 1890, who died two weeks after his father and is buried alongside him in Père-Lachaise. After Seurat died at his mother's home in March, 1891, his unfinished *Circus* attracted scant attention when exhibited a few months later at Les Indépendants.

Seurat received memorial exhibitions at Les XX in Brussels and at Les Indépendants in 1892. Paul Signac helped to revive Seurat's reputation in Neo-Impressionism's manifesto, *D'Eugène Delacroix au néo-impressionnisme* (Paris: Editions de la Revue Blanche, 1899). Seurat was a major innovator in painting and drawing and a forerunner of 20th-century modernism. Important Seurat retrospectives are listed in the Exhibitions section. A recent monumental retrospective (231 works shown) was held in 1991-92 at the Grand Palais, Paris and at the Metropolitan Museum of Art, New York. The impressive catalogue of this show includes current scholarship and outstanding reproductions. Of particular value to researchers are Robert L. Herbert's cogent commentary on Seurat literature and bibliography (pp. 425-32) and Anne Distel's definitive chronology (pp. 399-412).

Georges Pierre Seurat

Chronology, 1859–1891

Reliable, detailed chronologies of Seurat's life and career are plentiful; the definitive chronology to date, particularly for the crucial years 1885-91, is by Anne Distel in *Seurat* (exh. cat., Paris: Grand Palais; NY; Metropolitan Museum of Art, 1991):399-412. Among others, see John Rewald, *Seurat: A Biography* (NY: Abrams, 1990); Pierre Courhion, *Georges Seurat* (NY: Abrams, 1988):45-7; *Seurat: correspondances, témoignages, notes inédites, critiques* (Paris: Acropole, 1991):317-23; Catherine Grenier, *Seurat, catalogue complet des peintures* (Paris: Bordas, 1991):152-4; Sarah Carr-Gomm, *Seurat* (London: Studio Editors, 1993):140-1; Anne Distel, *Seurat* (Paris: Profils de l'art Chêne, 1994):156-9; Sarah Herring, "Chronology" in John Leighton and Richard Thomson, *Seurat and The Bathers* (London: National Gallery Publications; dist. in the U.S. by Yale University Press, 1997):152-3; and Erich Franz and Bernd Grove, *Georges Seurat Drawings* (Boston: Little, Brown, 1984):197-200. The following brief chronology includes only highlights.

1859

December 2
Birth of Georges Pierre Seurat in Paris at 60 rue de Bondy (now rue René Boulanger), in the 10th arrondissement. His father, Antoine-Chrisostôme (1815-91) aged 44, former court clerk at La Villette who becomes a wealthy real estate speculator, lives separately from the family at a summer house in Le Rincy, visiting once a week. His mother, Ernestine Faivre (1828-99) aged 31, is from an upper middle-class Parisian family. Seurat's older brother, Emile (1846-1906), spends his life as an unsuccessful writer. His older sister, Marie-Berthe (1837-1925), later marries Léon Appert, a well-known engineer and glassmaker.

1862

The Seurats move to a larger six-room apartment at 136 boulevard Magenta. Although Georges later occupies several studios, this remains his official address.

1870-71

During the Franco-Prussian War and the Paris Commune the Seurat family resides in Fontainebleau.

1874-77

Becomes interested in art in his last year in school and attends classes taught by the sculptor Justin Lequier at the municipal school of drawing in the nearby rue des Petits-Hôtels. Fellow students include Amand-Edmond Jean, a painter known later as Aman-Jean (1858-1936).

1878

Admitted to l'Ecole des Beaux-arts as a pupil of Henri Lehmann,(1814-82), a painter of academic nudes and a former pupil of Ingres.

Introduced to the writings of David Sutter, a Swiss aesthetician steeped in mathematics, philosophy, and optics.

1879

Leaves Lehmann's studio, ranking 47th among 80 students.

Begins a year of military service at Brest, where he draws the sea, beaches, and boats.

1880

Returns to Paris.

1881

Studies works by Delacroix and Puvis de Chavannes and visits the 6th Impressionist exhibition. Reads the French translation of Ogden Rood's *Modern Chromatics* (Paris: Baillère, 1881).

Spends two months at Pontaubert (near Avallon, Yonne) with Aman-Jean.

1882

Rents a tiny room at 19 rue de Chabrol near his mother's apartment where he lives until 1886 and executes many important works. Sees the Seventh Impressionist exhibition and Courbet retrospective.

1883

Exhibits for the first and only time in the official Salon, with a portrait drawing of Aman-Jean. Starts *Une Baignade, Asnières*.

1884

Une Baignade, Asnières, rejected by the Salon, shows at the Indépendants. After participating with Signac, Angrand, Cross, Dubois-Pillet, Redon, and Schuffenecker in creating La Société des Artistes Indépendants, Seurat makes preliminary sketches of *La Grande Jatte*.

1885

Studies Delacroix's retrospective at l'Ecole des Beaux-arts. Finishes *La Grande Jatte*.

Spends the summer at Grandcamp in Calvados. In the fall he reworks *La Grande Jatte* in a pointillist manner.

Signac introduces him to Camille Pissarro, who in turn introduces Seurat to Claude Monet.

1886

Shows *La Grande Jatte* and eight other works at the Eighth and final Impressionist exhibition, with the support of Pissarro over objections by Manet, Degas, and Guillaumin. Félix Fénéon, art critic of *La Vogue*, writes favorably of Seurat's technique of color division.

Meets Charles Henry (1859-1926), a young mathematician and art theorist.

1887

Attends the Exposition des XX in Brussels with Signac where Seurat shows seven paintings, including *La Grande Jatte*.

Exhibits sketches for *Les Poseuses* at the Salon des Indépendants (along with works by Angrand, Cross, Dubois-Pillet, Luce, Pissarro, Redon, Rousseau, and Signac) and begins *Parade de cirque* (*Circus Sideshow*).

1888

Publication of Charles Henry's *Cercle chromatique* (Paris: Charles Verdin, 1888), with illustrations by Signac.
Finishes *Les Poseuses* (*Models*), which he exhibits at the fourth Salon des Indépendants.

Spends part of the summer at Port-en-Bessin on the Channel.

1889

Submits nine paintings and three drawings to Les XX in Brussels.

Paints the Eiffel Tower and a portrait of Signac.

Lives with Madeleine Knobloch, a young working-class woman whose liaison with Seurat may have begun as early as 1885.

1890

Birth of Seurat and Madeleine Knobloch's son on February 16. Seurat acknowledges paternity and enters the child on the civil registers as Pierre Georges Seurat.

Exhibits *Le Chahut* and *Young Woman Powdering Herself,* first known portrait of Knobloch,

at the Indépendants.

Jules Christophe's article on Seurat appears in the series *Les Hommes d'aujourd'hui,* edited by Fénéon. Seurat writes to Fénéon on June 20 and lists the publications in art and color theory that he has read since 1876. Learns of van Gogh's suicide from Signac. Summer in Gravelines, where he learns of Dubois-Pillet's death on August 18.

1891

Shows at Les XX and at the seventh Société des Artistes Indépendants, where he hangs the unfinished *Le Cirque.*

March 26
Seurat falls ill while supervising the hanging of pictures at the Indépendants.

March 27
Returns with Knobloch, who is pregnant, and their son to his mother's apartment on boulevard Magenta.

March 29
Dies at 6 a.m. at age 31 of what is diagnosed as infectious angina (probably malignant diptheria).

March 31
Funeral of Seurat and burial in the family vault at Père-Lachaise cemetery.

April 13
Seurat's son Pierre dies and is buried alongside his father

May-August
Seurat's studio property and paintings are inventoried and divided up by his artist friends and Madeleine Knobloch. Théo Van Rysselberghe serves as arbiter between factions, who accuse each other of profiting from Seurat's untimely death.

1892

Les XX and Les Indépendants organize a tribute to Seurat at Léonce Moline's Galerie Laffitte.

1899

Signac's *D'Eugène Delacroix au néo-impressionnisme* is published in book form by *La Revue blanche.*

July 30
The artist's mother dies, leaving a life annuity of 1,200 francs to Madeleine Knobloch.

1900

Retrospective of Seurat's works at *La Revue blanche.* Fénéon acquires *Une Baignade,*

Asnières, Signac *Le Cirque*, and Monsieur Brû *La Grande Jatte.*

1903

Madeleine Knobloch dies of cirrhosis of the liver.

Georges Pierre Seurat

Bibliography

Note: For exhaustive bibliographies of literature on Seurat, including individual and group exhibitions, see in particular Henri Dorra and John Rewald, *Seurat: l'œuvre peint, biographie et catalogue critique* (Paris: Les Beaux-Arts, 1959); Robert L. Herbert, *Neo-Impressionism* (exh. cat., NY, Solomon R. Guggenheim Museum, 1968); John Rewald, *Neo-Impressionism* (NY: Abrams, 1990); Michael L. Zimmermann, *Seurat, Sein Werk und die Kunsttheoretische Debatte Seiner Zeit* (Weinheim: VCH; Antwerp: Mercator Fonds, 1991, English ed.: *Seurat and the Art Theory of his Time*):477-86; and *Seurat* (exh. cat., Paris, Grand Palais: NY, Metropolitan of Art, 1991). Some secondary sources identified in these works are not reproduced here.

I. Archival Materials

477. BRETON, ANDRE. *Letter*, 1954. Holograph, 3 p. Located at The Getty Research Institute for the History of Art and the Humanities, Special Collections, Los Angeles.

Concerns an exhibition of modern art, with special reference to Seurat and Paul Gauguin, and to Paul Signac's art collection. Includes a draft checklist of works to be shown at the exhibition. Breton (1896-1966) was a leading Surrealist writer and critic.

478. CHERET, JULES. *Correspondence*, 1878-1939. Ca. 160 items. Holographs, signed; typescripts; printed material. Located at The Getty Research Institute for the History of Art and the Humanities, Special Collections, Los Angeles.
Collection consists of ca. 25 letters from Chéret (1836-1932) to several correspondents, together with ca. 145 letters received, and some additional printed materials. Jules Chéret was a French painter, sculptor, and poster-maker known as the father of modern poster design. He collaborated with Seurat on various lithographs.

Arranged in 3 series: I. Letters, 1878-1926 (folder 1); II. Letters received, 1889-1932 (1939); III. Documents and printed matter, 1885-1939 (folders 11-12).

Series I. Letters, 1878-1926: Most concern work in progress and are addressed to, among others, the critics Félicien Champsaur, (1885-1887) and Armand Dayot (1888-1890), the German publisher Albert Langen (1895) and to the poet Marcel Schwob. Projects discussed include illustrations for the *Revue de l'art décoratif* and a cover for a book by Gustave Geffroy. The series includes a letter from Geffroy to Langen concerning the title of the book. Arranged in chronological order.

Series II. Letters received, 1889-1932 (1939): From fellow artists and literary figures including Albert Besnard, Gustave Geffroy, Léon Hennique, Gustave Kahn, Georges Lecomte, Camille Mauclair, Puvis de Chavannes, Charles Morice, J. E. Blanche, Claude Roger-Marx, Alfred Roll, Charles de Bussy, and Henri Ibels. Of particular interest are letters from Mauclair about an article for the *Revue de l'art décoratif* (1902); several others from various governmental agencies regarding the Hôtel de Ville commission (1896) and the Legion of Honor; and letters pertaining to the photographic reproduction of the Hôtel de Ville murals for *L'Artiste* and *La Vie illustrée* (1902-1903). Arranged in chronological order.

Series III. Documents and printed material, 1885-1939: Personal legal documents and printed materials, some pertaining to the Musée Chéret in Nice.

479. COURTHION, PIERRE. *Papers*, ca. 1925-85. 36 boxes. Located at The Getty Research Institute for the History of Art and the Humanities, Special Collections, Los Angeles.

Preparatory material and manuscripts for studies of various 19th and 20th century artists and art movements, including notes on Seurat. Includes photographs of works by Seurat. Courthion (b. 1902), a French art critic and historian, was director of Cité Universitaire de Paris from 1933-39. Also includes documentation of research travel, conferences and lectures, jury work on exhibitions, preparation of a motion picture, and a preliminary collection of material for an autobiography.

480. M. Knoedler & Co. *Exhibition Catalogs and Miscellaneous Materials*, 1913-55 (bulk 1949). 34 items. Located at The Getty Research Institute for the History of Art and the Humanities, Special Collections, Los Angeles.

Catalogues, leaflets, brochures, announcements, invitations, and miscellaneous ephemera of exhibitions held at the galleries of M. Knoedler & Co., New York City, including works by Seurat. Arranged chronologically.

481. NICOLSON, BENEDICT. *Manuscript Draft and Research Material on Seurat*, 1930-65 (bulk 1930-39). 1 bound manuscript draft. Located at The Getty Research Institute for the History of Art and the Humanities, Special Collections, Los Angeles.

One bound manuscript draft for an unpublished book on Seurat by Benedict Nicolson, editor of *Burlington Magazine*, with accompanying research material. Draft covers: Seurat's childhood; education; time in Paris; exhibitions; an 1891 inventory of his studio; sections on Impressionists, Post-Impressionists, color theory, pointillisme; bibliography; and an index. Research material includes over 100 photos of Seurat's work, magazine articles, correspondence, notes, drafts for articles, etc.. Also included are a letter from Ludovic R. Pissarro (22 Sept. 1938) and letters from William I. Homer and Robert L. Herbert.

482. SCHLEMMER, OSKAR. *Journal*, 1928-43. Typescript, ca. 100 p. Located at The Getty Research Institute for the History of Art and the Humanities, Special Collections, Los Angeles.

Transcripts of entries from Schlemmer's journals for the years 1935-43, except for September 1941, with scattered records from 1925. The transcript includes both whole entries that are not reflected in published selections and full entries where only extracts have been published. The journal is in diary form, with notes on daily activities, including his reading, but serves also as a vehicle for extended reflections on art and artists, art theory and techniques, and Schlemmer's own works. There is detailed discussion of color and form in abstraction, portrait and landscape painting, and the effect of the Nazis on art and artists. Artists mentioned prominently in his discussions and notes include: Emil Nolde, Julius Bissier, Paul Klée, Christian Rohlfs, Georg Muche, Willi Baumeister, Auguste Renoir, Giorgio de Chirico, Georges Rouault, Georges Seurat, Henri Rousseau, André Derain, Paul Cézanne, Hans von Marees, Eugène Delacroix, Caspar David Friedrich, and Otto Meyer-Amden ("OM" or "Otto Meyer") Schlemmer (1888-1943) was a German painter, designer, teacher at Bauhaus, and a stage designer. A list of entries, with a keyword description of subjects covered in each and a collation of this text with that of Tut Schlemmer, *Oskar Schlemmer, Briefe und Tagebuecher*, ed. by Tut Schlemmer (Stuttgart: Hatje, 1977), is available.

483. SIGNAC, PAUL. *Letters Sent, and Signac Family Correspondence*, 1860-1935. 98 items. Holographs signed; manuscript signed. Located at The Getty Research Institute for the History of Art and the Humanities, Special Collections, Los Angeles.

Letters from Signac to several colleagues discussing work in progress, exhibitions, contemporary art, La Société des Artistes Indépendants, and personal and financial matters. A significant number of these letters are addressed to Edouard Fer, a neo-impressionist disciple whose independent means and connections enabled him to promote Signac's career. Other correspondents include Camille Pissarro, Claude Monet, Georges Turpin, Henri Martineau, Georges Lecomte, and Luc-Albert Moreau. There is also a draft essay for a review of the Exposition des peintres provençaux held in 1902. Most of the letters in this collections are Signac family correspondence; some of these are addressed by Paul Signac to his cousins. (The repository also holds a significant series of Signac's correspondence within the papers of Théo Van Rysselberghe.)

In his 35 letters to Edouard Fer (1916-32, bulk 1918-21) Signac discusses the organization of exhibitions, mostly in Switzerland, and the critical reaction to his own work. He does not forget to offer Fer the occasional bit of advice. Other letters include ten to Pissarro (1886-99) in one of which he comments on Pissarro's stylistic evolution and his own recent landscape painting in the Midi (1897); a letter that recounts the formation of La Société des Artistes Indépendants in 1884 with mention of Redon, Seurat, and Théodore Rousseau; a letter to Georges Lecomte where Signac comments on Symbolism, Puvis de Chavannes, Maximilien Luce, and Lecomte's recent work; a letter from Brussels describing at great length a visit to a foundry (1897); two notes to Henri Martineau pertaining to Signac's study of Stendhal (1919, 1928); one letter to an unnamed critic thanking him for a favorable article and describing his trips to Brittany and Provence (1933); and one fragment of a letter in response to an inquiry on interior decorating. Includes a draft essay of a review of the Exposition des Peintres provençaux held in Marseilles in 1902. Signac family correspondence deals with family life, children, illness, vacations, money worries, marriages,

divorces and so forth. A small number of these are written by Paul Signac to his cousins. The rest are between other family members. Most of the letters seem to be about Julie and Alfred Signac's family—Paul Signac's aunt and uncle. Included are letters from his grandmother, grandfather, and cousins.

Organization: Letters from Signac to colleagues (folders 1-5), Manuscript (folder 6), Signac family correspondence (folders 7-18). Folder list available in repository.

484. VAN RYSSELBERGHE, THEO. *Correspondence*, ca. 1889-1926. ca. 225 items. Holographs, signed. Located at The Getty Research Institute for the History of Art and the Humanities, Special Collections, Los Angeles.

Collection contains 84 letters of Van Rysselberghe to, among others, Madame Rysselberghe, the dealer Huinck, Paul Signac, and Berthe Willière; and 141 letters received from colleagues including Henri Cross, Paul Signac, Camille Pissarro, and Henry Van de Velde. The letters, many of which are extensively illustrated, are largely theoretical in nature and explore all facets of art theory and practice associated with Neo-Impressionist milieu of the late 19th and early 20th centuries.
Organization: Series I. Letters to Madame Rysselberghe, ca. 1902-20 (folder 1); Series II. Miscellaneous letters, 1900-26 (folders 2-3); Series III. Letters received from Paul Signac, ca. 1892-1909 (folders 4-8); Series IV. Letters received from Henri Cross, 1908-10, n.d. (Folders 9-11); Series V. Miscellaneous letters received, ca. 1889-1905, n.d. (Folders 12-13)
Series I. Letters to Madame Rysselberghe, ca. 1902-20 (32 items). Thirty-two letters, a significant portion of which are dated 1918-20, include detailed discussion of travels, work in progress, especially on portraits, his own emotional state and personal matters. Van Rysselberghe writes of technical matters, including difficulties associated with painting "en plein air" and a decorative project underway for Armand Solvay, and describes in some detail his stay at the Château de Mariemont. Other letters also include discussion of upcoming exhibitions and comments on the writing of André Gide, Jacques-Emile Blanche, and Marcel Proust.
Series II. Miscellaneous letters, 1900-26 (52 items). Twenty letters to Van Rysselberghe's dealer Huinck concern practical matters associated with upcoming exhibitions in Holland such as the framing and packing of works of art, titles, dimensions and prices of paintings, train schedules, and fluctuating currency (1924-25). Nineteen letters and postcards to Berthe Willière on work, travel and personal matters (1909-26). In three letters to Paul Signac, Van Rysselberghe defends his criticism of Signac's work, explains his own working method, and responds to the suggestion that his work was adversely influenced by Maurice Denis (1909). One letter to André Gide concerns the "fond d'atelier" of Henri Cross and a possible retrospective exhibition (1918). Other correspondents include Pierre Bounier (1900, 1914), Armand Solvay (1922), and a M. Dunan (1925-26).
Series III. Letters received from Paul Signac, ca. 1892-1909 (74 items). Seventy-four detailed letters, many extensively illustrated with color and ink sketches, focus primarily on theoretical issues. Signac outlines ideas for work in progress, discusses color theory and the divisionist technique, and comments on a wide variety of matters, including Old Master painting and the work of Seurat, Maurice Denis, Odilon Redon, Paul Sérusier, Henri Cross, and Eugène Delacroix. In several essay-length letters, Signac attempts to render in a systematic manner the theory of Neo-Impressionism and his own approach to painting and avidly defends the pointillist technique. The letters also include discussion of practical matters relating to exhibitions and the sale of paintings, as practical matters relating to

exhibitions and the sale of paintings, as well as mention of literary interests and personal news.
Series IV. Letters received from Henri Cross, 1908-10, n.d. (53 items). Eleven letters addressed to Van Rysselberghe contain discussion of work in progress (illustrated) and working method and include mention of Félix Fénéon, Signac, and Henri Matisse. Forty-two letters, mostly personal in nature, are addressed to Madame Rysselberghe and contain some mention of literary and musical interests, daily activities, and art-related matters.
Series V. Miscellaneous letters received, ca. 1889-1905, n.d. (14 items). Includes four letters from Camille Pissarro concerning printmaking ventures and including mention of Octave Maus and André Marty (1895); two brief letters from Maximilien Luce (n.d.); one letter from Maurice Denis mentioning two portraits by Van Rysselberghe and commenting on personal travel plans (n.d.); and seven letters from Henry Van de Velde explaining in some detail his difficulties with the Neo-Impressionist style and outlining plans for an exhibition in Berlin designed to interest the German press in Neo-Impressionism (1890-1905).

II. Book Illustrated by Seurat

485. VERLAINE, PAUL MARIE. *Fêtes galantes; la bonne chanson; romances sans paroles*. Dessins de Seurat. Lausanne: Mermod, 1951. 132 p., illus.

III. Books

486. ABDY, JANE. *The French Poster: Chéret to Cappiello* London: Studio Vista, 1969. 176 p., illus.

a. U.S. ed.: NY: C. N. Potter, dist. by Crown, 1969.

487. AKINARI, TAKAHASHI, UEDA KOJI, and AKIYAMA KUNIHARU. *Sūral Georges Seurat*. Tokyo: Asahi Shinbunsha, 1993. 98 p., illus. (Seiyōhen, no. 26)

488. ALBERT, CHARLES. *Qu'est-ce que l'art?* Paris: Schleicher Frères, 1909. 238 p.

489. ALEXANDRIAN, SARANE. *Seurat*. Paris: Flammarion, 1980. 96 p., illus. (Les Maîtres de la peinture moderne)

Overview of life and career, heavily illustrated.
a. Another ed.: 1990.
b. U.S. eds.: *Seurat*. Trans. by Alice Sachs. NY: Crown, 1980; Collector's ed., Norwalk, CT: Easton Press, 1983.

490. ANGRAND, PIERRE. *Naissance des artistes indépendants, 1884*. Paris: Nouvelles Editions Debresse, 1965. 127 p.

491. APOLLINAIRE, GUILLAUME. *Chroniques d'art, 1902-1918*. Textes réunis avec préface et notes par L.C. Breunig, Paris: Gallimard, 1960. 524 p.

Reprints articles by Apollinaire on Seurat dated 1910-14.

492. APOLLONIO, UMBRO, *Disegni di Seurat*. Venice: Edizioni del Cavallino, 1947. 13 pl.

493. *Art et pub: art et publicité 1890-1990*. Exposition réalisée par le Centre Georges Pompidou, 31 octobre 1990-25 février 1991, Grande Galerie. Paris: Editions du Centre Pompidou, 1990. 560 p., illus.

Includes posters by Jules Chéret (1836-1932), a French painter, sculptor, and poster-maker known as the father of modern poster-design, who collaborated with Seurat on various lithographs.

494. ARWAS, VICTOR. *Affiches et gravures de la Belle-Epoque*. Paris: Flammarion, 1978. 96 p., illus.

495. ASTRUC, GABRIEL. *Le Pavillon des fantômes; souvenirs*. Paris: Bernard Grasset, 1929. 344 p.

a. Another ed.: Préface de Pierre Lebaillif. Paris: P. Belfond, 1987. 270 p., illus., 8 pl.

496. AUBRUN, MARIE-MADELEINE. *Henri Lehmann, 1814-1882: catalogue raisonné de l'œuvre*. Paris: Association Les Amis de Henri Lehmann, 1984. 2 vols.

Catalogue raisonné of Seurat's early teacher in 1878, a former student of Ingres.

497. BARGIEL-HARRY, RÉJANE. *Quel cirque. Affiches fin XIXème siècle collection Dutailly*. Textes par Réjane Bargiel, et al. Chaumont-en-Bassigny: La Bibliothèque en coproduction avec le Centre Régional du livre de Champagne-Ardennes, 1988. 64 p., illus.

Exhibition catalogue that includes circus posters by Jules Chéret shown at La Bibliothèque municipale de Chaumont (10 June-1 October 1988). Bibliography, pp. 58-9.

498. BARR, ALFRED HAMILTON, JR. *Georges Pierre Seurat: Fishing Fleet at Port-en-Bessin*. NY: Twin Editions, 1945.

499. BARTHELMESS, WIELAND. *Das Café-Concert als Thema der französischen malerei und Graphic des ausgehen den 19. Jahrhunderts*. Ph.D. diss., Freie Universität, Berlin, 1987. 329 p., illus.

500. BERTRAM, HILGE. *Georges Seurat-Tegninger*. Copenhagen: Wivels Forlag, 1946.

Introductory text by Bertram.

501. BILANG, KARLA. *Seurat*. Dresden: VEB Verlag der Kunst, 1987. 32 p., 15 illus., 7 col. (Maler und Werk)

Concise introduction to Seurat's work that emphasizes the importance his relationship with classical European painting and interest in theoretical problems.

502. BOWRON, EDGAR PETERS. *European Paintings Before 1900 in the Fogg Art Museum: A Summary Catalogue including Paintings in the Busch-Reisinger Museum*.

Cambridge: Harvard University Art Museums, 1990. 392 p., 850 illus. 66 col.

Catalogue raisonné that includes works by Delacroix, Manet, Monet, Degas, Moreau, Cézanne, Seurat, Renoir, van Gogh, Klimt, Munch, Pissarro, Gauguin and Toulouse-Lautrec.

503. BROIDO, LUCY. *The Posters of Jules Chéret, 46 Full-Color Plates and an Illustrated Catalogue Raisonné.* NY: Dover Publications, 1980. 60 p., illus., 46 col. pl.

a. 2nd ed.:1992. 78 p.

504. BROUDE, NORMA F., ed. *Seurat in Perspective.* Englewood Cliffs, NJ: Prentice-Hall, 1978. 180 p., 36 illus., 8 pl. (Artists in Perspective) (Spectrum Book)

Includes excerpts from Seurat's letters and criticism of major works from the 1880s to 1974. Contents: Part One–Seurat as Seen Through his own Writings, Through Comments by his Contemporaries, and by Other Artists: Writings by Seurat; Witness Accounts (Including Reported Statements by Seurat); Contemporary Criticism; Comments and Reactions of Other Artists, 1886 to the Present. Part Two–Critical Approaches to the Art of Seurat, 1898 to the Present: "From Eugène Delacroix to Neo-Impressionism," by Paul Signac; "Georges Seurat," by André Salmon; "Seurat's *La Parade*," by Roger Fry; "The Renaissance of Classical Sensibility in French Painting at the End of the Nineteenth Century," by Daniel Catton Rich; "Seurat and *La Grande Jatte*," by Meyer Schapiro; "Seurat as a Predecessor," by Jean Goldwater; "The Technique of Impressionism: A Reappraisal," by J. Carson Webster; "Artists' Quarrels (Including Letters by Pissarro, Signac, Seurat, and Hayet, 1887-1890)," by John Rewald; "Piero della Francesca–Seurat–Gris," by Lionello Venturi; "Seurat and Jules Chéret," by Robert L. Herbert; "Notes on Seurat's Palette," by William Innes Homer; "The Evolution of Seurat's Style," by Henri Dorra; "Seurat's Drawings," by Robert L. Herbert; "Seurat and the Science of Painting," by William Innes Homer; "Seurat and Piero della Francesca," by Albert Boime; "New Light on Seurat's 'Dot': Its Relation to Photo-Mechanical Color Printing in France in the 1880's," by Norma F. Broude.

505. BROUDE, NORMA, F. *Georges Seurat.* New York: Rizzoli, 1992. 24 p., illus.

Brief overview of the artist's life and career.

506. CACHIN, FRANÇOISE. *Seurat: le rêve de l'art-science.* Paris: Gallimard: Réunion des Musées Nationaux, Peinture, 1991. 144 p., illus. (Découvertes Gallimard, no. 108)

507. CALKINS, ROBERT G. *Seurat, Van Gogh, and Gauguin.* Department of Fine Arts, Harvard University, 20 March 1962. Unpublished research paper.

508. CAPITAINE, JEAN-LOUIS and CHRISTOPHE ZAGRODZKI. *Le Peintre et l'affiche de Lautrec à Warhol.* Rédaction du catalogue: Jean-Louis Capitaine, Christophe Zagrodzki. Paris: Musée de la Publicité; Union des Arts Décoratifs, 1988. 136 p., illus. In French and English.

Exhibition catalogue that includes posters by Jules Chéret, shown at the Musée de la Publicité, Paris, 23 March-11 May 1988.

509. CARADEC, FRANÇOIS and ANDRE WEILL. *Le Café-concert.* Paris:

Hachette/Massin, 1980. 190 p., illus., some col.

510. CARR-GOMM, SARAH. *Seurat*. London: Studio Editions, 1993. 139 col., illus. (Master Painters)

Plate-book with an introduction and critical commentary on Seurat's paintings.

511. *Catalogue de l'exposition d'affiches artistiques, françaises et étrangères, modernes et rétrospectives, qui a eu lieu au Cirque de Reims, du samedi 7 au mardi 17 novembre 1896, sous le haut patronage de M. P. Puvis de Chavannes*. Reims: Société des Amis des arts, 1896. 202 p.

Exhibition held in Reims, 7-17 November 1896, that included circus posters by Jules Chéret.

a. Reprint: Paris: Union Centrale des Arts Décoratifs, 1980.

512. CHADOURNE, ANDRE. *Les Cafés-concerts*. Paris: Librairie de la Denty; Société des Gens de Lettres, 1889.

513. CHASTEL, ANDRE. *Fables, formes, figures*. Paris: Flammarion, 1978. 2 vols.

Vol. 1, pp. 358-411, reprints three articles by Chastel on Seurat: "Une source oubliée de Seurat," *Archives de l'art français* 21(1950-57):400-7; "Seurat et Gauguin," *Art de France* 2(1962):297-305; "Le Système de Seurat" in *Tout l'œuvre peint de Seurat* (Paris: Flammarion, 1973):5-8.

514. CHEN, MEI-YEH. *Hsiu-la/Seurat*. Taipei shih: I shu tu Shu Kung ssu, 1992. 181 p., illus. (I shu hua lang tsung shu, no. 8)

515. *Le Cirque à Montmartre*. Paris: Musée du Vieux Montmartre, 1969.

Exhibition catalogue that includes lithographic circus posters by Jules Chéret.

516. *Le Cirque et le jouet*. Paris: Musée des Arts Décoratifs, 1984.

Catalogue of an exhibition of circus art held 18 Oct. 1984-28 Jan. 1985 that included posters by Jules Chéret.

517. COGNIAT, RAYMOND. *Seurat*. Paris: Hypérion, 1951. 48 p., illus. (Hypérion miniatures)

a. Another ed.: Paris: Fernand Nathan, 1953.
b. U.S. ed.: Trans. by Lucy Norton, NY: Hyperion Press, 1953.

518. CONSTANTINE, MILDRED and ALAN FERN. *Word and Image: Posters from the Collection of the Museum of Modern Art, 1968*. Greenwich, CT: New York Graphic Society, 1968.

Catalogue that includes posters by Jules Chéret.

519. COOPER, DOUGLAS. *Georges Seurat, 'Une Baignade, Asnières' in the Tate Gallery, London.* With an introduction by Douglas Cooper. London: Percy, Lund, Humphries, 1946. 24 p., 23 illus. (Gallery Books, no. 9)

520. COQUIOT, GUSTAVE. *Concerts d'été (impressions de Paris).* Paris, 1894.

521. COQUIOT, GUSTAVE. *Les Cafés-concerts.* Paris: Librairie d'art, 1896. 34 p., illus.

522. COQUIOT, GUSTAVE. *Dimanches d'été.* Paris, 1897.

523. COQUIOT, GUSTAVE. *Les Indépendants 1884-1920.* Paris: Librairie Ollendorff, 1920. 239 p., illus., 40 pl.

524. COQUIOT, GUSTAVE. *Seurat.* Avec 24 reproductions. Paris: Albin Michel, 1924. 255 p.

Early biography and critical appraisal.

525. COURTHION, PIERRE. *Seurat.* Paris: Cercle d'Art, 1969.

Detailed account of Seurat's life and work, including critical commentary on 40 paintings.
a. English eds.: *Georges Seurat.* Translated by Norbert Guterman. NY: H. N. Abrams, 1968; London: Thames Hudson, 1969. 160 p., illus; 1988; 1989.
b. German ed.: *Seurat.* Übertragen aus dem Französischen von Suzanne B. Milczewsky. Cologne: M. Dumont Schauberg, 1969. 159 p., illus.

526. COURTINE, ROBERT J. *Cafés et restaurants des boulevards, 1814-1914.* Paris: Perrin, 1984. 375 p., illus., 16 pl. (Présence de l'histoire) (La Vie parisienne, no. 1)

527. COUSTURIER, LUCIE. *Seurat.* Paris: G. Crès, 1921. 35 p., 41 illus. (Cahiers d'aujourd'hui)

Compilation of two articles that first appeared in *L'Art décoratif* (June 1912):357-72; (March 1914):357-72.
a. Second rev. ed.:1926.

528. CROW, THOMAS. *Seurat.* Television programme 7 of the Open University's *Modern Art and Modernism* course, Milton Keynes, 1982.

529. CUTTS, SIMON. *G. Seurat: 'Flotte à pêche, Port-en-Bessin'.* Nottingham, England: Tarasque Press, 1973. 1 folded sheet (4 p.), illus.

530. DELABORDE, HENRI. *Notice sur la vie et les ouvrages de M. Henri Lehmann. Lue dans la séance publique annuelle de l'Académie des Beaux-arts du 20 Octobre 1883.* Paris, 1883.

531. DISTEL, ANNE. *Seurat.* Paris: Chêne, 1991. 159 p., illus. (Profils de l'art)

Biographical and critical treatise.

532. DORRA, HENRI and JOHN REWALD. *Seurat: l'œuvre peint, biographie et catalogue critique*. Paris: Les Beaux-Arts, 1959. 311 p., illus., 3 col., pl. (L'Art français)

Catalogue raisonné of Seurat's paintings and associated drawings. Includes an extensive early bibliography, exhibitions list, and text citations, as well as a biography and stylistic criticism.
Reviews: W. Homer, *Art Bulletin* 42:3(Sept. 1960):228-33; B. Nicolson, *Burlington Magazine* 104:710(May 1962):213-64.

533. DUNSTAN, BERNARD. *Painting Methods of the Impressionists*. NY: Watson-Guptill; dist. in the U.K. by Phaidon, 1976. 184 p., illus.

a. Revised ed.: 1983.

534. DUPAVILLON, CHRISTIAN. *Architectures du cirque, des origines à nos jours*. Paris: Moniteur, 1982. 285 p., illus. (Collection Architecture 'Les Bâtiments')

535. EGLINTON, GUY. *Reaching for Art*. Boston: May and Co., 1931. 152 p., pl.

Reprints Eglinton's article, "The Theory of Seurat," *International Studio* 81(May1925):113-7; (July 1925):289-92.
a. Reprint: Freport, NY: Books for Libraries Press, 1967.

536. EVERDELL, WILLIAM R. *The First Moderns: Profiles in the Origins of Twentieth-Century Thought*. Chicago: University of Chicago Press, 1997. 501 p.

Includes a section on Seurat, pp.65-79.

537. *Exposition Jules Chéret: pastels, lithographies, dessins, affiches illustrées: décembre 1889-janvier 1890*. Préface de Roger Marx. Paris: Galeries du Théâtre d'Application, 1889. 10 p., 3 pl., illus.

a. Reprint: NY: Garland, 1981. 30 p., illus.

538. FABBRI, JACQUES, ed. *Clowns et farceurs*. Paris: Bordas, 1982.

539. FENEON, FELIX, ed. *L'Art moderne et quelques aspects de l'art d'autrefois*. Paris: Bernheim-Jeune, 1919. 2 vols.

540. FENEON, FELIX. *Oeuvres*. Introduction de Jean Paulhan. Paris: Gallimard, 1948. 478 p.

a. Another ed.: 1991.

541. FENEON, FELIX. *Au-delà de l'impressionnisme*. Textes réunis et présentés par Françoise Cachin. Paris: Hermann, 1966. 189 p., illus. (Miroirs de l'art)

542. FENEON, FELIX. *Oeuvres plus que complètes*. Textes réunis et présentés par Joan U. Halperin. Genève: Libraire Droz, 1970. 2 vols. (1087 p.), illus., 23 pl. (Histoire des idées et critique littéraire, no. 107)

Collection of critical writings by the influential art critic Félix Fénéon, who championed numerous Impressionist and Neo-Impressionist artists and was Seurat's most important critic. Volume 1, *Chroniques d'art*; volume 2, *Les Lettres, les mœurs*.

543. FORNERIS, JEAN. *Lautrec et Chéret*. Présentation de Jean Forneris. Nice: Direction des Musées de Nice, 1985.

Catalogue of an exhibition held in Ishikawa, Tokyo, Osaka, Okayama, and Sendai, Japan (Sept. 1985-Feb. 1986), that included posters by Chéret.

544. FORNERIS, JEAN and JACQUELINE FARAUT. *Jules Chéret, Collection du Musée des Beaux-arts de Nice*. Nice: Direction des Musées de Nice, 1987.

545. FRANZ, ERICH and BERND GROWE. *Georges Seurat: dessins*. Paris: Hermann, 1984. 204 p., illus.

Catalogue of an exhibition of 86 drawings held at Bielefeld and Baden-Baden, 1983-84.
a. Another ed.: 1990.
b. U.S. ed.: *Georges Seurat, Drawings*. Trans. by John William Gabriel. Boston: Little, Brown, 1984. 203 p., illus., some col.
Reviews: P. Winter, *Weltkunst* 53:23(1984):3453-5; N. Avruscio, H. and W. Kambartel, *Kritische Berichte* 2(1984):92-6.

546. FRY, ROGER. *Transformations; Critical and Speculative Essays on Art*. London: Chatto & Windus, 1926. 230 p., illus.

547. FRY, ROGER and ANTHONY BLUNT. *Seurat*. Foreword and notes by Sir Anthony Blunt and an essay by Roger Fry. London: Phaidon Press, 1965. (Phaidon Colour Library, no. 15)

Essay on Seurat by Fry was first published in *Transformations* (London: Chatto & Windus, 1926).
Review: Denys Sutton, *Apollo* 83:47(Jan. 1966):76-7
a. Hebrew ed.: *Sera*. Trans. by Aharon Amir. Tel Aviv: Revivim, [197-]

548. GEFFROY, GUSTAVE. *La Vie artistique, deuxième série*. Paris: Dentu, 1893.

Includes information on Seurat and lithographer Jules Chéret. Volume 2 of an 8-volume series (vols. 5-8 have Paris: H. Floury imprint).

549. GEORGE, WALDEMAR. *Seurat*. 24 phototypes; notice de Waldemar George. Paris: Librairie de France, 1928. 5 p., 24 pl. (Albums d'art Druet, no. 10)

550. GOULD, CECIL HILTON MONK. *Seurat's Bathers, Asnières and the Crisis of Impressionism*. London: National Gallery, 1976. 8 p., illus. (Painting in Focus, no. 6)

551. GOURARIER, ZEEV. *Les Manèges d'autrefois*. Paris: Flammarion, 1991. 235 p., illus., some col.

552. *Grandville au Musée Carnavalet*. Paris: Musée Carnavalet, 1987. 38 p., illus.

Exhibition catalogue (13 oct. 1987-3 Jan. 1988) that included lithographic posters by Jules Chéret.

553. GRENIER, CATHERINE. *Seurat: cataloguo completo dei dipinti*. Florence: Cantini, 1990. 159 p., illus. (I Gigli dell'arte, no. 10)

Catalogue raisonné of Seurat's paintings.
a. French ed.: *Seurat: catalogue complet des peintures*. Paris: Bordas 1991. 159 p., illus. (Les Fleurons de l'art, no. 1)
b. Spanish ed.: *Seurat: catálogo completo do pinturas*. Traduccion Gloria Cué. Torrejón de Ardoz, Madrid: Akal, 1992. 159 p., illus. (Cumbres del arte. Archivos de arte antiguo y moderno, no.3)

554. GROMAIRE, FRANÇOIS. *Gromaire: cinquante années de dessin, jour après jour*. Introduction par François Gromaire. Paris: Galerie de la Présidence, 1989.

Catalogue of an exhibition of drawings by Marcel Gromaire (1892-1971) that dated from 1916-65. Notes Gromaire's admiration for Seurat, Géricault, Matisse, and Rembrandt.

555. HALPERIN, JOAN UNGERSMA. *Félix Fénéon and the Language of Art Criticism*. Ann Arbor, Michigan: UMI Research, 1980.

556. HALPERIN, JOAN UNGERSMA. *Félix Fénéon, Aesthete and Anarchist in Fin-de-Siècle Paris*. Foreward by Germaine Brée. New Haven, CT: Yale University Press, 1988.

557. HAMMACHER, ABRAHAM-MARIE. *Silhouet van Seurat*. Otterlo: Kröller-Müller Museum, 1994. 83 p., illus.

a. English ed.: *Silhouette of Seurat*. Otterlo: Kröller-Müller Museum, 1994. 83 p., illus.

558. HAUKE, CESAR MANGE DE. *Seurat et son œuvre*. Paris: Gründ, 1961, 1962. 2 vols., illus. (Les Artistes et leurs œuvres, études et documents)

Volume 1 lists Seurat's paintings, with catalogues and reviews of Seurat exhibitions since 1886. Volume 2 lists Seurat's drawings. The *catalogue raisonné* was compiled beginning in the 1930s. Dating of works generally follows critic Félix Fénéon's chronology, and is gleaned from his writings.
Reviews: W. Homer, *Art Bulletin* 42 (Sept. 1960):228-33; W. Homer, *Burlington Magazine* ser. 6, 105 (June 1963):282-4.

559. HAUTECŒUR, LOUIS. Georges Seurat. Milan: Fratelli Fabbri, 1972. 96 p., 193 illus. (Gli impressionisti)

Study of Seurat's life and work introduced by two excerpts from books written in the 1920s, *Les Indépendants* by Gustave Coquiot (Paris: Librairie Ollendorff, 1920) and *Seurat* by Lucie Cousturier (Paris: G. Crès, 1926)
a. Another ed.: *Georges Seurat*. Traduzione Maria Paolo De Benedetti; ufficio editoriale: Marina Brizi; fotografi di redazione: Piero Baguzzi. Milan: F. Fabbri, 1974. 95 p., illus.

560. HEGO, JEAN-MARIE. *Où situer exactement 'Une Baignade, Asnières'?* Courbevoie,

1991. Unpublished typescript.

561. HERBERT, ROBERT L. *Seurat's Drawings.* NY: Shorewood Publishers, 1962. 194 p., illus., some col.

Standard source and first scholarly examination of Seurat's drawings.
a. English ed.: London: Studio Vista, 1962.
Review: D. C. Rich, *Art Journal* 24(1964-65):397-8.

562. HERBERT, ROBERT L. *Georges Seurat, 1859-1891.* Robert L. Herbert with Françoise Cachin, et al. NY: Metropolitan Museum of Art; dist. by Abrams, 1991. 450 p., illus.

563. HERZ-FISCHLER, ROGER. *An Examination of Claims Concerning 'The Golden Number.' Seurat, Gris, Mondrian, Ozenfant, Jeanneret.* Unpublished typescript, Carlton University, 1976.

One version later published as "An Examination of Claims Concerning Seurat and the "Golden Number," *Gazette des Beaux-arts*, ser. 6, 101(March 1983):109-12.

564. HOMER, WILLIAM INNES. *Georges Seurat: Port-en-Bessin.* Minneapolis: Minneapolis Institute of Arts, 1957. 41 p., illus.

565. HOMER, WILLIAM INNES. *Seurat and the Science of Painting.* Cambridge, MA: MIT Press, 1964. 327 p., illus.

Comprehensive discussion of Seurat's scientific and aesthetic art theory sources, including Chevreul, Rood, Henry, and other color theorists and scientists whom Seurat consulted.
a. Second ed.: 1970.
b. Reprint: NY: Hacker Art Books, 1985. 326 p., illus., 2 pl.
Reviews: L. D. Steefel, *Art Journal* 24:3(1964-65):306; 308; J. Russell, *Apollo* 81(May 1965):413-5; J. Killham, *British Journal of Aesthetics* (1965):309-10; H. Dorra, *Burlington Magazine* 108(1966):209; J. Hodkinson, *Journal of the Optical Society of America* 56:2(February 1966):262-3; R. Weale, *Palette* 40(1972):16-23.

566. INUI, YOSHIAKI. *Seurat.* Tokyo: Shinshosha, 1974. 93 p. (Bibliothèque des Beaux-arts/Shincho Art Library, no. 32)

567. ISHAGHPOUR, YOUSSEF. *Seurat: la pureté de l'élément spectral.* Paris: L'Echoppe, 1992. 1 vol. (Envois)

568. JANUSZCZAK, WALDEMAR, ed. *Techniques of the World's Great Painters.* Oxford: Phaidon, 1980. 192 p., illus., some col.

Discussion of Seurat's *Une Baignade, Asnières*, pp. 114-7.
a. U.S. ed.: Secaucus, NJ: Chartwell, 1980.

569. JEDDING, HERMANN. *Seurat: Text by Hermann Jedding.* Milan: Uffici Press, 1957. 26 p., col. illus. (Gallery of Art)

570. JOHNSON, MARC. *Jules Chéret. Divertissements*. Lausanne: Bibliothèque des arts, 1983. 66 p., col. illus. (Rythmes et couleurs)

571. KAHN, GUSTAVE. *Le Cirque solaire*. Paris: Editions de la Revue Blanche, 1899. 252 p.

572. KAHN, GUSTAVE. *L'Esthétique de la rue*. Paris: Charpentier, 1901. 308 p.

573. KAHN, GUSTAVE. *Les Dessins de Georges Seurat (1859-1891)*. Texte de Gustave Kahn. Paris: Bernheim-Jeune, 1928. 2 vols., 22 p., 128 pl.

Portfolios with facsimile reproductions of Seurat's drawings exhibited at Bernheim-Jeune, Paris in 1926.
a. U.S. ed.: *The Drawings of Georges Seurat*. Trans. by Stanley Appelbaum. NY: Dover, 1971.

574. KEMP, MARTIN. *The Science of Art: Optical Themes in Western Art from Brunelleschi to Seurat*. New Haven, CT: Yale University Press, 1990. 375 p., illus., some col.

See index for references to Seurat and Neo-Impressionism.
Reviews: P. Hills, *Art History* 14:4(1991):617-9; P. Maynard, *Journal of Aesthetics and Art Criticism* 52:2(Spring 1994):243.

575. KUROE, MITSUHIKO. *Pissarro, Sisley, Seurat*. Tokyo: Shueisha, 1973. In Japanese.

576. LAPRADE, JACQUES DE. *Georges Seurat*. Texte de Jacques de Laprade. Monaco: Aulard, 1945. 96 p., pl. (Documents d'art)

a. Other eds.: Paris: Somogy, 1951, 1954.

577. LAPRADE, JACQUES DE. *Seurat*. Paris: Editions Aiméry Somogy, 1945. 96 p., illus., some col.

Biographical and critical overview.

578. LEBENSZTEJN, JEAN-CLAUDE. *Chahut*. Paris: Hazan, 1989. 150 p., 53 illus., 1 col. pl.

Place one of Seurat's last major paintings (1889-90) in its social context.

579. LEE, ELLEN WARDWELL. *Seurat at Gravelines: The Last Landscapes*. With an essay by Jonathan Crary and biography by William H. Butler. Indianapolis: Indianapolis Museum of Art in cooperation with Indiana University Press, 1990. 80 p., illus.

Examines Seurat's late landscapes of Gravelines, France.

580. LEIGHTON, JOHN and RICHARD THOMSON. *Seurat and The Bathers*. With David Bomford, Jo Kirby, Ashok Ray. London: National Gallery Publications; dist. by Yale

University Press, 1997. 168 p., 178 illus., col. pl. 91 works shown.

Published to accompany an exhibition at the National Gallery, London (2 July-28 Sept. 1997) of Seurat's *Bathers at Asnières* (1884) and related sketches and works, including paintings by several other French artists. Essays concentrate on Seurat's early years, *The Bathers*, and *The Bathers* in its contexts. Includes a chronology (1859-1961), pp. 152-3 and a Bibliography, pp. 159-63.

581. LE MEN, SEGOLENE. *Seurat & Chéret: le peintre, le cirque et l'affiche.* Paris: CNRS Editions, 1994. 187 p., illus. (Les Insolites de la recherche)

Bibliography, pp. 181-88.

582. LE ROUX, HUGHES. *Les Jeux du cirque et la Fête foraine.* Paris: Plon et Nourrit, 1889.

583. LHOTE, ANDRE. *Georges Seurat.* Avec 32 reproductions en phototypie. Rome: Editions de 'Valori Plastici,' 1922. 14 p., pl. (Les Artistes nouveaux, ser. 1)

584. LHOTE, ANDRE. *Seurat.* Paris: Braun, 1948. 12 p., illus., 16 pl. (Collection "Plastique", no. 3)

585. LIST, HERBERT. *Herbert List: Young Men.* London: Thames and Hudson, 1988. 112 p., 72 illus.

Presents a selection of photographs by Herbert List on the subject of young men, influenced by classical and Renaissance art and relating to Greek sculpture as well as to the work of Cézanne, Seurat, and Picasso.

586. LÖVGREN, SVEN. *The Genesis of Modernism: Seurat, Gauguin, van Gogh, & French Symbolism in the 1880's.* Ph.D. diss., University of Uppsala, 1959; Stockholm: Almqvist & Wiksell, 1959. 178 p., illus.

Interpretative survey of the intellectual currents leading to Symbolism and the development of Post-Impressionism. Examines Symbolism in literature and painting with an analysis of key works by Seurat and others.

a. Other eds.: Bloomington: Indiana University Press, 1971. 241 p., 28 illus; New York: Hacker Art Books, 1983.

587. MADELEINE-PERDRILLAT, ALAIN. *Seurat.* Geneva: Skira, 1990. 215 p., illus. (Découverte du dix-neuvième siècle)

Describes Seurat's life and career, giving detailed analysis of paintings and preparatory drawings.

a. U.S. ed.: NY: Rizzoli, 1990. 215 p., 210 illus., 110 col.

588. MAINDRON, ERNEST. *Les Affiches illustrées.* Ouvrage orné de 20 chromolithographies par Jules Chéret. Paris: H. Launette et Cie, 1886.

589. MAINDRON, ERNEST. *Les Affiches illustrées, (1886-1895)*. Paris: G. Boudet; Ch. Tallandier, 1896. 251 p., illus., 72 col. pl. (Certaines en couleur)

590. MALHOTRA, RUTH; MARJAN RINKLEFF and BERND SCHÄLICKE. *Das Frühe Plakat in Europa und den USA, ein Bestaudkatalog*. Berlin: Mann, 1977. 2 vols.

See vol. 2 for information on posters by Seurat and Jules Chéret.

591. MARET, FRANÇOIS [Pseud. of Franz van Ermengen]. *Les Peintres luministes*. Brussels: Editions du Cercle d'Art, 1944. 45 p., 32 pl. (L'Art en Belgique)

Summary of Neo-Impressionist color theory, with particular attention to pigments used in Seurat's work.

592. MARKSCHIESS-VAN TRIX, JULIUS and BERNHARD NOWAK. *Artisen - und Zirkusplakate: ein internàtionaler historischer*. Leipzig: Edition Leipzig; Zurich: Atlantis, 1975. 269 p., illus.

593. MAUCLAIR, CAMILLE. *Jules Chéret*. Paris: M. Le Garrec, 1930. 133 p., illus., pl. 730 copies.

Illustrated biography of Chéret (1836-1932), a color lithographer who collaborated with Seurat on circus posters. Bibliography, pp. 127-9.

594. MAUCLAIR, CAMILLE. *Le Théâtre, le cirque, le music-hall, et les peintres du XVIII^e siècle à nos jours*. Préface de Camille Mauclair. Paris: E. Flammarion, 1926. 138 p., illus., pl.

595. MEDLYN, SALLY A. *The Development of Georges Seurat's Art, with Special Reference to the Influence of Contemporary Anarchist Philosophy*. M.A. thesis, University of Manchester, 1975.

596. MELLERIO, ANDRE. *La Lithographie originale en couleurs*. Paris: L'Estampe et l'Affiche, 1898.

597. MERKERT, JÖRN. *Zirkus Circus Cirque: 28. Berliner Festwochen 1978, Ausstellung vom 9.9.bis 5.11.1978*. Katalog hrsg. von Jörn Merkert. Berlin: National galerie, 1978. 247 p., illus.

Exhibition catalogue that includes circus posters by Jules Chéret (1836-1932).

598. MINERVINO, FIORELLA and ANDRE CHASTEL. *L'Opera Completa di Seurat*. Presentazione di André Chastel. Milan: Editore Rizzoli, 1972. 119 p., illus., 32 pl. (Classic dell'arte, no. 55)

Discusses Seurat's early training under Henri Lehmann (1814-82), one of Ingres's pupils, and how these early influences are reflected in the composition of his paintings and use of color.
a. French ed.: *Tout l'œuvre peint de Seurat*. Paris: Flammarion, 1973. 120 p., 468 illus. (Classiques de l'art)

599. MINKOWSKA, FRANÇOISE. *De van Gogh et Seurat aux dessins d'enfants. A la recherche du monde des formes (Rorschach)*. Commenté par F. Minkowska. Paris: Musée Pédagogique, 1949. 152 p., illus.

Catalogue of an exhibition on art and psychopathology held 20 April-14 May 1949.

600. MOLES, ABRAHAM. *L'Affiche dans la société urbaine*. Paris: Dunod, 1970. 153 p., illus., some col.

601. MORRIS, JOHNNY. *Have a Good Look with Johnny Morris: A Sunday Afternoon on the Island of La Grande Jatte* [by] *Georges Seurat*. London: Dobson, 1979. 22 p., col. illus.

602. MULLER, JOSEPH-EMILE. *Seurat, dessins*. Paris: Fernand Hazan, 1960. 12 p., 36 pl. (Bibliothèque Aldine des arts, no. 41)

603. NEVEUX, MARGUERITE. *Construction et proportion: apports germaniques dans une théorie de la peinture française de 1890 à 1950. Ph.D.* Ph.D. thesis, Univeristé de Paris, 1990.

Includes a lengthy examination of Seurat's stylistic proportions that concludes that he did not use the "golden section." Bibliography, pp. 727-52.

604. NOVOTNY, FRITZ. *Cézanne und das Ende der wissenschaftlichen Perspektive*. Vienna; Munich: A. Schroll, 1938. 214 p., pl.

Investigates Seurat's formal structure and objective or spatial description in comparison to Cézanne (see pp. 145-52, 188-96).

605. OGAWA, MASATAKA and TAKESHI KASHIWA. *Seurat*. Par Masataka Ogawa, Takeshi Kashiwa. Tokyo: Senshukai, 1978. 87 p., illus., 40 pl., 36 col. In Japanese (Les Peintres impressionnistes, no. 13)

606. PACH, WALTER. *George Seurat*. NY: Duffield, 1923. 30 p., pl. (Arts Monographs)

607. PERRUCHOT, HENRI. *La Vie de Seurat*. Avec la chronologie complète des sept premiers volumes de la série Art et destin [par] Henri Perruchot. Paris: Hachette, 1966. 269 p., illus.

Biography of Seurat that includes a bibliography (pp. 189-95) and a lengthy general chronology (pp. 205-69).

608. PERSIN, PATRICK-GILLES. *Aman-Jean: peintre de la femme*. Paris: S. Thierry; Bibliothèque des Arts, 1993. 224 p., illus.

609. PETRANSKY, LUDO. *Seurat a neoimpresionizmus*. Bratislava: Pallas, 1976. 185 p., illus. (Edícia Galéria, no. 2)

610. PRENDEVILLE, BRENDA. *Proportional Systems in Seurat*. M.A. thesis, University of London, Courtauld Institute of Art, 1970.

611. PRETINI, GIANCARLO. *L'Anima del Circo con le 'Memorie di Joseph Grimaldi' di Charles Dickens*. Undine: Trapezio Libri, 1990. 617 p., illus. (I Grandi Libri, no. 7)

612. *La Promenade du critique influent. Anthologie de la critique d'art en France, 1850-1900*. Textes réunis et présentés par Jean-Paul Bouillon, Nicole Dubreuil-Blondin, Antoinette Ehrard, Constance Naubert-Rieser. Paris: Hazan, 1990. 433 p., illus.

613. PY, CHRISTIANE and CECILE FERENCZI. *La Fête foraine d'autrefois; les années 1900*. Lyon: La Manufacture, 1987. 302 p., illus. (L'Histoire partagée)

614. REITER, BRIGITTA. *Seurat og hans venner: et kompendium om neoimpresionismen*. Samlet af Brigitta Reiter. Copenhagen: Kunstpædagogisk Skole, 1980. 98 p., illus.

Charts Seurat's Neo-Impressionist influences on Danish painters. Bibliography, pp. 96-8.

615. RENNERT, JACK. *100 Years of Circus Posters*. NY: Avon, 1974. 112 p., illus. (Flare Books)

a. French ed.: *100 ans d'affiches du cirque*. Traduit par Henri Veyrier. Paris: Anagramme, 1974. 112 p., illus.

616. REWALD, JOHN. *Georges Seurat*. Translated by Lionel Abel. NY: Wittenborn, 1943. 125 p., 96 pl.

Important early work on Seurat and standard biography.
a. 2nd rev. ed.: 1946. 125 p., 96 pl.
b. French ed., rev.: Paris: Editions Albin Michel, 1948.

617. REWALD, JOHN. *Seurat (1859-1891)*. Paris: Braun, 1954. 60 p., illus. (Les Maîtres)

618. REWALD, JOHN. *Seurat: A Biography*. NY: H. N. Abrams; London: Thames and Hudson, 1990. 248 p., 169 illus.

Marking the centenary of Seurat's death, Rewald examines the short life and seven-year career of Seurat. Eleven chapters analyze Seurat's painting technique, color theories, preparatory oil studies, charcoal and pencil studies, and a selection of other works. Includes reproductions of previously unpublished paintings from private collections and original documents and reminiscences by critic Félix Fénéon. Bibliography, pp. 231-43.

619. REY, ROBERT. *La Peinture française à la fin du XIXe siècle: la renaissance du sentiment classique Degas-Renoir-Gauguin-Cézanne-Seurat*. Paris: Les Beaux-Arts; Editions G. van Oest, 1931. 162 p., illus., 33 pl.

620. RICH, DANIEL CATTON. *Seurat and the Evolution of 'La Grande Jatte.'* Chicago, The Renaissance Society of the University of Chicago Press, [1935]. 125 p., illus. (Studies of Meaning in Art)

History, pictorial analysis, and influence of Seurat's *magnus opus*. Selected Bibliography, pp. 61-3.
a. Reprint: NY: Greenwood Press, 1969.

621. RICHARDSON, JOHN ADKINS, ed. *The Collection of Germain Seligmann: Paintings, Drawings and Works of Art*. NY: E. V. Thaw, 1979. 125 p., illus.

622. ROGER-MARX, CLAUDE, ed. *Les Maîtres de l'affiche*. Paris: Chaix, 1896-1900. 5 vols., pl.

a. U.S. ed.: *Masters of the Poster, 1896-1900*. Jack Rennert, ed. NY: Images Graphiques, 1977. 32 p., col. illus., 64 pl.

623. ROGER-MARX, CLAUDE. *Seurat*. Paris: G. Crès, 1931. 14 p., 32 pl. (Les Artistes nouveaux)

Standard early biography and critical appreciation.
a. Other eds.: 1985, 1989.
b. Chinese ed.: *Hsiu-la/Seurat*. Taipan: Yuan liu Chú pan shih yeh ku Fen yu Hsien Kung Ssu, 1995. 235 p., illus. (I Shu Chün Hsiang, no. 7)
Review: Denys Sutton, *Apollo* 83:47(Jan. 1966):76-7.

624. SALMON, ANDRE. *La Révélation de Seurat*. Brussels: Editions Sélection, 1921. (Tracts Sélection, études sur l'art nouveau, no. 2)

a. Reprint: *Propos d'atelier* (Paris: G. Crès, 1922):41-56.
Review: F. Fénéon, *Bulletin de la vie artistique* 3:1(1 Jan. 1922):11-2.

625. SCHAPIRO, MEYER. *Style, artiste, société*. Essais traduits par Blaise Allan. Paris: Gallimard, 1982. 441 p., illus.

French version of Schapiro's article, "New Light on Seurat," *ARTnews* 57:2(Apr. 1958):22-4, 44-5, 52 appears on pp. 361-82.

626. SELIGMANN, GERMAIN. *The Drawings of Georges Seurat*. NY: C. Valentin, 1947. 94 p., 13 illus., 46 pl.

Stylistic investigation of Seurat's drawings limited to works in U.S. collections.
Review: *Burlington Magazine* 89(1947):291.

627. SEURAT, GEORGES PIERRE. *Disegni de Seurat*. Venice: Edizioni del Cavallino, 1947. 13 pl.

628. SEURAT, GEORGES PIERRE. *Notes sur Delacroix*. Caen: L'Echoppe, 1987. 21 p., 3 illus. (Envois)

Reprints a text by Seurat first published in *Bulletin de la vie artistique* 3:7(April 1922):154-8, of notes written in February and November 1881. Includes an introduction by Félix Fénéon.

629. SEURAT, GEORGES PIERRE. *Seurat*. [Milan]: Antonio Vallardi Editore, [1956] 26 p.: col. illus. (Galleria d'arte)

630. SEURAT, GEORGES PIERRE. *Seurat*. London: Phaidon, 1965. 86 p., illus., 50 pl.

631. SEURAT, GEORGES PIERRE. *Seurat 1859-1891.* NY: Clarkson Potter, 1994. 44 p., col illus. (Pocket Painters)

632. SEURAT, GEORGES PIERRE. *Seurat: correspondances, témoignages, notes inédites, critiques.* Préface d'Eric Darragon. Choix de textes d'Hélène Seyrès. Paris: Acropole, 1991. 335 p., 14 illus., 8 pl. (Ecrits sur la peinture)

Anthology of Seurat's correspondence, notes, and extracts from reviews and critical publications, with contextual prefaces.

633. *Seurat's 'Bathers, Asnières' and the Crisis of Impressionism: Painting in Focus 6.* London: National Gallery, 1976.

634. SHAPIRO, BARBARA STERN. *Pleasures of Paris, Daumier to Picasso.* Barbara Stern Shapiro with the assistance of Anne E. Havinga. Essays by Susanna Barrows, Phillip Dennis Cate, and Barbara K. Wheaton. Boston: The Museum of Fine Arts, Boston; D. R. Godine, 1991. 192 p., illus.

Exhibition catalogue that includes posters by Jules Chéret, shown at The Museum of Fine Arts, Boston (5 June-1 Sept. 1991) and at the IBM Gallery of Science and Art, New York (15 Oct. 1991-28 Dec. 1991). Bibliography, p. 191.

635. SMITH, PAUL GERALD. *Seurat, the Language of Idealism, and the Concrete Conditions of Avant-garde Practice.* Ph.D. thesis, University of London, Courtauld Institute of Art, 1990. 409 p.

Bibliography, pp. 352-95.

636. SMITH, PAUL GERALD. *Seurat and the Language of the Avant-garde.* New Haven, CT: Yale University Press, 1997. 211 p., illus.

Examines Seurat's visual usage of prevailing late 19th century French avant-garde theories of expression.

637. STAROBINSKI, JEAN. *Portrait de l'artiste en saltimbanque.* Geneva: Albert Skira, 1970. 147 p. (Les Sentiers de la création, no. 7)

638. STRASSER, CATHERINE. *Seurat: Cirque pour un monde nouveau.* Paris: Adam Biro, 1991. 64 p., 43 illus., 1 col. (Collection "un sur un")

Describes the genesis of *Cirque,* an unfinished work exhibited in 1891, in the context of Seurat's paintings of interiors, the circus as a theme in 19th and 20th century art, and Seurat's scientific interest in light and color.

639. STUCKEY, CHARLES F. *Seurat.* Mount Vernon, NY: Artist's Limited Edition, 1984. 32 p., col. illus. (A Medaenas Monograph on the Arts)

640. *Studies for 'La Grande Jatte' and Other Pictures: February 5 to 25, 1935.* Chicago: Renaissance Society, 1935. 15 p., illus.

641. SUTTER, JEAN. *Recherches sur la vie de Georges Seurat (1859-1891). I. Les Chroniques familiales.* Paris, 1964. Unpublished typescript. 80 copies distributed to Les Amis de l'art de Seurat.

Includes important biographical notes.

642. TAKENAKA, IKU and MIEKAWA ATSUSHI. *Seurat et le Néo-impressionnisme.* Tokyo: Chuokoron-Sha, 1972. 133 p., illus., col. pl. In Japanese and French. (Les Grands maîtres de la peinture moderne, no. 9)

Japanese title: *Sura to Shin Ioshōha.*

643. TAVEL, HANS CHRISTOPH VON. *Le Cavalier bleu.* Exposition au Musée des Beaux-arts, Berne du 21 novembre 1986 à février 1987. Conception de l'exposition et du catalogue Hans Christoph von Tavel. 298 p., illus.

Exhibition catalogue of the Blue Rider Movement that included works by the color lithographer Jules Chéret (1836-1932) Bibliography, pp. 285-91.

644. TAZARTES, MAURIZIA. *Seurat.* Florence: Giunti, 1991. 50 p., illus. (Art dossier, no. 60)

645. TERRASSE, ANTOINE. *L'Univers de Seurat.* Paris: Scrépel; diffusion, Weber, 1976. 92 p., illus. (Les Carnets de dessins)

646. THERY, MARIANNE and DOMINIQUE BRISSON, eds. *Le Temps Seurat.* Paris: Réunion des Musées Nationaux, 1991. 96 p., illus., 4 pl. (Collection Le Temps)

647. THETARD, HENRY. *La Merveilleuse histoire du cirque.* Paris: Prisma, 1947. 2 vols., illus., col. pl.

a. Another ed.: Paris: Julliard, 1978. 639 p., illus., 26 pl.

648. THOM, IAN MACEWAN. *Georges Seurat: 'Une Baignade à Asnières.'* M. A. thesis, University of British Columbia, 1978. 135 p., illus.

Bibliography, pp. 127-32.

649. THOMAS, DAVID. *Manet, Monet, Seurat.* New York: Tudor, 1970.

650. THOMSON, RICHARD. *Seurat.* Oxford: Phaidon; Salem, NH: Salem House, 1985. 240 p., 225 illus.

Wide-ranging and eclectic examination of Seurat's life, career, and influence that draws on numerous sources. Selected Bibliography, pp. 235-6.
a. Another ed.: 1990.
Reviews: M. Ward, *Oxford Art Journal* 9:2(1986):79-80; K. Adler, *Burlington Magazine* 128:998(1986):364.

651. THON, CHRISTINA. "Zur Geschichte des französischen und belgischen Plakats" in

Das frühe Plakat in Europa und den USA. Ein Bestandskatalog. Vol. 2: *Frankreich und Belgien*, pp. 11-50. Ed. by R. Malhotra, M. Rinkleff, and B. Schlicke. Berlin: Gebr. Mann, 1977.

652. TILSTON, RICHARD. *Seurat*. Greenwich, CT: Smithmark; London: Bison Group, 1991. 176 p., col. illus.

653. *Les Usages de l'image au XIXe siècle*. Paris: Crépahis, 1992.

654. VALTON, EDMOND, et al. *Georges Seurat*. Brussels: [Veuve Monnon?], 1895.

Memorial brochure of funerary addresses by Edmond Valton, Président de la Société des Artistes Indépendants, and others, concluding with an appreciation by Seurat's mother to Valton, Jean Ajalbert, Armand Guillaumin, E. G. Cavallo-Peduzzi, Henri de Régnier, Camille Pissarro, Henri Gaudin, Paul Adam, and Ernesta Urban.

655. VAUCAIRE, MAURICE. *Effets de théâtre: la scène et la salle, le ballet, cafés-chantants, à la foire*. Paris: Lemerre, 1886. 134 p.

656. VENTURI, LIONELLO. *Mélanges Henri Focillon*. NY, 1947.

Reprints Venturi's article, "The Art of Seurat," *Gazette des Beaux-arts* ser. 6, 26:934(July-Dec. 1944):421-30.

657. WEILL, ALAIN. *A Hundred Years of Posters of the Folies-Bergères and the Music Halls of Paris*. NY: Images Graphiques, 1977. 112 p., illus., some col. (Poster Art Library)

a. French ed.: *100 ans d'affiches des music halls parisiens*. Paris: Chêne, 1977. 112 p., illus., some col.

658. WEILL, ALAIN. *Le Café-concert, 1870-1914. Affiches de la Bibliothèque du Musée des Arts décoratifs*. Paris: Musée des Arts Décoratifs, 1977. 60 p., illus., some col.

Exhibition of nightclub posters held at the Musée des Arts Décoratifs, (19 Oct. 1977-2 Jan. 1978). Catalogue distributed in the U.S. by Images Graphiques.

a. English ed.: *Circus People and Posters*. Trans. by Charles Dukes. Leipzig: Edition Leipzig, 1977.

659. WEILL, ALAIN. *L'Affichomanie. Collectionneurs d'affiches-affiches de collection, 1880-1900*. Conception et réalisation, Alain Weill. Paris: Musée de l'Affiche, 1980. 96 p., illus.

Exhibition catalogue that includes posters by the color lithographer Jules Chéret (1836-1932).

660. WEILL, ALAIN. *Le Cirque français*. Réalisation, Alain Weill, et al. Paris: Musée de l'Affiche, 1981. 72 p., illus.

Exhibition catalogue that includes circus posters by Jules Chéret. Bibliography, p. 70.

661. WEILL, ALAIN. *L'Affiche française*. Paris: P.U.F., 1982. 125 p., illus. (Que sais-je, no. 153)

662. WHITE, GABRIEL. *Reproductions of the Drawings of Seurat*. Introduction by Gabriel White. London: Arts Council of Great Britain, 1946. 14 p., 4 illus.

663. WILD, NICOLE and TRISTAN REMY. *Le Cirque; iconographie*. Catalogue par Nicole Wild et Tristan Rémy. Paris: Bibliothèque Nationale, 1969. 167 p., pl.

Exhibition of circus art and books from the Toole-Stott Circus Collection. Bibliography, pp. 151-2.

664. WILDENSTEIN, DANIEL. *Seurat*. Paris: Editions de Vergeures, 1982. 56 p., illus., some col. (A l'école des grands peintres, no. 19)

665. WILENSKI, REGINALD HOWARD. *Seurat (1859-1891)*. With an introduction and notes by R. H. Wilenski. NY: Pitman, 1951. 24 p., 10 col. illus.

666. WOTTE, HERBERT. *Georges Seurat*. Dresden: Verlag der Kunst, 1988. 223 p., 110 illus., 21 col.

Traces the life of Seurat, considering his childhood and life as a student at l'Ecole des Beaux-arts in Paris and examining his early work which consisted principally of drawings. Wotte discusses in detail a number of Seurat's paintings including *Une Baignade à Asnières*, *Un Dimanche Après-midi à l'Ile de la Grande-Jatte*, and *Les Poseuses*, and describes the artist as a reserved man, who preferred to paint from local landscapes. Considers the theory behind Seurat's pointillist technique and his tendency towards a more decorative and abstractionist mode of expression.

667. ZAGRODZKI, CHRISTOPHE and REJANE BARGIEL-HARRY. *Le Livre de l'affiche*. Paris: Editions Alternatives, 1985. 142 p., illus.

668. ZIMMERMANN, MICHAEL F. *Seurat, sein Werk und die Kunsttheoretische Debatte seiner Zeit*. Weinheim: VCH; Antwerp: Mercatorfonds, 1991. 495 p., illus.

Comprehensive study of Seurat's technique and style in relation to art theories of his time. Bibliography, pp. 477-86.
a. French ed.: *Les Mondes de Seurat: son œuvre et le débat artistique de son temps*. Traduit de l'allemand par Jérôme Ferry, Solange Schnall, Karin Fanny Willems. Antwerp: Fonds Mercator; Paris: Albin Michel, 1991. 493 p., illus.
b. English ed.: *Seurat and the Art Theory of his Time*. Antwerp: Fonds Mercator, 1991. 493 p., illus.

669. ZIMMERMANN, MICHAEL F. *Seurat, eine theoretische Monographie*. Ph.d. diss., Cologne, 1985.

IV. Articles

670. ABBOTT, JERE. *"Woman with a Monkey."* Smith College Museum of Art Bulletin 15(June 1934):12-3.

671. ABBOTT, JERE. "Two Drawings by Seurat." *Smith College Museum of Art Bulletin* 20(June 1939):19-24.

672. ABRAMOWICZ, JANET. "The Artist's Artist: Giorgio Morandi." *Artscanada* 35:220-1(April-May 1978):27-30. 10 illus.

Article on Morandi's association with the city of Bologna that mentions Seurat's influence on his etchings.

673. ADHEMAR, HELENE. "Galerie du Jeu de Paume: dernières acquisitions. *Revue du Louvre et des musées de France.* 23:4-5(1973):285-98. 16 illus.

Discusses, in part, a painting by Seurat in the Max and Rosy Kaganovitch donation to the Jeu de Paume, Paris, and a recent purchase of a Seurat work by the Museum.

674. "L'Affiche illustrée." *La Plume littéraire, artistique et sociale* 110(15 Nov. 1893).

Special number devoted to French lithograph posters.

675. AICHELE, K. PORTER. "Seurat's *Les Poseuses* in the Context of French Realist Literature." *Nineteenth-Century French Studies* 17:3-4(1989):385-96.

Analyzes the painting *Les Poseuses* (1886-88) in relation to criticism of Seurat's earlier work, *La Grande Jatte,*

676. ALZATE CUERVO, GASTÓN. "La Abstraccion Pictorica y la Musica." *Universitas Humanistica* 23:38(1993):72-7.

Compares early 20th century abstract art with musical abstract expressionism.

677. ANTOINE, JULES. "Georges Seurat." *La Revue indépendante* 19(April 1891):89-93.

Tribute and obituary published within a month of Seurat's death.

678. APOLLONIO, UMBRO. "Disegni di Georges Seurat" in *Venice, XXV Biennale 1950 Catalogo*, pp. 175-9.

679. AVRAMOV, DIMITUR. "Neoimpresionizmut Na Zhorzh S'ora" [The Neo-Impressionism of Georges Seurat]. *Problemi na Izkustvoto* 3(1975):36-43, 63. Summaries in Russian and French. 13 illus.

Examination of Seurat's art, with reference to Impressionism and its influence on Bulgarian painters A. Mitov, Murkichka, I. Angelov, and N. Petrov during the period 1907-10.

680. AVRUSCIO, N., H. KAMBARTEL, and W. KAMBARTEL. "Seurat in Schilda. Ein

anarchistischer Künstler im Lichte Kunsthistorischer Narrheit." *Kritische Berichte* 2(1984):92-6.

Includes a review of Erich Franz and Bernd Growe's *Georges Seurat: dessins* (Paris: Hermann, 1984).

681. AYRTON, MICHAEL. "Seurat's *Une Baignade, Asnières.*" *The Listener* (14 April 1960):660-2.

682. BACOU, ROSELINE. "Millet: poète du quotidien." *Plaisir de France* 41:432(Sept. 1975):38-43. 11 illus.

Study of Millet's drawing technique with brief references to Seurat.

683. BAKER, CHRISTOPHER. "Creating Distance in Landscape Painting: 3–Marks, Rhythm and Composition." *Artist* 103:12(Dec. 1988):13-5. 5 illus., 1 col.

Outlines methods of creating the illusion of distance in landscape painting using marks, rhythm, and composition.

684. BALLATORE, SANDY. "Aaron Karp." *Artspace* 14:5(July-Aug. 1990):37. 1 col. illus.

Discusses Karp's acrylic drawings and draws similarities to Seurat.

685. BAZIN, GERMAIN. "Seurat et le Vinci français." *Arts* (22-28 Jan. 1958):14.

686. BERALDI, HENRI. "Chéret" in *Les Graveurs du XIXe siècle* (Paris: Conquet, 1886).

687. BERGGRUEN, HEINZ and ELSPETH MONCRIEFF (Interviewer). *Antique Collector* 59:9(Sept. 1988):136-7. 3 illus.

Discussion of Berggruen's collection of modern art, which includes works by Seurat.

688. BERTHE, M. "Les Dessins de Georges Seurat." *Arts plastiques* (Brussels) (July-Aug. 1950):209-11.

689. BISSIERE, GEORGES. "Notes sur l'art de Seurat." *L'Esprit nouveau* 1:1(15 Oct. 1920):13-28.

690. BLOCH, ERNST. "Maler des gebliebenen Sonntags: in der Kunst ist der christliche Festtag immer das Jenseits der Beschwerde." *Du* 10(Oct 1995):38-42. 6 col. illus.

Examines images of rest, happiness, and the unity of mankind. Among the paintings analyzed is Seurat's *Un Dimanche à la Grande Jatte*.

691. BODE, URSULA. "Der schone Schein und der Geist der Malerei." *Kunst und Antiquitaten* 7-8(1991):44-9. 9 col. illus.

Analyzes series paintings of bathers by various artists from 1880 to 1920, including Seurat.

692. BOIME, ALBERT. "Seurat and Piero della Francesca." *Art Bulletin* 48:2(June 1965):265-71.

693. BOIME, ALBERT. "Studies of the Monkey by Seurat and Pisanello." *Burlington Magazine* 111(Feb. 1969):79-80.

694. BOIME, ALBERT. "The Teaching of Fine Arts and the Avant-garde in France during the Second Half of the Nineteenth Century." *Arts Magazine* 60:4(Dec. 1985):46-57. 11 illus.

Examines the French government's involvement with and reforms in teaching art in the second half of the 19th century, with reference to the results of these policies on several avant-garde artists, including Seurat.

695. BOIME, ALBERT. "Georges Seurat's *Un dimanche à la Grande Jatte* and the Scientific Approach to History Painting" in *Historienmalerei in Europa*, ed. by Mai Eckehard and Anke Repp-Eckert (Mainz: Verlag Philipp Von Zabern, 1990):303-33.

696. BOIS, YVES-ALAIN and J. CLAY. "Quelques aspects de l'art récent: introduction." *Macula* 5-6(Dec. 1979):190-3. 1 illus.

Mentions the grain of the paper in a drawing by Seurat as an argument for concentrating on "minor" details in art criticism.

697. BONNET, PAUL. "Seurat et le néoimpressionnisme." *Le Crocodile* (Lyon) (Nov.-Dec. 1957):6-22.

698. BOUCHOT-SAUPIQUE, JACQUELINE. "Trois dessins de Seurat." *Bulletin des musées de France* 12:7(Aug. 1947):15-9.

699. BOURET, JEAN. "Pour un portrait de Derain." *Galerie-jardin des arts* 167(March 1977):41-5. 6 illus.

Mentions Seurat's influence on André Derain as part of a larger portrait and tribute to Derain on the occasion of a Derain retrospective held at the Grand Palais, Paris.

700. BOURGET, JEAN-LOUP. "Tom Phillips." *Vie des arts* 20:82(Spring 1976):60-2, 93. 5 illus. In English and French.

Contrasts the pointillism of Seurat to the contemporary Canadian artist Tom Phillips.

701. BOUYEURE, CLAUDE. "De Manet à Matisse: sept ans d'enrichissements au Musée d'Orsay." *L'Oeil* 425(Dec. 1990):72-9. 15 col. illus.

With reference to the exhibition *From Manet to Matisse: Seven Years of Treasures from the Musée d'Orsay*, held at the Musée d'Orsay, Paris (Spring 1991), Bouyeure describes paintings by Seurat, among other artists.

702. BRAUN, ROGER. "Bibliographie et inconographie de l'affiche illustrée." *Le Vieux papier* (March 1908). Reprinted in *L'Affichomanie* (Paris: Musée de l'Affiche, 1980).

703. BREICHA, OTTO. "Der Wiener Maler Wolfgang Herzig." *Magazin Kunst* 16:pt. 2(1976):90-1. 3 illus.

Describes Seurat's and Cézanne's influence on Wolfgang Herzig, a Viennese pointillist.

704. BRETTELL, RICHARD R. "The Bartletts and the *Grande Jatte*: Collecting Modern Painting in the 1920s." *The Art Institute of Chicago Museum Studies* 12:2(1986):103-13. 7 illus., 3 col.

Discusses Frederic Bartlett's acquisition of Georges Seurat's *Sunday Afternoon on the Island of La Grande Jatte* in the context of his career as an avant-garde collector in the 1920s.

705. BRETTELL, RICHARD R. "'Nadar' and a Photograph of Stéphane Mallarmé." *Library Chronicle of the University of Texas* 14(1980):34-45.

Examines the artistry and techniques of the Parisian photographic studio of Nadar, founded by Gaspard Félix Tournachon in the 1840s and continued by his son Paul, whose work may have had some influence upon Georges Seurat.

706. BROUDE, NORMA F. "New Light on Seurat's 'Dot': Its Relation to Photo-Mechanical Color Printing in France in the 1880s." *Art Bulletin* 56:4(Dec. 1974):581-9. 9 illus. Reprinted in *Seurat in Perspective*, ed. by Norma Broude (Englewood Cliffs, NJ: Prentice-Hall, 1978):163-75.

Examines the influence of color photo-mechanical printing processes introduced in France in the 1880s on Seurat's technique and stylistic development.

707. BROUDE, NORMA F. "The Influence of Rembrandt Reproductions on Seurat's Drawing Style: A Methodological Note." *Gazette des Beaux-arts* ser. 6, 88:1293(Oct. 1976):155-60. 6 illus. Summary in French.

Discusses the influence of 13 reproductions of Rembrandt etchings in *Le Figaro* on Seurat.

708. BROUDE, NORMA F. "Will the Real Impressionists Please Stand Up?" *ARTnews* 85:5(May 1986):84-9. 6 col. illus.

With reference to the exhibition *The New Painting: Impressionism 1874-86*, held at the National Gallery of Art, Washington, D.C. (July 1986), Broude elaborates on the diversity of the movement. Includes a brief reference to Seurat.

709. BUCHLOH, BENJAMIN H. D. "Gerhard Richter's Facture: Between the Synecdoche and the Spectacle." *Art and Design* 5:9-10(1989):40-5. 5 illus., 4 col.

Examines Richter's large-scale abstract paintings in light of the history of mechanical painting, from Seurat to Richter's grey series.

710. BÜNEMANN, HERMANN. "Georges Seurat als Zeichner." *Kunst* 65(1966-67):644-6.

711. CACHIN-NORA, FRANÇOISE. "Apollinaire voleva chiamare futurista tutta l'arte

moderna." *Bolaffiarte* 4:33(Oct. 1973):49-51. 4 illus.

Article on Italian Futurists that discusses possible Neo-Impressionist influences on Severini and Seurat's dot technique on Severini and Balla.

712. CALVO SERRALLER, FRANCISCO. "Meyer Schapiro." *Kalias* 7:13(1995):105-7. 1 illus. In Spanish.

Discusses contributions of Meyer Schapiro to art history several generations, including his work on Seurat.

713. CARRIER, DAVID. "Learning from Seurat and Vallotton." *Tema Celeste* 35(April-May 192):19. 2 illlus.

Compares the critic Félix Vallotton to Georges Seurat, highlighting Seurat's active innovation and Vallotton's cynical observation.

714. CARTER, DENNY. "A Symbolist Portrait by Edmond Aman-Jean." *Bulletin of the Cleveland Museum of Art* 62:1(Jan. 1975):3-10. 13 illus.

The *Portrait of a Woman (Meditation)* exhibited at the salon of 1891 by Edmond Aman-Jean (1858-1936) is discussed in relation to the portraiture of Whistler and Degas. Mentions Aman-Jean's early association with Seurat (1878-80), Puvis de Chavannes, and the Rose+Croix.

715. CATE, PHILLIP DENNIS. "The Japanese Woodcut and the Flowering of French Color Printmaking." *ARTnews* 74:3(March 1975):26-9. 6 illus.

Relates the influence of Japanese prints on late 19th century French graphic art, including works by Seurat.

716. CATE, PHILLIP DENNIS. "The 1880s: The Prelude" in *The Color Revolution* (Santa Barbara; Salt Lake City, 1978):1-15.

717. CATE, PHILLIP DENNIS. "The French Poster 1868-1900" in *American Art Posters of the 1890s in the Metropolitan Museum of Art*. (exh. cat., NY: Metropolitan Museum of Art; Harry N. Abrams, 1987):57-96.

718. CAWS, MARY ANN. "Dancing with Mallarmé and Seurat and Loïe Fuller, Hérodiade and La Goulue" in *Artistic Relations: Literature and the Visual Arts in Nineteenth-Century France*, ed. by Peter Collier and Robert Lethbridge (New Haven: Yale University Press, 1994):291-302.

719. CHABANNE, THIERRY. "L'Espagne des références." *Beaux-arts magazine* 50(Oct. 1987):56-63. 5 col. illus.

Discusses modern Spanish art; in particular, Juan Gris' references to Seurat and Ingres.

720. CHASTEL, ANDRE. "Le Mutisme de Seurat et la psychologie de l'art." *Cahiers du sud* (Marseille) 3(1948):530-6.

721. CHASTEL, ANDRE. "Une Source oubliée de Seurat." *Archives de l'art français* 22(1950-57)13:400-07. Also in Chastel's *Fables, formes, figures* (Paris: Flammarion, 1978):385-92.

722. CHASTEL, ANDRE. "Seurat et Gauguin." *Art de France* 2(1962):297-304. Also in Chastel's *Fables, formes, figures* (Paris: Flammarion, 1978):393-403.

723. CHASTEL, ANDRE. "Seurat-Fénéon." *Le Monde* (30 Dec. 1970). Also in *L'Image dans le miroir* (Paris: Gallimard, 1980):215-22.

724. CHRISTIN, ANNE-MARIE. "La Lettre dans l'affiche française (1780-1900)" in *Ecritures* (Paris: Le Sycomore, 1982):325-48.

725. CHRISTOPHE, JULES. "Georges Seurat." *Les Hommes d'aujourd'hui* 8:368(March-April 1890):2-4.

Issue dedicated to Seurat, with a cover drawing by Maximilien Luce.

726. CINOTTI, MIA. "La Musica Sopra la Tavolozza." *Arte* 17:176(July-Aug. 1987):50-3, 102. 5 illus., 3 col.

Examines the paintings of Vittore Grubicy (1851-1920), who was influenced early in his career by Seurat and Signac.

727. CLAYSON, S. HOLLIS. The Family and the Father: The *Grande Jatte* and its Absences." *The Art Institute of Chicago Museum Studies* 14:2(1989):154-64. 7 illus.

Notes possible reasons for the absence of various social groupings depicted in Seurat's *A Sunday Afternoon on the Grande Jatte* of the figure of the father, including government policies that until recently declared Monday (not Sunday) a day of rest.

728. CLOSE, CHUCK and LISA YUSKAVAGE (Interviewer). "Chuck Close." *Bomb* 52(Summer 1995):30-5. 3 illus.

Close discusses his background and work with comparisons to Seurat.

729. COGNIAT, RAYMOND. "Les Héritiers de l'impressionnisme." *Plaisir de France* 41:424(Nov. 1974):34-41. 12 illus.

Article on Post-Impressionist innovation that credits Seurat with laying the foundations of Cubism.

730. COLLINS, R. BRADFORD. "The Poster as Art: Jules Chéret and the Struggle for the Equality in the Arts in Late Nineteenth Century France." *Design Issue* 2(Spring 1985):41-50.

731. COMERFORD, JACKIE. "Shopping Bag Design." *Studio Magazine* 6:6(Nov.-Dec. 1988):42-7. 8 col. illus.

Presents examples from a collection of shopping bag art, including designs inspired by

Matisse and Seurat.

732. COURTHION, PIERRE. "Juan Gris, le logicien du cubisme." *XX^e Siècle* No. 43, vol. 36:43(Dec. 1974):36-43. Summary in English. 8 illus.

Article on Gris' life and work that draws parallels to Seurat and Neo-Impressionism.

733. COUSTURIER, EDMOND. "L'Art aux murs." *L'En-dehors* (10 July 1892).

734. COUSTURIER, LEON. "Georges Seurat." *L'Art décoratif* (20 June 1912):357-72.

Republished with "Les Dessins de Seurat," *L'Art décoratif* (March 1914):97-106, in *Seurat* (Paris: G. Crès, 1922).

735. COUSTURIER, LUCIE. "Les Dessins de Seurat." *L'Art décoratif* (March 1914):97-106.

Republished with "Georges Seurat," *L'Art décoratif* (20 June 1912):357-72, in *Seurat* (Paris: G. Crès, 1922).

736. DALE, DAVID. "Essentials of Painting Pastel Landscapes." *American Artist* 59:39(Oct. 1995):34-9, 73-4. 12 illus., 11 col.

Mentions Seurat's influence on how Dale, an American landscapist, selects colors and subject matter.

737. DANTO, ARTHUR C. "Men Bathing, 1883: Eakins and Seurat." *ARTnews* 94:3(March 1995):95-6. 2 col. illus.

Compares and contrasts two paintings produced in 1883 by Thomas Eakins and Georges Seurat: Eakins's *The Swimming Hole* and Seurat's *Une Baignade, Asnières*. Comments on modernistic and subversive features of each painting.

738. DARRAGON, ERIC. "Seurat, Honfleur et la *Maria* en 1886." *Bulletin de la Société de l'histoire de l'art français* (1984):263-80. 17 illus.

Examines Seurat's work at the port of Honfleur, France in the summer of 1886, in particular a painting of the cargo ship the *Maria*.

739. DARRAGON, ERIC. "Pégase à Fernando: à propos de *Cirque* et du réalisme de Seurat en 1891." *Revue de l'art* 86(1989):44-57. 24 illus.

Detailed examination of Seurat's painting *Cirque* (1890-91), concentrating on its realism, its different levels of information and luminous composition, and setting it within the context of other paintings with circus themes. Includes a description of the Cirque Fernando in Paris, depicted by Seurat.

740. DAULTE, FRANÇOIS. "Une Collection impressionniste à Regent's Park." *L'Oeil* 223(Feb. 1974):36-45. 16 illus.

Describes the French Impressionist and Post-Impressionist collection of the American ambassador to Great Britain, with an outline of the criteria by which pictures are chosen. Reproduces *La Grande Jatte, temps gris* by Seurat.

741. DEENE, J. F. VAN. "Georges Seurat." *Maandblad voor Beeldende Kunsten* 6(June 1931):163-76.

742. DELORME, ELEANOR PEARSON. "Seurat's *Le Cirque.*" *Marsyas* 19(1977-78):45-51.

743. DENVIR, BERNARD. "Beyond the Picturesque." *Art and Artists* 13:8(Dec. 1978):20-3. 4 illus.

Advances the claim that Seurat, far more than Cézanne, was the real precursor of Cubism and Futurism.

744. DENVIR, BERNARD. "Individual Temperaments." *Art and Artists* 14:9(Jan. 1980):12-7. 5 illus.

Focuses on the 1979-80 exhibition of Post-Impressionism at the Royal Academy of Arts, London, that mentions Seurat's contributions to Post-Impressionism's dazzling variety.

745. DITTMAN, LORENZ. "Seurat's Ort in der Geschichte des Helldunkel" in *Baukunst des Mittelalters in Europa; Hans Erich Kubach zum 75. Geburstag* (Stuttgart: Stuttgarter Gesellschaft für Kunst and Denkmalpflege, 1989).

746. DORRA, HENRI. "Re-Naming a Seascape by Seurat." *Gazette des Beaux-arts* ser. 6, 51:1068(Jan. 1958):41-8.

747. DORRA, HENRI. "The Evolution of Seurat's Style" in *Seurat, l'œuvre peint* (Paris: Les Beaux-arts, 1959):lxx-cvii.

748. DORRA, HENRI. "Charles Henry's 'Scientific' Aesthetic." *Gazette des Beaux-arts* 74:1211(Dec. 1969):345-56.

749. DORRA, HENRI and SHEILA C. ASKIN. "Seurat's Japonisme." *Gazette des Beaux-arts* ser. 6, 73:1201(Feb. 1989):81-94.

750. DORRA, HENRI. "Seurat's Dot and the Japanese Stippling Technique." *Art Quarterly* 33:2(Summer 1970):108-13.

751. DORRA, HENRI. "Japanese Sources for Two Paintings by Seurat." *Gazette des Beaux-arts* ser. 6, 114:1448(Sept. 1989):95-9. 4 illus. Summary in French.

Considers and identifies the influence of Japanese sources on two paintings by Seurat, *Parade de Cirque* (1887-88) and *Les Poseuses* (1886-88).

752. DORRA, HENRI. "Valenciennes's Theories: From Newton, Buffon and Diderot to Corot, Chevreul, Delacroix, Monet and Seurat." *Gazette des Beaux-arts* 124:1510(Nov. 1994):185-94. 8 illus., 2 col.

Discusses the influence of theories of perspective and landscapes by Pierre Henri de Valenciennes in his *Elemens de perspective pratique à l'usage des artistes* (1800), on late 19th century artists such as Monet, Pissarro, and Seurat.

753. DORSEY, DEBORAH. "Draw like Seurat." *The Artist's Magazine* 13:2(1 Feb. 1996):64.

Recommends Seurat's "value-based drawing approach" to working artists.

754. DUBINSKI, KRZYSZTOF. "Ogrod Balthusa" [Balthus's Garden]. *Sztuka* (Poland) 11:3(1986):32-4. 4 illus.

Traces the life and artistic development of Balthus (b. 1908), including a possible influence of Seurat.

755. DUCHAMP, MARCEL. "A Complete Reversal of Art Opinions by Marcel Duchamp, Iconoclast." *Studio International* 189:973(Jan.-Feb. 1975):29. 1 illus.

Opinion piece that mentions Seurat, among other artists.

756. DUNSTAN, BERNARD. "Looking at Paintings." *American Artist* 41:415(Feb. 1977):84-5. 2 illus.

Analyzes Seurat's *Sunday Afternoon on the Island of La Grande Jatte* (1884-86).

757. DURAND, XAVIER. "L'Art social au théâtre: deux expériences (1893-1897)." *Le Mouvement social* (April-June 1975):13-33.

758. DUTHUIT, GEORGES. "Seurat's System." *The Listener* (London) 17:421(3 Feb. 1937):210-1.

759. DUTHUIT, GEORGES. "Georges Seurat, voyant et physicien." *Labyrinthe* (Geneva) (Dec. 1946).

760. DUTHUIT, GEORGES. "La Griffe du nombre" in *L'Image et l'instant* (Paris: José Corti, 1961).

761. DUVE, THIERRY DE. "The Readymade and the Tube of Paint." *Artforum* 24(May 1986):110-21.

Mentions Seurat's pointillist technique.

762. EGLINTON, GUY. "The Theory of Seurat." *International Studio* 81(May 1925):113-7; (July 1925):289-92. Reprinted in Eglinton's *Reaching for Art* (Boston: May and Co., 1931).

763. EISENMAN, STEPHEN F. "Seeing Seurat Politically." *The Art Institute of Chicago Museum Studies* 14:2(1989):211-21, 2479. 7 illus.

Considers Seurat's politics and their effect on his work with an analysis of *A Sunday*

Afternoon on the Grande Jatte (1884-85).

764. ELDERFIELD, JOHN. "The Garden and the City: Allegorical Painting and Early Modernism." *Bulletin of the Museum of Fine Arts, Houston* 7:1(Summer 1979):3-20. 25 illus.

Cites the work of Seurat and other artists in this examination of the role of allegory in a world where late 19th century technology seemed to lead to an ideal society. Originally the John A. Beck memorial lecture, 1977.

765. FABIANI, ENZO. "Il divisionismo nacque sull'isola della *Grande Jatte*." *Arte* 19:198(July-Aug. 1989):62-7. 8 illus., 7 col.

Examines Seurat's *La Grande Jatte* (1884-85), tracing the stages which led to Seurat's execution of it, his orientation towards pointillism and divisionism, and the subsequent development of his style.

766. FAUCHER, MICHEL and DADO. "Dado: Le *Bain à Asnières* de Seurat–chef d'œuvre de la lumière." *Arts* 32(11 Sept. 1981):10. 1 illus.

Analysis by the Montenegran painter Dado of Seurat's *Bain à Asnières*, commenting in particular on the artist's use of light.

767. FAUNCE, SARAH. "Seurat and 'the Soul of Things'" in *Belgian Art*, 1880-1914 (exh. cat., Brooklyn Museum of Art, 1980):41-56.

768. FENEON, FELIX. "L'Impressionnisme aux Tuileries." *L'Art moderne* 6(19 Sept. 1886):302.

Critic Fénéon's groundbreaking review of Seurat's art shown at the 8th Impressionist exhibition that included the first use of the term "Neo-Impressionism."

769. FENEON, FELIX. "*La Grande-Jatte*." *L'Art moderne* 1(6 Feb. 1887):43[+].

770. FENEON, FELIX. "Notes et notules." *Entretiens politiques et littéraires* (April 1891):141.

Anonymously published obituary notice.

771. FENEON, FELIX. "Note sur Seurat." *Entretiens politiques et littéraires* 2:13(1891).

772. FENEON, FELIX. "Influences, à propos de la *Révélation de Seurat* par A. Salmon." *Bulletin de la vie artistique* 3:1(1 Jan. 1922):11-2.

773. FENEON, FELIX. "Sur Georges Seurat." *Bulletin de la vie artistique* 3(15 June 1922):278-9.

774. FENEON, FELIX. "Précisions concernant Seurat." *Bulletin de la vie artistique* 5:16(15 Aug. 1924):358-60.

775. FENEON, FELIX. "Georges Seurat und die öffentliche Meinung." *Der Querschnitt* (Berlin) (Oct. 1926):767-70. Republished in a French version as "Sur Georges Seurat," *Bulletin de la vie artistique* (15 Nov. 1926):347-8.

776. FENEON, FELIX. "*Le Cirque* de Seurat." *Bulletin de la vie artistique* 7(15 March 1926):85-6.

777. FENEON, FELIX. "Sur Georges Seurat." *Bulletin de la vie artistique* 7:20(15 Nov. 1926):347-8.

778. FENEON, FELIX. "Ecrits sur Georges Seurat" in Henri Dorra and John Rewald, *Seurat, l'œuvre peint* (Paris: Les Beaux-arts, 1959):x-xxxi.

779. FERGUSON, SUZANNE and DOUGLAS A. NOVERR. "Poetic Responses to Seurat's *La Grande Jatte*." *Mosaic: A Journal for the Interdisciplinary Study of Literature* 20:1(Winter 1987):97-111.

780. FIEDLER, INGE. "Materials used in Seurat's *La Grande Jatte*, including Color Changes and Notes on the Evolution of the Artist's Palette." *American Institute for Conservation of Historic and Artistic Works* (May 1984):43-51.

781. FIEDLER, INGE. "A Technical Evaluation of the *Grande Jatte*." *The Art Institute of Chicago Museum Studies* 14:2(1989):173-9, 244-5. 4 illus.

Detailed description of the Art Institute of Chicago's Conservation's Department 1982 comprehensive technical study of *A Sunday Afternoon on the Grande Jatte* (1884-85), describing tests and results and commenting on how this data may be used in interpretations.

782. FLATOW, SHERYL. "The Perfectionist: Mandy Patinkin Tackles Roles the Hard Way." *Connoisseur* 214(Sept. 1984):69.

Article on Patinkin's portrayal of Seurat in the musical *Sunday in the Park with Georges* by Stephen Sondheim.

783. FLEISHER, P. "Tachism Revived: A Visit to William Ronald's Studio." *Art Magazine* 5:16(Winter 1974):6-7. 2 illus.
Account of Canadian painter Ronald's recent work, whose technique has a calligraphic quality that Fleisher believes resembles Seurat's.

784. FELS, FLORENT. "Les Dessins de Seurat." *L'Amour de l'art* 8(Feb. 1927):43-6.

785. FELS, FLORENT. "La Peinture française aux XIXᵉ et XXᵉ siècles–Seurat." *ABC, Magazine d'art* 3:35(Nov. 1927):282-7.

786. FRIEND, MILES EDWARD. "Seurat: the Pointillist Drawings." *Southeastern College Art Conference Review* 9:3(Spring 1978):121-4.

787. FRY, ROGER. "Georges Seurat." *The Dial* 81(Sept. 1926):224-32.

Reprinted in *Transformations* (London: Chatto & Windus, 1926):188-96; and, in part, in

Seurat, ed. by Anthony Blunt (London: Phaidon, 1965):9-22.

788. FRY, ROGER. "Seurat's *La Parade*." *Burlington Magazine* 55:321(Dec. 1929):289-93.

789. GABETTI, B., ed. "Il collezionista americano, I: una signora a New York." *Bolaffiarte* 4:30(May-June 1973):58-9. 7 illus.

Collection of primarily European works that includes paintings by Seurat.

790. GAGE, JOHN. "Colour in History: Relative and Absolute." *Art History* 1(March 1978):104-30.

791. GAGE, JOHN. "The Technique of Seurat: A Reappraisal." *Art Bulletin* 69:3(Sept. 1987):448-54. 1 illus.

Explores the question of Seurat's attitude toward theoretical sources and examines the way in which his technique in the major paintings of the mid-1880's is related to them. Explains Seurat's reading and painterly experiments based on a specific philosophy of perception, arguing that Seurat's debt to Chevreul was more profound than his debt to any more recent theorist. Concludes that Seurat's technique can justifiably be understood as "scientific," though he was not truly familiar with the color science of his period.

792. "Gauguin—van Gogh—Seurat." *Das Kunstwerk* (Baden) 3(1950):16-22.

793. GEDO, MARY MATHEWS. "Chicago Artists Celebrate *La Grande Jatte*." *New-Art-Examiner* 13(Mar. 1986):26-8.

794. GEDO, MARY MATHEWS. "The *Grande Jatte* as the Icon of a New Religion: A Psycho-Iconographic Interpretation." *The Art Institute of Chicago Museum Studies* 14:2(1989):222-37. 11 illus.

Although *A Sunday Afternoon on the Grande Jatte* has often been interpreted as a comment on a degenerate and alienated society in decline, Gedo argues that such a reading of this deliberately obscure painting has no firm evidence. Provides a profile of Seurat and his life and career, before describing in detail the creation of *A Sunday Afternoon on the Grande Jatte* and subsequent interpretations of its iconography, symbolism, and meaning. Concludes that the painting reflects Seurat's own isolated, meditative character rather than any political stance.

795. GEFFROY, GUSTAVE. "Chéret" in *La Vie artistique, deuxième série* (Paris: Dentu, 1893).

796. "Georges Seurat." *Emporium* (Bergamo) (July 1950):7-10.

797. GILL, IAIN DICKSON. "Composing the Picture: Seurat's *Une Baignade, Asnières*, 1883-84." *Artist* 102:11(Nov. 1987):36-7. 2 illus., 1 col.

Analyzes the painting's composition for its implied third dimension, quotes contemporary criticism of Seurat, and shows how Seurat developed his unique color system.

798. GILLE, PHILIPPE. "Revue bibliographique." *Le Figaro* (26 Jan. 1881).

Mention of Ogden N. Rood's *Théorie scientifique des couleurs* (1881) in a book review, that perhaps motivated Seurat to purchase a copy shortly thereafter.

799. GOLDWATER, ROBERT JOHN. "Some Aspects of the Development of Seurat's Style." *Art Bulletin* 23:2(June 1941):117-31. For a response by H. Hope, see *Art Bulletin* (March 1943):79.

Influential essay on Seurat's stylistic development.

800. GOLDWATER, ROBERT JOHN. "L'Affiche moderne; a Revival of Poster Art after 1880." *Gazette des Beaux-arts* (Dec. 1942):173-82.

801. GOULD, CECIL HILTON MONK. "Seurat's *Bathers, Asnières* and the Crisis of Impressionism." *Painting in Focus* (National Gallery, London) 6 (1976).

802. "The *Grande Jatte* at 100." *The Art Institute of Chicago Musem Studies* 14:2(1989).

Special issue commemorating the 100th anniversary of Seurat's *Sunday at the Grande Jatte*.

803. GREAVES, L. "Georges Seurat — *Une Baignade, Asnières*." *Royal Society Arts Journal* (London) (2 Aug. 1946):565-6.

804. GREENWOOD, MICHAEL. "A Gentle Olympian: Pierre Puvis de Chavannes." *Artscanada* 34:216-7(Oct.-Nov. 1977):21-34. 22 illus.

Study of Puvis de Chavannes's career that mentions his influence on Seurat and other contemporary artists.

805. GRIGORE, VASILE. "Constantin Blendea: rigoare si sentiment." *Arta* (Romania) 36:3(1989):24-6. 10 illus., 7 col.

Analyzes the relationship between the disciplined form and energy of Blendea's paintings, citing parallels in the work of Seurat.

806. GROWE, BERND. "Eine Wiedergefundene Zeichnung von Georges Pierre Seurat." *Pantheon* 42:3(July/Sept. 1984):265-6.

807. HALPERIN, JOAN UNGERSMA. "Scientific Critisism and le beau moderne of the Age of Science." *Art Criticism* 1:1(Spring 1979):55-71.

Describes critic Félix Fénéon's encounter with Seurat in the spring of 1886 at the eighth and last group show of the Impressionists, and his reaction to *La Grande Jatte*.

808. HAMLIN, LOUISE. "Yvonne Jacquette." *Arts Magazine* 57:1(Sept. 1982):26. 1 illus.

Review of an exhibition of oil paintings and works on paper by Yvonne Jacquette at the Brooke Alexander Gallery, New York (13 April-8 May 1982) that traces a divisionist influence traced to Seurat.

809. "Hans Haacke Repeats Himself." *Domus* 566(Jan. 1977):51. 3 illus. In English and Italian.

Description of Haacke's *Seurat: Les Poseuses (small version) 1888-1975*, consisting of a color reproduction of Seurat's painting accompanied by 14 equally sized panels.

810. HASKELL, FRANCIS. "The Sad Clown" in *French Nineteenth Century Painting and Literature*, ed. by Ulrich Finke (Manchester: Manchester University Press, 1972):2-16.

811. HAYAMI, AKIRA. "Chuushoo: Atarashii Kaigani Mukatte–1910-20 No Kaiga-Ten" [Abstraction: Towards New Painting During 1910-20 Exhibition]. *Mizue* 904(July 1980):78-9. 4 illus.

Mentions Seurat's naturalistic realism contributions to the history of painting since the late 19th century.

812. HEFTING, PAUL H. "Figuurstudie, Georges Seurat, 1859-1891." *Vereniging Rembrant Verslag* (1975):50-1.

813. HELION, JEAN. "Seurat as a Predecessor." *Burlington Magazine* 69:400(July 1936):4, 8-14. Also printed in *The League* 8:4(April 1937):10-19.

814. HELION, JEAN. "Poussin, Seurat et le double rhythme." *Axis* (London) (Summer 1936):9-17. Reprinted in English translation as "Poussin, Seurat and Double Rhythm" in *The Painter's Object*, ed. by M. Evans (London, 1937):94-107.

815. HENNING, EDWARD B. "Two New Paintings in the Neo-Plastic Tradition." *Bulletin of the Cleveland Museum of Art* 62:4(April 1975):106-19. 18 illus.

Biographical accounts of Burgoyne Diller and Leon Polk Smith with detailed discussion of their work, including Seurat's influence on Diller.

816. "Henri Rousseau and Modernism" in *Henri Rousseau* (Paris: Grand Palais, 1984):35-89.
Considers Rousseau in the context of his contemporaries, comparing him especially to Gauguin and Seurat.

817. HERBERT, ROBERT L. "Seurat in Chicago and New York." *Burlington Magazine* 100:662(May 1958):146-55.

818. HERBERT, ROBERT L. "Seurat and Jules Chéret." *Art Bulletin* 40:2(June 1958):156-62. Reprinted in *Seurat in Perspective,* ed. By Norma Broude. (Englewood Cliffs, NJ: Prentice-Hall, 1978):111-5.

819. HERBERT, ROBERT L. "Seurat and Puvis de Chavannes." *Yale University Art Gallery Bulletin* 25:2(Oct. 1959):22-9.

820. HERBERT, ROBERT L. "Seurat and Emile Verhaeren: Unpublished Letters." *Gazette des Beaux-arts* ser. 6, 54:1091(Dec. 1959):315-28.

821. HERBERT, ROBERT L. "A Rediscovered Drawing for Seurat's *Baignade*."
Burlington Magazine 102:689(Aug. 1960):368-70.

822. HERBERT, ROBERT L. "A Newly Discovered Drawing for Seurat's *Baignade*."
Yale Art Gallery Bulletin 27(April 1962):36-42.

823. HERBERT, ROBERT L. "Seurat's Theories" in *The Neo-Impressionists*, ed. by Jean
Sutter (Greenwich, CT: New York Graphic Society, 1970):23-46.

824. HERBERT, ROBERT L. "*Parade de Cirque* de Seurat et l'esthétique scientifique de
Charles Henry." *Revue de l'art* 50(1980):9-23. 21 illus.

Focuses on *Cirque parade* (1887-88) since its exhibition at the Salon des Indépendants of
1888, the least studied of Seurat's paintings. Details the influence of Charles Henry and
Humbert de Superville on Seurat's color and aesthetic theories.

825. HERBERT, ROBERT L. "Seurat: A Lifetime of Light." *ARTnews* 90(Nov.
1991):114-19. 7 illus., 3 col.

Challenges the popular notion that Seurat's canvases are fragile and that he produced a
limited output by claiming that 6 large canvases, 60 smaller ones, 170 panels, 230 completed
drawings, 45 fragmentary drawings, and an additional 250 drawings from his youth all
survive. While he challenged Impressionism, Seurat was not, Herbert concludes, a complete
radical, but was conservative in many ways.

826. HERZ-FISCHLER, ROGER. "An Examination of Claims Concerning Seurat and 'The
Golden Number'." *Gazette des Beaux-arts* ser. 6, 101:1370(March 1983):109-12. Summary
in French.

Although several critics maintain that Seurat made use of the "Golden Number," Herz-
Fischler maintains that this is not born out by an examination of written sources, nor is there
evidence for it in Seurat's writings or paintings.

827. HINES, JACK. "Creative Process: Seurat to Remington." *Southwest/Art* 21(March
1992):34-5.

828. HOLLOWAY, R. ROSS. "Seurat's Copies after Antique Sculpture." *Burlington
Magazine* 105:723(June 1963):284.

829. HOMER, WILLIAM INNES. "Seurat's *Port-en-Bessin*." *Minneapolis Institute of Arts
Bulletin* 2(Summer 1957):17-41.

830. HOMER, WILLIAM INNES. "Seurat's Formative Period—1880-1884." *The
Connoisseur* (London) 142:571(Sept. 1958):58-62.

831. HOMER, WILLIAM INNES. "Notes on Seurat's Palette." *Burlington Magazine*
101:674(May 1959):192-3.

832. HOMER, WILLIAM INNES. "Further Remarks on Seurat's *Port-en-Bessin*."
Minneapolis Institute of Art Bulletin (Oct.-Dec. 1959):12-5.

833. HOMER, WILLIAM INNES. "Concerning Muybridge, Marey and Seurat." *Burlington Magazine* ser. 6, 104:714(Sept. 1962):391-2.

834. HOUSE, JOHN. "Meaning in Seurat's Figure Paintings." *Art History* 3:3(Sept. 1980):345-56. 10 illus.

Detailed discussion of each of Seurat's seven finished figure paintings, with special attention to the *Une Baignade* and the *Grande Jatte* (both painted in 1884). Presents sources and ideologies that suggest that the basic concerns in these figure paintings are the contrasts between the natural and the synthetic and the artificiality of modern society.

835. HOUSE, JOHN. "Reading the *Grande Jatte.*" *The Art Institute of Chicago Museum Studies* 14:2(1989):115-31, 240-1. 16 illus.

A Sunday Afternoon on the Grande Jatte has been recognized as a manifesto painting by artists and critics alike since its first public showing in 1886. House examines various interpretations and advances the theory that the painting avoids conventional iconography and symbolism.

836. HOUSSAYE, HENRY. "Le Salon de 1882, I: la grande peinture et les grands tableaux." *Revue des deux mondes*, ser. 3, 51(1 June 1882):561-86.

837. HUGHART, DOROTHY. "In the Park." *Shuttle, Spindle and Dyepot* 20(Fall 1989):22-3.

838. HUYGHE, RENE. "*Trois poseuses* de Seurat." *Bulletin des musées de France* 12:7(Aug. 1947):7-14.

839. HUYSMANS, JORIS-KARL. "Chéret" in *Certains* (Paris: Tresse et Stock, 1889). Reprinted in *L'Art moderne/certains* (Paris: Union Générale d'Editions, 1975):313-20.

840. ISAACSON, JOEL. "Impressionism and Journalistic Illustration." *Arts Magazine* (June 1982):95-115.

841. JAMOT, PAUL. "Artistes contemporains: Ernest Laurent." *Gazette des Beaux-arts* ser. 4, 50(March 1992):173-203.

842. JAMOT, PAUL. "Une étude pour le *Dimanche à la Grande Jatte* de Georges Seurat." *Bulletin des musées de France* 2:3(March 1930):49-52.

843. JENSEN, JOYCE K. and SHARON L. CALHOON. "A Grand New IMA." *Arts Indiana* 12:7(Oct. 1990):21-7. 12 illus.

In anticipation of the re-opening of the Indianapolis Museum of Art, the authors highlight the building's renovations and collections, including works by Seurat.

844. JIRAT-WASIUTYNSKI, THEA. "Tonal Drawing and the Use of Charcoal in Nineteenth-Century France." *Drawing* 11:6(1990):121-4.

845. JIRAT-WASIUTYNSKI, VOJTECH and THEA JIRAT-WASIUTYNSKI. "The Uses

of Charcoal in Drawing." *Arts Magazine* (1980):128-35.

846. JOHNSON, ROBERT FLYNN. "Forum: Edwin Dickinson's *Long Point Light*." *Drawing* 8:5(Jan.-Feb. 1987):107-8. 1 illus.

Compares Dickinson's *Long Point Light* drawing (1937) to Seurat's evocation of the spirit of a place.

847. KAENEL, PHILIPPE. "Affiche et électricité: entre beaux-arts et publicité" in *Autour de l'électricité. Un siècle d'affiche et de design*, by Jacques Monnier-Raball, Philippe Kaenel, and Giorgio Fonio (Lausanne: Editions de La Tour, 1990):60-139.

848. KAHN, GUSTAVE. "Georges Seurat." *L'Art moderne* (Brussels) 11:14(5 April 1891):107-10.

Tribute and obituary. Reprinted in *Vallotton et autres* (Paris, 1895).

849. KAHN, GUSTAVE. "Au temps du pointillisme." *Mercure de France* 171:691(1 April 1924):5-23.

Important text that relates Seurat and the Neo-Impressionists to Symbolism by supportive critic and personal friend.

850. KAHNWEILER, DANIEL HENRY. "La Place de Georges Seurat." *Critique* 2(Jan.-Feb. 1947):54-9.

Reprinted in *Confessions esthétiques* (Paris: Gallimard, 1963):180-90.

851. KATZ, LESLIE. "Seurat: Allegory and Image." *Arts* 32(April 1958):40-7.

Observations on Seurat's late paintings.

852. KEMP, WOLFGANG. "Seurats Rahmen und Rahmenfiguren" in *Der Anteil des Betrachters Rezeptionsästhetische Studien zur Malerei des 19 Jahrhunderts* (Munich: Mäander, 1983):86+(Chapter 5).

853. KENDALL, RICHARD. "Highlights and Shadows." *Apollo* 133(June 1991):420-1.

854. KIMBALL, ROGER. "Seurat's Enduring Champion." *Art and Antiques* 18(March 1995):117-8.

855. KLEPAC, LOU. "Giorgio Morandi." *Art and Australia* 16:4(June 1979):349.

Describes Morandi's career and influences, including Cézanne, Rousseau, and Seurat.

856. KOCH, ROBERT. "The Poster Movement and Art nouveau." *Gazette des Beaux-arts* (Nov. 1956):285-96.

857. KRAMER, HILTON. "Critic's Notebook: Seurat's Last Landscapes." *Art and Antiques* 8(Jan. 1991):83-4.

858. KRAMER, HILTON. "Seurat in Paris." *New Criterion* 9:10(June 1991):4-8.

Re-evaluation of Seurat's work on the occasion of the opening of a centenary exhibition of Seurat's work at the Grand Palais, Paris. Encourages a new aesthetic-based approach and fresh consideration of his entire œuvre, including the often neglected landscape paintings and drawings.

859. KRAMER, HILTON. "Seurat, One Hundred Years Later." *New Criterion* 9(June 1991):4-8.

860. LANDOLT, HANS PETER. "Die Sammlug Robert von Hirsch: Gemalde und Zeichnungen." *Du* 8:447(May 1978):40-73. 35 illus.

Examines the collection and collecting criteria of Robert von Hirsch, including drawings by Seurat.

861. LANGAARD, JOHN H. "Georges Seurat." *Kunst og Kultur* (Oslo) 9(1921):32-41.

862. LAUDE, JEAN. "Le Monde du cirque et ses jeux." *Revue d'esthétique* 4(1953):411-33.

863. LEARY, R. H. "Japanese and French Paintings in the Bridgestone Museum of Art." *Arts of Asia* 3:4(July-Aug. 1973):32-40. 29 illus.

The Bridgestone Museum of Art, Tokyo, is the private collection of Shojiro Ishibashi, founder of the Bridgestone Tire Company. Bridgestone's European paintings include many from K. Matsukata's collection, amassed in Paris between the wars. Many European masters are represented, including works by Seurat.

864. LEBENSZTÉJN, JEAN-CLAUDE. "Esquisse d'une typologie." *Revue de l'art* 26(1974):46-56. 16 illus. Summary in English.

Mention of Seurat in this philosophical article regarding the interrelation between symbol and icon.

865. LEBENSZTÉJN, JEAN-CLAUDE. "*Chahut*: le lieu, la danse." *Critique* 490(March 1988):236-51.

866. LEBOVICI, ELISABETH. "Achever la peinture." *Cahiers du Musée National d'art moderne* 40(Summer 1992):12-35. 15 illus.

Discusses the relationship between time and painting and the issue of completion with particular reference to the works of On Kawara. Includes a passing reference to Seurat.

867. LEE, ALAN. "Seurat and Science." *Art History* 10:2(June 1987):203-26. 1 illus.

Reinterprets Seurat's understanding of scientific color theories of Chevreul and Rood, claiming that Seurat's method and Fénéon's criticism are more value- and aesthetic-based than scientific.

868. LEE, ELLEN WARDWELL. "Seurat Centenary." *Art Journal* 51(Summer 1992):104-5[+].

869. LE MEN, SEGOLENE. "French Circus Posters." *Print Quarterly* 8:4(1991):363-87.

870. LE MEN, SEGOLENE. "L'Art de l'affiche à l'Exposition universelle de 1889." *Bulletin de la Bibliothèque nationale* (June 1991):64-71.

871. LE PAUL, CHARLES-GUY. "Maurice Denis: l'inspiration et la vision bretonnes." *L'Oeil* 288-89(July-Aug. 1979):38-43. 7 illus.

Discusses the life and work of Maurice Denis (1870-1943), emphasizing his primacy as a Breton artist and contemporary of Gauguin, Seurat, Bonnard and Vuillard.

872. LEVY, LOUIS. "Daumier, le japonisme et la nouvelle peinture." *Gazette des Beaux-arts* 103:1382(March 1984):103-10. 5 illus. Summary in English.

Details Daumier's role in depicting modern life through lithographs and his influence on Impressionism and Seurat.

873. LEVY-GUTMANN, ANNY. "Seurat et ses amis." *Art et décoration* 63(1934):36-7.

874. LHOTE, ANDRE. "Seurat." *Formes de couleurs* (Lausanne) (1948):6-7.

875. LHOTE, ANDRE. "Seurat" in *La Peinture libérée* (Paris: Grasset, 1956).

876. LONGHI, ROBERTO. "Un Disegno per la *Grande Jatte* et la cultura formale di Seurat." *Paragone* (Florence) 1:1(Jan. 1950):40-3.

877. LOUGHERY, JOHN. "Minor Masters, Neglected Giants." *Hudson Review* 45(Summer 1992):287-92.

878. LYNN, E. "Henry Moore, Francis Bacon and Bridget Riley." *Art and Australia* 14:3-4(Jan.-June 1977):302-7. 5 illus.

Refers to Seurat's influence on the Australian painter Bridget Riley.

879. MABILLE, PIERRE. "Dessins inédits de Seurat." *Minotaure* 3:11(15 May 1938):3-9.

880. MACANDREW, HUGH. and KEITH ANDREWS. "A Saenredam and a Seurat for Edinburgh." *Burlington Magazine* 134:957(Dec. 1982):752-5.

Highlights Seurat's *conté* crayon on paper drawing, *Seated Nude Boy* (1884), the final study of the central figure in the painting *Bathers, Asnières*.

881. MACKWORTH, CECILY. "Montparnasse and 18 Villa Seurat." *Twentieth Century Literature* 33(Fall 1987):274-9.

882. MAINDRON, ERNEST. "Les Affiches illustrées." *Gazette des Beaux-arts* (Nov. 1884):419-33; (Dec. 1884):535-47.

883. MAKAROVA, A. "Mir Trevog I Nadezhdy: O Polotnakh Milenko Stanchicha" [World of Anxiety and Hope: On the Canvases of Milenko Stancic]. *Iskusstov* 11(1982):45-8. 9 illus.

Analysis of the paintings of Croatian artist Miljenko Stancic (1926-77) that draws stylistic similarities with Seurat.

884. MANSON, JAMES BOLIVAR. "*La Baignade.*" *Apollo* 1:5(May 1925):299-300.

Early description and critical analysis of Seurat's *La Baignade* (1884), owned by the Tate Gallery, London.

885. MARLAIS, MICHAEL ANDREW. "Seurat et ses amis de l'Ecole des Beaux-arts." *Gazette des Beaux-arts* ser. 6, 114:1449(Oct. 1989):153-68. 17 illus.

Examines the relationship between Seurat and fellow students at the l'Ecole des Beaux-arts in Paris, including Edmond Aman-Jean and Alexandre Séon, all of whom were influenced by Puvis de Chavannes, whose work was constructed on the golden section and enjoyed great success in Salon circles. Seurat's concern with exactitude and proportion suggests that he may have worked in Puvis' studio. Marlais attempts to clarify the nature of the mathematical structures in Seurat's paintings.

886. MARQUIS, JEAN-MARIE. "La Collection Berggruen: le classicisme de l'art moderne." *Musées de Genève* 287(July-Aug. 1988):2-7. 6 illus.

Survey of the range of works in the collection of Heinz Berggruen, including works by Seurat.

887. MARUSSI, GARIBALDO. "Seurat e il divisionismo." *Arti* 7(1963):11-22.

888. MASHECK, JOSEPH. "Pictures of Art." *Artforum* 17:8(May 1979):26-37. 34 illus.

Studies the use of the rectangle as a motif in modern abstractionism and fundamental organizing principle in western art with a reference to Seurat.

889. MAUS, OCTAVE. "Les Vingtistes parisiens." *L'Art moderne* 6(27 June 1886):201-4.

Laudatory article on Neo-Impressionism that proclaimed Seurat "the Messiah of a new art."

890. MAYNARD, PATRICK. "Martin Kemp, *The Science of Art: Optical Themes in Western Art from Brunelleschi to Seurat*; Erwin Panofsky, *Perspective as Symbolic Form.*" *Journal of Aesthetics and Art Criticism* 52:2(Spring 1994):243.

Book reviews.

891. MCMULLEN, ROY. "*Sunday Afternoon on the Island of La Grande Jatte.*" *Horizon* 13:3(1971):82-95.

Examines Seurat's famous painting in term of the reactions of contemporaries, who thought it humorous, and in today's terms as a statement of human loneliness.

892. MEISSNER, TONI. "Wo das Fleisch faul sein darf." *Pan* 8(1988):26-37. 15 illus., 14 col.
Examines the theme of bathing in the arts; examples cited include works by Seurat.

893. MENNA, F. "Quella domenica, alla *Grande Jatte*." *Qui arte contemporanea* 13(May 1974):24-32. 9 illus.

Defines the "Criticist" character of much of modern art in its analytical and linguistic role, as exemplified in Seurat's painting *La Grande Jatte*.

894. "Der Mensch atmet durch." *Pan* 1:supp.(1992):30-3. 4 col. illus.

Describes the discovery of the weekend excursion by the Parisian bourgeoisie as recorded in the paintings of Seurat, Sisley, Monet, and other Impressionists.

895. MILLER, ARTHUR I. "Aesthetics, Representation and Creativity in Art and Science." *Leonardo* 28:3(1995):185-92. 13 illus.

Examines the relationship between art and science and argues that the two disciplines are linked in their attempts to represent the natural world. Examples cited include works by Seurat.

896. MINKOWSKA, FRANÇOISE. "De van Gogh et de Seurat aux dessins d'enfants." *Revue de l'esthétique* 2(April-June 1949):207-9.

897. MOLNAR, SANDOR. "A logika es a metafizika kettos vilagossaga: gondolatok a parizsi Seurat-kiallitas kapcsan" [The Double Light of Logic and Metaphysics: Reflections on the Seurat Exhibition in Paris]. *Uj Muveszet* (Hungary) 3:3(March 1992):36-41. 4 col. illus.

Reports on an exhibition of paintings and drawings by Seurat at the Grand Palais, Paris (9 April-12 Aug. 1991). Provides biographical details as well as an account of Seurat's evolution as an artist and the most important influences on a style with strong geometrical elements, including Leonardo da Vinci, Piero della Francesca, Uccello, Vermeer, and Cézanne.

898. MONKLAND, G. "Samuel Courtauld." *Pictures and Prints* 133(Summer 1975):5-8. 3 illus.

Account of Courtauld's patronage of the arts as reflected in the Courtauld Institute of Art's masterpieces, including works by Seurat, donated to the National and Tate Galleries.

899. MOORE, PAUL. "Marie Gelinas: la petite histoire en images." *Magazin'Art* 7:2(Winter 1994-95):68-70, 104. 5 col. illus. Summary in English.

Examines the work of the Canadian painter Marie Gelinas, who began painting at the age of 74. Compares her art to that of Monet and Seurat.

900. MORIN, LOUIS. "Jules Chéret." *L'Artiste* (Jan. 1894).

901. NAEF, HANS. "Zur zeichnerischen kunst von Seurat." *Du* 12(1948):39-42.

902. NANTEUIL, LUC DE. "Seurat: une certaine révolution." *Connaissance des arts* 470(April 1991):36-43. 8 col. illus.

Appraisal of the exhibition of the works of Seurat held at the Grand Palais, Paris (Spring 1991), the first time that his works were brought together from private collections worldwide.

903. NATANSON, THADEE. "Un primitif d'aujourd'hui, Georges Seurat." *La Revue blanche* 21(15 April 1900):609-14.

904. NEVE, CHRISTOPHER. "The Poetry Takes Care of Itself: Seurat Paintings and Drawings." *Country Life* 164:4248(7 Dec. 1978):1964-5. 5 illus.

Examines a small exhibition of 9 paintings and 15 drawings by Seurat. Many of the works were part of his preparation for his seven major set pieces but others exist in their own right.

905. NEVE, CHRISTOPHER. "Vision and Inner Vision: Cross-Currents in Post-Impressionism." *Country Life* 166:4300(6 Dec. 1979):2158-9. 4 illus.

Comments on the Royal Academy's exhibition of post-impressionist paintings, which included works by Seurat.

906. NEWMAN, T. "French Painting and the Circus." *Antique Dealer and Collector's Guide* (Nov. 1976):80-3. 9 illus.

Traces the history of circuses from Philip Astley's at the end of the 18th century with particular reference to French developments and their presentation in the visual arts. Artists whose work is discussed include Seurat.

907. NEWMARCH, ANTHONY. "Seurat." *Apollo* 32(July 1940):11-2.

908. NICOLSON, BENEDICT. "Seurat's *La Baignade.*" *Burlington Magazine* 79:463(Nov. 1941):138-46.

909. NIEHAUS, KASPER. "Georges Seurat" in *Elsvier's Geillustred Maandschrift* (Amsterdam) 79:5(Jan.-June 1930):297-312.

910. NOCHLIN, LINDA. "How Feminism in the Arts can Implement Cultural Change." *Arts in Society* 11:1(Spring-Summer 1974):80-9. 6 illus.

Article on Feminist art criticism that mentions Seurat's color scheme.

911. NOCHLIN, LINDA. "Seurat's *Grande Jatte*: An Anti-Utopian Allegory." *The Art Institute of Chicago Museum Studies* 14:2(1989):133-53, 241-2. 26 illus.

Interprets Seurat's *A Sunday Afternoon on the Grande Jatte* as an anti-utopian allegory.

a. Reprint: *The Politics of Vision: Essays on Nineteenth-Century Art and Society.* (NY:

Harper & Row, 1989).

912. NOCHLIN, LINDA. "Body Politics: Seurat's *Poseuses*." *Art in America* 82:3(March 1994):70-7, 121, 123. 8 illus., 6 col.

Explains that in his two versions of the *Poseuses*, the large one in the Barnes Collection (1886-88) and the smaller one in the Berggruen Collection (1888), Seurat rejected the traditional notion of the female nude as timeless and quintessentially natural. Instead, he presented the three models as nothing more or less than what they were — contemporary urban working women. Adapted from a 1991 lecture delivered at New York's Metropolitan Museum of Art.

913. NOURRIAUD, NICOLAS. "Seurat en pointillé." *Beaux arts magazine* 89(April 1991):54-65. 25 illus., 18 col.

With reference to an exhibition at the Grand Palais, Paris, Nourriaud considers Seurat's rightful place in art history.

914. OCHSE, MADELEINE. "Georges Seurat (1859-1891) ou la folie de la certitude." *Jardin des arts* (1972):56-60.

915. O'DONOVAN, LEO J. "Georges Seurat: 'There is Genius!'" *America* 165:15(16 Nov. 1991):366-368.

916. ORTON, FRED and GRISELDA POLLOCK. "Les Données bretonnantes: la prairie de representation." *Art History* 3:3(Sept. 1980):314-44. 8 illus. In English.

Objects to the term "Post-Impressionism," arguing that it is part of a strategy to classify and contain diverse and complex practices and discussing its use in art historical writings.

917. ORAMAS, LUIS PEREZ. "Seurat: The Winds Moan in Secret." *Art Nexus* 3(Jan. 1992):129-31, 205-7. 3 illus., 1 col. In English and Spanish.

Discusses Seurat's three masterworks — *Une Baignade à Asnières*, *La Grande Jatte*, and *Les Poseuses* — and the impact of Seurat's pointillist technique.

918. O'TOOLE, J. HANSON. "Henri-Gabriel Ibels and Georges Seurat: An Attribution Confirmed." *Bulletin of the Cleveland Museum of Art* 69:7(Sept. 1982):236-43. 11 illus.

Discusses a charcoal drawing *The Circus* (c. 1892) attributed to Seurat. O'Toole suggests that it ought to be attributed to Henri-Gabriel Ibels (1867-1936), who made a color lithograph with the same title in which three figures are identical to figures in the drawing. Speculates on the possible connection between Seurat and Ibels and describes similarities in style.

919. OZENFANT, AMEDEE. "Seurat." *Cahiers d'art* 1(Sept. 1926):171-3.

920. PACH, WALTER. "Georges Seurat." *The Arts* 3:5(March 1923):161-74. Reprinted in Pach's *Georges Seurat* (New York: Duffield, 1923).

921. PACHECO, PATRICK. "Point Counterpoint." *Art and Antiques* (Oct. 1991):70-5. 10 illus., 8 col.

Five contemporary artists discuss the relevance of Seurat's work to art today: Catherine Murphy (b. 1946), Chuck Close (b. 1940), Richard Pousette-Dart (b. 1916), Will Barnet (b. 1911), and George Tooker (b. 1920).

922. PACINI, PIERO. "Percorso Prefuturista di Gino Severini, 5." *Critica D'Arte* 43:157-9(1978):177-94. 30 illus.

Final part of a survey of Severini's works before he turned to Futurism in 1910, dealing with his portraits, landscapes, and graphic works executed in Paris and Civray between 1907 and 1909. Stresses the influence of Seurat and van Gogh, whose paintings were on display at this time in important retrospectives.

923. PALMER, FREDERICK. "Oil Painting Techniques: Painting with Optical Mixtures." *The Artist* 103(Nov. 1988):17-9.

924. PARINAUD, ANDRE. "Ici commence l'art moderne." *Galerie-jardin des arts* 139(July-Aug. 1974):67-82. 19 illus.

Examination of 19 color illustrations with explanatory captions that traces the development of late 19th-early 20th century painting to indicate the importance of Impressionism in this development, including a work by Seurat.

925. PARKER, ROBERT ALLERTON. "The Drawings of Georges Seurat." *International Studio* (Sept. 1928):17-23.

926. PEARSON, ELEANOR. "Seurat's *Le Cirque*." *Marsyas* 19(1977-78):45-51. 4 illus.

927. PERL, JED. "After Monet." *Modern Painters* 6:1(Spring 1993):30-4. 6 illus., 5 col.

Reference to Seurat in this discussion of the changing assessment of Monet's works and Impressionism in general.

928. PFEIFER, NETTA. "Pat Skiba." *Southwest Art* 18:9(Feb. 1989):66-70. 5 col. illus.

Article on the artist Pat Skiba's soft-edged pointillism and debt to Seurat.

929. "Pointillism, with Paint and Camera: Pictures by Seurat and Neugass." *Design* (Columbus, Ohio) (March 1952):141.

930. POUND, FRANCIS. "Michael Shepherd." *Art New Zealand* 19(Autumn 1981):18-21, 60-1. 5 illus.

Notes Seurat's influence on this contemporary New Zealand artist.

931. PRAK, NIELS LUNING. "Seurat's Surface Pattern and Subject Matter." *Art Bulletin* 53:3(Sept. 1971):367-78.

932. PRAT, VERONICA. "Extrait du roman d'un collectionneur." *Connaissance des arts* (France) 358(Dec. 1981):102-7. 7 illus.

Brief insights into the life and activities of collector Jacques Dubourg, indicating the extent of his work as a dealer and exhibition organizer, and highlighting his collection, including works by Seurat.

933. PRENDEVILLE, BRENDA. "Cézanne, Seurat and the Building of Light." *Artscribe* 20(Nov. 1979):19-23. 8 illus.

Examines how Cézanne and Seurat used light in their work.

934. PYE, PATRICK. "The Emptiness of the Image: The Case of Seurat." *Studies* (Ireland) 81:321(1992):57-70.

Examines artistic and intellectual influences on Seurat, suggesting that his technique created "empty images" that permit the viewer to perceive them in a Christian context.

935. "Quelques esquisses et dessins de Georges Seurat." *Documents* (Sept. 1929):183-7.

936. RATCLIFF, CARTER. "Odd Men Out." *Art in America* 69:6(Summer 1981):102-10. 9 illus.

Mention of Seurat in a discussion of how artists have treated *commedia dell'arte* characters.

937. REWALD, JOHN. "Camille Pissarro and some of his Friends." *Gazette des Beaux-arts* ser. 6, 23(1943):363-76.

938. REWALD, JOHN. "Georges Seurat." *Burlington Magazine* (Sept. 1944):231-2.

Letter to the editor concerning Seurat.

939. REWALD, JOHN. "Félix Fénéon." *Gazette des Beaux-arts* ser. 6, 32(July-Aug. 1947):45-62; 33(Feb. 1948):107-26.

940. REWALD, JOHN. "Seurat." *Arts* (Paris) (17 Sept. 1948).

Includes extracts of Rewalds's book, *Seurat* (Paris: Editions Albin Michel, 1948).

941. REWALD, JOHN. "Seurat: The Meaning of the Dots." *ARTnews* 48:2(April 1949):24-7, 61-3.

Reprinted in Rewald's *Studies in Post-Impressionism* (NY: Harry N. Abrams, 1986).

942. REWALD, JOHN. "La Vie et l'œuvre de Georges Seurat" in *Seurat, l'œuvre peint* (Paris: Les Beaux Arts, 1959):xxxiii-lxxviii.

943. REWALD, JOHN and BARBARA ROSE (Interviewer). "In Cézanne Country with John Rewald." *Journal of Art* 3:1(Oct. 1990):26-8. 5 illus., 4 col.

Rewald discusses his research on Cézanne, the theoretical nature of French art history, his respect for the Symbolist writer Félix Fénéon who provided him with a personal link to Seurat, Fénéon's involvement with anarchism, his books on Impressionism and Post-Impressionism, and his recent book *Seurat: A Biography* (NY: Abrams; London: Thames and Hudson, 1990).

944. REY, ROBERT. "A propos du *Cirque* de Seurat au Musée du Louvre." *Beaux-arts* 4:6(15 March 1926):87-8.

945. RICH, DANIEL CATTON. "The Place of Seurat." *The Art Institute of Chicago Quarterly* 52(1 Feb. 1958):2-5.

946. RILEY, BRIDGET. "The Artist's Eye: Seurat." *Modern Painters* 4:2(Summer 1991):10-4. 7 illus., 6 col.

Reappraisal of Seurat's work with reference to the centennial exhibition at the Grand Palais, Paris in 1991.

947. RILEY, BRIDGET and JAMES ROBERTS (Interviewer). "Visual Fabric." *Frieze* 6(Sept.-Oct. 1992):20-3. 4 illus., 2 col.

Australian painter Bridget Riley discusses the color experiments of Seurat and contemporaries, among other topics.

948. RIOPELLE, CHRISTOPHER. "Renoir: The Great Bathers." *Philadelphia Museum of Art Bulletin* 86:367-8(Fall 1990):5-40. 43 illus, 12 col.

On the occasion of the exhibition *Renoir: The Great Bathers* at the Philadelphia Museum of Art, (9 Sept.-25 Nov. 1990), Riopelle examines and assesses this painting, drawing on related pictures and preparatory studies assembled. Discusses Renoir's opposition to the cold formalism of Seurat's pointillist style.

949. RITCHIE, ANDREW CARNDUFF. "*Le Chahut* Acquired by Albright." *Art Quarterly* 3(1943):228-9.

Concerns the acquisition of Seurat's *Le Chahut* (1889-90) by the Albright Art Gallery, Buffalo.

950. RITCHIE, ANDREW CARNDUFF. "An Important Seurat." *Gallery Notes, Albright Art Gallery, Buffalo* 10:1(May 1943):4-5.

Concerns the acquisition of Seurat's *Le Chahut*.

951. ROBERTSON, MARTIN. "Michelangelo and Seurat." *Burlington Magazine* (Nov. 1953):371.

Letter to the editor that compares Michelangelo's and Seurat's drawings.

952. ROGER-MARX, CLAUDE. "Georges Seurat." *Gazette des Beaux-arts* ser. 5, 16:782(Dec. 1927):311-8.

953. ROGER-MARX, CLAUDE. "Seurat" in *Maîtres du XIX^e et du XX^e* (Geneva: Pierre Cailler, 1954).

954. ROH, FRANZ. "Das geheimnis der Stille — Seurat als Zeichner." *Das Kunstwerk* 1-2(1956-57):7-8.

955. ROSENTHAL, DEBORAH and JED PERL. "Zone Painting." *Arts Magazine* 55:7(March 1981):160.

Describes "zone painting," showing how it can be used to approach artists as diverse as Poussin, Seurat, Kandinsky, Klée, Bonnard, Braque, Matisse, Léger, Torres-Garcia, and Picasso.

956. ROSENTHAL, LEON. "Ernest Laurent." *Art et décoration* 3(1911):6-76.

957. ROSSEN, SUSAN F. "The *Grande Jatte* at 100." *The Art Institute of Chicago Museum Studies* 14:2(1989):112-3, 240.

Preface to this special issue on *La Grande Jatte*.

958. ROUSSEAU, MICHEL. "De Cézanne et Seurat à l'art présent." *Musée vivant* 34(1948):1, 13-8.

959. RUBIN, JAMES H. "Seurat and Theory: The Near-Identical Drawings of the Café-concert." *Gazette des Beaux-arts* ser. 6, 76(Oct. 1970):237-46.

960. RUBIN, WILLIAM. "Shadows, Pantomimes and the Art of the Fin de Siècle." *American Magazine of Art* (March 1953):114-22.

961. RUSSELL, JOHN. "Seurat as Theorist and Investigator." *Apollo* 81(May 1965):413-5.

Review of William I. Homer's *Seurat and the Science of Painting* (Cambridge, MA: MIT Press, 1964).

962. RUSSELL, JOHN. "The *Grande Jatte* at 100." *The Art Institute of Chicago Museum Studies* 14:2(1989):238-9.

Epilogue to this special issue on *La Grande Jatte*.

963. SAKAGAMI, KEIHO. "L'Evolution de la touche de Seurat à travers ses marines." *Bulletin de la société franco-japonaise d'art et d'archéologie* 5(1985):18-33.

964. SALMON, ANDRE. "Georges Seurat." *Burlington Magazine* 37:210(Sept. 1920):115-22.

Text nearly identical to Salmon's *La Révélation de Seurat* (Brussels: Editions Sélection, 1921); also included in *Propos d'atelier* (Paris: G. Crès, 1922).

965. SALMON, ANDRE. "Die Offenbarung Seurats." *Das Kunstblatt* (22 Oct. 1922):

415-530.

German translation of a plaquette published in Brussels in 1921.

966. SALMON, ANDRE. "Seurat." *L'Art vivant* 37(15 July 1928):525-7.

967. SAURE, WOLFGANG. "Geometrie, Konstruktion, Harmonie." *Kunst* 2(1987):160-5. 9 col. illus.

Study of the work of Marcelle Cahn (1895-1981) which describes her paintings, drawings, and collages, and the influence of Seurat.

968. SCHAEFER, PATRICK. "Les Passions d'un homme de goût." *L'Oeil* 396-97(July-Aug. 1988):26-33. 13 illus., 6 col.

Mentions works by Seurat in the collection of Heinz Berggruen.

969. SCHAPIRO, MEYER. "Seurat and *La Grande Jatte*." *Columbia Review* 17:1(Nov. 1935):9-16.

Places Seurat's painting in its contemporary social context.

970. SCHAPIRO, MEYER. "Nature of Abstract Art." *Marxist Quarterly* (Jan.-March 1937):77-98.

971. SCHAPIRO, MEYER. "New Light on Seurat." *ARTnews* 57:2(April 1958):22-4, 44-5, 52.

Reprinted in *Modern Art, 19th and 20th Centuries. Selected Papers* (NY: George Braziller, 1978). French version in *Style, artiste et société* (Paris: Gallimard, 1982):361-82.

972. SCHAPIRO, MEYER. "Seurat: Reflections." *ARTnews Annual* 21(1964):18-41.

973. SCHARF, AARON. "Painting, Photography and the Image of Movement." *Burlington Magazine* 104(May 1962):186-95.

See also letters by William I. Homer and Scarf's response in *Burlington Magazine* (Sept. 1962):391-2.

974. SCHIFF, BENNETT. "Let's go get Drunk on the Light Once More." *Smithsonian* 22:7(1991):100-11.

Appreciation of Seurat's drawings, with reference to the 1990-91 retrospective held at the Metropolitan Museum of Art, New York and the Grand Palais, Paris.

975. SCHMIDT, F. "Georges Seurat." *Die Kunst* (Munich) (July 1949):141-2.

976. SCHMIDT, MARIANNE. "Die Kunst des entspannten Lebens." *Pan* 1 supp. (1992):14-8. 4 col. illus.

Describes the Impressionists' depiction of seascapes and idyllic scenes of urbanites enjoying the seaside, illustrated by paintings by Monet, Renoir, Degas, and Seurat.

977. SCHULTZE, JURGEN. "Das Bestimmte und das Unbestimmte: zu Redons Hell-Dunkel-Strukturen." *Niederdeutsche Beitrage zur Kunstgeschichte* 24(1985):201-8. 7 illus. Studies the drawings and lithographs of Odilon Redon, with reference to his characteristic contrast of light and dark, and compares it to Seurat.

978. SCHWARTZ, DELMORE. "Seurat's *Sunday Afternoon Along the Seine.*" *Art and Antiques* 15(Summer 1993):128.

979. "The Science of Seurat." *Time* (20 Jan. 1958):70-3.

980. SEMIN, DIDIER. "Note sur Seurat et le cadre." *Avant-guerre* 2(1981):53-9.

Focuses on Seurat's painted borders and frames.

981. SERULLAZ, MAURICE. "Ainsi est né l'impressionnisme." *Galerie jardin des arts* 139(July-Aug. 1974):26-33. 28 illus.

Discusses his introduction to *L'Encyclopédie de l'impressionnisme*, in which Serullaz traces the origins of Impressionism, finding the essential elements of eye, light, and outdoor scenes in unexpectedly early artists. Describes the intellectual approach of Seurat and Signac.

982. SEURAT, GEORGES PIERRE and FENEON, FELIX. "Notes inédites de Seurat sur Delacroix [1881]." *Bulletin de la vie artistique* 3:7(1 April 1922):154-8. Reprint: Caen: L'Echoppe, 1987. 21 p., 3 illus.

Texts by Seurat written in February and November 1881. Includes an introducion by Félix Fénéon.

983. SEURAT, GEORGES PIERRE. "*The Circus* (1890-91)." *The Artist* 107(April 1992):20.

984. SEURAT, GEORGES PIERRE. "*L'Echouage à Grandchamp* (1885)." *Apollo* 126(Dec. 1987):front page.

985. SEURAT, GEORGES PIERRE. "*Femme avec deux fillettes* (*conté* crayon, ca 1887)." *Connaissance des arts* 455(Jan. 1990):125.

986. SEURAT, GEORGES PIERRE. "*Garçonnet assis* (crayon and gouache)." *Connaissance des arts* 452(Oct. 1989):12.

987. SEURAT, GEORGES PIERRE. "*La Grande Jatte* (1884-86)." *Connoisseur* 214(July 1984):47.

988. SEURAT, GEORGES PIERRE. "Etude pour *La Grande Jatte.*" *Connoisseur* 215(April 1985):40.

989. SEURAT, GEORGES PIERRE. "*Sunday Afternoon on the Island of La Grande Jatte.*"

Landscape Architecture 77(Nov.-Dec. 1987):31. 78(Jan.-Feb. 1988):17.

990. SEURAT, GEORGES PIERRE. *"A Sunday Afternoon on the Island of La Grande Jatte* (1884)." *The Art Institute of Chicago Museum News* 71(Jan.-Feb. 1992):53.

991. SEURAT, GEORGES PIERRE. *"A Sunday Afternoon on the Island of La Grande Jatte* (1885)." *American Artist* 57(July 1993):12.

992. SEURAT, GEORGES PIERRE. *"Le Nœud noir (conté* crayon, ca 1882)." *Connaissance des arts* 467(Jan. 1991):70.

993. SEURAT, GEORGES PIERRE. *"Une Périssoire* (ca 1887)." *Burlington Magazine* 129(Nov. 1987):xxi.

994. SEURAT, GEORGES PIERRE. *"Les Poseuses."* *Connaissance des arts* 436(June 1988):48-9.

995. SEURAT, GEORGES PIERRE. *"Les Poseuses* (1886-88)." *Art and Antiques* 15(April 1993):43.

996. SEURAT, GEORGES PIERRE. *"La Seine à la Grande Jatte* (ca 1885)." *L'Oeil* 348-49(July-Aug. 1984):16.

997. "Seurat: 1859-1891." *Drawing* 13(July-Aug. 1991):37.

998. "Seurat for Buffalo." *Art Digest* (15 May 1943):5.

Concerns the acquisition of Seurat's *Le Chahut* (1889-90) by the Albright Art Gallery, Buffalo.

999. SIEBELHOFF, ROBERT. "Jan Toorop's Early Pointillist Paintings." *Oud Holland* 89:2(1975):86-97. 13 illus.

Examines the key influence that membership in Les XX in Brussels had on Toorop (1858-1928). Through annual exhibitions Toorop became acquainted with the work of van Gogh, Gauguin, Seurat, Signac, and the Belgian symbolists. Toorop's Neo-Impressionist period, from 1888-1891, is characterized by a pointillist technique.

1000. SIGNAC, PAUL. "Un Camarade impressionniste: impressionnistes et révolutionnaires." *La Révolte* 4(13-19 June 1891):3-4.

Tribute to Seurat, shortly after his death.

1001. SILVER, KENNETH ERIC. "Futurism on the Grand Canal." *Art in America* 74:10(Oct. 1986):114-25. 16 illus., 15 col.

Review of the inaugural show of Futurist art held in the newly renovated Palazzo Grassi, Venice. Seurat is seen as the most important artistic source for Futurism and Giacomo Balla's versions of Seurat's work as the highlight of the exhibition.

1002. SIMMONDS, R. "Introduction à l'œuvre gravé de Henry Moore." *Nouvelles de l'estampe* 32(March-April 1977):17-20. 4 illus.

Account of Moore's printmaking from early woodcuts and experiments with lithography after World War II to etchings after 1951. Describes influences on Moore, particularly that of Seurat.

1003. SIMPSON, IAN. "Seurat's *Gravelines*." *Artist* 98:8(Aug. 1983):16-7. 2 illus.

Study of Seurat's painting *Gravelines* in the Courtauld Collection, London, relating it to other works by Seurat and to his development of pointillism.

1004. SITWELL, OSBERT. "*Les Poseuses*." *Apollo* (June 1926):345.

1005. SKRAPITS, JOSEPH C. "Shades of Grey: The Drawings of Georges Seurat." *American Artist* 56:596(March 1992):44-9, 70-2. 7 illus.

Reflects on Seurat's career, the progression of his drawing style, his legacy, and discusses the logic of his pointillist technique.

1006. SLATIN, PETER. "The Greening of Seurat." *ARTnews* 91(Oct. 1992):17.

1007. SLAUGHTER, ANN MARIE. "Seurat Topiary Grows in Ohio." *Art in America* 80(Jan. 1992):27.

1008. SLEVOGT, ESTHER. "Georges Seurat: einst als Kleckser beschimpft, nun als Pionier der Moderne gefeiert." *Pan* 6(1991):18-29. 14 illus., 13 col.

Examines the life and work of Georges Seurat on the occasion of the centenary exhibition at the Grand Palais, Paris. Includes a brief glossary and biography as well as commentary on his contemporaries.

1009. SMITH, PAUL GERALD. "Seurat and the Port of Honfleur." *Burlington Magazine* ser. 6, 126:978(Sept. 1984):562-9.

Examines three seascapes by Seurat at the Port of Honfleur before 1887. Compares photographs of the port to Seurat's treatments.

1010. SMITH, PAUL GERALD. "Paul Adam, Soi et Les 'Peintres impressionnistes': la genèse d'un discours moderniste." *Revue de l'art* 82(1988):39-50. 11 illus.

Analyzes two texts by critic Paul Adam on Impressionsim and Neo-Impressionsim, specifically *Soi* (Paris: Tress & Stock, 1886) and "Les Peintres impressionnistes," *La Revue contemporaine* (May 1886):541-51.

1011. SMITH, PAUL GERALD. "Seurat: the Natural Scientist?" *Apollo* 132:346(Dec. 1990):381-5. 4 illus. 3 col.

Argues that the three paintings by Seurat in the Heinz Berggruen collection on loan to the National Gallery, London are evidence against the idea that Seurat's work was in a

scientific style.

1012. SMITH, PAUL GERALD. "Was Seurat's Art Wagnerian? And What If it Was?" *Apollo* 134:353(July 1991):21-8. 5 illus., 2 col.

Suggests that Seurat was familiar with and enthusiastic about Wagnerian aesthetics and that his late paintings conform consistently to ideas expressed in this theory. Stresses Seurat's association with the Wagnerian theorist Téodor de Wyzewa and finds evidence of quasi-musical harmony in *Le Cirque* (1890-91) and *La Parade* (1887-88).

1013. SMITH, PAUL GERALD. "Seurat et le paysage." *L'Estampille* 1(April-May 1991):30-5.

1014. SMITH, PAUL GERALD. "Missing the Point..." *Art History* 15:4(Dec. 1992):541-6.

Reviews six new books on Seurat, which fail to consider important ideological and aesthetic questions concerning his connection to idealism and symbolism. Seurat's scientific theories are not questioned and these works tend toward hagiography rather than analysis.

1015. STALLER, NATASHA. "Babel: Hermetic Languages, Universal Languages, and Anti-Languages in fin de siècle Parisian Culture." *Art Bulletin* 76(June 1994):331-54.

Contends that Seurat and other painters evoked linguistic themes that were also debated in official French culture.

1016. STEINER, WENDY. "Divide and Narrate: The Icon-Symbol in Seurat." *Word and Image* 2:4(Oct.-Dec. 1986):342-8. 5 illus.

States that Seurat's work was seminal in that his fragmentation enhanced pictorial representation by highlighting the opposition of iconic and symbolic representationality, and his divisionism leads towards narrative, as evident in *Les Poseuses* (1886-88).

1017. STILLSON, BLANCHE. "*Port of Gravelines* (Petit Fort-Philippe) by Georges Seurat." *Bulletin of the Art Association of Indianapolis, Indiana* (Oct. 1945):25-7.

1018. STUMPEL, JEROEN. "The *Grande Jatte*, that Patient Tapestry." Simiolus 14:3-4(1984):209-24. 7 illus.

Presents new ideas on Seurat's painting *Un Dimanche de l'été à l'Ile de la Grande Jatte* (1884-86), including how closely Seurat imitated tapestry weaving when he painted the picture.

1019. SUMMONS, ELIZABETH. "Eric Thake." *Art and Australia* 15:1(Sept. 1977):47-54. 11 illus.

Review of the life and work of Eric Thake occasioned by a retrospective exhibition held in 1976, illustrated by his painting *Seurat in Carlton* (1970).

1020. "*Sunday at the Grande Jatte*." *Life* (23 July 1951):60-4.

1021. SUTTON, DENYS. "The Master of the Independents." *Apollo* 83:47(Jan. 1966):76-7.

Reviews Roger Fry and Anthony Blunt's *Seurat* (London: Phaidon, 1965) and John Russell's *Seurat* (NY: Praeger; Oxford University Press, 1965).

1022. THAW, EUGENE VICTOR. "Courtauld the Collector." *New Criterion* 13:8(April 1995):74-6.

With reference to works in the exhibition *Impressionism for England: Samuel Courtauld as Patron and Collector at the Courtauld Institute Galleries in London* (17 June-25 Sept. 1994), Thaw explains the importance for art in Britain of Courtauld's patronage of the National Gallery and the University of London, and comments on the recent move of the Courtauld Institute's collection to Somerset House. Mentions works by Seurat in the Courtauld collection.

1023. THOMSON, RICHARD. "'Les Quat' Pattes: The Image of the Dog in Late Nineteenth-Century French Art." *Art History* 5:3(March 1982):323-37. 15 illus.

Examines several meanings of the image of the dog in late 19th century France painting, including canine symbolism in Seurat's *Dimanche après-midi à l'Ile de La Grande Jatte*.

1024. THOMSON, RICHARD. "The *Grande Jatte*: Notes on Drawing and Meaning." *The Art Institute of Chicago Museum Studies* 14:2(1989):180-97, 245-6. 28 illus.

Considers *A Sunday Afternoon on the Grande Jatte* in relation to the population of Paris at the time and to other works exhibited with it at the 1886 Salon, in order to gauge how consistent the painting was with avant-garde French painting of the time.

1025. THOMSON, RICHARD. "Rinsing out the Eyes: The Lingering Secrets in Seurat's Suburban Motifs." *Times Literary Supplement* 4597(10 May 1991):14.

1026. THOMSON, RICHARD. "Aclarando los ojos." *Kalias* 3:6(Oct. 1991):117-23. 8 col. illus. In Spanish.

With reference to an exhibition traveling from Paris to New York in 1991 to mark the centenary of the death of Seurat, Thomson traces the development of the painter's style from the oils of the 1870s to the circus scenes and seascapes of the 1880s. Analyzes Seurat's use of "suburban" motifs, with especial reference to his transformation of conventional genres such as the seascape into some of the most unusual paintings of the 19th century by employing the technique of pointillism.

1027. TINTEROW, GARY. "Miracle au Met." *Connaissance des arts* 472(June 1991):32-41. 10 col. illus.

Commentary on a bequest of 53 Impressionist and Post-Impressionist paintings made to the Metropolitan Museum of Art in New York by Walter Annenberg, including works by Seurat.

1028. TURR, KARINA. "Grenzen der Malerei." *Weltkunst* 57:11(1 June 1987):1529-35. 8 illus., 7 col.

Originally delivered as a lecture in January 1987, this article explores the use of color in the works of modern artists such as Kandinsky, Pollock, Barnett Newman, Mark Rothko, van Gogh, Turner, Marcel Duchamp and Robert Delaunay, with a passing reference to Seurat in her discussion of Jackson Pollock.

1029. TURR, KARINA. "Jenseits von Op Art? Uberlegungen zu Farbstreifen Bridget Rileys." *Pantheon* 44(1986):157-63.

Examines the work of Bridget Riley, who began her career as a painter in the late 1950s with copies of older works and Seurat-inspired landscapes.

1030. URRUTIA, ANTONIO. "Georges Seurat (1859-1891) o los discretos fundamentos de la modernidad." *Goyá* 223-24(July-Oct. 1991):92-5.

1031. VAN DE VELDE, HENRY. "Notes sur l'art: *Chahut.*" *La Wallonie* (Liège) 5(1890):122-5.

1032. VAN DE VELDE, HENRY. "Georges Seurat." *La Wallonie* (Liège) 6:3-4(April 1891):167-71.

Obituary and tribute to Seurat.

1033. VARGA, MIKLOS N. "L'Utopia moderna di Seurat." *Terzo Occhio* 17:3(Sept. 1991):23-6. 4 illus.

The centenary exhibition of the work of Seurat held at the Grand Palais in Paris in 1991 brought together paintings and drawings which illustrated all phases of his development. Briefly discusses several individual works shown at the exhibition and mentions some omissions.

1034. VARNEDOE, J. KIRK T. "Private Light: Hammershoei." *Art in America* 71:3(March 1983):110-7. 13 illus.

Discusses Danish painter Vilhelm Hammershoei's (1864-1916) career and œuvre, which shows the influence of Whistler and Seurat.

1035. VENTURI, LIONELLO. "The Art of Seurat." *Gazette des Beaux-arts* ser. 6, 26:934(July-Dec. 1944):421-30.

1036. VENTURI, LIONELLO. "Piero della Francesca—Seurat—Gris." *Diogenes* (Madison, Wisconsin) 2(Spring 1953):19-23.

1037. VERHAEREN, EMILE. "Georges Seurat." *La Société nouvelle* (Brussels) 7:1(April 1891):420-38. Revised version published in Verhaeren's *Sensations* (Paris: G. Crès, 1927).

Critical tribute and obituary of Seurat.

1038. VILMOUTH, JEAN-LUC. "'Matisse dessinait en touchant le genou de ses modèles': Un Entretien Avec Jean-Luc Vilmouth." *Macula* 5-6(Dec. 1979):249-66. 27 illus.

Mentions Seurat's influence on Vilmouth.

1039. VOLLICHARD, DOMINIQUE. "Georges Seurat et Paul Verlaine: l'ombre et la mélancolie." *L'Oeil* 430(May 1991):40-3. 4 illus.

Links Seurat to the poet Paul Verlaine (1844-96). Each *conté* crayon drawing by Seurat is accompanied by one of Verlaine's poems.

1040. "Un vrai Seurat perdu à Sainte-Anne trouvé aux Puces." *Paris-Match* (3 May 1958).

1041. WAGNER, GEOFFREY. "Art and the Circus." *Apollo* 82:42(Aug. 1965):134-6. 3 illus.

Mentions Seurat's *Le Cirque* (1890-91).

1042. WALLER, BRET. "Consider Carving Small Masterpieces out of a Monolith." *The Art Institute of Chicago Museum News* 70:3(May-June 1991):82-4. 1 illus.

Discusses the advantages of quality "minishows" with reference to a recent exhibition of paintings and six related studies by Seurat at the Indianapolis Museum of Art (1991).

1043. WALLWORTH, B. "Painting in Focus: *Une Baignade, Asnières* by Georges Pierre Seurat (1859-1891)." *Arts Review* 28:11(28 May 1976):267. 1 illus.

Analysis of Seurat's painting in the National Gallery, London.

1044. WALTER, FRANÇOIS. "Du paysage classique au surréalisme, Seurat." *Revue de l'art* 63(1933):165-76.

1045. WARD, MARY MARTHA. "The Rhetoric of Independence and Innovation" in *The New Painting, Impressionism 1874-1886*, ed. by Charles S. Moffett. (Geneva: Richard Burton; dist. in the U.S. by University of Washington Press, Seattle, 1986):41-2.

1046. WAUTERS, ALPHONSE-JULES. "Aux XX, Seurat, *La Grande Jatte*." *La Gazette* (Brussels) (28 Feb. 1887).

1047. WEBSTER, J. CARSON. "The Technique of Impressionism: A Reappraisal. *"College Art Journal"* 4:1 (Nov. 1944):3-22.

Examines in part Seurat's pointillist technique.

1048. WERNER, BRUNO F. "Georges Seurat." *Die Kunst* 65:3(Feb. 1932):147-51.

1049. WHELAN, RICHARD. "'Le Roi' Fénéon and the Neo-Impressionists." *Portfolio* 3:2(March-April 1981):46-55. 13 illus.

Charts the career and influence of critic Félix Fénéon (1861-1944), then a young war ministry clerk, who supported Seurat's pointillist painting *La Grande Jatte* when he showed it for the first time in 1886. Fénéon subsequently wrote the earliest critical study of this key work and established himself as the most perceptive and articulate critic and spokesman for

the Neo-Impressionists. His influence was long and extensive — from the 1880s to the 1920s — first as editor of important avant-garde magazines (*La Revue Indépendante*, *La Revue blanche*), then as an influential art dealer.

1050. WINTER, P. "Modellierung durch das Licht." *Weltkunst* 53:23(1983-84):3453-5.

Reviews Erich Franz and Bern Growe's *Georges Seurat: dessins* (Paris: Hermann, 1984).

1051. WOIMANT, FRANÇOISE and BRIGITTE BAER. "Donald Sultan." *Nouvelles de l'estampe* 88-9(Oct. 1986):21-31. 12 illus.

Summarizes recent French exhibitions of works by the American painter and engraver Donald Sultan (b. 1951). Mentions Sultan's creative debt to Seurat.

1052. WOOD, JOHN. "Autochrome." *American History Illustrated* 29:1(1994):54-63.

Outlines the autochrome color photographic process developed at the end of the 19th century by French inventors Auguste and Louis Lumière, and presents a portfolio of autochrome pictures and portraits by various artists. This first practical method of reproducing color photographically created images reminiscent of Impressionist painting, particularly Seurat's pointillist works.

1053. WYZEWA, TEODOR DE. "Georges Seurat." *L'Art dans les deux mondes* 22(18 April 1891):263-4.

Obituary and tribute. Reprinted in *Valton et autres* (Paris, 1895).

1054. "X-Rays Reveal 'Indiscreet' Self-Portrait of Seurat." *New York Times* (6 Feb. 1958).

1055. XURIGUER, G. "Yo Marchand or the Blazons of Memory." *Cimaise* 30:165(July-Sept. 1983):25-36. 12 illus. Also in French.

Traces the origins and artistic development of the painter Yo Marchand, who was initially drawn to Turner, van Gogh, Seurat, and Braque before being influenced by the work of Kandinsky and Alberto Burri.

1056. YARD, SALLY. "John Roy's Recent Paintings." *Arts Magazine* 56:6(Feb. 1982):150-1. 2 illus.

Account of Roy's artistic development since the late 1960s that mentions Seurat's influence in Roy's application of small marks of color.

1057. ZANETTI, PAOLA SERRA. "Tra uomini cupi e donnone sfasciate." *Arte* 22:232(Sept. 1992):48-53. 7 col. illus.

Discusses the career of William De Kooning (1904-96) from his early life in Amsterdam to success in New York and notes his attraction to Seurat, among other artists.

1058. ZERVOS, CHRISTIAN. "Un dimanche à *La Grande Jatte*, et la technique de Seurat." *Cahiers d'art* 3:9(1928):361-75.

1059. ZIMMERMANN, MICHAEL F. "Seurat und *La Grande Jatte*. Die neue Forschung. Zu einem Symposium in Art Institute of Chicago." *Kunstchronik* 41:2(1988):37-40.

1060. ZIMMERMANN, MICHAEL F. "Seurat, Charles Blanc, and Naturalist Art Criticism." *The Art Institute of Chicago Museum Studies* 14:2(1989):199-209, 246-7. 11 illus.

Studies French writer and art critic Charles Blanc's (1813-82) influence on Seurat, not only emphasizing Blanc's color theory and technique, but also examining the wider influence of Blanc's eclectic art theory on Seurat. *La Grande Jatte* (1884-85) is analyzed and presented as a synthesis of Seurat's early work.

1061. ZIMMERMANN, MICHAEL F. "Die 'Erfindung' Pieros und seine Wahlverwandtschaft mit Seurat." *Studies in the History of Art* 48(1995):268-301.

V. Selected Individual Exhibitions

Note: For comprehensive lists of individual exhibitions to 1959, see Henri Dorra and John Rewald's *Seurat: l'œuvre peint, biographie et catalogue critique* (Paris: Les Beaux-Arts, 1959) and César M. de Hauke's *Seurat et son œuvre* (Paris: Gründ, 1951-62, vol. 1).

1888, January-February	Paris, Bureaux de *La Revue indépendante, exposition de janvier* (cat. 159 et 165); *Exposition de février* (cat. 160).
1892, February	Brussels, Société des XX. *Exposition rétrospective Georges Seurat.*
1892	Paris, *La Revue blanche. Exposition posthume Seurat.*
1895, February-March	Paris, *Exposition de panneaux et dessins de Seurat.*
1900, March-April	Paris, *La Revue blanche. Georges Seurat.*
1905, March-April	Paris, Société des Artistes indépendants. *Exposition rétrospective* Seurat.
1908-09, 14 December-9 January	Paris, Galerie Bernheim-Jeune. *Exposition Georges Seurat.*
1920, January	Paris, Galerie Bernheim-Jeune. *Exposition Georges Seurat.* Préface de Paul Signac.
1922, October	Paris, Galerie Devambez. *Vingt dessins de Seurat.*
1924, 4-27 December	New York, Joseph Brummer Gallery, *Paintings and Drawings by Georges Seurat.* Preface by Walter Pach.
1926, April-May	London, Lefèvre Galleries, *Exhibition of Pictures and Drawings by Georges Seurat.*
1926, 29 November-24 December	Paris, Galerie Bernheim-Jeune. *Les Dessins de Seurat.* Préface par Lucie Cousturier.

1928	Berlin, Galerie Flechtheim. *Seurat.*
1929	New York, Knoedler Galleries. *'La Parade' by Georges Seurat, 1859-1891.* 4 p.
1935, February	Chicago, Renaissance Society, University of Chicago. *Twenty-Four Paintings and Drawings by Georges Pierre Seurat.*
1936, 3-29 February	Paris, Galerie Paul Rosenberg. *Seurat.*
1947, 4-29 March	New York, Buchholz Gallery. *Seurat, his Drawings.*
1949, 19 April-7 May	New York, Knoedler Galleries. *Seurat 1859-1891, Paintings and Drawings.*
1950	Rome, Galleria dell'Obelisco. *Georges Seurat* (drawings). Preface by Umbro Apollonio.
1957, November-December	Paris, Musée Jacquemart-André. *Seurat.*
1958, 16 January-11 May	Chicago, Art Institute of Chicago. *Seurat, Paintings and Drawings.* Catalogue introductions by Daniel Catton Rich, with an essay on Seurat's drawings by Robert L. Herbert. Also shown New York, Museum of Modern Art (24 March-11 May 1958). 92 p., 66 illus., 3 col.
	Review: R. Herbert, *Burlington Magazine* 100:662(May 1958):146-55.
1977, 29 September-27 November	New York, Metropolitan Museum. *Seurat, Drawings and Oil Sketches from New York Collections.*
1978, 15 November-15 December	London, Artemis, David Carritt Ltd. *Seurat Paintings and Drawings.* Catalogue essays by John Richardson and Richard Wollheim. 71 p., illus.
	Reviews: H. Mullaly, *Apollo* 108:202(Dec. 1978):444-5; B. Wallworth, *Arts Review* 30:24(8 Dec. 1978):676.
1983-84, 30 October-11 March 1984	Bielefeld, Kunsthalle. *Georges Seurat: Zeichnungen.* Also shown Baden-Baden, Stäatliche Kunsthalle (15 Jan.-11 March 1984). Edited by Erich Franz and Bernd Growe. Munich: Prestel, 1983. 203 p., 167 illus. 86 drawings shown.
	Exhibition of drawings from 1875-90 with complete catalogue descriptions that aimed to show his development from student sketches to mature works and to free Seurat from the tag of Neo-Impressionism. Reviews: P. Winter, *Kunstwerk* 36:6 (Dec. 1983): 52-3; *Goya* 178(Jan.-Feb. 1984):231

1986, 18 May-17 June	Chicago, Roy Boyd Gallery. *The Grand Example of 'La Grande Jatte': Seurat and Chicago Art.* Curated by Mary Mathews Gedo. 1 folded sheet.
1990, 14 October-25 November	Indianapolis, Indianapolis Museum of Art. *Seurat at Gravelines: The Last Landscapes.* Sponsored by Robert H. Mohlman; March Supermarkets, Inc. of Indianapolis; National Endowment for the Arts, Washington, D.C. Catalogue essays by Ellen Wardell Lee, Jonathan Crary, and William M. Butler. 80 p., 36 illus., 7 col.

Exhibition of Seurat's last four landscapes paintings and related sketches completed at Gravelines, France. Lee's essay "Seurat at Gravelines: The Last Landscapes," compares each of the four works to present-day scenes and an analysis of Seurat's working techniques and aesthetics. Crary's essay, "Seurat's Modernity," places Seurat's œuvre in relation to contemporary social issues. Butler's biography chronicles the artist's life and development.

1991-92, 9 April-12 January	Paris, Grand Palais. *Georges Seurat 1859-1891.* Also shown NY, Metropolitan Museum of Art (24 Sept. 1991-12 Jan. 1992). Catalogues by Robert L. Herbert; texts by Françoise Cachin, Anne Distel, Susan Alyson Stein, Gary Tinterow. Paris: Réunion des Musées Nationaux; NY: Metropolitan Museum of Art; dist. by Harry N. Abrams, 1991. 464 p., 352 illus., 244 col. 321 works shown.

Exhibition of paintings and drawings representing Seurat's entire career that demonstrate his importance to modern aesthetics and art theories. Essays examine his posthumous role as a major proponent of Neo-Impressionist "scientific" color theories and specific series paintings. See also *A Study of Visitors to Seurat* (NY: Metropolitan Museum of Art, 1992; 50 p.) for more information about the NY exhibition.

Reviews: F. Cachin, *Revue du Louvre et des musées de France* 41 (March 1991):10-2; G. Burn, *Arts Review* 43 (17 May 1991): 242; *Gazette des Beaux-arts* ser. 6, 118 (Sept. 1991):2-3; P. Carrier, *Arts Magazine* 66 (Dec. 1991):61.

VI. Selected Group Exhibitions After 1959

Note: For comprehensive lists of group exhibitions to 1959, see Henri Dorra and John Rewald's *Seurat: l'œuvre peint, biographie et catalogue critique* (Paris: Les Beaux-Arts, 1959) and César M. de Hauke's *Seurat et son œuvre* (Paris: Gründ, 1961-62, vol. 1).

1963	Hamburg, Kunstverein. *Cézanne, Gauguin, van Gogh, Seurat.*
1972	London, British Museum. *The Art of Drawing, 11000 B.C. - A.D. 1900.* 79 p., 23 illus.
1973-74, 25 October- 7 January	Paris, Musée du Louvre. *Dessins français du Metropolitan Museum of Art, New York: De David à Picasso.* Paris: Editions des Musées Nationaux, 1973. 164 p., 188 illus.
1974	NY, Museum of Modern Art. *Seurat to Matisse: Drawing in France; Selections from the Collection of the Museum of Modern Art.* Sponsored by the National Endowment for the Arts. Edited by William S. Lieberman. 103 p., 91 illus.
1974, 24 April-16 June	Cambridge, Harvard University, Fogg Art Museum. *Color in Art: A Tribute to Arthur Pope.* 136 p., 96 illus.
1980, 23 April-29 June	NY, Brooklyn Museum. *Belgian Art 1880-1914.* Also organized by the Ministries of Communities of the Government of Belgium. 256 p., 246 illus. Included works by Seurat and Sarah Faunce's essay, "Seurat and 'the Soul of Things'."
1980	NY, Metropolitan Museum of Art. *19th Century French Drawings from the Robert Lehman Collection.* Catalogue by George Szabo. 92 p., 87 illus. Drawings in various media, including sketches by Seurat and watercolors by Cross.
1984, 3 February-29 April	Edinburgh, National Gallery of Scotland, Department of Prints and Drawings. *Rembrandt to Seurat: Drawings and Prints Acquired in the Past Five Years.* 12 p., illus.
1985-86, 23 November- 12 January	Washington, D.C., Phillips Collection. *French Drawings from the Phillips Collection.* Sponsored by the National Endowment for the Arts, Washington, D.C. Catalogue by Sasha M. Newman. 8 p., 5 illus. Included drawings by Seurat and Cross, among other artists.
1987, 16 September- 8 November	Cleveland, Cleveland Museum of Art. *Creativity in Art and Science, 1860-1960.* Sponsored by Ohio Arts Council. Catalogue by Edward B. Henning. Bloomington: Indiana University Press; in cooperation with the Cleveland Museum of Art, 1987. 143 p., 77 illus., 8 col. Exhibition that surveyed parallel developments in science and the visual arts, including a section on Post-Impressionism represented by works of Seurat.

1989-90, 21 May-4 November	Philadelphia, Philadelphia Museum of Art. *Masterpieces of Impressionism & Post-Impressionism: The Annenberg Collection.* Also shown Washington, D.C., National Gallery of Art (Summer 1990); Los Angeles, Los Angeles County Museum of Art (16 Aug. - 4 Nov. 1990). 204 p., 243 illus., 49 col.

Exhibition of paintings collected by Walter and Lee Annenberg that included works by Seurat.

1989	Salzburg, Galerie Sals. *Seurat und sein Kreis.* Katalogbearbeitung, Marena Marquet. Übersetzung aus dem Englischen, Uta Attwood. 128 p., illus.
1990-91, 13 November-15 August	NY, National Academy of Design. *De main de maître: trois siècles de dessins français dans la collection Prat.* Also shown Forth Worth, Kimbell Art Museum (11 Feb. - 21 April 1991); Ottawa, National Gallery of Canada (15 July - 15 Aug. 1991). Preface by Shirley L. Thompson. Catalogue by Pierre Rosenberg. Ottawa: National Gallery of Canada; Paris: Réunion des Musées Nationaux, 1990. 277 p., 246 illus., 16 col.

Exhibition of drawings by French artists in the collection of Louis-Antoine Prat that included works by Seurat.

1991, 16 January-21 April	London, National Gallery. *Van Gogh to Picasso: The Berggruen Collection.* Catalogue essays by Richard Kendall, Lizzie Barker, and Camilla Cazalet. 209 p., 145 illus., 84 col.

Exhibition of painting and drawings from the Heinz Berggruen Collection lent to the National Gallery, London for a minimum of five years. Reunited sketches and studies by Seurat with final paintings held in the National Gallery.

1993, 1 April-8 August	NY, Metropolitan Museum of Art. *Infra-Apparel.* Catalogue by Richard Martin and Harold Koda. 130 p., 70 illus., 44 col.

Exhibition on the theme of the evolution of costumes that included painting, photographs, and apparel as well as portraits by Seurat, Manet, and Toulouse-Lautrec.

1994, 9 June-6 September	NY, Museum of Modern Art. *Masterpieces from the David and Peggy Rockefeller Collection: Manet to Picasso.* Catalogue by Kirk Varnedoe and David Rockefeller. NY: Museum of Modern Art; dist. in the U.S.A. and Canada by Harry N. Abrams, and elsewhere by Thames and Hudson, 1994. 100 p., 28 illus., 22 col. 21 works shown.

Included works by Seurat, Pissarro and other late 19th and early 20th century French artists.

1994-95, 21
September-22
January

NY, Pierpont Morgan Library. *The Thaw Collection: Master Drawings and New Acquisitions.* Introduction by Eugene Victor Thaw. Preface by Charles E. Pierce. Foreword by Charles Ryskamp. 284 p., 270 illus., 12 col.

Exhibition of drawing in the collection of Eugene and Clare Thaw that included drawings by Seurat and Pissarro.

1995, 4 May-22
August

NY, Museum of Modern Art. *Masterworks from the Louise Reinhardt Smith Collection.* Foreword by Richard E. Oldenburg. Preface by William Rubin. Introduction by Kirk Varnedoe. 96 p., 37 illus, 4 col.

Exhibition that included works by Seurat.

Camille Pissarro

Biography

Radical in art and politics, Pissarro was the only painter to exhibit in all eight Impressionist shows held between 1874 and 1886. He was revered as a teacher by generations of artists and was at the vanguard of several late 19th-century French avant-garde movements. His Neo-Impressionist phase, from 1885 to 1890, is possibly the most studied period of his career. Those who knew Pissarro invariably describe him as a fatherly or patriarchal figure. His extensive correspondence of nearly 2,100 extant letters, edited by Janine Bailly-Herzberg and published in five volumes (Paris: Presses Universitaires de France; Pontoise: Editions du Valhermeil, 1980-91) reveal the extent of his influence and the passionate resolve of his personality. Of his patience and abilities as a mentor to a host of different artists—including Cézanne, Gauguin, van Gogh, and fellow Neo-Impressionists—Mary Cassatt supposedly said that Pissarro "could have taught stones to draw." He was a dedicated family man with eight children, six of whom were artists. For a few years his eldest son Lucien (1863-1944) joined the Neo-Impressionist ranks.

Camille Pissarro was born in 1830 at Charlotte Amalie on the island of St. Thomas, Danish Virgin Islands to a Jewish family of French/Portuguese descent who operated a general mercantile business. He attended school at Passy, near Paris, from 1842 to 1847, where he was encouraged to draw and visit museums. Returning to St. Thomas in the late 1840s, he studied with Fritz Melbye (1826-96), a Dutch marine painter. The two traveled to Venezuela in 1852 and shared a studio in Caracas for over a year. Both artists painted directly from nature and closely observed the effects of natural light. Although fewer than 50 paintings survive from the first 15 years of Pissarro's career, a substantial body of drawings of rural landscapes, market scenes, and ports are studied for clues to his evolution as an Impressionist. These subjects recur in Pissarro's mature works. He returned to Paris in 1855 in time for l'Exposition Universelle.

In Paris, Pissarro shared a studio with Danish artists, including Fritz Melbye's brother Anton. He attended private classes at l'Ecole des Beaux-arts in 1856 and at l'Académie Suisse in 1859, where he met Cézanne, Monet, and Armand Guillaumin. His paintings were accepted for exhibition at the official Salons almost every year until 1870. In 1861, he registered as a Louvre copyist. Although he maintained a studio in Paris, he preferred to live in rural areas such as Montmorency, La Roche-Guyon, Varenne-Saint-Maur, Louveciennes, and Pontoise, where he resided and painted from 1886-88 and 1872-82. In 1860, he met Julie Vellay. They had eight children between 1863 and 1884 and were married in London in 1871.

Pissarro's landscapes of the 1860s reflect the influence and inspiration of Corot,

Daubigny, Chintreuil, and Courbet. In 1866, he moved to Pontoise and began a series of large *plein air* landscapes that were praised for their simplicity and realism. In Louveciennes in 1869 he began to paint in a purely Impressionist style and worked fervently to perfect the new style with younger artists such as Monet whom he had met at l'Académie Suisse and the Café Guerbois. During the Franco-Prussian War (1870-71), his house was ransacked by Prussian troops and many of his earliest Impressionist canvasses were destroyed. Pissarro fled to London, where he kept in touch with Monet, Daubigny, and the art dealer Paul Durand-Ruel. He resettled in Pontoise in 1872.

Impressionist paintings completed in London and Pontoise in the early 1870s are often regarded as his most successful. Using a lighter brush-stroke and a brighter palette applied in patches of unmixed colors, Pissarro's aim was to record emotions (*sensations*) experienced in nature. Pissarro showed his new works with other Impressionists at their first major exhibition in 1874. As a leading Impressionist, he worked with Cézanne and Degas in the 1870s and with Gauguin after 1879. In 1882, he moved from Pontoise to the small village of Osny and two years later to Eragny-sur-Epte in Normandy, where he bought a large house and converted the barn into a studio.

Pissarro met Seurat in October, 1885 and was Neo-Impressionism's first convert. Pointillism was a natural stylistic development from the expanded pure-color range he had used since the late 1870s. For the next five years Pissarro found new direction and inspiration in Neo-Impressionism's fascination with the science and optics of color. The older, established Impressionist brought Seurat, Signac, and his son Lucien into the final Impressionist show in May, 1886, where he proudly referred to the new group as "scientific Impressionists." Pissarro was invigorated by the younger artists and Symbolist writers, with whom he shared anarchist sensibilities. He exhibited with Les XX in Brussels in 1887, 1889, and 1891.

In the late 1880s, Pissarro began to complain of Neo-Impressionism's compositional rigidity and slowly modified his tiny pointillist brush-strokes, although he observed division of colors until 1891. In the last decade of his life he returned to a purer Impressionist style and struck a balance between urban and rural subjects. He produced important series of cityscapes of Rouen, Paris, Dieppe, and Le Havre. Pissarro was an equally prolific and innovative draughtsman. Large numbers of drawings from each decade of his career survive; the most notable collection is in the Ashmolean Museum, Oxford. He was also an original printmaker, hailed in particular for experimental monotypes produced in collaboration with Degas between 1879 and 1882.

Camille Pissarro

Chronology, 1830–1903

Information for this chronology was gathered from Ludovic Rodo Pissarro and Lionello Venturi's 2-volume *catalogue raisonné, Camille Pissarro, son art, son œuvre* (Paris: Paul Rosenberg, 1939); *Correspondence de Camille Pissarro*, ed. by Janine Bailly-Herzberg (Paris: Presses Universitaires de France; Pontoise: Editions du Valhermeil, 1980-91); *Camille Pissarro, 1830-1903* (exh. cat., London, Hayward Gallery, 1980); John Rewald, *Camille Pissarro* (London: Thames and Hudson, 1963); Kathleen Adler, *Camille Pissarro: A Biography* (NY: St. Martin's Press, 1977); Raymond Cogniat, *Pissarro* (Paris: Flammarion, 1974); Christopher H. Lloyd, *Camille Pissarro* (NY: Rizzoli 1981); Martin Reid, *Pissarro* (London: Studio, 1993); Christopher H. Lloyd, "Camille Pissarro" in *The Dictionary of Art* (NY: Grove, 1996)24:878-84; and Ralph E. Shikes and Paula Harper, *Pissarro: His Life and Work* (NY: Horizon Press, 1980), among other sources.

1830

July 10
Birth of Jacob-Abraham-Camille Pissarro at Charlotte Amalie, St. Thomas, Danish Virgin Islands into a family of French, originally Portuguese, descent. His father, Frédéric Pissarro, and mother, Rachel Petit (née Manzana Pomié), operate a small general mercantile business.

1842-47

Attends the Pension Savary boarding school in Passy, near Paris, where his artistic inclinations begin to emerge.

1847

Returns to Charlotte Amalie and trains in the family business.

1849-50

Meets and studies with Fritz Melbye (1826-96), a Danish marine artist, and is persuaded towards a career in art.

1852-54

Travels with Melbye to Venezuela. They share a studio in Caracas for over a year. Numerous watercolors and drawings survive from this period, although only two dated paintings are recorded.

1855, October

Leaves his family for Paris; his arrival coincides with l'Exposition Universelle. Stays with relatives and shares a studio with Danish artists Anton Melbye (brother of Fritz) and David Jacobsen (1821-71).

1856

Attends private classes at l'Ecole des Beaux-arts, Paris. Meets Corot and other artists.

1857

Receives a generous allowance from his father. The Pissarro family vacations at Montmorency, where Pissarro paints.

1859

Attends l'Académie Suisse, Paris, where he meets Cézanne, Monet, and Armand Guillaumin. First submission to the Salon, a landscape entitled *Picnic at Montmorency*, is accepted. He exhibits again at the Salon in 1864, 1865, 1866, 1868, 1869, and 1870.

1860

Forms a liaison with Julie Vellay, a wine-grower's daughter from Burgundy who had worked for the Pissarro family. They have eight children between 1863 and 1884 and are married in London in 1871.

1861

Registers as a copyist in the Louvre.

1863, February

Birth of son Lucien (1863-1944) in Paris, who becomes a painter, printmaker and typographical designer under his father's tutelage.

1864

Works in Paris and its environs.

1865

Death of his father and birth of daughter Jeanne (Minette).

1866

Meets frequently with Monet, Renoir, and Sisley at Frédéric Bazille's studio. Has a falling out with Corot but remains friendly with Daubigny. Lives in Pontoise until 1868 (and later from 1872 to 1882) and maintains a studio in Paris. Emerges as a major independent artist whose large-scale Salon works are praised in the press, particularly by Emile Zola.

1867

Works are rejected by the Salon. Bazille suggests setting up an alternative Salon.

1868

Paints blinds for a local company to earn money.

1869

Moves to Louveciennes and begins to paint in a pure Impressionist style.

1870, July-1871

Outbreak of the Franco-Prussian War. Moves to Montfoucault. The family's house in Louveciennes is ransacked by Prussian troops and many works are destroyed. Moves with his family to London where he meets Monet, Daubigny, and Paul Durand-Ruel, who runs a Bond Street Gallery. Returns to Louveciennes in 1871. His second son Georges is born in November 1871.

1872

Settles again in Pontoise and works with Cézanne and Guillaumin, often in nearby Osny and Auvers-sur-Oise. Emulates Millet in exploring rural themes around Pontoise and at Montfoucault near Mayenne in Brittany, a farm owned by Ludovic Piette, an artist friend who dies in 1878.

1873

Shows works at Durand-Ruel's London gallery and maintains close relations with Cézanne, Guillaumin, and Théodore Duret.

1874

January
Public auction yields 1,850 francs for Pissarro's works. Durand-Ruel stops buying paintings because of economic crisis.
April-May
First Impressionist group exhibition, a financial disaster that depresses Pissarro, who nevertheless exhibits at the seven subsequent Impressionist shows in 1876, 1877, 1879, 1880, 1881, 1882, and 1886.
August
Paints at Montfoucault.

1875

Works in Pontoise with Cézanne and spends fall at Montfoucault.

1876

April
Second Impressionist show includes 12 paintings by Pissarro.
Fall at Montfoucault.

1877

Shows 22 works at the third Impressionist exhibition.

1878

April
Death of Ludovic Piette.
21 November
Birth of son Ludovic-Rodolphe (Ludovic-Rodo).

1879

Shows 38 works at the fourth Impressionist show. Gauguin stays in Pontoise. Pissarro produces 11 etchings.

1880

Shows paintings and etchings at the fifth Impressionist show.

1881

February
Durand-Ruel resumes buying Pissarros.
April
Sixth Impressionist exhibition includes 28 paintings by Pissarro.
Summer
Gauguin and Guillaumin work with Pissarro at Pontoise.

1882

Moves from Pontoise to Osny, a small neighboring village. Shows 36 works at the seventh Impressionist show. Tries his hand at sculpture under Gauguin's instruction.

1883

First one-artist show at Durand-Ruel. During the summer Gauguin visits him and Pissarro spends seven weeks in the fall in Rouen. Devises more complex compositions, including crowded marketplace scenes with greater numbers of figures.

1884

Moves from Osny to Eragny-sur-Epte in Normandy, where he rents and later purchases a large house, converting the barn into a studio. Paints watercolors. Birth of his youngest son Paul-Emile.

1885

Meets Théo van Gogh, Signac, and Seurat and adopts the pointillist style favored by the Neo-Impressionists.

1886

Shows 20 works in various media at the final Impressionist show. Meets Vincent van Gogh.

1887

Meets Maximilien Luce.

1888

Sells etchings but Durand-Ruel declines to represent Pissarro's pointillist paintings.

1889

His mother dies, aged 94.
Prepares an album of 28 drawings entitled *Turpitudes sociales* that depict scenes from the lives of urban proletariats and deal with themes of poverty, repression, crime, and exploitation.

1890

Visits London with Luce and paints cityscapes.

1892

Durand-Ruel organizes a successful major retrospective. Pissarro aids families of arrested or exiled anarchist friends but condemns violence. Visits his son Lucien in London, again with Luce, where he executes his Kew Gardens series.

1893

Paints Parisian cityscapes. In March, Durand-Ruel shows 41 works and later buys paintings for 23,000 francs. Meets Toulouse-Lautrec. Undergoes an eye operation for dacryocystitis. In the last decade of his life he returns to a purer Impressionist style that favors urban motifs in Paris, Rouen, Dieppe, and Le Havre, usually viewed from hotel windows.

1894

Installs a printing press at Eragny. Flees to Knokke-sur-mer, Belgium to escape anarchist violence.

1895

Visits Rouen and sees Monet's cathedrals series.

1896

Two productive stays in Rouen yield 41 paintings.

1897

Spends May-July in London because of Lucien's illness. Exhibits 42 paintings in New York City. His son Félix dies.

1898

Paints in Paris and Rouen and is distraught over the Dreyfus affair.

1899

Begins Tuileries Gardens series.

1900

Starts Louvre-Pont Neuf series and visits Dieppe.

1901

Paints with his son Georges at Moret-sur-Loing and starts his Dieppe series.

1902

Paints in Paris, Dieppe, Eragny, and Moret.

1903

Spends summer in Le Havre.
13 November
Dies in Paris and is buried in Père Lachaise Cemetery.

Camille Pissarro

Bibliography

Note: The most comprehensive bibliography on Pissarro, prepared by Martha Ward, appears in *Pissarro* (exh. cat., London, Hayward Gallery and Boston, Boston Museum of Fine Arts, 1980-81):250-61. For an updated bibliography, see Mary Martha Ward, *Pissarro, Neo-Impressionism, and the Spaces of the Avant-Garde* (Chicago: University of Chicago Press, 1996):331-37. For an earlier bibliography and exhibitions list that cites over 500 sources, see Ludovic Rodo Pissarro and Lionello Venturi's *catalogue raisonné, Camille Pissarro, son art, son œuvre* (Paris: Paul Rosenberg, 1939)1:331-32. Other well-organized Pissarro bibliographies are available in Ralph E. Shikes and Paula Harper, *Pissarro: His Life and Work* (NY: Horizon Press, 1980):349-54 and Richard R. Brettell and Joachim Pissarro, *The Impressionist and the City: Pissarro's Series Paintings* (exh. cat., Dallas, Dallas Museum of art, 1992-93):218-29. Some secondary sources identified in these works are not reproduced here.

I. Archival Materials

1062. PISSARRO, CAMILLE. *Letters*, 1882-1903. Holographs, signed. 50 items. Located at The Getty Research Institute for the History of Art and the Humanities, Special Collections, Los Angeles.

Includes letters to family members, critics, dealers, and colleagues. Letters written from London, Paris and Eragny to his wife Julie, sons Rodophe and Lucien, and niece Esther, discuss financial matters, health, travel plans and provide instructions regarding the sale of works of art, including prices, and the shipment of paintings and materials (19 items, 1890-1903). Other letters are addressed to: Georges de Bellio (1882-91); Paul Durand-Ruel (1888); Maximilien Luce (1889-90); Georges Petit (1889); Theodore Child (1889); Gustave Geffroy (1890); Claude Monet (1890-91); Paul Signac (1894); Hippolyte Petitjean (1893,

1897); Ambroise Vollard (1896); and André Portier (1897); and include mention of personal matters, upcoming exhibitions and work in progress. Collection also includes two pages of notes listing paintings done at Le Havre, giving the subject and buyer in some instances (21 Sept. 1903) arranged in chronological order.

1063. DEGAS, EDGAR. *Letters*, 1880-98. Holographs, signed. ca.15 items. Located at The Getty Research Institute for the History of Art and the Humanities, Special Collections, Los Angeles.

Letters comment on a wide variety of matters including an exhibition of Gauguin's work, travel in the Midi, his own career as an artist, a pastel by Delacroix, Mary Cassatt's experiments in engraving, work on the journal *Le Jour et la nuit*, as well as work in progress on fans and waxes. Correspondents include Camille Pissarro, Henri Rouart, Louis Bradquaval, the dealer Adrien Beugniet, Maria Valadon, Albert Bartholome, Evariste de Valernes, and Georges Charpentier.

1064. GAUGUIN, PAUL. *Letters and Writings*, 1879-1903. 24 items. Holographs, manuscripts. Located at The Getty Research Institute for the History of Art and the Humanities, Special Collections, Los Angeles.

Letters to Camille Pissarro, Emile Schuffenecker, Emile Bernard and to several other correspondents; letters of Mette Gauguin to Pissarro and André Level; and essays and notes written by Gauguin on social, religious, and aesthetic issues.

Organization: I. Letters (folders 1-3); II. Essays and notes (folders 4-5).
Series I. Letters; Sixteen letters written over a twenty year period treats a wide variety of topics ranging from practical and legal matters to issues in contemporary art. Of special interest are letters to Camille Pissarro concerning potential exhibitions and the promotion of Pissarro's work (1879-85); to Emile Schuffenecker discussing the sale of paintings and financial concerns (1885-90); to Emile Bernard describing in detail his plans for an "atelier du Tropique" and commenting on "primitive" life; to Henri Bataille, director of the *Journal des artistes*, musing on the "style nouveau" in painting and decorative arts (1894); and to the French lawyer and newspaper editor Léonce Brault protesting racial injustice in Tahiti. Other correspondents include Ambroise Vollard, George Daniel de Monfreid and William Mollard. Collection also includes letters by Gauguin's wife Mette to Camille Pissarro recommending the painter Mogens Ballin and to the art dealer André Level (1914). Also included is a brief letter from Gustave Geffroy to Gauguin and a previously unpublished letter from Gauguin to the Danish painter Willemsen, as printed in *Les Marges* (L'Année littéraire).
Series II. Essays and notes: Consists of several sheets of an essay on social issues including the education of children, marriage and prostitution; a draft of a letter proposing a book on art and commenting on the "madness" of van Gogh; and a fragment of a letter describing technical aspects of his work and characterizing contemporary painting in Paris. Also includes seven pages of notes containing musings on spiritual matters – the saints, the writings of Paul, the Bible, and the parables of Jesus. With two pencil sketches and a note from Louis Vauxcelles verifying the authenticity of the manuscript (1932).

1065. LUCE, MAXIMILIEN. *Letters, Sketches, and Exhibition Catalogues*, 1899-1930, 44 items. Holographs, signed; sketches; printed materials. Located at The Getty Research Institute for the History of Art and the Humanities, Special Collections, Los Angeles.

Among the letters are 12 to assorted correspondents, 6 to Jean Charlot, and 12 to Louise and Frédéric Luce, Maximilien's son and daughter-in-law. Many letters include sketches in pencil and ink and generally concern personal matters with some mention of work in progress. One letter to Charlot contains brief references to paintings seen during travels, while one letter to Aynaud mentions plans to visit Holland with Kees van Dongen and Ludovic Rodo Pissarro (n.d.). Other correspondents are Miguet, Oulevey, Charles Remond, and Camille Pissarro. In addition to the drawings on his letters, there are 11 separate small sketches by Luce done in pencil and ink, with two in watercolor. Sketches include seascapes, landscapes, and figure drawings. Exhibition ephemera consists of two small catalogues and three announcements or listings of work for Luce exhibits in private galleries between 1899 and 1930. One catalogue contains illustrations and an essay by Gustave Geffroy (1907).

Organized in 5 folders: letters (folders 1-3); sketches (folder 4); exhibition catalogs and ephemera (folder 5).

1066. MARTY, ANDRE. *Letters and Manuscripts Received*, ca. 1886-1911. ca. 230 items. Located at The Getty Research Institute for the History of Art and the Humanities, Special Collections, Los Angeles.

Marty (b. 1857) was a French editor, director of *Le Journal des artistes*, and publisher of prints and books on the arts. Includes letters from more than 50 artists and art critics primarily concerning publication of the print portfolio, *L'Estampe originale*, but also referring to projects for illustrated books, monographs on art, exhibitions and art criticism. Most letters are addressed to André Marty, though a few are to his junior partner, Henri Floury. Included in the collection are two short manuscripts on the decorative arts, by Gustave Geffroy and Octave Uzanne.
Letters relating to *L'Estampe originale* (1893-95) provide detailed technical information about print states, color, choice of paper, and preferences for particular printers and engravers. They also chronicle problems of artistic and journalistic collaboration and offer clues as to the publisher's marketing strategies. Of particular interest are letters from Georges Auriol (5) about his designs for decorative borders; from the sculptor Alexandre Charpentier (16) discussing his innovative "timbre sec," and dickering over prices; from Maximilen Luce (1) with instructions for printing engravings; from Monet (1) expressing uncertainty about working in lithography; from Roger Marx (23) concerning his preface and the promotion of the portfolios; from Van Rysselberghe (1) promising to enlist other Belgian artists; from Lucien Pissarro (13) about distribution of the publication in England, and his own prints; and from Félix Vallotton (1) regarding control over editions and financial terms. Among the letters containing comments on specific prints and details on technical matters are those from Eugène Carrière (13); Signac (1); Joseph Pennell (6); Camille Pissarro (8); and Félicien Rops (3). There are also some artists who plan to withdraw from the project, for example Zandomeneghi, Blanche, Khnopff, and Duez.
Letters treating other subjects include five from Paul Ranson (n.d.) discussing wallpaper and tapestry designs; letters of 1897 from Ernest Chaplet and Auguste Delaherche about a ceramics exhibition sponsored by *Le Figaro*; a long, detailed letter from Gabriel Mourey (1893) discussing his plans for a series of monographs on contemporary French and British artists; seven letters (1894-99) from Lucien Pissarro about projects for illustrated books; two letters from Paul Signac (1894, n.d.); and a file of letters (34) from Gustave Geffroy on various journalistic matters, including the publication of his collected criticism and the brochure promoting his project for a "Musée du soir." A sketch by Carrière for the cover of the brochure is also included in the collection. In addition to Geffroy and Marx, critics

represented by significant groups of letters are Arsène Alexandre, Henry Nocq, Moreau-Nelaton, Thadée Natanson, Félix Fénéon, Frantz Jourdain, and Emile Verhaeren. A three-page draft manuscript (n.d.) by Octave Uzanne concerns the subject of art and industry and functionalism in the decorative arts. A one-page manuscript by Geffroy (1899) is an open letter to the Director of Fine Arts advocating independent exhibition by decorative artists for the World's Fair of 1900. Letters are arranged alphabetically by author.

1067. MONET, CLAUDE. *Letters*, 1864-1925. ca. 200 items. Holographs, signed. Located at The Getty Research Institute for the History of Art and the Humanities, Special Collections, Los Angeles.

Collection assembled from various sources that includes both private and professional correspondence, much of it with dealers, suppliers, critics, and other artists, as well as extensive files of letters to Camille Pissarro, Gustave Geffroy, and Alice Monet. Though the subjects touched upon and the addressees largely parallel those in the published correspondence, most of this group is in fact unpublished.

Letters addressed to his wife Alice include 15 that antedate their marriage and 21 from 1896-97. Some of their themes are Monet's frustration with the weather and its effect upon his painting, his health, and a lawsuit. Of note among 37 letters to Camille Pissarro are ones concerning finances, the death of Sisley in 1899, and l'Exposition Universelle et internationale de 1900. In the eight letters to Mme. Pissarro (1903-14), Monet offers the widow advice about the exhibition sale of her husband's work. The 35 letters to Geffroy (1887-1925) cover a wide range of subjects including Monet's work and exhibitions, mutual friends, Japanese art, the weather, and specific articles of Geffroy's.

The more than 50 miscellaneous items (1864-1924) include sizable groups of letters to Thiebault-Sisson (1920), Georges Petit (1888-90), and F. Deconchy (1900-02), as well as two letters to Bazille (1865), and single letters to Boudin, Paul Helleu, Giuseppe de Nittis (1887), and Georges de Bellio.

Organization: I. Letters to Alice (Hoschede) Monet, ca. 1891, 1896-97 (folder 1); II. Letters to Camille Pissarro and his wife, 1884-1914 (folder 2); III. Letters to Gustave Geffroy, 1887-1925 (folder 3); IV Misc. letters, 1864-1925 (folders 4-7). Files arranged chronologically.

1068. RENOIR, AUGUSTE. *Letters*, 1882-1919. 16 items. Holographs, signed. Located at The Getty Research Institute for the History of Art and the Humanities, Special Collections, Los Angeles.

Fifteen letters addressed to, among others, Paul Bérard (1882-87, n.d.), Julie Manet (1910), Gustave Geffroy (1895-96), Motte, and Mme. Roussel-Masure. Largely personal in nature, the letters contain some discussion of work in progress, dealers, and travel plans, including a trip to Argenteuil with Gustave Caillebotte. Renoir comments briefly on a painting by Monet, and exhibition organized with Pissarro to celebrate the French centenary, furniture, and the art criticism of Charles Ephrussi. With one photograph of Renoir in his studio taken in 1917 and signed by the artist. Arranged in chronological order.

1069. ROUART, HENRI. *Letters*, 1876-94. 4 items. Holographs, signed. Located at The Getty Research Institute for the History of Art and the Humanities, Special Collections, Los Angeles.

Four letters from Rouart (1833-1912) to Camille Pissarro, including a sympathy note of 1874 (with an oblique reference to the first Impressionist exhibition) and two letters about a subscription for a tombstone for Stanislas Lépine (1835-92). Rouart was an amateur French painter, collector, industrialist, lifelong friend to Degas and staunch supporter of the Impressionists. Most of Rouart's collection was sold in 1912 at the Galerie Manzi-Joyant, Paris.

1070. SIGNAC, PAUL. *Letters Sent and Signac Family Correspondence*, 1860-1935. 93 items. Holographs, signed; manuscript signed. Located at The Getty Research Institute for the History of Art and the Humanities, Special Collections, Los Angeles.

Letters from Signac to several colleagues discussing work in progress, exhibitions, contemporary art, La Société des Artistes Indépendants, and personal and financial matters. A significant number of these letters are addressed to Edouard Fer, a Neo-Impressionist disciple whose independent means and connections enabled him to promote Signac's career. Other correspondents include Camille Pissarro, Claude Monet, Georges Turpin, Henri Martineau, Georges Lecomte, and Luc-Albert Moreau. There is also a draft essay for a review of l'Exposition des Peintres provençaux, held in 1902. Most of the letters in this collections are Signac family correspondence; some of these are addressed by Paul Signac to his cousins. The repository also holds a significant series of Signac's correspondence within the papers of Théo Van Rysselberghe.

In his 35 letters to Edouard Fer (1916-1932, bulk 1918-21), Signac discusses the organization of exhibitions, mostly in Switzerland, and critical reaction to his own work. He does not forget to offer Fer occasional advice. Other letters include ten to Pissarro (1886-99), in one of which he comments on Pissarro's stylistic evolution and his own recent landscape painting in the Midi (1897); a letter that recounts the formation of La Société des Artistes Indépendants in 1884 with mention of Redon, Seurat, and Théodore Rousseau; a letter to Georges Lecomte where Signac comments on Symbolism, Puvis de Chavannes, Maximilien Luce, and Lecomte's recent work; a letter from Brussels describing at great length a visit to a foundry (1897); two notes to Henri Martineau pertaining to Signac's study of Stendhal (1919, 1928); one letter to an unnamed critic thanking him for a favorable article and describing his trips to Brittany and Provence (1933); and a fragment of a letter in response to an inquiry on interior decorating.

Includes a draft essay of a review of l'Exposition des Peintres provençaux held in Marseilles in 1902, and an introductory statement on the exhibition followed by remarks characterizing the work of individual painters including Jean-Antoine Constantin, Emile Loubon, Auguste Aiguier, Gustave Ricard, Adolphe Monticelli, and Paul Guigou.

Signac family correspondence deals with family life, children, illness, vacations, money worries, marriages, divorces, and so forth. A small number of these are written by Paul Signac to his cousins. The rest are between other family members. Most of the letters seem to be about Julie and Alfred Signac's family – Paul Signac's aunt and uncle. Included are letters from his grandmother, grandfather, and cousins.

Organization: Letters from Signac to colleagues (folders 1-5), Manuscript (folder 6), Signac family correspondence (folders 7-18). Folder list available in repository.

1071. VAN RYSSELBERGHE, THEO. *Correspondence*, ca. 1889-1926. ca. 225 items. Holographs, signed. Located at The Getty Research Institute for the History of Art and the Humanities, Special Collections, Los Angeles.

Collection contains 84 letters of Van Rysselberghe to, among others, Madame Rysselberghe,

the dealer Huinck, Paul Signac, and Berthe Willière; and 141 letters received from colleagues including Henri Cross, Paul Signac, Camille Pissarro, and Henry Van de Velde. The letters, many of which are extensively illustrated, are largely theoretical in nature and explore all facets of art theory and practice associated with the Neo-Impressionist milieu of the late 19th and early 20th centuries.

Organization: Series I. Letters to Madame Rysselberghe, ca. 1902-20 (folder 1); Series II. Miscellaneous letters, 1900-26 (folders 2-3); Series III. Letters received from Paul Signac, ca. 1892-1909 (folders 4-8); Series IV. Letters received from Henri Cross, 1908-10, n.d. (folders 9-11); Series V. Miscellaneous letters received, ca. 1889-1905, n.d. (folders 12-13) Series I. Letters to Madame Rysselberghe, ca. 1902-20 (32 items). Thirty-two letters, a significant portion of which are dated 1918-20, include detailed discussion of travels, work in progress, especially on portraits, his own emotional state and personal matters. Van Rysselberghe writes of technical matters, including difficulties associated with painting *en plein air* and a decorative project underway for Armand Solvay, and describes in some detail his stay at the Château de Mariemont. Other letters also include discussion of upcoming exhibitions and comments on the writing of André Gide, Jacques-Emile Blanche, and Marcel Proust.
Series II. Miscellaneous letters, 1900-26 (52 items). Twenty letters to Van Rysselberghe's dealer Huinck concern practical matters associated with upcoming exhibitions in Holland such as the framing and packing of works of art, titles, dimensions and prices of paintings, train schedules, and fluctuating currency (1924-25). Nineteen letters and postcards to Berthe Willière on work, travel, and personal matters (1909-26). In three letters to Paul Signac, Van Rysselberghe defends his criticism of Signac's work, explains his own working method, and responds to the suggestion that his work was adversely influenced by Maurice Denis (1909). One letter to André Gide concerns the "fond d'atelier" of Henri Cross and a possible retrospective exhibition (1918). Other correspondents include Pierre Bounier (1900, 1914), Armand Solvay (1922), and a M. Dunan (1925-26).
Series III. Letters received from Paul Signac, ca. 1892-1909 (74 items). Seventy-four detailed letters, many extensively illustrated with color and ink sketches, focusing primarily on theoretical issues. Signac outlines ideas for work in progress, discusses color theory and the divisionist technique, and comments on a wide variety of matters, including Old Master painting and the work of Seurat, Maurice Denis, Odilon Redon, Paul Sérusier, Henri Cross, and Eugène Delacroix. In several essay-length letters, Signac attempts to render in a systematic manner the theory of Neo-Impressionism and his own approach to painting and avidly defends the pointillist technique. The letters also include discussion of practical matters relating to exhibitions and the sale of paintings, as well as mention of literary interests and personal news.
Series IV. Letters received from Henri Cross, 1908-10, n.d. (53 items). Eleven letters addressed to Van Rysselberghe contain discussion of work in progress (illustrated) and working method and include mention of Félix Fénéon, Signac, and Henri Matisse. Forty-two letters, mostly personal in nature, are addressed to Madame Rysselberghe and contain some mention of literary and musical interests, daily activities, and art-related matters.
Series V. Miscellaneous letters received, ca. 1889-1905, n.d. (14 items). Includes four letters from Camille Pissarro concerning printmaking ventures and including mention of Octave Maus and André Marty (1895); two brief letters from Maximilien Luce (n.d.); one letter from Maurice Denis mentioning two portraits by Van Rysselberghe and commenting on personal travel plans (n.d.); and seven letters from Henry Van de Velde explaining in some detail his difficulties with the Neo-Impressionist style and outlining plans for an exhibition in Berlin designed to interest the German press in Neo-Impressionism (1890-1905).

II. Primary Works

1072. PISSARRO, CAMILLE. "Des lettres inédites de Camille Pissarro à Octave Mirbeau (1891-1892) et à Lucien Pissarro (1898-1899)." *La Revue d'art ancien et moderne* 58(March 1930):173-90; (April 1930):223-6.

Edited and introduced by Charles Kunstler.

1073. PISSARRO, CAMILLE. *Letters to his Son Lucien*, edited with the assistance of Lucien Pissarro by John Rewald. Translated from the French ms. by Lionel Abel. NY: Pantheon, 1943. 367 p., illus., pl.
Compilation of complete or excerpted versions of 477 letters dating from 1883 to 1903. Extracts first appeared in *Gazette des Beaux-arts* ser. 6, 23(April 1943):237-50; (June 1943):363-76; 24(Aug. 1943):107-22.
a. Other eds.: Mamaroneck, NY: Paul P. Appel, 1972. 394 p., 89 illus; Santa Barbara: Peregrine Smith, 1981. 480 p., illus.; NY: Da Capo Press, 1995.
b. English ed.: London: K. Paul, Trench, Trubner, 1943; London: Routledge & Kegan, 1980.
c. French ed.: *Lettres à son fils Lucien*. Paris: Albin Michel, 1950. Includes 30 letters from Lucien to Camille.
d. German ed.: *Camille Pissarro, Briefe an seinen Sohn Lucien*. Erlenbach-Zurich: E. Reutsch, 1953. 424 p., 61 illus.
Reviews: *Gazette des Beaux-arts* ser. 6, 25(Feb. 1944):127-8; *Art Digest* 18(15 Feb. 1944):25; *American Artist* 8(April 1944):36; C. Greenberg, *The Nation* 158:24 (June 1944): 740-2; *Connoisseur* 114(Sept. 1944):59; *Magazine of Art* 38(Jan. 1945):36; *ARTnews* 44(1 March 1945):24; *Art Bulletin* 27(June 1945):158-9; *College Art Journal* 5(Nov. 1945):63-7; *Burlington Magazine* 88(Jan. 1946):24; *Werk* 41(July 1954):supp. 162; *Encounter* 56:4(1981):67-74.

1074. PISSARRO, CAMILLE. "Lettres inédites de Pissarro à Claude Monet." *L'Amour de l'art* 26(1946):58-65.

Edited and introduced by Jules Joëts.

1075. PISSARRO, CAMILLE. "Lettres de Pissarro à Paul Signac et Félix Fénéon." *Les Lettres françaises* (8-15 Oct. 1953):9.

Introduced and edited by Geneviève Cachin-Signac.

1076. PISSARRO, CAMILLE. *Archives de Camille Pissarro*. Dont la vente aux enchères publiques aura lieu Hôtel Drouot salle no. 6 le vendredi 21 novembre 1975. Préface par Michel Melot. Rédaction Geneviève Cusset et Maryse Castaing: Paris: Maison Charavay, 1975. 88 p., pl.

Auction sale catalogue of Pissarro's archives, held at l'Hôtel Drouot, Paris, on 21 Nov. 1975. Includes excerpts from 15 letters of Pissarro to his niece, Esther Isaacson.

1077. PISSARRO, CAMILLE. *Autographes et documents divers*. Paris: Drouot, 1977.

Auction sale catalogue that includes Pissarro's letters to Monet, held at l'Hôtel Drouot, Paris, on 15 June 1977.

1078. PISSARRO, CAMILLE. *Correspondance de Camille Pissarro*, édition critique de Janine Bailly-Herzberg. Préface de Bernard Dorival. Ouvrage publié avec le concours du Centre National des lettres. Paris: Presses Universitaires de France, 1980-91. 5 vols., illus. Vols. 2-5 published by Editions du Valhermeil (Pontoise).

Complete correspondence of Camille Pissaro, transcribed, edited, classified, documented, and annotated by Bailly-Herzberg, comprising 2,092 letters. Vol. 1, 1865-1885; vol. 2 1886-1890; vol. 3, 1891-1894; vol. 4, 1895-1898; vol. 5, 1899-1903. "Liste des destinations," vol. 1, pp. 373-6; vol. 2, pp. 385-8; vol. 3, pp. 541-7; vol. 4, pp. 535-40; vol. 5. Includes bibliographical references.
Reviews: R. Pickvance, *Burlington Magazine* 125:967(Oct. 1983):630-1; R. Shiff, *Art Bulletin* 66:4(Dec 1984):681-90; J. Pissarro, *Apollo* 136:369(Nov. 1992):339-41; R. Pickvance, *Burlington magazine* 136:1090(Jan 1994):39-40.

1079. PISSARRO, CAMILLE. *Camille Pissarro: Turpitudes sociales*. André Fermigier. Genèva: Skira, 1972. 28 p., illus.

"Facsimilé d'un album de dessins inédits de Pissarro exécuté en 1890 et inspiré du journal *La Révolte*."

1080. PISSARRO, CAMILLE and HENRI MATISSE. "Conversation with Pissarro" in Alfred H. Barr, Jr., *Matisse: His Art and His Public* (NY: Metropolitan Museum of Art, 1951):38. Reprinted in *Impressionism in Perspective*, ed. by Barbara E. White (Englewood Cliffs, NJ: Prentice-Hall, 1978):26.

III. Books

1081. ADHEMAR, JEAN. *La Lithographie en France au XIXe siècle*. 50 planches avec une étude. Paris: Editions Tel, 1944. 8 p., illus., 50 pl. (L'Estrampe française, 2)

1082. ADLER, KATHLEEN. *Aspects of Camille Pissarro, 1871-1883*. M.A. thesis, Courtland Institute, London, 1969.

1083. ADLER, KATHLEEN. *Camille Pissarro: A Biography*. NY: St. Martin's Press, 1978. 208 p., illus., 8 pl.

Biography of Pissarro that includes excerpts of correspondence and some previously unpublished works.
a. English ed.: London: Batsford, 1978. 208 p., illus., 8 pl.
Reviews: G. Grigson, *Country Life* 163:4211(23 March 1978); R. Shone, *Times Literary Supplement* (21 July 1978):814; J. Russell, *New York Times* (6 Aug. 1978):D21; C. Lloyd, *Burlington Magazine* 120:907(Oct. 1978):683-4; A. Werner, *American Artist* 43(March 1979):22.

1084. Ashmolean Museum, Oxford. *Treasures of the Ashmolean Museum: An Illustrated Souvenir of the Collection*. Oxford: Ashmolean Museum, 1985. 112 p., 130 col. illus.

Pictorial survey of the museum's art collections that features works by Pissarro and outlines its history since 1683.
a. Another ed.: 1995. 119 p., col. illus.

1085. AURIER, GABRIEL-ALBERT. *Oeuvres posthumes.* Paris: Mercure de France, 1893. 480 p., illus.
Includes a lengthy section of art criticism on Pissarro, pp. 5-44.

1086. BAILLY-HERZBERG, JANINE. *Correspondance de Camille Pissarro à son fils Georges dit Manzana et à sa nièce Esther Isaacson, commentaires et étude critique.* Diplôme de troisième cycle, Paris IV Sorbonne, Art et archéologie, sous la direction de Bernard Dorival.

Reprints and annotates 180 letters from Camille Pissarro to his son Georges ("Manzana") and to his niece, Esther Isaacson, with critical analysis.

1087. BAILLY-HERZBERG, JANINE. *Pissarro et Paris.* Paris: Flammarion, 1992. 126 p., illus.

Details Pissarro's Parisian cityscapes. Bibliographical references, p. 29.

1088. BENSUSAN-BUTT, JOHN. *On Naturalness in Art; A Lecture Based on the Sayings of Painters and Others, with a Postscript on Aesthetics and Index of Sources.* Colchester, England: J. Bensusan-Butt [Wellingborough, Northants: Skeleton's Press], 1981. 64 p., 2 illus.

Text of a lecture that presents sayings of artists from the 11th century to Picasso, including quotations from Pissarro, delivered to art history students at Essex University in March 1978.

1089. BERNARD, BRUCE, ed. *The Impressionist Revolution.* London: Orbis, 1986. 272 p., 254 illus., 250 col.

Traces the evolution of Impressionism by focusing on the careers of seven principal founders, including Pissarro. Annotations on 135 masterworks appear separately after the illustrations.
a. French ed.: *La Révolution impressionniste.* Traduit de l'anglais par Denis-Armand Canal. Paris: Herscher, 1991. 270 p., illus.

1090. BOULTON, ALFREDO. *Camille Pissarro en Venezuela.* Caracas: Editorial Arte, 1966. 97 p., illus. Summary in French and English.

Details Pissarro's years in Venezuela, 1852-54, where he studied with Frederick Melbye. "Frederick Siegfried George Melbye, Elsinore 1826-Shanghai 1896: su obra en Venezuela," pp. 57-65.
Review: T. Crombie, *Apollo* new ser. 96(Aug. 1972):169.

1091. BRETTELL, RICHARD R. *Pissarro and Pontoise: The Painter in a Landscape.* Ph.D. diss., Yale University, 1977. 474 p., illus., 72 pl.

Examines the relationship between the town of Pontoise and landscape paintings executed there by Pissarro from 1866 to 1883. The first part is critical, the second historical. The final chapter deals with Pissarro's detachment from his environment.
a. Published ed.: With assistance from Joachim Pissarro. New Haven: Yale University Press, 1990. 227 p., illus.; bibliography, pp. 218-22.
b. French ed.: *Pissarro et Pontoise: un peintre et son paysage.* Traduit de l'anglais par

Solange Schnall. Pontoise: Editions du Valhermeil, 1991. 226 p., 172 col. illus.
Reviews: P. Smith, *Times Literary Supplement* 4579 (4 Jan. 1991): 7; C. Campbell, *Burlington Magazine* 133:1057(Apr. 1991):264-5; G. Pollock, *Oxford Art Journal* 14:2(1991):96-103.

1092. BRETTELL, RICHARD R. and CHRISTOPHER LLOYD. *A Catalogue of the Drawings of Camille Pissarro in the Ashmolean Museum, Oxford.* Oxford: Clarendon Press; NY: Oxford University Press, 1980. 225 p., 500 illus., 234 pl.

Catalogue raisonné of 378 Pissarro drawings in the Ashmolean Museum, Oxford. The introduction describes the collection's origin and significance, aspects of Pissarro's drawings, material and techniques, and collaborations with his son Lucien. Includes full catalogue entries, descriptions, and black-and-white reproductions.
Reviews: J. House, *Times Literary Supplement* (7 Nov. 1980):1259-60; V. S. Pritchett, *New York Review of Books* 28:8(14 May 1981):8-12; B. Shapiro, *Master Drawings* 20:4(Winter 1982):393-8; D. Thistlewood, *Journal of Aesthetics and Art Criticism* 21:4(Autumn 1981): 378-380; R. Thompson, *Burlington Magazine* 124: 1948(March 1982):163-164; R. Shiff, *Art Bulletin* 66(Dec. 1984):681-90.

1093. BRETTELL, RICHARD R. *An Impressionist Legacy: The Collection of Sara Lee Corporation.* NY: Abbeville; dist. in the U.K. and Europe by pandemic, London, 1986. 127 p., 80 col. illus.

Catalogue raisonné of the collection of paintings and sculpture on permanent display at the Chicago headquarters of the Sara Lee Corporation, acquired from the personal collection of the company's founder, Nathan Cummings. Includes works by Pissarro.
a. 2nd ed.: 1987. 127 p., col. illus.
b. 3rd ed.: 1990. 152 p., col. illus.

1094. BRIMO, ALBERT. *Auvers-sur-Oise, mémoire d'un village: C.-F. Daubigny, Cézanne, Pissarro, van Gogh, Zadkine et les autres.* Editions de la Butte aux Cailles, 1990. 167 p., illus.

1095. BROWN, RICHARD FARGO. *The Color Technique of Camille Pissarro.* Ph.D. diss., Harvard University, 1952; 1980. 302 p.

Examines Pissarro's use of color throughout his career. Includes a 13-page bibliography.

1096. CATE, PHILLIP DENNIS. *From Pissarro to Picasso: Color Etching in France: Works from the Bibliothèque nationale and the Zimmerli Art Museum.* New Brunswick, NJ: Zimmerli Art Museum; Paris: Flammarion, 1992. 198 p., illus.

Reviews: B. Walker, *Apollo* new ser. 136(Nov. 1992):342; Q. Blake, *Times Literary Supplement* 4683(1 Jan. 1993):15.

1097. CEZANNE, PAUL. *Paul Cézanne: correspondance.* Recueillie, annotée et préfacée par John Rewald. Paris: B. Grasset, 1937. 316 p., illus., 47 pl.

Selection of letters from Cézanne to family, friends, and fellow-artists including Zola and Pissarro, dating from 1858 to 1906.
a. Another ed.: Paris: Editions Grasset et Fasquelle, 1978.

b. English eds.: *Paul Cézanne: Letters.* Trans. by Marguerite Kay. London: B. Cassirer, 1941. 308 p., pl.; Oxford: B. Cassirer, 1976. 374 p.
c. U. S. eds.: NY: Hacker Art Books, 1976, 1984; NY: Da Capo Press, 1995. 376 p., illus.
d. Finnish ed.: *Paul Cézanne: Kirjeenvaihto.* Suomen Taiteilijaseura, 1984. 342 p., 18 illus.

1098. CHARDEAU, JEAN. *Les Dessins de Caillebotte.* Présentés par Jean Chardeau. Préface de Kirk Varnedoe. Paris: Hermé, 1989. 127 p., 19 illus, 84 col.

Presents Gustave Caillebotte's preparatory drawings that reveal both his adherence to an academic approach and his striking perspectives. Situates him firmly in the Impressionist movement and reproduces correspondence between Degas and Pissarro.

1099. COGNIAT, RAYMOND. *Pissarro.* Paris: Flammarion, 1974. 95 p., illus. (Les Maîtres de la peinture moderne)

Popular illustrated biography of Pissarro useful for reproductions. Bibliography, p. 93.
a. U.S. eds.: Trans. by Alice Sachs. NY: Crown Publishers, 1975, 1977, 1981, 1983; Norwalk, CT: Easton Press, Collector's ed., 1982, 1988.

1100. CRESPELLE, JEAN-PAUL. *La Vie quotidienne des impressionnistes: du Salon des refusés (1863) à la mort de Manet (1883).* Paris: Hachette, 1981. 286 p.

Places Impressionism in French cultural life by piecing together letters, souvenirs, and testimonies of the artists and their acquaintances. Includes a chronology of principal events over a 20-year period and a bibliography.

1101. DAIX, PIERRE. *Paul Gauguin.* Paris: J.-C. Lattès, 1989. 418 p., illus., 16 pl.

Biography of Gaugin (1848-1903) that studies his early life, development as an artist, and relationship with Pissarro.

1102. DELTEIL, LOYS. *Camille Pissarro, Alfred Sisley, Auguste Renoir.* Paris: Chez l'auteur, 1923. 1 vol. (Le Peintre-graveur illustré; XIXe et XXe siècles, tome 17)

Catalogue of engravings of French artists of the 19th and early 20th centuries; volume 17 of Delteil's 31-volume illustrated catalogue published in Paris from 1906 to 1930. See also J. Cailac, "The Prints of Camille Pissarro; a Supplement to the Catalogue by L. Delteil," *Print Collector's Quarterly* 19(Jan. 1923):74-86.

1103. DOBELL, STEVE. *Pissarro, 1830-1903.* London: Pavillon, 1995. 44 p., col. illus.

1104. DOESER, LINDA. *The Life and Work of Pissarro: A Compilation of Works from the Bridgeman Art Library.* London: Parragon, 1994. 79 p., col. illus.
Brief study of Pissarro followed by a catalogue of works in the Bridgeman Art Library, London.

1105. DUNSTAN, BERNARD. *Painting Methods of the Impressionists.* NY: Watson-Guptill, 1976. 184 p., illus., 33 col.

Concentrates on 19th century artists from a painter's perspective (Dunstan is a British painter) that shows how the artists worked in their studios and selected subject matter. Observations

on Monet, Renoir, Degas, and Pissarro form the core of the work. Bibliography, p. 180.
a. Revised ed.: 1983. 160 p., 210 illus., 176 col.
b. Chinese ed.: 1982. 215 p., illus.

1106. DURET, THEODORE. *Histoire des peintres impressionnistes: Pissarro, Claude Monet, Sisley, Renoir, Berthe Morisot, Cézanne, Guillaumin.* Paris: H. Floury, 1906. 208 p., illus., pl. Edition de luxe: cent exemplaires numerotés sur papier du Japon.

Duret's famous early study of Impressionism that includes a chapter on Pissarro.
a. Other eds.: 1919, 1922.
b. German eds.: *Die Impressionisten.* Berlin: Cassirer, 1909. 220 p., illus., 12 pl.; 1914, 1918, 1920, 1923.
c. English eds.: *Manet and the French Impressionists.* Trans. by J. E. C. Flitch. London: G. Richards, 1912. 256 p., illus, 38 pl.
d. U.S. eds.: Philadelphia: J. B. Lippincott, 1912. 256 p., illus.; Freeport, NY: Books for Libraries Press, 1971.

1107. DUVIVIER, CHRISTOPHE and GERARD BOUTE. *Armand Guillaumin, 1841-1927: les années impressionnistes.* Pontoise: Musée Pissarro, 1991. 79 p., illus.

Exhibition catalogue (shown 5 Oct.-17 Dec. 1991) of works by Pissarro's friend and early Impressionist colleague.

1108. ELIAS, JULIUS. *Camille Pissarro.* Berlin, 1914.

1109. FERMIGIER, ANDRE. *Turpitudes sociales: Pissarro et l'anarchie.* Geneva: Editions d'Art Albert Skira, 1972. 28 p., illus.

Includes a pamphlet (8 p.) by Fermigier, "Pissarro et l'anarchie."

1110. FOLEY, RUTH. *Camille Pissarro's 'Turpitudes sociales': Documents of History.* 1982.

1111. FRANCASTEL, PIERRE. *Monet, Sisley, Pissarro.* Texte de Pierre Francastel. Paris: A. Skira, 1939. 16 p., illus., 13 col. pl. (Les Trésors de la peinture française. XIX^e siècle, no. 13)

a. Other eds.: 1946, 1948.
b. U.S. ed.: NY: French and European Publications, 1939.

1112. FRANCISCONO, MARCEL MICHAEL. *The Divisionist Paintings of Camille Pissarro.* M.A. thesis, New York University, Institute of Fine Arts, 1959.

1113. FRASCINA, FRANCIS, et al. *Modernity and Modernism: French Painting in the Nineteenth Century.* New Haven; London: Yale University Press; Open University, 1993. 297 p., illus.

Examines Realism, Impressionism, and Post-Impressionism in France with particular emphasis on Manet, Monet, Cézanne, Pissarro, and Morisot.

1114. *French Impressionistic Painters: Pissarro, Raffaëlli, Renoir, and Sisley. A*

Scrapbook of Reproductions of Paintings, etc. NY: New York Public Library, 1931. 1 vol. unpaged.

1115. GACHET, PAUL, ed. *Lettres impressionnistes: Pissarro, Cézanne, Guillaumin, Renoir, Monet, Sisley, Vignon, van Gogh, et autres: M^mes Pissarro, Lucien Pissarro...*ornées de 16 portraits. Paris: B. Grasset, 1957. 188 p., illus., 16 pl.

1116. GAUGUIN, PAUL. *Correspondance de Paul Gauguin: documents, témoignages.* Edition établie par Victor Merlhès. Paris: Fondation Singer-Polignac, 1984-. 3 vols. (vol. 1:561 p., 74 illus.)

First of three projected volumes that presents 194 Gauguin letters, 1873-88, 139 fully transcribed from original documents. Includes more than 50 previously unpublished letters from Gauguin to Pissarro, 1879-86.
Review: R. Pickvance, *Burington Magazine* 127:987(June 1985):394-5.

1117. GERHARDT, E. *Camille Pissarro, peintre et anarchiste.* Diplôme de l'Ecole des hautes études en sciences sociales, Université de Paris, 1980.

1118. GIRIEUD, J., ed. *Les Amis des monuments Rouennais; pour la maison du XV^e siècle de la rue Saint-Romain, protestations.* Rouen, 1900.

Includes a letter from Pissarro urging preservation of historic structures in Rouen.

1119. GLATZ, ANTON C. *Ladislav Mednyānszky a Strāžky.* Bratislava: Slovenskā Nārodnā Galēria, 1990. 101 p., 72 illus., 8 col.

Exhibition catalogue of paintings by Ladislav Mednyānszky (1852-1919) dating from 1873-1918 that considers the influence of Pissarro and Sisley on the artist.

1120. GORE, FREDERICK and RICHARD SHONE. *Spencer Frederick Gore 1878-1914.* Exh. cat, London, Anthony d'Offay Gallery (11 Feb.-30 March 1983). 70 p., 68 illus.

Catalogue of an exhibition of oil paintings by Gore that mentions Pissarro's influence.

1121. GOTTHARD, JEDÖCLA. *Pissarro.* Paris, 1924.

1122. GRABER, HANS. *Impressionisten-Briefe. Camille Pissarro, Alfred Sisley, Claude Monet, Auguste Renoir.* Basel: B. Schwabe, 1934. 128 p., illus., 15 pl.

1123. GRABER, HANS. *Camille Pissarro, Alfred Sisley, Claude Monet, nach eigenen und fremden Zeugnissen.* mit vierzig Tafeln. Basel: B. Schwabe, 1943. 322 p., illus., pl.

See pages 19-107 for the section on Pissarro's life and work.

1124. GUERMAN, MIKHAIL. *Kamil' Pissarro. Albom.* Tekst na angl. Avtor-sosr. Moscow: Aurora, 1973.

a. U.S. ed.: *Camille Pissarro.* Translated from the Russian by Mark Ashworth. NY: H.N. Abrams; Leningrad: Aurora art Publishers, 1979. 14 p., illus, 14 pl. (Masters of World Paintings)

1125. GÜNTHER, H. *Camille Pissarro.* Munich; Vienna; Basel: K. Desch, 1954.

1126. HAVEN, SHELLEY. *Camille Pissarro: An Investigation of his Intaglio Prints.* M.A. thesis, University of Iowa, 1976. 41 p.

1127. HEMMINGS, FREDERIC WILLIAM JOHN. *The Life and Times of Emile Zola.* London: Paul Elek, 1977. 192 p, 75 illus.

Biography of Zola that relates his friendship with Cézanne, Pissarro, and other Impressionists, including his disillusionment with the movement as demonstrated in later art criticism and in his 1886 novel, *L'Oeuvre.*
a. U.S. ed.: NY: Scribner, 1977.

1128. HESS, WALTER. *Das Problem der Farbe in den Selbstzeugnissen der Maler von Cézanne bis Mondrian.* Munich: Prestel, 1953. 194 p., illus.

Analysis of color controversies in the late 19th and early 20th centuries drawn from artists' statements, including several by Signac and Seurat.
a. 2nd ed.: Mittenwald: Mäander, 1981. 203 p., 3 illus.
Review: H. Matile, *Panthéon* 44:1(Jan.-March 1983):88-9.

1129. HITZEROTH, WOLFRAM. *Paul Baum (1859-1932): ein Leben als Landschaftsmaler.* Marburg: Hitzeroth Verlag, 1988. 603 p., illus.

Detailed study of the German Impressionist Paul Baum that notes Pissarro's influence in Baum's use of pointillism in his landscapes.

1130. HOLL, J.-C. *Camille Pissarro et son œuvre.* Paris: H. Daragon, 1904.

Compilation of articles and criticism on Pissarro previously published (see *L'Oeuvre d'art international* 7(Oct.-Nov. 1904):129-56).

1131. HOUSE, JOHN. *Impressions of France; Monet, Renoir, Pissarro, and their Rivals.* With contributions from Ann Dumas, Jane Mayo Roos, and James F. McMillan. Boston: Museum of Fine Arts, 1995. 304 p., illus.

Exhibition catalogue (London, Hayward Gallery and Boston, Boston Museum of Fine Arts, 1995-96) that traced the development of Salon landscapes and Impressionist landscapes from 1860 to 1890.

1132. HOUSSIN, MONIQUE. *Lettres de peintres.* Préface de François Nourissier. Paris: Messidor, 1991. 215 p., 60 illus., 33 col.

Anthology of letters by painters, including Pissarro. Houssin's general introduction is followed by reproductions of the letters and notes on recipients.

1133. HUDA, VELIA. *Camille Pissarro.* London: Knowledge Publications, 1967. 8 p., illus., 16 pl. (The Masters, no. 72)

Brief biography of Pissarro with representative plates of major works. Includes bibliographical references, p. 3.

1134. *The Impressionists: Renoir, Manet, Monet, Pissarro, Sisley, Degas.* Paris: Les Editions du Chêne, 1950. 4 p., 8 col. pl. (Museum of Masterpieces)

1135. IOUDENITCH, INGA VADIMOVNA. *Pēzazhi Pissarro v Ēritazhe.* Leningrad: Izdvó Gos. Ērmitazha, 1963. 23 p., illus.

Deals with Pissarro's landscapes in The Hermitage Museum, St. Petersburg.
a. French ed.: *Paysage de Pissarro à l'Hermitage.* Leningrad: Aurora, 1963.

1136. IWASAKI, YOSHIKAZU and TAKESHI KASHIWA. *Pissarro.* Textes de Yoshikazu Iwasaki, Takeshi Kashiwa. Tokyo: Senshukai, 1978. 87 p., 35 col. illus. (Les Peintres impressionnistes, no. 2)

1137. JARVIS, J. A. *Camille Pissarro.* Virgin Islands, 1947.

1138. JEDLICKA, GOTTHARD. *Pissarro.* Bern: A. Scherz, 1950. 31 p., illus., 53 pl.

Plate-book arranged chronologically with brief text.

1139. JUSZCZAK, WIESLAW, comp. *Teksty o mlarzach: antologia polskiej Krytyki artystycznej, 1890-1918.* Zakland Narodowy im. Ossolīnskich, 1976. 478 p.

Collection of essays by Polish critics on various topics of art written between 1890 and 1918 published by the Polish Academy of Sciences. They refer primarily to Polish artists but also mention foreign painters such as Pissarro.

1140. KAKISU, TSUNEAKI. *The Family Tree of Painting.* NY: Philosophical Library, 1982. 154 p., illus.

Offers a new critical theory of painting based on creative work in photography and discusses its application to the work of Pissarro, Cézanne, and other artists.

1141. KATES, LAURA RHODA. *Camille Pissarro and Neo-Impressionism.* M.A. thesis, University of California, Berkeley, 1975. 84 p., illus.

Bibliography, pp. 57-62.

1142. KOENIG, LEO. *Kamil Pisaro.* Paris: Le Triangle, 1927. 16p., illus., 12 pl. In Yiddish.

1143. KUNSTLER, CHARLES. *Paul-Emile Pissarro.* Trente-neuf reproductions de tableaux dont trois portraits par C. Pissarro. Paris: Girard & Brunino, 1928. 515 copies.

Biography of one of Camille Pissarro's sons, also an artist, that includes reminiscences of painting with his father.

1144. KUNSTLER, CHARLES. *Pissarro; villes et campagnes.* Lausanne: International Art Book, 1967. 67 p., 28 col. pl. (Rythmes et couleurs, vol. 11)

Brief anecdotal coverage of Pissarro's city and landscapes. Bibliography, pp. 63-4.

a. U.S. ed.: *Pissarro; Cities and Landscapes.* NY: French & European Publications, 1967. 64 p., col. illus.

1145. KUNSTLER, CHARLES. *Camille Pissarro.* Milan: Fratelli Fabbri, 1972. 96 p., illus., some col. (Gli Impressionisti)

Most important for oversize reproductions of Pissarro's works.
a. French ed.: Paris: Diffusion Princesse, 1974. 95 p., illus.
b. English ed.: Trans. by Kerry Milis. London: Cassell, 1988. 94 p., illus.

1146. KUNSTLER, CHARLES. *Camille Pissarro.* Paris: G. Crès & Cie, 1930. 14 p., 32 pl. (Collection les Artistes nouveaux)

Plate-book with a brief biography and critical appraisal.

1147. KUNTER, JANET. "Texas Rangers: Dallas — Acquisitions are only Part of the Action." *ARTnews* 8:10(Dec. 1982):86-8. 7 illus.

Report of recent acquisitions by art museums and galleries in Dallas that mentions the gift of 38 paintings and sculptures from the Meadows Foundation, including works by Pissarro and Monet.

1148. KUROE, MITSUHIKO. *Pissarro, Sisley, Seurat.* Tokyo: Shueisha, 1973. In Japanese.

1149. LANGDON, HELEN. *Impressionist Seasons.* Oxford: Phaidon, 1986. 80 p., 40 illus., 32 col.

Presents 32 annotated examples of Impressionist works that have the seasons as their theme, including several by Pissarro.
a. U.S. ed.: NY: Universe Books, 1986.

1150. LANT, ANTONIA. *Pissarro, Degas and Cassatt as Printmakers.* Ph.D. diss., University of Leeds. 1979.

1151. LEARD, LINDSAY. *The Société des Peintres-graveurs: Printmaking 1889-1897.* Ph.D. diss., Columbia University, 1992. 616 p., illus.

Examines the establishment and activities of this society, founded in 1889 by Félix Bracquemond, Degas, Pissarro, Cassatt, Rodin, Redon, the critic Philippe Burty, and the dealer Paul Durand-Ruel to promote printmaking. Describes the society's six exhibitions and critical reactions. Bibliography, pp. 557-616.

1152. LECOMTE, GEORGES CHARLES. *L'Art impressionniste d'après la collection privée de M. Durand-Ruel.* Paris: Chamerot et Renouard, 1892. 270 p., 36 illus.

1153. LECOMTE, GEORGES CHARLES. *Camille Pissarro.* Paris: Bernheim-Jeune, 1922. 104 p., illus.

Biography and critical appraisal of Pissarro that includes firsthand observations and descriptions of the artist. The final chapter excerpts passages from letters by Pissarro to the critic Octave Mirbeau (1850-1917).

1154. LEYMARIE, JEAN and MICHEL MELOT. *Les Gravures des impressionnistes: Manet, Pissarro, Renoir, Cézanne, Sisley; œuvre complète.* Introduction par Jean Leymarie. Catalogue par Michel Melot. Paris: Arts et Métiers Graphiques, 1971. 325 p., illus., 290 pl., 14 col.

Catalogue of Pissarro's etchings, lithographs, and woodcuts, many in color reproductions.
a. U.S. ed.: *The Graphic Works of the Impressionists.* Trans. by Jane Brenton. NY: H. N. Abrams, 1972. 353 p., 445 illus., 17 col.
b. English ed.: London: Thames & Hudson, 1972. 353 p., 445 illus., 17 col.

1155. LLOYD, CHRISTOPHER H. *Pissarro.* Oxford: Phaidon; NY: Dutton, 1979. 16 p., col. illus., 48 pl.

Biographical and critical introduction followed by full-page color plates.

1156. LLOYD, CHRISTOPHER H. *Pissarro.* With notes by Amanda Renshaw. Oxford: Phaidon, 1979. 126 p., 48 col. illus. (Colour Library)

a. Another ed.: 1992.

1157. LLOYD, CHRISTOPHER H. *Camille Pissarro.* Geneva: Skira; London: Macmillan; NY: Rizzoli, 1981. 151 p., illus., 50 col.

Review: J. Pissarro, *Art Book Review* 2:5(1983):38.

1158. LLOYD, CHRISTOPHER H., ed. *Studies on Camille Pissarro.* London; NY: Routledge & Kegan Paul, 1986. 140 p., 67 illus.

Collection of ten essays, most of which originated as papers given at conference and lecture series held in conjunction with the 1980-81 retrospective exhibition *Pissarro* (held in London, Paris, and Boston). Includes Linda Nochlin, "Camille Pissarro: The Unassuming Eye"; John House, "Camille Pissarro's Idea of Unity"; Ralph E Shikes, "Pissarro; Political Philosophy and his Art"; Martin Reid, "The Pissarro Family in the Norwood Area of London, 1870-1"; Anne Distel, "Some Pissarro Collectors in 1874"; Christopher Lloyd, "Camille Pissarro and Rouen"; Françoise Cachin, "Some Notes on Pissarro and Symbolism"; Kathleen Adler, "Camille Pissarro: City and Country in the 1890s"; Michel Melot, "A Rebel's Role: Concerning the Prints of Camille Pissarro"; and Barbara Stern Shapiro, "Camille Pissarro, Rembrandt, and the Use of Tone."

1159. MA, FENG-LIN. *K'a-mi-erh Pi-sha-lo.* T'ien-chin: T'ien-chin jen min mei shu ch'u pan she, 1981. 12 p., illus., 28 pl.

1160. MACDUFFEE, ALLISON. *Camille Pissarro's Market and Fair Scenes, 1881-1895.* M.A. thesis, Queen's University, 1988. 237 p., illus.

1161. MAITRON, JEAN. *Le Mouvement anarchiste en France.* Paris: François Maspero, 1975. 2 vols.

1162. MALVANO, LAURA. *Camille Pissarro.* Milan: Fratelli Fabbri, 1965. 7 p., illus., 16 pl. (I Maestri del colore, 70).

a. French ed.: Paris: Hachette, 1967.

1163. MANET, JULIE. *Journal, 1893-1899: sa jeunesse parmi les peintres impressionnistes et les hommes de lettres.* Préface de Jean Griot. Paris: C. Klincksieck, 1979. 288 p., 8 illus., 4 pl.

Diary of Julie Manet (b. 1878), daughter of Eugène Manet and Berthe Morisot and niece of Edouard Manet, that spans the period from 1893, when she was 14, to 1899. Details her artistic formation, influences, and associations with painters (including Pissarro), authors, and politicians.
a. Other eds.: Introduction par Rosalind de Boland Roberts et Jane Roberts. Paris: Editions Scala, 1987. 200 p., illus.; 1988.
b. English ed.: *Growing up with the Impressionists: The Diary of Julie Manet.* London: Sotheby's; NY: Sotheby's; Harper & Row, 1987.
c. German ed.: *Das Tagebuch der Julie Manet: eine Jugend im Banne der Impressionisten.* Deutsch von Sybille A. Rott-Illfeld. Munich: Goldmann, 1990. 253 p., 2 illus.

1164. MANSON, JAMES BOLIVAR. *Camille Pissarro; a Lecture Delivered by the late James Bolivar Manson to the Ben Uri Art Society on January 23rd, 1944.* London: Gollancz, 1946. 18 p., pl.

1165. MAUCLAIR, CAMILLE. *Les Maîtres de l'Impressionnisme, son histoire, leur histoire, leur esthétique, leurs œuvres.* Paris: Ollendorf, 1923.

Revised edition of Mauclair's early writings on Impressionism.

1166. MCLEAVE, HUGH. *A Man and his Mountain: The Life of Cézanne.* London: W. H. Allen, 1977. 324 p.

Fictionalized biography of Cézanne that includes details of contacts with Pissarro, Renoir, and Zola.

1167. MCQUILLAN, MELISSA ANN. *Impressionist Portraits.* London: Thames and Hudson, 1986. 200 p., 138 illus., col.

Examines the portraits and self-portraits of major Impressionist painters, organized into three chronological sections from 1864 to 1886. Includes commentary on works by Pissarro.
a. U.S. ed.: Boston: Little, Brown, 1986.

1168. MEADMORE, WILLIAM SUTTON. *Lucien Pissarro: un cœur simple.* London: Constable, 1962. 251 p., illus.
Biography of Camille's son that includes family anecdotes.
a. U.S. ed.: NY: Knopf, 1963. 251 p., illus., 14 pl.

1169. MEIER, G. *Camille Pissarro.* Leipzig, 1965.

1170. MEIER-GRAEFE, JULIUS. *Impressionisten: Guys, Manet, Van Gogh, Pissarro,*

Cézanne. Mit einer Einleitung über den Wert der französischen Kunst und sechzig Abbildungen. Munich: R. Piper, 1907. 210 p., illus.

Reprints on pages 153-72 of Meier-Graefe's article on Pissarro first published in *Kunst und Künstler* 2(Sept. 1904):475-88.

1171. MELOT, MICHEL. *Estampe impressionniste.* Notices rédigées par Michel Melot. Paris: Bibliothèque Nationale, 1974. 183 p., illus.

History of Impressionism which focuses on contributions made by printmaking to its development. Studies prints by Pissarro and other artists in terms of social and economic conditions, techniques, and composition.
a. U.S. ed.: *The Impressionist Print.* Trans. by Caroline Beamish. New Haven; London: Yale University Press, 1996. 296 p., 300 illus., 60 col.

1172. MENDGEN, EVA A. *Künstler rahmen ihre Bilder: zur Geschichte des Bilderrahmens zwischen Akademie und Sezession.* Ph.D., Bonn University, 1991.

Deals with the history of artists' materials, picture frames, and framing techniques in the 19th century, including references to Pissarro and his contemporaries.
a. Published ed.: Konstanz: Hartung-Gorre, 1991. 433 p., illus.

1173. MIRBEAU, OCTAVE. *Des artistes: première série, 1885-1896. Peintres et sculpteurs. Delacroix, Claude Monet, Paul Gauguin, J.-F. Raffaëlli, Camille Pissarro, Auguste Rodin, etc.* Paris: E. Flammarion, 1922. 294 p.

Articles by Mirbeau, reprinted from various journals.

1174. MIRBEAU, OCTAVE. *Des artistes: deuxième série: peintres et sculpteurs 1897-1912, musiciens, 1884-1902: Claude Monet, Camille Pissarro, Vincent van Gogh, Auguste Rodin, César Franck, Gounod, Franz Servais, l'opéra, l'opérette.* Paris: E. Flammarion, 1925.

1175. MIRBEAU, OCTAVE. *Correspondance avec Camille Pissarro.* Edition établie, présentée et annotée par Pierre Michel et Jean-François Nivet. Tusson, Charente: Du Lérot, 1990. 219 p., illus., 8 pl.

Bibliography, pp. 211-12.

1176. MOORE, GEORGE. *Modern Painting.* London; NY: W. Scott, Ltd., 1893. 248 p.

See the chapter, "Monet, Sisley, Pissarro, and the Decadence."
a. Other eds.: 1898, 1900, 1913, 1923.
b. U.S. eds.: NY: C. Scribners 1893, 1894, 1923.

1177. MOORE, GEORGE. *Reminiscences of the Impressionist Painters.* Dublin: Maunsel, 1906. 48 p. (Tower Press Booklets, no. 3)

For information on Pissarro, see pages 39-41.

1178. MORICE, CHARLES. *Quelques maîtres modernes: Whistler, Pissarro, Fantin-Latour, Constantin Meunier, Paul Cézanne.* Paris: Société des Trente, 1914. 122 p.

Expanded version of earlier essays. For information on Pissarro, see pages 28-45.

1179. MRÀZ, BOHUMÍR. *Francouzští impresionisté: Kresby: Manet, Degas, Morisotová, Monet, Renoir, Sisley, Pissarro, Cézanne.* Prague: Odeon, 1984. 205 p., illus.

Study and catalogue of French Impressionist drawings. Bibliography, pp. 203-5.
a. German ed.: *Zeichnungen der französischen Impressionisten.* Übersetzt von Robert Bartos. Hanau: W. Dausien, 1985. 206 p., illus.
b. Spanish ed.: *Dibujos de impresionistas franceses.* Barcelona: Polígrafa, 1985. 209 p., illus.
c. French ed.: *Aquarelles et dessins impressionnistes.* Traduction du tchèque, Raphaël Rodriguez. Gennevilliers: Ars Mundi, 1987. 206 p., illus.

1180. NATANSON, THADEE. *Peints à leur tour.* Paris: A. Michel, 1948. 388 p., pl.

Personal reminiscences that includes a chapter on Pissarro.

1181. NATANSON, THADEE. *Pissarro.* Lausanne: Editions Jean Marguerat, 1950. 31 p., illus., 54 pl.

Biography and reminiscences of Pissarro illustrated with reproductions of major works. Bibliography, p. 29.

1182. NOCHLIN, LINDA. *The Politics of Vision: Essays on 19th Century Art and Society.* NY: Harper & Row, 1989. 200 p., 57 illus. (Icon Editions)

Nine essays that explore the interaction of art, society, ideas, and politics in the 19th century, including references to Pissarro.

1183. PAIEWONSKY, ISIDOR. *Jewish Historical Development in the Virgin Islands 1665-1959.* Isidor Paiewonsky, 1959. 24 p., illus.

Includes details about Pissarro's family history and his early life in St. Thomas, Virgin Islands.

1184. PASSERON, ROGER. *La Gravure impressionniste: origines et rayonnement.* Paris: Bibliothèque des Arts, 1974. 224 p., illus.

Overview of the graphic work of the Impressionists that includes examples by Pissarro.
a. English ed.: *Impressionist Prints: Lithographs, Etchings, Drypoints, Aquatints, Woodcuts.* London: Phaidon, 1974. 222 p., illus.
b. U.S. ed.: NY: Dutton, 1974. 222 p., illus.

1185. PATAKY, DĒNES. *Pissarro.* Budapest, 1972.

1186. PICA, VITTORIO. *Gl'impressionisti Francesi.* Bergamo: Istituto Italiano d'Arti Grafiche, 1908. 212 p., pl.

For information on Pissarro and Sisley, see pp. 125-38.

1187. PIERCE, PATRICIA JOBE. *Richard Earl Thompson, American Impressionist: A Prophetic Odyssey in Paint,* ed. by John Douglas Ingraham. San Francisco: Richard-James Publications, 1982. 244 p., illus.

Study of Thompson's (b. 1914) life and work that begins with a history of American Impressionism. Notes the debt to Pissarro and Monet for his divisionist style.

1188. PIETTE, LUDOVIC. *Mon cher Pissarro: lettres de Ludovic Piette à Camille Pissarro.* Commentaires de Janine Bailly-Herzberg; préface de Edda Maillet. Paris: Editions du Valhermeil, 1985. 143 p., illus., 8 pl.

Selected correspondence from Piette (1826-78) to Pissarro. Bibliography, p. 143.

1189. PIPER, DAVID. *Artists' London.* London: Weidenfeld and Nicolson, 1982. 160 p., 137 illus.

Surveys artistic views of London from the Middle Ages to the present. The chapter on 19th century artists includes references to Pissarro and examples of his London cityscapes.
a. U.S. ed.: NY: Oxford University Press, 1982.

1190. PISSARRO, JOACHIM. *Camille Pissarro.* New York: H. N. Abrams, 1993. 309 p., illus., some col.

Biography of Pissarro, written by his grandson.
a. French ed: Marigny-le-Châtel: Hermé, 1995. 312 p., 354 illus.; 205 col.

1191. PISSARRO, JULIE. *Quatorze lettres de Julie Pissarro.* Préface d'Edda Maillet. Pontoise: Amis de Camille Pissarro; La Ferté-Milon: L'Arbre, 1984. 28 p.

1192. PISSARRO, LUCIEN. *The Letters of Lucien to Camille Pissarro, 1883-1903,* ed. by Anne Thorold. Cambridge; NY: Cambridge University Press, 1993. 796 p., 181 illus.

Includes 361 letters from Lucien to his father sent from various residences in England published in French with extensive notes by Thorold in English at the end of each letter. Also includes a small number of letters from Lucien to his mother, Julie, and a few from his wife, Esther Bensusan, written around the time of Lucien's stroke in 1897. Illustrated with reproductions of engravings and block prints by Lucien.
Reviews: K. Adler, *Burlington Magazine* 131:1091 (1994): 121-122; N. Davenport, *Nineteenth Century French Studies* 23(Spring/Summer 1995):550-1.

1193. PISSARRO, LUDOVIC RODOLPHE and LIONELLO VENTURI. *Camille Pissarro, son art, son œuvre.* Paris: Editions Paul Rosenberg, 1939. 2 vols., 342 p., 1632 [i.e. 1688] pl. vol. 1, Texte; vol. 2, Planches.

Biography, catalogue, and critical analysis of Pissarro's œuvre. Text volume lists 1,664 paintings, gouaches, pastels, détrempes, and painted ceramics. Volume 2 contains 1,632 illustrations. Includes a comprehensive bibliography (vol. 1, pp. 311-32), arranged chronologically, that lists over 500 books, newspaper and periodical articles, reviews of

exhibitions, and ephemera published before 1939. Venturi wrote the critical study of Pissarro's work; the artist's son prepared the catalogue.
a. U.S. ed.: San Francisco: Alan Wofsy Fine Arts, 1989. 2 vols., illus. Selected bibliography by Martha Ward, vol. 1, pp. 343-54.

1194. *Pissarro.* Paris: Hachette, 1967. 8 p., illus., 16 pl. (Chefs-d'œuvre de l'art, no. 62. Grands peintres)

1195. PREUTU, MARINA. *Pissarro: monografie.* Bucharest: Meridiane, 1974. 80 p., illus. (Maēstrii artei universale)

Bibliography, p. 79.

1196. RECCHILONGO, BENITO. *Camille Pissarro: grafica anarchia.* Rome: Istituto della Enciclopedia Italiana, 1981. 152 p., illus., 37 pl. (Bibliotheca biographica, 26)

1197. REID, MARTIN. *Pissarro.* London: Studio, 1993. 144 p., illus.

1198. REWALD, JOHN. *Camille Pissarro au Musée du Louvre.* Paris; Brussels: Editions Marion, 1939. 24 p., 10 col. pl.

Color plates accompanied by brief text.
a. English ed.: Paris: Marion Press, 1939. 26 p., col. illus.

1199. REWALD, JOHN. *Pissarro.* Paris: Braun; NY: E. S. Herrmann, 193?. 60 p., 60 illus. (Collection Les Maîtres)

Chronologically arranged plate-book.

1200. REWALD, JOHN. *Camille Pissarro (1830-1903).* Paris: Flammarion, 1954. 1 vol., illus. (Le Grand art en livre de poche, of 18)

Bibliography, p. 74.
a. U.S. ed.: NY: H.N. Abrams, in assoc. with Pocket Books, 1954. 74 p., illus.

1201. REWALD, JOHN. *Pissarro.* Paris, 1962.

1202. REWALD, JOHN. *Camille Pissarro.* London: Thames and Hudson, 1963. 160 p., illus., 48 col. pl. (Library of Great Painters)

Heavily illustrated account of Pissarro's life and career that includes full-page color plates and documentary photographs. Selected bibliography, p. 160.
a. Another ed.: "Concise ed.," London: Thames and Hudson, 1991. 126 p., illus.
b. Japanese ed.: Tokyo: Bijutsu Shuppan-sha, 1968. 161 p.
c. Italian ed.: Milan: Garzanti, 1983. 162 p., 120 illus., 48 col.
d. U.S. ed.: NY: H.N. Abrams, 1989. 126 p., illus.
Reviews: N. Kent, *Arts Magazine* 38(Feb. 1964):66; *American Artist* 28(March 1964):18.

1203. REWALD, JOHN. *Studies in Impressionism,* ed. by Irene Gordon and Frances Weitzenhoffer. London: Thames and Hudson, 1985. 232 p., 119 illus., 8 col.

Includes an essay by Rewald on Pissarro, Nietzche, and Kitsch.
a. U.S. ed.: NY: Harry N. Abrams, 1986.
Reviews: R. Thomson, *Burlington Magazine* 128:997(April 1986):297-8; E. Thaw, *New Republic* 194:26(30 June 1986):40-1; J. House, *Art History* 9:3(Sept. 1986):369-76.

1204. RITTMAN, ANNEGRET. *Die Druckgraphik Camille Pissarros*. Ph.D. thesis, Münster (Westfalen) University, 1989.

a. Printed ed.: Frankfurt am Main; Bern; New York; Paris; P. Lang, 1991. 395 p., illus.

1205. ROFFO, STEFANO, ed. *Camille Pissarro*. NY: Gramercy Books, 1994. 92 p., col. illus. (Gramercy Great Masters)

Heavily illustrated biography of Pissarro.

1206. ROGER-MARX, CLAUDE. *Camille Pissarro, graveur*. Portrait inédit de l'artiste dessiné et gravé sur bois par Lucien Pissarro. Paris: G. Gallimard, 1920. 63 p., pl. (pp. 13-63). (Les Graveurs français nouveaux, 1)

Biographical introduction followed by reproductions of Pissarro's prints. Bibliography, p. 11.
a. Another ed.: Paris: Editions de la Nouvelle Revue Française, 1929.

1207. ROSENTHAL, DONALD. *The Charlotte Dorrance Wright Collection, Philadelphia Museum of Art*. Philadelphia: Philadelphia Museum of Art, 1978. 48 p., 50 illus., 4 col.

Catalogue of a collection bequeathed to the museum of several generations of Impressionist and Post-Impressionist artists that includes works by Pissarro.

1208. ROSTRUP, HAAVARD. *Histoire du Musée d'Ordrupgaard, 1918-1978: d'après des documents inédits*. Traduction anglaise de Janet Ronje et française de François Marchetti. Copenhagen: Gyldendals, 1981. 103 p., 42 illus., 24 col. Summaries in French and English.

History of the museum's collection of 19th century French and Danish art founded by Wilhelm Hansen and now a state museum. Includes representative holdings by Pissarro.

1209. ROUX, PAUL DE. *Pissarro: villes et campagnes*. Paris: Herscher, 1995. 64 p., col. illus. (Le Musée miniature)

Includes bibliographical references, p. 64.

1210. RYAN, MAUREEN. *Peasant Painting and its Criticism in France, 1875-1885: Themes and Debates*. Ph.D. diss., University of Chicago, 1986. 320., illus.

1211. SCHIRRMEISTER, ANNE. *Camille Pissarro*, ed. by Anne Coffin Hanson and Joanna Ekman. Mount Vernon, NY: Artist's Limited Edition, 1982. 18 p., col. illus., 15 pl. (Medaenas Monograph on the Arts)

1212. SEIBERLING, GRACE. *Monet in London*. Atlanta: High Museum of Art; Seattle:

dist. by the University of Washington Press, 1988. 104 p., 70 illus., 37 col.

Catalogue of an exhibition of Monet's paintings of London from his first visit with Pissarro in 1870-71, held at Atlanta's High Museum of Art (9 Oct. 1988-8 Jan. 1989).

1213. SELIGMAN, PATRICIA. *Pissarro.* Secaucus, NJ: Chartwell Books, 1989. 64 p., col. illus. (History and Techniques of the Great Masters)

1214. SHANES, ERIC. *Impressionist London.* NY; London; Paris: Abbeville, 1994. 184 p., 144 illus., 104 col.

Overview of Impressionism in London at the end of the 19th century that includes both British and foreign painters, such as Pissarro. Bibliography, pp. 176-8.

1215. SHIKES, RALPH E. and PAULA HARPER. *Pissarro: His Life and Work.* NY: Horizon Press, 1980. 362 p., 210 illus., 21 col.

Major biography and critical analysis of Camille Pissarro; includes a comprehensive bibliography, pp. 349-54.
a. English ed.: London: Quartett Books, 1980.
Reviews: T. Lask, *New York Times* (4 Jan. 1980):C22; A. Broyard, *New York Times* (11 July 1980):C26; J. Russell, *New York Times Book Review* (20 July 1980):7, 25; D. Burkhart, *Artweek* 11:32(4 Oct. 1980):16; P. Karmel, *Art in America* 68:8(Oct. 1980):15; J. House, *Times Literary Supplement* (7 Nov. 1980):1259-60; G. Weisberg, *ARTnews* 79:10(Dec. 1980):10; V. S. Pritchett, *New York Review of Books* 28:8(14 May 1981):8-12.

1216. SICKERT, WALTER R. *A Free House; or The Artist as Craftsman,* ed. by Osbert Sitwell. London: Macmillan, 1947. 361 p., illus., pl.

Includes reminiscences of Pissarro and comments on his work.

1217. SILVESTRE, PAUL-ARMAND. *Portraits et souvenirs, 1888-1891.* Paris: Charpentier, 1891. 366 p.

1218. SMITH, PAUL GERALD. *Impressionism, Beneath the Surface.* NY: H. N. Abrams, 1995. 176 p., illus., some col. (Perspectives)

Includes a chapter on Pissarro.

1219. SONN, RICHARD DAVID. *Anarchism and Cultural Politics.* Lincoln: University of Nebraska Press, 1989. 365 p., illus.

1220. STEIN, MEIR. *Idé og form: fransk kunst: fra barok til impressionisme.* Copenhagen: Krohn, 1981. 263 p., 66 illus. (Skrifter/Selskab for fransk Kunst, 1)

Essays on French art that include references to Pissarro.

1221. STONE, IRVING. *Depths of Glory: A Biographical Novel of Camille Pissarro.* With a portfolio of drawings by the Artist. Franklin Center, PA: Franklin Library, 1985. 647 p., illus., 16 pl. Limited edition signed by Stone.

Fictionalized account of Pissarro's life. Bibliography, pp. 639-47.
a. Trade eds.: Garden City, NY: Doubleday, 1985. 653 p.; NY: Plume, 1995.
b. English ed.: London: Bodley Head, 1985. 579 p.
c. German ed.: *Die Tiefen des Ruhms.* Zurich: Diana Verlag, 1985. 599 p.
d. Spanish eds.: *Abismos de gloria.* Buenos Aires: Emecé Editores, 1986. 535 p.; Barcelona: Plaza Janés, 1989.
e. Chinese ed.: *Kō wang feng liu.* Beijing: Kuo chi wen chū pan kung ssu, 1994. 660 p.
Review: *Art in America* 74(Feb. 1986):19.

1222. TABARANT, ADOLPHE. *Pissarro.* 40 planches hors-text en héliogravure. Paris: Editions F. Rieder, 1924. 63 p., illus., 40 pl. (Maîtres de l'art moderne)

Early biography and appreciation of Camille Pissarro with black-and-white plates. Details Pissarro's early Impressionist career, based on the papers of Eugène Murer (1846-1906) and on information suppled by the artist's family. "Note bibliographique," p. 60.
a. Another eds.: 1931.
b. English ed.: Trans. by J. Lewis May. London: John Lane; The Bodley Head, 1925. 63 p., 40 pl.
c. U.S. ed.: NY: Dodd, Mead, 1925. 63 p., 40 pl.

1223. VENTURI, LIONELLO, comp. *Les Archives de l'impressionnisme. Lettres de Renoir, Monet, Pissarro, Sisley et autres. Mémoires de Paul Durand-Ruel. Documents.* Paris; NY: Durand-Ruel, 1939. 2 vols., pl.

Compilation of letters from Impressionist painters addressed to the dealer Paul Durand-Ruel that include his reminiscences. For letters from Pissarro to Durand-Ruel and to Octave Maus, see vol. 2, pp. 9-52, 232-40.
a. Reprint: NY: B. Franklin, 1968. 2 vols

1224. VENTURI, LIONELLO. *Impressionists and Symbolists: Manet, Degas, Monet, Pissarro, Sisley, Renoir, Cézanne, Seurat, Gauguin, van Gogh, Toulouse-Lautrec.* Translated from the Italian by Francis Steegmuller. NY: C. Scribner's 1950. 244 p., illus., 64 pl. (Modern Painters, 2)

a. Other eds.: NY: Cooper Square Publishers, 1973. 244 p., illus., 118 pl.

1225. VENTURI, LIONELLO. *De Manet à Lautrec: Manet, Degas, Monet, Pissarro, Sisley, Renoir, Cézanne, Seurat, Gauguin, van Gogh, Toulouse-Lautrec.* Florence: Del Turco, 1952. 217 p., illus. (Maestri moderni, 4)

Overview of French Impressionism and Post-Impressionism. Bibliography, pp. 191-205.
a. French ed.: Traduit de l'italien par Juliette Bertrand. Paris: Albin Michel, 1953. 313 p

1226. VOLKMAN, KARL FRANKLIN. *Camille Pissarro's 'Jardinère' (1884-1885) in the Context of his Early Genre Paintings: 1872-1886.* Ph.D. diss., Ohio State University, 1985. 332 p., illus.

Concentrates on the imagery and background of the four harvest scenes on ceramic tile that comprise Pissarro's *Jardinière: St. Martin's Fair at Pontoise, Potato Harvest, Apple Picking,* and *Female Peasant in a Cabbage Field.* Bibliography, pp. 237-57.

1227. WARD, MARY MARTHA. *Camille Pissarro in the 1880s.* Ph.D. diss., Johns Hopkins University, 1983. 414 p., illus.

Analyzes Pissarro's paintings in the 1880s and his efforts to synthesize Impressionism with a Neo-Impressionist technique. Includes Impressionist criticism, including an 1880 commentary by Zola, and examines letters by Pissarro and Gauguin. Bibliography, pp. 350-65.

1228. WARD, MARY MARTHA. *Pissarro, Neo-Impressionism, and the Spaces of the Avant-Garde.* Chicago: University of Chicago Press, 1996. 353 p., illus., 4 pl.

Examines how 1880s French art institutions, criticism, and marketing shaped Neo-Impressionism into paintings first modern avant-garde movement. Bibliography, pp. 331-7.

1229. WEIN, JO ANN. *Pissarro's Market Women: The Imagery of Social Relations in an Industrial Society.* Ph.D. diss., City University of New York, 1990. 432 p.

Examines Pissarro's portraits of market women created in the 1880s and notes that these works represent a growing political and sociological interest in the role of working women. Considers Degas' influence on Pissarro's portraiture and situates the works in the context of Pissarro entire œuvre.

1230. WHITE, BARBARA EHRLICH, ed. *Impressionism in Perspective.* Englewood Cliffs, NJ: Prentice-Hall, 1978. 165 p., 26 illus., 6 pl. (The Artist in Perspective; A Spectrum Book)

Includes essays on Pissarro's letters to his son Lucien and dealings with Matisse, as well as Richard F. Brown's essay, "Impressionist Technique: Pissarro's Optical Mixture" (pp. 114-21), which first appeared in *Magazine of Art* 43(Jan. 1950):12-5.

1231. WHITE, HARRISON C. and CYNTHIA A. WHITE. *Canvases and Careers: Institutional Change in the French Painting World.* New York; London: Wiley, 1965. 167 p.

Mentions business and financial aspects of Pissarro's career.
a. Another ed.: Chicago: University of Chicago Press, 1993. 173 p., illus.
b. French ed.: *La Carrière des peintres au XIXᵉ siècle: du système académique au marché des impressionnistes.* Préface de Jean-Paul Bouillon. Traduit par Antoine Jaccottet. Paris: Flammarion, 1991. 166 p., illus.

1232. WILDENSTEIN, DANIEL. *Claude Monet: biographie et catalogue raisonné.* Lausanne; Paris: Bibliothèque des Arts, 1974-91. 4 vols.

Includes transcriptions of letters from Monet to Pissarro.

1233. WILMERDING, JOHN, ed. *Essays in Honor of Paul Mellon, Collector and Benefactor.* Washington, D.C.: National Gallery of Art; dist. by Trevor Brown Associates, London and University Press of New England, 1986. 427 p., illus.

Collection of essays written as a tribute to Paul Mellon, collector of 19ᵗʰ century French

paintings. Includes a commentary on Pissarro's *Seated Peasant Women* by John House (pp. 155-71).

IV. Articles

Note: A comprehensive list of over 500 books, newspaper and periodical article reviews of exhibition, and ephemera dating 1863-1939, some not reproduced here, is available in Ludovic Rodolphe Pissarro and Lionello Venturi, *Camille Pissarro, son art, son œuvre* (Paris: Paul Rosenberg, 1939), vol. 1, pp. 311-32. For a more current and well-organized bibliography of Pissarro literature, see Ralph E. Shikes and Paula Harper, *Pissarro: His Life and Work* (NY: Horizon Press, 1980), pp. 349-54.

1234. ADAM, PAUL. "Peintres impressionnistes." *La Revue contemporaine* 4(April-May 1886):548-9.

1235. ADAM, PAUL. "Camille Pissarro" in *Petit bottin des lettres et des arts* (Paris: E. Giraud, 1886):98.

1236. ADHEMAR, HELENE. "Galerie du Jeu de Paume: dernières acquisitions." *Revue du Louvre et des musées de France* 23:4-5(1973):285-98. 16 illus.

Account of two impressive collections received by the Jeu de Paume Museum, Paris. The collection of Dr. Eduardo Mollard included six canvases by Pissarro. The Max and Rosy Kaganovitch collection also included paintings by Pissarro and Seurat.

1237. ADLER, KATHLEEN. "Cézanne's Bodies." *Art in America* 78:3(March 1990):234-7, 277 illus., 4 col.

Examines in part Pissarro's contention that Cézanne was not an Impressionist because no matter what he painted, "it was always the same picture."

1238. ADLER, KATHLEEN. "*Objets de luxe* or Propaganda? Camille Pissarro's Fans." *Apollo* 136:369(Nov. 1992):301-6. 6 illus. (2 col.)

Describes Pissarro's interest in decorating fans and their various subject matter. Pissarro's art fans range from crayon sketches to elaborate gouache designs on silk.

1239. ADLOW, DOROTHY. "Camille Pissarro." *Christian Science Monitor* (7 Sept. 1939).

1240. AF BUREN, JAN. "Borjan och Slutet på en Konstnarskarriar." *Konsthistorisk Tidskrift* 48:3(Dec. 1979):154-7. 4 illus.

Studies the influence of prints by Rembrandt and Pissarro on two etched self-portraits by Anders Zorn (1860-1920).

1241. ALEXANDRE, ARSENE. "Camille Pissaro [*sic*]." *Paris* (28 Feb. 1890). See also *Paris* (2 Feb. 1892) and (8 March 1894).

1242. ALEXANDRE, ARSENE. "Vues de Paris de M. Pissarro." *Le Figaro* (13 June 1898).

1243. ALEXANDRE, ARSENE. "Un mot sur Pissarro." *Comœdia* (22 Jan. 1910).

1244. ANZANI, GIOVANNI. "Cézanne, la coscienza critica della modernità." *Terzo Occhio* 21:4(Dec. 1995):32-6. 5 illus.

Overview of Cézanne's works and career that notes inspiration from Pissarro and Manet.

1245. "Artists and Works" in *The Peasant in French 19th Century Art*, ed. by James Thompson (Dublin: Douglas Hyde Gallery, Trinity College, 1980):99-163. 75 illus.

Mentions Pissarro's paintings of French peasant life, as one of 22 artists examined.

1246. "Au jour le jour: encore des peintres... Camille Pissarro." *Le Temps* (17 March 1893).

1247. AURIER, GABRIEL-ALBERT. "Camille Pissarro." *Revue indépendante* 14(March 1890):503-15.

1248. AUSTIN, LLOYD JAMES. "Mallarmé critique d'art" in *The Artist and Writer in France; Essays in Honor of Jean Seznec,* ed. by Francis Haskell, Anthony Levi, and Robert Shackleton (Oxford: Clarendon Press, 1974):153-62.

Discusses Mallarmé's art criticism and references to Pissarro in his influential article, "The Impressionists and Edouard Manet," *Art Monthly Review* (1876).

1249. AVRAMOV, DIMITUR. "Iz Istoriyata na edna Artistichna Epopeya, 2." *Problemi na Izkustvoto* 4(1974):32-46. 18 illus. In Bulgarian. Russian and French summaries.

Second part of an article on Impressionism that focuses on the lives of its most famous adherents, including Pissarro.

1250. BAILEY, MARTIN. "Théo van Gogh Identified: Lucien Pissarro's Drawings of Vincent and his Brother." *Apollo* 139:388(June 1994):44-6. 4 illus.

Concerns a drawing by Lucien Pissarro that the author believes portrays the van Gogh brothers. Comments on the relationship between the van Goghs and Lucien and Camille Pissarro.

1251. BAILLY-HERZBERG, JANINE. "Manzana—Pissarro 1871-1961: artiste 'charnière'." *Galerie Jardin des arts* 128(June 1973):70-3. 4 illus.

With reference to an exhibition held at the Galerie Dario Boccara, Paris, this article describes the life and career of Georges "Manzana" Pissarro, a son of Camille Pissarro, who painted Impressionist works until his father's death in 1903. Traces Manzana's changes in style and decorative work in furniture, glass, lacquers, and leather to his death in 1961. Brief extracts by contemporary critics accompany the text.

1252. BAILLY-HERZBERG, JANINE. "Essai de reconstitution grâce à une

correspondance inédite du peintre Pissarro au magasin que le fameux marchand Samuel Bing ouvrit en 1895 à Paris pour lancer l'Art nouveau." *Connaissance des arts* 283(Sept. 1975):72-81.

Recounts Samuel Bing's interest in and promotion of Art nouveau in Paris in the late 19th and early 20th centuries, based in part on unpublished letters of Pissarro. Pissarro and other Neo-Impressionists exhibited at Siegfried Bing's Galerie l'Art Nouveau, opened in 1895 in the rue Chauchat.

1253. BAILLY-HERZBERG, JANINE. "Camille Pissarro et Rouen." *L'Oeil* 312-3(July-Aug. 1981):54-9. 6 illus.

Examines Pissarro's sojourn in Rouen in October-November 1883 and the importance of the 13 canvasses and 22 engravings based on Rouennais subjects that he produced between 1883 and 1887. Comments that this urban experience introduced a gothic element into his art.

1254. BATES, HERBERT ERNEST. "French Painters: Pissarro and Sisley." *Apollo* 55(June 1952):176-80.

1255. BENISOVICH, MICHEL N. and JAMES DALLETT. "Camille Pissarro and Fritz Melbye in Venezuela." *Apollo* new ser., 84(July 1966):44-7. illus.

1256. BERALDI, HENRI. "Camille Pissarro" in *Les Graveurs du XIX^e siècle* (Paris: L. Conquet, 1891): vol. 11, pp. 12-4.

1257. BERG, ADRIAN and ANDREW LAMBIRTH (Interviewer). "Pissarro: Teeming Streets." *Royal Academy Magazine* 39(Summer 1993):30-3. 2 col. illus.

Interview with the painter Adrian Berg (b. 1929) in which he expresses his reactions to Pissarro's paintings exhibited in the traveling show *The Impressionist and the City* (1992-93). Berg comments on Pissarro's "honesty" and interest in portraying people.

1258. BERGER, JOHN. "From a Train Window." *Réalités* 280(March 1974):15-7. 1 illus.

Compares a landscape by Pissarro to a glimpse out of a moving train.

1259. BERMAN, AVIS. "Camille Pissarro: A Gentle Visionary of the Everyday." *Smithsonian* 12:3(1981):48-57.

General biographical article on Pissarro as a founding member of Impressionism, on the occasion of the 150th anniversary of his birth and a retrospective exhibition held at the Hayward Gallery, London.

1260. BERMUDEZ, LOLA. "Mirbeau—Pissarro: 'Le Beau fruit de la lumière'" in *Octave Mirbeau: Actes du colloque international d'Angers* du 19 au 22 septembre 1991, ed. by Pierre Michel and Georges Cesbron (Angers: PU d'Angers, 1992):91-100.

Discusses the association between Octave Mirbeau (1848-1917), secretary of the Belgian exhibition societies Les XX and La Libre Esthétique, and Pissarro.

1261. BERNIER, ROBERT. "Les Nouvelles installations et les collections du Los Angeles County Museum." *L'Oeil* 123(March 1965):36.

Illustrated with Pissarro's *Place du Théâtre Français* (1898).

1262. BERNIER, ROBERT. "Le Socialisme et l'art: peintres et sculpteurs." *La Revue socialiste* 13(1891):599-604.

1263. BESSON, GEORGE. "L'Impressionnisme et quelques précurseurs." *Bulletin des expositions* 3(22 Jan.-13 Feb. 1932).

Review of an exhibition of Impressionist paintings at Galerie d'Art Braun, Paris that includes the text of a letter by Pissarro.

1264. BLAYNEY-BROWN, DAVID. "Nineteenth-Century Drawings." *Apollo* 117:254(April 1983):308-11. 4 illus.

Overview of the collection of the 19th century drawings in the Ashmolean Museum, Oxford. The French section includes graphic works by Pissarro.

1265. BODELSEN, MERETE CHRISTENSEN. "Early Impressionist Sales, 1874-94, in the Light of Some Unpublished 'procès-verbaux.'" *Burlington Magazine* 110(June 1968):330-49.

1266. BODELSEN, MERETE CHRISTENSEN. "Gauguin, the Collector." *Burlington Magazine* 112:810(Sept. 1970):590-612. 13 illus.

Includes a catalogue of Gauguin's collection that lists work by Pissarro.

1267. BONAFOUX, PASCAL. "Regards croisés." *Connaissance des arts* 419(Jan. 1987):28-35. 9 col. illus.

Examines the popularity of exchanging artist portraits in the late 19th century as a mark of respect and opportunity to study each other's style. Artists discussed include Manet, van Gogh, Renoir, Bazille, Monet, Pissarro, and Degas.

1268. BOUILLON, JEAN-PAUL. "L'Impressionnisme." *Revue de l'art* 51(1981):75-85. 5 illus.

Survey of current criticism and publications on Impressionism that have resulted in a reappraisal and reassessment of the movement. Argues that newly published materials on major artists, including Pissarro, have added to new interpretations.

1269. BOULTON, ALFREDO. "Un Error sobre Camille Pissarro." *El Nacionál* (Caracas) (12 Nov. 1972).

1270. BOULTON, ALFREDO. "Camille Pissarro in Venezuela." *Connoisseur* 189:759(May 1975):36-42. 12 illus., 1 col.

Describes the young Pissarro's visit to Venezuela in 1852-54 with the Danish painter

Frederick Siegfried Georg Melbye and attempts to distinguish between their sketches. Pissarro's sketches anticipate certain Impressionist tendencies. A portrait sketch by Melbye is believed to be the only likeness of Pissarro before 1870.

1271. BOULTON, ALFREDO. "Un Error sobre Camille Pissarro." *Boletin Histórica* (Caracas), 38(May 1975):239-43.

Corrects an erroneous identification of Pissarro in a photograph reproduced in the author's book, *Camille Pissarro en Venezuela* (Caracas: Editorial Arte, 1966), by citing new evidence on sketches of the artist made by friends that show how Pissarro looked at the time of his visit.

1272. BOULTON, ALFREDO. "Camille Pissarro en Caracas, 1852-54." *Boletin de la Academia Nacional de la Historia* (Venezuela) 64:253(1981):21-8.

On the occasion of the 150th anniversary of Pissarro's birth in Charlotte Amelie, St. Thomas, Virgin Islands, the author recounts Pissarro's relationship with his great-grandfather and his stay in Venezuela as a young painter in 1852-54.

1273. BOUYER, RAYMOND. "Au paysage moderne avec Paul Huet, Pissarro, Sisley." *Bulletin de la Revue d'art* 57(April 1930):149-51.

1274. BRETTELL, RICHARD R. "The Cradle of Impressionism" in *A Day in the Country: Impressionism and the French Landscape*, ed. by A. P. A. Belloli (Los Angeles: Los Angeles County Museum of Art, 1983):79-87. 13 illus.

Describes the valley of the Seine west of Paris where early Impressionists Renoir, Monet, and Pissarro painted outdoors in the late 1860s. Gives reasons why they choose this area and comments on the small villages where they lived for various lengths of time – Bougival, Louveciennes, and Marly-le-Roi.

1275. BRETTELL, RICHARD R. "The Fields of France" in *A Day in the Country: Impressionism and the French Landscape,* ed. by A. P. A. Belloli (Los Angeles: Los Angeles County Museum of Art, 1983):241-7. 8 illus.
Relates Pissarro's series of paintings *The Four Seasons* (1872-73) to France's nationalistic pride in its agriculture industry, as well as Monet's paintings of haystacks and grain fields to the appreciation of harmony with nature.

1276. BRETTELL, RICHARD R. "Pissarro, Cézanne, and the School of Pontoise" in *A Day in the Country: Impressionism and the French Landscape,* ed. by A. P. A. Belloli (Los Angeles: Los Angeles County Museum of Art, 1983):175-82. 12 illus.

Concentrates on the School of Pontoise, a group of Impressionists led by Pissarro in the 1870s and 1880s, whose work was distinctly rural and criticized for its vulgarity of subject matter. Pontoise and environs played an important role not only in Pissarro's development as a painter but also in that of Cézanne (who was there in 1873-75 and 1879-82) and Gauguin (during the late 1870s and early 1880s).

1277. BRETTELL, RICHARD R. "Private Art for Private Lives" in *Heirs to Impressionism: André and Berthe Noufflard* (Memphis: Dixon Gallery and Gardens, 1988).

In this touring exhibition catalogue, Brettell's essay compares the Noufflard's art and outlook to Pissarro.

1278. BRETTELL, RICHARD R. "Pissarro in Louveciennes: An Inscription and Three Paintings." *Apollo* 136:369(Nov. 1992):315-9. 4 illus., 2 col.

Examines a notebook inscription and three paintings by Pissarro in Louveciennes, 1869-71, and describes the collaboration between Renoir and Monet in Louveciennes and Turner's influence on Pissarro. Provides details of Pissarro's time in the village and his interest in light and atmospheric effects there.

1279. BROOKNER, ANITA. "Pissarro at Durand-Ruel's." *Burlington Magazine* 104(Aug. 1962):363.

1280. BROUDE, NORMA F. "Macchiailioli as 'Proto-Impressionists'; Realism, Popular Science and the Re-shaping of *Macchia* Romanticism, 1862-1886." *Art Bulletin* 12:52(Dec. 1970):409. Illus.

Illustrated with Pissarro's *Landscape, Vicinity of Pontoise* and *In the Kitchen-Garden.*

1281. BROWN, RICHARD FARGO. "Impressionist Technique: Pissarro's Optical Mixture." *Magazine of Art* 43(Jan. 1950):12-5. Reprinted in Barbara E. White, ed., *Impressionism in Perspective* (Englewood Cliffs, NJ: Prentice-Hall, 1978):114-21.

1282. BRUNET, FREDERIC. "Une importante rétrospective: la réalité colossale de Cézanne." *Parcours* (Canada) 2:1(Autumn 1995):48-9. 2 col. illus.

With reference to the Cézanne retrospective at the Grand Palais, Paris (1995-96), Brunet considers the development of Cézanne's style and Pissarro's influence on him in 1872, when he introduced Cézanne to *plein air* painting.

1283. BUHOT, FELIX [pseud. Pointe-Sèche]. "Le Whistlerisme et le Pissarisme à l'exposition des XXXIII." *Le Journal des arts* (13 Jan. 1888).

1284. BURT, MARIANNA REILEY "Découverte: le pâtissier Murer, ami des impressionnistes." *L'Oeil* 245(Dec. 1975):54-61, 92. 13 illus.

Profiles the painter Eugène Murer (1846-1906), a baker and early collector of Impressionism whose friendship with leading Impressionists lasted into the 1890s. Includes extracts from correspondence with Pissarro.

1285. BURY, A. "Time Avenges." *Connoisseur* 145(March 1960):46.

Illustrated with Pissarro's *Louveciennes.*

1286. BURY, A. "Camille Pissarro." *Connoisseur* 147(March 1961):51.

Illustrated with Pissarro's *Jeanne Pissarro lisant.*

1287. CABANNE, PIERRE. "Un Pissarro pour un St. Honoré." *Bolaffiarte* 5:42(Summer 1974):60-2. 10 illus.

Describes the support of small collectors and admirers of Impressionism in the early 1870s.

1288. CACHIN, FRANÇOISE. "Un défenseur oublié de l'art moderne." *L'Oeil* 90(June 1962):54.

Illustrated with Pissarro's *Le Jardin d'Octave Mirbeau.*

1289. CACHIN-SIGNAC, GENEVIEVE. "Autour de la correspondance de Signac." *Arts* 7(Sept. 1951):8.

Includes the text of a letter from Pissarro to Signac.

1290. CAILAC, JEAN "The Prints of Camille Pissarro; a Supplement to the Catalogue by L. Delteil." *Print Collector's Quarterly* 19(Jan. 1932):74-86. illus.

Supplemental material to Loys Delteil's 1923 catalogue of Pissarro's prints.

1291. "Camille Pissarro. (1830-1903): la nature, son unique souci." *Jardin des arts* 208(March 1972): 58-61. 4 illus.

1292. "Camille Pissarro." *L'Art moderne* (7 Feb. 1892):47.

1293. "Camille Pissarro." *Connoisseur* 143(April 1959):116.

1294. "Camille Pissarro." *Apollo* 136:369(Nov. 1992):277-342.

Special issue devoted to the artist with 12 articles: MaryAnne Stevens, "The Urban Impressionist: Pissarro's Cityscapes: Series and Serialism," pp. 278-83; Christopher Lloyd "'Paul Cézanne, Pupil of Pissarro': An Artistic Friendship," pp. 284-90; John Rewald, "Pissarro's Paris and his France. The Camera Compares," pp. 291-4; Barbara Stern Shapiro, "Pissarro as Printmaker: Some Questions and Answers," pp. 295-300; Kathleen Adler, "*Objets de luxe* or Propaganda? Camille Pissarro's Fans," pp. 301-6; Richard Shiff, "The Work of Painting: Camille Pissarro and Symbolism," pp. 307-10; Christopher Campbell, "Pissarro and the Palette Knife: Two Pictures from 1867," pp. 311-4; Richard R. Brettell, "Pissarro in Louveciennes: An Inscription and Three Paintings," pp. 315-9; Joel Isaacson, "Pissarro's Doubt: Plein Air Painting and the Abiding Questions," pp. 320-4; Kristen L. Erickson, "A Continuing Collection: Recent Acquisitions by the Pissarro Archive in Oxford," pp. 325-7; "Pissarro and Photography? A Comparative Montage," pp. 328-9; Anne Thorold, "Learning from Pissarro: The Artist as Teacher," pp. 330-3. See also Joachim Pissarro, "Reading Pissarro," pp. 339-41.

1295. CAMPBELL, CHRISTOPHER B. "Pissarro and the Palette Knife: Two Pictures from 1867." *Apollo* 136:369(Nov. 1992):311-4. 3 illus., 1 col.

Concerns two works by Pissarro in 1867 that reveal his palette knife technique – *Still Life* and *Une place à La Roche-Guyon.* Comments on Courbet's palette knife technique and the influence that Pissarro and Cézanne had on each other and how Pissarro's work became more sophisticated and flexible after 1867.

1296. CARDON, L. "Camille Pissarro." *L'Evénement* (6 March 1894).

1297. "Le Centenaire de Pissarro." *Art et décoration* 56(Dec. 1929):supp. 14.

1298. CHAMPA, KERMIT SWILER. "Pissarro—the Progress of Realism" in *Studies in Early Impressionism* (New Haven: Yale University Press, 1973):67-79.

1299. CHAMPSAUR, FELICIEN. ["Camille Pissarro."] *Revue moderne et naturaliste* (Oct. 1880).

1300. CHARENSOL, GEORGES. "Notice sur Camille Pissarro" in *Dictionnaire biographique des artistes contemporains* (Paris: Art Edition,1934):vol. 3.

1301. COE, RALPH T. "Camille Pissarro in Paris: A Study of his Later Development." *Gazette des Beaux-arts* ser. 6, 43(Feb. 1954):93-118, 128-34. 17 illus. French summary.

1302. COE, RALPH T. "Camille Pissarro's *Jardin des Mathurins;* an Inquiry into Impressionist Composition." *Nelson Gallery Atkins Museum Bulletin* 4(1963):1-22.

1303. COOLUS, ROMAIN "A Pissarro." *La Revue blanche* new ser., 2(Feb. 1892):125.

Poem in tribute to Pissarro.

1304. COOPER, DOUGLAS. "Painters of Auvers-sur-Oise." *Burlington Magazine* 97(April 1955):100-5.

1305. CUNNINGHAM, CHARLES C. "Portraits by Pissarro and Carrière." *Wadsworth Atheneum Bulletin* ser. 4, 1(Spring 1958):15-7.

Illustrated with Pissarro's *Portrait of Minette.*

1306. DARWENT, CHARLES. "A Myth Exploded: Pissarro at the Burrell." *Country Life* 184:18 (May 1990):164. 1 illus.

1307. DAULTE, FRANÇOIS. "Les Impressionnistes de la collection Jaime Ortiz-Patino." *L'Oeil* 405(April 1989):40-5. 8 col. illus.

Describes Ortiz-Patino's family, background, and collection of Impressionist paintings, including works by Pissarro.

1308. DAULTE, FRANÇOIS. "Le Musée de Fukushima et ses collections." *L'Oeil* 354-5(Jan.-Feb. 1985):20-9. 18 illus.

Profiles the design and contents of the Fukushima Museum on the Island of Honshū in Japan, including works by Pissarro and other French Impressionists.

1309. DAVIS, F. "Haunting Vision of Spring." *Country Life* 163(9 March 1978):618. illus.
Illustrated with Pissarro's *Pruniers en fleurs.*

1310. DE BONILLA, NUÑEZ JOSE. "Camille Pissarro: un antillano de raices hispanohebreas." *Horizontes* (Puerto Rico) 25:50(1982):27-35.

Delves into Pissarro's family origins — birth on the Island of St. Thomas to Jewish parents, his father the nephew of his mother's first husband and the ensuing religious scandal — and the antisemitism he suffered during the Dreyfus affair.

1311. DE GRADA, RAFFAELE. "Il maestro degli Impressionisti." *Arte* 23:238(March 1993):92-7. 6 col. illus.

With reference to the traveling exhibition, *The Impressionist and the City: Pissarro's Series Paintings* (1992-93), De Grada discusses Pissarro's significance within the Impressionist movement as a teacher and his anarchist politics.

1312. DE LA VILLEHERVE, ROBERT. "Choses du Havre: les dernières semaines du peintre Camille Pissarro." *Havre Eclair* 1(25 Sept. 1904).

Newspaper account of the last weeks of Pissarro's life.

1313. DELANCON, JOEL. "Un défenseur oublié d'E. Manet et des peintres impressionnistes: Paul-Armand Silvestre (1837-1901)." *Gazette des Beaux-arts* 117:1466(March 1991):17-39. 8 illus.

Profiles the art critic Paul-Armand Silvestre's early recognition and support of Manet and the Impressionists, especially Manet, Pissarro, and Sisley.

1314. DENIS, MAURICE. "Camille Pissarro." *L'Occident* (Dec. 1903).

Reprinted in Denis' *Les Théories; 1890-1910* (Paris: Bibliothèque de l'Occident, 1912).

1315. DENOINVILLE, GEORGES. "Les Eaux-fortes originales de Camille Pissarro." *Byblis* 7:27(1928).

1316. DENVIR, BERNARD. "La Dolce vita." *Art and Artists* 13:4(Aug. 1978):12-7. 5 illus.
Overview of the late 19th century's *belle epoque* that shows how artists, particularly Pissarro, Bonnard and Matisse, responded by recording its images, self-indulgence, and material rewards.

1317. DENVIR, BERNARD. "Pissarro: Patriarch of Impressionism." *Royal Academy Magazine* 39(Summer 1993):26-9. 14 illus., 7 col.

Explains Pissarro's organizational and supportive activities in the Impressionist movement and how his ethical beliefs, atheism, socialism, anarchism, and idealism shaped relations with other artists and affected his paintings.

1318. DESCARS, C. "Les Maisons à pans de bois." *L'Oeil* 312-3(July-Aug. 1981):26-31. 10 illus.

Architectural tour and history of Rouen's wood-framed houses, whose façades and other features delighted Pissarro enough to record his pleasure in a letter to his son Lucien in 1869.

1319. "Dessins inconnus de Camille Pissarro: '*Turpitudes sociales*.'" *Labyrinthe* (15 Nov. 1944).

1320. DEWHURST, WYNFORD. "Camille Pissarro, Renoir, Sisley" in *Impressionist Painting* (London: G. Newnes, Ltd., 1904):49-56.

1321. DISTEL, ANNE. "Un achat par l'Etat d'estampes de Camille Pissarro en 1890, et les débuts d'un Cabinet des estampes au Musée du Luxembourg." *Nouvelles d'estampe* (March-April 1984):8-13. 2 illus.

Concerns two landscape etchings by Pissarro, now in the Musée d'Orsay, Paris.

1322. DORRA, HENRI. "Extraits de la correspondance d'Emile Bernard des débuts à la Rose+Croix (1876-1892)." *Gazette des Beaux-arts* 96:1343(Dec. 1980):235-42. 1 illus. Summary in English.

Presents excerpts from Bernard's letters that shed light on various painters, including Pissarro in 1892.

1323. DRUICK, DOUGLAS W. and PETER ZEGERS. "Degas and the Printed Image, 1856-1914" in *Edgar Degas: The Painter as Printmaker*, ed. by S. W. Reed and Barbara Stern Shapiro (Boston: Boston Museum of Fine Arts, 1984):xv-lxxii. 46 illus.

Account of Degas' involvement with printmaking that mentions never-realized plans with Mary Cassatt and Pissarro for an illustrated periodical.

1324. DUBOSC, GEORGES. "Le Peintre Pissarro à Rouen." *Journal de Rouen* (16 Nov. 1903).

1325. DUBOSC, GEORGES. "Camille Pissarro à Rouen." *Journal de Rouen* (6 Jan. 1924).

1326. DUHEM, HENRI. "Camille Pissarro, souvenirs." *Le Beffroi* (Dec. 1903). Reprinted in Duhem's *Impressions d'art contemporain* (Paris: E. Figuière, 1913).

1327. DUNSTAN, BERNARD. "Painters' Techniques in the Nineteenth Century: The Impressionist Period." *Artist* 90:2(Oct. 1975):60-3. 4 illus.

Concentrates on the Impressionists' *plein air* technique and their conception of when a painting was finished. Describes techniques of individual artists, including Pissarro.

1328. DUNSTAN, BERNARD. "Looking at Paintings with Bernard Dunstan." *American Artist* 42:428(March 1978):52-3. 2 illus.
Dunstan's analysis of Pissarro's *Bather in the Woods*.

1329. DURAND-RUEL SNOLLAERTS, CLAIRE. "Pissarro dans les villes." *Connaissance des arts* 497(July-Aug. 1993):50-5. 8 col. illus.

Considers the cityscapes Pissarro produced during the last ten years of his life (1893-1903), with reference to the exhibition *Pissarro: The Impressionist and the City* (1992-93). Describes his urban landscapes of Rouen, Dieppe, and Paris, and maintains that the most important series was that of Paris.

1330. DURET, THEODORE. "Camille Pissarro." *Gazette des Beaux-arts,* ser. 3, 32(1 May

1904):395-405. Expanded version in Duret's *Histoire des peintres impressionnistes* (Paris: H. Floury, 1906).

1331. EHRET, GLORIA. "Fondation Bemberg: zu einem neueroffneten Museum in Toulouse." *Weltkunst* 65:5(1 March 1995):593. 2 illus.

Short tour of Toulouse's new museum, Fondation Bemberg, and its collection which includes works by Pissarro.

1332. EISENDRATH, WILLIAM. N. "Paintings and Sculpture in the Collection of Mrs. Mark C. Steinberg." *Connoisseur* 154(March 1965):217.

Illustrated with a still-life by Pissarro.

1333. ELLERSIECK, B. J. "The Brahmin Impressionist: Lilla Cabot Perry." *Art Voices; South* 1:6(Nov.-Dec. 1978):61-2. 2 illus.

Profiles the U.S. painter who spent ten summers studying with Monet at Giverny, where she also became familiar with Pissarro's work.

1334. ERICKSON, KRISTEN L. "Orovida Camille Pissarro." *Women's Art Magazine* 41(July-Aug. 1991):12-3. 3 illus.

Biographical study of Orovida Pissarro (1893-1968), daughter of Lucien and granddaughter of Camille, that traces her development as an artist under her father's tutelage and enthusiasm for Near Eastern and Asian art.

1335. ERICKSON, KRISTEN L. "A Continuing Collection: Recent Acquisitions by the Pissarro Archive in Oxford." *Apollo* 136:369(Nov. 1992):325-7. 2 illus.

Describes the Pissarro archive at the Ashmolean Museum, Oxford, one of the premier centers for the study of Pissarro. Details post-1978 donations and describes recent acquisitions such as a woodblock drawings, correspondence, wills, manuscripts, anarchist books from Pissarro's library, as well as art and literary journals that belonged to Pissarro, some with original illustrations.

1336. ERICKSON, KRISTEN. "The Art of Orovida: Looking Beyond the Pissarro Family Legacy." *Woman's Art Journal* 15:2(Fall 1994-Winter 1995):14-20. 5 illus.

Profiles the British painter and etcher Orovida Pissarro (1893-1968), daughter of Lucien and granddaughter of Camille and the first female artist in the Pissarro family.

1337. ESPOSITO, CARLA. "Notes sur la collection d'un excentrique: les estampes du Dr. Gachet." *Nouvelles de l'estampe* 126(Dec. 1992):4-8. 6 illus.

Paul Gachet (1828-1909) was an engraver who collected Impressionist works, later donated by his son to the French state. Gachet began producing engravings in 1872 and influenced others, including Pissarro, to try the medium. His entire collection of over 1,000 works was auctioned in May 1993.

1338. EVANS, M. "Techniques of Painting, Pt. II; A Study of Impressionism." *Coronet* 6:2(1 June 1939).

1339. FAGUS, FELICIEN. "Petite gazette d'art: Camille Pissarro." *La Revue blanche* (1 April 1899).

1340. FAGUS, FELICIEN. "Notes sur Pissarro." *La Plume* (1 Dec. 1903).

1341. FELDMAN, MORTON. "After Modernism." *Art in America* 59(Nov.-Dec. 1971):68-77.

Illustrated with Pissarro's *Self-Portrait* (1898).

1342. FENEON, FELIX. "Cassatt, Pissarro." *Le Chat noir* (April 1891).

Reprinted in Fénéon's *Oeuvres plus que complètes,* ed. by Joan U. Halperin (Paris; Geneva: Halperin, 1970), vol. 1, pp. 185-86.

1343. FERMIGIER, ANDRE. "Pissarro et l'anarchie." 8 p.

Pamphlet tipped into Pissarro's *Turpitudes sociales* (reprint: Geneva: Skira, 1972).

1344. FIERENS, PIERRE. "Beaux-arts: Pissaro [sic]." *Journal des débats* 37(7 March 1930): 401-3.

1345. FLECK, ROBERT. "Zum Malen blieb ihm nur die Pause." *ART: das Kunstmagazin* 2(Feb. 1995):86-7. 4 col.

Biography of Armand Guillaumin (1841-1927), on the occasion of a retrospective exhibition of his work at the Musée des Beaux-arts, Clermont-Ferrand (1995), that mentions his association with Pissarro.

1346. FONTAINAS, ANDRE. "Art moderne – Camille Pissarro." *Mercure de France* (May 1899).

1347. FORTUNY, PASCAL. "Pissarro et Guillaumin." *Bulletin de la vie artistique* (15 July 1922).

1348. FOSSIER, FRANÇOIS. "Il fiore dell Impressionisme." *Quaderni d'Arte della Valle d'Aosta* 4:13(June-Sept. 1990):3. 1 illus.

Discusses Impressionist engraving, including examples by Pissarro.

1349. FRANCIS, HENRY S. "Black Crayon Drawing of a Cowherdess by Pissarro." *Bulletin of the Cleveland Museum of Art* 35(June 1948):103.

1350. FRANCIS, HENRY S. "Le Fond de l'Hermitage." *Cleveland Museum of Art Bulletin* 39(April 1952):64-6.

1351. FRIED, MICHAEL. "Between Realisms: From Derrida to Manet." *Critical Inquiry* 21:1(Autumn 1994):1-36. 18 illus.

Considers a series of self-portraits by Henri Fantin-Latour and contemporary artists such as Pissarro in relation to modes of reality theories in the writings of Jacques Derrida.

1352. GAINES, CHARLES. "Art: Conversations." *Architectural Digest* 41:6(June 1984):142-7. 5 illus.

Presents well-known depictions of intimate conversations by artists including Vuillard, Alma-Tadema, Pissarro, and Degas.

1353. GANZ, HANS. "Camille Pissarro." *Kunst und Künstlers* 28(May 1930):341-3.

1354. GAUNT, WILLIAM. Masterpieces from the Great Age of French Landscape." *Connoisseur* 148(Dec. 1961):317.

Illustrated with Pissarro's *Jardin des Tuileries, matin, printemps.*

1355. GEFFROY, GUSTAVE. "Camille Pissarro" in "Histoire de l'impressionnisme," *La Vie artistique* ser. 3(1894): 1-53, 96-110.

1356. GEFFROY, GUSTAVE. "Camille Pissarro." *Le Journal* (25 June 1899).

1357. GEFFROY, GUSTAVE. "Camille Pissarro." *La Vie artistique* ser. 6(1900).

1358. GEFFROY, GUSTAVE. "Lettres de Pissarro à Claude Monet" in *Claude Monet, sa vie, son œuvre* (Paris: G. Crès, 1922):9-17. Reprint: Paris: Editions Macula, 1980, pp. 269-77.

1359. GEORGE, WALDEMAR. "Pissarro." *L'Art vivant 2* (15 March 1926):201-4

1360. GERBE, LEON. "Camille Pissarro: le rustique de l'impressionnisme." *Le Peuple* (30 March 1938).

1361. "Gifts in Remainder." *Philadelphia Museum of Art Bulletin* 60:283-4(Fall 1964):13.

Illustrated with Pissarro's *Eragny, paysage d'été.*

1362. GILBERT-ROLFE, JEREMY. "The Impressionist Revolution and Duchamp's Myopia." *Arts Magazine* 63:1(Sept. 1988):61-7. 1 col. illus.

Expounds on the revolutionary nature of Impression by analyzing 1898 Parisian street scene by Pissarro, along with works by Monet and Cézanne. Contrasts Duchamp's anti-art tradition as rationalist and historicist in its insistence on recovering the artistic ideals that Impressionism tried to repudiate.

1363. GILLILAND, JEAN. "Claude Monet's Garden at Giverny." *Ashmolean* 19(Winter 1991):16-7. 1 illus.

Briefly discusses correspondence between Monet and Pissarro about how to eradicate pond weeds.

1364. GOMBRICH, ERNST HANS. "Recognising the World." *Royal Academy Magazine* 39(Summer 1993):3. 1 col. illus.

Briefly analyzes Pissarro's masterful depiction of light in cityscapes featured at the Royal Academy of Arts, London exhibition, *The Impressionist and the City* (2 July-10 Oct. 1993).

1365. GOTTE, GISELA. *"La Moisson à Saint-Briac:* ein Landschaftsbild von Emile Bernard aus dem Jahr 1889." *Neusser Jahrbuch* (1984):37-40. 2 illus.

Examines Bernard's 1889 painting, *Harvest at Saint-Briac*, newly acquired by the Clemens-Sels-Museum in Neuss, created after a visit to Gauguin in Pont-Aven at the time when Bernard was struggling to free himself from the influence of his master Pissarro.

1366. GOUK, ALAN. "Principle, Appearance, Style." *Studio International* 187:967(June 1974):292-5. 1 illus.

Attempts to define and describe the term "plasticity" by concentrating on flatness and spatial illusions manifest in paintings by Hans Hofmann, Pissarro, Cézanne, Monet, and others.

1367. GOUK, ALAN. "Pissarro." *Artscribe* 27(Feb. 1981):22-9. 15 illus.

Biographical and stylistic study of Pissarro's relationship with other Impressionists, with particular reference to works by Corot, Manet, and Cézanne.

1368. GREEN, NICHOLAS. "Dealing in Temperaments: Economic Transformation of the Artistic Field in France during the Second Half of the Nineteenth Century." *Art History* 10(March 1987):59-75.

1369. GUTTERMAN, SCOTT. "Pissarro as Innovator." *Art and Antiques* 18(June 1995):80.

1370. HAMILTON, GEORGE HEARD. "The Philosophical Implications of Impressionist Landscape Painting." *Houston Museum of Fine Arts Bulletin* 6:1(Spring 1975):2-17. 9 illus.

Discusses various meanings of Impressionism and its attempt to record the precise moment, with reference to works by Monet, Pissarro, and others.

1371. HARRIS, DALE. "Art: Belle Epoque Prints." *Architectural Digest* 50(April 1993):166-9.

1372. HERBERT, ROBERT L. and EUGENIA W. HERBERT. "Artists and Anarchism: Unpublished Letters of Pissarro, Sisley and Others." *Burlington Magazine* 102:692-3(Nov. and Dec. 1960):473-82, 517-22. Translated into French as "Les Artistes et l'anarchisme."

1373. HERBERT, ROBERT L. "City vs. Country: The Rural Image in French Painting from Millet to Gauguin." *Artforum* 8:6(Feb. 1970):44-55.

Illustrated with Pissarro's *Peasants in the Fields* and *Modern Times* (lithograph).

1374. HERRMANN, LUKE. "From Marco Zoppo to Claude Monet: Pictures from the

Collection of the Earl of Inchcape." *Connoisseur* 148:596(Oct. 1961):151-4.

Illustrated with Pissarro's *Pontoise, Bords de l'Oise.*

1375. HESS, CHARLES. "Perceptual Transparency in Cézanne's Paintings." *Structuralist* 27-8(1987-88):40-7. 8 illus., 2 col.

Studies Cézanne's color contrasts in 1872-74, the period when he worked with Pissarro.

1376. HILLER, JACK. "The Western Taste for Japanese Prints." *Storia dell'arte* 27(May-Aug. 1976):113-20. 48 illus.

Examines the influence of Japanese prints on European art beginning in the mid-1800s, especially works by Utamaro, Hokusai, and Hiroshige. Cites Pissarro, van Gogh, Cézanne, Gauguin, and Toulouse-Lautrec as artists strongly affected by Japanese art.

1377. HIND, ARTHUR M. "Camille Pissarros Graphische Arbeiter. Seine Radierungen, Lithographien und Monotypien und Lucien Pissarros Holzschnitte nach seines Vaters Zeichnungen." *Die graphischen Küste* 31(1908):34-48.

1378. HOLL, J.-C. "Camille Pissarro et son œuvre." *L'Oeuvre d'art international* 7(Oct.-Nov. 1904):129-56. Expanded version: *Portraits d'hier* 3(July 1911):35-64.

1379. HOLL, J.-C. "Pissarro," *Art et les artistes* 22(Feb. 1928):144-70. Illus., 1 pl.

1380. HOUSE, JOHN. "New Material on Monet and Pissarro in 1870-71." *Burlington Magazine* 120:907(Oct. 1978):636-42. 4 illus.

Concerns Pissarro's and Monet's works displayed at the German Gallery, New Bond Street, London in December 1870, an exhibition mounted by Paul Durand-Ruel, and their contributions to the International Exhibition, South Kensington in May 1871. Surveys known details of the painters' dealings in London and the range of their contacts, reconstructing links between French and British artists during the Franco-Prussian War.

1381. HOUSE, JOHN. "Camille Pissarro's *Seated Peasant Woman:* The Rhetoric of Inexpressiveness" in *In Honor of Paul Mellon*, ed. by John Wilmerding (Washington, D.C.: National Gallery of Art; dist. by Trevor Brown Associates, London and University Press of New England, 1986):155-71.

1382. HOUSE, JOHN. "Anarchist or Esthete? Pissarro in the City." *Art in America* 81:11(Nov. 1993):80-9, 141-3. 15 col. illus.

Analyzes the series of cityscapes painted between 1893 and his death in 1903 that reveal Pissarro's attitude toward the city. Although Pissarro viewed the city as a metaphor for capitalist evil, he created more than 200 urban scenes, often depicted from a high viewpoint and at a great distance. Concludes that Pissarro painted cityscapes to exert his independence as an anarchist aesthete and to satisfy dealers who had a ready market for such works.

1383. HOUSE, JOHN. "The Impressionist Vision of London," in *Victorian Artists and the City: A Collection of Critical Essays* (NY: Pergamon Press, 1980):78-90. 11 illus.

Examines 19th century representations of the Thames River, beginning with Whistler and continued by Pissarro, Monet, and others.

1384. HUTTON, JOHN. "Camille Pissarro's *Turpitudes Sociales* and Late Nineteenth Century Anarchist Anti-Feminism." *History Workshop Journal* 24(1987):32-61.

1385. HUTTON, JOHN. "'*Les Prolos Vagabondent*': Neo-Impressionism and the Anarchist Image of the *Trimardeur*." *Art Bulletin* 72(June 1990):296-309.

Discussion of Neo-Impressionism's concept of "integral image" that conveys meaning without titles or conventional allegories, with reference to the anarchist icon of the tramp, identified here as nonconformist hero and prototypical social victim. Reproduces examples by Pissarro, Luce, Cross, and Van Rysselberghe, among other artists.

1386. HUYGHE, RENE. "Assez d'escroquerie à la Révolution: le matérialisme a vécu en art." *Galerie-jardin des arts* 144(Feb. 1975):40-7. 14 illus.

Interview with critic René Huyghe, wherein he argues that the Impressionists were less revolutionary than generally believed by remaining faithful to the reproduction of the natural world and by their nostalgia for pre-industrial scenes. Maintains that Monet's interpretation of the effect of light free from logical perspective is unequaled, followed by Renoir, Pissarro, and Sisley.

1387. ISAACSON, JOEL. "Pissarro's Doubt: Plein Air Painting and the Abiding Questions." *Apollo* 136:369(Nov. 1992):320-4. 7 illus., 2 col.

Challenges Maurice Merleau-Ponty's essay,"Cézanne's Doubt," by arguing that Merleau-Ponty neglects Pissarro's influence on Cézanne and their extensive early practice of *plein air* painting. Compares Pissarro's approach to landscape with that of Corot and considers innovative aspects of Pissarro's landscapes.

1388. ISAACSON, JOEL. "Constable, Duranty, Mallarmé, Impressionism, Plein Air, and Forgetting." *Art Bulletin* 76:3(Sept. 1994):427-50. 13 illus., 4 col.

Explains artistic distancing from intellectual concerns, characteristic of the Impressionists, including examples from Pissarro's paintings.

1389. IVES, COLTA FELLER. "French Prints in the Era of Impressionism and Symbolism." *Metropolitan Museum of Art Bulletin* 46:1(Summer 1988):3-57. 55 illus., 36 col.

Discusses prints by 11 French artists in the late 19th century, including Pissarro and Signac.

1390. IVES, COLTA FELLER. "Camille Pissarro: *Woman at a Well*." *Metropolitan Museum of Art Bulletin* 51(Fall 1993):47.

1391. JAMPOLLER, LILI. "Théo van Gogh and Camille Pissarro: Correspondence and an Exhibition." *Simiolus* 16:1(1986):50-61. 10 illus.

Details relations between Théo van Gogh and Pissarro with reference to van Gogh's

involvement in an exhibition of Pissarro's paintings at Boussod, Valadon & Cie, Paris in 1890. Nineteen letters by van Gogh to Pissarro (1888-90) are appended.

1392. JEDLICKA, GOTTHARD. "Camille Pissarro." *Galerie und Sammler* (Zurich) 1-2(Jan.-Feb. 1938).

1393. JEUDWINE, WYNNE R. "Modern Paintings from the Collection of W. Somerset Mangham." *Apollo* 64(Oct. 1956):101-3.

Illustrated with Pissarro's *Winter Landscape, Louveciennes* and *Rouen.*

1394. JOËTS, JULES. "Camille Pissarro et la période inconnue de St. Thomas et de Caracas." *Amour de l'art* 27 (1947):91-97.

Details Pissarro's early life and family background in the Virgin Islands and in Venezuela.

1395. JOHNSON, KEITH "Le Cinquantenaire de la Galerie Lefèvre." *L'Oeil* 257(Dec. 1976):20-7. 10 illus.

Celebration of London's Galerie Lefèvre's 50th anniversary that mentions exhibitions of Fantin-Latour and Pissarro arranged by founder Léon Lefèvre.

1396. JOURDAIN, FRANTZ. "Hommes du jour: Camille Pissarro." *L'Eclair* (June 1898).

1397. JOURDAIN, FRANTZ. "Camille Pissarro." *Les Temps nouveaux* (19-25 Dec. 1903).

1398. KAHN, GUSTAVE. "Art, une rétrospective, Camille Pissarro." *Mercure de France* 101: 1 (Feb. 1913): 636-7.

1399. KAHN, GUSTAVE. "Camille Pissarro." *Mercure de France* 218 (15 March 1930):257-66.

1400. KAHN, GUSTAVE. "La Rétrospective de Pissarro." *Mercure du France.* 218 (5 March 1930):697-700.

1401. KAHN, GUSTAVE. "Les Maîtres d'hier: Camille Pissarro." *Le Quotidien* (6, 7 Sept. 1933).

1402. KALITINA, NINA N. "Demokraticheskoe Iskusstvo Frantsii Kontsa XIX Veka." *Iskusstvo* 11(1974):6208. 8 illus.

Survey of social and democratic motives behind late 19th century French art, including the influence of Pyotr Kropotkin's idea that art is the greatest means of communication between people. Artists with a particular interest in social problems were van Gogh and Pissarro.

1403. KALITINA, NINA N. "Encore une page de l'histoire de la critique artistique française: Octave Mirbeau." *Acta Historiae Artium* (Hungary) 27:1-2(1981):187-90.

Examines Octave Mirbeau's (1848-1917) art criticism and enthusiasm for Impressionism, particularly Monet and Pissarro.

1404. KINGSLEY, APRIL. "Camille Pissarro." *Horizon* 24:5(May 1981):44-51. 10 illus.

Stresses Pissarro's importance as a teacher, mentor, and innovator and assesses the effect that Seurat and Neo-Impressionism had on his later work.

1405. KIRCHBACH, WOLFGANG. "Pissarro und Raffaëlli, zwei Impressionisten." *Die Kunst unserer Zeit* 25 (1904):117-36.

1406. KJAERBOE, JETTE. "David Jacobsen: Paris 1855-1869." *Kunstmuseets arsskrift* 64-67(1977-80):83-106. 15 illus. In Danish, summary in French.

Profile of the Danish painter David Jacobsen's years in Paris, where he became a friend of Pissarro.

1407. KRAMER, HILTON. "Impressionist City: Camille Pissarro Mastered the Modern Subject par Excellence." *Art and Antiques* 15(April 1993):79-80.

1408. KRAMER, HILTON. "Getting to Know Pissarro." *New Criterion* 13:8(April 1995):5-8.

Appraisal of Pissarro's paintings with reference to works included in the exhibition *Camille Pissarro: Impressionist Innovator*, held at the Jewish Museum, New York (26 Feb.-16 July 1995).

1409. KRIEGER, PETER. "Max Liebermanns Impressionisten-Sammlung und ihre Bedeutung für sein Werk" in *Max Liebermann in seiner Zeit* (Berlin: Staatliche Museen, Nationalgalerie, 1979):60-71. 18 illus.

Account of Liebermann's encounters with Impressionism in Berlin and his collection of works by Manet, Monet, Pissarro, and others.

1410. KUNSTLER, CHARLES. "Les Eaux-fortes de Camille Pissarro." *Le Figaro artistique* (17 March 1927).

1411. KUNSTLER, CHARLES. "Camille Pissarro." *La Renaissance* 11(Dec. 1928):497-508.

1412. KUNSTLER, CHARLES. "La Maison d'Eragny." *ABC, Magazine artistique et littéraire* 5(March 1929):79-83.

1413. KUNSTLER, CHARLES. "Camille Pissarro, West Indies." *Gazette des Beaux-arts* ser. 4, 22(Oct. 1942): 57-60.

1414. LA FARGE, H. A. "Impressionist Three Plus One." *ARTNews* 67(Oct. 1968):62.

Illustrated with Pissarro's *Path and Slopes at Auvers*.

1415. *"Landscape with Trees, Two Figures on a Road, and Mountains in Background."* *Yale University Art Gallery Bulletin* 35:1(Summer 1974):35.

Drawing attributed to Pissarro.

1416. LANGDON, HELEN. "City Streets and Wooded Minds: The Twin Visions of Modernity of Pissarro *père et fils*." *Times Literary Supplement* 4713(30 July 1993):16.

1417. LANGER, G. "European Art." *Art and Australia* 20:4(Winter 1983):494-503. 17 illus.

Surveys the European Art Collection, Queensland Art Gallery, Brisbane, including works by Pissarro.

1418. LANT, ANTONIA. "Purpose and Practice in French Avant-Garde Print-Making of the 1880s." *Oxford Art Journal* 6:1(1983):18-29. 9 illus.

Examines unconventional Impressionist printmaking techniques adopted by Degas, Cassatt, and Pissarro in the late 1870s.

1419. LAPRADE, JACQUES DE. "Pissarro et ses fils." *Beaux-arts* (7 Dec. 1934):6.

1420. LAPRADE, JACQUES DE. "Camille Pissarro après des documents inèdits." *Beaux-arts chroniques des arts* (17 April 1936):1; (24 April 1936):7.

Includes letters from Pissarro to critic Théodore Duret (1838-1927) and Eugène Murer.

1421. LARGUIER, LEO. "Les Ventes Camille Pissarro." *L'Art vivant* (1 Jan. 1929).

1422. LAURENT, PIERRE. "Eau-forte de M. Pissarro." *Les Beaux-arts illustrés* 3(1879):96.

1423. LEARY, R. H. "Japanese and French Paintings in the Bridgestone Museum of Art." *Arts of Asia* 3:4(July-Aug. 1973):32-40. 29 illus.

Features the Bridgestone Museum of Art, Tokyo, the private collection of Shojiro Ishibashi, the founder of the Bridgestone Tyre Company. Its focus is on Impressionism and includes works by Pissarro and Seurat, among many other French and Japanese artists.

1424. LECOMTE, GEORGES CHARLES. "Camille Pissarro." *Les Hommes d'aujourd'hui* 8:366(1890).

1425. LECOMTE, GEORGES CHARLES. "Toiles récentes de M. Camille Pissarro." *Art et critique* 2(6 Sept. 1890):573-4.

1426. LECOMTE, GEORGES CHARLES. "M. Camille Pissarro." *La Plume* (1 Sept. 1891):301-2.

1427. LECOMTE, GEORGES CHARLES. "Quelques syndiques: Camille Pissarro." *Les Droits de l'homme* (4 June 1898).

1428. LECOMTE, GEORGES CHARLES. "La Renaissance idéaliste." *Revue de l'évolution sociale, scientifique et littéraire* 2(15 March 1892):169-73.

1429. LECOMTE, GEORGES CHARLES. "L'Art impressionniste." *Revue de l'évolution sociale, scientifique et littéraire* 2(1 April 1892):213-7.

1430. LECOMTE, GEORGES CHARLES. "Un centenaire: un fondateur de l'impressionnisme, Camille Pissarro." *Revue de l'art ancien et moderne* 57(March 1930):157-72. illus. English summary.

1431. LEE, DAVID. "First Impressions of London." *Arts Review* 45(July-Aug. 1993):40-2. 2 col. illus.

Studies Pissarro's and Monet's paintings of London on their visits in the 1870s and explores Pissarro's reaction to rejection by the Royal Academy in 1871 as expressed in correspondence to a friend in France.

1432. LEMME, I. A. "Le Collezioni di Don Antonio." *Bolaffiarte* 5:39(April 1974):30-3. 23 illus.

Traces the origins and development of the collection of Antonio Santamarina, a Bueños Aires collector, that included works by Pissarro and other Impressionists and was auctioned at Sotheby's on April 2, 1974.

1433. LESBATS, ROGER. "Titres de gloire, titres de noblesse de Camille Pissarro." *Le Populaire* (14 March 1930).

1434. LETHEVE, JACQUES. "J.-K. Huysmans et les peintres impressionnistes: une lettre inédite à Camille Pissarro." *Bulletin de la Bibliothèque nationale* 4(June 1979):92-4.

1435. LEWIS, DAVID. "Museum Impressions." *Carnegie Museum* 59:12(Nov.-Dec. 1989):14-8, 46-9. 8 illus., 4 col.

Behind-the-scenes look at the five museums who organized the exhibition *Impressionism: Selections from Five American Museums* (June 1989-March 1990). Mentions works exhibited by Pissarro and other artists.

1436. LILLEY, E. D. "Zola and Pissarro: A Coincidence." *Burlington Magazine* 129:1006(Jan. 1987):24-5. 1 illus.

Compares Pissarro's *Jardin des Mathurins* (1876) to a passage in Emile Zola's *L'Oeuvre* (1886).

1437. LLOYD, CHRISTOPHER H. "Camille Pissarro and Hans Holbein the Younger." *Burlington Magazine* 117:872(Nov. 1975):722-6. 11 illus.

Relates Pissarro's colored lithograph, *La Charrue,* to Holbein's woodcut of a ploughman from the *Dance of Death* series (scene 38) and the influence of paintings in the Reel Collection exhibited at the National Gallery, London in June 1871.

1438. LLOYD, CHRISTOPHER H. "Camille Pissarro: Drawings or Prints?" *Master Drawings* 18:3(Autumn 1980):264-8. 6 illus.

Settles the question of whether two works by Pissarro presented to the Ashmolean Museum, Oxford are drawings or prints by stating that both are hybrids produced by "*gillotage*," a 19th-century method of preparing drawings for reproduction named after the inventor of zincography.

1439. LLOYD, CHRISTOPHER H. "Camille Pissarro: Towards a Reassessment." *Art International* 25:1-2(Jan. 1982):59-66. 5 col. illus.

Examines the importance of Pissarro's correspondence, especially letters to his son Lucien, that reveal Pissarro's widespread influence on contemporary artists and developments.

1440. LLOYD, CHRISTOPHER H. "Camille Pissarro at Princeton: Checklist of Drawings by Camille Pissarro in the Collection of the Art Museum, Princeton University." *Record of the Museum, Princeton University* 41:1(1982):2-15. 19 illus.

1441. LLOYD, CHRISTOPHER H. "Camille Pissarro and Japonisme" in *Japonisme in Art: An International Symposium*, ed. by Yamada Chisaburō (Tokyo: Committee for the year 2001, 1980):173-88. 5 illus.

1442. LLOYD, CHRISTOPHER H. "Camille Pissarro and the Caribbean." *Horizontes* (Puerto Rico) 28:56(1985):19-33. 5 illus.

Describes the influence on Pissarro of his early years on St. Thomas (1847-52) and in Venezuela (1852-55).

1443. LLOYD, CHRISTOPHER H. "Reflections on La Roche-Guyon and the Impressionists." *Gazette des Beaux-arts* 105(Jan. 1985):37-44. 14 illus. Summary in French.

Examines paintings by Pissarro, Cézanne, and Braque of the landscape surrounding La Roche-Guyon, a village on the Seine half-way between Paris and Rouen featured extensively in late 19th century French paintings.

1444. LLOYD, CHRISTOPHER H. "The Market Scenes of Camille Pissarro." *Art Bulletin of Victoria* 25(1985):16-32. 17 illus., 1 col.

Discusses Pissarro's scenes of peasants at market, with reference to his drawing *Study of a Woman Picking Up a Basket*, recently acquired by the National Gallery of Victoria, Melbourne. The drawing is a study of Pissarro's *Poultry Market, Gisors* (1885).

1445. LLOYD, CHRISTOPHER H. "Paul Cézanne, Pupil of Pissarro: An Artistic Friendship." *Apollo* 136:369(Nov. 1992):284-90. 11 illus., 3 col.

Describes the working and personal relationships between Pissarro and Cézanne, beginning with their meeting in 1862, and the ways that they influenced each other throughout their careers. Details how Cézanne's landscapes became more objective and analytical in the early 1870s under Pissarro's guidance.

1446. LOUCHEIM, A. B. "Buddy de Sylva: Gift to Hollywood." *ARTnews* (Sept. 1946).

1447. LOUVRIER, MAURICE. "Le Peintre Camille Pissarro et les Rouennais." *Rouen Gazette* (1928).

1448. LUCIE-SMITH, EDWARD. "The Pissarro Family." *Art and Artists* 12:9(Jan. 1978):8-13. 7 illus.
With reference to exhibitions of Camille Pissarro at Morley College, London and another at the Anthony d'Offay Gallery, London of his son Lucien's works, Lucie-Smith traces influences on the two artists and their lasting importance.

1449. "M. Camille Pissarro." *L'Art français* (25 March 1893).

1450. MACGREGOR, NEIL. "Dublin Blooms." *Burlington Magazine* 126:972(March 1984):130-1. 1 col. illus.

Editorial on recent improvements at the National Gallery of Ireland, Dublin that notes the purchase in 1983 of Pissarro's *Chrysanthemums in a Chinese Vase* (ca. 1870).

1451. MAI, EKKEHARD. "Alte Künstler-Junge Kunst: zur Avantgarde der 'späten Jahre'." *Kunstwerk* 39:2(April 1986):6-20. 10 illus.

Deals with late works of various artists including Pissarro and the problem of generation and legacy.

1452. MAILLET, EDDA. "La Politique d'enrichissements du Musée de Pontoise; acquisitions depuis 1978." *Revue du Louvre et des musées de France* 31:5-6(1981):394-5. 5 illus.

Discusses efforts of the Musée de Pontoise to become more than a regional museum, particularly in its acquisition of 20th century French works. Mentions the Musée Pissarro, also in Pontoise, whose collection is devoted to Pissarro, his son Lucien, and their contemporaries.

1453. MAKES, FRANTISHEK. "Konsthartsernas Roll vid Konstförfalskning." *Paletten* 1(1974):13-5. 10 illus. In Swedish.

Examines forgeries of works by Pissarro and other artists and elaborates on chemical analyses of resins that indicate age and paint type.

1454. "Maler des Grunen — la couleur verte chez Pissarro." *Deutsche Kunst und Dekoration* (May 1914).

Article on Pissarro's use of the color green. Signed "R-Br."

1455. MANSON, JAMES BOLIVAR. "Camille Pissarro, 1830-1930." *The Studio* 6(June 1930):409-15. 7 illus.

1456. MANSON, JAMES BOLIVAR. "Camille Pissarro." *The Studio* 79(May 1920):82-8.

1457. MANTHORNE, KATHERINE. "Caribbean Beginnings of Camille Pissarro." *Latin American Art* 2:3(Summer 1990):30-5. 6 illus., 5 col.

Relates Pissarro's early years in the Virgin Islands and Venezuela to his work, noting that his Caribbean years influenced early studies of the effects of light and color and made him socially aware and helped shape his liberal political philosophy.

1458. MARRIOTT, CHARLES. "M. Vallotton and Mr. Pissarro." *Outlook* (16 Oct. 1920).

1459. MATHIEU, PIERRE-LOUIS. "Huysman, inventeur de l'impressionnisme." *L'Oeil* 341(Dec. 1983):42-3.

1460. MAUCLAIR, CAMILLE. "Les Artistes secondaires de l'impressionnisme" in *L'Impressionnisme, son histoire, son esthétique, ses maîtres*. Paris: Librairie de l'Art Ancien et Moderne, 1904.

1461. MEIER-GRAEFE, JULIUS. "Camille Pissarro." *Kunst und Künstler* 2:12(Sept. 1904):475-88. Reprinted in Meier-Graefe's *Impressionisten: Guys, Manet, van Gogh, Pissarro, Cézanne* (Munich: R. Piper, 1907), pp. 153-72.

1462. MELLERIO, ANDRE. "Les Artistes à l'atelier: C. Pissarro." *L'Art dans les deux mondes* 6(June 1891):31.

1463. MELOT, MICHEL. "L'Estampe impressionniste et la réduction au dessin." *Nouvelles de l'estampe* 19(Jan.-Feb. 1975):11-5, 56. 12 illus.

Overview of Impressionist printmaking and the radical technique of inking by artists to create monotypes. Explains that Pissarro and Degas rejected excessive inking but explored methods of combining engraving and printing to liberate them from drawing.

1464. MELOT, MICHEL. "La Pratique d'un artiste: Pissarro graveur en 1880." *Histoire et critique des arts* 2(June 1977):14-38. English revised version: "Camille Pissarro in 1880: An Anarchistic Artist in Bourgeois Society." *Marxist Perspectives* 2:8(Winter 1979-80):22-54. 9 illus.

Concentrates on Pissarro's anarchistic idealism as expressed especially in his prints.

1465. MELROD, GEORGE. "Pissarro Works Return Home." *Art and Antiques* 19(Nov. 1996):17.

1466. "Die Metropole." *Pan* 1:supp.(1992):23-5. 4 illus., 3 col.

Describes Paris's enormous urban renewal program during Baron Haussmann's direction (1850-80) and cityscapes of the same period by Pissarro, Manet, and Monet.

1467. MIRBEAU, OCTAVE. "Camille Pissarro." *L'Art dans les deux mondes* (10 Jan. 1891):83-4.

1468. MIRBEAU, OCTAVE. "Camille Pissarro." *L'Art dans les deux mondes* (6 June 1891).

1469. MIRBEAU, OCTAVE. "Camille Pissarro." *Le Figaro* (1 Feb. 1892). Reprinted in Mirbeau's *Des artistes, première série* (Paris: E. Flammarion, 1922), vol. 2, pp. 145-53.

1470. MIRBEAU, OCTAVE. "Famille d'artistes." *Le Journal* (6 Dec. 1897). Reprinted in Mirbeau's *Des artistes, première série* (Paris: E. Flammarion, 1922), vol. 2.

1471. MONNERET, SOPHIE. "Pissarro entre rêves et sensations." *Connaissance des arts* 348(Feb. 1981):28-35. 9 illus.

Outlines Pissarro's life, work, and influence as a teacher with reference to the major retrospective exhibition, *Pissarro* (1980-81), shown at the Hayward Gallery, London; Grand Palais, Paris; and Boston Museum of Fine Arts, Boston.

1472. MONNERET, SOPHIE. "Turner et la France." *Connaissance des arts* 357(Nov. 1981):96-101. 9 illus.

Describes Turner's visits to France and the paintings that he saw, including influences by Poussin and Watteau. In turn, Turner influenced the French Impressionists, including Pissarro, Manet, and Sisley.

1473. MOORE, GEORGE. "Monet, Sisley, Pissarro and the Decadence" in Moore's *Modern Painting* (London; NY: W. Scott, Ltd., 1893):84-90.

1474. MOREL, HENRY. "Camille Pissarro." *Le Réveil* (24 June 1883).

Review of Pissarro's first single-artist show of 70 paintings, held at Galerie Durand-Ruel, Paris.

1475. MORICE, CHARLES. "Deux morts: Whistler, Pissarro." *Mercure de France* 1(April 1904):72-97. Expanded version in Morice's *Quelques maîtres modernes* (Paris: Société des Trente, 1914):28-45.

1476. MORRIS, SUSAN. "Room at the Top." *Antique Collector* 62:10(Nov. 1991):96-8. 2 col. illus.

Highlights the art collection of Jeffrey Archer, the core of which is Post-Impressionist drawings and watercolors, including works by Pissarro, Signac, and Vuillard.

1477. MRAVIK, LASZLO. "'Et in Arcadia Ego': II Resz." *Uj Muveszet* (Hungary) 2:11(Nov. 1991):4-11. 8 illus.

Second in a series devoted to art treasures of Hungarian origin in the former U.S.S.R., including paintings by Pissarro and Manet taken from Hungarian private collections in the 1940s.

1478. MUTHER, RICHARD. "Camille Pissarro." *Geschichte der Malerei im XIX. Jahrhundert* (Munich) 2(1893):638-43.

1479. NATANSON, THADEE. "L'Apôtre Pissarro" in Natanson's *Peints à leur tour* (Paris: Albin Michel, 1948):59-63.

1480. NEILSON, NANCY WARD. "An Impressionist Print by Camille Pissarro." *Saint Louis Art Museum Bulletin* 11:3(May-June 1975):48-9. 1 illus.

Features Pissarro's *St. Martin's Fair at Pontoise* (etching and aquatint, 1879), recently acquired by the St. Louis Art Museum. Only nine impressions are listed by Loys Delteil (no. 21); the St. Louis example is one of two impressions of the third state.

1481. NEMECZEK, ALFRED. "Vincent van Gogh in Paris: das Fest der Farben." *ART: das Kunstmagazin* 11(Nov. 1994):14-34, 37. 42 col. illus.

Details van Gogh's early work, his move to Paris, and the influence of Monet, Pissarro, and Signac on his style and color techniques.

1482. NEUGASS, FRITZ. "Camille Pissarro 1830-1903 zur Zentenarausstellung in der Orangerie des Tuileries." *Die Kunst für Alle* 6(May 1930):232-9. English version: "Camille Pissarro: 100ᵗʰ Anniversary, July 10, 1930." *Apollo* 12(July 1930):65-7.

Illustrated with Pissarro's *L'Avenue de l'Opéra, Effet de neige,* and *Vue de Rouen.*

1483. NEUGASS, FRITZ. "Camille Pissarro." *Deutsch Kunst und Dekoration* 34(Dec. 1930):152-64. illus.

1484. NEVE, CHRISTOPHER. "A View of the River: The Impressionists in London." *Country Life* 153:3942(11 Jan. 1973):100-1. 3 illus.

1485. NEWTON, JOY. "Zola and Pissarro, with Four Unpublished Letters." *Laurels* 51:2(Fall 1980):89-99.

1486. NICOLSON, BENEDICT. "The Anarchism of Camille Pissarro." *The Arts* 11:2(1946):43-51.

1487. NICULESCU, REMUS. "Georges de Bellio, l'ami des impressionnistes." *Revue romaine d'histoire de l'art* 1:2(1964):209-78. Reprinted in *Paragone* 21(Sept. 1970):25-66; (Nov. 1970):41-55.

Includes correspondence from Pissarro to de Bellio.

1488. NOCHLIN, LINDA. "Camille Pissarro: The Unassuming Eye." *ARTnews* 64(April 1965):24-7, 59-62. illus.

Examination of Pissarro's style and technique with reference to a retrospective exhibition of French Impressionism and Post-Impressionism at Wildenstein Gallery, NY (1965).

1489. O'CONNOR, J., Jr. "From our Permanent Collection: *The Great Bridge at Rouen.*" *Carnegie Institute Magazine* 25(Sept. 1951):236-7.

1490. ORTON, FRED and GRISELDA POLLOCK. "Les Données bretonnantes: la prairie de représentation." *Art History* 3(Sept. 1980):314-44.

1491. OSBURN, ANNIE. "William Preston." *Southwest Art* 19:10(March 1990):84-8. 5 illus., 4 col.

Suggests Pissarro and Corot as influences on Preston's concern with surfaces and variations of color.

1492. OSBURN, ANNIE. "K. Douglas Wiggins." *Southwest Art* 20:10(March 1991):68-72. 5 illus., 4 col.

Identifies Pissarro and van Gogh as sources of inspiration for Wiggins' use of color and undulating forms, among other influences.

1493. PALMER, FREDERICK. "Oil Painting Techniques 3: The Impressionists." *Artist* 103:9(Sept. 1988):28-31. 6 illus., 2 col.

Deals in part with techniques of specific artists and pigments in the palettes of Renoir, Monet, and Pissarro.

1494. PARINAUD, MARIE-HELENE. "Le Cas Monet." *Galerie-jardin des arts* 139(July-Aug. 1974):51-5. 12 illus.

Presents Monet's life and career, including his association with Pissarro in London and his development as an Impressionist.

1495. PARKS, R. O. *"Woman Washing her Feet at the Brook."* *Bulletin of the John Herron Institute of Art* 35(Oct. 1948):23-4.

1496. PASSERON, ROGER. "La Gravure des peintres impressionnistes." *L'Oeil* 223(Feb. 1974):20-7. 7 illus.

Examines the Impressionists' interest in printmaking and their admiration of great engravers of the past.

1497. PATAKY, DÉNES. "Sur quelques dessins impressionnistes du Musée des Beaux-arts." *Bulletin du Musée Hongrois des Beaux-arts* 43(1975):109-24. In French and Hungarian. 19 illus.

Describes relatively unknown Impressionist drawings in the Museum of Fine Arts, Budapest, including three works by Pissarro.

1498. *"Path by the River*, a Rare Painting by Pissarro on Permanent Loan from the Lucas Collection." *Baltimore Museum of ARTnews* 8(Jan. 1946):4-6.

1499. PEPPIATT, MICHAEL. "Father of Us All." *Horizon* 16:2(Spring 1974):14-29. 12 illus.

Studies Cézanne's life, career, and revolutionary use of perspective that prefigured Cubism. Under the influence of Pissarro, Cézanne simplified his palette to the primary colors.

1500. PERRUCHOT, HENRI. "Pissarro et le néo-impressionnisme." *Jardin des arts* (Nov. 1965):48-57.

1501. PERUCCHI-PETRI, URSULA. "Was Cézanne Impressionist? Die Begegnung zwischen Cézanne und Pissarro." *Du* 35:9(Sept. 1975):50-65. 14 illus., 4 col. Summary in English.

Compares Cézanne's early work with later paintings to show the tremendous transformation in his art. Notes Pissarro's and Impressionism's influences in the 1870s and differing opinions on Cézanne's classification as an Impressionist.

1502. PIGUET, PHILIPPE, et al. "Cézanne au Grand Palais." *L'Oeil* 474(Sept. 1995):32-47. 19 illus., 16 col.

Four essays on different aspects of Cézanne's work in light of the retrospective exhibition at the Grand Palais, Paris (1995-96). Several essays mention Pissarro's influence and relationship with Cézanne.

1503. PISSARRO, JOACHIM. "Correspondance de Camille Pissarro." *Apollo* new ser. 136:369 (Nov. 1992):339-41.

1504. PISSARRO, LUDOVIC-RODOLPHE. "The Etched and Lithographed Work of Camille Pissarro." *Print Collector's Quarterly* 9(Oct. 1922):274-301.

1505. PISSARRO, LUDOVIC-RODOLPHE [pseud. L. Rodo]. "Au sujet de Pissarro." *Beaux-arts* 74(26 June 1936):2.

1506. "Pissarro and Photography? A Comparative Montage." *Apollo* 136:369(Nov. 1992):328-9. 4 illus.
Demonstrates the similarity between a painting by Pissarro of l'avenue de l'Opéra, Paris (1898) and an 1890s photograph of the same scene. Suggests that Pissarro was influenced by contemporary photography.

1507. "Pissarro and Pissarro." *Connaissance des arts* 498(Sept. 1993):14-5.

1508. "Pissarro, o il dramma del divisionismo." *Sele Arte* 1(July-Aug. 1952):15-8.

1509. PLEYNET, MARCEL and C. MILLET (Interviewer). "Cézanne: contre les professeurs et les historiens." *Art press international* 18(May 1978):12-7. 11 illus.

Interview with Pleynet regarding the paucity of critical analysis of Cézanne's work. Includes comments on Cézanne's work by other painters, including Pissarro.

1510. POINSOT, JEAN-MARC. "Quand l'œuvre a lieu." *Parachute* (Canada) 46(March-May 1987):70-7. 4 illus. Summary in English.

Emphasizes the value of exhibitions and museum collections on modern art, with special reference to works by Pissarro, Carl André, and Joseph Kosuth.

1511. [Pointe Sèche, pseud.] "Le Whistlerisme et le Pissarrisme à l'exposition des XXXIII." *Le Journal des arts* (13 Jan. 1888).

1512. POLLOCK, GRISELDA. "Don't Take the Pissarro: But Take the Monet and Run! Or Memoirs of a Dutiful Daughter." *Oxford Art Journal* 14:2(1991):96-103.

Marxist-feminist critique of two recent books, Richard R. Brettell's *Pissarro and Pontoise: The Painter in a Landscape* (New Haven: Yale University Press, 1990) and Paul H. Tucker's

Monet in the 90s/The Series Paintings (New Haven: Yale University Press, 1990).

1513. "Portrait." *Art Digest* 20(Feb. 1946):15.

1514. "Portrait by Cézanne." *Parnassus* 1(April 1929):13; *ARTnews* 45(April 1946):25; *Burlington Magazine* 101(May 1959):173.

1515. "Portrait [head] by M. Luce." *ARTnews* 52(Dec. 1953):28.

1516. "Portrait [seated figure] by M. Luce." *Gazette des Beaux-arts* ser. 6, 42(July 1953):41.

1517. "Portrait by P. Gauguin." *Gazette des Beaux-arts* ser. 6, 47(Jan.-April 1956):65.

1518. "Portrait of Eugène Murer." *Springfield Museum of Art Bulletin* 18(Feb. 1952):1-2.

1519. POULAIN, GASTON. "Camille Pissarro, chantre de l'Ile-de-France, et son rôle d'initiateur." *Comœdia* (22 Feb. 1930).

1520. RAVIN, JAMES G. "Art and Medicine: Pissarro." *Bulletin of the Academy of Medicine of Toledo and Luces County* 72:2(March-April 1981).

1521. RAVIN, JAMES G. "Opthalmology and the Arts: Pissarro's Lacrimal Problems." *Opthalmic Forum* 2:1(1984).

1522. "Recent Acquisitions at the Cleveland Museum of Art I: Department of Western Art." *Burlington Magazine* 133:1054(Jan. 1991):63-8. 20 illus., 3 col.
Features a selection of 20 works acquired by the museum since 1988, including Pissarro's *The Lock at Pontoise* (1872).

1523. REFF, THEODORE. "Copyists in the Louvre." *Art Bulletin* 46(Dec. 1964):556.

1524. REFF, THEODORE. "Pissarro's Portrait of Cézanne." *Burlington Magazine* 109(Nov. 1967):626-33.

1525. REFF, THEODORE. "The Pictures within Cézanne's Pictures." *Arts Magazine* 53:10(June 1979):90-104. 39 illus.

Studies Cézanne's use of paintings and painted screens as symbolic and decorative devices in his portraits, genre scenes, and still lifes, including paintings by himself, Pissarro, and Armand Guillaumin.

1526. REID, MARTIN. "Camille Pissarro: Three Paintings of London of 1871. What do they Represent?" *Burlington Magazine* 119:889(April 1977):253-61. 18 illus., 1 col.

Identifies the sites of three paintings by Pissarro during his stay in Upper Norwood near London in 1870-71 by comparing them to contemporary photographs and Ordnance Survey maps. *Penge Station, Upper Norwood* show Lordship Lane Station on the old Crystal Palace Railway; *Church on Westow Hill* (1871) is a view of All Saints Church, Upper Norwood, seen from the north side of Beulah Hill; *Near Sydenham Hill* shows the former Church of

England Chapel in West Norwood Cemetery and is identified as the painting entitled *Vue du Cimitière de Lower Norwood,* exhibited at Durand-Ruel in 1894.

1527. REIDEMEISTER, LEOPOLD. "L'Ile-de-France et ses peintres." *L'Oeil* 124(April 1965):16.

Illustrated with Pissarro's *Rue de Pontoise.*

1528. REUTERSWALD, O. "The 'Violetomania' of the Impressionists." *Journal of Aesthetics and Art Criticism* (Dec. 1950).

1529. REUTERSWALD, O. "The Accentuated Brush Stroke of the Impressionists." *Journal of Aesthetics and Art Criticism* (March 1952).

1530. REWALD, JOHN. "L'Oeuvre de jeunesse de Camille Pissarro." *L'Amour de l'art* 17(April 1936):141-5. 11 illus.

1531. REWALD, JOHN. "Paysages de Paris, de Corot à Utrillo." *La Renaissance* (Jan.-Feb. 1937).

1532. REWALD, JOHN. "Camille Pissarro: His Work and Influence." *Burlington Magazine* 72(June 1938):280-91. illus.

1533. REWALD, JOHN. "Camille Pissarro in the West Indies." *Gazette des Beaux-arts* ser. 6, 22(Oct. 1942):57-60.

1534. REWALD, JOHN. "Pissarro's Paris and his France: The Camera Compares." *ARTnews* 42:6(1 March 1943):14-7; correction 42:7(15 March 1943):72. Reprinted in *Apollo* 136:369(Nov. 1992):291-4. 10 illus.

Pioneering article that suggests that eye troubles led Pissarro to cityscapes. Examines his approach to painting and compares various cityscapes to photographs of the scenes by Rewald.

1535. REWALD, JOHN. "Pissarro and his Circle." *ARTnews* 44(15 Oct. 1945):16-8.

1536. REWALD, JOHN. "Théo van Gogh, Goupil, and the Impressionists." *Gazette des Beaux-arts* ser. 6, 81(Jan. and Feb. 1973):6-108. 34 illus.

1537. REWALD, JOHN. "The Impressionist Brush." *Metropolitan Museum of Art Bulletin* 32:3(1973-74):2-56.

Illustrated with reproductions of six paintings by Pissarro.

1538. REY, ROBERT. "Pissarro aux Iles Vierges." *Beaux-arts* 74(1 May 1936):6.

1539. RIBNER, JONATHAN. P. "Copenhagen's French Masterpieces." *Arts Magazine* 56:4(Dec. 1981):156-7. 5 illus.

Singles out works by Pissarro, Corot, and Gauguin that form part of the collection of

Wilhelm Hansen, inherited by the Danish state in 1951 and the basis of the Ordrupgaard's collection of over 100 French paintings, pastels, watercolors, and sculptures.

1540. RIOUT, DENYS. "La Peinture monochrome: une tradition niée." *Cahiers du Musée National d'Art moderne* 30(Winter 1989):81-98. 17 illus.

1541. RIVIERE, GEORGES. "Les Intransigeants et les impressionnistes." *L'Artiste* (1 Nov. 1887).

1542. ROGER-MARX, CLAUDE. "Centenaire de la naissance de Camille Pissarro." *L'Europe nouvelle* (1 March 1930).

1543. ROGER-MARX, CLAUDE. "Les Eaux fortes de Pissarro, Galerie Bline." *La Renaissance* 10(Apr. 1927): 203-5.

1544. ROGER-MARX, CLAUDE. "Camille Pissarro." *Les Annales politiques et littéraires* 15(Dec. 1928): 578-79.

1545. ROQUE, GEORGES. "Chevreul and Impressionism: A Reappraisal." *Art Bulletin* 78(March 1996):26-39. 3 illus.

Reexamines the debate concerning the influence of Michel-Eugène Chevreul's law of simultaneous contrast on Impressionism. Argues that Pissarro and Monet incorporated their knowledge of color theory into their paintings, contradicting the assumption that the Impressionists simply used their eyes.

1546. ROSENSAFT, JEAN BLOCH. "Le Néo-impressionnisme de Camille Pissarro." Traduit de l'anglais par Betty Crey. *L'Oeil* 223(Feb. 1974):52-7, 75. 9 illus.

Details the factors behind Pissarro's sudden change of style in 1886, when he embraced the pointillist technique and became a disciple of Seurat.

1547. ROSLAK, ROBYN SUE. "The Politics of Aesthetic Harmony: Neo-Impressionism, Science, and Anarchism." *Art Bulletin* 73(Sept. 1991):381-90.

1548. ROUSSEAU, CLAUDIA. "Cézanne, Dr. Gachet, and the Hanged Man." *Source: Notes in the History of Art* 6:1(Fall 1986):29-35. 4 illus.

Traces the influence of Dr. Paul-Ferdinand Gachet, a medical doctor and artist in Pissarro's circle in the early 1870s, on Cézanne's "hanged man" motif adopted from the Hanged Man of Tarot cards and used for awhile by Cézanne as a kind of signature.

1549. ROVER, ANNE. "Pissarro's Prints in Bremen: Some Discoveries." *Print Quarterly* 7:4(Dec. 1990):436-44. 12 illus.

Describes three prints by Pissarro — *Effet de pluie* (1879), *Femme vidant une brouette* (1878), and *Portrait of a Child* (1883-84) — found at the Kupferstichkabinett of the Kunsthalle, Bremen. Sixteen Pissarro prints from the collection of Dr. H. H. Meier of Bremen were bequeathed to the museum after his death in 1905.

1550. RUSSELL, JOHN. "Pissarro's Paintings — 'Icons of Stability.'" *New York Times* (6 Aug. 1978):D20-1. 1 illus.

Advances Pissarro's stature as an artist by examining three paintings held in New York museums — *Jallais Hill, A Climbing Path at the Hermitage,* and *A Hillside near Pontoise.*

1551. RUTTER, FRANK. "Camille Pissarro and the London Group." *Sunday Times* (London) (16 May 1920).

1552. SAUNIER, CHARLES. "L'Art nouveau: Camille Pissarro." *La Revue indépendante* 23(April 1892):30-40.

1553. SAURE, WOLFGANG. "Giuseppe De Nittis: ein italienischer Impressionist in Paris und London." *Weltkunst* 64:18(15 Sept. 1994):2349-51. 4 col. illus.

Profiles this Italian Impressionist painter's life and career, with particular attention to his contacts with leading Impressionists in Paris such as Pissarro, Degas, Manet, Sisley, and Monet.

1554. SAYRE, A. H. "Developments in the Style of Camille Pissarro." *ARTnews* 34:8(14 March 1936).

1555. SCHAEFER, SCOTT. "Impressionism and the Popular Imagination" in *A Day in the Country: Impressionism and the French Landscape*, ed. by A.P.A. Belloli (Los Angeles: Los Angeles County Museum of Art, 1983):325-45. 8 illus.

Charts changing attitudes towards Impressionism from the 1860s to the 1890s and notes the important role of various art critics in promoting their art. Comments on individual collectors and dealers, including when Paul Durand-Ruel met and patronized Pissarro and Monet during the Franco-Prussian War.

1556. SCHLUMBERGER, EMILE. "Les Impressionnistes peintres du bonheur; mais de quel bonheur?" *Connaissance des arts* 263(Jan. 1974):54.

Illustrated with Pissarro's *Effet de neige* (detail).

1557. SCHMALENBACH, WERNER and EVA KARCHER (Interviewer). "Eine Ahnung von Moderne." *Pan* 1:supp.(1992):6-13. 8 illus., 6 col.

Schmalenbach, founder of the Kunstsmmlung, Nordrhein-Westfalen, Düsseldorf, discusses the aims of Impressionism and violent critical reactions. Techniques of "pure" Impressionists such as Monet, Pissarro, and Sisley are compared to works by Cézanne, Picasso, and the Cubists.

1558. SCHNEIDER, LAURIE. "Art and Psychoanalysis: The Case of Paul Cézanne." *Arts in Psychotherapy* 13:3(Fall 1986):221-8.

Psychoanalyses Cézanne's personal life and career development in the 1860s and 1870s by focusing on sexual fantasies manifest in his paintings and his avoidance of female nude models that was resolved through his friendship with Pissarro, who is considered a father-figure.

1559. SCHNESSEL, S. MICHAEL. "Racing with the Light." *American Artist* 57:613(Aug. 1993):40-5. 6 col. illus.

Profiles the U.S. artist Steve Allrich, known for Cape Cod landscapes, and cites Pissarro as an influence.

1560. SEITZ, WILLIAM C. "Relevance of Impressionism." *ARTnews* 67(Jan. 1969):29⁺.

Illustrated with Pissarro's *Self-Portrait; Place du Théâtre Français; Jardin des Tuileries: Spring Morning;* and *Road to Osny, Pontoise.*

1561. "*Self-Portrait*: Etching for Boston." *Boston Museum of Fine Arts Bulletin* 58:313-4(1960):104.

1562. SERRI, JEROME. "Le Moulin de La Couleuvre à Pontoise." *Sites et monuments* 88(Oct.-Dec. 1979):8-11. 2 illus.

Account of efforts to save the watermill of La Couleuvre (Quartier du Pâtis, Pontoise), a structure painted by Cézanne and Pissarro.

1563. SHAPIRO, BARBARA STERN. "Four Intaglio Prints by Camille Pissarro." *Boston Museum of Fine Arts Bulletin* 69:357(1971):131-41.

Illustrated with Pissarro's prints *Sous bois à l'hermitage; Paysage sous bois à l'hermitage, Pontoise;* and *Sente des pouilleux.*

1564. SHAPIRO, BARBARA STERN and MICHEL MELOT. "Catalogue sommaire des monotypes de Camille Pissarro." *Nouvelles de l'estampe* 19(Jan.-Feb. 1975):16-23. 30 illus.

Summary catalogue of Pissarro's monotypes that have appeared in public and private collections since the artist's death in 1903, including a note on three metal-relief engravings not catalogued by Loys Delteil. Pissarro seems to have learned the monotype technique from Degas and developed a robust style, usually in black-and-white with touches of color.

1565. SHAPIRO, BARBARA STERN. "Pissarro as Printmaker: Some Questions and Answers." *Apollo* 136:369(Nov. 1992):295-300. 8 illus.

Discusses Pissarro's interest in printmaking and his innovative techniques.

1566. SHIFF, RICHARD. "Review Article." *Art Bulletin* 66:4(Dec. 1984):681-90.

Reviews five books on Pissarro: Janine Bailly-Herzberg, ed., *Correspondance de Camille Pissarro* (Paris: P.U.F., 1980); Richard Brettell and Christopher Lloyd, *A Catalogue of Drawings by Camille Pissarro in the Ashmolean Museum, Oxford* (Oxford: Oxford University Press, 1980); Ralph E. Shikes and Paula Harper, *Pissarro: His Life and Work* (NY: Horizon Press, 1980); Christopher Lloyd, *Camille Pissarro* (NY: Rizzoli, 1981); and the exhibition catalogue, *Camille Pissarro, 1830-1903* (London: Arts Council of Great Britain, 1980). Argues that all five do not delve deeply into interpreting Pissarro's work and do not significantly expand knowledge of the artist.

1567. SHIFF, RICHARD. "The Work of Painting: Camille Pissarro and Symbolism." *Apollo* 136:369(Nov. 1992):306-10. 5 illus., 3 col.

Focuses on Pissarro's reaction to Symbolist criticism and to Gabriel-Albert Aurier's publication, *Le Symbolisme en peinture* (Caen: L'Echoppe, 1991). Examines Pissarro's work in the 1890s and considers how he was affected by the art criticism of Octave Mirbeau and Georges Lecomte.

1568. SHIFF, RICHARD. "'Il faut que les yeux soient émus': impressionnisme et symbolisme vers 1891." Traduit par Jeanne Bouniort. *Revue de l'art* 96(1992):24-30. 5 illus.

Describes how three art critics—Octave Mirbeau, Gustave Geoffroy, and Georges Lecomte—defended the work of Impressionists such as Monet, Pissarro, Cézanne, and the Symbolists.

1569. SHONE, RICHARD. "Pissarro's Late Series Paintings." *Burlington Magazine* 135:1088(Nov. 1993):775-6. 2 illus.

1570. SILVESTRE, PAUL-ARMAND. "Oeuvres de M. Camille Pissarro." *L'Art français* (10 March 1894).

1571. SMALL, C. "Pissarro, Monet and Sisley in the Glasgow Collection." *Scottish Art Review* 6:3(1957):2-6.

Illustrated with Pissarro's *Tuileries* and *Tow Path: Market.*

1572. SMITH, PAUL GERARD. "Paul Adam, *Soi* et les 'peintres impressionnistes': la genèse d'un discours moderniste." *Revue de l'art* 82(1988):39-50. 11 illus.

Analyzes two texts by Adam on Impressionism and Neo-Impressionism: *Soi* (Paris: Tress & Stock, 1886) and "Les Peintres impressionnistes," *La Revue contemporaine* (May 1886):541-51, with particular reference to Pissarro and Seurat.

1573. SMITH, PAUL GERARD. "'Parbleu': Pissarro and the Political Colour of an Original Vision." *Art History* 15:2(June 1992):223-47. 13 illus.

Examines various factors and facets of Pissarro's approach to painting, including his debt to science, his Impressionist color vision, his originality, and his remarkable sensitivity to the color blue.

1574. SOISSONS, COMTE DE. "The Etchings of Camille Pissarro." *The Studio* (15 Oct. 1903).

1575. SOKOLOV, M. "Nasledie Morisa Utrillo." *Tvorchestvo* (U.S.S.R.) 12(1983):21-3. 4 illus.

Overview of Maurice Utrillo's early works that credits influence to Pissarro and Cézanne.

1576. SPIELMANN, HEINZ. "Fächer und Fächerbilder; Kunst des späteren 19. und des 20. Jahrhunderts; Erwerbungen 1967-1969, Museum für Kunst und Gewerbe, Hamburg."

Jahrbuch der Hamburger Kunstsammlungen 14-5(1970):367-8.

Illustrated with Pissarro's *Fächerblatt.*

1577. STAVITSKY, GAIL BETH. "Childe Hassam in the Collection of the Museum of Art, Carnegie Institute." *Carnegie Magazine* 56:4(July-Aug. 1982):27-36. 19 illus., 5 col.

Profiles the U.S. Impressionist Childe Hassam and notes the influence of Pissarro and Monet on several of Hassam's street scenes.

1578. STEADMAN, DAVID W. "French Painting: Romanticism to Surrealism." *Apollo* 109:204(Feb. 1979):150-6. 14 illus.

Highlights works by French artists in the Honolulu Academy of Arts collection, including Pissarro.

1579. STEELE, R. "French Impressions." *Art and Australia* 22:1(Spring 1984):87-93. 8 illus.

Survey of the Art Gallery of New South Wales' collection of French Impressionist paintings, including two by Pissarro: *The Weir* (1872) and *Peasant House* (1887).

1580. STEIN, SUSAN ALYSON. "Camille Pissarro: *The Cabbage Gatherer."* *Metropolitan Museum of Art Bulletin* 52(Fall 1994):50.

1581. STEPHENS, H. G. "Camille Pissarro, Impressionist." *Brush and Pencil* (March 1904).

1582. STEPNEY. "Pittura come verità." *Notiziario arte contemporanea* 11(Nov. 1972):17.

Examines Barnett Newman's exhibition at the Grand Palais, Paris, making reference to Pissarro as an influence.

1583. STEVENS, MARYANNE. "The Urban Impressionist: Pissarro's Cityscapes—Series and Serialism." *Apollo* 136:369(Nov. 1992):278-83. 8 illus., 7 col.

Discusses Pissarro's 11 cityscapes series, 1892-1903, seven of which depict Paris, and remarks on differences between Pissarro's work and Monet's and Sisley's series paintings.

1584. STORSVE, PER JONAS. "Leben und Werk." *Du* 9(Sept. 1989):78-85. 28 illus., 1 col.

Biographical chronology of Paul Cézanne that includes extracts from his letters to Pissarro, Zola, and other friends.

1585. SUTCLIFFE, ANTHONY. "The Impressionists and Haussmann's Paris." *French Cultural Studies* 6(June 1995):197-219.

Describes Pissarro and Gustave Caillebotte as the only Impressionists who included Baron Haussmann's extensive Paris renovations in their works while other Impressionists preferred people.

1586. SUTTON, DENYS. "Revolutionary Quartet." *Apollo* new ser. 77(June 1963):478-81.

Illustrated with Pissarro's *Hermitage in Pontoise*.

1587. SWEET, FREDERICK A. "Pissarro's *Young Woman Mending*." *Chicago Art Institute Quarterly* 54(April 1960):17-9.

1588. SWICKLIK, MICHAEL. "French Painting and the Use of Varnish, 1750-1900." *Studies in the History of Art* 41(1993):156-74. 1 illus.

Analyzes the types of varnish used and methods of varnishing in France, focusing on the work of the Impressionists including Pissarro. Concludes that many Impressionists rejected varnishing to achieve specific aesthetic effects and that their works were later revarnished for preservation.

1589. TABARANT, ADOLPHE. "Pissarro et Guillaumin." *Le Bulletin de la vie artistique* (15 April 1922).

1590. TABARANT, ADOLPHE. "Le Faux Pissarro du Musée de Lille." *Le Bulletin de la vie artistique* (15 May 1925).

1591. TABARANT, ADOLPHE [L'Imagier, pseud.]. "De Pissarro à Sisley." *L'Oeuvre* (1 March 1930).
1592. TAYLOR, J. R. "First Impressions." *Art & Artists* 188(May 1982):24-5.

Traces the influence of London on some key figures of early modern art, including Pissarro and Monet. Illustrated with Pissarro's *Penge Station, Upper Norwood*.

1593. THAU, CARSTEN. "Bevægelsens anatomi: Toulouse-Lautrecs Paris." *Louisiana Revy* (Denmark) 35:1(Nov. 1994):18-29. 11 col. illus.

Describes the modernization of Paris during the Second Empire and cityscapes by artists such as Pissarro and Toulouse-Lautrec.

1594. THAW, EUGENE VICTOR. "Courtauld the Collector." *New Criterion* 13:8(April 1995):74-6.

Historical overview of the Courtauld Institute Gallery, London and its recent move to the Somerset House. A donation by Samuel Courtauld in 1923 enabled the National Gallery to acquire works by Pissarro and Seurat, among other French modernists.

1595. THIBAUT, MATTHIAS. "Impressionismus in Britain: London, Barbican Art Gallery — bis 7. mai." *Weltkunst* 65:7(1 April 1995):932. 1 illus.

Traces the development of Impressionism, including the arrival of Monet, Pissarro, and Sisley in London in 1870.

1596. THIEBAULT-SISSON ALBERT. "Camille Pissarro et son œuvre." *Le Temps* (30 Jan. 1921).

1597. THIEBAULT-SISSON ALBERT. "Le Centenaire du peintre Camille Pissarro (1830-1903)." *Le Temps* (22 Feb. 1930).

1598. THOMAS, K. "Fragile Preziosen." *Weltkunst* 52:3(1 Feb. 1982):192-5. 10 illus.

Review of an exhibition of Cézanne's watercolors at the Kunsthalle, Tübinger that notes the early influence of Pissarro and Manet on Cézanne's work.

1599. THOMSON, BRENDA. "Camille Pissarro and Symbolism: Some Thoughts Prompted by the Recent Discovery of an Annotated Article." *Burlington Magazine* 124:946(Jan. 1982):14-23. 10 illus.

Annotations by Pissarro of an article by Gabriel-Albert Aurier, "Le Symbolisme en peinture," *Mercure de France* (March 1891), recently discovered in the library of the Ashmolean Museum, Oxford reveal Pissarro's hostility to Symbolism. Background to the appearance of the article is presented before the annotations are discussed in detail.

1600. THOMSON, RICHARD. "Drawings by Camille Pissarro in Manchester Public Collections." *Master Drawings* 18:3(Autumn 1980):257-63, 322-6. 6 illus.

Studies five drawings executed from the early 1880s to 1890s that provided insights into the working methods and motifs used by Pissarro in mid-career. The five drawings are *Shepherdess, Stevedore; Les Moyettes à Eragny, Landscape, Eragny*; and *Gossip*.

1601. THOMSON, RICHARD. "Pissarro and the Figure." *Connoisseur* 207:833(July 1981):187-90. 7 illus.

Reassessment of Pissarro's figure studies, including peasants in rural settings and in rural markets.

1602. THOMSON, RICHARD. "Camille Pissarro, *Turpitudes sociales* and the Universal Exhibition of 1889." *Arts Magazine* 56:8(April 1982):82-8. 15 illus.

Discusses Pissarro's album of 28 drawings entitled *Turpitudes sociales* that he sent to his niece Esther Issacson in England in 1889, which was eventually acquired by Daniel Skira. The drawings show scenes from the lives of urban proletariats and deal with themes of poverty, repression, crime, and exploitation. Quotations from the journal *La Révolte* are paired with the images. Examines Pissarro's political positions and attitudes at the time and his reaction to the Universal Exhibition of 1889 in Paris.

1603. THOMSON, RICHARD. "The Sculpture of Camille Pissarro." *Source* 2:4(Summer 1983):24-8. 3 illus.

Infers that Pissarro was an infrequent sculptor, based on a letter of 1882 from Pissarro to Gauguin as well as on drawings by Pissarro and his son Lucien. Apparently, none of Pissarro's sculptures have survived.

1604. THOROLD, ANNE. "The Pissarro Collection at the Ashmolean Museum." *Burlington Magazine* 120:907(Oct. 1978):642-5.

Details the Pissarro family gift and archive donated to the Ashmolean Museum, Oxford, 1950-52, comprising paintings, drawings, prints, woodblocks, letters, and documents. An inventory lists original works by Camille, Lucien, Georges ("Manzana"), Félix (Jean Roch), Ludovic-Rodolphe (Ludovic-Rodo), Paul-Emile (Paulémile), Orovida and Esther Pissarro, song book *Eragny Artists,* plaster head of Camille Pissarro by Paulin, bronze of Lucien by Dora Gordine, and oil painting of Orovida by Carel Weight. Documentary material includes letters of Camille and his wife Julie, Lucien, Esther, other children, family, and important other correspondents (writers, editors, painters including Cassatt, Duret, Gauguin, Geffroy, Grave, Fénéon, Hayet, Lecomte, Manson, Mirbeau, Monet, Petitjean, Van Rysselberghe, and Signac). The inventory also lists Camille and Julie's estates, Eragny Press material including books, diaries, account books, Ludovic-Rodo books, Orovida letters, catalogue of oils, Hugues Pissarro book, journals and catalogues, gallery and museum letters, paint recipes, and receipts.

1605. THOROLD, ANNE. "Learning from Pissarro: The Artist as Teacher." *Apollo* 136:369(Nov. 1992):330-3. 4 illus., 1 col.

Appreciation of Pissarro's talents as a mentor and teacher to Cézanne, Gauguin, van Gogh, and Signac that focuses on Pissarro's character and temperament as well as his working relationships with Cézanne and Gauguin. Extracts on art from Pissarro's letters to his son Lucien are included.

1606. TINTEROW, GARY. *"Côte des Grouettes, near Pontoise."* *Metropolitan Museum of Art Bulletin* 50(Fall 1992):46.

1607. TINTEROW, GARY. *"The Garden of the Tuileries on a Spring Morning."* *Metropolitan Museum of Art Bulletin* 50(Fall 1992):50.

1608. "Toledo Acquires *Peasant Women Resting.*" *ARTNews* 33(23 Feb. 1935):8.

1609. TSCHAEGLE, R. *"Banks of the Oise, near Pontoise* by Camille Pissarro." *John Herron Institute of Art Bulletin* 28(Feb. 1941):7-13.

1610. TURNER, E. H. "Impressionist Paintings in Canadian Collections." *Canadian Art* 17(July 1960):204-5.

Illustrated with Pissarro's *Fenaison à Eragny* (cover), *Factory on the Oise,* and *Orchard.*

1611. UEBERWASSER, WALTER. "Corot, Renoir, Pissarro, Cézanne und Degas aus einer schweizerischen Privatsammlung. *Du* (1952). 14 p., 9 col. pl.

1612. VAIZEY, MARINA. "Camille Pissarro: Poet of the Ordinary." *Portfolio* 3:3(May-June 1981):54-61. 10 illus.

Account of Pissarro's life and work, including his importance as a teacher of other Impressionists.

1613. VANGELDER, PAT. "Going with the Flow." *American Artist* 59:632(March 1995):28-33. 5 col. illus.

Critique of recent work by the U.S. artist Linda Plotkin that briefly traces the history of the monotype process and notes its popularity among late 19th century artists such as Pissarro.

1614. VAUXCELLES, LOUIS. "Notes sur Camille Pissarro." *L'Univers Israelite* (16 Dec. 1927).

1615. VAUXCELLES, LOUIS. "La Gloire de Camille Pissarro." *Excelsior* (22 Feb. 1930).

1616. VENTURI, LIONELLO. "L'Impressionismo." *Arte* new ser. 6(March 1935):118-49.

1617. VENTURI, LIONELLO. "Impressionism." *Art in America* 24(July 1936):94-110.

General article on Impressionism, illustrated by Pissarro's *Haystack* (1873), *Saint Sever* (1898), and *Pontoise* (1868).

1618. VERGNON, DOMINIQUE. "Pissarro dans la ville." *Estampille. L'Object d'art* 272(1993): 46-53. 7 illus. Summary in English.

With reference to the exhibition *The Impressionist and the City: Pissarro's Series Paintings* (Dallas, Dallas Museum of Art and two other venues, 1992-93), Vergnon concentrates on the cityscapes of Pissarro's last ten years.

1619. VON GEHREN, G. "Ein Impressionist mit Sinnlichkeit und Intellekt." *Weltkunst* 51:1(1 Jan. 1981):24-5. 5 illus.

Biographical account of Pissarro's artistic development that traces his early life and training, his meeting with Corot and his extended stay in London in 1870, and his emergence as a father-figure to younger Impressionists. Pissarro was the only painter to exhibit in all eight Impressionist exhibitions.

1620. WARD, MARY MARTHA. "The Rhetoric of Independence and Innovation" in *The New Painting: Impressionism, 1874-1886*, ed. by Charles S. Moffett (San Francisco: Fine Arts Museum of San Francisco, 1986):421-42.

1621. WARD, MARY MARTHA. "Impressionist Installations and Private Exhibitions." *Art Bulletin* 73:4(Dec. 1991):599-622. 13 illus.

Examines the exhibitions, installations, and presentations of the Impressionists and early shows of La Société des Artistes Indépendants. Concludes by detailing Pissarro's contribution to modern art installations.

1622. WARNER, M. "Tears in the Mind's Eye: From David to Pissarro." *Encounter* 56:4(1981):67-74.

Composite review of five books on David, Delacroix, the German Romantics, and Pissarro, including *Letters to his son Lucien* (Santa Barbara: Peregrine Smith, 1981) and the exhibition catalogue *Pissarro* (London: Hayward Gallery, 1980).

1623. WEBSTER, J. CARSON. "Techniques of Impressionism: A Reappraisal." *College Art Journal* 4(Nov. 1944).

1624. WEISBERG, GABRIEL P. "Pissarro, a Creative Dynamo who Continually Renewed Himself." *ARTnews* 80:7(Sept. 1981):128-31. 6 illus., 3 col.

Focuses on the totality of Pissarro's œuvre — painting, drawing, printmaking, painted fans, and ceramics — with reference to the exhibition *Pissarro* held at the Hayward Gallery, London; the Grand Palais, Paris; and at the Museum of Fine Arts, Boston (1980-81). Concludes that Pissarro appreciated academic painting techniques and imagery, while at the same time learning new approaches from avant-garde colleagues.

1625. WEISBERG, GABRIEL P. "Jules Breton, Jules Bastien-Lepage, and Camille Pissarro in the Context of 19ᵗʰ Century Peasant Painting and the Salon." *Arts Magazine* 56:6(Feb. 1982):115-9 11 illus.

Suggests that Pissarro's use of poses and compositional organization derived from peasant themes in works by Jules Breton and Jules Bastien-Lepage shown in the 1870s at Parisian salons, despite Pissarro's insistence that he never examined these paintings. Argues that the so-called avant-garde of the time may have been more aware of academic painting than has been previously acknowledged.

1626. WENTWORTH, MICHAEL J. "Energized Punctuality: James Tissot's *Gentleman in a Railway Carriage*." *Worcester Art Museum Journal* 3(1979-80):8-27. 15 illus.

Examines Tissot's flight to London in 1871 as a refugee from the Paris Commune with special attention to the painting *Gentleman in a Railway Carriage*. Tissot's influences included Pissarro, Degas, and Manet, among other artists.

1627. WERNER, ALFRED. "Quiet Grandeur: The Oeuvre of Pissarro." *Arts Magazine* 39(March 1965):30-5. 6 illus., 1 col.

1628. WERNER, ALFRED. "Humble and Colossal Pissarro." *Commentary* 18(July 1954):47-55. Revised in *American Artist* 37:372(July 1973):20-5, 64-5. 8 illus.

Summarizes Pissarro's life and analyzes his approach to painting, noting an increasing appreciation in the 1970s for his use of color, etching, skills, deliberate choice of humble subjects for portraiture, and camaraderie among fellow artists.

1629. "Windows Open to Nature." *Metropolitan Musem of Art Bulletin* 27:1(Summer 1968):33.

Illustrated with Pissarro's *Jallais Hill, Pontoise*.

1630. WOIMANT, FRANÇOISE and MARIE-CECILE MIESSNER. "Les Enrichissements 1994 de la Bibliothèque Nationale de France en estampes modernes." *Nouvelles de l'estampe* 141(July 1995):11-9. 17 illus.

Reports on 3,168 works by more than 150 artists acquired by the Bibliothèque Nationale in 1994, including engravings by Pissarro.

1631. WYKES-JOYCE, MAX. "Look at the Highlights." *Art & Artists* 201(June 1983):18-9.

Examines painting techniques of the Impressionists. Illustrated with Pissarro's *Rue St. Lazare* (cover).

1632. YOUNG, VERNON. "Stockholm" *Arts Magazine* 39:3(Dec. 1964):18-9.

Exhibition review illustrated with a reproduction of Pissarro's *Haystack* (1873).

1633. ZAHAR, MARUL. "Dialogue sur l'impressionnisme." *Peintre* 480(1 March 1974):3-9.

Describes Impressionism on the occasion of its centenary in an imaginary conversation. States that only Monet, Pissarro, and Sisley were "pure Impressionists" at the first exhibition in 1874.

1634. ZOLA, EMILE. "Le Naturalisme au Salon." *Le Voltaire* (18, 19, 22 June 1880).

V. Individual Exhibitions

1883, May-June	Paris, Galerie Durand-Ruel. *Exposition des œuvres de C. Pissarro.* 70 works shown.
	Reviews: E. Jacques, *L'Intransigeant* (14 May 1883); F. Henriet, *Le Journal des arts* (25 May 1883); H. Morel, *Le Réveil* (24 June 1883).
1890, February	Paris, Galerie Boussod-Valadon. *Exposition d'œuvres récentes de Camille Pissarro.* Préface par Gustave Geffroy. Catalogue published by Impr. G. Chamerot, Paris. 22 p.
1892, February	Paris, Galeries Durand-Ruel. *Exposition Camille Pissarro.* Préface par Georges Lecomte. Catalogue published by Impr. de l'art, E. Ménard, Paris. 30 p.
	Review: A. Germain, *L'Ermitage* 4(1892):117-8.
1893, March	Paris, Galeries Durand-Ruel. *Exposition d'œuvres récentes de Camille Pissarro.* Catalogue published by Impr. de l'art, E. Ménard, Paris. 8 p., 2 illus.
	Review: E. Cousturier, *Les Entretiens politiques et littéraires* 3(1893):331-3.
1896, 15 April-9 May	Paris, Galeries Durand-Ruel. *Exposition d'œuvres de Camille Pissarro.* Préface par Arsène Alexandre. Catalogue published by Impr. de l'Art, E. Moreau. 17 p.
	Review: F. Fénéon, *La Revue blanche* 2(1896):480.
1898	Paris, Galerie Durand-Ruel. *Camille Pissarro.* Préface par Gustave Geffroy.

1904	Paris, Galerie Durand-Ruel. *Exposition de l'œuvre de Camille Pissarro.* Préface par Octave Mirbeau. 24 p., 3 illus.
1907	Paris, Galerie Eugène Blot. *Exposition Camille Pissarro.* Préface par Georges Lecomte.
1911	Paris, Salon d'Automne. *Les Eaux-fortes et les lithographies de Camille Pissarro.* Préface par Théodore Duret.
1911	London, Stafford Gallery. *Camille Pissarro.* Preface by Walter Sickert.
1920, May	London, Ernest Brown & Phillips, Leicester Gallery. *Memorial Exhibition of the Works of Camille Pissarro (1830-1903).* Preface by J. B. Manson. Introduction by Campbell Dodgson. 24 p.
	Includes Dodgson's essay, "On the Etchings and Lithographs of Camille Pissarro."
1921	Paris, Galerie Nunès et Fiquet. *Collection de Mme Veuve C. Pissarro.* Préface par Gustave Geffroy.
1927, 18 March-15 April	Paris, Max Bine. *Exposition des eaux-fortes de Camille Pissarro.* Préface par Claude Roger-Marx. 58 p., illus.
1927, December	London, Ernest Brown & Phillips, Leicester Gallery. *Exhibition of Etchings and Lithographs by Camille Pissarro (1830-1903): Reynolds Room.* 20 p., illus.
1928, 3 December	Paris, Galerie Georges Petit. *Collection Camille Pissarro: catalogue des œuvres importantes de Camille Pissarro et des tableaux, pastels, aquarelles, gouaches par Cassatt, Cézanne, et al. composant la collection de Camille Pissarro.* 86 p., 59 pl. of works by Pissarro.
1928, 7-8 December	Paris, Hôtel Drouot. *l'Oeuvre gravé et lithographié de Camille Pissarro, eaux-fortes, aquatintes, lithographies, monotypes et des tableaux, aquarelles, pastels, dessins par Camille Pissarro, composant la collection Camille Pissarro, dont la deuxième vente aux enchères publiques aura lieu à Paris...vendredi 7 et samedi 8 décembre 1928.* Introduction par Jean Cailac. 54 p., 18 pl.
1929, 12-13 April	Paris, Hôtel Drouot. *L'Oeuvre gravé & lithographié de Camille Pissarro (deuxième partie) et des estampes modernes composant la collection Camille Pissarro, dont la troisième vente aura lieu à Paris, Hôtel Drouot les 12 et 13 avril 1929.* Commissaires-priseurs: M. F. Lair Dubreuil, M. André Desvouges. Expert: M. Jean Cailac. Paris: G. Petit, 1929. 36 p., pl.

1930, February-March	Paris, Musée de l'Orangerie. *Centenaire de la naissance de Camille Pissarro.* Introductions par Adolphe Tabarant (pp. 3-4) et de Robert Rey. Paris: Musées Nationaux, 1930. 23 p., illus., 8 pl. 139 paintings, 57 drawings, pastels and watercolors, and 80 etchings shown.

Reviews: A. Warnod, *Comœdia* 20(Feb. 1930); Thiébault-Sisson, *Le Temps* (22 Feb. 1930); L. Vauxcelles, *Excelsior* (22 Feb. 1930); C. Kunstler, *Art vivant* (1 March 1930); R. Rey, *Bulletin des Musées de France* (March 1930); C. Roger-Marx, *L'Europe nouvelle* (1 March 1930); *Art et décoration* 57(March 1930):supp. 3-4; P. Fierens, *ARTnews* 28(15 March 1930):30; *Cicerone* 22:7(April 1930):25, supp. 7; F. Neugass, *Die Kunst* 61(May 1930):233-9.

1931, June	London, Ernest Brown & Phillips, Leicester Gallery. *Exhibition of Gouaches, Pastels & Drawings by Camille Pissarro (1830-1903).* Preface by Walter Sickert. 12 p.

Review: H. Furst, *Apollo* 14(Aug. 1931):122.

1931, 26 June	Paris, Hôtel Drouot. *Tableaux, aquarelles, pastels, dessins par Camille Pissarro, 1830-1903, composant la collection de A. Bonin et dont la vente aux enchères publiques aura lieu Hôtel Drouot, salle no. 8 le vendredi 26 juin 1931.* Paris: Impr. Lahure, 1931. 24 p., 7 illus.
1931, 27 June-3 October	Millbank, London, National Gallery. *Exhibition of Oil Paintings by Camille Pissarro (1830-1903).* Foreword by J. B. Manson. 7 p.

Review: H. Furst, *Apollo* 14(Aug. 1931):122.

1933	NY, Durand-Ruel Galleries. *Exhibition of Paintings by Camille Pissarro.* 1 vol., unpaged.

Reviews: *ARTnews* 31(7 Jan. 1933):6; *Art Digest* 7(15 Jan. 1933):14.

1936, 2-28 March	NY, Durand-Ruel Galleries. *Exhibition of Paintings, Camille Pissarro.* 1 folded sheet.
1936, 22 May-11 June	Paris, Galerie Marcel Bernheim. *Les Premières époques de Camille Pissarro de 1858 à 1884.* 1 folded sheet.
1941, 24 March-15 April	NY, Durand-Ruel Galleries. *The Art of Camille Pissarro in Retrospect.* 1 vol. unpaged, illus.
1944, 12-26 April	NY, Carroll Carstairs Galleries. *Paintings of Paris by Camille Pissarro.* *10th Anniversary Exhibition.* Preface by G. Wescott. 4 p., 8 pl.

Review: *ARTnews* 43(15 April 1944):23.

1945, 25 October-24 November	NY, Wildenstein & Co. *Camille Pissarro: His Place in Art.* A loan exhibition for the benefit of the Goddard Neighborhood Center. Prepared by Vladimir Visson and Daniel Wildenstein. 44 p., illus. 50 works shown.
	Review: *Art Digest* 20(1 Nov. 1945):14.
1946, 8-30 January	Chicago, Arts Club of Chicago. *Exhibition of Paintings by Camille Pissarro.* 1 folded sheet.
1950, 28 June-25 July	London, Matthiesen Gallery. *A Camille Pissarro Exhibition.*
	Reviews: *Illustrated London News* 217(22 July 1950):153; *Burlington Magazine* 92(Aug. 1950):234.
1950, June	Paris, Galerie André Weil. *Pissarro.* Exhibition for the benefit of the Museum of Jerusalem. Préface par Georges Huisman. 44 paintings shown.
1950	London, Matthiesen Gallery. *Camille Pissarro.* 55 paintings, drawings, pastels and watercolors shown.
1955	London, Ernest Brown & Phillips, Leicester Galleries. *Collection of Pastels and Studies by Camille Pissarro (1830-1903).* With a preface by Lulie Abul-Huda. 23 p. 37 works shown.
1956, 26 June-14 September	Paris, Galeries Durand-Ruel. *Exposition Camille Pissarro (1830-1903).* Organisée au profit de la Société des amis du Louvre. Introduction par René Domergue. 32 p., illus., 17 pl. 111 works shown.
	Review: *Time* 68(10 Sept. 1956):98-9.
1957, 19 January-10 March	Bern, Berner Kunstmuseum. *Camille Pissarro, 1830-1903.* Introduction by François Daulte. 20 p., illus., 8 pl. 138 paintings, pastels, drawings, and etchings shown.
	Review: *Werk* 14(March 1957):supp. 53.
1957, October	NY, Peter H. Deitsch Fine Arts. *Camille Pissarro: Drawings, Watercolors and Rare Prints.* 10 p., illus. (Catalogue no. 5)
	Reviews: *ARTnews* 56(Oct. 1957):18; *Arts Magazine* 32(Oct. 1957):54.
1958, June	London, Ernest Brown & Phillips, Leicester Gallery. *Exhibition of Drawings by Camille Pissarro (1830-1903).* 16 p.

1959, 8 April London, Sotheby's. *Catalogue of Modern Etchings, Aquatints and Lithographs Comprising a Fine Collection of Etchings by Camille Pissarro, the Property of Orovida Pissarro...which will be Sold by Auction.* 40 p., 5 pl.

1959 Caracas, Museo de Bellas Artes. *Pissarro en Venezuela — Dibujos de Camille Pissarro.* Preface by Alfredo Boulton.

1960, 9-31 January Palm Beach, Florida, Society of the Four Arts. *Loan Exhibition of Paintings and Drawings by Camille Pissarro, 1830-1903.* 27 p, illus.

1962, 23 April-5 May NY, Hammer Galleries. *Camille Pissarro, 1830-1903: Drawings.* 1 vol. unpaged.

Review: *ARTnews* 61(May 1962):16.

1962, 29 May -28 September Paris, Galerie Durand-Ruel. *C. Pissarro, 1830-1903.* Exposition organisée au profit de la Société des Amis du Louvre. Introduction par Jacques Dupont. 32 p., illus., 17 pl.

Reviews: A Brookner, *Burlington Magazine* 104(Aug. 1962):363; P. Schneider, *ARTnews* 61(Sept. 1962):48.

1964 NY, Hammer Galleries. *Camille Pissarro in Venezuela.* Catalogue by John Rewald. 64 p., illus.

Exhibition of Pissarro's work in Venezuela, 1852-54. Reproduces 65 drawings of Venezuela and St. Thomas, U.S. Virgin Islands.

1965, 23 March-5 April NY, Beilin Gallery. *C. Pissarro.* Exhibition for the benefit of the Association for the Help of Retarded Children, New York League, Jr. Division. 7 p., illus.

1965, 25 March-1 May NY, Wildenstein Galleries. *Loan Exhibition, C. Pissarro.* For the benefit of Recording for the Blind, Inc. Foreword by Dr. John Rewald. 1 vol. unpaged, illus., 89 pl., 3 col.

Reviews: N. Rosenthal, *Art in America* 53(April 1965):117; L. Nochlin, *ARTnews* 64(April 1965):24-7[+]; J. Lanes, *Burlington Magazine* 107(May 1965):275-6.

1966, 23 January-24 February Winterthur, Kunstmuseum Winterthur. *Camille Pissarro, 1830-1903.* Introduction by Carl H. Jucker. 8 p. 34 prints shown.

Review: *Werk* 53(March 1966):supp. 58.

1967, 1-24 February London, Ernest Brown & Phillips, Leicester Galleries. *Exhibition of Early and Other Drawings by Camille Pissarro (1830-1903).* 14 p., illus. (Catalogue no. 1324)

1968, 1 February-6
March

NY, Center for Inter-American Relations, Art Gallery. *Pissarro in Venezuela.* A loan exhibition presented in collaboration with the Banco Central de Venezuela in association with the Museo de Bellas Artes, Caracas, and the Drawing Society. Introduction by Alfredo Boulton. Translated and edited by Stanton L. Catlin and Phyllis Freeman. NY: J. B. Watkins, 1968. 32 p., 17 illus.

Boulton's introduction (pp. 5-18) is a translation of the Spanish portion of his book, *Camille Pissarro en Venezuela* (Caracas: Editoriale Arte, 1966).
Review: T. Crombie, *Apollo* new ser. 96(Aug. 1972):169.

1968, June-July

London, Marlborough Fine Art. *Pissarro in England: A Loan Exhibition of Works by Camille Pissarro (1830-1903).* Drawn from public and private collections in England and Scotland in aid of the Save the Children Fund and Children and Youth Aliyah. Introduction by John Rewald. 76 p., 19 illus., 45 pl., 7 col.

Includes Rewald's essay, "Pissarro, the White Knight of Impressionism."

1973

Boston, Boston Museum of Fine Arts. *Camille Pissarro, the Impressionist Printmaker.* Text by Barbara S. Shapiro. 58 p., 45 illus.

Exhibition of examples of Pissarro's printmaking that includes several states of the same print. Bibliography, p. 16.

1976-77, 5
December-9 January

West Palm Beach, Florida, Norton Gallery and School of Art. *Pissarro Drawings from the Collection of Mr. and Mrs. F. L. Schoneman.* Preface by Richard A. Madigan; essay and checklist by Richard R. Brettell. 8 p., 3 illus. 18 drawings shown.

Exhibition of Pissarro's drawings that date from 1853 to 1903.

1977

London, New Grafton Gallery. *Paintings by Camille Pissarro.*

Review: H. Mullaly, *Apollo* 106:187(Sept. 1977):247.

1977-78, 3
November-26 March

London, Morley Gallery. *Camille Pissarro: Drawings from the Ashmolean Museum, Oxford.* Also shown Nottingham, Nottingham University Art Gallery (11 Jan. - 11 Feb. 1978) and Eastbourne, Towner Art Gallery, Manor House (25 Feb. - 26 March 1978). Selected, prefaced and annotated by Lulli Huda. Foreword by Cyril Reason.

Supported by the Arts Council of Great Britain. 44 p., 11 illus. 65 works shown.

Cross-section of Pissarro's drawings held at the Ashmolean Museum, Oxford that includes detailed biographical information and period photographs. Bibliography, pp. 18-9. Reviews: C. Bugler, *Arts Review* 29:24(25 Nov. 1977):713; K. Roberts, *Burlington Magazine* 119:897(Dec. 1977):874-77; H. Mullaly, *Apollo* 106:190(Dec. 1977):513

1978, 24 February-21 April — Paris, Ambassade du Venezuela. *Camille Pissarro au Venezuela.* Catalogue par Richard Soler. Paris: Les Presses Artistiques, 1978. 32 p., 22 illus. 40 works shown.

Watercolors and drawings form the Museo des Bellas Artes, Caracas and the Banco Central de Venezuela, Caracas, completed by Pissarro in Venezuela from 1852 to 1854.

1978, June-July — Caracas, Ministerio de Relaciones Exteriores. *El Pintor Camille Pissarro en Venezuela, 1852-1854; exposición de dibujos y pinturas.* Fotografias, Francisco Caula, et al. Caracas: Ministerio de Relaciones Exteriores, 1978. 23 p., illus.

1978 — London, J. P. L. Fine Arts. *A Selection of Drawings, Watercolours and Pastels by Camille Pissarro, c. 1853-1903.* 1 vol. unpaged.

1980, 18 May-22 June — Memphis, Dixon Gallery and Gardens. *Homage to Camille Pissarro: The Last Years, 1890-1903.* A loan exhibition under the high patronage of His Excellency, François de Laboulaye, the Ambassador of the Republic of France to the United States of America. Organized and edited by Michael Milkovich. Essay by Martha Ward. 112 p., 69 illus., 33 col. 66 works shown (26 paintings, 7 drawings, 33 prints).

Exhibition initiated upon the Gallery's acquisition of Pissarro's late painting, *La Jetée du Havre, haute mer, soleil, matin* (1903) that coincided with the 150th anniversary of the artist's birth. Includes an essay by Martha Ward, "Transitional Years," which focuses on the period (1890-1903) when Pissarro turned away from Neo-Impressionism. Full catalogue entries with explanatory notes are provided.

1980, 27 September-2 November — Colchester, England, The Minories. *Camille Pissarro: Etchings and Lithographs.* Introduction by John Bensusan-Butt. 12 p., 8 illus. 34 works shown.

Bensusan-Butt's introductory essay, "The 'Impressions gravées' of Camille Pissarro," describes his love of printmaking and printmaking techniques.

1980, 29 October-5
December

London, J. P. L. Fine Arts. *Camille Pissarro 1830-1903: Drawings, Watercolours and Pastels.* 60 p., 60 illus.

Annotated exhibition catalogue that contains no text except for a brief biography of the artist.

1980-81, 30 October-
9 August

London, Hayward Gallery. *Pissarro.* Also shown Paris, Grand Palais 30 Jan.-27 April 1981) and Boston, Boston Museum of Fine Arts (19 May-9 Aug. 1981). Introduction by John Rewald. Catalogue annotated entries and introductions by Christopher Lloyd, Anne Distel, and Barbara Stern Shapiro. Illustrated chronology by Janine Bailly-Herzberg. Bibliography by Martha Ward. London: Arts Council of Great Britain, 1980; Paris: Editions de la Réunion des Musées Nationaux, 1981. 264 p., 312 illus., 17 col. 230 works shown.

Exhibition of paintings, prints, drawings, fans, and ceramics representative of Pissarro's entire œuvre on the 150th anniversary of his birth. Essays include "Camille Pissarro: A Revision," by Richard Brettell and "Looking at Pissarro," by Françoise Cachin. Includes full catalogue entries, illustrated chronology, and an extensive bibliography (pp. 250-61).

Reviews: M. Wykes-Joyce, *Antique Dealer and Collectors Guide* (Nov. 1980):76-8; R. Shone, *Burlington Magazine* 122:932(Nov. 1980):780-3; F. Davis, *Country Life* 168:4342(6 Nov. 1980):1648-9; J. House, *Times Literary Supplement* (7 Nov. 1980):1259-60; W. Borders, *New York Times* (27 Dec. 1980):11; G. von Gehren, *Weltkunst* 51:1(Jan. 1981):24-5; M. Bouisset, *Goyá* 160(Jan.-Feb. 1981):223; E. Lucie-Smith, *Art International* 24:5-6(Jan.-Feb. 1981):72-6; W. Feaver, *ARTnews* 80:2(Feb. 1981):201, 203; A. Gouk, *Artscribe* 27(Feb. 1981):22-9; M. Vaizey, *Gazette des Beaux-arts* 97(Feb. 1981):12 supp.; S. Monneret, *Connaissance des arts* 348(Feb. 1981):28-35; A Pistel, *Revue du Louvre et des musées de France* 31:191981):66-7; G. Vignoht, *Peintre* 620(1 March 1981):8-10; V. S. Pritchett, *New York Review of Books* 28:8(14 May 1981):8-12; M. Vaizey, *Portfolio* 3:3(May-June 1981):54-61; H. Kramer, *New York Times* (31 May 1981):D1, D29; G. Weisberg, *ARTnews* 80(Sept. 1981):128-31; *Du* 1(1981):86.

1980-81, 22
November-31
January

Pontoise, Musée Pissarro. *Pissarro & Pontoise.* Textes par Jean-Philippe Lachenaud, Jean Leymarie, Tibor Meray, Janine Bailly-Herzberg, Edda Maillet, Jerôme Serri, et Charles Oulmont. 40 p., 36 illus., 9 col. 95 works shown.

Loan exhibition of paintings, gouaches, watercolors, pastels, drawings, engravings, lithographs, and sketches by Pissarro in celebration of the 150th anniversary of the birth of the artist and to inaugurate the opening of the Musée Pissarro, Pontoise, achieved through the efforts of l'Association des Amis de Camille Pissarro. Catalogue texts describe the museum's founding and Pissarro's artistic ties to the Pontoise landscape.

1980

Caracas, Museo de Bellas Artes. *Camille Pissarro en Caracas 1852/1854.* Exposición organizada en conmemoración de los ciente cincuenta años de su nacimento. Text by Alfredo Boulton. Caracas: Museo de Bellas Artes, 1980. 38 p., illus. In Spanish and French.

1981, 4 February-26
April

Paris, Centre cultured du Marais. *Pissarro: monde rural, art politique; 50 dessins — 196 documents.* Centre de Recherches par les expositions et le spectacle (CRES). Textes par Christopher Hamilton Lloyd et Anne Thorold. Paris: CRES, 1981. 64 p., 53 illus., 246 works shown.

Selection of 50 Pissarro drawings of peasants and 196 documents (photographs, drawings, paintings, correspondence, and archival material) that demonstrate Pissarro's connections to the late 19th century artistic, literary, and political life in Paris. Based in part on the exhibition, *Artists, Writers, Politics: Camille Pissarro and his Friends,* Oxford, Ashmolean Museum (1 Nov. 1980-4 Jan. 1981), and drawn from the Ashmolean's Pissarro Family Archives.

1984, 6 March-27
April

London, J. P. L. Fine Arts. *Camille Pissarro, 1830-1903: Drawings, Watercolours and Pastels.* 48 p., illus.

Reviews: O. Blakeston, *Arts Review* 36:6(30 March 1984:159; *Art & Artists* 211(April 1984):29-30.

1984, 9 March-1 July

Tokyo, Isetan Museum of Art. *Retrospective Camille Pissarro.* Also shown Fukuoka, Fukuoka Art Museum (25 April-20 May 1984); Kyoto, Kyoto Municipal Museum of Art (26 May-1 July 1984). Catalogue supervised by Prof. Chuji Ikegami, edited by committee. Texts by Christopher Lloyd and Barbara S. Shapiro. Tokyo: Art Life, 1984. 154 p., illus. In Japanese and English.

Bibliography, p. 154.

1984, 27 July-15
September

Salzburg, Galerie Salis. *Camille Pissarro, 1830-1903: Aquarelle, Pastelle, Zeichnungen.* Festspielausstellung 1984. 52 p., illus.

1984-85, 17
November-28
February

Pontoise, Musée Pissarro. *Camille Pissarro: 1830-1903.* Pontoise: Musée de Pontoise, 1985. 24 p., illus.

1986, 15 November-
14 December

Aulnay-sous-Bois, Galerie d'expositions de l'Hôtel de Ville d'Aulnay-sous-Bois. *Camille Pissarro: gravures, dessins.* 64 p., illus.

1989, 27 May-31
October

Pontoise, Musée Pissarro. *Camille Pissarro, 1830-1903.* 8 p., illus., 11 pl.

1989, October

Richmond, England, Museum of Richmond and Riverside Room. *Pissarro in Richmond: Camille Pissarro and his Artistic Family in Kew, Chiswick, and Richmond.* Published to coincide with the exhibition *Pissarro in Richmond* shown at the Museum of Richmond the Riverside Room. Catalogue by Nicholas Reed. London: Lilburne, 1989. 25 p.,19 illus.

1989

London, South Bank Centre. *Camille Pissarro: Impressionist Work.* Text by Richard Thomson.

1990, 8 March-17
June

Birmingham, City Museum and Art Gallery. *Camille Pissarro: Impressionism, Landscape, and Rural Labour.* Also shown Glasgow, Burrell Collection (14 May-17 June 1990). Catalogue by Richard Thomson. London: South Bank Centre, 1990. 127 p., illus.

Bibliography, pp. 119-20.
Reviews: C. Darwent, *Country Life* 184:18(3 May 1990):164; M. Clarke, *Burlington Magazine* 132:1047(June 1990):427-9.

1990-91, 27
November-20
January

Bremen, Kunsthalle Bremen. *Camille Pissarro: Radierungen, Lithographien, Monotypien aus deutschen und osterreichischen Sammlungen.* Bearbeitag von Anne Röver. 111 p., 129 illus.

Exhibition of Pissarro's etchings, lithographs, and monotypes from German and Austrian collections. Rover's introduction outlines Pissarro's printmaking techniques and development.

1992, 20 February-12
April

Caracas, Museo de Bellas Artes. *C. Pissarro: ráices y vegetacion — dibujos y acuerelas, Venezuela 1852-1854.* Introduction by Elizabeth Lizarralde. Text by Marco Rodriguez del Camino. 104 p., illus. (Exposićion no. 981; catalogo no. 865).

Exhibition of works completed by Pissarro during his two-year stay in Venezuela from the collection of the Museo de Bellas Artes, Caracas

1992	Caracas, Centro Cultural Consolidado. *I Bienal Camille Pissarro*. 54 p., illus.
1992-93, 15 November- 10 October	Dallas, Dallas Museum of Art. *The Impressionist and the City: Pissarro's Series Paintings.* Also shown Philadelphia, Philadelphia Museum of Art (7 March - 6 June 1993); London, Royal Academy of Arts (2 July - 10 Oct. 1993). Catalogue by Richard R. Brettell and Joachim Pissarro, edited by MaryAnne Stevens. New Haven: Yale University Press, 1992. 230 p., 223 illus., 213 col. 154 works shown.

Exhibition of Pissarro's urban series paintings of Paris, Rouen, Dieppe, and Le Havre dating from 1896-1903. Brettell's essay considers Pissarro's influences and the events that led to this choice of subject matter. Joachim Pissarro's essay focuses of difficulties of series paintings and historical and technical precedents for Pissarro's works.

a. French ed.: *Pissarro et la ville.* Traduit de l'anglais par Noëlle Alcoa. Paris: Editions du May, 1993. 280 p., illus.
Reviews: R. Brettell, *Apollo* 138:380(Oct. 1993): 207-11; R. Shone, *Burlington Magazine* 135:1088(Nov. 1993): 775-6; J. Da Costa Nuñes, *Nineteenth Century Studies* 8(1994): 105-18.

1993	London, J. P. L. Fine Arts. *Camille Pissarro, 1830-1903: Paintings, Pastels, Watercolours and Drawings.* 8 p. (1 folded sheet), col. illus.
1993	Paris, Galerie Private.

Review: L. Pythoud, *L'Oeil* 454(Sept. 1993):79.

1994	Caracas, Centro Cultural Consolidado. *Il Bienal Camille Pissarro.* 51 p., illus.
1994	Jerusalem, Israel Museum. *Camille Pissarro: Impressionist Innovator.* Catalogue by Joachim Pissarro and Stephanie Rachum. 278 p., illus. 129 works shown. (Catalogue no. 360)

Exhibition of paintings, drawings and watercolors by Pissarro organized chronologically and by subject. Includes an introductory essay, "Pissarro's Memory," by Joachim Pissarro, and a bibliography.

1996-97, 16 December-14 March	St. Thomas, U.S. Virgin Islands, Lilienfeld House. *Camille Pissarro in the Caribbean, 1850-1855: Drawings from the Collection at Olana.* Also shown NY, The Jewish Museum (31 Aug. - 16 Nov. 1997). This exhibition commemorates the Bicentennial of the Hebrew Congregation of St. Thomas, U.S. Virgin Islands. Introduction by Joachim Pissarro. Texts by Richard R. Brettell, Karen Zukowski, and Judith Cohen. 46 works on paper.

Drawings and sketches by Pissarro from the Olana State Historic Site, Hudson, New York, that until recently were attributed to Pissarro's Danish colleague, Fritz Melbye.

VI. Selected Group Exhibitions

1870, December	London, German Gallery, New Bond Street.
	First exhibition mounted by Paul Durand-Ruel in London that included works by Pissarro and Monet. See John House, "New Material on Monet and Pissarro in London in 1870-71," *Burlington Magazine* 120:907(Oct. 1978):636-42 for an historical overview.
1888, 25 May-25 June	Paris, Durand-Ruel et fils. *Exposition.* 4 p.
	Exhibition of works by Pissarro and other Impressionists.
1891, 17-28 March	Boston, Chase's Gallery. *Catalogue of Paintings by the Impressionists of Paris: Claude Monet, Camille Pissarro, Alfred Sisley, from the Galleries of Durand Ruel.* 15 p.
1899, April	Paris, Galeries Durand-Ruel. *Exposition de tableaux de Monet, Pissarro, Renoir & Sisley.* 16 p.
1900, 19 June	Paris, Hôtel Drouot. *Catalogue de tableaux modernes par Boudin, Guillaumin, Lépine, Claude Monet, Pissarro, Sisley, Ziem.* Composant la collection de M. Ibos. 20 p., illus., pl.
1910, 25 June	Paris, Galerie Durand-Ruel. *Tableaux par Monet, C. Pissarro, Renoir et Sisley.* 8 p.
1913-14, 20 December-8 January	NY, Durand-Ruel Galleries. *Exhibition of Paintings Representing Still Life and Flowers by Manet, Monet, Pissarro, Renoir, Sisley, André d'Espagnat.* 4 p.
1925, 18 February-March	NY, Durand-Ruel Galleries. *Exhibition of Paintings by Camille Pissarro and Alfred Sisley.* 8 p.
1931, 2-30 May	Amsterdam, Kusthandel Huick & Scherjon N.V. *Catalogues van de Tentoonstelling eener verzameling Schilderijen door: Claude Monet, Pissarro en Sisley.*
1931, 12 October-2 November	NY, Durand-Ruel Galleries. *Exhibition of Paintings by Degas, Renoir, Monet, Pissarro and Sisley prior to 1880.* 1 vol. unpaged, illus.
1932, 4-25 January	NY, Durand-Ruel Galleries. *Exhibition of Pastels and Gouaches by Edgar Degas and Camille Pissarro.* 8 p.
1934	Paris, Galerie Marcel Bernheim. *Pissarro et ses fils.* Préface par Gustave Kahn.

1935, 22 April-11 May	NY, Durand-Ruel Galleries. *Exhibition of Patels and Gouaches by Degas, Pissarro, Renoir, and Cassatt.* 1 vol. unpaged, 2 illus.
1936, April-May	London, Ernest Brown & Phillips, Leicester Galleries. *Catalogue of an Exhibition of Paintings by Sisley, Renoir, Pissarro, Monet, Boudin, Cassatt.* 25 p., 6 illus.
1937, 11-30 January	NY, Durand-Ruel Galleries. *'Views on the Seine' by Monet, Pissarro, Renoir, Sisley.* Commemorating the fiftieth anniversary of the Durand-Ruel Galleries in New York, 1887-1937. 7 p., illus.
1937	London, Lefevre Gallery. *Pissarro and Sisley.* 16 p., 4 illus.
	Review: *ARTnews* 35(13 Feb. 1937):12.
1938, 11 June-9 July	Paris, Galerie Paul Rosenburg. *Differents aspects de la peinture française depuis 1900 (Pissarro à Utrillo).* 1 p.
1938	London, Rosenberg & Helft. *Pictures by Monet, Pissarro, Renoir, Sisley.* 11 p., illus. (Catalogue no. 18)
1938	San Francisco, San Francisco Museum of Art. *Impression, Paintings by Monet, Pissarro, Renoir, Seurat, Sisley.* 4 p., illus.
1939	London, Stafford Gallery. *Constable, Bonington, Pissarro.* Catalogue by John Rewald. 4 p.
1943, June	London, Leicester Galleries. *Catalogue of an Exhibition of (1) Three Generations of Pissarro: Camille, Lucien, Orovida (2) Paintings and Drawings by Lord Methuen.* 16 p.
	Review: J. Gordon, *London Studio* 26(Aug. 1943):58; 26(Sept. 1943):89-90.
1948	NY, Durand-Ruel Galleries. *Paintings of Ships: Monet, Pissarro, Renoir, Sisley, Redon, Morisot.* 4 p.
1949	Basel, Kunsthalle. *Impressionisten: Monet, Pissarro, Sisley: Vorläufer und Zeitgenossen.* 39 p., illus., 32 pl.
	Review: *Werk* 36(Nov. 1949):supp. 153-4.
1954	London, Ohana Gallery. *Three Generations of Pissarros, 1830-1954.* Preface by John Rewald.
	Included works by Camille, Lucien, Manzana (Georges), Félix, Ludovic Rodo, Paulémile, and Orovida Pissarro.

1955, June-July

London, Marlborough Fine Arts. *Camille Pissarro, 1830-1903; Alfred Sisley, 1839-1899.* Exhibition in aid of the Save the Children Fund and Children and Youth Aliyah. Preface by A. Clutton-Brock. 42 p., 10 pl. 30 works by Pissarro.

1965

NY, Wildenstein Galleries. *Olympia's Progeny: French Impressionist an Post-Impressionist Paintings 1865-1905: Manet, Degas, Monet, Renoir, Pissarro, Sisley, Cézanne, van Gogh, Gauguin, Toulouse-Lautrec.* 106 p., 86 illus., 4 col.

Review: H. La Farge, *ARTnews* 64:7(Nov. 1965):50-1,66-7.

1966, 15 January-26 February

NY, Bianchini Gallery. *Master Drawings: Pissarro to Lichtenstein.* Also shown Cincinnati, Contemporary Arts Center (7-26 Feb. 1966). 36 p., illus.

1968, 24 October-30 November

NY, Acquavella Galleries. *Four Masters of Impressionism: Monet, Pissarro, Renoir, Sisley.* 1 vol. unpaged, col. pl.

1972, 17 May-17 June

Paris, Galerie Schmit. *Les Impressionnistes et leurs précurseurs.* Introduction par François Daulte. 95 p., 71 illus.

1973, 3 January-11 March

London, Hayward Gallery. *The Impressionists in London.* Introduction by Alan Bowness. Texts by Anthea Callen. 80 p., 66 illus.

Exhibition of works by Monet, Pissarro, Sisley, Renoir, Derain, and Kokoschka. Review: C. Neve, *Country Life* 153:3942(11 Jan. 1973):100-1.

1974, 13 January-28 July

Salt Lake City, University of Utah Fine Arts Museum. *Social Concern and the Workers: French Prints from 1830-1910.* Also shown Cleveland, Cleveland Museum of Art (12 March - 12 May 1974) and Indianapolis, Indianapolis Museum of Art (11 June - 28 July 1974). Catalogue by Gabriel P. Weisberg. 138 p., 77 illus. 85 works shown.

Included anarchist and socialist prints by Pissarro.

1974, 4 August-15 September

Bremen, Kunsthalle. *Die Stadt: druckgraphische Zyklen des 19. und 20.Jahrhunderts.* Katalogbearbeitung Gerhard Gerkens, Ulrike Kocke, Bernhard Schnackenurg. 87 p., illus.

Exhibition of graphic works based on city themes that included some of Pissarro's views of Rouen.

1976-77, 10 December- 28 February	Pontoise, Musée de Pontoise. *Camille Pissarro: sa famille, ses amis.* Organisée par les Amis de Camille Pissarro. 20 p., 7 illus. 96 works shown.
	Included 35 prints, drawings and paintings by Camille Pissarro, 14 works by his children, and paintings, drawings, watercolors and prints by friends and contemporaries, mostly borrowed from the French private collections.
1977-78, 4 December-8 January	Memphis, Dixon Gallery and Gardens. *Impressionists in 1877: A Loan Exhibition.* Introduction by Michael Milkovich. 81 p., 40 illus., 9 col. 30 works shown.
	Commemorative centennial exhibition of 14 of the 18 French artists who participated in the 3rd Impressionist show in Paris in 1877.
1978, 15 March-16 April	London, Belgrave Gallery. *Jewish Artists of Great Britain 1845-1945.* Catalogue by I. Grose. 64 p., 86 illus.
	Included works by Pissarro family artists.
1978, April-1 October	London, British Museum. *From Manet to Toulouse-Lautrec: French Lithographs 1860-1900.* Texts by F. Carey and A. Griffiths.
	Exhibition of prints from the British Museum, largely a part of the Campbell Dodgson donation that included works by Pissarro.
1978-79, 18 November-8 February	Pontoise, Musée de Pontoise. *Camille Pissarro, Charles-François Daubigny, Ludovic Piette.* Introduction par Edda Maillet. Textes par C. Lobstein et A. Watteau. 24 p., 12 illus.
	Review: *L'Oeil* 282-3(Jan.-Feb. 1979):68.
1979-80, 2 November-6 January	Ann Arbor, University of Michigan. Museum of Art. *The Crisis of Impressionism 1878-1882.* Catalogue by Joel Isaacson, with the collaboration of Jean-Paul Bouillon, Dennis Costanzo, Phylis Floyd, Laurence Lyon, Matthew Rohn, Jacquelynn Baas Slee, and Inga Christine Swenson. 220 p., 78 illus., 6 col. 56 works shown.
	Exhibition of paintings, prints, and sculptures by leading Impressionists including Pissarro, who is identified as a colorist and landscapist.
1980-81, 1 November-4 January	Oxford, Oxford University, Ashmolean Museum. *Artists, Writers, Politics: Camille Pissarro and his Friends.* Catalogue by Anne Thorold. 78 p., 14 illus., 144 works shown.

Exhibition of archival materials, photographs, drawings, paintings and other works drawn from the Pissarro Family Archive presented to the Ashmolean Museum in 1950 by Esther Pissarro, the wife of Camille's son Lucien. Correspondence between Camille and Lucien from 1883-1903 formed the basis of the exhibition.

1982-83, 16 October-
30 January

Pontoise, Musée Pissarro. *Camille Pissarro et son fils Lucien: John Bensusan-Butt.* Textes par J.-P. Lachenaud, Edda Maillet, Anne Thorold, John Bensusan-Butt. 16 p., 20 illus. 68 works shown.

Exhibition of paintings, drawings, and prints by Pissarro that illustrate his influence on his son Lucien. Includes a selection of Lucien's paintings and engravings and watercolors by Bensusan-Butt, a friend of Lucien who was also influenced by Camille.

1986, 1 August-19
October

Edinburgh, National Gallery of Scotland. *Lighting up the Landscape: French Impressionism and its Origins.* Catalogue by Michael Clarke 104 p., 70 illus., 21 col.

Exhibition of French Impressionist landscape that highlighted works by Monet and Pissarro, including Pissarro's *The Banks of the Marne at Chennevières* (1865) and *Kitchen Garden at L'Hermitage, Pontoise* (1874).

1986

South Yarra, Victoria, Australia, Tolarno Galleries. *Camille Pissarro and his Friends.* 9 p., illus., 37 pl.

1988

San Francisco, Pasquale Iannetti Art Galleries. *Pissarro & Manet: Impressionist Printmakers.* Catalogue and texts by Sarah Spencer. 16 p., 50 illus. (Catalogue 13)

1989, 29 June-9 July

Canberra, Australian National Gallery. *Irises and Five Masterpieces.* Catalogue by Diana de Bussy. Perth: Bond Corporation, 1989. 28 p., 6 col. illus.

Exhibition from the collections of Alan Bond, who purchased one of van Gogh's *Irises.* De Bussy writes briefly about Bond's collection, which includes works by Pissarro.

1989

Munich, Staatliche Graphische Sammlung, Neue Pinakothek. *Druckgraphikim 19.Jahrhundert: Techniken, Aufgaben, Moglichkeiten.*

Exhibition of 19th century prints including several by Pissarro.

1991, 8-27 April — Tokyo, Zen International Fine Art. *Five Masterpieces of Impressionist Paintings.* Texts by Robert Rosenblum and Joachim Pissarro. 48 p., 11 illus., 5 col. In Japanese and English.

Exhibition of five masterpieces, including Pissarro's *Les Carrières du chou, Pontoise* (1882) and *Vieilles maisons à Eragny* (1884).

1992 — Wilmington, NC, St. John's Museum of Art. *Cassatt, Degas and Pissarro: A State of Revolution.* Anne G. Brennan, curator; Donald Furst, contributing essayist. 20 p., illus.

1992-93, 27 September-15 September — New Brunswick, NJ, Jane Voorhees Zimmerli Art Museum. *From Pissarro to Picasso: Colour Etchings in France: Works from the Bibliothèque Nationale and the Zimmerli Art Muesum.* Also shown Amsterdam, Rijksmusuem Vincent van Gogh (12 Feb.-18 April 1993) and Paris, Bibliothèque Nationale (5 June-15 Sept. 1993). Foreword by Emmanuel le Roy Ladeine; preface by Phillip Dennis Cate; with additional text by Marianne Grivel. New Brunswick, NJ: Zimmerli Art Museum; Paris: Flammarion, 1992. 198 p., 216 illus., 168 col.

Exhibition of French printmaking in the late 19th and early 20th centuries that included examples by Pissarro and references to his innovations and creativity.
a. French ed.: *De Pissarro à Picasso: l'eau-forte en couleurs en France.* Paris: Flammarion, 1992.

1995-96, 18 May-14 January — London, Hayward Gallery. *Landscapes of France: Impressionism and its Rivals.* Also shown Boston, Boston Museum of Fine Arts (4 Oct. 1995-14 Jan. 1996). Introduction and essay by John House, with contributions from Ann Dumas, Jane Mayo Roos, and James F. McMillan. 304 p., 188 illus., 141 col. 113 works shown.

Exhibition of Impressionist and other landscapes by French painters dating 1860-90 that included 11 examples by Pissarro. The Boston exhibition was entitled *Impressions of France: Monet, Renoir, Pissarro, and their Rivals.* Bibliography, pp. 299-303.

1995, 8 July-1 October — Honfleur, Musée Eugène Boudin. *La Seine sous ses ponts: de Paris.* Sponsored by Crédit Agricole du Calvados. Textes par Julien Green, René Kuss, Anne-Marie Bergeret-Gourbin, François Beaudouin. Arcueil: Editions Anthèse, 1995. 95 p., 81 illus., 71 col.

Exhibition of paintings and prints that depict the Seine, including works by Pissarro.

1995 Chicago, R. S. Johnson Fine Art. *Pissarro to Picasso: A Selection of Paintings, Drawings, and Bronzes.* 64 p., col. illus.

Paul Signac

Biography

Signac was Seurat's closest associate and Neo-Impressionist's foremost publicist and memorialist. Generally regarded as having a more even and outgoing temperament than Seurat, Signac was born in 1863 to a fairly wealthy family of Parisian saddlers. Unlike many struggling artists, Signac enjoyed the freedom of financial independence his entire life. He owned a villa in Saint-Tropez, maintained a studio in Paris from 1882 on, travelled widely on painting excursions, owned sailboats (32, by one count), and loved the sea. A visit to an exhibition of Monet's works in 1880 propelled him towards a career in art. Except for a short period of instruction in 1883, Signac had no formal art training. His early landscapes and still-lifes demonstrate the Impressionist influence of Monet and Sisley.

Already friendly with Henri Rivière and Armand Guillaumin, Signac met Seurat in 1884 at the founding of La Société des Artistes Indépendants, where Seurat exhibited *Bathers at Asnières* (1884). A bond formed on the spot. Seurat shared nascent Neo-Impressionist color theory and technique, persuading Signac to remove earth pigments from his palette and adopt divisionism. Signac introduced Seurat to the Impressionist milieu and young Symbolist writers, particularly at his Montmartre studio and home in Asnières where important alliances were cemented during the critical years 1886-88. Under Seurat's tutelage Signac became totally immersed in Neo-Impressionism. Signac favored landscapes and seascapes but in emulation of Seurat he produced occasional large views of contemporary interiors with figures posed in stiff profile. At the final Impressionist show of 1886, he exhibited *Les Modistes*, one of his first major Neo-Impressionist works.

Signac frequented avant-garde literary and musical circles and was a close friend of the Symbolist writer Félix Fénéon, who devoted several articles to his work. Critics Alexandre Arsène and Antoine de la Rochefoucauld were also loyal to him. In 1887, he met and explained Neo-Impressionist principles to Vincent van Gogh, whom he visited in Arles in 1889. Signac exhibited with Les XX in Brussels in 1888 and 1890 and later at La Libre Esthétique. He was also instrumental in initiating Théo Van Rysselberghe and Henry Van de Velde into Neo-Impressionism. Signac partipated every year in the Salon des Indépendants and served first as its Vice President and then as President from 1908 until the year before his death in 1935.

Following Seurat's death in 1891, Signac introduced abstract visual rhythms and more subjectivity into his canvasses. In 1892, he moved to a villa in Saint-Tropez and became a close colleague to Henri Edmond Cross, who painted in nearby Saint-Clair. The two Neos hosted a generation of younger artists until Cross's death in 1910, especially the

Fauves during their formative 1902-06 period. Matisse spent the summer of 1904 with Signac and experimented freely with a Neo-Impressionist technique.

Signac designed the illustrations for color theorist Charles Henry's influential *Cercle chromatique et rapporteur esthétique* (Paris: Charles Verdin, 1888). His famous defense of the Neo-Impressionist aesthetic and cogent explanation of its precepts, begun in 1895, was published in book form as *D'Eugène Delacroix au néo-impressionnisme* (Paris: Editions de la Revue Blanche, 1899). Known as the manifesto of the movement, it attracted a wide readership among European artists. In later years Signac contributed prefaces to exhibitions, authored a book on Johan Jongkind's watercolors (1927), and as President of Les Indépendants ensured the vitality of its exhibitions which welcomed both the Fauves and the Cubists.

Paul Signac

Chronology, 1863–1935

Information for this chronology was gathered from Floyd Ratcliff, *Paul Signac and Color in Neo-Impressionism* (NY: Rockefeller University Press, 1992); *Signac et la libération de la couleur: de Matisse à Mondrian* (exh. cat., Paris: Réunion des Musées Nationaux, 1997); George Szabo, *P. Signac: Paul Signac (1863-1935): Paintings, Watercolors, Drawings and Prints. Robert Lehman Collection Drawings Galleries* (exh. cat., NY: Metropolitan Museum of Art, 1977); and Françoise Cachin, *Paul Signac* (Paris: Bibliothèque des Arts, 1971), among other sources.

1863

11 November
Birth of Paul Signac at 33 rue Vivienne, next door to the Paris Bourse, son of a bourgeois family of shopkeepers. Paul's father owns a saddler's shop in the Passage de Panoramas. The family maintains a home in Montmartre and a second residence outside the city in Asnières. Family investments provide a comfortable income throughout his life.

1870s

Studies at Collège Rollin, boulevard de Clichy.

1879

Visits the Impressionists exhibition on avenue de l'Opéra and is impressed by Manet's paintings. Reportedly thrown out by Gauguin for copying Degas's works.

1880

Death of Signac's father.
June
Attends the Monet retrospective at the offices of the art review journal, *La Vie moderne*.

1881

Withdraws from Collège Rollin and declares his intention to become an Impressionist painter.

1882-83

Takes up painting in his first studio in Montmartre. His early works are heavily influenced by Monet. On the prow of his first boat (by one count, he will own 32 during his life) he paints the names of Monet, Zola, and Wagner. Meets the painter Armand Guillaumin, who provides important encouragement. Frequents the free studio of the 1842 Prix de Rome winner Jean-Baptiste Bin and the Chat-Noir cabaret. Contributes two articles to Rodolphe Salis's *Le Chat noir*.

1884

Founding member of the Salon des Indépendants. Meets Georges Seurat, who exhibits *Bathers at Asnières.*

1885

Meets Pissarro. Paints at the port of Saint-Briac during the summer. Under Seurat and Pissarro's influence he moves toward a Neo-Impressionist technique and pointillist brushstroke.

1886

Paints on the Seine and in Collioure and Concarneau. First divisionist canvasses in May-April. Exhibits at the 8th and final Impressionist show, rue Laffitte, Paris at Pissarro's invitation. Meets van Gogh in Paris and influences him to experiment with divisionism.

1888

Exhibits with Les XX in Brussels. Begins a long friendship with Henry Van de Velde. Designs color publicity lithographs for Charles Henry's *Cercle chromatique et rapporteur esthétique* (Paris: Charles Verdin, 1888).

1889

Studies the color theories of Charles Henry, a chemist, color theorist, and librarian at the Sorbonne. Designs posters and illustrations for his books and speaking engagements.

1891

Elected a foreign member of Les XX. Introduces musical tempos into the titles of works, underscoring his interest in abstract visual patterns and in Baudelaire's theory of correspondences. Death of Seurat. Paints at Concarneau.

1892

Organizes Seurat retrospectives in Brussels and Paris. Begins to exhibit watercolors. An avid sailor who later cruises to ports in France, Italy, Holland and Constantinople, he sails his boat *Olympia* to Saint-Tropez in May and establishes a permanent residence there. Henri Edmond Cross, who had already relocated to nearby Saint-Clair, was influential in Signac's move from Paris. Marries Berthes Robles, a relative of the Pissarros. The marriage soon

fails and he lives with Jeanne Selmersheim-Desgrange, a jewelry designer and painter. They have one daughter, Ginette.

1894

Reads Delacroix's *Journal*. Paints almost entirely in his studio from sketches and watercolors made on location. Begins *Au temps d'harmonie*, a large allegorical canvas of an ideal society. The finished mural is later painted in the town hall of Montreuil, his only large mural. Shows at the inaugural Salon de la Libre Esthétique, Brussels.

1895

Enlarges divisionist strokes into more luminous color spots.

1896

First notes for his essay *D'Eugène Delacroix au néo-impressionnisme*. Travels to Holland and Italy.

1897

Visits Mont Saint-Michel. First lithographs. Purchases a small villa named La Hune in Saint-Tropez, where he lives with his mistress Jeanne Selmersheim-Desgrange.

1898

Travels to London to see Turner's works, "the most useful lesson in painting ever to be gotten." Publication of *D'Eugène Delacroix au néo-impressionnisme*, serialized in three parts in *La Revue blanche*. An extract translated into German appears in *Pan* (July 1898):55-62. Exhibits with other Neo-Impressionists at the Keller Gallery, Berlin, through intermediator Count Harry Kessler, the first Neo-Impressionist show in Germany.

1899

La Revue blanche publishes *D'Eugène Delacroix au néo-impressionnisme* in book form, Signac's most important historical and theoretical work in which he defends Neo-Impressionism and attempts to place it within an historical context. The Neo-Impressionist manifesto is widely read by artists in France and Germany (where it is translated in 1903) and by the Italian Futurists and the Fauves. Shows at Durand-Ruel, Paris.

1901

Second Neo-Impressionist exhibition at Keller and Reiner, Berlin and at Gallery Arnold, Dresden.

1902

Exhibits at Gallery Arnold, Dresden and at the Kaiser-Wilhelm Museum, Krefeld. First individual exhibition at Galerie de l'Art nouveau, Paris, owned by Siegfried Bing.

1903

Shows with other Neo-Impressionists at Gallery Cassirer, Hamburg and in Berlin with Denis, Cross, Van Rysselberghe, Vuillard, and Bonnard at the Weimar Museum in the summer.

1904

Travels to Venice. Paints with Cross and Matisse in Saint-Tropez, where Matisse is indoctrinated in Neo-Impressionist color theories and pointillism. Shows in Dresden and Munich. Holds a single-artist exhibition at Galerie Druet, Paris, for which the critic Félix Fénéon writes the catalogue preface.

1906

Second trip to Holland. Shows ten works at the Berliner Sezession.

1907

Individual exhibition at Galerie Bernheim-Jeune, Paris. Travels to Constantinople.

1908

Elected President of La Société des Artistes Indépendants. Participates in the first Toison d'or exhibition in Moscow with three works. Revisits Venice.

1910

Death of Henri Edmond Cross affects him as greatly as Seurat's death in 1891. Shows six works at the Sonderbund exhibition, Cologne.

1911

Two-artist show with Cross's works at Druet, Paris.

1912

Shows 18 works at the international Sonderbund exhibition, Cologne.

1913-19

Spends the war years at Antibes with Jeanne Selmersheim-Desgrange.

1914

Anonymous publication of a miniature four-page tribute to the French writer Stendhal entitled *Aide-mémoire Stendhal-Beyle*, described by one admirer as "the smallest great book in the world." Signac admired Stendhal's libertarian and internationalist perspectives.

1920-30

Lives and works in Paris, Brittany, and Vendée. Paints watercolors in more than 200 French ports and harbors.

1927

Publishes a book on the painter Johan Barthold Jongkind (1819-91), whom he admires as a precursor of both Impressionism and Neo-Impressionism and whose watercolors he collects. The result is a remarkable treatise on watercolors.

1930

Retrospective at Bernheim-Jeune, Paris.

1931

Retrospective at the Carnegie Institute, Pittsburgh.

1931-34

Continues his watercolor series of French ports.

1935

Prepares an essay, "Le Sujet en peinture," for *L'Encyclopédie française*.
15 August
Dies in Paris after a short illness.

Paul Signac

Bibliography

I. Archival Materials

1635. SIGNAC, PAUL. *Letters Sent and Signac Family Correspondence*, 1860-1935. 93 items. Holographs, signed; manuscript signed. Located at The Getty Research Institute for the History of Art and the Humanities, Special Collections, Los Angeles.

Letters from Signac to several colleagues discussing work in progress, exhibitions, contemporary art, La Société des Artistes Indépendants, and personal and financial matters. A significant number of these letters are addressed to Edouard Fer, a Neo-Impressionist disciple whose independent means and connections enabled him to promote Signac's career. Other correspondents include Camille Pissarro, Claude Monet, Georges Turpin, Henri Martineau, Georges Lecomte, and Luc-Albert Moreau. There is also a draft essay for a review of l'Exposition des Peintres provençaux, held in 1902. Most of the letters in this collection are Signac family correspondence; some of these are addressed by Paul Signac to his cousins. The repository also holds a significant series of Signac's correspondence within the papers of Théo Van Rysselberghe.

In his 35 letters to Edouard Fer (1916-32, bulk 1918-21), Signac discusses the organization of exhibitions, mostly in Switzerland, and critical reaction to his own work. He does not forget to offer Fer occasional advice. Other letters include ten to Pissarro (1886-99), in one of which he comments on Pissarro's stylistic evolution and his own recent landscape painting in the Midi (1897); a letter that recounts the formation of La Société des Artistes

Indépendants in 1884 with mention of Redon, Seurat, and Théodore Rousseau; a letter to Georges Lecomte where Signac comments on Symbolism, Puvis de Chavannes, Maximilien Luce, and Lecomte's recent work; a letter from Brussels describing at great length a visit to a foundry (1897); two notes to Henri Martineau pertaining to Signac's study of Stendhal (1919, 1928); one letter to an unnamed critic thanking him for a favorable article and describing his trips to Brittany and Provence (1933); and a fragment of a letter in response to an inquiry on interior decorating.

Includes a draft essay of a review of l'Exposition des Peintres provençaux held in Marseilles in 1902 and an introductory statement on the exhibition followed by remarks characterizing the work of individual painters including Jean-Antoine Constantin, Emile Loubon, Auguste Aiguier, Gustave Ricard, Adolphe Monticelli, and Paul Guigou.

Signac family correspondence deals with family life, children, illness, vacations, money worries, marriages, divorces, and so forth. A small number of these are written by Paul Signac to his cousins. The rest are between other family members. Most of the letters seem to be about Julie and Alfred Signac's family – Paul Signac's aunt and uncle. Included are letters from his grandmother, grandfather, and cousins.

Organization: Letters from Signac to colleagues (folders 1-5), Manuscript (folder 6), Signac family correspondence (folders 7-18). Folder list available in reppository.

1636. ANGRAND, CHARLES and PAUL SIGNAC. *Letters*, ca. 1925. 2 items. Holographs, signed. Located at The Getty Research Institute for the History of Art and the Humanities, Special Collections, Los Angeles.
One letter is from Angrand to an unnamed woman (possibly Maximilien Luce's wife), thanking her for her appreciation of his drawings. Since she is going to Anvers, he sends greetings to Luce and promises that a letter will follow soon. The second is a letter written by Paul Signac on the blank side of an exhibition catalogue of Angrand's works at the Galerie L. Dru in Paris (23 March-April 1925). Signac tells Dru that he does not consider himself qualified to present such an important artist as Angrand, who has been regularly exhibiting his creations at the Salon des Indépendants for 35 years, and is indeed better qualified to present himself to the public. Signac's letter is reproduced in *Charles Angrand, correspondances, 1883-1926*, ed. by François Lespinasse (Rouen: F. Lespinasse, 1988):404-5.

1637. BRETON, ANDRE. *Letter*, 1954. Holograph, 3 p. Located at The Getty Research Institute for the History of Art and the Humanities, Special Collections, Los Angeles.

Concerns an exhibition of modern art, with special reference to Seurat and Paul Gauguin, and to Signac's art collection. Includes a draft checklist of works to be shown at the exhibition. Breton (1896-1966) was a leading Surrealist writer and critic.

1638. CROTTI, JEAN. *Papers*, 1910-73. Ca. 1,000 items (2 microfilm reels). Located at the Archives of American Art, Smithsonian Institution, Washington D.C.

Biographical material, autobiographical notes, various writings, clippings, photographs, miscellaneous printed material, and letters to various artists, including Signac. Crotti (1878-1958) was a French avant-garde painter of Swiss birth.

1639. HAUPTMANN, IVO. *Letters Received*, 1919-43. 30 items. 6 folders. Holographs, signed. Located at The Getty Research Institute for the History of Art and the Humanities,

Special Collections, Los Angeles.
Includes two letters and two postcards from Paul Signac (1924), that discuss his projects and outline general tendencies in French art, exhibitions, and politics (folder 6). Organized in alphabetical order by correspondent. Hauptmann (1886-1973) was a German painter.

1640. HEROLD, ANDRE-FERDINAND. *Letters Received from Stuart Merrill and Others*, 1892-1936. 164 items. Holographs, signed; typescripts, signed. Located at The Getty Research Institute for the History of Art and the Humanities, Special Collections, Los Angeles.

Collection of letters from poets and artists including four from Paul Signac (1916, 1926, n.d.; see Series II, Letters from Others, 1893-1936). Herold (1865-1940) was a French poet, dramatist, and translator of Greek and Sanskrit works.

1641. JOURDAIN, FRANCIS or FRANTZ. *Letters Received*, 1950-54. 4 items. Located at The Getty Research Institute for the History of Art and the Humanities, Special Collections, Los Angeles.

Four letters that concern Paul Signac from Nesto Jacometti (1898-1973) and Mme. Jean-Paul Signac. Jourdain (1876-1958) was an art critic and historian.

1642. MARTY, ANDRE. *Letters and Manuscripts Received*, ca. 1886-1911. ca. 230 items. Located at The Getty Research Institute for the History of Art and the Humanities, Special Collections, Los Angeles.

Marty (b. 1857) was a French editor, director of *Le Journal des artistes*, and publisher of prints and books on the arts. Includes letters from more than 50 artists and art critics primarily concerning publication of the print portfolio, *L'Estampe originale*, but also referring to projects for illustrated books, monographs on art, exhibitions and art criticism. Most letters are addressed to André Marty, though a few are to his junior partner, Henri Floury. Included in the collection are two short manuscripts on the decorative arts, by Gustave Geffroy and Octave Uzanne.
Letters relating to *L'Estampe originale* (1893-95) provide detailed technical information about print states, color, choice of paper, and preferences for particular printers and engravers. They also chronicle problems of artistic and journalistic collaboration and offer clues as to the publisher's marketing strategies. Of particular interest are letters from Georges Auriol (5) about his designs for decorative borders; from the sculptor Alexandre Charpentier (16) discussing his innovative "timbre sec," and dickering over prices; from Maximilen Luce (1) with instructions for printing engravings; from Monet (1) expressing uncertainty about working in lithography; from Roger Marx (23) concerning his preface and the promotion of the portfolios; from Van Rysselberghe (1) promising to enlist other Belgian artists; from Lucien Pissarro (13) about distribution of the publication in England, and his own prints; and from Félix Vallotton (1) regarding control over editions and financial terms. Among the letters containing comments on specific prints and details on technical matters are those from Eugène Carrière (13); Signac (1); Joseph Pennell (6); Camille Pissarro (8); and Félicien Rops project; for example Zandomeneghi, Blanche, Khnopff, and Duez.
Letters treating other subjects include five from Paul Ranson (n.d.) discussing wallpaper and tapestry designs; letters of 1897 from Ernest Chaplet and Auguste Delaherche about a ceramics exhibition sponsored by *Le Figaro*; a long, detailed letter from Gabriel Mourey (1893) discussing his plans for a series of monographs on contemporary French and British

artists; seven letters (1894-99) from Lucien Pissarro about projects for illustrated books; two letters from Paul Signac (1894, n.d.); and a file of letters (34) from Gustave Geffroy on various journalistic matters, including the publication of his collected criticism and the brochure promoting his project for a "Musée du soir." A sketch by Carrière for the cover of the brochure is also included in the collection. In addition to Geffroy and Marx, critics represented by significant groups of letters are Arsène Alexandre, Henry Nocq, Etienne Moreau-Nelaton, Thadée Natanson, Félix Fénéon, Frantz Jourdain, and Emile Verhaeren. A three-page draft manuscript (n.d.) by Octave Uzanne concerns the subject of art and industry and functionalism in the decorative arts. A one-page manuscript by Geffroy (1899) is an open letter to the Director of Fine Arts advocating independent exhibition by decorative artists for the World's Fair of 1900. Letters are arranged alphabetically by author.

1643. PISSARRO, CAMILLE. *Letters*, 1882-1903. Holographs, signed. 50 items. Located at The Getty Research Institute for the History of Art and the Humanities, Special Collections, Los Angeles.

Includes letters to family members, critics, dealers, and colleagues. Letters written from London, Paris and Eragny to his wife Julie, sons Rodophe and Lucien, and niece Esther, discuss financial matters, health, travel plans and provide instructions regarding the sale of works of art, including prices, and the shipment of paintings and materials (19 items, 1890-1903). Other letters are addressed to: Georges de Bellio (1882-1891); Paul Durand-Ruel (1888); Maximilien Luce (1889-90); Georges Petit (1889); Theodore Child (1889); Gustave Geffroy (1890); Claude Monety (1890-91); Paul Signac (1894); Hippolyte Petitjean (1893, 1897); Ambroise Vollard (1896); and André Portier (1897); and include mention of personal matters, upcoming exhibitions and work in progress. Collection also includes two pages of notes listing paintings done at Le Havre, giving the subject and buyer in some instances (21 Sept. 1903) arranged in chronological order.

1644. ROUDINESCO, ALEXANDRE. *Letters Received*, 1918-1949. 74 items. Holographs, signed. Located at The Getty Research Institute for the History of art and the Humanities, Special Collections, Los Angeles.

Letters to the Paris collector Dr. Alexandre Roudinesco (b. 1883) from various French avant-garde (primarily Fauve) painters. Most date from the 1930's and represent an unusually intimate and informative relationship between artist and patron. Letters include 30 from Maurice de Vlaminck (1932-49); 28 from Raoul Dufy (1918-36); 8 from Paul Signac (1926-34); 6 from Kees van Dongen (1930); and 2 from Georges Rouault.

1645. THIEBAULT-SISSON, ALBERT. *Letters Received*, 1886-1920. ca. 50 items. Holographs, signed. Located at The Getty Research Institute for the History of Art and the Humanities, Special Collections, Los Angeles.

Thirty-seven letters addressed to Thiebault-Sisson (1901-21) in his capacity as art critic for the journal *Le Temps*. Most of the letters express appreciation for positive reviews and mention briefly work in progress. Correspondents include J. F. Raffaëlli (1894, 1915), J. C. Cazin (1895), Puvis de Chavannes (1896-1897), J. P. Laurens (n.d.), Walter Crane (1894), Alfred Roll (1895), Paul Signac (n.d.), Albert Besnard (n.d.), Jules Desbois (1916), Antoine Bourdelle (1916, 1920) and Ignacio Zuloaga (1917). There are nine additional letters – six addressed to other writers at *Le Temps*, from, among others, J.-L. Gerome (n.d.), F. L.

Français (1875), and Jules Breton (1895); and three addressed to Albert Thiebault-Sisson (1918-20). Collection also contains printed materials, including newspaper clippings and an exhibition catalogue of Adolphe Willette (1916).

Organization: I. Letters received, 1886-1920, folders 1-3 (in chronological order); II. Miscellaneous letters, folder 4; III. Printed materials, folder 5.

1646. VAN DONGEN, KEES. *Letters*, 1912-52. 15 items. Holographs, signed. Located at The Getty Research Institute for the History of Art and the Humanities, Special Collections, Los Angeles.

Collection of personal and professional correspondence to and from various artists and critics, including one letter to Paul Signac, reporting on the anticipated defense of La Société des Artistes Indépendants by the government official Paul Boncourt (1912). Van Dongen (1877-1968) was a prominent Dutch-born Fauve and Parisian society portraitist.

1647. VAN RYSSELBERGHE, THEO. *Correspondence*, ca. 1889-1926. ca. 225 items. Holographs, signed. Located at The Getty Research Institute for the History of Art and the Humanities, Special Collections, Los Angeles.

Collection contains 84 letters of Van Rysselberghe to, among others, Madame Rysselberghe, the dealer Huinck, Paul Signac, and Berthe Willière; and 141 letters received from colleagues including Henri Cross, Paul Signac, Camille Pissarro, and Henry Van de Velde. The letters, many of which are extensively illustrated, are largely theoretical in nature and explore all facets of art theory and practice associated with the Neo-Impressionist milieu of the late 19th and early 20th centuries.

Organization: Series I. Letters to Madame Rysselberghe, ca. 1902-20 (folder 1); Series II. Miscellaneous letters, 1900-26 (folders 2-3); Series III. Letters received from Paul Signac, ca. 1892-1909 (folders 4-8); Series IV. Letters received from Henri Cross, 1908-10, n.d. (Folders 9-11); Series V. Miscellaneous letters received, ca. 1889-1905, n.d. (Folders 12-13)
Series I. Letters to Madame Rysselberghe, ca. 1902-20 (32 items). Thirty-two letters, a significant portion dated 1918-20, include detailed discussion of travels, work in progress, especially on portraits, his own emotional state and personal matters. Van Rysselberghe writes of technical matters, including difficulties associated with painting "en plein air" and a decorative project underway for Armand Solvay, and describes in some detail his stay at the Château de Mariemont. Other letters also include discussion of upcoming exhibitions and comments on the writing of André Gide, Jacques-Emile Blanche, and Marcel Proust.
Series II. Miscellaneous letters, 1900-26 (52 items). Twenty letters to Van Rysselberghe's dealer Huinck concern practical matters associated with upcoming exhibitions in Holland such as the framing and packing of works of art, titles, dimensions and prices of paintings, train schedules, and fluctuating currency (1924-25). Nineteen letters and postcards to Berthe Willière on work, travel, and personal matters (1909-26). In three letters to Paul Signac, Van Rysselberghe defends his criticism of Signac's work, explains his own working method, and responds to the suggestion that his work was adversely influenced by Maurice Denis (1909). One letter to André Gide concerns the "fond d'atelier" of Henri Cross and a possible retrospective exhibition (1918). Other correspondents include Pierre Bounier (1900, 1914), Armand Solvay (1922), and a M. Dunan (1925-26).
Series III. Letters received from Paul Signac, ca. 1892-1909 (74 items). Seventy-four

detailed letters, many extensively illustrated with color and ink sketches, focusing primarily on theoretical issues. Signac outlines ideas for work in progress, discusses color theory and the divisionist technique, and comments on a wide variety of matters, including Old Master painting and the work of Seurat, Maurice Denis, Odilon Redon, Paul Sérusier, Henri Cross, and Eugène Delacroix. In several essay-length letters, Signac attempts to render in a systematic manner the theory of Neo-Impressionism and his own approach to painting and avidly defends the pointillist technique. The letters also include discussion of practical matters relating to exhibitions and the sale of paintings, as well as mention of literary interests and personal news.

Series IV. Letters received from Henri Cross, 1908-10, n.d. (53 items). Eleven letters addressed to Van Rysselberghe contain discussion of work in progress (illustrated) and working method and include mention of Félix Fénéon, Signac, and Henri Matisse. Forty-two letters, mostly personal in nature, are addressed to Madame Rysselberghe and mention literary and musical interests, daily activities, and art-related matters.

Series V. Miscellaneous letters received, ca. 1889-1905, n.d. (14 items). Includes four letters from Camille Pissarro concerning printmaking ventures and including mention of Octave Maus and André Marty (1895); two brief letters from Maximilien Luce (n.d.); one letter from Maurice Denis mentioning two portraits by Van Rysselberghe and commenting on personal travel plans (n.d.); and seven letters from Henry Van de Velde explaining in some detail his difficulties with the Neo-Impressionist style and outlining plans for an exhibition in Berlin designed to interest the German press in Neo-Impressionism (1890-1905).

II. Primary Bibliography

a. Books

1648. SIGNAC, PAUL. *D'Eugène Delacroix au néo-impressionnisme.* Paris: Editions de la Revue blanche, 1899. 104 p.

Manifesto of Neo-Impressionism, begun in 1895. Before its appearance in book form, the essay was serialized in *La Revue blanche* in May and June 1898. Lengthy excerpts also appeared in German in *Pan* (July 1898):55-62.

a. Other eds.: Paris: H. Floury, 1911. 118 p. (Petite Bibliothèque d'art moderne); Paris: H. Floury, 1921. 113 p.; Paris: Librairie Floury, 1939. Illustrée de vingt-cinq reproductions. 129 p., illus; Paris: Hermann, 1964. Introduction et notes par Françoise Cachin. 171 p., illus. (Miroirs de l'art). Bibliography, pp. 166-72; Paris: Hermann, 1978. 205 p., illus. (Collection Savoir). Bibliography, pp. 191-9.
b. German ed.: *Von Eugen Delacroix zum Neo-Impressionismus.* Einzige deutsche autorisierte Übersetzung. Krefeld: Rheinische Verlagsanstalt, G.A. Hohns Söhne, 1903. 108 p.; 1910.
c. Danish ed.: 1936.
d. Italian eds.: *Da Delacroix al neoimpressionismo.* Saggio introduttivo e traduzione di Raffaele Mormone. Naples: Societa Editrice Napoletana, 1979. 124 p. (Studi e testi di storia e critica dell'arte, 9); Naples: Liguori Editore, 1993. A cura di Enrico Maria Davoli; introduzione di Renato Barilli. 171 p., col. illus.
e. U.S. ed.: *Paul Signac and Color in Neo-Impressionism.* By Floyd Ratliff. Including the first English edition of *From Eugène Delacroix to Neo-Impressionism by Paul Signac.*

Translated from the third French edition (Paris: H. Floury, 1921) by Willa Silverman. NY: Rockefeller University Press, 1992. 317 p., illus, some col.

1649. SIGNAC, PAUL. *Aide-mémoire Stendhal-Beyle.* Antibes, Dec. 1913-Jan. 1914. 59 or 118 copies (see André Salmon, *Souvenirs sans fin*, 1945, p. 170) and Félix Fénéon, *Bulletin de la vie artistique* (15 May 1926):153.

Miniature 4-page pamphlet anonymously published as an "autobiography" of French writer Marie-Henri Beyle (1783-1842), who wrote under the name Stendhal and whose libertarian and internationalist perspectives Signac admired.

1650. SIGNAC, PAUL. *Jongkind.* Paris: G. Crès, 1927. 134 p., illus., 1 col., 82 pl. (collection des Cahiers d'aujourd'hui)

Signac's appreciation of Johan Barthold Jongkind (1819-91), whom he admired as a precursor of both Impressionism and Neo-Impressionism and whose watercolors Signac collected. Signac's acclaimed discourse on watercolor forms is included in a chapter entitled "Traité de l'aquarelle."

1651. SIGNAC, PAUL. *Journal de Paul Signac.* Extracts from 1900-01 published by George Besson in *Arts de France* 11(1947):97-102 and for 1902-09 in *Arts de France* 17-9(1947):75-82; for 1894-95 by John Rewald in *Gazette des Beaux-arts* 36(July-Sept. 1949):97-128; for 1897-99 in *Gazette des Beaux-arts* 39(April 1952):265-84; and for 1898-99 in *Gazette des Beaux-arts* 42(July-Aug. 1953):27-57.

b. Articles

1652. HENRY, CHARLES and PAUL SIGNAC. "Application de nouveaux instruments de précision à l'archéologie, en particulier à l'étude morphologique des trois types d'amphores dans l'antiquité." *Revue archéologique* (1890):187-213.

Includes an analysis of profiles on Greek vases from Cnide, Thasos, and Rhodes by Signac. a. Published ed.: *Application de nouveaux instruments de précision (Cercle chromatique, rapporteur et triple-décimètre esthétique) à l'archéologie.* Paris: Leroux, 1890.

1653. HENRY, CHARLES and PAUL SIGNAC. "L'Esthétique des formes." *La Revue Blanche* (Aug., Oct., Dec. 1894; Feb. 1895).

a. Published ed.: *Quelques aperçus sur l'Esthétique des formes.* Dessins et calculs de Paul Signac. Paris: Editions de La Revue Blanche, 1895.

1654. SIGNAC, PAUL. "Une trouvaille." *Le Chat noir* (11 Feb. 1882) Reprinted in *Anthologie du pastiche*, ed. by Léon Deffoux and Pierre Dufay (Paris: G. Crès , 1926). 2:152-4. See also *Bulletin de la vie artistique* (15 Oct. 1926):312-3.

1655. SIGNAC, PAUL. "Une crevaison." *Le Chat noir* (25 March 1882).

1656. SIGNAC, PAUL. "Impressionnistes et révolutionnaires." *La Révolte* (13-19 June 1891).

Anonymous article by Signac, attributed to him by John Russell.

1657. SIGNAC, PAUL. "Hector Guimard, l'art dans l'habitation moderne, le Castel Béranger." *La Revue blanche* (15 Feb. 1899):317-9.

1658. SIGNAC, PAUL and J. GUENNE. (Interviewer). "Entretien avec Paul Signac." *L'Art vivant* (20 March 1925).

1659. SIGNAC, PAUL. *Mercure de France* (Nov. 1903):432.
Opinion regarding Charles Morice's article on Paul Gauguin.

1660. SIGNAC, PAUL. *Bulletin de la vie artistique* (15 Feb. 1922); (1 Dec. 1922), (15 April 1923), (16 July 1924).

Various opinions and declarations.

1661. SIGNAC, PAUL. *Bulletin de l'art ancien et moderne* (Sept.- Oct. 1929) and (Jan. 1930).

Regards art works and Romanticism.

1662. SIGNAC, PAUL. "Charles Henry." *Les Cahiers de l'Etoile* (Jan.-Feb. 1930):721.

Signac's contribution to a special issue devoted to the color theorist Charles Henry.

1663. SIGNAC, PAUL. [statement in] *Ceux qui ont choisi. Contre le fascisme en Allemagne. Contre l'impérialisme en France.* Paris: A.E.A.R., 1933.

1664. SIGNAC, PAUL. "Le Sujet en peinture" in *L'Encyclopédie Française* (Paris: Société de Gestion de l'Encyclopédie Française, 1935-), vol. 16, pp. 84-7. Reprinted in *D'Eugène Delacroix au néo-impressionnisme,* ed. by Françoise Cachin (Paris: Hermann, 1964). See also *Bulletin de la vie artistique* (16 July 1924):367.

1665. SIGNAC, PAUL. "Letter to Félix Fénéon, 1894, Watercolor Presented to J. Rewald by Fénéon." *Arts Magazine* 31(Jan. 1957):18.

1666. SIGNAC, PAUL. "Les Lettres de Paul Signac à Octave Maus (avec l'index des noms cités)." Introduction et éditées par M. J. Chartrain-Hebbelinck. *Bulletin des Musées Royaux des Beaux-arts.* 18:1-2(1969):52-102. 20 illus. Summary in Dutch.

c. Prefaces to Exhibition Catalogues by Signac

1667. SIGNAC, PAUL. *Catalogue de l'Exposition des XX.* Brussels, 1890. Reprinted in *Art et critique* (1 Feb. 1890).

Signed "S. P."

1668. SIGNAC, PAUL. *Henri Person.* Galerie Bernheim-Jeune, Paris, Feb. 1913.

1669. SIGNAC, PAUL. *J. Cambier.* Galerie l'Artistique, Nice, 1918.

1670. SIGNAC, PAUL. *Georges Seurat.* Galerie Bernheim-Jeune, Paris, Jan. 1920.

1671. SIGNAC, PAUL. *Vingt-trois artistes soviétiques.* Galerie Billiet, Paris, April-May 1933.

1672. SIGNAC, PAUL. "Le Néo-impressionnisme, documents" in *Seurat et ses amis.* Galerie Beaux-arts, Paris, Dec. 1933. Reprinted in *Gazette des Beaux-arts* (Jan. 1934):49-59 and as an appendix to *D'Eugène Delacroix au néo-impressionnisme,* ed. by Françoise Cachin (Paris: Hermann, 1964).

1673. SIGNAC, PAUL. *L'Exposition cinquantenaire de la Société des Artistes Indépendants.* Société des Artistes Indépendants, Paris, Feb.-March 1934. See also "Peinture 1880," *Beaux-arts* (12 Feb. 1934).

d. Book Illustrated by Signac

1674. NAU, JOHN-ANTOINE. *Hiers bleus: poésies.* Paris: Librairie Léon Vanier, éditeur; A. Messein, succr., 1904. 165 p. 20 copies printed on Vélin d'Arches mould-made paper watermarked with the device of the Société des XX.

Author's copy, inscribed "Pour Paul Signac, peintre habituel de Sa Majesté le roi Soleil" by Nau. Includes 56 watercolor drawings in various sizes by Signac, the first (p. 1) and last (p. 160) signed in pencil.

III. Books

1675. BESSON, GEORGE. *Paul Signac.* Paris: Rombaldi, 1935. 14 p., 16 p., 32 pl. (Collection "Les Artistes nouveaux")

Includes statements by Signac and bibliographic references.

1676. BESSON, GEORGE. *Signac: dessins.* Texte par George Besson. Paris: Braun, 1950. 11 p., 16 pl. (Collection "Plastique" 7)

1677. BESSON, GEORGE. *Paul Signac, 1863-1935.* Paris: Braun, 1950. 63 p., illus. In French, English, and German. (Collection "Les Maîtres")

Bibliography, p. 63.

1678. BESSON, GEORGE. *Dessins et estampes de la collection George et Adèle Besson.* Besançon: Musée des Beaux-arts et d'archéologie, 197. 84 p., 219 illus.

Catalogue raisonné to the collection of 20th century prints and drawings assembled by George and Adèle Besson and donated to the Musée des Beaux-arts et d'archéologie in Besançon, France in 1970. Includes works by 40 European artists, including Signac.

1679. CACHIN, CHARLES. *Paul Signac, dernier carnet de voyage.* Texte de Charles Cachin; avant-propos de Françoise Cachin, St-Badolph: M.-J. Jacomet, 1990. 2 vols., illus. 325 copies.

Includes full-color facsimile reproductions of a sketchbook by Signac (Carnet 35), accompanied by a commentary volume. Vol. 1, text; vol. 2, facsimile.

1680. CACHIN, FRANCOISE. *Paul Signac.* Paris: Bibliothèque des Arts, 1971. 141 p., illus., some col.

Detailed life and analysis of Signac, with an extensive bibliography, pp. 131-8.
a. Italian eds.: Milan: Silvano Editoriale d'Arte, 1970, 1971. 141 p., illus., some col.
b. U.S. ed.: Trans. from the French by Michael Bullock. Greenwich, CT: New York Graphic Society, 1971. 141 p.

1681. COUSTURIER, LUCIE. *P. Signac.* Paris: G. Crès, 1922. 46 p., illus., 45 pl. (Cahiers d'aujourd'hui)

Extracts appeared in *Cahiers d'aujourd'hui* 7(1921):39-41 and 10(1922):205-7 before book publication.

1682. FENEON, FELIX. *Paul Signac.* Paris: Vanier, 1890. (Les Hommes d'aujourd'hui)

1683. GAUGUIN, PAUL. *Correspondance de Paul Gauguin: documents, témoignages.* Rédigé par Victor Merlhès. Paris: Fondation Singer-Polignac, 1984. 562 p., 80 illus., 15 col.

Collection of all known existing letters written by Gauguin between 1873 and 1888, with detailed commentary by Merlhès. Correspondents included Signac.

1684. GRAVE, JEAN, ed. *Guerre-militarisme.* Avec dix dessins de Heidbrinck, Hénault, Hermann-Paul, Jehannet, Lefèvre, Luce, Signac, Steinlen, Vallotton, Vuillaume; gravés par Berger. Paris, Les Temps Nouveaux, 1902. 406 p., illus. (Bibliothèque documentaire)

1685. *Hsiu-la, 1859-1891; Hsi-nieh-kō, 1863-1935.* Shang-hai: Shang-hai jen min mei shu chū pan she, 1981. 64 p., illus., some col. In Japanese. Cover title, *Seurat, 1859-1891; Signac, 1863-1935,* also in English. (Shih chieh mei shu chia hua kū)

1686. KALITINA, NINA N. *Paul Signac.* Leningrad: Izdatelstvo Iskusstvo, 1976. 143 p., illus., some col. In Russian.

First Russian monograph devoted to Signac, based on a study of Signac's works found in the former U.S.S.R. and in French museums and private collections. The first chapter describes Signac's life and his artistic milieu. The second focuses on his landscapes, genre paintings, still lifes, and portraits; the third on his drawings and watercolors; and the fourth on his literary and critical writings.

1687. KORNFELD, EBERHARD W. and PETER A. WICK. *Catalogue raisonné de l'œuvre gravé et lithographié de Paul Signac.* Preface by E. W. Kornfeld. Translated by Jean Fournier and Edwin Engelberts. Bern: Kornfeld et Klipstein, 1974. 66 p., illus., some col.

Catalogue raisonné of Signac's prints and lithographs. Includes bibliographic references.

1688. LEMOINE, SERGE. *The Grenoble Museum of Art.* Paris: Musées et Monuments de

France, 1988. 135 p., illus., 193 col.
Selective catalogue of works in the permanent collection, including works by Signac from the Agutte-Sembat gift in 1923.

1689. MURA, ANNA MARIA. *Paul Signac.* Milan: Fratelli Fabbri, 1966. 7 p., illus., 16 pl., some col. (I Maestri del colore, 180)

1690. OBERTHUR, MARIEL. *L'Art bohème: un cabaret artistique et littéraire à Montmartre—le Chat noir.* Paris: Philippe Sers, 1992. 304 p., 400 illus., 75 col.

Examines the popular Parisian cabaret, Le Chat noir, in Montmartre, a meeting place for artists and literary figures in the late 19th and early 20th century which counted Signac and Seurat among its clientele.

1691. PRESTON, STUART. *Edouard Vuillard.* New York: Harry N. Abrams 1972, 160 p., 159 illus. (Great Painters)

Biographical introduction to Vuillard that discusses his relationships with Signac and Gauguin, among other painters.

1692. RATLIFF, FLOYD. *Paul Signac and Color in Neo-Impressionism.* Including the first English edition of *From Eugène Delacroix to Neo-Impressionism* by Paul Signac; translated from the third French edition (H. Floury, Paris, 1921) by Willa Silverman. New York: Rockefeller University Press, 1992. 317 p., illus., some col.

Detailed scientific and psychophysiological analysis of Signac's divisionist color technique and application. Bibliography, pp. 287-91; Glossary, pp. 297-302.

1693. ROGER-MARX, CLAUDE. *Aquarellistes contemporains.* Paris: E. Vairel, 1950. 11 p., 10 col. pl. (Histoire de l'aquarelle, no. 9)

Includes a section on Signac's watercolors.

1694. ROUX-CHAMPION, VICTOR J. *Dix peintres au XXᵉ siècle.* Paris, 1927.

1695. RUSSELL, JOHN. *Vuillard.* London: Thames and Hudson, 1971. 238 p., 225 illus.

Reprints a text by Signac about a visit to Edouard Vuillard in 1898.

1696. SANDOZ, MARC. *Signac et Marquet à La Rochelle, Les Sables d'Olonne, La Chaume, Croix-de-Vies: Influence du site sur leur œuvre; œuvres inédites, (1911-1933).* Paris: Editart, 1957. 31 p., illus.

1697. SIGNAC, PAUL. *Signac.* Paris: Hachette, 1967. 8 p., illus. 16 pl. (Chefs-d'œuvre de l'art. Grands peintres, 78)

1698. THOMSON, BELINDA and SARGY MANN. *Bonnard at Le Bosquet.* Exh. cat., London, Hayward Gallery (29 June-29 August 1994); Newcastle-upon-Tyne, Laing Art Gallery. Sponsored by British Telecom. London: South Bank Centre, 1994. 133 p., 115 illus., 39 col.

Catalogue of an exhibition of 71 paintings and drawings created by Pierre Bonnard at the Villa du Bosquet in southern France. Thomson's essay discusses Signac's influence on Bonnard.

1699. VAN GOGH, VINCENT. *Briefe an Emile Bernard, Paul Gauguin, Paul Signac und andere.* Herausgegeben von Hans Graber. Basel: B. Schwabe, 1921. 105 p., illus., 14 pl.

Includes letters to Signac.
a. Other eds.: 1923, 1925, 1929, 1938.

1700. VAN GOGH, VINCENT. *Vincent van Gogh: Letters from Provence.* Selected and introduced by Martin Bailey. London: Collins & Brown, 1992. 160 p., illus., 159 col.

Selection of letters written during his three years in Provence, including several to Paul Signac.

1701. WATANABE, YASUKO and TAKESHI KASHIWA. *Signac.* Tokyo: Senshukai, 1978. 87 p., illus., 38 pl., 32 col. (Les Peintres impressionnistes, no. 14)

1702. WERTH, MARGARET. *Le Bonheur de vivre: The Idyllic Image in French Art, 1891-1906.* Ph.D. diss., Harvard University, 1994. 584 p.

Analyzes the pastoral image and ideal in French art from 1891-1906, including the motif of humans in harmony with nature as expressed in the works of Signac and other artists.

1703. WILKIN, KAREN. *Houghton Cranford Smith, 1887-1983.* Exh. cat., NY; Grace Borgenicht Gallery (7 March-4 April 1990).

Exhibition of paintings by Smith (1887-1983) dating from 1915 to the 1960s. Essay includes references to the influence of Signac and other Neo-Impressionists.

IV. Articles

1704. ALEXANDRE, ARSENE. "Paul Signac, président des Indépendants." *Comœdia* (26 March 1910).

1705. APOLLINAIRE, GUILLAUME. "D'Eugène Delacroix au néo-impressionnisme." *L'Intransigeant* (7 Aug. 1911). Reprinted in *Chroniques d'art* (1960):192-3.

Review of the 1911 Floury edition of Signac's book that explains the history and principles of Neo-Impressionism, first published by *La Revue blanche* in 1899.

1706. "Une aquarelle de Paul Signac, acquise par l'Etat au Salon des Indépendants." *Bulletin de la vie artistique* (1 March 1923):112.

1707. ARGÜELLES, JOSE A. "Paul Signac's *Against the Enamel of Background Rhythmic with Beats and Angles, Tones and Colors, Portrait of M. Félix Fénéon in 1890, opus 217.*" *Journal of Aesthetics and Art Criticism* 28:1(Fall 1969):49-53.

1708. BATES, HERBERT ERNEST. "French Painters IV: Signac and Cross." *Apollo* 55(May 1952):135-9. illus.

1709. BESSON, GEORGE. "Paul Signac et la peinture murale." *Beaux-arts magazine* (11 March 1938):3.

1710. BESSON, GEORGE. "Paul Signac." *Arts de France* 2(15 Jan. 1946).

1711. BESSON, GEORGE. "Une des grandes aventures de la peinture: l'œuvre de Paul Signac." *Arts* (26 Oct. 1951):1, 5.

1712. BESSON, GEORGE. "Lettré, marin, sportif, Paul Signac met en théorie l'impressionnisme." *Galerie des arts* (Nov. 1963):26-8.

1713. BLANCHE, JACQUES-EMILE. "Frantz Jourdain et Paul Signac." *Beaux-arts* (20 Sept. 1935):1⁺.

1714. BOGEMSKAYA, KSENIYA. "Pol' Sin'yak." *Tvorchestvo* 6(1988):23-5. 4 illus., 1 col. In Russian.

Short examination of the career and work of Signac on the 125th anniversary of his birth. Mentions his contacts with Soviet artists after the Russian Revolution and his role in the anti-Nazi movement.

1715. BREUNING, MARGARET. "Signac's Science." *Art Digest* 26:4(15 Nov. 1951):18.

Review of the Signac exhibition at Fine Arts Association, New York City.

1716. CACHIN, FRANÇOISE. "*Le Portrait de Fénéon* par P. Signac, une source inédite." *La Revue de l'art* 6(1969):90-91. Illus.

1717. "Caricature by E. Bernard." *Gazette des Beaux-arts* ser. 6, 45(April 1955):233.

1718. CACHIN, FRANÇOISE and PETER KROPMANNS (Interviewer). "Das Portrait: Françoise Cachin in Interview." *Museum-Kunde* 60:1-3(1995):61-3. 1 illus.

Cachin, Directeur des Musées de France, explains her responsibilities and challenges in developing France's museums. Also relates her experiences as founding director of the Musée d'Orsay, Paris (1986-94) and as a granddaughter of Paul Signac.

1719. CACHIN-SIGNAC, GINETTE. "Autour de la correspondance de Signac." *Arts* (7 Sept. 1951):8.

1720. CARTER, C. "Signac's *Pont l'Abbé* Acquired by Aberdeen Art Gallery." *Burlington Magazine* 107(Oct. 1965):5.

1721. CHABANNE, THIERRY. "Plein cap sur Signac." *Beaux-arts magazine* 103(July-Aug. 1992):69-75. 15 col. illus.

With reference to a recent exhibition, *Centenaire de l'arrivée de Paul Signac à Saint-Tropez*

en 1892 at the Musée de l'Annonciade in Saint-Tropez, celebrating Signac's arrival in the small fishing village, Chabanne describes Signac's association with Saint-Tropez and his pointillist technique.

1722. CHASTEL, ANDRE. "L'Oeuvre et le souvenir de Paul Signac." *Le Monde* (25 Oct. 1951).

1723. CHASTEL, ANDRE. "Une source oubliée de Seurat." *Nouvelles archives de l'art français* (1959):400-7.

1724. COGNIAT, RENE. "Paul Signac, Odilon Redon et les décorateurs Chaplet et Gaillard." *Beaux-arts magazine* (16 Feb. 1934).

1725. COLE, HENRI. "Point of Views." *Art and Antiques* 8:6(Summer 1991):70-3, 96. 6 col. illus.

Mentions Signac's works inspired by Cap Canaille, Cassis, along with other painters who worked there.

1726. "Comment Signac rencontra Guillaumin." *Beaux-arts* (11 March 1938).

1727. CONNETT, MAUREEN. "Sickert the European." *Antique Dealer and Collectors Guide* 46:7(Feb. 1993):40-2. 7 illus.

Recounts the experiences of English painter Walter Sickert (1860-1942) in France, including his friendship with Signac in Paris.

1728. COUSTURIER, LUCIE. "Paul Signac." *La Vie* 5(23 March 1912):157-8.

1729. CROW, THOMAS. "Modernisme et culture de masse dans les arts visuels." *Cahiers du Musée National d'art moderne* 19-20(June 1987):20-51.

1730. D., V. A. "Our Places/Ourselves: The Landscape as Subject." *Davenport Municipal Art Gallery Bulletin* 2(1978). 4illus.

Mentions works by Signac in the Davenport Art Gallery.

1731. DAVIS, F. "Talking about Salesrooms." *Country Life* 158(11 Sept. 1975):634-5.

Illustrated with Signac's *Ile aux moines.*

1732. D., M. [Maurice Denis?]. "Aquarelles de Paul Signac." *L'Occident* (July 1902):52-3.

1733. DENVIR, BERNARD. "Sense and Sensibility: The Significance of Signac." *Art and Artists* 242(Nov. 1986):23-5. 3 illus., 1 col.

Reappraises Signac's importance in the Neo-Impressionist movement and in the art of his time, with reference to an exhibition of watercolors and drawings at Marlborough Fine Art, Ltd., London (Nov.-Dec. 1986).

1734. DESCARGUES, PIERRE. "Racontez Docteur Roudinesco." *Connaissance des arts* 204(Feb. 1969):68-73. 12 col. illus.

Illustrated with Signac's *Vue de la Salis, près d'Antibes.*

1735. DESHAIRS, LEON. "Les Aquarelles de Paul Signac." *Art et décoration* (Jan. 1921):11-6.

1736. DORIVAL, BERNARD. "Un ensemble de Paul Signac: nouvelles acquisitions." *La Revue des arts* 8:1(Jan. 1958):52-4. illus.

Illustrated with Signac's *La Grève de Pontorson* and *Le Viaduc d'Asnières.*

1737. DORR, GOLDWAITHE H. III. "Putnam Dana McMillan Collection." *Minneapolis Art Institute Bulletin* 50(Dec. 1961):52-3.

Illustrated with Signac's *Boulevard de Clichy.*

1738. DORRA, HENRI. "Charles Henry's 'Scientific' Aesthetic." *Gazette des Beaux-arts* ser. 6, 74(Dec. 1969):349+.

1739. ERASMUS, P. M. "The French Collection of the Johannesburg Art Gallery." *Apollo* 102:164(Oct. 1975):280-5. 16 illus.

Highlights particular French paintings in the collection of the Johannesburg Art Gallery, including canvases by Signac.

1740. ESCHOLIER, RAYMOND. "Seurat et ses amis." *Le Journal* (20 Dec. 1933):5.

Review of exhibition held in Paris at La Gazette des Beaux-arts (1933-34).

1741. "Les Etapes de la peinture contemporaine." *Beaux-arts* (15 Dec. 1933):1.

1742. FAGUS, F. "Décoration de la Mairie d'Asnières." *La Revue blanche* (1 Jan. 1901):61-3.

1743. FENEON, FELIX. "L'Affiche de M. Paul Signac." *La Revue indépendante* (Oct. 1888):137-8.

1744. FENEON, FELIX. "Signac." *Les Hommes d'aujourd'hui* 8:373(1890). See also *l'Art moderne* 36(7 Sept. 1890):281-6.

1745. FENEON, FELIX. "P. Signac." *La Plume* (1 Sept. 1891):292-9.

1746. FLAMANT, E.-CHARLES. "Signac, ses amis, ses tableaux, ses gouaches." *Connaissance des arts* (Summer 1966).

1747. FLOUQUET, PIERRE-LOUIS. "Peinture et poésie: réponses de Marc Chagall, James Ensor, Wassily Kandinsky, Paul Signac et Piet Mondrian." *Courrier du Centre International d'études poétiques* (Jan. and June 1992):193-4, 99-102.

1748. FORGES, MARIE-THERESE LEMOYNE DE. "Un nouveau tableau de Puvis de Chavannes au Musée du Louvre: *Jeunes filles au bord de la mer,* panneau décoratif." *La Revue du Louvre et des musées de France.* 20:4-5(1970):251-2.

1749. FOSCA, FRANÇOIS. "Les Historiens d'art et la technique impressionniste." *Etudes d'art* 6(1951):5-32.

1750. FRECHES-THORY, CLAIRE. "La Donation Ginette Signac." *La Revue du Louvre et des musées de France* 28:2(1978):107-12. 8 illus.

Discusses drawings by Signac, Cross, Van Rysselberghe, and Luce donated by Madame Signac to the Louvre's Cabinet des dessins. The two works by Signac are *La Femme sous la lampe* and *Venise, la voile verte.*

1751. FRECHES-THORY, CLAIRE. "Paul Signac: acquisitions récentes." *La Revue du Louvre et des musées de France* 33:1(1983):35-46. 10 illus., 1 col.

Revises and corrects information (particularly dates) in the *catalogue raisonné* of Signac's color lithographs by reference to recently discovered letters of Signac to André Marty, an editor, director of *Le Journal des artistes,* and publisher of prints and books on the arts. An appendix provides the French text of the eight original letters.

1752. GAUNT, WILLIAM. "Masterpieces from the Great Age of French Landscape." *Connoisseur* 148(Dec. 1961):318.

Illustrated with Signac's *Port de Portrieux.*

1753. GEFFROY, GUSTAVE. "Luce et Signac." *Le Journal* (10 Dec. 1894).

1754. GILMOUR, PAT. "New Light on Paul Signac's Colour Lithographs." *Burlington Magazine* 132:1045(April 1990):271-5. 3 illus.

1755. GROOM, GLORIA. "The Art Institute of Chicago." *Apollo* 142:406(Dec. 1995):59-61. 4 illus., 2 col.

Discusses in part an early landscape by Paul Signac, *Les Andelys, Côte d'Aval* (1886), recently acquired by the Art Institute of Chicago.

1756. GUEGAN, STEPHANE. "Grenoble: un Louvre en Isère." *Beaux-arts magazine* 120(Feb. 1994):62-75. 22 illus., 20 col.

Historical overview of the Musée de Grenoble, founded in 1776, on the occasion of the opening of a new art gallery. Mentions works by Signac housed in the new space.

1757. GUENNE, JACQUES. "Paul Signac et Frantz Jourdain." *L'Art vivant* (Oct. 1935):229.

1758. GUILBEAUX, HENRI. "Paul Signac et les Indépendants." *Les Hommes du jour* (22 April 1911).

1759. HAHNLOSER-INGOLD, MARGRIT. "Paul Signac, 1863-1935: Meister des Aquarells." *Weltkunst* 56:14(15 July 1986):1989-90. 4 illus. (col.)

1760. HAMMACHER, ABRAHAM MARIE. "Van Gogh's Relationship with Signac" in *Van Gogh's Life in his Drawings*, exh. cat., Marlborough Fine Art, London, May-June 1962.

1761. HERBERT, ROBERT L. and EUGENIA W. HERBERT. "Artists and Anarchism: Unpublished Letters of Pissarro, Signac, and Others." *Burlington Magazine* 102(Nov. and Dec. 1960):472-82, 519-21.

1762. HILDEBRANDT, HANS. "Paul Signac." *Aussaat* 1-2(1947):28-32.

1763. "Hommage à Paul Signac." *L'Humanité* (5 March 1938).

Special issue devoted to Signac with contributions by A. André, Aragon, George Besson, Pierre Bonnard, Jean Cassou, Frantz Jourdain, and Maximilien Luce.

1764. HUNTOON, SIRI. "Signac's Science." *ARTnews* 91:9(Nov. 1992):17.

1765. IVANOFF, NICOLAS. "Venise dans la peinture française." *Archives de l'art français* 25(1978):389-99. 10 illus.

Traces the inspiration and association of the city of Venice for French artists from the 18th to early 20th centuries, including Paul Signac.

1766. IVES, COLTA. "French Prints in the Era of Impressionism and Symbolism." *Metropolitan Museum of Art Bulletin* 46:1(Summer 1988):3-57, 55 illus., 33 col.

Overview of French printmaking in the late 19th century that mentions works by Signac and Pissarro, among other artists.

1767. JOURDAIN, FRANTZ. "Paul Signac." *Arts-documents* 13(Oct. 1951):5.

1768. KAHN, GUSTAVE. "Deux morts: Paul Signac, Frantz Jourdain." *Mercure de France* (1 Oct. 1935):168-73.

Obituary notice and memorial to Signac and the writer Frantz Jourdain.

1769. LAPRADE, JACQUES DE. "Le Peintre Paul Signac." *Beaux-arts* (23 Aug. 1935):1 p. illus.

Memorial tribute.

1770. LEMOINE, SERGE. "Signac et la couleur." *Connaissance des arts* 537(March 1997):30-9.

1771. LEVY-GUTMANN, ANNY. "Seurat et ses amis." *Art et décoration* (Jan. 1934):36-7.

Review of exhibition held at Galerie Wildenstein, Paris (Dec. 1933-Jan. 1934).

1772. MONERY, JEAN-PAUL. "Paul Signac et Saint-Tropez: *Saint-Tropez, l'orage* entre au Musée de l'Annonciade." *La Revue du Louvre et des musées de France* 43(Oct. 1993):7-10.

1773. MORRIS, SUSAN. "Room at the Top." *Antique Collector* 62:18(Nov. 1991):96-8. 2 col. illus.

Feature on the art collector Jeffrey Archer, whose collection includes Neo-Impressionist drawings and watercolors by Signac, Pissarro, and other artists.

1774. NEILSON, NANCY WARD. "A Neo-Impressionist Lithograph by Paul Signac." *Saint Louis Art Museum Bulletin* 10:1(Jan.-Feb. 1974):4-5. 1 illus.

Highlights Signac's lithograph, *Port of St. Tropez* (1897-98), probably prepared for the third edition (never published) of Ambroise Vollard's *L'Album des peintres-graveurs,* but issued separately.

1775. Obituaries: *Art et décoration* 64(Aug. 1935):supp.35; *Kunst* 71(Sept. 1935):supp. 7; *Schöne Heim* (Sept. 1935):supp. 7; *ARTnews* 33(14 Sept. 1935):10; *Art Digest* 9(Sept. 1935):18; *Amour d'art* 16(Oct. 1935):299; A. Watt, *Apollo* 22(Oct. 1935):238; *Bulletin de la Revue d'art* 68(Nov. 1935):345-6.

1776. "Paul Signac." *Gil Blas* (27 March 1892). Reprinted in *L'Art moderne.*

1777. "Peinture 1880." *Beaux-arts* (2 Feb. 1934):3.

1778. PERNOUD, EMMANUEL. "La Couleur dans tous ses états." *Nouvelles de l'estampe* 122(Apr.-June 1992) [titre du fascicule: *De Bonnard à Baselitz: l'estampe des novateurs*]:13-17. 1 illus.

Mentions a color print by Signac.

1779. PIERRE, ARNAULD. "Signac: couleur au point." *Beaux-arts magazine* 154(March 1997):72-9.

1780. "Portrait." *Beaux-arts* 10(Feb. 1932):15.

1781. "Portrait by G. Seurat." *Gazette des Beaux-arts* ser. 6, 11(Jan. 1934):54; *Bulletin de la Revue d'art* 65(March 1934):51; *Studio* 155(March 1958):86.

1782. RATCLIFF, CARTER. "In Detail: Matisse's *Dance.*" *Portfolio* 3:4(July-Aug. 1981):38-45. 13 illus., 6 col.

Analysis of Henri Matisse's *Dance I, Dance II,* and *Music* that mentions the influence of Paul Signac.

1783. RENE-JEAN. "Pour son cinquantenaire, le Salon des Indépendants a rappelé à lui ses vétérans." *Comœdia* (2 Feb. 1934).

1784. RENE-JEAN. "Paul Signac." *Comœdia* (18 Aug. 1935).

1785. REVEL, JEAN-FRANÇOIS. "Charles Henry et la science des arts." *L'Oeil* 119(Nov. 1964):20-7⁺.

1786. REWALD, JOHN. "Des Signac inconnus à Düsseldorf." *Arts* 382(24 Oct. 1952):7.

1787. ROCHEFOUCAULD, ANTOINE DE LA. "Paul Signac." *Le Cœur* 2(May 1893):4-5.

1788. ROGER-MARX, CLAUDE. "Paul Signac." *L'Amour de l'art* (Feb. 1933):36-40. Reprinted in *L'Histoire de l'art contemporain*, sous la direction de René Huyghe avec le concours de Germain Bazin (Paris: Alcan, 1935).

1789. *"St. Malo* by Paul Signac." *Milwaukee Art Institute Bulletin* 9(Feb. 1935):5.

1790. SALMON, ANDRE. "Bouquet pour Signac." *Beaux-arts* (2 Feb. 1934):2.

1791. SANDOZ, MARC. "L'Oeuvre de P. Signac à La Rochelle, Croix-de-Vie, Les Sables d'Olonne de 1911 à 1930." *Bulletin de la Société de l'histoire de l'art français* (1955).

1792. SANDOZ, MARC. "Le Peintre Paul Signac à La Rochelle et sur les côtes charentaises et poitevines." *Cahiers de l'Ouest* (1957).

1793. SCHLUMBERGER, JEAN. *"De Delacroix au néo-impressionnisme*, par Paul Signac." *La Nouvelle revue française* (1 Aug. 1911):239-41.

Review of the 1911 Floury edition of Signac's Neo-Impressionist manifesto.

1794. SHIKES, RALPH E. and STEVEN HELLER. "The Art of Satire: Painters as Caricaturists and Cartoonists." *Print Review* 19(1984):8-125.

Mentions Signac's political caricatures.

1795. SPANGENBERG, KRISTIN L. "The Print Collection of the Cincinnati Art Museum." *Print Review* 6(1976):27-38. 13 illus.

Highlights the Cincinnati Art Museum's print collection, the core of which came from Herbert Greer French's bequest of 800 prints, including works by Signac.

1796. SPRINGER, ANNE MARIE. "Terrorism and Anarchy: Late 19ᵗʰ Century Images of a Political Phenomenon in France." *Art Journal* 38:4(Summer 1979):261-6. 8 illus.

Examines imagery and iconography relating to French political turmoil in the late 19ᵗʰ century, including examples by Signac and Pissarro.

1797. SWANSON, ROBERT. "Looking at a Painting of Constantinople by Paul Signac." *Hudson Review* 35:4(1982):578-9.
Poetry inspired by a painting by Signac.

1798. THEODORE, E. "L'Art français à Venise." *Le Bulletin de la vie artistique* (1 May 1920):294-6.

1799. THIEBAUT, PHILIPPE. "Art nouveau et néo-impressionnisme: les ateliers de Signac." *Revue de l'art* 92(1991):72-8. 13 illus.

Relates Signac's domestic arrangements to the art of his time, beginning with the artist's residence in the Castel Béranger built by Hector Guimard. Cites Signac's journals to show that Art nouveau was not a homogenous movement. Refers to Signac's friendship with the interior designer and later fellow Neo-Impressionist Théo Van Rysselberghe.

1800. THOMSON, BELINDA. "Paul Signac Watercolours and Drawings." *Burlington Magazine* 129(Jan. 1987):45-6.

1801. VAN GOGH, VINCENT. "Letters to Gauguin and Signac." *Studio* 155(March 1958):86.

1802. "Venise." *Bulletin de la vie artistique* (1 July 1920):436.

1803. WAGNER, ANNI. "Besuch im Musée de l'Annonciade in St. Tropez." *Kunst und das Schone Heim* 88:8(Aug. 1976):465-72. 6 illus. Summary in English.

Traces the influence of Saint-Tropez and surrounding regions on Paul Signac and the artists' colony that developed there in the 1920s. The role of Georges Grammont in encouraging artists to paint there and the eventual building of the Musée de l'Annonciade to house Grammont's collection of French paintings from 1890 to 1949 are described.

1804. WILHELM, JACQUES. "Paris Seen by Painters." *Apollo* 106:190(Dec. 1977):478-89. 15 illus.

Describes the print room at the Musée Carnavalet, Paris, including the painting *Windmills at Montmartre* (1884) by Signac.

1805. YONEMURA, NORIKO. "Paul Signac no suisai-ga." *Mizue* 939(Summer 1986):21-35. 16 illus., 12 col.

Detailed analysis of Signac's watercolor technique, particularly his use of outline over light and shade. Argues that Signac's watercolors are more natural and expressive than his theoretical and artificial oil paintings.

V. Individual Exhibitions

1902, June Paris, Galerie de l'Art moderne Bing (Art nouveau). *Exposition d'œuvres de Paul Signac.* Préface par Arsène Alexandre. Catalogue par P. L. Garnier.

Reviews: O. Maus, *L'Art moderne* (8 June 1902):196-7; E. Cousturier, *La Revue blanche* (June 1902):213-4; M. Denis, *L'Occident* (July 1902):52-3.

1904, 13-31 December	Paris, Galerie Druet. *Exposition Paul Signac.* Préface par Félix Fénéon. Revised text of Fénéon's preface appeared in *L'Art moderne* (18 Dec. 1904):409-10. Reviews: *Gil Blas* (17 Dec. 1904); C. Saunier, *Revue universelle* (1 March 1905):121-2.
1907, 21 January-2 February	Paris, Bernheim-Jeune. *Exposition Paul Signac.* Préface par Paul Adam. Catalogue par Octave Maus. 16 p., illus. Revised text of Adam's preface appeared in *L'Art moderne* (20 Jan. 1907):20-1. See also Adam's *Dix ans d'art français* (Paris, 1909):36-8. Review: P. Jamot, *La Chronique des arts et de la curiosité* (26 Jan. 1907):28.
1913, 24 November-6 December	Paris, Bernheim-Jeune. *Exposition Paul Signac.* 9 p., illus. Reviews: L. Vauxcelles, *Gil Blas* (30 Nov. 1913); C. Saunier, *La Grande revue* (10 Dec. 1913):615-23; G. Kahn, *Mercure de France* (16 Dec. 1913):825.
1923	Paris, Galerie Bernheim Jeune, *Exposition Paul Signac.* Review: G. Kahn, *Mercure de France* (1 July 1923):207.
1927, February-March	Berlin, Galerie M. Goldschmidt. *Paul Signac, Sonderausstellung.* In German and French. "Exposition de Signac placée sous les auspices de l'Association Française d'exposition et d'échanges artistique."
1927	Paris, Galerie Bernheim-Jeune. *Exposition d'aquarelles de P. Signac.* Review: G. Kahn, *Mercure de France* (1 Nov. 1927):630.
1930, 19-30 May	Paris, Bernheim-Jeune. *Exposition Paul Signac: du lundi 19 mai au vendredi 30 mai 1930.* 1 p., 56 pl. Reviews: P. Fierens, *ARTnews* (14 June 1930):22; P. Berthelot, *Beaux-arts* 8(June 1930):24.
193-	Vienna, Neue Galerie. *Paul Signac.* Catalogue par Claude Roger-Marx. 23 p. In French and German. On cover: Paul Signac, VII. Ausstellung, Neue Galerie.
1935, November	Amsterdam, Huinck & Scherjon, N.V., Kunsthandel. *Tentoonstelling van Schilderijen en Aquarellen door Paul Signac.* 18 p., 8 illus.

1950, January- February	Mulhouse, Musée de Mulhouse. *Paul Signac ardent et sage.* Préface par Francis Jourdain.
	Revised text of Jourdain's preface appeared in *Estampes* 1(Jan.-Feb. 1950) and in *Arts* (19 Oct. 1951):1-2.
1951, 25 October- 2 December	Paris, Musée National d'art moderne. *P. Signac.* Catalogue a été réalisé par Gabrielle Vienne. Préface par Jean Cassou. Paris: Editions des Musées Nationaux, 1951. 18 p., illus.
	Review: *ARTnews* 50(Jan. 1952):48.
1951, 5-24 November	New York, Fine Arts Associates. *Paul Signac.* 16 p., 8 illus.
	Includes excerpts from Signac's diary and a chronology. Reviews: M. Breuning, *Art Digest* 26:4(15 Nov. 1951):18; *ARTnews* 50(Dec. 1951):49.
1954, 11 March- 15 April	London, Marlborough Fine Art Ltd. *Paul Signac, 1863-1935.* *Retrospective Exhibition.* Catalogue by George Besson with an essay by Paul Gay. 32 p., illus., 13 pl.
	Bibliography, p. 32. Reviews: *Illustrated London News* 224(20 March 1954):451; *ARTnews* 53(May 1954):45; *Connoisseur* 133(June 1954):260.
1954, October	Boston, Museum of Fine Arts. *Paul Signac Exhibition.* Text by Peter A. Wick.
	Highlighted by Wick in *Bulletin of the Museum of Fine Arts, Boston* 52(October 1954):65-73. Review: *Arts Digest* 29(1 Dec. 1954):17.
1958, April-May	London, Marlborough Fine Art Ltd. *La Création de l'œuvre chez* *Paul Signac.* Préface par Paul Gay. 48 p., illus.
	Reviews: *Connoisseur* 141(April 1958):115, 262; *Burlington* *Magazine* 100(May 1958):186; *Apollo* 67(May 1958):152[+]; *ARTnews* 57(June 1958):38-9.
1959	Belgrade, Narodni Muzej. *Paul Signac i njegovi prijatelji.* Prefaces by Veljko Petrovic and Paul Gay.
1963-64, December- February	Paris, Musée du Louvre. *Signac.* Catalogue a été rédigé par Mademoiselle Marie-Thérèse Lemoyne, avec le concours de Madame Pierre Bascoul-Gauthier. Paris: Ministère d'Etat Affaires Culturelles, 1963. 133 p., illus., 4 pl. 139 paintings, drawings, watercolors, and notebooks shown.

Bibliography, pp. 117-33.
Reviews: M. T. de Forges, *Revue du Louvre et des musées de France* 13:6(1963):245-54; P. Schneider, *ARTnews* 62(Feb. 1964):52-3; *Domus* 411(Feb. 1964):53; E. Roditi, *Apollo* new ser. 79(March 1964):240-1; G. Schurr, *Connoisseur* 155(March 1964):190.

1968, 10 February-9 March

New York, Charles E. Slatkin Galleries. *Paul Signac, 1863-1935: An Exhibition of Drawings, Watercolors, & Pastels.* 8 p., illus.

Review: *ARTnews* 67(March 1968):24.

1977

London, J.P.L. Fine Arts. *P. Signac, 1863-1935: Drawings and Watercolors.* Uxbridge, Middlesex: Hillingdon Press, 1977. 1 vol., illus., some col.

1977, 30 Aug.-27 November

New York, Metropolitan Museum of Art. *P. Signac: Paul Signac (1863-1935): Paintings, Watercolors, Drawings and Prints. Robert Lehman Collection Drawings Galleries.* Text by George Szabo. 55 p., illus.

"This exhibition represents the complete holdings of Paul Signac's works in the Metropolitan Musuem of Art, the majority of which are in the Robert Lehman Collection." Includes bibliographies.
Reviews: J. Russell, *New York Times* (4 Sept. 1977):D17; *Art International* 21(Oct.-Nov. 1977):57-8.

1981

London, J. P. L. Fine Arts. *P. Signac (1869-1935): Drawings and Watercolors.* 44 p., illus., some col.

Review: O. Blakeston, *Arts Review* 33:21(23 Oct. 1981):472.

1986, 24 July-15 September

Salzburg, Galerie Salis. *Paul Signac, 1863-1935: Aquarelle, Ölgemälde, Zeichnungen: Festspielausstellung 1986.* Introductory essay by Margrit Hahnloser-Ingold.

1986, November-December

London, Marlborough Fine Art Ltd. *Paul Signac, 1863-1935: Watercolours and Drawings.* 88 p., 117 illus., 91 col.

Introduction discusses the evolution of Signac's work on paper, Pissarro's influence, and Signac's method of using watercolors as preliminary studies for oils before producing them as independent works. Traces Signac's predilection for brown ink drawings to his friendship with van Gogh. Exhibition celebrated the 40th anniversary of the Marlborough Gallery. Bibliography, p. 87.
Reviews: G. Burn, *Arts Review* 38(5 Dec. 1986):665; B. Denvir, *Art and Artists* 242(Nov. 1986):23-5; B. Thomson, *Burlington Magazine* 129:1006(Jan. 1987):45-6.

1989, 26 January- 20 March	Melun, Musée de Melun, Espace Saint-Jean. *P. Signac: aquarelles.* Catalogue réalisé par Annie-Claire Lussiez, assistée de Annette Gelinet. 24 p., illus.

Bibliographical references, p. 22.

1990	St. Louis, Greenberg Gallery. *P. Signac: Watercolors.* Also shown Santa Fe, Gerald Peters Gallery. Catalogue by Lauri Thompson. Essay by Dr. Charles Cachin, trans. into English by Isabel Balzer. 42 p., 13 col. illus. 13 watercolors and pen and ink washes on paper shown. In English and French.

Exhibition that highlighted the development of Signac's watercolor technique over a period of 50 years.

1992, 20 June-13 December	Saint-Tropez, Musée de l'Annonciade. *Signac & Saint-Tropez: 1892-1913.* Also shown Reims, Musée des Beaux-arts (6 November-13 December 1992). Commissariat, Jean-Paul Monery, Marina Ferretti-Bocquillon; avec la participation de Véronique Alemany-Dessaint. Besançon: Néo-Typo, 1992. 117 p., 112 illus., 71 col.

Exhibition of paintings, watercolors, and drawings, dating 1892-1913, that focus on the landscape around Saint-Tropez on the centenary of Signac's arrival in the town in May 1892. Foreward outlines Signac's association with the town. Essays describe his arrival and reasons for staying, the evolution of his painting and the influence of pointillism, and the importance of Signac's watercolors and drawings.
Reviews: *Connaissance des arts* 485(July-Aug. 1992):20; *L'Oeil* 446(Nov. 1992):87.

VI. Group Exhibitions

1888	Brussels, Salon des XX.
1886	Paris, rue Laffitte, VIII^e exposition impressionniste.
1894	Brussels, Salon de la Libre Esthétique.
1894, 22 November-8 December	Paris, Galerie Moline, 20, rue Laffitte. *Maximilien Luce et Paul Signac.*

Exhibition of 27 canvasses by Luce and watercolors by Signac.
Reviews: G. Geffroy, *La Vie artistique* 6 ser.(10 Dec. 1894):286-91; E. Pilon, *La Plume* (Dec. 1894):504.

1898, 22 October- 2 December	Berlin, Keller und Reiner.
	First Neo-Impressionist exhibition in German, made possible through the intercession of Count Harry Kessler.
1899	Paris, Durand-Ruel.
1904, 27 March-1 May	Munich, Exposition Phalanx.
1906, Spring	Berlin, *Berliner Sezession.* 10 works.
1906-07, September- January	Munich, Kunstverein. *Artistes français.* Also shown Frankfurt, Karlsruhe, Stuttgart, Dresden.
1908, 11 April-24 May	Moscow, Toison d'or. 3 works.
1910, 10 July-9 October	Cologne, Sonderbund. 6 works.
1911, 19 June-3 July	Paris, Galerie Druet. *Exposition de peintures & d'aquarelles de Henri Edmond Cross & Paul Signac.* 8 p.
	Reviews: G. Apollinaire, *L'Intransigeant* (28 Jan. 1911); H. Ghéon, *La Nouvelle revue française* (1 March 1911):467-77.
1912, 25 May-30 September	Cologne, Sonderbund. 18 works.
1953-54, 4 December-17 January	Los Angeles County Musuem. *Watercolors by Paul Signac, with Two of his Paintings, and Works by Georges Seurat and Henri Edmond Cross.* 20 p., illus.
	Review: *ARTnews* 52(Jan. 1954):20.
1955, 2-31 May	Cambridge, MA, Harvard University, Fogg Art Museum. *From Sisley to Signac: A Museum Course Exhibition.* 12 p., illus.
1955, 20 June-20 July	Poitiers, Musées de Poitiers. *Exposition Signac et Marquet.* 8 p.
1955, 24 November	Bern, Kornfeld und Klipstein. *Graphik und Handzeichnungen moderner Meister: Daumier, Degas, Van Gogh, Holder, Kandinsky, Klee, Kokoschka, Macke, Marees, Picasso, Schieler, Signac, Toulouse-Lautrec.* Auktion 80. 24 November 1955. 45 p., illus., 27 pl., some col.
1958, 19 November	NY, Parke-Bernet Galleries. *Major Works by Bonnard, Cézanne, Degas, Raoul Dufy, Manet, Matisse, Modigliani, Monet, Morisot, Picasso, Pissarro, Renoir, Rouault, Segonzac, Signac, Utrillo, Van Gogh, Vlaminck and Vuillard.* From the Collection of Arnold Kirkeby. Public auction sale, November 19. New York, Parke-Bernet Galleries, 1958. 91 p., illus., some col.

1959 Paris, Musée National d'Art moderne. *Le Dessin français de
 Signac aux abstraits.* Cette exposition circulante a été organisée par
 le Service éducatif de la Direction des Musées de France, grâce au
 concours du Musée National d'Art moderne. Catalogue a été établi
 par Simone Virault et Michel Hoog. Introduction par Bernard
 Dorival. Paris: Editions des Musées Nationaux, 1959. 48 p., illus.,
 4 pl.

 Bibliography, p. 47.

1962, 29 March- Lausanne, Galerie Paul Vallotton. *Auberjonois, Brianchon, Derain,
28 April Despiau, Domenjoz, Dufresne, Dufy, Dunoyer de Segonzac, De La
 Fresnaye, Friesz, Laprade, Lecoultre, Luce, Manguin, Marquet,
 Matisse, Ottesen, Picasso, Pissarro, Signac, Soutter, Tal Coat,
 Toulouse-Lautrec, Valadon, Vallotton: dessins, aquarelles,
 gouaches: exposition.* 15 p., illus.

1962, May-June London, Marlborough Fine Art Ltd., *Van Gogh's Life in his
 Drawings; Van Gogh's Relationship with Signac.* Text by Abraham
 M. Hammacher. 120 p., illus., Catalogue no. 100.

 Review: M. Amaya, *Apollo* new ser. 76(May 1962):217.

1963, 11 April NY, Parke-Bernet Galleries. *Paintings, Drawings, Sculptures:
 Buffet, Chirico, Dufy, Edzard, Gromaire, Lebasque, Luks, Mane-
 Katz, Marsh, Matisse, Modigliani, Renoir, Signac, Tchelitchew,
 Villon, Vlaminck.* Belonging to various owners, including Leo L.
 Heaps, John V. N. Dorr, Tobé C. Davis. Public auction, April 11,
 1963. 53 p., illus. (Exhibition and sale – Parke-Bernet Galleries,
 no. 2185)

1966, 15 July-15 Nice, Académie Internationale d'été de Nice, Musée des Ponchettes.
August *Comprendre la peinture du XXᵉ siècle: Signac.* [et al.]. 1 vol.

1966 Basel, Galerie Beyeler. *Autour de l'impressionnisme: Manet,
 Pissarro, Sisley, Monet, Rodin, Renoir, Van Gogh, Gauguin,
 Toulouse-Lautrec, Degas, Cézanne, Signac, Vlaminck, Derain,
 Vuillard, Ensor, Bonnard.* 76 p., illus., some col.

1968, 20 July-21 La Rochelle, Musée des Beaux-arts, Ville de La Rochelle. *La
September Rochelle, Les Sables d'Olonne par Signac, Marquet, Friesz et
 d'autres peintres issus du fauvisme.* 46 p., illus.

1968, 10 October NY, Parke-Bernet Galleries. *School of Paris Paintings: Including
 Major Works by Cross, Dufy, van Dongen, Friese, Luce, Pascin,
 Signac, Utrillo, Vlaminck.* From the collection of Doctor
 Roudinesco; sold by his order. Public auction October 10, 1968.
 121 p., illus., some col.

1969 Athens, Hilton Hotel. *Peinture en France de Signac aux
 surréalistes.* 50 p., illus.

1973-75 NY, Museum of Modern Art. *Drawings from the Kroller-Müller National Museum, Otterlo.* Also shown Canada and Mexico (1974-75). Under the auspices of the International Council of the Museum of Modern Art. Texts by R.W.D. Oxenaar and William S. Lieberman. 96 p., 65 illus. 118 drawings.

Exhibition of works on paper from the late 19th and early 20th century, dominated by van Gogh and including works by Signac, Redon, and Toorop, among other European artists.

1975 Saint-Tropez, Musée de l'Annonciade. *Paul Signac et ses amis.* Exposition organisée par la Ville de Saint-Tropez. 10 p., illus.

1980, 15 October-15 November NY, Acquavella Galleries. *XIX and XX Century Master Paintings.* 51 p., 23 illus.

Exhibition of works by 18 European and American artists, including Signac and Seurat.

1981, 10 November-14 March 1982 NY, Metropolitan Museum of Art. *Twentieth Century French Drawings from the Robert Lehman Collections.* Catalogue by George Szabo. 19 works by Signac.

1985, 16 March-5 May St. Petersburg, Florida, Museum of Fine Arts. *French Marine Paintings of the Nineteenth Century.* Sponsored by the National Endowment for the Arts, Washington, D.C. and the State of Florida, Department of State. Text by Michael Milkovich. 51 p., 34 illus.

Exhibition of marine paintings by 13 French artists, including Signac and Luce. Milkovich's introductory text describes the French realists and Impressionists' fascination with the sea.

1986, 20 March-26 April Lausanne, Galerie Paul Vallotton. *Paul Signac et les maîtres suisses et français du XIXe et XXe siècle.* 32 p., illus., some col.

1986-87, 31 May-18 January Raleigh, North Carolina Museum of Art. *French Paintings from the Chrysler Museum.* Also shown Birmingham, Alabama, Museum of Art (6 Nov. 1986 - 18 Jan. 1987).
Organized by Chrysler Museum. Introduction by William J. Chiego. Catalogue by Jefferson C. Harrison. 139 p., 90 illus., 45 col.

Exhibition of French paintings in the Chrysler Museum, including works by Signac. Includes a short essay on each artist, annotations, and exhibition histories for each painting.

1987, 9 August-15 November Lugano, Villa Favorita. *Impressionisten und Post-Impressionisten aus sowjetischen Museen II.* Texts by Albert Kostenevich, Marina Bessonova, and E. Georgievskaya. Milan: Electa, 1987. 143 p., 80 illus., 40 col. 40 works shown. In German and English.

Exhibition of paintings from the Pushkin Museum, Moscow and the Hermitage Museum, Leningrad. Essays trace the history of French collections in Russia since the 18th century, focusing on the Shchukin and the Morozov brothers' collections formed at the turn of the 20th century.

1987, 13 September-15 January

NY, Jewish Museum. *The Dreyfus Affair: Art, Truth and Justice.* Catalogue by Norman L. Kleeblatt. Berkeley: University of California Press, 1987. 316 p., 341 illus.

Exhibition of photographs, paintings, prints, posters, and cartoons documenting France's Alfred Dreyfus Affair (1894). Includes works by Signac and Pissarro, among other artists.

1988-89, 2 October-5 March

Bremen, Kunsthalle. *Französische Kunst des 19. Jahrhunderts aus dem Museum der bildenden Kunste Budapest: Gemälde, Aquarelle, Zeichnungen.* Also shown Munich, Neue Pinakothek (20 Jan.-5 March 1989). Texts by Brigitta Cifka and Veronika Kaposy. 119 p., 50 illus., 42 col.

Exhibition of 19th and 20th century French art from the Museum of Fine Arts, Budapest, that included works by Signac and Pissarro.

1989, 16 March-22 April

Lausanne, Galerie Paul Vallotton. *Maîtres suisses et français des XIX^e et XX^e siècles.* 28 p., 28 illus., 18 col. 84 paintings shown.

Exhibition of paintings by 51 late 19th- and 20th-century French and Swiss artists, including Paul Signac.

1989, 18 May-3 September

Lyon, Musée des Beaux-arts. *De Géricault à Léger: dessins français des XIXe et XXe siècles dans les collections du Musée des Beaux-arts de Lyon.* Organisée par la Direction Régionale des affaires culturelles. Catalogue par Dominique Brachlianoff. 164 p., 133 illus., 21 col. 130 drawings.

Included drawings by Signac, among other French artists.

1989-90, November-January

Les Sables d'Olonne, Musée de l'Abbaye Sainte-Croix. *Albert Marquet aux Sables-d'Olonne, 1921-1933.* 32 p., illus., some col.

Exhibition featuring works by Albert Marquet, Jean Launois, Paul-Emile Pajot, Jean Puy, and Paul Signac. Bibliographic references, pp. 31-2.

1989-90, 7 December-14 January

Linz, Stadtmuseum Linz-Nordico. *Meisterzeichnungen der la klassischen Moderne: die graphische Sammlung des Linzer Stadtmuseums-Nordico.* 126 p., 94 illus., 8 col.

Included modern drawings by Signac, Barlach, Degas, Bone, Klimt, Kokoschka, and Schiele.

1992, 2 July-5
September

Lausanne, Galerie Paul Vallotton. *Maîtres suisses et français des XIXe et XXe siècles: huiles, aquarelles et dessins.* 17 p., 16 col. illus. 66 works shown.

Exhibition of paintings, watercolors, pastels, and illustrated books by 40 Swiss and French artists, including works by Signac.

1992, 19
September-29
November

Rotterdam, Museum Boymans-van Beuningen. *Impressionism: Through Clear Eyes — the Movement and its Precursors.* Catalogue by Piet de Jonge and Annetje Boersma. 228 p., 295 illus., 197 col.

Exhibition of paintings, sculpture, lithographs, and drawings by artists of the Barbizon School, the Impressionists, and the Post-Impressionists, including works by Signac.

1993, 26 March-
23 May

NY, Brooklyn Museum. *Manet to Picasso: Prints and Drawings from the Brooklyn Museum.* Text by Linda Konheim Kramer. 8 p., 6 illus.

Exhibition of prints and drawings made in Paris between 1871 and 1937, including works by Signac.

1993, May-
September

Lausanne, Fondation de l'Hermitage. *Claude Monet et ses amis.* Organized in collaboration with the Musée Marmottan, Paris.

Retrospective exhibition of Monet's years at Giverny, 1883-1926, which included 24 paintings by Monet and works of other artists, including Signac.
Review: F. Daulte, *L'Oeil* 452(June 1993):32-9.

1994, 26 March-3
October

Albi, Musée Toulouse-Lautrec. *De Renoir à Signac: œuvres sur papier. Collection du Musée Albert-André de Bagnols-sur-Cèze.* Also shown Bagnols-sur-Cèze, Musée Albert-André (18 June-3 Oct. 1994). 56 p., illus., some col.

1994, 14 October-
5 December

Rome, Palazzo delle Esposizioni. *Signac, Bonnard, Matisse: neoimpressionisti, nabis, fauves del Museo dell'Annonciade di Saint-Tropez.* A cura di Jean-Paul Monery. Naples: Electa, 1994. 103 p., illus., some col.

Bibliographical references, p. 103.

1996-97, 1
December-31
August

Münster, Westfälisches Landesmuseum für Kunst und Kulturgeschichte. *Farben des Lichts: Paul Signac und der Beginn der Moderne von Matisse bis Mondrian.* Also shown Grenoble, Musée de Grenoble (9 March-25 May 1997; Weimar, Kunstsammlungen zu Weimar (15 June-31 August 1997).

Herausgegeben von Erich Franz; mit dem Text 'Neoimpressionismus' von Paul Signac und Beiträgen von Cor Blok [et al.]. Kataloggesamtredaktion, Erich Franz. Redaktion, Annegret Rottmann, Andrea Witte. Ostfildern: Edition Tertium, 1996. 400 p., illus.

Exhibition of 124 paintings by 37 European artists, including 42 works by Signac and 11 works by Cross. Reprints Signac's "Le Néo-impressionnisme" essay, a summary of his *D'Eugène Delacroix au néo-impressionnnisme,* first published in *La Revue blanche* in May and June 1898 and in German in the magazine *Pan* (July 1898):55-62.

a. French ed.: *Signac et la libération de la couleur: de Matisse à Mondrian.* Paris: Réunion des Musées Nationaux, 1997. 398 p., illus.

Théo Van Rysselberghe

Biography

Van Rysselberghe, the sole major non-French Neo-Impressionist, was responsible for extending the movement in Belgium. His pointillist portraits and landscapes were also admired in Berlin and Vienna at the end of the century. Van Rysselberghe was born in Ghent and enrolled in l'Académie van Beeldende Kunsten at an early age. His elder brothers were engineers and architects, including Octave (1855-1929), who earned an international Art nouveau reputation. A pupil of Jean-François Portaels, director of l'Académie Royale des Beaux-arts in Brussels, Théo first exhibited at the Brussels Salon in 1881. The following year he received a travel grant to Spain and Morocco, accompanied by Dario de Regoyos and Constantin Meunier. This was the first of many painting excursions to North Africa, the Near East, and eastern and western Europe. He exhibited picturesque Mediterranean canvasses in 1883 and participated in the historic founding of Les XX, Belgium's premier avant-garde exhibition society, on October 28, 1883.

Membership in Les XX and close ties to its dynamic secretary, Octave Maus (1856-1919), catapulted Van Rysselberghe into vanguard European artistic and literary societies. Whistler, Manet, Degas, and Renoir were early Impressionist influences. In 1886, Van Rysselberghe and the Symbolist poet and critic Emile Verhaeren attended the final Impressionist show in Paris. Like many viewers, they were stunned by Seurat's *La Grande Jatte*. The following year when Seurat exhibited with Les XX, Van Rysselberghe began to adopt a pointillist technique for a series of portraits.

Van Rysselberghe continued in the Neo-Impressionist vein into the 1890s, exhibiting with Les XX until it dissolved in 1893 and after 1894 with its successor, La Libre Esthétique (for whom he created the distinctive cyclamen illustration for its exhibition catalogue and received virtual individual shows in 1898 and 1904), and at Les Indépendants in Paris. Single-artist exhibitions were held at rue Laffitte in Paris in 1895, at the Maison des artistes in 1902, Druet in 1905, Bernheim-Jeune in 1908, Brussels in 1922 and 1927, Braun in 1932, and Ghent in 1962 to mark the centenary of his birth.

In the early 1890s he turned to graphic and decorative arts, including book illustrations for Emile Verhaeren and other authors. In 1895, he created furniture, stained glass, jewelry, and mural decorations for clients of Siegfried Bing's l'Art nouveau gallery in Paris. After 1903 his pointillist technique relaxed and by 1908 it was abandoned. Despite extensive travel and pressing decorative arts commissions, Van Rysselberghe maintained a close association with Signac over the years and spent time with him at Saint-Tropez, contributing to the development of Fauvism and encouraging the Fauves to exhibit in Brussels from 1906 on.

Théo Van Rysselberghe

Chronology, 1862–1926

Information for this chronology was gathered from *Theo Van Rysselberghe: néo-impressionniste* (Brussels: Pandora, 1993):201-3; Jane Block, "Théophile Van Rysselberghe" in *The Dictionary of Art* (NY: Grove, 1996)31:888-9; and Serge Goyens-de Heusch, *L'Impressionnisme et le fauvisme en Belgique* (Anvers: Fonds Mercator, 1982), among other sources.

1862

November 23
Birth of Van Rysselberghe at quai des Tanneurs, Ghent, the youngest son of Jean-Baptiste Van Rysselberghe, a businessman from Minderhout near Hoogstraten and Romanie Rommens. The family had lived in Ghent since 1856. Théo's older brothers included François, an industrial engineer; Charles-Jules, a city architect who designed Ghent's museum of Fine Arts; Julien-Marie, a civil engineer and professor; and Octave-Joseph, also an architect who develops an international reputation. Théo's sister, Sylvie-Marie, marries a Chilean engineer and friend of their oldest brother.

1880

Van Rysselberghe completes studies at Ghent's l'Académie des Beaux-art, where he studies under Théodore Canneel and paints several portraits of family members and friends. Moves to Ixelles and enrolls at l'Académie de Bruxelles, studying under the portraitist Herbo and being influenced by the orientalism of Jean-François Portals, director of the Academy.

1881

Shows two portraits and a landscape at the Brussels Salon.

1882

Exhibits a collection of paintings at the Cercle artistique de Gand. Receives a travel grant from the city of Ghent to continue training abroad. Departs for Spain with Dario de Regoyos, Constantin Meunier, and Frantz Charlet in October. Travels to Morocco with Charlet, where he paints a series of small-format paintings.

1883

Meets the poet Emile Verhaeren (1855-1916) upon his return from Morocco, who becomes a staunch ally, friend, and model. Shows Moroccan works at the Palais des Beaux-arts in Brussels and stays at Knokke on the northern Belgian coast for the summer, accompanied by Dario de Regoyos, Rodolphe Wytsman, and Willy Schlobach. Visits Haarlem to see the paintings of Frans Hals.

October 28
Helps found Les XX in Brussels, a group of avant-garde Belgian artists that includes Franz Charlet, Paul Dubois, James Ensor, Alfred William Finch, Charles Goethals, Fernand Khnopff, Dario de Regoyos, Van Rysselberghe, Willy Schlobach, Guillaume Van Strydonck, and Rodolphe Wytsman. Les XX holds annual shows in Brussels from 1884 to 1893 and invites non-Belgians to exhibit with them. Initiates a lifelong friendship with Octave Maus (1856-1919), secretary and supporter of Les XX.

November
Second trip to Morocco, accompanied by Charlet, with financial support from the city of Ghent.

1884

Resides almost the entire year in Morocco, except for a short summer trip to Seville. Shares a studio in Tangiers with Charlet. Returns to Belgium in November.

1885

Exhibits five Moroccan paintings and a portrait, *Les Sœurs Schlobach*, at Les XX in Brussels.

1886

Paints portraits. Attends the final Impressionist show in Paris with Verhaeren, where Van Rysselberghe is captivated by Seurat's *La Grande Jatte* and other Neo-Impressionist works. Makes friends with Parisian divisionist painters and begins to visit regularly. Shows 11 works at Les XX.

1887

Shows a new series of portraits and two cityscapes at Les XX, where Seurat's *La Grande Jatte* receives the most attention, both positive and negative. Spends the summer at a fisherman's hut at Knokke, painting sand dunes and seascapes that show a divisionist influence and receiving visits from Verhaeren. Accompanies Edmond Picard on an official mission to Morocco to establish a railroad. Picard later publishes an account of the trip illustrated by Van Rysselberghe entitled *El Moghreb-Al-Aksa*.

1888

Returns from Morocco with divisionist cityscapes, including his first true Neo-Impressionist

painting, *Campement près d'une ville marocaine*. Does not exhibit at Les XX. Adopts a pointillist style in *Portrait d'Alice Sèthe*, the first of three portraits of the Sèthe sisters.

1889

Continues to experiment with pointillist portraits.

September 16
Marries Maria Monnom, daughter of the Veuve Monnom and heiress to the Monnom firm, which publishes *Jeune Belgique* and *L'Art moderne*. The couple lives at 442 avenue Louise, Brussels, after a honeymoon in Brittany.

1890

Visits Florence, Vernoa, Venice, and Pérouse with his wife. Spends the summer at Thuin. Birth of their only child, Maria. Shows eight paintings at Les XX, and for the first time, at the Salon des Indépendants in Paris, where *Portrait d'Alice Sèthe* receives favorable reviews.

1890-95

Period of purest Neo-Impressionist work, including numerous landscapes, seascapes, and portraits. Continues to travel regularly, visiting the Netherlands, Athens, Istanbul, Bucharest, Budapest, Vienna, London, Berlin, Moscow, and St. Petersburg during these years. Exhibits at Les XX until it is dissolved in 1893, at the Salon des Indépendants, Paris, and after 1894 at La Libre Esthétique. Around 1890 shows an interest in graphic work, decorative art, and book illustration, the latter aided by his connection with Verhaeren.

1893

Les XX dissolve and Octave Maus forms La Libre Esthétique, which showcases Belgian avant-garde art until 1914. Van Rysselberghe ardently supports the new association and serves as an advisor to Maus, although his artistic center increasingly becomes Paris. Initiates an important and long-lasting collaboration with the Brussels publisher Edmond Deman and illustrated books, beginning with an illustrated edition of *Campagnes hallucinées*.

1894

Designs a stylized cyclamen cover for the first La Libre Esthétique exhibition catalogue and shows a portrait and two seascapes.

1895

Almanach, a collection of poems by Verhaeren illustrated and ornamented by Van Rysselberghe, is issued by the Brussels publisher Dietrich & C^ie^. Meets the French poet Francis Vielé-Griffin (1864-1937) and paints a portrait of his wife. The two families establish a lasting friendship. Creates furniture, jewelry, and stained glass, for Siegfried Bing's L'Art nouveau gallery in Paris.

1896

Shows in Dresden and visits Signac in Saint-Tropez. Begins the large canvas *L'Heure embrasée*, on which he works for more than a year. Begins to abandon divisionist application in favor of a freer brushstroke.

1897

Designs the poster for La Libre Esthétique. Revisits major European cities and stays with Vielé-Griffin in Touraine. His mother dies on December 13 and he considers moving to Paris.

1898

Participates in La Libre Esthétique with a variety of work. Accompanies Signac to London and the Netherlands. Shows in Krefeld, Berlin, and The Hague. Moves to Paris and lives during the summer at Ambleteuse near Boulogne close to the family of Georges Flé, a musical composer.

1899

Shows in the Vienna Secession, in Dresden, and in Paris. His illustrated edition of Villiers de l'Isle-Adam's *Histoires souveraines* is hailed as an art nouveau masterpiece. For the next several years the family vacations in Ambleteuse, where Van Rysselberghe paints the port, beaches, landscapes, and portraits of family members and friends.

1901

Exhibits paintings of Ambleteuse and the Netherlands and etchings at the eighth La Libre Esthétique.

1902

Paints a decorative mural for Victor Horta's art nouveau Hôtel Solvay in avenue Louise, Brussels. Shows in Rome, Paris, Dresden, and Berlin.

1903

Shows portraits at La Libre Esthétique. Visits Henry Van de Velde in Weimar, accompanied by André Gide, a new acquaintance. Shows with other Neo-Impressionists in Weimar, Berlin, and Hamburg.

1904

Only Belgian artist to exhibit with French Impressionists at La Libre Esthétique, where he shows *La Lecture par Emile Verhaeren*. Vacations with the family in Luxemburg; paints in Brittany and at Cavalière on the Riviera.

1905-10

Shows in Paris and Munich in 1905; shows *La Lecture par Emile Verhaeren* in Ghent in 1906, purchased by the city's Musée des Beaux-arts; and at La Libre Esthétique, 1908-10. Replaces pointillism with a more realistic and conventional style, preferring portraits, female nudes, and landscapes. Executes decorative panels for the Nocard family at Neuilly-sur-Seine. Travels widely in Italy and the Netherlands and resides in Luxemburg, Brittany, and Cavalière. In 1910 he moves to Saint-Clair, near Lavandou and Cavalière, to live in a villa designed by his brother Octave.

1910-26

Retires to Saint-Clair for the remainder of his life, where he paints bathers and landscapes, family portraits, and self-portraits.

1920-24

Executes ten panels representing provencial gardens at the Château de Pachy near Mariemont, a château designed by his brother Octave. Receives another commission for decorative murals from the Dorville family in Paris.

1926

December 14
Dies at Saint-Clair.

Théo Van Rysselberghe

Bibliography

I. Archival Materials

1806. VAN RYSSELBERGHE, THEO. *Correspondence*, ca. 1889-1926. ca. 225 items. Holographs, signed. Located at The Getty Research Institute for the History of Art and the Humanities, Special Collections, Los Angeles.

Collection contains 84 letters of Van Rysselberghe to, among others, Madame Van Rysselberghe, the dealer Huinck, Paul Signac, and Berthe Willière; and 141 letters received from colleagues including Henri Cross, Paul Signac, Camille Pissarro, and Henry Van de Velde. The letters, many of which are extensively illustrated, are largely theoretical in nature and explore all facets of art theory and practice associated with the Neo-Impressionist milieu of the late 19th and early 20th centuries.

Organization: Series I. Letters to Madame Van Rysselberghe, ca. 1902-20 (folder 1); Series II. Miscellaneous letters, 1900-26 (folders 2-3); Series III. Letters received from Paul Signac, ca. 1892-1909 (folders 4-8); Series IV. Letters received from Henri Cross, 1908-10, n.d. (Folders 9-11); Series V. Miscellaneous letters received, ca. 1889-1905, n.d. (Folders 12-13)
Series I. Letters to Madame Van Rysselberghe, ca. 1902-20 (32 items). Thirty-two letters, a significant portion dated 1918-20, include detailed discussion of travels, work in progress, especially on portraits, his own emotional state and personal matters. Van Rysselberghe writes of technical matters, including difficulties associated with painting "en plein air" and a decorative project underway for Armand Solvay, and describes in some detail his stay at the Château de Mariemont. Other letters also include discussion of upcoming exhibitions and comments on the writing of André Gide, Jacques-Emile Blanche, and Marcel Proust.
Series II. Miscellaneous letters, 1900-26 (52 items). Twenty letters to Van Rysselberghe's

dealer Huinck concern practical matters associated with upcoming exhibitions in Holland such as the framing and packing of works of art, titles, dimensions and prices of paintings, train schedules, and fluctuating currency (1924-25). Nineteen letters and postcards to Berthe Willière on work, travel, and personal matters (1909-26). In three letters to Paul Signac, Van Rysselberghe defends his criticism of Signac's work, explains his own working method, and responds to the suggestion that his work was adversely influenced by Maurice Denis (1909). One letter to André Gide concerns the "fond d'atelier" of Henri Cross and a possible retrospective exhibition (1918). Other correspondents include Pierre Bounier (1900, 1914), Armand Solvay (1922), and a M. Dunan (1925-26).

Series III. Letters received from Paul Signac, ca. 1892-1909 (74 items). Seventy-four detailed letters, many extensively illustrated with color and ink sketches, focusing primarily on theoretical issues. Signac outlines ideas for work in progress, discusses color theroy and the divisionist technique, and comments on a wide variety of matters, including Old Master painting and the work of Seurat, Maurice Denis, Odilon Redon, Paul Sérusier, Henri Cross, and Eugène Delacroix. In several essay-length letters, Signac attempts to render in a systematic manner the theory of Neo-Impressionism and his own approach to painting and avidly defends the pointillist technique. The letters also include discussion of practical matters relating to exhibitions and the sale of paintings, as well as mention of literary interests and personal news.

Series IV. Letters received from Henri Cross, 1908-10, n.d. (53 items). Eleven letters addressed to Van Rysselberghe contain discussion of work in progress (illustrated) and working method and include mention of Félix Fénéon, Signac, and Henri Matisse. Forty-two letters, mostly personal in nature, are addressed to Madame Van Rysselberghe and contain some mention of literary and musical interests, daily activities, and art-related matters.

Series V. Miscellaneous letters received, ca. 1889-1905, n.d. (14 items). Includes four letters from Camille Pissarro concerning printmaking ventures and including mention of Octave Maus and André Marty (1895); two brief letters from Maximilien Luce (n.d.); one letter from Maurice Denis mentioning two portraits by Van Rysselberghe and commenting on personal travel plans (n.d.); and seven letters from Henry Van de Velde explaining in some detail his difficulties with the Neo-Impressionist style and outlining plans for an exhibition in Berlin designed to interest the German press in Neo-Impressionism (1890-1905).

1807. MARTY, ANDRE. *Letters and Manuscripts Received*, ca. 1886-1911. ca. 230 items. Located at The Getty Research Institute for the History of Art and the Humanities, Special Collections, Los Angeles.

Marty (b. 1857) was a French editor, director of *Le Journal des artistes*, and publisher of prints and books on the arts. Includes letters from more than 50 artists and art critics primarily concerning publication of the print portfolio, *L'Estampe originale*, but also referring to projects for illustrated books, monographs on art, exhibitions and art criticism. Most letters are addressed to André Marty, though a few are to his junior partner, Henri Floury. Included in the collection are two short manuscripts on the decorative arts, by Gustave Geffroy and Octave Uzanne.

Letters relating to *L'Estampe originale* (1893-95) provide detailed technical information about print states, color, choice of paper, and preferences for particular printers and engravers. They also chronicle problems of artistic and journalistic collaboration and offer clues as to the publisher's marketing strategies. Of particular interest are letters from Georges Auriol (5) about his designs for decorative borders; from the sculptor Alexandre Charpentier (16) discussing his innovative "timbre sec," and dickering over prices; from

Maximilien Luce (1) with instructions for printing engravings; from Monet (1) expressing uncertainty about working in lithography; from Roger Marx (23) concerning his preface and the promotion of the portfolios; from Van Rysselberghe (1) promising to enlist other Belgian artists; from Lucien Pissarro (13) about distribution of the publication in England, and his own prints; and from Félix Vallotton (1) regarding control over editions and financial terms. Among the letters containing comments on specific prints and details on technical matters are those from Eugène Carrière (13); Signac (1); Joseph Pennell (6); Camille Pissarro (8); and Félicien Rops project; for example Zandomeneghi, Blanche, Khnopff, and Duez.

Letters treating other subjects include five from Paul Ranson (n.d.) discussing wallpaper and tapestry designs; letters of 1897 from Ernest Chaplet and Auguste Delaherche about a ceramics exhibition sponsored by *Le Figaro*; a long, detailed letter from Gabriel Mourey (1893) discussing his plans for a series of monographs on contemporary French and British artists; seven letters (1894-99) from Lucien Pissarro about projects for illustrated books; 2 letters from Paul Signac (1894, n.d.); and a file of letters (34) from Gustave Geffroy on various journalistic matters, including the publication of his collected criticism and the brochure promoting his project for a "Musée du soir." A sketch by Carrière for the cover of the brochure is also included in the collection. In addition to Geffroy and Marx, critics represented by significant groups of letters are Arsène Alexandre, Henry Nocq, Etienne Moreau-Nélaton, Thadée Natanson, Félix Fénéon, Frantz Jourdain, and Emile Verhaeren. A three-page draft manuscript (n.d.) by Octave Uzanne concerns the subject of art and industry and functionalism in the decorative arts. A one-page manuscript by Geffroy (1899) is an open letter to the Director of Fine Arts advocating independent exhibition by decorative artists for the World's Fair of 1900. Letters are arranged alphabetically by author.

1808. MAUS, OCTAVE. *Letters*, 1892-93. 3 items. Holographs, signed; printed matter. Located at The Getty Research Institute for the History of Art and the Humanities, Special Collections, Los Angeles.

Two letters, 1892 (discussing Van Rysselberghe) and 1893, describing and enclosing the manifesto prospectus for the Belgian exhibition avant-garde society, La Libre Esthétique. Maus (1856-1919) was secretary and a principal force behind both Les XX and La Libre Esthétique.

1809. MOUREY, GABRIEL. *Letters Received*, 1898-1906, n.d. 12 items. Holographs, signed. Located at The Getty Research Institute for the History of Art and the Humanities, Special Collections, Los Angeles.

Letters written to the French art critic Gabriel Mourey (1865-1943): Albert Boertsoen thanks Mourey for sending an article on Fiereus-Jevaert and a book (n.d.). Emile Claus (1849-1924) is confident of the success of a new society, especially because of its president (1899), and praises an article by Mourey (1906). Fernand Khnopff (1858-1921) writes regarding Mourey's impending trip to Belgium (1898), his literary success and art reviews (1900, n.d.), and Khnopff's work shown at the New Gallery in Knightsbridge (1898, n.d.). Three letters from Théo Van Rysselberghe inquire after subscriptions to the Rodin banquet and apartments with studios at St. Cloud (1900). An unidentified correspondent discusses a painting received well at Libre Esthétique, Brussels. Arranged chronologically by correspondent then chronologically. Unidentified writers follow all others.

1810. VAN DE VELDE, HENRY. *Letters Sent*, 1892-1957. 21 items. Holographs, signed.

Located at The Getty Research Institute for the History of Art and the Humanities, Special Collections, Los Angeles.

Thirteen letters and two postcards to Théo Van Rysselberghe or his wife Maria (1892-1953). Topics include: illustrated publications, decorative arts, group exhibitions, collectors, and a lecture on the relationship of medium to artistic result. The remainder of the collection consists of one letter to Van de Velde's wife Maria, four letters to the painter Ludwig von Hofmann (1922-57), and one letter from Maria Van de Velde to the publisher Max Brockhaus. Van de Velde (1863-1957) was a Belgian designer, architect, painter, writer, and leading figure in the creation of Art nouveau in the 1890's.

II. Primary Bibliography

1811. VAN RYSSELBERGHE, THEO. "Les Lettres de Van Rysselberghe à Octave Maus." *Bulletin des Musées Royaux des beaux-arts de Belgique* 15:1-2(1966):55-112.

Edited by Marie-Jeanne Chartrain-Hebbelinck.

1812. VAN RYSSELBERGHE, THEO and PIERRE ANGRAND. "Ce qu'il convient de voir en 1902 au pays belge" (lettre inédite de Théo Van Rysselberghe à Charles Angrand). *Gazette des Beaux-arts* 110:1422-3 (July-Aug. 1987):49-50. 1 illus.

Includes transcripts of a letter written by Van Rysselberghe to Charles Angrand in 1902, advising Angrand which paintings, museums, and architecture to see on his visit to Belgium, plus a shorter letter inviting Angrand to visit him in Paris.

III. Books Illustrated by Van Rysselberghe

1813. *Campagnes hallucinées*. Brussels: Edmond Deman, 1893.

1814. FLE, GEORGES. *Poésies mises en musique*.

1815. VERHAEREN, EMILE. *Almanach: cahiers de vers*. Ornementé par Théo Van Rysselberghe. Brussels: Dietrich & Co., 1895.

1816. VILLIERS DE L'ISLE-ADAM, PHILIPPE-AUGUSTE, COMTE DE. *Histoires souveraines*. Brussels: Edmond Deman, 1899. 367 p.

IV. Books

1817. BLOCK, JANE. *Les XX and Belgian Avant-Gardism, 1868-1894.* Ann Arbor, Michigan: UMI Press, 1984. 2 vols., 436 p., illus.

Bibliography, pp. 192-282.

1818. CANNING, SUSAN MARIE. *A History and Critical Review of the Salons of Les Vingt, 1884-1893*. Ph.D. diss., Pennsylvania State University, 1980. 529 p., illus.

1819. CANNING, SUSAN MARIE. *Le Cercle des XX.* Antwerp, 1989.

1820. COLIN, PAUL. *La Peinture belge depuis 1830.* Brussels: Editions des Cahiers de Belgique, 1930. 509 p., illus.

1821. DE MONT, POL. *Koppen en busten, aanteekeningen over de Kunstbeweging van dezen tijd.* Brussels: H. Lambertin, 1903.

1822. FELTKAMP, R. *Catalogue Raisonné of the Work of Théo Van Rysselberghe.* 1990 or 1991?

1823. FIERENS, PAUL. *Théo Van Rysselberghe; avec une étude de Maurice Denis.* Brussels: Editions de la Connaissance, 1937. 35 p., 49 pl.

Reprints Denis' preface to the 1927 exhibition catalogue, *Théo Van Rysselberghe: exposition d'ensemble.* Note bibliographique, p. 32.

1824. GERARD, F. *150 Brabant, 1836-1986: een selectie uit het kunstpatrimonium van de provincie; Brabant: une séléction du patrimoine artistique de la province.* Brussels: Députation Permanente de la Province de Brabant, 1986. 336 p., 153 col. illus. In Dutch and French.

Celebration of the 150th anniversary of the Belgian province of Brabant, which mentions Théo Van Rysselberghe, among other artists.

1825. GOYENS DE HEUSCH, SERGE. *L'Impressionnisme et le fauvisme en Belgique.* Préface par Philippe Robert-Jones. Anvers: Fonds Mercator; Paris: A. Michel, 1988. 477 p., illus.

Bibliography, pp. 473-4.

1826. HAESAERTS, LUC and PAUL HAESAERTS. *Flandre, essai sur l'art flamand depuis 1880, l'impressionnisme.* Paris: Editions des Chroniques du Jour, 1931. 1 vol., illus.

1827. HOOZEE ROBERT and HELKE LAUWAERT. *Théo Van Rysselberghe: néo-impressionniste.* Catalogue, Robert Hoozee, Helke Lauwaert; essais, Jane Block, Adrienne et Luc Fontainas. Ghent: Pandora, 1993. 205 p., illus.

Catalogue of an exhibition held at the Musée des Beaux-arts, Ghent, 20 March-6 June, 1993. Chronology, pp. 201-3; Bibliography, pp. 203-5.

1828. JANS, ADRIEN. *De Montmartre à Montparnasse.* Brussels; Paris; Amiens: Société Générale d'Editions; Sodi, 1968. 139 p., illus. (Culture et humanisme)

1829. LEMONNIER, CAMILLE. *L'Ecole belge de peinture, 1830-1905.* Brussels: G. van Oest, 1906. 239 p., 101 pl., illus.

1830. *Les XX Brussels: catalogue des dix expositions annuelles.* Brussels: Centre International pour l'Etude du XIXe Siècle, 1981. 310 p., illus.

Includes facsimiles of the annual exhibition catalogues of Les XX, originally issued 1884-93.

1831. MARET, FRANCOIS [pseud. of Franz van Ermengen]. *Les Peintres luministes.* Brussels: Editions du Cercle d'Art, 1944. 45 p., 32 pl. (L'Art en Belgique)

1832. MARET, FRANÇOIS [pseud. of Franz van Ermengen]. *Théo Van Rysselberghe.* Edité par De Sikkel pour le Ministère de l'instruction publique. Antwerp: De Sikkel, 1948. 16 p., 25 pl., 1 col. pl. (Monographies de l'Art belge)

a. Dutch ed.: 1949.

1833. MONT, KAREL MARIA POLYDOR DE. *Zuid-en Noordnederlandse Kunstenaars: I, Van nu: I, Théo Van Rysselberghe.* 1902. 16 p.

1834. PICARD, EDMOND. *El Moghreb Al Aksa; une mission belge au Maroc.* Avec interprétation par Théo Van Rysselberghe et frontispice par Odilon Redon. Brussels: F. Lacomblez; F. Larcier, 1889. 422 p., illus., pl.

Account of an official visit to Morocco by Picard and Van Rysselberghe in 1887 on railroad business.

1835. POGU, GUY. *Théo Van Rysselberghe: sa vie.* Paris: Premiers Eléments, 1963. 29 p.

1836. ROBERTS-JONES, PHILIPPE. *Du réalisme au surréalisme, la peinture en Belgique de Joseph Stevens à Paul Delvaux.* Brussels: Laconti, 1969. 199 p., illus., (Belgique, art du temps)

Broad survey of Belgian art from 1848 to the Second World War, including references to Les XX and Van Rysselberghe.
a. English ed.: *From Realism to Surrealism: Painting in Belgium from Joseph Stevens to Paul Delvaux.* Trans. by C. H. Mogford. Brussels: Laconti, 1972. 199 p., 88 illus. (Belgium, Art of our Time)

1837. SAINT-CLAIR, MARIE. [pseud. of Marie Van Rysselberghe]. *Galerie privée.* Paris: Gallimard, 1947. 189 p.

a. Reprint: *Il y a quarante ans.* Préface de Béatrix Beck. Paris: Gallimard, 1968. 205 p.

1838. VAN DE VELDE, HENRY. *Van de Velde. Récit de ma vie. Anvers-Bruxelles-Paris-Berlin. I. 1863-1900.* Texte établi et commenté par Ann van Loo, avec la collaboration de Fabrice van de Kerckhove. Brussels: Versa; Paris: Flammarion, 1992-. Vol. 1-.

1839. VAN SPEYBROECK, MARIA THERESIA. *Franse invloeden op het Belgisch impressionisme en neo-impressionnisme.* Ph.D. diss., Université de Gand, 1976. 2 vols.

1840. VERHAEREN, EMILE. *A Marthe Verhaeren, deux cent dix-neuf lettres inédites, 1889-1916.* Paris: Mercure de France, 1951. 458 p.

V. Articles

1841. ADAMS, BROOKS. "Mussels and Windmills: Impressionism in Belgium and Holland" in *World Impressionism: The International Movement, 1860-1920*, ed. by Norma Broude (NY: Harry N. Abrams, 1994): 248-73, 413. 33 illus., 17 col.
Surveys the development of Impressionism in the Netherlands, introduced into Belgium by the group Les XX, which included James Ensor, Félicien Rops, Emile Claus, Guillaume Vogels, Théo Van Rysselberghe, Henri Evenpoël, and Anna Boch, among other artists.

1842. BERNARD, CHARLES. "Théo Van Rysselberghe." *La Nation belge* (12 March 1922).

1843. BLOCK, JANE. "What's in a Name? The Origins of 'Les XX'." *Bulletin des Musées Royaux des Beaux-arts de Belgique* new ser. 30-3:1-3(1981-84):135-42.

1844. BLOCK, JANE. "A Study in Belgian Neo-Impressionist Portraiture." *Art Institute of Chicago Museum Studies* 13:1(1987):36-51. 16 illus.

1845. BLOCK, JANE. "Théophile Van Rysselberghe" in *The Dictionary of Art* (NY: Grove, 1996)31:888-9.

1846. BRINTON, CHRISTIAN. "Théo Van Rysselberghe." *Scribner's Magazine* 59:6(June 1916):773-6. 3 illus.

1847. CHARTRAIN-HEBBELINCK, MARIE-JEANNE. "Théo Van Rysselberghe: le groupe des XX et La Libre Esthétique." *La Revue belge d'archéologie et d'histoire de l'art* 34:1-2(1965):113-34.

1848. COLLEYE, HUBERT. "Théo Van Rysselberghe." *La Métropole* (29 Aug. 1937).

1849. DE BUSSCHER, ISABELLE. "Théo Van Rysselberghe, période divisionniste, 1888/89-1909." *Revue des archéologues et historiens d'art de Louvain* 6(1973):240-2.

1850. DE GUILLEBON, CLAUDIE. "Une œuvre dévoilée. *La Lecture* de Théo Van Rysselberghe" in *Musée des Beaux-arts de Gand* (Paris: Musées 2000, 1988):56-61.

1851. DE MONT, POL. "Théo Van Rysselberghe." *L'Art et la vie* 1:1(1902):1-15.

1852. EECKHOUT, PAUL. "Théo Van Rysselberghe, *La Lecture*." *Openbaar Kunstbezit in Vlaanderen* 5(1967):1-16.

1853. FONTAINAS, ANDRE. "Théo Van Rysselberghe." *L'Art et les artistes* (Nov. 1919).

1854. FONTAINAS, LUC and ADRIENNE FONTAINAS. "Biographie et bibliographie d'Edmond Deman." *Bulletin du Bibliophile* 3(1986):309-79; 4(1986):485-582.

1855. HARDY, ADOLPHE. "L'Exposition Théo Van Rysselberghe." *Journal de Bruxelles* 9(March 1922).

1856. HELLENS, FRANZ. "A La Libre esthétique, les panneaux décoratifs de Théo Van

Rysselberghe." *L'Art moderne* 31:13(1911):97-8.

1857. HENRION-GIELE, SUZANNE. "Etude sur Théo Van Rysselberghe, années de formation, 1877-1888." *Revue des archéologues et historiens d'art de Louvain* 6(1973):216-21.

1858. HENRY, J. "L'Exposition Van Rysselberghe, Charlet et Dario de Regoyos." *La Revue pour tous* (8 April 1883).

1859. LEMONNIER, CAMILLE. "Théo Van Rysselberghe." *Voir et lire* (1926):172.

1860. LYBAERT, KAREL. "Vierjaarlijksche tentoonstelling van Schoone Kunsten te Gent" in *De Vlaamsche Kunstbode* (Anvers, 1906).

1861. MABILLE DE PONCHEVILLE, ANDRE. "Théo Van Rysselberghe." *Gand artistique* 5:1(1926):5-16, supp.

1862. MAUCLAIR, CAMILLE. "Théo Van Rysselberghe." *L'Art décoratif* (March 1903):81-9.

1863. MAUS, OCTAVE. "Théo Van Rysselberghe." *Journal de Genève* (13 May 1916).

1864. MURALLAH, BERK. "Une toile inconnue de Théo Van Rysselberghe dans un palais du Bosphore." *Les Beaux-arts* (8 March 1969).

1865. ROBERTS-JONES, PHILIPPE. "Khnopff en Perspective" in *Fernand Khnopff, 1858-1921* (Hamburg: Hamburger Kunsthalle, 1980):13-6. 4 illus. In German.

Assesses Khnopff's career and work, including his involvement as a founding member of Les XX in the 1880s, along with James Ensor, Théo Van Rysselberghe, and Guillaume Vogels, which was responsible for a late 19th century renaissance in Belgian art.

1866. RODENBACH, GEORGES. "L'Art à Gand-exposition Théo Van Rysselberghe." *L'Art moderne* 3:12(1883):95-7.

1867. SCHEERLINCK, KARL. "De eeuwwisseling (ca. 1885-1918)." *Openbaar Kunstbezit in Vlaanderen* 33:3(July-Sept. 1995):88-99. 16 illus., 8 col.

Discusses Belgian poster art in the late 19th and early 20th centuries and the transition from posters as an advertising medium to an art form, including posters by Van Rysselberghe and Georges Lemmen.

1868. SIEBELHOFF, ROBERT. "Toorop, Van de Velde, Van Rysselberghe and the Hague Exhibition of 1892." *Oud Holland* 95:2(1981):97-107. 6 illus.

1869. SIGNAC, PAUL. "Fragments du journal." *Arts de France* 11-2(1947):17-8.

Edited by George Besson.

1870. "Théo Van Rysselberghe." *Les Beaux-arts* (29 June 1962).

Special issue devoted to Van Rysselberghe. Includes contributions by Paul Eeckhout, Marie-Jeanne Chartrain-Hebbelinck, Jean Warmoes, Jean Griffin, and Léon-Louis Sosset.

1871. "Théo Van Rysselberghe — Frantz Charlet — Dario de Regoyos." *L'Art moderne* 3:14(1883):112.

1872. VAN DE WOESTIJNE, KAREL. "Théo Van Rysselberghe." *Elseviers Geïllustreerd Maandschrift* (Nov. 1910). Reprinted in *Kunst en geest in Vlaanderen* (Bussum: Van Dishoeck, 1930).

1873. VAN DE WOESTIJNE, KAREL. "Théo Van Rysselberghe." *Nieuwe Rotterdamsche Courant* (25, 27, 30 March 1922).

1874. VAN DE WOESTIJNE, KAREL. "Kunst te Brussel, Théo Van Rysselberghe." *Nieuwe Rotterdamsche Courant* (21 April 1926).

1875. VAN DE WOESTIJNE, KAREL. "Théo Van Rysselberghe." *Nieuwe Rotterdamsche Courant* (15 Dec. 1926).

1876. VAN DEN KERKHOVE-ROBBRECHT, R. "Theodoor Van Rysselberghe en zijn eerste reis naar Spanje en Marokko (Oktober 1882-Maart 1883)" in *Miscellanea Jozef Duverger* (Ghent: Vereniging voor de Geschiedenis der Textielkunsten, 1968)1:396-401.

1877. VAN ZYPE, GUSTAVE. "Notice sur Théo Van Rysselberghe, membre de l'Académie." *Annuaire de l'Académie Royale des sciences, des lettres et des beaux-arts de Belgique* 98(1932):96-134.

1878. VAN ZYPE, GUSTAVE. "Théo Van Rysselberghe." *L'Indépendance belge* (10 March 1922).

1879. VAUXCELLES, LOUIS. "Théo Van Rysselberghe au Luxembourg." *Le Petit messager* (June 1916).

1880. VERHAEREN, EMILE. "Théo Van Rysselberghe." *L'Art moderne* 18:2(13 March 1898):86-7.

1881. VERHAEREN, EMILE. "Théo Van Rysselberghe." *Ver Sacrum* 2:2(1899):1-31.

1882. VERONESI, GIULIA. "Neo-impressionisti: Paul Signac et Théo Van Rysselberghe." *Emporium* (March 1964).

VI. Exhibitions (Individual and Group)

1881	Brussels, Salon de Bruxelles. 2 portraits and 1 landscape.
1882, February	Ghent, *Cercle artistique*.
1883	Brussels, Palais des Beaux-arts de Bruxelles.
1885	Brussels, *Les XX*. 5 paintings, 1 portrait.

1886	Brussels, *Les XX.* 10 portraits and 1 cityscape.
1887	Brussels, *Les XX.* Portraits and cityscapes.
1890	Brussels, *Les XX.* 8 paintings, including 3 inspired by Brittany.
1890	Paris, Salon des Indépendants.
1891	Paris, Salon des Indépendants.
1891	Brussels, *Les XX.*
1892	Brussels, *Les XX.*
1892	The Hague, *Cercle artistique.*
1893	Paris, Salon des Indépendants.
1893	Brussels, *Les XX.*
1894	Brussels, La Libre Esthétique. 1 portrait and 2 seascapes.
1895	Paris, Salon des Indépendants.
1895	Paris, Galerie Laffitte. *Exposition Théo Van Rysselberghe.* First retrospective. Included 10 Neo-Impressionist portraits.
1896	Dresden.
1898	Brussels, La Libre Esthétique. 11 paintings, 10 studies of nudes, pastels, watercolors, and prints.
1898	Krefeld. *Flämische Künstler.*
1898	Berlin, Keller & Reiner. Retrospective of major works organized by Henry Van de Velde.
1898	The Hague.
1899	Vienna. *Secession.*
1899	Paris, Salon des Indépendants.
1899	Dresden.
1900, 17 May	Paris, Hôtel Drouot. *Collection Bing. Catalogue des tableaux modernes; œuvres de Besnard, Cottet, Thaulow, Brangwyn, Maurice Denis, Ibels...Rops, Toulouse-Lautrec, Van Rysselberghe.*
1901	Brussels, La Libre Esthétique. Paintings and engravings.
1901	The Hague.
1901	Paris.

1901	Darmstadt.
1901	Bilbao.
1902	Rome.
1902	Paris.
1902	Dresden.
1902	Berlin, Galerie Cassirer.
1903	Brussels, La Libre Esthétique.
1903	Weimar. *Neo-Impressionismus*. Also shown in Berlin and Hamburg.
1904	Brussels, La Libre Esthétique.
1905	Paris.
1905	Munich.
1906	Ghent. Salon de Gand.
1908	Brussels, La Libre Esthétique.
1909	Brussels, La Libre Esthétique.
1910	Brussels, La Libre Esthétique.
1927, 25 November-6 December	Brussels, Galerie Giroux. *Théo Van Rysselberghe: exposition d'ensemble*. Préface de Maurice Denis.
1962, 1 July-16 December	Ghent, Museum voor Schone Kunsten. *Rétrospective Théo Van Rysselberghe*. Catalogue par Paul Eeckhout. Introduction par Georges Chabot. 78 p., 70 pl.
1962	Luxembourg, Musée d'Histoire et d'art. *Théo Van Rysselberghe 1862-1926*. 16 pl.
1962	Brussels, Musées Royaux des Beaux-arts. *Le Groupe des XX et son temps*. Catalogue par F.-C. Legrand.
1975, 19 April-29 June	Ghent, Musée des Beaux-arts. *Gent, 1000 jaar Kunst en Cultuur, muurschilderkunst, schilderkunst, tekenkunst, graveerkunst, beeldhouwkunst*.
1980, 23 April-29 June	NY, Brooklyn Museum. *Belgian Art, 1880-1900*. 256 p., illus. Text in English, French, Dutch.
	Includes Jane Block's essay, "Les XX: Forum of the Avant-garde," pp. 17-40.
1980, 4 October-14 December	Ghent, Musée des Beaux-arts. *Het landschap in de Belgische Kunst 1830-1914.* Introduction by Robert Hoozee.

1980-81, 19 December-15 February	Brussels, Palais des Beaux-arts. *Art nouveau en Belgique.*
1984, 8 September-26 December	Kanazawa, Salle MRO. *Exposition le Néo-impressionnisme.* Also shown in other venues in Japan. Introduction by Yasuo Kamon and M. Spehl-Robeyns.
1987, 7 May-28 June	Brussels, Musées Royaux des Beaux-arts de Belgique. *Académie Royale des Beaux-arts de Bruxelles. 275 ans d'enseignement.*
1989, 31 March-21 May	Munich, Kunsthalle der Hypo-Kulturstiftung. *James Ensor: Belgium um 1900.* Catalogue by Lydia Schoonbaert, A. M. Hammacher, Werner Schmalenbach, and Herwig Todts. Published in association with Hirmer Verlag, Munich, 1989. 272 p., illus., 109 col. illus. Exhibition of paintings, drawings, and watercolors by James Ensor, presented alongside works by 19 contemporaries including Théo Van Rysselberghe, and constituting a survey of turn-of-the-century Belgian art.
1989	Salzburg, Galerie Salis. *Théo Van Rysselberghe, 1862-1926; Oil Paintings, Pastels, Drawings.*
1990, 17 March-17 June	Pontoise, Musées de Pontoise, Tavet et Pissarro. *Néo et post-impressionnistes belges dans les collections privées de Belgique.* Also shown Charleroi, Musée des Beaux-arts (18 May-17 June 1990). Introduction par Maxime Longree.
1990, 15 September-25 November	's-Hertogenbosch, Noordbrabants Museum. *Een feest van kleur, post-impressionisten uit particulier bezit.* Catalogue by John Sillevis, Hans Verbeck, and Hans Kraan.
1990, 12 October-10 December	Brussels, Musée Communal d'Ixelles. *L'Impressionnisme et le fauvisme en Belgique.* Catalogue par Serge Goyens-de Heusch.
1991, 15 March-2 June	Brussels, Galerie CGER. *Fin de siècle; dessins, pastels et estampes en Belgique de 1885 à 1905.* Introduction par Marc Lambrechts.
1992, 12 April-6 June	New Brunswick, NJ, Jane Voorhees Zimmerli Art Museum. *Homage to Brussels, the Art of Belgian Posters, 1895-1915.*
1992-93, 31 October-5 September	Ghent, Musée des Beaux-arts. *Les Vingt en de avant-garde en België, preten, tekeningen en boeken.* Also shown Lawrence, KS, Spencer Museum of Art (24 Jan.-21 March 1993); Williamstown, MA, Sterling and Francine Clark Art Institute (12 April-13 June 1993);

Cleveland, Cleveland Museum of Art (13 July-5 Sept. 1993). Catalogue texts by Jane Block, Susan M. Canning, Donald Friedman, Sura Levine, Alexander Murphy, and Carl Strikwerda. Edited by Stephen H. Goddard.

a. U.S. ed.: *Les XX and the Belgian Avant-garde: Prints, Drawings, and Books, ca. 1890.* Lawrence: Spencer Museum of Art, University of Kansas, 1992. 400 p., 234 illus., 19 col.

1993, 20 March-6 June

Ghent, Musée des Beaux-arts. *Théo Van Rysselberghe: néo-impressionniste.* Catalogue, Robert Hoozee, Helke Lauwaert; essais, Jane Block, Adrienne et Luc Fontainas. Ghent: Pandora, 1993. 205 p., illus.

Chronology, pp. 201-3; Bibliography, pp. 203-5.

1994, 7 July-2 October

London, Royal Academy of Art. *Impressionism to Symbolism: The Belgian Avant-garde, 1880-1900.* Edited by MaryAnne Stevens with Robert Hoozee; with contributions by Jane Block [et al.]. 296 p., illus.

Includes an essay by Jane Block, "Les XX and La Libre Esthétique: Belgium's Laboratories for New Ideas." Bibliography, pp. 286-7.

Henri Edmond Cross

Biography

Although Cross became acquainted with the Neo-Impressionists in the mid-1880s, his conversion to the movement and style was not fully realized until 1891, the year of Seurat's death. Cross was therefore a seminal figure in Neo-Impressionism's second phase, roughly 1896 to 1906. His artistic training occurred in Lille under the tutelage of Alphonse Colas (1818-87), followed by a move to Paris in 1881 and instruction in the studio of Emile Dupont-Zipcy (1822-65). Sombre-toned realist portraits and still-lifes dominated his early work.

In 1884, Cross helped to found La Société des Artistes Indépendants, where he met many Neo-Impressionists. Signac was a major influence in the 1890s, particularly after Cross moved to Cabasson and later Saint-Clair on the Mediterranean, where he lived until his death in 1910. Besides Signac, Cross was close to Angrand, Luce, Van Rysselberghe, and Félix Fénéon. He exhibited at La Libre Esthétique in Brussels and was drawn to Art nouveau designs. Seascapes and village scenes were preferred subjects. With his neighbor and friend Signac, Cross influenced Matisse, Derain, Puy, Valtat, Manguin, Camoin, Marquet, and other Fauve artists who visited them in the Midi in the 1890s and early 1900s. After the mid-1890s, Cross abandoned tiny pointillist dots for larger, mosaic-like brushstrokes that prefigured both Fauvism and Cubism. The nude bathers and mythological figures such as nymphs and fauns that Cross introduced into his late seascapes became common motifs in Fauve paintings.

Cross shared the utopian and anarchist philosophies of other Neo-Impressionists and created lithographs and cover illustrations for several socialist magazines. Eye problems beginning in the 1880s and later bouts of arthritis kept his artistic output small, although successful single-artist shows were held at Galerie Druet in 1905 and at Bernheim-Jeune in 1907, 1910, and 1913. Health problems limited his travels to annual trips to Paris and two visits to Italy in 1903 and 1906.

Henri Edmond Cross

Chronology, 1856–1910

Information for this chronology was gathered from Isabelle Compin, *H. E. Cross* (Paris: Quatre Chemins-Editart, 1964); *Signac et la libération de la couleur: de Matisse à Mondrian* (Paris: Réunion des Musées Nationaux, 1997):130-1; and Martha Ward, "Henri Edmond Cross" in *The Dictionary of Art* (NY: Grove, 1996)8:204-5.

1856

Birth of Henri Delacroix in Douai, the only surviving child of Alcide Delacroix, a French adventurer and failed businessman, and British-born Fanny Woollett.

1878

Student at Les Ecoles Académiques de dessin et d'architecture, Lille, in the studio of the painter Alphonse Colas (1818-87).

1881

Moves to Paris to continue art studies in the studio of Emile Dupont-Zipcy (1822-65). Adopts an abbreviated English version of his name, Henri Cross, to avoid confusion with his namesake, the painter Eugène Delacroix.

1883

Paints on the French Mediterranean coast and meets Signac.

1884

Founding member of La Société des Artistes Indépendants, where he regularly exhibits from 1891 to his death. Associates with the Neo-Impressionists, including Seurat, Angrand, and Dubois-Pillet.

1886

Invited by Octave Maus to participate in the fourth Salon des XX in Brussels, which is

dominated by Neo-Impressionism. Signs his works Henri Edmond Cross to avoid confusion with the painter Henri Cross.

1891

Moves to the Mediterranean, first settling in Cabasson and later in Saint-Clair. Paints his first purely Neo-Impressionist canvas, *Portrait de Mme Cross*.

1892

Visits regularly and exchanges paintings with Signac. Modifies his pointillist technique.

1893

Paints *L'Air du soir*, which Matisse sees in Signac's dining room and influences his *Luxe, calme et volupté*.

1895

Invited by Maus to participate with Pissarro and Signac in the Libre Esthétique exhibition in Brussels. Cross also sends paintings to the 1897, 1901, 1904, 1908, and 1909 shows. Exhibits in Samuel Bing's *L'Art nouveau à Paris* show (Dec. 1895 - Jan. 1896).

1896

Translates John Ruskin's *The Elements of Drawing* for Signac. Contributes an anonymous lithograph, *The Wanderer*, to Jean Grave's anarchist review, *Les Temps nouveaux*.

1898

Participates with Signac, Luce, and Van Rysselberghe in Germany's inaugural Neo-Impressionist show at the Keller und Reiner Gallery, Berlin, arranged by Harry Kessler. The German art magazine *Pan* publishes a supplement illustrated with chromolithographs by Cross, Luce, Signac, and Van Rysselberghe.

1899

Shows six canvasses at the Neo-Impressionist exhibit held at Galerie Durand-Ruel, Paris.

1902

Shows with French and German Neo-Impressionists in Hamburg and Berlin at the Cassirer Gallery. Count Harry Kessler commissions a painting.

1903

Stays most of the year in Paris. Participates in Neo-Impressionist exhibits in Dresden, Weimar, and Munich. Kessler and Eberhard von Bodenhausen purchase paintings. Visits Venice.

1904

Matisse, who lives with Signac in Saint-Tropez, visits frequently. Shows in Weimar and Dresden.

1905

First single-artist exhibition at Galerie Druet, Paris (30 paintings, 30 watercolors). Catalogue preface written by the Belge poet Emile Verhaeren. Shows again with other Neo-Impressionists in Weimar.

1906

Shows four paintings and four watercolors in the traveling German show, *Artistes français.*

1907

Retrospective exhibition organized by Félix Fénéon at Galerie Bernheim-Jeune, Paris includes 38 oils and 51 watercolors. Catalogue preface by Maurice Denis.

1908

Sends two paintings to the Toison d'or exhibition, Moscow. Also shows at Galerie Druet, Paris.

1909

Participates with 27 watercolors in Bernheim-Jeune's *Aquarelle et pastel* show.

1910

16 May
Dies of cancer at age 54.

Henri Edmond Cross

Bibliography

I. Archival Materials

1883. CROSS, HENRI EDMOND. *Letters Sent by H. E. Cross, with Sheet of Notes*, 1893-1906. 4 items. Holographs, signed. Located at The Getty Center for the History of Art and the Humanities, Special Collections, Los Angeles.

Letters are to a M. LeComte and to Georges Jean-Aubry (1882-1950), concerning current salon exhibitions and personal matters. One sheet of notes contains a passage on color quoted from a dictionary, notes on artists and supplies, and a small pencil sketch.

1884. VAN RYSSELBERGHE, THEO. *Correspondence*, ca. 1889-1926. ca. 225 items. Holographs, signed. Located at The Getty Research Institute for the History of Art and the Humanities, Special Collections, Los Angeles.

Collection contains 84 letters of Van Rysselberghe to, among others, Madame Van Rysselberghe, the dealer Huinck, Paul Signac, and Berthe Willière; and 141 letters received from colleagues including Henri Cross, Paul Signac, Camille Pissarro, and Henry Van de Velde. The letters, many of which are extensively illustrated, are largely theoretical in nature and explore all facets of art theory and practice associated with the Neo-Impressionist milieu of the late 19th and early 20th centuries.

Organization: Series I. Letters to Madame Van Rysselberghe, ca. 1902-20 (folder 1); Series II. Miscellaneous letters, 1900-26 (folders 2-3); Series III. Letters received from Paul Signac, ca. 1892-1909 (folders 4-8); Series IV. Letters received from Henri Cross, 1908-10, n.d. (Folders 9-11); Series V. Miscellaneous letters received, ca. 1889-1905, n.d. (Folders 12-13)

Series I. Letters to Madame Van Rysselberghe, ca. 1902-20 (32 items). Thirty-two letters, a significant portion dated 1918-20, include detailed discussion of travels, work in progress, especially on portraits, his own emotional state and personal matters. Van Rysselberghe writes of technical matters, including difficulties associated with painting "en plein air" and a decorative project underway for Armand Solvay, and describes in some detail his stay at the Château de Mariemont. Other letters also include discussion of upcoming exhibitions and comments on the writing of André Gide, Jacques-Emile Blanche, and Marcel Proust.

Series II. Miscellaneous letters, 1900-26 (52 items). Twenty letters to Van Rysselberghe's dealer Huinck concern practical matters associated with upcoming exhibitions in Holland such as the framing and packing of works of art, titles, dimensions and prices of paintings, train schedules, and fluctuating currency (1924-25). Nineteen letters and postcards to Berthe Willière on work, travel, and personal matters (1909-26). In three letters to Paul Signac, Van Rysselberghe defends his criticism of Signac's work, explains his own working method, and responds to the suggestion that his work was adversely influenced by Maurice Denis (1909). One letter to André Gide concerns the "fond d'atelier" of Henri Cross and a possible retrospective exhibition (1918). Other correspondents include Pierre Bounier (1900, 1914), Armand Solvay (1922), and a M. Dunan (1925-26).

Series III. Letters received from Paul Signac, ca. 1892-1909 (74 items). Seventy-four detailed letters, many extensively illustrated with color and ink sketches, focusing primarily on theoretical issues. Signac outlines ideas for work in progress, discusses color theory and the divisionist technique, and comments on a wide variety of matters, including Old Master painting and the work of Seurat, Maurice Denis, Odilon Redon, Paul Sérusier, Henri Cross, and Eugène Delacroix. In several essay-length letters, Signac attempts to render in a systematic manner the theory of Neo-Impressionism and his own approach to painting and avidly defends the pointillist technique. The letters also include discussion of practical matters relating to exhibitions and the sale of paintings, as well as mention of literary interests and personal news.

Series IV. Letters received from Henri Cross, 1908-10, n.d. (53 items). Eleven letters addressed to Van Rysselberghe contain discussion of work in progress (illustrated) and working method and include mention of Félix Fénéon, Signac, and Henri Matisse. Forty-two letters, mostly personal in nature, are addressed to Madame Van Rysselberghe and contain some mention of literary and musical interests, daily activities, and art-related matters.

Series V. Miscellaneous letters received, ca. 1889-1905, n.d. (14 items). Includes four letters from Camille Pissarro concerning printmaking ventures and including mention of Octave Maus and André Marty (1895); two brief letters from Maximilien Luce (n.d.); one letter from Maurice Denis mentioning two portraits by Van Rysselberghe and commenting on personal travel plans (n.d.); and seven letters from Henry Van de Velde explaining in some detail his difficulties with the Neo-Impressionist style and outlining plans for an exhibition in Berlin designed to interest the German press in Neo-Impressionism (1890-1905).

II. Books

1885. COMPIN, ISABELLE. *H. E. Cross*. Préface de Bernard Durival. Paris: Quatre Chemins-Editart, 1964. 367 p., illus.

Important biography and critical analysis. Includes a *catalogue raisonné,* extensive lists of

exhibitions (pp. 347-54), and a bibliography (pp. 355-62).
Review: P. Vépierre, *L'Oeil* 120(Dec. 1964):82.

1886. COUSTURIER, LUCIE. *Henri Edmond Cross*. Paris: G. Crès, 1932. 13 p., illus., 32 pl. (Les Artistes nouveaux)

First monograph on Cross. Revised version of text from Cousturier's article "H. E. Cross," *L'Art décoratif* 29(March 1913):117-32.

1887. REWALD, JOHN. *Henri Edmond Cross: carnet de dessins*. Présentation de John Rewald. Paris: Berggruen & Cie, 1959. 2 vols. (22, 60 p.), illus., some col.

Includes sketchbook facsimiles.

III. Articles

1888. ANGRAND, CHARLES. "Henri Edmond Cross." *Les Temps nouveaux* 16(23 July 1910):7.

Tribute written shortly after Cross's death.

1889. APOLLINAIRE, GUILLAUME. "La Vie artistique: H. E. Cross." *L'Intransigeant* (31 Oct. 1910). Reprinted in his *Chroniques d'art* (Paris: Gallimard, 1960):128.

Concerns Cross's single-artist exhibition at Galerie Bernheim-Jeune, Paris (17 Oct.-5 Nov. 1910).

1890. "L'Atelier de Cross." *Bulletin de la vie artistique* 2(15 Oct. 1921):537. 1 illus.

1891. B., J. "Henri Edmond Cross." *Arts* (7 July 1950):4.

1892. BATES, HERBERT ERNEST. "French Painters IV: Signac and Cross." *Apollo* 55(May 1952):135-9. 8 illus.

1893. BEAUNIER, ANDRE. "Les Morts d'hier: H. E. Cross." *Le Figaro* (29 May 1910):3.

Obituary and tribute to Cross.

1894. BESSON, GEORGE. "Le Scandale Cross." *Les Lettres françaises* (14 June 1956).

1895. CACHIN, FRANÇOISE. "Colored Fleas in Modern Ears: Neo-Impressionists at the Guggenheim Museum." *ARTnews* 66(Feb. 1968):34-5, 56-7. 6 illus.

Review of the exhibition *Neo-Impressionism* held at the Guggenheim Museum, NY (Feb.-April 1968), illustrated with Cross's *Cascading Hair* (ca. 1892).

1896. CACHIN, FRANÇOISE. "Les Néo-Impressionnistes et le Japonisme, 1885-1893"

in *Japonisme in Art: An International Symposium* (Dec. 1979):225-37. 15 illus.

Describes the influence of Japanese prints on Cross, Seurat, and Signac, illustrated with Cross's *Les Iles d'or* and *La Chevelure*.

1897. CACHIN-SIGNAC, GINETTE. "Autour de la correspondance de Signac." *Arts* (7 Sept. 1951).

Includes a letter by Cross to Luce written during the summer of 1895.

1898. COUSTURIER, LUCIE. "H. E. Cross." *L'Art décoratif* 29 (March 1913):117-32. 15 illus., 1 col. Revised version in Cousturier's *H. E. Cross* (Paris: Crès, 1932).

1899. DESCARGUES, PIERRE. "Racontez Docteur Roudinesco." *Connaissance des arts* 204(Feb. 1969):68-73. 12 illus.

Illustrated with Cross's *Les Haleurs de filet* (1892).

1900. DORIVAL, BERNARD. "Un an d'activité au Musée d'Art moderne. II, les achats des Musées nationaux." *Musées de France* (Dec. 1948):294.

1901. DORIVAL, BERNARD. "*Portrait de Mme Henry Edmond Cross*, acquis par le Musée d'Art moderne." *Revue des arts* 6(March 1956):50-2.

1902. FENEON, FELIX. "Les Carnets de H. E. Cross." *Bulletin de la vie artistique* 3(15 May 1922):229-31; 3:11(1 June 1922):254; 3(1 July 1922):302; 4(1 Sept. 1922):392; 5(15 Sept. 1922):425; 6(1 Oct. 1922):447; 7(15 Oct. 1922):469. 10 illus.

1903. FONTAINAS, ANDRE. "Les Poèmes. Henri de Régnier: Vestigia Flammae." *Mercure de France* 152(1 Dec. 1921):436-456.

1904. FRECHES-THORY, CLAIRE. "La Donation Ginette Signac." *Revue du Louvre et des musées de France* 28:2(1978):107-12. 8 illus.

Highlights Ginette Signac's gifts of art works to the Louvre, including *L'Air du soir*, *Femme lisant sous la lampe*, and *Le Naufrage* by Cross.

1905. GHEZ, OSCAR. "Impressionism and After: The Petit Palais, Geneva." *Connoisseur* 192:773(July 1976):216-23. 11 illus.

Describes the collection of Impressionist and Post-Impressionist works by Cross and the Pointillists in the Petit Palais, Geneva.

1906. GRAUTOFF, OTTO. "H. E. Cross" *Cicerone* (1910):416.

1907. GUILLOUET, JACQUES. "Un artiste douaisien méconnu: H. E. Cross." *Les Amis de Douai* (March-April 1956).

Revision of Guillouet's preface to the exhibition catalogue, *Exposition Henri Edmond Cross* (Douai, Bibliothèque municipale, 10 June-22 July 1956).

1908. HERBERT, ROBERT L. and EUGENIA W. HERBERT. "Artists and Anarchism, Unpublished Letters of Pissarro, Signac and Others." *Burlington Magazine* 102:692 (Nov. 1960): 473-82; 102: 693(Dec. 1960):517-22.

Includes letters from Cross to Jean Grave, publisher of *Les Temps nouveaux*. a. French trans.: *Le Mouvement social* 36 (July-Sept. 1961):2-9.

1909. HOOG, MICHEL. "La Direction des beaux-arts et les Fauves 1903-1905." *Art de France* 3(1963):363-6.

1910. KUNKEL, PAUL. "For Collectors: The Rediscovered Neo-Impressionists." *Architectural Digest* 40:4(April 1983):68-76.

Illustrated with Cross's *Arbres* (1909).

1911. LEROUX, JULES. "Un artiste douaisien méconnu: Henri Edmond Cross." *La Vie douaisienne* (29 April 1911); 140-3(20 May, 27 May, 3 June, 10 June 1911):137; 149(22 July 1911):1.

1912. MONOD, FRANÇOIS. "M. H. E. Cross, peintre de la lumière." *Art et décoration* supp. (June 1907):2.

1913. MORICE, CHARLES. "Mort d'Henri Edmond Cross." *Mercure de France* (1 June 1910):545.

1914. NAU, JOHN-ANTOINE. "Henri Edmond Cross." *La Phalange* (20 July 1910):11-2. Reprinted in Nau's *En suivant les Goélands* (Paris: Crès, 1914) and in Nau's *Poèmes triviaux et mystiques* (Paris: Messein, 1924):33.

Poem entitled "Quaforzain. Tableau de l'ami H. E. Cross" in tribute of Cross, published shortly after his death.

1915. "Nécrologie." *Chronique des arts et de la curiosité* (21 May 1910):166.

Obituary of Cross.

1916. "La Palette: courrier des ateliers." *Paris-journal* (18 May 1910):5.

Obituary notice.

1917. "Portrait by T. Van Rysselberghe." *Gazette des Beaux-arts* ser. 6, 11(Jan. 1934):55.

Discusses Van Rysselberghe's portrait of Cross.

1918. REGNIER, HENRI DE. "Médaillon." *Mercure de France* (1 Dec. 1921).

1919. REVEL, JEAN-FRANÇOIS. "Charles Henry et la science des arts." *L'Oeil* 119(Nov. 1964):22.

1920. REWALD, JOHN. "Cross" in *Dictionnaire de la peinture moderne* (Paris: Hazan, 1954).

Revision of Rewald's introduction to the Cross exhibition held at Fine Arts Associates, NY (16 April-5 May 1951).

1921. ROYERE, JEAN. "Le Poète J. A. Nau." *La Phalange* (15 Sept. 1907):215.
1922. VAN RYSSELBERGHE, MARIA [pseud. M. Saint-Clair]. "Portrait du peintre H. E. Cross." *Nouvelle revue française* 53(1 July 1939):123-7. Reprinted in her *Galerie privée* (Paris: Gallimard, 1947):25-38.

1923. VERHAEREN, EMILE. "Henri Cross." *Paris-journal* (28 May 1910):1.

Article published shortly after Cross's death.

1924. VERHAEREN, EMILE. "Henri Edmond Cross." *Nouvelle revue française* (July 1910):44-50. Also appeared in Verhaeren's *Sensations* (Paris: Crès, 1927):204-8.

IV. Individual Exhibitions

For an extensive list of individual and group exhibitions of Cross, see Isabelle Compin, *H. E. Cross* (Paris: Quatre Chemins-Editart, 1964):355-62.

1905, 21 March-8 April	Paris, Galerie Druet. *Henri Edmond Cross*. Catalogue préface par Emile Verhaeren. 30 paintings, 30 watercolors.
	Reviews: L. Vauxcelles, *Gil Blas* (26 March 1905); R. Marx, *Chronique des arts et de la curiosité* (8 April 1905):107; C. Morice, *Mercure de France* (April 1905):611; A. Mockel, *L'Express* (Liège) (21 April 1905).
1907, 22 April-8 May	Paris, Galerie Bernheim-Jeune. *Henri Edmond Cross*. Préface par Maurice Denis. 34 paintings, 51 watercolors.
	Revised version of Denis's preface also appeared in *Kunst und Künstler* 5(1907):374; in his *Théories* (Paris: Bibliothèque de l'Occident, 1913):152; and in the Galerie Bernheim-Jeune, Paris 1937 Cross exhibition catalogue. Review: P. Jamot, *Chronique des arts et de la curiosité* (4 May 1907):156.

1910, 17 October-5
November

Paris, Galerie Bernheim-Jeune. *Exposition Henri Edmond Cross: œuvres de la dernière période*. Préface par Maurice Denis. 16 p. 41 paintings, 28 watercolors.

Reviews: H. Guilbeaux, *Les Hommes du jour* (29 Oct. 1910); H. Bidou, *Chronique des arts et de la curiosité* (5 Nov. 1910):267; F. Monod, *Art et décoration* supp. (Nov. 1910):1; L. Werth, *La Phalange* (20 Nov. 1910):472; *Notes d'art et d'archéologie* (Dec. 1910):164; F. M., *L'Art et les artistes* (Dec. 1910):135; J. Rivière, *Nouvelle revue française* (Dec. 1910):805.

1911, 18 March-23
April

Brussels, La Libre Esthétique. *Rétrospective H. E. Cross*. Préface de Maurice Denis. 26 paintings, 12 watercolors. Same text by Denis as his 1910 Bernheim-Jeune preface. Denis's preface also appeared in *Kunst und Künstler* 9(1911):294 and in his *Théories* (Paris: Bibliothèque de l'Occident, 1913):156.

1911, 9 July-6 August

Douai, Hôtel de Ville, Société des Amis des arts. *Rétrospective Cross*. 6 paintings.

1913, 24 February-7
March

Paris, Galerie Bernheim-Jeune. *Henri Edmond Cross*. 48 paintings, 71 watercolors, 12 drawings.

Reviews: R. Jean, *Chronique des arts et de la curiosité* (1 March 1913):67; A. Dervaux, *La Plume* (15 March 1913):612; G. Kahn, *Mercure de France* (16 March 1913):417.

1916, May

Paris, Galerie Bernheim-Jeune. *H. E. Cross*. No catalogue.

Review: G. Kahn, *Mercure de France* (1 May 1916):134.

1921, 28 October

Paris, Hôtel Drouot. *Vente atelier H. E. Cross*. Texts by Henri de Régnier, Emile Verhaeren, John-Antoine Nau, and Maurice Denis. 68 paintings, 449 sheets of watercolors and drawings, 9 prints, 28 watercolors. Auction sale of the contents of Cross's studio.

1922, November-
December

Lyon, Galerie Saint-Pierre. *Henri Edmond Cross*.

1923-24, 26
December-16 January

Paris, Galerie Bernheim-Jeune. *Henri Edmond Cross*. No catalogue. Paintings.

1926, 13-27 February

Paris, Galerie Jacques Rodrigues-Henriques. *H. E. Cross*. Watercolors and drawings.

1927, 25 April-14 May	Paris, Galerie Dru. *H. E. Cross.* Paintings, watercolors, drawings.
	Review: G. Charensol, *L'Art vivant* (1 June 1927).
1937, 10-30 April	Paris, Galerie Bernheim-Jeune. *Exposition rétrospective Henri Edmond Cross.* Préface de Maurice Denis. 55 paintings, 33 watercolors, and 30 drawings shown.
	Denis's preface is revised from the preface to the 1907 Bernheim-Jeune exhibition catalogue. Reviews: *Beaux-arts* (16 April 1937):1; C. Roger-Marx, *London Studio* 14(July 1937):50.
1950, 23 June-8 July	Paris, Galerie Jacques Dubourg. *Henri Edmond Cross.* 8 paintings, 15 watercolors, 15 drawings.
1951, 16 April-5 May	NY, Fine Arts Associates, Otto M. Gerson. *Henri Edmond Cross.* Introduction by John Rewald. 16 p., illus. 12 paintings, 8 watercolors.
	Reviews: H. L. F., *ARTnews* 50(May 1951):43; *Art Digest* 25(1 May 1951):16.
1990, 30 June-1 October	Saint-Tropez, Musée de l'Annonciade. *Paysages méditerranéens d'Henri Edmond Cross.* 44 p., illus.

V. Group Exhibitions

1881	Paris, Salon des Artistes Français. 2 paintings.
1883	Paris, Salon des Artistes Français. 1 painting.
1884, 15 May-1 July	Paris, Salon des Artistes Indépendants. 1 painting.
1886, 21 August-21 September	Paris, Société des Artistes Indépendants. 7 paintings.
1887, 26 March-3 May	Paris, Société des Artistes Indépendants. 6 paintings.
1889, February	Brussels, *Les XX.* 6 paintings.
1892, 19 March-27 April	Paris, Société des Artistes Indépendants. 7 paintings.
1892-93, 2 December-8 January	Paris, Hôtel Brébant. *Exposition des peintres néo-impressionnistes.* 5 paintings.

1893-94, December-January	Paris, 20 rue Laffitte. *Groupe des peintres néo-impressionnistes*. 1st exhibition.
1894, February	Paris, 20 rue Laffitte. *Groupe des peintres néo-impressionnistes*. 2nd exhibition.
1894, March	Paris, 20 rue Laffitte. *Groupe des peintres néo-impressionnistes*. 3rd exhibition. 1 painting.
1894-95, 15 December-5 January	Paris, 20 rue Laffitte. *Cross et Petitjean.* Second special show of the Groupe des peintres néo-impressionniste that included a series of Cross's paintings from 1884-94.
1895, 23 February-1 April	Brussels, La Libre Esthétique. 4 paintings.
1895-96, 27 December-January	Paris, Hôtel Bing. Salon de l'Art nouveau. 4 paintings.
1897, 3 April-31 May	Paris, Société des Artistes Indépendants. 8 paintings.
1898, 22 October-2 December	Berlin, Harry Kessler. *Peintres néo-impressionnistes.*
1899, 10-31 March	Paris, Galerie Durand-Ruel. 6 paintings.
1901, 1-31 March	Brussels, La Libre Esthétique. 4 paintings.
1901, 20 April-21 May	Paris, Société des Artistes Indépendants. 6 paintings, 4 drawings.
1902, 29 March-5 May	Paris, Société des Artistes Indépendants. 10 paintings.
1903, January	Hamburg, Gallerie P. Cassirer. *Neo-impressionisten.* Also shown in Berlin. 8 paintings.
1904	Helsinki, Exposition d'Artistes français et belges. 3 paintings. Reviews: *Gil Blas* (26 March 1905); C. Morice, *Mercure de France* (April 1905):611; R. Marx, *Chronique des arts et de la curiosité* (8 April 1905):107
1906	Berlin, 11. Ausstellung der Berliner Secession. 5 paintings. 4 watercolors.
1906, September	Munich, Kunstverein. *Französische Künstler*. 4 paintings, 4 watercolors.

1906, October	Frankfurt, Kunstverein. *Französische Künstler*. 4 paintings, 4 watercolors.
1906, November	Dresden, Gallerie Arnold. *Französische Künstler*. 4 paintings, 4 watercolors.
1906, December	Karlsruhe, Kunstverein. *Französische Künstler*. 4 paintings, 4 watercolors.
1907, January	Stuttgart, Kunstverein. *Französische Künstler*. 4 paintings, 4 watercolors.
1907, 28 May-21 July	Krefeld, Kaiser Wilhelm Museum. 4 paintings.
1909, May	Paris, Galerie Bernheim-Jeune. *Aquarelles et pastels de Cézanne, Cross, Degas, Jongkind, C. Pissarro, Roussel, Signac, Vuillard*. 18 watercolors.
1910, 17-28 May	Paris, Galerie Bernheim-Jeune. *Nus*. 6 paintings.
	Reviews: A. Alexandre, *Le Figaro* (20 May 1910); A. Alexandre, *Comœdia* (28 May 1910):3; H. Bidou, *Chronique des arts et de la curiosité* (5 Nov. 1910):267; *Notes d'art et d'archéologie* (Dec. 1910):164.
1911, 19 June-3 July	Paris, Galerie Druet. *Exposition de peintures et aquarelles de H. E. Cross et P. Signac*. 6 paintings, watercolors.
	Reviews: H. Guilbeaux, *Les Hommes du jour* (5 July 1911).
1914, 8-16 June	Paris, Galerie Bernheim-Jeune. *Le Paysage du Midi*. 7 paintings, 3 watercolors, 6 drawings.
1925, January	Paris, Galerie Bernheim-Jeune. *Aquarelles de Signac et Cross*. Watercolors. No catalogue.
1926, 20 February-21 March	Paris, Rétrospective de la Société des Artistes Indépendants. *Trente ans d'art indépendant, 1884 à 1914*. 7 paintings.
1933-34, December-January	Paris, Gazette des Beaux-arts. *Seurat et ses amis, la suite de l'Impressionnisme*. 7 paintings, 5 watercolors, 1 drawing.
1937, 20 January-27 February	London, Wildenstein Galleries. *Seurat and his Contemporaries*. 7 paintings.
1942	Paris, Galerie Charpentier. *Un siècle d'aquarelle*. 8 watercolors.
1942-43, 12 December-15 January	Paris, Galerie de France. *Les Néo-impressionnistes*. 6 paintings.
1952, June-October	Venice, XXVIᵉ Biennale. *Le Divisionnisme français*. 4 paintings.

1953, 18 November-
21 December

NY, Wildenstein Galleries. *Seurat and his Friends.* 9 paintings, 6 watercolors, 1 drawing.

1953-54, 4 December-
17 January

Los Angeles, Los Angeles County Museum. *Watercolors by Paul Signac, with Two of his Paintings, and Works by Georges Seurat and Henri Edmond Cross.* 20 p., illus.

1955, 15 April

Paris, Société des Artistes Indépendants. *Hommage à P. Signac et ses amis,* 4 paintings, 1 watercolor.

1956, 10 June-22 July

Douai, Bibliothèque municipale. *Exposition Henri Edmond Cross et ses amis: Seurat, Signac, Angrand, Luce, Lucie Cousturier, Van Rysselberghe (centenaire de H. E. Cross).* Préface par Jacques Guillouet. 16 p. 15 paintings, 12 watercolors, 33 drawings, 1 print.

A revised version of Guillouet's preface appeared in *Les Amis de Douai* (March-April 1956).

1958, 25 February-15
March

Paris, Galerie André Maurice. *Les Néo-impressionnistes.* 3 paintings, 30 watercolors and drawings. No catalogue.

1958, 31 May-8 July

Saint-Denis, Musée Municipal. *M. Luce et son milieu, les impressionnistes.* 2 paintings, 3 drawings.

1958, 27 June-October

Paris, Musée National d'Art moderne. *De l'Impressionnisme à nos jours.* 4 watercolors.

1958, Summer

Annecy, Palais de l'Isle. *Impressionnistes peintres de l'eau.* 3 paintings, 1 watercolor.

1958, 15 November-
14 December

Luxembourg, Musée de l'Etat. *Du néo-impressionnisme à nos jours.* 3 watercolors.

1959, November-
December

Paris, Galerie Bernheim-Jeune. *Signac et Cross.* 8 watercolors. No catalogue.

1960, 23 July-31
August

Honfleur, Grenier à sel, Société des Artistes honfleurais. *Les Peintres pointillistes.* 2 paintings.

1960-61, 4 November-
23 January

Paris, Musée National d'Art moderne. *Les Sources du XX^e siècle.* 2 paintings.

1961, 2 May-10 June

Paris, Galerie de Paris. *Les Amis de Saint-Tropez.* 5 paintings, 6 watercolors, 1 drawing.

1961, 6 June-7 July

Paris, Galerie Bellier. *Les Néo-impressionnistes.* 4 paintings, 1 watercolor.

1962, 17 February-31
May

Brussels, Musées Royaux des Beaux-arts de Belgique. *Le Groupe des XX et son temps.* Also shown Otterlo, Rijksmuseum Kröller-Müller (15 April-31 May 1962). 2 paintings.

1962, April-May	Paris, Galerie Beaux-arts. *L'Aquarelle en France au XXe siècle*. 8 watercolors.
1966, 7-25 June	London, Arthur Tooth and Sons. *Pointillisme: A Loan Exhibition of Paintings by Angrand, Cross, Dubois-Pillet* [et al.]. 10 p., 26 pl.
1977, 28 March-29 May	Paris, Musée National du Louvre, Cabinet des dessins. *La Collection Armand Hammer*. Introduction par Emmanuel de Margene; avant-propos par John Walker. 76 p., 46 illus., 21 col. 44 works shown.

Exhibition of 19th century French drawings, watercolors, and pastels that included works by Cross.
Review: J.-P. Dauriac, *Panthéon* 35:3(July-Sept. 1977):267-8.

1977, 28 March-29 May	Paris, Musée National du Louvre, Cabinet des dessins. *De Burne-Jones à Bonnard; dessins provenant du Musée National d'art moderne*. Avant-propos par Maurice Serullaz; préface par Pierre Georgel; catalogue par Jacqueline LaFargue. 63 p., 113 illus. 113 works shown.

Included works by Cross and Signac.
Reviews: B. Scott, *Apollo* 105:184(June 1977):490; M. Serullaz, *Revue du Louvre et des musées de France* 27:2(1977):103.

1977, 2 July-23 October	Copenhagen, Statens Museum for Kunst, Kobberstiksamlingen. *Herbert Melbye's Samling; en illustreret oversigt*. Text by Erik Fischer. 79 p., 69 illus. In Danish and English.

Highlights from the Melbye collection of drawings, watercolors, and prints, including examples by Cross and Signac.

1980	NY, Metropolitan Museum of Art. *19th Century Drawings from the Robert Lehman Collection*. Catalogue by George Szabo. 92 p., 87 illus. 85 works shown.

Included drawings by Seurat and watercolors by Cross.

1985-86, 23 November-12 January	Washington D. C., Phillips Collection. *French Drawings from the Phillips Collection*. Sponsored by the National Endowment for the Arts, Washington, D.C. Catalogue by Sasha M. Newman. 8 p., 5 illus.

Exhibition of drawings by French artists and artists who worked in France, including examples by Cross and Seurat.

1996-97, 1 December-
31 August

Münster, Westfälisches Landesmuseum für Kunst und Kulturgeschichte. *Signac et la libération de la couleur: de Matisse à Mondrian.* Sous la direction de Erich Franz. Avec un texte de Paul Signac et des contributions de Cor Blok [et at.]. Also shown Grenoble, Musée Grenoble (9 March-25 May 1997); Weimar, Kunstammlungen zu Weimar (15 June-31 Aug. 1997). Paris: Réunion des Musées Nationaux, 1997. 397 p., illus., some col.

Included 11 paintings by Cross (see pages 119-31).

Charles Angrand

Biography

Angrand trained as an artist at the city of Rouen's l'Académie de peinture et de dessin but was turned down by l'École des Beaux-arts in Paris. He moved to Paris anyway in 1882 and took a job teaching mathematics at the Collège Chaptal. He made contacts among avant-garde artistic and literary circles and in 1884 helped to found La Société des Artistes Indépendants. Paintings of rural subjects in the early 1880s demonstrate the Impressionist influences of Monet and Pissarro with their broken brushstroke and luminous coloration.

Angrand gravitated towards Neo-Impressionism through association with Seurat, Signac, and others in the group, completing the transition by 1887. He was also close to the Symbolists' circle, especially Félix Fénéon, Gustave Kahn, Robert Caze, and Emile Verhaeren, whom regarded him as a leading Neo in their reviews. Angrand met Vincent van Gogh in 1887 and showed regularly at Les Indépendants in Paris until his death. He exhibited often in Rouen and at Galerie Druet, Durand-Ruel, and Bernheim-Jeune in Paris. In 1891, he was invited to show with Les XX in Brussels, around the same time that he turned away from painting to *conté* crayon drawings and pastels. Like other Neo-Impressionists, he submitted illustrations to anarchist publications such as *Les Temps nouveaux*.

In 1896, Angrand retreated to Saint-Laurent-en-Caux and lived thereafter virtually as a recluse. He spent a year in Dieppe before World War I and returned to Rouen for the remainder of his life. Although the last 30 years of his life were spent in isolation, Angrand was a prolific and thoughtful correspondent and a provocative Neo-Impressionist. The crayon drawings of the 1890s and large pastels of 1910-25 are among his finest work.

Charles Angrand

Chronology, 1854–1926

Information for this chronology was gathered from François Lespinasse, *Charles Angrand, 1854-1926* (Rouen: Le Cerf, 1982):97-109 and Charles Angrand, *Correspondences 1883-1926*, ed. by François Lespinasse (Rouen: F. Lespinasse, 1988):15-7.

1854

April 19
Birth of Charles Angrand at Criquetot-sur-Ouville, Seine-Maritime in the Pays de Caux, son of Charles P. Angrand (1829-96) and Marie E. Grenier (1833-1905). Siblings include Maria Angrand (1852-1921) and Paul Angrand (1868-1924). His father is a schoolmaster, later elected mayor in 1892.

1854-73

Studies under the tutelage of his father and at l'Ecole Normale d'instituteurs de Rouen, where he lodges and receives awards in 1871, 1872, and 1873. Studies art with Gustave Morin at l'Académie de peinture et de dessin, Rouen. Other students include Albert Lebourg, Philippe Zacharie, Léon Jules Lemaître, Paul Angrand, Charles Frechòn, and Joseph Delattre.

1874

Selected to attend college at Lillebonne but becomes a junior assistant instructor at the Lycée Corneille de Rouen.

1875

Appointed teacher of secondary instruction. Visits Paris for the first time to view the Corot retrospective exhibition at l'Ecole des Beaux-arts. Morin is appointed director of the Rouen Museum. His father Charles Angrand retires from teaching.

1878

Exhibits at the Salon Municipal de Rouen.

1880-82

Shares prizes at l'Académie de peinture et de dessin, Rouen with Charles Frechon.

1882

Leaves Rouen in September at the same time as Louis Anquetin and Edouard Dujardin, colleagues at the Lycée Corneille, to become a staff member at the Collège Chaptal in Paris. Lives in a modest room at the college, 47 boulevard des Batignolles, situated near the cafés where artists gather — the Café d'Athènes, Guerbois, and the Chat Noir. Immerses himself in Parisian avant-garde artistic life. Participates at the Salon Municipal de Rouen in October.

1883

First Parisian exhibitions but rejected by the official salon. Joins the Société des Artistes in July and exhibits two canvasses rejected by the Jeunes artistes salon with them in December. Attracts the attention of critic Félix Fénéon.

1884

Participates in the foundation of the Salon des Artistes Indépendants and exhibits two paintings at their first show (10 December 1884 - 20 January 1885), a failure which closes 2,300 francs in debt.

1886

Shows six paintings at the second Salon des Indépendants, which are favorably reviewed by Fénéon. Becomes friends with Seurat and Vincent van Gogh, who offers to exchange a picture with him before leaving for southern France in October.

1887

Shows first divisionist painting, *L'Accident*, at the Salon des Indépendants. Sends three paintings to an exhibition in Copenhagen; *Les Poules* is purchased by Mr. Van Cutsen for 300 francs. The same collector acquires Seurat's *La Grève du Bas-Butin*. Paints outdoors with Seurat on the Island of La Grande Jatte.

1888

Shows at La Revue indépendante, Salon des Indépendants, Salon Municipal de Rouen, and at Galerie Legrip in Rouen, the first provincial gallery to display a pointillist painting.

1889

Shows nine paintings at the second Exposition des 33, Paris.

1890

Participates in the Salon des Indépendants and in the first Impressionists and Symbolists show at Le Barc de Bouteville, Paris.

1891

Shows with Les XX in Brussels. Turns to black-and-white charcoal and *pierre noir* drawings. Merits a place in Seurat's last painting, *Le Cirque*. According to Fénéon, "between the horse's tail and the clown performing a somersault, one can see, just behind the bench, a spectator wearing a jaunty top hat: Angrand in 1891." Death of Seurat.

1896

May 23
Death of his father. Returns to Saint-Laurent-en-Caux after 14 years in Paris to live with his mother.

1897

Begins his *Maternity* series.

1899

Shows six drawings at Durand-Ruel's.

1900

Commission for the curtain of the Salle des Fêtes de Saint-Laurent-en-Caux. *La Revue blanche*, with the help of Félix Fénéon, organizes a large retrospective of 323 works by Seurat.

1902

Travels to Bruges with his brother Paul to see the *Exposition des primitifs Flamands*. Meets Pissarro in Dieppe.

1903

Death of Pissarro.

1905

Deaths of his friend Léon Jules Lemaître (June 6) and his mother (September 9).

1906-08

Returns to oil painting with brilliant colors.

1907

Revisits Bruges to see the exhibition of the Toison d'or.

1908

Becomes a member of the group Les XXX in Rouen. Fénéon becomes art director at Galerie Bernheim. Signac elected president of La Société des Indépendants.

1910

May 16
Death of his close friend Henri Edmond Cross. Angrand writes a tribute in *Les Temps nouveaux* (23 September 1910).

1913

Moves permanently to 33 quai de Paris, Rouen, to live with his older sister in a studio apartment on the fifth floor.

1916

Accidental death of poet Emile Verhaeren, who was visiting Rouen to see l'Exposition des Artistes Rouennais, *Pour leurs mutilés*, held to aid Belgian war disabled.

1917

Death of his older nephew at the front. The Musée d'Helsingfors purchases a pastel.

1921

City of Rouen acquires a pastel, *Les Bûcherons*.

1922

Surgery at the clinic of Bruyères, near Rouen.

1924

Death of his brother Paul Angrand.

1925

March 23-April 9
Individual show of 25 pastels at Galerie L. Dru, Paris. Catalogue preface by Paul Signac.

1926

March 15
Le Cirque by Seurat hung in the Louvre.
April 1
Death of Angrand in Rouen.

Charles Angrand

Bibliography

I. Archival Materials

1925. ANGRAND, CHARLES and PAUL SIGNAC. *Letters*, ca 1925. 2 items. Holographs, signed. Located at The Getty Research Institute of Art and the Humanities, Special Collections, Los Angeles.

One undated letter is from Angrand to an unnamed woman (possibly Maximilien Luce's wife), thanking her for her appreciation of his drawings. Since she is going to Anvers, he sends greetings to Luce and promises that a letter will follow soon. The second is a letter written by Paul Signac on the blank side of an exhibition catalogue of Angrand's works at the Galerie L. Dru in Paris (23 March-9 April 1925). Signac tells Dru that he does not consider himself qualified to present such an important artist as Angrand, who has been regularly exhibiting his creations at the Salon des Indépendants for 35 years, and is indeed better qualified to present himself to the public. Signac's letter is reproduced in *Charles Angrand, correspondances, 1883-1926*, ed. by François Lespinasse (Rouen: F. Lespinasse, 1988):404-5.

II. Books

1926. ANGRAND, CHARLES. *Charles Angrand: correspondances 1883-1926.* Editées par François Lespinasse. Rouen: F. Lespinasse, 1988. 407 p.

Bibliography, pp. 406-7, includes mentions of Angrand in Rouen and Parisian newspapers: "Bibliographie de la presse rouennaise," p. 407 and "Bibliographie de la presse parisienne," p. 407.

1927. ANGRAND, PIERRE. *Naissance des artistes indépendants*. Paris: Nouvelles Editions Debresse, 1965. 127 p.

History of La Société des Artistes Indépendants, Paris, founded in 1884 with the help of Charles Angrand, by the painter's nephew.

1928. DURANTY, EDMOND. *La Nouvelle peinture. A propos d'un groupe d'artistes qui expose dans les Galeries Durand-Ruel*. Paris: E. Dentu, 1876. 58 p.

a. Other eds.: Paris: Floury, 1946; Caen: L'Echoppe, 1988.

1929. LESPINASSE, FRANÇOIS. *Charles Angrand, 1854 - 1926*. Rouen: Le Cerf, 1982. 109 p., illus., 12 pl.

Bibliography, pp. 91-2.

1930. WELSH-OVCHAROV, BOGOMILA. *The Early Works of Charles Angrand and his Contact with Vincent van Gogh*. Utrecht; The Hague: Editions Victorine, 1971. 63 p., illus.

III. Articles

1931. ADAM, PAUL. "L'Art symboliste." *La Cravache* (22 March 1889).

1932. ANGRAND, CHARLES. "Henri Edmond Cross." *Les Temps nouveaux* (23 Sept. 1910).

Tribute and memorial to his friend and fellow Neo-Impressionist, who died 16 May 1910.

1933. ANGRAND, PIERRE. "Charles Angrand" in *The Neo-Impressionists*, ed. by Jean Sutter (Greenwich, CT: New York Graphic Society, 1970):77-88.

1934. ANTOINE, D. "Impressionnistes et synthétistes." *Art et critique* (9 Nov. 1889).

1935. BESSON, GEORGE. "Pourquoi oublier Charles Angrand?" *Les Lettres françaises* 548 (25 Dec. 1954 - 6 Jan. 1955):9.

1936. BONAFOUX, PASCAL. "Lettre ouverte au Ministre de la Culture à propos d'un *Paysage aux environs de Paris*." *L'Oeil* 460 (April 1994):52-7. 6 col. illus.

Open letter to the French Minister of Culture requesting an enquiry into the provenance and attribution of a painting called *Paysage aux environs de Paris*, commonly attributed to van Gogh since its discovery in 1885. Bonafoux cites evidence that Angrand may be its creator.

1937. ["Charles Angrand"].
Various periodical articles that appeared in the following journals and newspapers: *Chronique de Rouen* (11 Aug. 1881); *Nouvelliste de Rouen* (29 Sept. 1882); *Journal des artistes* (12 Dec. 1884); *Le Petit rouennais* (26 Oct. 1886); *Journal des artistes* (29 Aug. 1886); *L'art moderne* (19 Sept. 1886); *Journal des artistes* (8 May 1887); *Nouvelliste de Rouen* (16 Apr. and 3 Oct. 1888); *La Revue indépendante* (March 1888); *Journal de Rouen*

(2 Oct. 1888); *Le Cravache* (catalogue des XXXIII) (19 Jan. 1889); *Nouvelliste de Rouen* (24 Jan. 1890); *La Vie artistique* (22 Apr. 1890); *La Vie artistique* (10 Apr. 1891); *La Vie artistique* (29 March 1892); *L'Echo de Paris* (26 Nov. 1892); *L'Art français* (3 Dec. 1892); *L'Eclair* (25 March 1899); *Gil Blas* (13 Jan. 1904); *Comœdia* (23 March 1912); *Par chez nous,* Revue normande de littérature et d'art (Feb.-March 1921); *Journal de Rouen* (4 Apr. 1926); *Normandie illustrée* (June 1926); *La Vie* (1 Oct. 1936).

1938. DESDOZEAUX, D. "Les Artistes indépendants." *La Cravache* (9 June 1888).

1939. FENEON, FELIX. "Catalogue des 33." *La Cravache* (19 Jan. 1889.

1940. KAHN, GUSTAVE. "Chronique de la littérature et de l'art." *La Revue indépendante* 6(Jan. 1888):146-51.

1941. LE FUSTEL, JEAN. "Les Palettes, Ch. Angrand." *Journal des artistes* 6:18(8 May 1887):139-40.

1942. LEROY. "L'Exposition des impressionnistes." *Le Charivari* (25 April 1874).

1943. MARX, ROGER. "L'Art décoratif et les 'symbolistes.'" *Le Voltaire* (23 April 1892).

1944. MAUCLAIR, CAMILLE. "Lettre sur la peinture." *Mercure de France* (July 1894).

1945. NOYER, GEORGES. "La Chronique artistique." *Chronique de Rouen* (11 Aug. 1881).

1946. VAN RYSSELBERGHE, THEO and PIERRE ANGRAND. "Ce qu'il convient de voir en 1902 au pays belge." *Gazette des Beaux-arts* 110: 1422-3 (July-Aug. 1987):49-50. 1 illus.

Includes transcripts of a letter written by Van Rysselberghe to Charles Angrand in 1902, advising Angrand which paintings, museums, and architecture to see on his visit to Belgium, plus a shorter letter inviting Angrand to visit him in Paris.

IV. Individual Exhibitions

1925, 23 March -9 April	Paris, Galerie L. Dru. *Exposition Charles Angrand.* Préface de Paul Signac. 25 pastels.
1960-61, December-January	Paris, Galerie André Maurice. *Exposition Charles Angrand.*
1976, 19 June-20 September	Dieppe, Chateau-Musée de Dieppe. *Charles Angrand,* 1854-1926. 46 p.

V. Group Exhibitions

1878	Rouen, 26^{ème} Salon Municipal de Rouen. 1 work, *Fleurs des champs*.
1880	Rouen, 28^{ème} Salon Municipal de Rouen.
1882, October	Rouen, 30^{ème} Salon Municipal de Rouen. 2 works.
1883	Paris, Galerie Vivienne, Journal des artistes.
1883	Paris, Arts incohérents (Arrivée des cinq Galets).
1883, December	Paris, Société des Jeunes artistes.
1884	Rouen, Salon Incohérent des arts incohérents.
1884-85, 10 December-20 January	Paris, Pavillon des Champs-Elysées. *Société des Artistes Indépendants*. 2 works.
1886, August	Paris, Société des Artistes Indépendants. 6 works.
1886	Rouen, Salon Municipal de Rouen. 1 work.
1887, May	Paris, Salon des Indépendants. 4 works, including an early pointillist canvas, *L'Accident*.
1887	Paris, Galerie G. Petit. *Exposition de la Société des 33.*
1888	Paris, La Revue Indépendante. 2 works.
1888	Paris, Salon des Indépendants. 3 works.
1888, April	Rouen, Galerie Legrip, Amis des arts. 1 work, *La Moisson*.
1888	Copenhagen. 2 works, including *Les Poules*, a canvas purchased by collector M. Van Cutsem, who also buys a painting by Seurat.
1888, October	Rouen, Salon Municipal de Rouen. 1 painting, *Une Couseuse*, a portrait of his mother painted in 1885.
1889, January	Paris, Galerie G. Petit. *Deuxième exposition de la Société des 33.* 9 paintings.
1889	Rouen, Salon des Arts incohérents (la Belle nature).
1889	Rouen, Concours de la Société des Amis des arts. 4 works.
1890	Paris, Salon des Indépendants.
1890	Paris, Le Barc de Bouteville. Exposition des peintres impressionnistes et symbolistes.
1891	Paris, Salon des Indépendants.
1891	Brussels, Exposition des XX. 7 works.
1892	Paris, Salon des Indépendants.

1892-93, 2 December- 8 January	Paris, Le Barc de Bouteville, Hôtel Brébant, *Peintres néo-impressionnistes.* 8 works.
1893	Paris, Salon des Indépendants.
1893	Paris, Le Barc de Bouteville.
1893	Anvers. 5 works.
1894	Paris, Salon des Indépendants.
1894	Paris, Le Barc de Bouteville.
1895	Paris, Salon des Indépendants.
1899, 20-31 March	Paris, Galerie Durand-Ruel. 6 drawings.
1901, January	Berlin, Galerie Keller und Reiner.
1901	Paris, Salon des Indépendants.
1901	Dresden, Galerie Gutbier.
1903	Paris, Salon des Indépendants.
1903	Dieppe, Salon de la Société des Amis des arts.
1904	Paris, Galerie Druet.
1904	Dieppe, Salon de la Société des Amis des arts.
1905	Paris, Salon des Indépendants.
1905	Dieppe, Salon de la Société des Amis des arts.
1906	Paris, Salon des Indépendants.
1907	Paris, Salon des Indépendants.
1908	Paris, Salon des Indépendants.
1909	Paris, Salon des Indépendants.
1909	Paris, Galerie Druet.
1910	Paris, Salon des Indépendants.
1911	Paris, Salon des Indépendants.
1912	Paris, Salon des Indépendants.
1913	Paris, Salon des Indépendants.
1913	Paris, Galerie Druet.
1914	Paris, Salon des Indépendants.

1916-17, November–January	Rouen, Exposition des Artistes Rouennais. *Pour leurs mutilés*. 1 work, *Une femme qui coud*. Exhibition to aid Belgian war disabled. Angrand's friend Emile Verhaeren is accidentally killed in Rouen at the end of his visit to the exhibition.
1919, 20 January	Paris, Galerie Crès. *Les Indépendants*.
1920	Paris, Salon des Indépendants.
1920	Rouen, Salon des Artistes Rouennais.
1920	Venice, Biennale.
1921	Rouen, Galerie Moderne.
1922	Paris, Salon des Indépendants.
1922	Rouen, Salon des Artistes Rouennais.
1923	Paris, Salon des Indépendants.
1923	Rouen, Salon des Artistes Rouennais.
1924	Paris, Salon des Indépendants.
1924	Rouen, Salon des Artistes Rouennais.
1925	Paris, Salon des Indépendants.
1925	Rouen, Salon des Artistes Rouennais.
1926	Paris, Salon des Indépendants.
1966	London, Arthur Tooth and Sons. *Pointillisme: A Loan Exhibition of Paintings by Angrand, Cross, Dubois-Pillet* [et al.]. 10 p., 26 pl.
1995, 7 June - 29 July	Charleroi, Belgium, Musée des sciences de Parentville. *Maximilien Luce, 1858-1941: peintre anarchiste*. Préface de Jean Agamemnon. Catalogue par Jean-Jacques Heirwegh. Collaboration: Jean-François Füeg, Aline Dardel. Brussels: Université libre de Bruxelles, 1995. 74 p., illus. 123 works shown. Luce retrospective that focused on paintings and propagandist images for the popular press (1880-1914) and included works by associates of Luce such as Angrand, Eugène Boch, Gisbert Combaz, L. Gousson, and Constantin Meunier.

Maximilien Luce

Biography

Painter, illustrator, engraver, graphic artist, and anarchist, during his long and varied career Maximilien Luce never left his working-class Montparnassian upbringing behind. The son of a railway clerk and mother whose peasant family was new to Paris, Luce showed early artistic promise. At age 14 he was apprenticed for three years to Henri-Théophile Hildebrand (1824-97), a wood-engraver best known for reinterpretations of Gustave Doré's illustrations for Dante's *Divine Comedy*. In 1876, Luce joined the studio of Eugène Froment (1844-1900), whose shop produced woodcuts for magazines such as *L'Illustration* and the *Graphic* of London. He attended classes at l'Académie Suisse and in the studio of the fashionable portraitist Carolus-Duran, an affiliation that lasted until 1885. In 1882, the invention of zincography virtually eliminated xylography as a profession and Luce became a full-time painter. With Léo Gausson and Emile-Gustave Peduzzi (Cavallo-Peduzzi), he painted Impressionist landscapes around Gausson's home village of Lagny-sur-Marne.

By 1887, Luce had met the Pissarros, Seurat, Signac, and other Neo-Impressionists. He moved to Montmartre and became a full-fledged Neo-Impressionist. Luce showed with the group at Les Indépendants every year and with Les XX in Brussels in 1889 and 1892. In 1888, the influential Neo-Impressionist critic Félix Fénéon arranged his first single-artist show on the premises of *La Revue indépendante*.

Like most Neo-Impressionists, Luce was a political anarchist. He contributed numerous illustrations to socialist magazines of the day, such as Jean Grave's *La Révolte* (later renamed *Les Temps nouveaux*) and befriended many anarchist-communist leaders and writers. In July 1894, he was imprisoned for 42 days in Mazas Prison in the aftermath of the government's crackdown following the assassination of President Sadi Carnot. To document the experience and to publicize the anarchist cause, the artist issued an album of ten lithographs entitled *Mazas* (1894). Throughout his long career Luce chose proletariat subjects that express a passionate solidarity with the common man.

Following Seurat's untimely death in 1891, Luce, Signac, and Fénéon were selected to inventory Seurat's studio and to distribute his works among friends and colleagues. Luce traveled widely during the 1890s – to London with Pissarro and with Signac to Saint-Tropez in 1892, to Brittany in 1893, and to Belgian's infamous coal country around Charleroi and the Sambre Valley where Vincent van Gogh had lived a decade earlier. In later years he divided his time between Paris and the riverside village of Rolleboise, west of Mantes, where he purchased a country house in 1920.

Luce's attraction to Neo-Impressionism and his political activism had waned by the

end of the century and he reverted to a more traditional Impressionist style. Luce was one of the most prolific Neo-Impressionists. Jean Bouin-Luce and Denise Bazetoux's two-volume *catalogue raisonné* identifies more than 2,000 oil paintings and similarly large numbers of pastels, gouaches, watercolors, drawings, and over 100 prints. The Musée Maximilien Luce in Mantes-la-Jolie owns a significant collection of his works.

Maximilien Luce

Chronology, 1858–1941

Information for this chronology was gathered from Philippe Cazeau, *Maximilien Luce* (Lausanne; Paris: La Bibliothèque des Arts, 1982):195-201; *Maximilien Luce, 1858 -1941: The Evolution of a Post-Impressionist* (exh. cat., NY: Wildenstein Galleries, 1997):27-32; Jean Bouin-Luce and Denise Bazetoux, *Maximilien Luce: catalogue raisonné de l'œuvre peint* (Paris: Editions JBL, 1986), vol. 1; and Jean Sutter, *Maximilien Luce, 1858-1941: peintre anarchiste* (Paris: Galerie des Vosges, 1986).

1858

13 March
Birth of Maximilien-Jules-Constant Luce in Paris to Charles-Désiré Luce (1823-88) and Louise-Joséphine Dunas (1822-78). Charles is a railway clerk and Louise-Joséphine is from a peasant family in the Beaune region that recently resettled in Paris. The family lives modestly at 13, rue Mayet in the Montmartre section of Paris (6th arrondissement).

1864

The family moves to the rue d'Odessa and Maximilien enrolls in l'Ecole communale on the Chaussée du Maine.

1871

Luce witnesses the brutal suppression of the Commune insurrectionists by Republican troops from Versailles.

1872-75

Begins a three-year apprenticeship as a wood-engraver with Henri-Théophile Hildebrand (1824-97), a xylographer best known for his wood-engravings of Gustave Doré's illustrations for Dante's *Divine Comedy*. At night Luce attends drawing classes at a school on the rue de Vaugirard taught by an artist named Truffet and Jules-Ernest Paris (1827-95), a friend of Corot and an admirer of Manet. Luce begins oil painting. The family moves to Montrouge, a working-class Parisian suburb. Later takes courses from Diogène Maillard (1840-1926), who taught drawing at the Gobelins tapestry works.

1875-76

November
Apprenticeship ends and he joins the studio of the highly successful artist Eugène Froment (1844-1900) at 230, rue du Faubourg Saint-Jacques, where he produces prints for such publications as *L'Illustration* and *The Graphic*. At Froment's studio he befriends Léo Gausson and Emile-Gustave Cavallo-Peduzzi, with whom he paints near Gausson's home at Lagny-sur-Marne. Furthers his artistic training at the Académic Suisse, where he meets Louis-Gabriel Lennivaux, supervisor of Carolus-Duran's studio. Carolus-Duran (1837-1917) was a fashionable portrait painter and teacher of John Singer Sargent.

1877

Travels with Froment to London for two months where they make engravings. Continues at l'Académie Suisse and enters Carolus-Duran's studio upon his return to Paris.

1878

20 April
Death of his mother at Montrouge.

1879

7 November
Begins four years of military service in the 48th regiment of the Infanterie de ligne, stationed at Guingamp in Brittany. His father remarries.

1880

1 October
Promoted to corporal. Decorates the walls of the officers' mess hall at Guingamp. Befriended by Alexandre Millerand, the future President of the French Republic.

1881

8 January
Resumes the rank of soldier, 2nd class at his own request. Through the intervention of Carolus-Duran, Luce is transferred to barracks in Paris near the Parc de Reuilly.

1882

Divides his free time between the studios of Carolus-Duran, Froment, and Auguste Lançon a painter and engraver.

1883

27 September
Leaves military service. Increasing unemployment among engravers due to the invention of zincography prompts Luce to concentrate instead on painting.

1884-85

Through his friends Gausson and Cavallo-Peduzzi he is exposed to Seurat's divisionism and begins to adopt a pointillist technique. Leaves Carolus-Duran's studio. Rents a studio in rue du Vieux-Pont-de-Sèvres. La Société des Artistes Indépendants is organized and opens its first salon in December 1884, where Seurat shows a study of *Un Dimanche sur l'Ile de la Grande Jatte.*

1886

20 August-21 September
At the second salon of the La Société de Artistes Indépendants Seurat shows ten works, including the finished *Un Dimanche sur l'Ile de la Grande Jatte.* Luce refines his divisionist technique during a productive period.

1887

Moves to 6 (later 16), rue Cortot in Montmartre and joins La Société des Artistes Indépendants, at whose third spring show Luce exhibits seven works including *La Toilette,* which is purchased by Signac for 50 francs. Luce's submissions favorably impress Camille Pissarro and the influential critic Félix Fénéon, who introduces Luce to Seurat and Signac. Luce also becomes acquainted with Albert Dubois-Pillet, Charles Angrand, Armand Guillaumin, Henri Edmond Cross, Petitjean, and Lucien Pissarro. Luce exhibits at Les Indépendants until his death in 1941, except from 1915-19. Paints at Lagny during the summer and at Laval in September. Creates his first Neo-Impressionist portrait, *Madame Georges Gausson and her Son.* Jean Grave founds *La Révolte* (later *Les Temps nouveaux*), a bi-weekly communist-anarchist magazine on which Luce will later collaborate.

1888

Shows ten paintings at the fourth Salon of La Société des Artistes Indépendants. In July, he holds his first single-artist show (ten paintings) at the offices of *La Revue indépendante.* During the same month he and Gausson spend time with Pissarro at Eragny-Bazincourt. On July 28, Jules Christophe publishes the first article on Luce in *La Cravache parisienne.* Luce's father dies on August 7.

1889

A confirmed anarchist, Luce collaborates with Emile Pouget on the newly founded socialist-anarchist newspaper, *Le Père Peinard.* In February and March, Luce sends six canvasses to Les XX in Brussels, where he meets the avant-gàrde society's founder Octave Maus (1856-1919), the poet Emile Verhaeren (1855-1916), and the Belge Neo-Impressionist painter Théo Van Rysselberghe. Stays with Pissarro at Eragny-Bazincourt and with Signac at Herblay during the summer. Participates in the fifth exhibition of La Société des Artistes Indépendants, where he is elected a member.

1890

Works in Paris and its environs, cheifly at La Frette and Herblay. In July, Jules Christopher devotes a special issue of *Les Hommes d'aujourd'hui* to Luce. Publishes *Coins de Paris: le*

petit betting, an album of 8 lithographs of racetracks in Saint-Ouen with a text by Gustave Bogey.

1891

31 March
Death of Seurat. At the request of the late painter's mother, Luce, Signac, and Fénéon compile an inventory of Seurat's studio and distribute his works among friends and colleagues. Luce himself owned 13 paintings and drawings by Seurat. Collaborates with Zo d'Axa on an anarchist broadside, *L'En dehors*. In September, Georges Darien writes a favorable article on Luce in *La Plume*.

In October, Luce is called up again to serve in the army, this time based in Paris. Shows with other Impressionist and Symbolist painters at le Barc de Boutteville's first exhibition.

1892

Participates in the ninth exhibition of Les XX, Brussels. Visits London during spring with Pissarro, while recovering from the trauma of a failed romance. Joins Signac at Saint-Tropez, where the Mediterranean light affects him greatly and where he returns in subsequent years.

1893

Moves to 16, rue Cortot, Montmartre. Meets Ambroisine Bouin, who becomes his companion and wife. Travels to Brittany in the summer, staying at Camaret with visits to Brest and Plougastel. Gérault-Richard founds a socialist magazine, *Le Chambard*, for which Luce collaborates.

1894

5 June
Birth of Frédéric Luce, the couple's first child, who dies on 2 September 1895.
24 June
Assassination of Sadi Carnot, President of the Third Republic, by the Italian anarchist Santo Jeronimo Caserio.
8 July–17 August
Luce is arrested on suspicion of collusion in the Carnot assassination and is incarcerated in Mazas prison, released at the conclusion of the so-called "Procès des Trente."
Publishes *Mazas*, an album of ten lithographs on the life of political prisoners in Mazas prison (text by Jules Vallès). Shows 22 works with Signac and other Neo-Impressionists at Léonce Moline's gallery, 20, rue Laffitte.

1895

Participates in the second Libre Esthétique show in Brussels. Stays with Pissarro at Eragny-Bazincourt after the death of his son in September. Invited by Emile Verhaeren, Luce makes his first trip to Belgium. Stays in Charleroi and visits the coal-mining district of Boringe, the "pays noir," with Théo Van Rysselberghe.

1896

Concludes his Belgian trip with visits to Couiller, Marchienne, Marcinelle, and Châtelet.
20 July
Birth of Frédéric Luce, second child of Maximilien and Ambroisine Bouin.
Completes a series of drawings after Constantin Meuniet's (1831-1905) sculptures of Belgian coal miners for the periodical *Le Scandale*. The drawings are exhibited at Samuel Bing's Art nouveau gallery in Paris (Dec. 1895-Jan. 1896) and engraved and published in an album entitled *Les Gueules noires,* with a preface by Charles Albert. During the visit to Paris of Spain's King Alfonso XIII, Luce is detained by the police for a short time as a "dangerous anarchist."

1897

Shows at the Libre Esthétique, Brussels and at the 15th exhibition of the *Peintres impressionnistes et symbolistes,* Galerie Le Barc de Boutteville, Paris. Voices dissatisfaction with Neo-Impressionism and begins a gradual stylistic return to Impressionism.

1899

Two successful shows at Galerie Durand-Ruel, Paris. The second (16 October-1 November) showcases 61 paintings, 33 of which depict coal-mining scenes of Belgian's "pays noir."

1900

Shows 20 paintings at the Libre Esthétique, including 17 from his Charleroi series. Spends the summer at Méréville, where he returns in later years. Rents a studio in Auteuil (Paris) at 102, rue Boileau. Pouget founds *La Voix du peuple,* the official periodical of the Confédération Générale du Travail (C.G.T.), to which Luce contributes illustrations.

1901-04

Paints at Méréville and at Moulineux, near Estampes, during summers. Produces portraits of family members and friends, flowers, and Parisian urban scenes.

1902

May
Individual show at Ambroise Vollard's gallery, Paris.

1903

Spends the summer at Moulineux, where he returns in 1904 and 1905. In November, Pissarro dies in Paris. The Luce family adopts Georges Bouin, an orphaned nephew of Ambroisine.

1904

Shows at the *Peintres impressionnistes et symbolistes,* Paris and at the Libre Esthétique,

Brussels. Holds a large exhibition at Galerie Druet, Paris in March; catalogue preface by Félix Fénéon.

1905

Exhibits *Une rue de Paris en mai 1871*, first of a series that depicts Luce's memories of the carnage of the suppression of the Commune, at the 21st Salon de La Société des Artistes Indépendants. Buffalo Bill and his troupe of American Indians visit Paris; Luce executes a series of colorful paintings.

1906

March-April
Single-artist show of 58 works, Galerie Druet. Paints from nature on holiday near Auxerre and at Arcy-sur-Cure, near Vermenton (Yonne).

1907

February
Individual exhibition (54 works) at Bernheim-Jeune, arranged by Fénéon with catalogue preface by Gustave Kahn.
May-July
Visits the Fauve painter Kees Van Dongen in Rotterdam. Also travels to Dordrecht, The Hague, Amsterdam, and the Meuse Valley.

1908

Participates in La Libre Esthétique, Brussels and vacations in the Yonne department. Gustave Hervé begins the anarchist magazine, *La Guerre sociale*, to which Luce will submit illustrations.

1909

The popular journal, *Les Hommes du jour*, dedicates an issue to Luce. He is elected Vice President of La Société des Artistes Indépendants and receives a single-artist show at Bernheim-Jeune that includes 40 landscapes from Holland. Emile Verhaeren contributes the preface.

1910

Produces a series of paintings of floods in Paris. Shows again at Bernheim-Jeune. His friend Henri Edmond Cross dies.

1911

Shows at the Kunsthaus, Zurich and at the Les Indépendants, Paris.

1912

January
Holds another individual exhibition at Bernheim-Jeune.

1914

February
Galerie Choiseul shows a number of paintings of laborers. Spends summer at Kermouster and Lézardrieux in Brittany and visits Rouen.

1915-16

Paints a series of the Parisian train station Gare de l'Est, where wounded soldiers arrive from the front.

1916

October-November
Bernheim-Jeune holds an exhibition of his train-station pictures, *Les Gares de Paris pendant la guerre.*
27 November
Emile Verhaeren is accidentally killed by a train in Rouen, after leaving Luce and Angrand.

1917

Discovers the picturesque village of Rolleboise, near Mantes on the Seine, and purchases a house there. Visits Monet in nearby Giverny. Divides his time between Rolleboise and Paris in the years that follow.

1920

Moves to an apartment at 16, rue de Seine, which remains his Paris residence until his death. Purchases a small house near the church in Rolleboise.

1921

April
Poet Tristan Klingsor publishes a laudatory essay on Luce in *L'Art et l'artiste.* Shows at Galerie L. Dru.

1922

May
Galerie Durand-Ruel holds a single-artist exhibition.

1924

March
Durand-Ruel organizes another individual show.
Travels to Belgium and visits Saint-Omer.

1926

February-March

Luce shows several works at Les Indépendants; 30-year retrospective.
March
Galerie Druet holds an individual show. Death of Charles Angrand.

1928

Adolphe Tabarant publishes *M. Luce* (Paris: Editions Crès), the first monograph on the artist.
Visits Honfleur.

1929

June
Successful 50-year retrospective at Bernheim-Jeune.

1930

January
Exhibition at Galerie Dru.
Paints at Honfleur, Le Tréport, and Saint-Malo.

1932

February-March
Participates in *Le Néo-impressionnisme* retrospective at Galerie Braun, Paris. Preface by
Paul Signac.

1933-34

Galerie des Beaux-arts holds a major Neo-Impressionist show, *Seurat et ses amis, la suite
de l'impressionnisme*, at which Luce is well represented.

1935

Signac dies in Paris.
15 August
Luce is elected President of Les Indépendants.

1936

Paints in Saint-Malo.

1937
January-February
Participates in Gallery Wildenstein's *Seurat and his Contemporaries* exhibition in London.

1940

30 March
Marries his common-law wife, Ambroisine Bouin, in Paris.
May-June

German troops invade France and Luce stays with friends in Montargis. Returns to Paris at end of year.
7 June
Ambroisine Bouin dies in Rolleboise, leaving Luce grief-stricken.

1941

7 February
Luce dies at the age of 83 at his rue de Seine residence and is buried at Rolleboise.
May
Memorial exhibition held at La Bibliothèque nationale.

1942

March-April
Memorial exhibition at Les Indépendants.

Maximilien Luce

Bibliography

I. Archival Materials

1948. LUCE, MAXIMILIEN. *Letters, Sketches, and Exhibition Catalogues*, 1899-1930, 44 items. Holographs, signed; sketches; printed materials. Located at The Getty Research Institute for the History of Art and the Humanities, Special Collections, Los Angeles.

Among the letters are 12 to assorted correspondents, 6 to Jean Charlot, and 12 to Louise and Frédéric Luce, Maximilien's son and daughter-in-law. Many letters include sketches in pencil and ink and generally concern personal matters with some mention of work in progress. One letter to Charlot contains brief references to paintings seen during travels, while one letter to Aynaud mentions plans to visit Holland with Kees van Dongen and Ludovic Rodo Pissarro (n.d.). Other correspondents are Miguet, Oulevey, Charles Rémond, and Camille Pissarro. In addition to the drawings on his letters, there are 11 separate small sketches by Luce done in pencil and ink, with two in watercolor. Sketches include seascapes, landscapes, and figure drawings. Exhibition ephemera consists of two small catalogues and three announcements or listings of work for Luce exhibits in private galleries between 1899 and 1930. One catalogue contains illustrations and an essay by Gustave Geffroy (1907).

Organized in 5 folders: letters (folders 1-3); sketches (folder 4); exhibition catalogs and ephemera (folder 5).

1949. LUCE, MAXIMILIEN. *Lettres de Luce à Cross*. Holographs, signed. Located at Paris, Fondation Wildenstein.

Letters of Luce to Henri Edmond Cross, donated by Frédéric Luce.

1950. ANGRAND, CHARLES and PAUL SIGNAC. *Letters*, ca. 1925. 2 items. Holographs, signed. Located at The Getty Research Institute for the History of Art and the Humanities, Special Collections, Los Angeles.

One undated letter is from Angrand to an unnamed woman (possibly Maximilien Luce's wife), thanking her for her appreciation of his drawings. Since she is going to Anvers, he sends greetings to Luce and promises that a letter will follow soon. The second is a letter written by Paul Signac on the blank side of an exhibition catalogue of Angrand's works at the Galerie L. Dru in Paris (23 March-9 April 1925). Signac tells Mr. Dru that he does not consider himself qualified to present such an important artist as Angrand, who has been regularly exhibiting his creations at the Salon des Indépendants for 35 years, and is indeed better qualified to present himself to the public. Signac's letter is reproduced in *Charles Angrand, correspondances, 1883-1926*, ed. by François Lespinasse (Rouen: F. Lespinasse, 1988):404-5.

1951. GEFFROY, GUSTAVE. *Correspondence and manuscripts*, 1884-1926. ca 80 items. Manuscripts; printed matter. Located at The Getty Research Institute for the History of Art and the Humanities, Special Collections, Los Angeles.

Correspondence by the French art critic Gustave Geffroy (1855-1926) with artists and other writers on both professional and personal matters, manuscripts of essays on Cézanne, Gauguin, Raffaëlli, A. Barbier, and the Salon of 1924, and miscellaneous printed matter. Organization: I. Letters, ca. 1901-1926, (folder 1); II. Letters received, 1884-1924, (folders 2-3) arranged alphabetically; III. Manuscripts (folders 4-7); IV. Printed matter (folder 8). Series I. Seventeen letters to André Barbier, Georges Charpentier, Frantz Jourdain, and several unidentified correspondents concerning publications, the business of l'Académie Goncourt, and personal matters. Notable are a letter to another journalist giving advice about the placement of articles; one using the sickness of a friend's child as a pretext to comment on his own physical and psychological health; several postcards and a letter of 1923 from Brittany evoking the landscape in detail for an artist friend and including sketches for paintings Geffroy is planning to execute. The letters make mention in passing of Rodin, Daudet, Clemenceau, Luce, Anquetin, Raffaëlli, Maurice Hamel, Zola, Rosny, and Céard.

1952. MARTY, ANDRE. *Letters and Manuscripts Received*, ca. 1886-1911. ca. 230 items. Located at The Getty Research Institute for the History of Art and the Humanities, Special Collections, Los Angeles.

Marty (b. 1857) was a French editor, director of *Le Journal des artistes*, and publisher of prints and books on the arts. Includes letters from more than 50 artists and art critics primarily concerning publication of the print portfolio, *L'Estampe originale*, but also referring to projects for illustrated books, monographs on art, exhibitions and art criticism. Most letters are addressed to André Marty, though a few are to his junior partner, Henri Floury. Included in the collection are two short manuscripts on the decorative arts, by Gustave Geffroy and Octave Uzanne.
Letters relating to *L'Estampe originale* (1893-95) provide detailed technical information about print states, color, choice of paper, and preferences for particular printers and engravers. They also chronicle problems of artistic and journalistic collaboration and offer clues as to the publisher's marketing strategies. Of particular interest are letters from Georges Auriol (5) about his designs for decorative borders; from the sculptor Alexandre Charpentier (16) discussing his innovative "timbre sec," and dickering over prices; from

Maximilen Luce (1) with instructions for printing engravings; from Monet (1) expressing uncertainty about working in lithography; from Roger Marx (23) concerning his preface and the promotion of the portfolios; from Van Rysselberghe (1) promising to enlist other Belgian artists; from Lucien Pissarro (13) about distribution of the publication in England, and his own prints; and from Félix Vallotton (1) regarding control over editions and financial terms. Among the letters containing comments on specific prints and details on technical matters are those from Eugène Carrière (13); Signac (1); Joseph Pennell (6); Camille Pissarro (8); and Félicien Rops project; for example Zandomeneghi, Blanche, Khnopff, and Duez. Letters treating other subjects include five from Paul Ranson (n.d.) discussing wallpaper and tapestry designs; letters of 1897 from Ernest Chaplet and Auguste Delaherche about a ceramics exhibition sponsored by *Le Figaro*; a long, detailed letter from Gabriel Mourey (1893) discussing his plans for a series of monographs on contemporary French and British artists; seven letters (1894-99) from Lucien Pissarro about projects for illustrated books; two letters from Paul Signac (1894, n.d.); and a file of letters (34) from Gustave Geffroy on various journalistic matters, including the publication of his collected criticism and the brochure promoting his project for a "Musée du soir." A sketch by Carrière for the cover of the brochure is also included in the collection. In addition to Geffroy and Marx, critics represented by significant groups of letters are Arsène Alexandre, Henry Nocq, Moreau-Nelaton, Thadée Natanson, Félix Fénéon, Frantz Jourdain, and Emile Verhaeren. A three-page draft manuscript (n.d.) by Octave Uzanne concerns the subject of art and industry and functionalism in the decorative arts. A one-page manuscript by Geffroy (1899) is an open letter to the Director of Fine Arts advocating independent exhibition by decorative artists for the World's Fair of 1900. Letters are arranged alphabetically by author.

1953. PISSARRO, CAMILLE. *Letters*, 1882-1903. Holographs, signed. 50 items. Located at The Getty Research Institute for the History of Art and the Humanities, Special Collections, Los Angeles.

Includes letters to family members, critics, dealers, and colleagues. Letters written from London, Paris and Eragny to his wife Julie, sons Rodophe and Lucien, and niece Esther, discuss financial matters, health, travel plans and provide instructions regarding the sale of works of art, including prices, and the shipment of paintings and materials (19 items, 1890-1903). Other letters are addressed to: Georges de Bellio (1882-91); Paul Durand-Ruel (1888); Maximilien Luce (1889-90); Georges Petit (1889); Theodore Child (1889); Gustave Geffroy (1890); Claude Monet (1890-91); Paul Signac (1894); Hippolyte Petitjean (1893, 1897); Ambroise Vollard (1896); and André Portier (1897); and include mention of personal matters, upcoming exhibitions and work in progress. Collection also includes two pages of notes listing paintings done at Le Havre, giving the subject and buyer in some instances (21 Sept. 1903) arranged in chronological order.

1954. SIGNAC, PAUL. *Letters Sent and Signac Family Correspondence*, 1860-1935. 98 items. Holographs, signed; manuscript signed. Located at The Getty Research Institute for the History of Art and the Humanities, Special Collections, Los Angeles.

Letters from Signac to several colleagues discussing work in progress, exhibitions, contemporary art, La Société des Artistes Indépendants, and personal and financial matters. A significant number of these letters are addressed to Edouard Fer, a neo-impressionist disciple whose independent means and connections enabled him to promote Signac's career. Other correspondents include Camille Pissarro, Claude Monet, Georges Turpin, Henri Martineau, Georges Lecomte, and Luc-Albert Moreau. There is also a draft essay for a

review of l'Exposition des Peintres provençaux held in 1902. Most of the letters in this collections are Signac family correspondence; some of these are addressed by Paul Signac to his cousins. The repository also holds a significant series of Signac's correspondence within the papers of Théo Van Rysselberghe.

In his 35 letters to Edouard Fer (1916-32, bulk 1918-21), Signac discusses the organization of exhibitions, mostly in Switzerland, and the critical reaction to his own work. He does not forget to offer Fer occasional advice. Other letters include ten to Pissarro (1886-99) in one of which he comments on Pissarro's stylistic evolution and his own recent landscape painting in the Midi (1897); a letter that recounts the formation of La Société des Artistes Indépendants in 1884 with mention of Redon, Seurat, and Théodore Rousseau; a letter to Georges Lecomte where Signac comments on Symbolism, Puvis de Chavannes, Maximilien Luce, and Lecomte's recent work; a letter from Brussels describing at great length a visit to a foundry (1897); two notes to Henri Martineau pertaining to Signac's study of Stendhal (1919, 1928); one letter to an unnamed critic thanking him for a favorable article and describing his trips to Brittany and Provence (1933); and fragment of a letter in response to an inquiry on interior decorating.

Includes a draft essay of a review of l'Exposition des Peintres provençaux held in Marseilles in 1902, and an introductory statement on the exhibition followed by remarks characterizing the work of individual painters including Jean-Antoine Constantin, Emile Loubon, Auguste Aiguier, Gustave Ricard, Adolphe Monticelli, and Paul Guigou.

Signac family correspondence deals with family life, children, illness, vacations, money worries, marriages, divorces, and so forth. A small number of these are written by Paul Signac to his cousins. The rest are between other family members. Most of the letters seem to be about Julie and Alfred Signac's family–Paul Signac's aunt and uncle. Included are letters from his grandmother, grandfather, and cousins.

Organization: Letters from Signac to colleagues (folders 1-5), Manuscript (folder 6), Signac family correspondence (folders 7-18). Folder list available in repository.

1955. VAN RYSSELBERGHE, THEO. *Correspondence*, ca. 1889-1926. ca. 225 items. Holographs, signed. Located at The Getty Research Institute for the History of Art and the Humanities, Special Collections, Los Angeles.

Collection contains 84 letters of Van Rysselberghe to, among others, Madame Van Rysselberghe, the dealer Huinck, Paul Signac, and Berthe Willière; and 141 letters received from colleagues including Henri Cross, Paul Signac, Camille Pissarro, and Henry Van de Velde. The letters, many of which are extensively illustrated, are largely theoretical in nature and explore all facets of art theory and practice associated with the Neo-Impressionist milieu of the late 19th and early 20th centuries.

Organization: Series I. Letters to Madame Van Rysselberghe, ca. 1902-20 (folder 1); Series II. Miscellaneous letters, 1900-26 (folders 2-3); Series III. Letters received from Paul Signac, ca. 1892-1909 (folders 4-8); Series IV. Letters received from Henri Cross, 1908-10, n.d. (Folders 9-11); Series V. Miscellaneous letters received, ca. 1889-1905, n.d. (Folders 12-13).

Series I. Letters to Madame Van Rysselberghe, ca. 1902-20 (32 items). Thirty-two letters, a significant portion dated 1918-20, include detailed discussion of travels, work in progress, especially on portraits, his own emotional state and personal matters. Van Rysselberghe writes of technical matters, including difficulties associated with painting "en plein air" and a decorative project underway for Armand Solvay, and describes in some detail his stay at

the Château de Mariemont. Other letters also include discussion of upcoming exhibitions and comments on the writing of André Gide, Jacques-Emile Blanche, and Marcel Proust. Series II. Miscellaneous letters, 1900-26 (52 items). Twenty letters to Van Rysselberghe's dealer Huinck concern practical matters associated with upcoming exhibitions in Holland such as the framing and packing of works of art, titles, dimensions and prices of paintings, train schedules, and fluctuating currency (1924-25). Nineteen letters and postcards to Berthe Willière on work, travel, and personal matters (1909-26). In three letters to Paul Signac, Van Rysselberghe defends his criticism of Signac's work, explains his own working method, and responds to the suggestion that his work was adversely influenced by Maurice Denis (1909). One letter to André Gide concerns the "fond d'atelier" of Henri Cross and a possible retrospective exhibition (1918). Other correspondents include Pierre Bounier (1900, 1914), Armand Solvay (1922), and a M. Dunan (1925-26).

Series III. Letters received from Paul Signac, ca. 1892-1909 (74 items). Seventy-four detailed letters, many extensively illustrated with color and ink sketches, focusing primarily on theoretical issues. Signac outlines ideas for work in progress, discusses color theroy and the divisionist technique, and comments on a wide variety of matters, including Old Master painting and the work of Seurat, Maurice Denis, Odilon Redon, Paul Sérusier, Henri Cross, and Eugène Delacroix. In several essay-length letters, Signac attempts to render in a systematic manner the theory of Neo-Impressionism and his own approach to painting and avidly defends the pointillist technique. The letters also include discussion of practical matters relating to exhibitions and the sale of paintings, as well as mention of literary interests and personal news.

Series IV. Letters received from Henri Cross, 1908-10, n.d. (53 items). Eleven letters addressed to Van Rysselberghe contain discussion of work in progress (illustrated) and working method and include mention of Félix Fénéon, Signac, and Henri Matisse. Forty-two letters, mostly personal in nature, are addressed to Madame Van Rysselberghe and contain some mention of literary and musical interests, daily activities, and art-related matters.

Series V. Miscellaneous letters received, ca. 1889-1905, n.d. (14 items). Includes four letters from Camille Pissarro concerning printmaking ventures and including mention of Octave Maus and André Marty (1895); two brief letters from Maximilien Luce (n.d.); one letter from Maurice Denis mentioning two portraits by Van Rysselberghe and commenting on personal travel plans (n.d.); and seven letters from Henry Van de Velde explaining in some detail his difficulties with the Neo-Impressionist style and outlining plans for an exhibition in Berlin designed to interest the German press in Neo-Impressionism (1890-1905).

II. Books Illustrated by Luce

1956. BOGEY, GUSTAVE. *Coins de Paris: le petit betting*. Suite de huit lithographies par Maximilien Luce. Paris: A. Ferrond; E. Bénézit-Constant, 1890. 8 p., 8 pl.

Includes eight lithographs by Luce of racetracks in Saint-Ouen.

1957. VALLES, JULES. *Mazas*. Texte de Jules Vallès. Publié avec l'autorisation de Séverine. Lithographies par Maximilien Luce. Paris: A l'Estampe Originale, 1894. 9 p., pl.

Includes ten lithographs by Luce on the life of political prisoners in Mazas prison, where Luce was incarcerated from 8 July to 17 August 1894 on suspicion of collusion in the

assassination on 24 June of Sadi Carnot, President of the Third Republic, by the Italian anarchist Santo Jeronimo Caserio.

1958. LUCE, MAXIMILIEN. *Les Gueules noires.* Préface par Charles Albert. Paris, 1896.

Album of ten engraved drawings inspired by Constantin Meunier's (1831-1905) sculptures of the lives of Belgian coal miners that were produced for the periodical *La Sociale* and first shown at Galerie Bing, Paris (Dec. 1895-Jan. 1896).

III. Books

1959. AGAMEMNON, JEAN. *Musée Maximilien Luce de Mantes-la-Jolie.* Préface par Armand Lanoux, 1975. Mantes-la-Jolie: Musée Maximilien Luce, 1975.

Introductory visitor's booklet for the Musée Maximilien Luce. Lanoux's preface is entitled "Lumière de Luce."

1960. BOUIN-LUCE, JEAN and DENISE BAZETOUX. *Maximilien Luce: catalogue raisonné de l'œuvre peint.* Préface de Carol Heitz. Collaboratrice pour la documentation: Christine Veyssière. Traduction anglaise par Denis Mahaffey. Paris: Editions JBL, 1986. 2 vols. (243, 640 pp.). In French and English. (Edition complète)

Catalogue raisonné of Luce's paintings and painted ceramics with 2,730 illustrated entries. Volume 1 includes biographical information, a survey of his paintings, career, and association with Neo-Impressionism, a discussion of his anarchist politics and propagandist printmaking for the popular press, information on his work as a ceramist, and an extensive bibliography (1885-1983; pp. 167-94). Chronlogy, pp. 22-30; Exhibitions list, pp. 195-243. Volume 2 is chiefly color illustrations of his œuvre.

1961. CAZEAU, PHILIPPE. *Maximilien Luce.* Avec la collaboration de Sylvie Ferrand-Minvielle et Béatrice de Verneilh. Lausanne: Bibliothèque des Arts, 1982. 227 p. illus.

Heavily illustrated (sketches, drawings, paintings, pastels, watercolors, and graphic works) biography that includes a chronology (pp. 195-201), bibliography (pp. 203-14), and an exhibitions list (pp. 209-14).

1962. COQUIOT, GUSTAVE. *Les Indépendants, 1884-1920.* Paris: Ollendorff, 1920. 239 p., illus., 40 pl.

Mentions Luce on pages 49-50.

1963. DENIZEAU, GERARD. *Maximilien Luce: le monde du travail.* M.A. thesis, Paris IV (Sorbonne), 1983.

1964. DORIVAL, BERNARD. *Les Etapes de la peinture française contemporaine.* Paris: Gallimard, 1943-48.
4 vols.

Volume 1, *De l'impressionnisme au fauvisme. 1833-1905,* mentions Luce on pages 258-60, 272.

1965. ESCHOLIER, RAYMOND. *La Peinture française. XX^e siècle.* Paris: Floury, 1937. 144 p., illus., col. pl.

Mentions Luce on pages 6-7.

1966. FONTAINAS, ANDRE and LOUIS VAUXCELLES. *Histoire générale de l'art français. De la Révolution à nos jours.* Paris: Librairie de France, 1922. 3 vols., illus., 124 pl., 20 col.

Volume 1, *La Peinture. La Gravure. Le Dessin,* mentions Luce in Chapter 14, "Le Divisionnisme," pages 242-3.

1967. HOLL, J.-C. *La Jeune peinture contemporaine: Maurice Denis, Georges d'Espagnat, Albert André, Maximilien Luce, Paul Signac, Charles Guérin, Pierre Laprade, Henri Déziré, Albert Marquet, Louis Charlot, Claude Rameau, Charles Lacoste.* Paris: La Renaissance Contemporaine, 1912.

Includes a chapter on Luce, pages 61-7.

1968. KLINGSOR, TRISTAN L. *La Peinture.* Paris: F. Rieder, 1921. 124 p., illus. (L'Art français depuis vingt ans, 3)

Mentions Luce on pages 57, 69-70.

1969. LAY, HOWARD GEORGE. *La Fête aux boulevards extérieurs: Art and Culture in fin de siècle Montmartre.* Ph.D. diss., Harvard University, 1991. 270 p.

Focuses on the cultural transformation of the Montmartre area of Paris from 1880 to 1895, with special attention to artists such as Toulouse-Lautrec and Maximilien Luce. Relates Montmartre's bohemian culture and popular entertainments to its rapidly developed artistic community.

1970. MELLERIO, ANDRE. *La Lithographie originale en couleurs.* Paris: Publication de l'Estampe et de l'Affiche, 1898. 43 p., illus., 1 pl.

Luce's lithographs are mentioned on pages 17, 23, and 26.

1971. SCHEIDIG, WALTHER. *Meisterworke der malerei.* Schätzeans Kleinen und Mittleren Sammlungen. Leipzig: Edition Leipzig, 1964. 159 p., illus., some col.

Mentions Luce on pages 124-5.

1972. SUTTER, JEAN, ed. *Les Néo-impressionnistes.* Neuchâtel: Ides et Calendes, 1970.

Includes a chapter on Luce by Jean Sutter.
a. U.S. ed.: Greenwich, CT: Trans. by Chantal Deliss. New York Graphic Society, 1970. 232 p., illus., col.

1973. SUTTER, JEAN. *Luce, les travaux et les jours.* Lausanne: International Art Book, 1971. 63 p., col. illus. (Rythmes et couleurs, 2).

1974. SUTTER, JEAN. *Maximilien Luce 1858-1941: peintre anarchiste.* Paris: Galerie des Vosges, 1986. 140 p., illus.

Biography with little criticism. Includes exhibitions lists, pages 129-40.

1975. TABARANT, ADOLPHE. *Maximilien Luce.* Paris: G. Crès, 1928. 74 p., illus., 39 pl.

Early biography of Luce that reproduces representative works.

1976. TURPIN, GEORGES. *Dix-huit peintres indépendants.* Paris: Georges Girard, 1931. 217 p., illus.

Includes a chapter on Luce, pages 129-40.

IV. Articles

1977. AGAMEMNON, JEAN. "Luce à Rolleboise." *Annales historiques du Mantois* 4,5:6,7(1978-79):46-58, 33-41, 21-30.

Three-part article on Luce's long association with Rolleboise, a village on the banks of the Seine west of Paris in the Mantois region where he purchased a house in 1917 and where he is buried. The articles are subtitled: "La Dernière période de Luce"; "La Dernière période de Luce, 2ᵉ partie"; and "La Dernière période de Luce, sites et motifs."

1978. ALEXANDRE, ARSENE. "L'Oeuvre de Maximilien Luce." *Cahiers de Belgique* 10(Dec. 1929):382-5.

1979. BESSON, GEORGE, ed. "Fragments du journal de Paul Signac." *Arts de France* 11-2(1947):101-2.

Entry for 18 April 1901 mentions Luce.

1980. BESSON, GEORGE. "Maximilien Luce." *Parallèle 50*(26 June 1952).

1981. C., D. "Maximilien Luce." *Arts* 157-8(12 and 19 March 1948):1, 5.

1982. C., P. "Hommage à Maximilien Luce." *Beaux-arts* new ser., 20(23 May 1941):5.

Obituary and tribute.

1983. CHRISTOPHE, JULES. "Maximilien Luce." *La Cravache parisienne* 388(28 July 1888).

1984. CHRISTOPHE, JULES. "Maximilien Luce." *Les Hommes d'aujourd'hui* 8:376(1890).

1985. CHRISTOPHE, JULES. "Les Portraits du prochain siècle." *La Plume* 107(1 Oct. 1893):416.

1986. COGNIAT, RAYMOND. "Maximilien Luce à Charleroi." *Le Figaro* (26 Nov. 1966).

1987. DARIEN GEORGES. "Maximilien Luce." *La Plume* 57(1 Sept. 1891):299-300.

1988. DE VERNEILH, BEATRICE. "Maximilien Luce et Notre-Dame de Paris." *L'Oeil* 332(March 1983):24-31. 10 illus.

Discusses Luce's series of ten paintings of the Cathedral of Notre-Dame, Paris, executed at the turn of the century. De Verneilh divides the paintings into five groups of two, according to theme and composition. All seem to have been painted from the Quai Saint-Michel and show the western façade and part of the south.

1989. DORNAND, GUY. "Maximilien Luce, peintre du travail et par avance maître du réalisme socialiste." *Libération* (3 May 1951):2.

1990. DORR, GOLDWAITHE H. III. "Putnam Dana McMillan Collection." *Minneapolis Institute of Art Bulletin* 50(Dec. 1961):50-1.

Illustrated with Luce's *Notre-Dame*.

1991. DURAN-TAHIER, H. "Exposition des néo-impressionnistes." *La Plume* 88(15 Dec. 1892):531.

Exhibition review that mentions Luce.

1992. "Example of Luminosity through Divisionism." *Springfield Museum of Art Bulletin* 21(June 1955):6.

Illustrated with Luce's *Quai à Camavert-Finistère*.

1993. "Exposition Maximilien Luce." *L'Art moderne* 15:44.

1994. FLAX, NEIL M. "Maximilien Luce." *Les Hommes du jour* 60(13 March 1909).

1995. FRADISSE, OLGA. "Luce et les néo-impressionnistes." *La Revue des arts* 8(1958):199-200.

1996. GEFFROY, GUSTAVE. "Luce et Signac." *Le Journal* (10 Dec. 1894).

1997. GEFFROY, GUSTAVE. "Luce et Signac." *La Vie artistique* 6(1894):286.

Concerns paintings by Luce and Signac shown at the 20 rue Laffitte, Paris exhibition sponsored by the Groupe des Peintres néo-impressionnistes.

1998. GUILLEMOT, MAURICE. "Maximilien Luce." *Le Carnet des artistes* 12(15 July 1917):3-5.

1999. "Hommage à Paul Signac. Son compagnon de toutes les luttes: Maximilien Luce. Président de la Société des Artistes Indépendants." *L'Humanité* (5 March 1938):8.

2000. JEROMACK, PAUL. "Maximilien Luce: Guilt – or Fame by Association?" *Art Newspaper* 8(May 1997):48.

2001. KLINGSOR, TRISTAN L. "Maximilien Luce." *L'Art et l'artiste* new ser., 3(1921):287-90.

2002. ["Maximilien Luce."] *Le Journal* (16 and 21 Oct. 1895).

Brief critical notices of Luce.

2003. MAZARS, PIERRE. "Luce comme lumière." *Le Figaro* (26 July 1977).

2004. MOREAU-VAUTHIER, PAUL. "Le Peintre Maximilien Luce." *Art et artiste* new ser. 21(Nov. 1930):58-61.

Brief biographical and critical account illustrated with Luce's *Vue de Dordrecht* and *Paysage, dans l'Yonne*.

2005. "Le Musée Maximilien Luce de Mantes-la-Jolie." *Bulletin municipal officiel, Mantes-la-Jolie* 104(March 1972):12-4.

2006. PEILLEX, GEORGES. "Entrée dans les arts par la petite porte, Luce était classé 'anarchiste dangereux'." *L'Amateur d'art* (19 March 1970):7.

2007. "Portrait by J. Texcier." *Revue de l'art bulletin* 59(March 1931):110.

2008. "Portrait Bust by A. Marque." *Beaux-arts* (2 Feb. 1934):5.

2009. "Portrait by C. Le Breton." *Beaux-arts* (18 Jan. 1935):1; *Revue de l'art bulletin* 67(Feb. 1935):67.

2010. RAMBOSSON, YVANHOË. "Exposition permanente des peintres impressionnistes et symbolistes." *La Plume* 71(1 April 1892):165.

Exhibition review that mentions Luce.

2011. REY, ROBERT. "Notices." *L'Amour de l'art* (1933):39

Brief mention of Luce following Rey's article, "Le Néoimpressionnisme. I. Doctrine et artistes," pp. 33-5.

2012. SAUNIER, CHARLES. "Exposition des peintres impressionnistes et symbolistes." *La Plume* 66(15 Jan. 1892):52.

Exhibition review that mentions Luce.

2013. SAUNIER, CHARLES. "Maximilien Luce." *Art et décoration* 15(May 1904):supp., 2-3.

2014. SHIKES, RALPH E. and STEVEN HELLER. "The Art of Satire: Painters as

Caricaturists and Cartoonists." *Print Review* 19(1984):8-125. illus.

See pages 37-9 for information on Luce and reproductions of his *La Vache à lait, Filles à soldats, Comment on entraîne les marins russes*, and *Les Chaouchs s'amusent*.

2015. SIGNAC, PAUL. *"Maximilien Luce* (Pen, brush, brown ink, and pencil, 1890)." *Burlington Magazine* 128(Nov. 1986):39.

Portrait of Luce by Signac.

2016. TEXCIER, JEAN. "Maximilien Luce." *Triptyque* 8(May 1927):25-32.

2017. TEXCIER, JEAN. "L'Exemple de Maximilien Luce." *Gavroche* (13 Feb. 1947):1-2.

2018. TEXCIER, JEAN. "Maximilien Luce." *Le Populaire* (27 June 1952).

2019. TURPIN, GEORGES. "Maximilien Luce." *L'Acropole* 12(June-July 1951):30-2.

2020. UHDE-BERNAYS, HERMANN. "Die Tschudispende." *Kunst and Künstler* 10(May 1912):387.

V. Individual Exhibitions

1888, July	Paris, 11, Chaussée d'Antin. *La Revue indépendante.* Luce. 10 paintings.
	Review: G. Kahn, *La Revue indépendante* 8:122(Aug. 1888):315-6.
1895, 21 October-5 November	Paris, passage des Princes. *Petite Revue documentaire. Maximilien Luce.*
	Exhibition sponsored by Eugène Baillet. Review: *L'Art moderne* 15:44(3 Nov. 1895):349.
1899, 16 October-1 November	Paris, Galerie Durand-Ruel. *Maximilien Luce.* 61 paintings shown, 33 of which depict Belgium's coal-mining region.
1902, May	Paris, Galerie Vollard. *Maximilien Luce.*
1904, 8-26 March	Paris, Galerie Druet. *Maximilien Luce.* Préface par Félix Fénéon. 9 paintings, 80 studies, and 200 drawings shown.
	Review: R.M., *La Chronique des arts et de la curiosité* 12(19 March 1904):102. Supplement to *Gazette des Beaux-arts.*

1906, 23 April-12 May — Paris, Galerie Druet. *Maximilien Luce.*

Review: F. Monod, *Art et décoration* 19(June 1906):supp., 2.

1907, 15-28 February — Paris, Galerie Bernheim-Jeune. *Exposition Luce.* Préface par Gustave Geffroy. 54 works shown.

Review: P. Jamot, *La Chronique des arts et de la curiosité* 8(23 Feb. 1907):60. Supplement to *Gazette des Beaux-arts.*

1909, 19 April-1 May — Paris, Galerie Bernheim-Jeune. *Luce.* Préface d'Emile Verhaeren. 65 paintings shown, including 40 Dutch landscapes.

1910, 14-19 November — Paris, Galerie Bernheim-Jeune. *Luce.*

1911, February — Zurich, Kunsthaus. *Maximilien Luce.*

1912, 15-24 January — Paris, Galerie Bernheim-Jeune. *Luce.*

Review: J. René, *La Chronique des arts et de la curiosité* 3(20 Jan. 1912):20. Supplement to *Gazette des Beaux-arts.*

1914, 2-20 February — Paris, Galerie Choiseul. *Maximilien Luce.* Préface par Pierre Hamp.

Review: L. Hautecœur, *La Chronique des arts et de la curiosité* 8(21 Feb. 1914):59. Supplement to *Gazette des Beaux-arts.*

1914 — Düsseldorf, Galerie Flechtheim. *Maximilien Luce.*

1916, 23 October-11 November — Paris, Galerie Bernheim-Jeune. *Luce–Les Gares de Paris pendant la guerre.*

1920, May — Paris, Galerie Marseille. *Maximilien Luce.*

1921, 11-30 April — Paris, Galerie L. Dru. *Exposition Luce.*

1922, 2-20 May — Paris, Galerie Durand-Ruel. *Exposition Maximilien Luce, Quarante-quatre dessins.* 44 drawings.

1924, 17-31 March — Paris, Galerie Durand-Ruel. *Exposition Maximilien Luce.*

Review: *La Renaissance de l'art français et des industries de luxe* 7(April 1924):222.

1926, March — Paris, Galerie Druet. *Maximilien Luce.*

Review: R. Bouyer, *Bulletin de l'art ancien et moderne* 727(April 1926):120-1. Supplement to *Revue de l'art.*

1929, 1-15 June	Paris, Galerie Bernheim-Jeune. *50 ans de peinture: Maximilien Luce*. Fifty-year retrospective.
	Includes various critical texts.
1930, 11-31 January	Paris, Galerie Brû. *Maximilien Luce*.
1937, 27 May-12 June	Paris, Galerie Jacques Rodrigues-Henriques. *Maximilien Luce*.
1938, 4-19 November	Paris, Galerie Jacques Rodrigues-Henriques. *Maximilien Luce–sur les berges*.
1941, 17 May-14 June	Paris, Galerie Berri-Raspail. *Rétrospective: Maximilien Luce*. Préface par Adolphe Tabarant.
	Includes additional critical and memorial texts.
1942, 6 March-6 April	Paris, Société des Artistes Indépendants, Musée d'Art moderne de la Ville de Paris, *Exposition posthume de Maximilien Luce*.
1948, 10-27 March	Paris, Galerie de l'Elysée. *Maximilien Luce, exposition rétrospective*.
	Reviews: *Arts* (12 March 1948):1; (19 March 1948):5.
1948, March	Paris, Galerie Lorenceau. *Quelques peintures de Maximilien Luce*.
1949, 25 June-3 July	Mantes-la-Jolie, Salle municipale, Salon des peintres mantois. *Rétrospective Maximilien Luce*.
1951, 22 April-11 May	Paris, 16 rue de Seine, Frédéric Luce. *Travail-peintures de Maximilien Luce*.
	Exhibition held at Frédéric Luce's Parisian residence, Maximilien's second son.
1952, 27 March-14 April	Lausanne, Galerie Paul Vallotton. *Maximilien Luce*.
1952, 17 June-2 July	Paris, Galerie Marseille. *Maximilien Luce*. Préface par George Besson.
1954, 12 October-6 November	London, Wildenstein Galleries. *Paintings by Maximilien Luce*.
	Reviews: *Apollo* 60(Nov. 1954):114; *Studio* 149(Jan. 1955):29.
1958, 18 January-13 February	Paris, Galerie Sagot-le-Garrec. *Estampes et dessins de Maximilien Luce*.
	Exhibition to commemorate the centenary of Luce's birth.

1958, 17 January-March	Paris, Maison de la Pensée française. *Maximilien Luce, 1858-1941*. Préface par George Besson et autres textes.
	Review: *ARTnews* 57(March 1958):46.
1959, June	Paris, Galerie Henri Bénézit. *Luce: époque néo-impressionniste, 1886-1901*. Préface par Jean Sutter. 1 folded sheet, illus.
1960, 17 November-10 December	Bern, Galerie Auriga. *Maximilien Luce*.
1962	Mantes-la-Jolie, Salon. *Rétrospective Maximilien Luce*.
1966, 29 October-4 December	Charleroi, Palais des Beaux-arts. *Maximilien Luce*. Tricentenaire de Charleroi. Introduction par Robert Rousseau. Préface par George Besson. 36 p., 40 pl.
	Exhibition in commemoration of Charleroi's tricentennial.
1972, November-December	Geneva, Galerie des Granges. *Maximilien Luce*.
1973, 16-24 June	Mantes-la-Jolie, Hôtel de Ville. *Maximilien Luce*.
1975	Nantes, Hôtel de Ville. *Maximilien Luce*.
	Review: *Connoisseur* 190(Nov. 1975):213.
1977, 24 June-30 September	Albi, Musée Toulouse-Lautrec, Palais de la Berbie. *Luce*. Textes de Michel Castel, Jean Devoisins, Jean Agamemnon, Jean-Alain Meric. 24 p., 16 illus., 7 col. 87 works shown.
	Retrospective exhibition of paintings, lithographs, drawings, and pastels dating 1880-1939. Review: *L'Oeil* 264-5(July-Aug. 1977):51.
1983, 24 February-30 April	Paris, Musée Marmottan. *Maximilien Luce*. 40 p., illus.
	Review: *Connaissance des arts* 373(March 1983):24.
1987, 16 May-13 September	Pontoise, Musée Pissarro. *Maximilien Luce*. 20 p., illus., 8 col.
1986	Paris, Galerie des Vosges. *Maximilien Luce, 1858-1941: peintre anarchiste*. Catalogue par Jean Sutter. 140 p.
1987-88, 27 November-30 January	Paris, Galerie H. Odermatt. *Maximilien Luce: époque néo-impressionniste 1887-1903*. Catalogue par Philippe Cazeau. 51 p., col. illus.

1997, 6 May-7 June	NY, Wildenstein Galleries. *Maximilien Luce, 1858-1941: The Evolution of a Post-Impressionist*. Texts by Eliot W. Rowlands and Joachim Pissarro. 129 p., illus., some col. 93 works shown.

Includes a biographical introduction by Eliot W. Rowlands (pp. 17-23), maps (pp. 23-24), a chronology (p. 27), and an essay by Joachim Pissarro, "Luce and Pissarro: Neo-Impressionism, Anarchy, Truth and Utopia" (pp. 9-15).

VI. Group Exhibitions

1887-1940	Paris, Salon de la Société des Artistes Indépendants.

Beginning with 7 paintings at the third Salon des Indépendants in 1887, Luce participated every year until 1940, except 1915-19, and was elected President in 1935. For a complete list of works shown, see Jean Sutter, *Maximilien Luce 1858-1941, peintre anarchiste* (Paris: Galerie des Vosges, 1986):129-35.

1889, 13 February-13 March	Brussels, *VI^e Exposition des XX*. Préambule par Octave Maus. 6 works, including *La Toilette* (owned by Paul Signac) and *Terrains à Montmartre* (owned by Camille Pissarro).
1890, 6-26 March	Paris, Galeries Durand-Ruel. *Peintres-graveurs*.
1891, November-December	Paris, Le Barc de Boutteville. *Peintres impressionnistes et symbolistes*. First group show.
1892, February	Brussels, *IX^e Exposition des XX*. 4 works shown.
1892, May	Paris, Le Barc de Boutteville. *Peintres impressionnistes et symbolistes*. Second group show.
1892-93, 2 December-8 January	Paris, Hôtel Brébant. *Exposition des peintres néo-impressionnistes*. 13 paintings shown.
1893, May	Anvers, Seconde exposition de l'Association pour l'art.
1893	Paris, Le Barc de Boutteville. *V^e Exposition des peintres impressionistes et symbolistes*.
1894, 22 November-8 December	Paris, 20, rue Laffitte, Galerie Léonce Moline. *Néo-impressionnistes*. 22 works shown.
1895, 23 February-1 April	Brussels, La Libre Esthétique. 4 works shown. Second Libre Esthétique exhibition.
1895-96, 27 December-January	Paris, Galerie Bing. Salon de l'Art nouveau.

1897, 25 February-1 April	Brussels, La Libre Esthétique. 3 paintings (priced from 75 to 400 francs) and 3 color lithographs (25 francs each). Fourth Libre Esthétique exhibition.
1897, 1 December	Paris, Le Barc de Boutteville. *XV^e Exposition des peintres impressionnistes et symbolistes.*
1898	Berlin, *Peintres néo-impressionnistes.*
	Sponsored by Count Harry Kessler.
1899, 10-31 March	Paris, Galerie Durand-Ruel. *Néo-impressionnistes.*
1900, 1-31 March	Brussels, La Libre Esthétique. 20 works shown, priced from 250 to 1,000 francs, including 17 from his Charleroi series. Seventh Libre Esthétique exhibition.
1901	Berlin, Galerie Keller und Reiner.
1903, Summer	Weimar.
1904, 25 February-29 March	Brussels, La Libre Esthétique. *Peintres impressionnistes.* 5 works shown.
1905	Paris, Galerie Prath et Maynier. *I^{re} Exposition des artistes impressionnistes.*
1908, 1 March-15 April	Brussels, La Libre Esthétique. 3 works shown.
1908, 1 October-1 November	Zurich, Kunthaus. *Französischen Impressionisten.*
1911, February	Zurich, Kunsthaus.
1912, February	Paris, Galerie Choiseul.
1914, 2-20 February	Paris, Galerie Choiseul. Préface de Pierre Hamp.
1914, April	Paris, Galerie Choiseul. *Montmartre.*
1914, 8-16 June	Paris, Galerie Bernheim-Jeune. *Le Paysage du Midi.*
1916, 5-16 June	Paris, Galerie Bernheim-Jeune.
1918, November	Paris, Galerie du Luxembourg. *Exposition permanente des néo-impressionnistes.*
1922	Brussels, Musées Royaux des Beaux-arts. *Les Maîtres de l'impressionnisme.*
1922, 13-21 May	Issy-les-Moulineaux, Hôtel de Ville.
1931, 5-19 December	Paris, Galerie Durand-Ruel. *Fleurs et natures mortes.*
1932, 25 February-17 March	Paris, Galerie Braun. *Le Néo-impressionnisme.* Préface par Paul Signac.

1933-34, December-15 January	Paris, Galerie des Beaux-arts. *Seurat et ses amis: la suite de l'impressionnisme*. Préface par Paul Signac.
1936-37, 23 December-25 January	Rotterdam, Museum Boymans. *De divisionisten van Georges Seurat tot Jan Toorop.*
1937, 20 January-27 February	London, Wildenstein Galleries. *Seurat and his Contemporaries*. Preface by Paul Signac (1933 catalogue preface translated into English).
1937, June-October	Paris, Petit Palais. *Les Maîtres de l'art indépendant, 1895-1937.*
1937, November	Zurich, Galerie Alkuargus. *Le Néo-impressionnisme*. Also shown Zurich, Galerie U. Sammler.
1938, 3 February-10 April	Paris, Musée de l'Art vivant, Maison de la culture. *Oeuvres de la fin du XIX^e siècle.*
1938, 17 May-3 June	Paris, Galerie Jacques Rodrigues-Henriques. *Quelques œuvres échangées jadis entre eux.*
1939, 20 February-12 March	Paris, Galerie des Beaux-arts. *L'Art contemporain*. Préface par George Besson.
1941, 12-31 May	Paris, Bibliothèque nationale, *Société des Peintres-graveurs français, Bibliothèque nationale. Hommage à Maximilien Luce.*
1942, 29 April	Paris, Galerie René Drouin. *Rivages de France.*
1942, June	Paris, Galerie Charpentier. *Le Paysage français de Corot à nos jours.*
1942-43, 12 December-15 January	Paris, Galerie de France. *Les Néo-impressionnistes.*
1943	Paris, Galerie Charpentier. *Scènes et figures parisiennes.*
1949-50, 10 December-5 March	London, Royal Academy of Arts. *Landscape in French Art, 1500-1900*. Introduction by Bernard Dorival.
1950, 2 November-2 December	London, Redfern Gallery. *Pointillists and their Period.*
1952	Venice, XXVI^e Biennale di Venezia. Catalogue includes a text by Raymond Cogniat, "Il divisionismo in Francia."
1953, 18 November-26 December	NY, Wildenstein Galleries. *Seurat and his Friends.*
1954, September	Stockholm, Liljevalchs Konsthall. *Cézanne till Picasso.*
1955, 15 April-8 May	Paris, Société des Artistes indépendants, Grand Palais. *Hommage à Paul Signac et ses amis*. Text by George Besson.

1955, October-November	Cologne, Galerie Abels. *Französische Gemälde des 19. Und 20. Jahrhunderts.*
1956, 10 June-22 July	Douai, Bibliothèque municipale. *Henri-Edmond Cross et ses amis.* Centenary exhibition of H. E. Cross, that included works by Luce.
1957, 4-22 February	Galerie Vendôme. *Luce—Peské—Maufra—Duval—Gozlan.*
1958, 31 May-8 July	Saint-Denis, Musée Municipal. *M. Luce et son milieu, les néo-impressionnistes.* Centennial exhibition honoring Luce. Review: *Revue des arts* 8(July 1958):199-200.
1958	Luxembourg, Musée des Beaux-arts. *Du néo-impressionnisme à nos jours.*
1960, 27 April-21 May	Paris, Galerie Marcel Guiot. *Bonnard et son époque, 1890-1910.*
1960, 22 October-30 November	Bern, Klipstein and Kornfeld. *Choix d'une collection privée, Sammlungen G. P. und M. E.*
1960, 23 July-31 August	Honfleur, Société des Artistes honfleurais. Grenier à sel. *Le Paysage normand: les peintres pointillistes.*
1960, July-September	Nice, Palais de la Méditerranée. *Peintres à Nice et sur la Côte d'Azur, 1860-1960.*
1961, March-May	Paris, Musée Carnavalet. *Paris vu par les maîtres de Corot à Utrillo.*
1961, 6 June-7 July	Paris, Galerie J.-C. et J. Bellier. *Les Néo-impressionnistes.*
1962, 17 February-31 May	Brussels, Musées Royaux des Beaux-arts de Belgique. Le Groupe des XX et son temps. Also shown Otterlo, Rijksmuseum Kröller-Müller (15 April-31 May 1962).
1962, 10 March-20 April	Cologne, Gemälde-galerie Abels. *Französische Maler der Nachimpressionismus.*
1962, 30 October-17 November	NY, Hammer Galleries. *Seurat and his Friends.*
1963, 1-31 May	London, Terry-Engel Gallery. *Paysages de France.*
1964	Lausanne. *Chefs-d'œuvre des collections suisses de Manet à Picasso.*
1964, June-September	Annecy, Musée Château. *Maîtres connus et méconnus de Montmartre à Montparnasse.*

1965, 20 January-14 March	New Haven, CT, Yale University Art Gallery. *Neo-Impressionists and Nabis in the Collection of Arthur G. Altschul.*
1965, March-April	London, Arthur Tooth Galleries. *The Rim of Impressionism.*
1965, 23 April-10 May	Paris, Société des Artistes indépendants, Grand Palais. *Rétrospective: les premiers indépendants, 1884-1894.* Texte par Raymond Charmet.
1965, July-October	Vevey, Musée Jenisch. *De Vallotton à Desnos.*
1966, 7-25 June	London, Arthur Tooth Galleries. *Pointillisme: A Loan Exhibition of Paintings by Angrand, Cross, Dubois-Pillet, Luce* [et al.]. 10 p., 26 pl.
1966	London, Kaplan Gallery. *Impressionist and Post-Impressionist Paintings, Watercolors, Pastels and Drawings.*
1967, 25 April-27 May	London, Arthur Tooth Galleries. *The Rim of Impressionism II.*
1967, 24 May-27 June	Paris, Galerie Hervé. *Quelques tableaux de maîtres néo-impressionnistes.*
1967	Viroflay, XV^e Exposition. *Quinze ans ou l'essor d'un salon: souvenir de Corot.*
	Text on Maximilien Luce by A. Dunoyer de Segonzac.
1968, February-April	NY, Solomon R. Guggenheim Museum. *Neo-Impressionism.* Catalogue by Robert L. Herbert.
1968	Tucson, University of Arizona Art Gallery. *Homage to Seurat [et al.] from the Collection of Mr. And Mrs. W. J. Holliday, Indianapolis.*
1968	Geneva, Petit Palais. *L'Aube du XX^e siècle, de Renoir à Chagall.*
1969, 7 May-7 June	Paris, Galerie Schmit. *Cent ans de peinture française.*
1969, 20 May-20 June	Geneva, Petit Palais. *Rétrospective 1910. Le Salon des Indépendants de Paris.*
1969, 18-28 December	St. Petersburg, Florida, Museum of Fine Arts. *The Circle of Seurat from the Holliday Collection.*
1970	Geneva, Petit Palais. *L'Art au service de la paix: XXV^e anniversaire des Nations Unies.*
1970, April-October	Paris, Vision Nouvelle. *La Belle époque de la lithographie en couleurs.*
1970, June-September	Riom, Musée Mandet. *Collections privées d'Auvergne.*

1971, 18-30 January NY, Hammer Galleries. *Neo-Impressionism.*

1971, 24 February-20 March Paris, Galerie Boissière. *Arbres.*

1971, 18 March-13 September Saint-Denis, Musée d'Art et d'histoire, Exposition du centenaire. *La Commune de Paris, 1871-1971.*

1971, 19 March-25 April Coral Gables, Florida, University of Miami, Lowe Art Museum. *French Impressionists Influence American Artistes.*

1971, 13 May-30 July NY, Pierpont Morgan Library, Benjamin Sonnenberg Collection. *Artists and Writers.*

1971, 2-19 June Paris, Galerie J.-P. Wick. *Quelques paysagistes de 1850 à 1900.*

1972-73, 23 December-25 February Nice, Galerie des Ponchettes. *Les Peintres de Saint-Tropez.*

1975 Saint-Tropez, Musée de l'Annonciade. *Paul Signac et ses amis à Saint-Tropez de 1892 à 1914.*

1979-80, 17 November-16 March London, Royal Academy of Arts. *Post-Impressionism.*

1985, 18 June-30 July London, Connaught Brown. *Aspects of Post Impressionism.* 36 p., 23 illus., 4 col.

Exhibition of works by various Post Impressionists, including Luce.

1990, 19 April-2 June London, Connaught Brown. *Spring Exhibition.* 32 p., 18 illus., 15 col. No text.

Included works by Luce.

1992, 9 November-21 December Stuttgart, Kunsthaus Buhler. *Deutsche und französische Gemälde des 19 und fruhen 20. Jahrhunderts.* 72 p., 34 col. illus.

Exhibition of nine German and ten French artists, including Luce.

1995, 7 June-29 July

Charleroi, Belgium, Musée des sciences de Parentville. *Maximilien Luce, 1858-1941: peintre anarchiste*. Préface par Jean Agamemnon. Catalogue par Jean-Jacques Heirwegh. Collaboration: Jean-François Füeg, Aline Dardel. Brussels: Université Libre de Bruxelles, 1995. 74 p., illus., 123 works shown.

Exhibition of paintings, drawings, prints and illustrations by Luce, accompanied by works from associates such as Charles Angrand, Eugène Boch, Gisbert Combaz, Léo Gausson, and Constantin Meunier. The exhibition explored the anarchist movement from 1880 to 1914 with attention to propagandist images in the popular press.

No date

NY, Wally Galleries. *Three French Masters: Henri-Martin, Maurice Utrillo, Maximilien Luce*. 12 p., illus., some col.

Albert Dubois-Pillet

Biography

Louis-Auguste-Albert Dubois, who began adding his mother's birth name to paintings around 1884, was born in Paris and reared in Toulouse. A career military officer, he graduated from l'Ecole Impériale Militaire at Saint-Cyr in 1867. Dubois fulfilled various provincial military assignments before settling in Paris as a member of La Garde Républicaine in 1880. Earlier, he had fought in the Franco-Prussian War (1870-71) and was a prisoner of war in Westphalia, Prussia.

Dubois-Pillet was an accomplished self-taught artist. The Salons of 1877 and 1879 accepted his still-lifes but rejected more experimental paintings after he came to Paris. His famous *Dead Child* (1881), shown at Les Indépendants in 1884, inspired a grisly scene in Zola's novel *L'Oeuvre* (1886) where the fictitious painter Claude Lantier dispassionately records the changing facial hues of his recently deceased infant son.

Dubois-Pillet met Seurat, Angrand, and Signac in 1884. His Neo-Impressionist works, which date from 1886, include portraits, still-lifes, cityscapes, and river scenes. He experimented constantly with pointillist color dots and tonal gradations. In the early years of Neo-Impressionism, his studio-apartment at 19 Quai Saint-Michel was the movement's unofficial headquarters. Quietly ignoring the army's orders against exhibiting, Dubois-Pillet showed regularly at Les Indépendants, in Nantes in 1886, and with Les XX in Brussels in 1888 and 1889. At the 1888 Indépendants exhibition, Dubois-Pillet exhibited a pointillist frame around a circular painting called *Table Lamp*. He also played a key role in founding and administering La Société des Artistes Indépendants. He authored the group's statutes and was its chief organizer until 1888.

Dubois-Pillet was posted to Le Puy in November, 1889 and died there in August, 1890 during a smallpox epidemic. His last paintings portray the distinctive landscape and churches of the Auvergne. Late in life he began to modify divisionism with a triad color theory (reds, greens, violets) that he called *passage*. Contributing to his reputation as an enigmatic Neo-Impressionist, a fire apparently destroyed most of his œuvre. Roger Gounot's *catalogue raisonné* (1969) lists extant works.

Albert Dubois-Pillet

Chronology, 1846–1890

Information for this chronology was gathered from Lily Bazalgette, *Albert Dubois-Pillet, sa vie et son œuvre (1846-1890)* (Paris: Gründ Diffusion, 1976); Roget Grounot, "Le Peintre Dubois-Pillet," *Cahiers Haute-Loire* (1969):99-131; and Martha Ward, "Louis-Auguste-Albert Dubois-Pillet" in *The Dictionary of Art* (NY: Grove Press, 1996)9:323-4.

1846

28 October
Birth of Albert Dubois in Paris. His family soon moves to Toulouse.

1867

Graduates from l'Ecole Impériale Militaire in Saint-Cyr and begins a lifelong career as an army officer.

1870 -71

Serves in the Franco-Prussian War. Captured by Germans, he is held a prisoner of war in Westphalia, Prussia. Upon release he rejoins the Versailles army and participates in the suppression of the Commune.

1870s

Army officer at various provincial postings.

1877

First still-life is accepted at the official Salon.

1879

Appointed to la Légion de la Garde Républicaine in Paris. Shows again at the Salon, where subsequent experimental work is rejected from 1880-83.

1881

Completes *Dead Child*, shown at Les Indépendants in 1884. The painting inspires a grisly scene in Emile Zola's novel *L'Oeuvre* (1886).

1884

Founding member of La Société des Artistes Indépendants, where he meets Seurat, Signac, and Angrand. He helps write the exhibition society's statues, leverages freemasonic connections with city officials to obtain favorable exhibition venues and terms, and is the chief organizer within it for the Neo-Impressionists. Begins signing his paintings "Dubois-Pillet" (Pillet was his mother's birth name) to help his military and artistic career.

1885

Experiments with pointillism and divisionist color harmonies.

1886

First fully Neo-Impressionist canvasses. Executes pointillist pen-and-ink drawings with Signac. Army orders him to cease participating in exhibitions and to withdraw from Les Indépendants, which requests he quietly ignores. Shows in Nantes.

1887

Publishes pointillist drawings in *La Vie moderne*.

1888

Exhibits with Les XX in Brussels and at Les Indépendants, where his circular painting *Table Lamp* sports a pointillist frame. First single-artist show at the offices of *La Revue indépendante*.

1889-90

Experiments with *passage*, a triad color theory (reds, greens, violets) based upon optical excitement and fatigue studies by the English scientist Thomas Young (1773-1829).

1889

December
Army transfers him to Le Puy, perhaps in response to his defiance of orders forbidding him to exhibit. Final works depict landscapes and churches of the Auvergne.

1890

18 August
Dies in Le Puy during a smallpox epidemic.

1891

Les Indépendants mount a memorial exhibition of 64 paintings.

Albert Dubois-Pillet

Bibliography

I. Archival Materials

2021. DUBOIS-PILLET, ALBERT. *Lettres inédites de Dubois-Pillet à Octave Maus.* Holographs. Located at Musées Royaux des Beaux-arts de Belgique, Brussels.

Includes 4 letters, dated 5 December 1887, 19 December 1887, 10 January 1888, 19 November 1889, to Maus (1856-1919), secretary of Les XX and La Libre Esthétique exhibition societies and co-founder of Belgium's leading avant-garde art journal, *L'Art moderne.*

2022. DUBOIS-PILLET, ALBERT. *Letter*, 1888. Holograph, signed. 1 p. Located at The Getty Research Institute for the History of Art and the Humanities, Special Collections, Los Angeles, California.

Letter from Paris dated 23 March 1888 to an unidentified correspondent proposing to sell "l'art moderne" during a present exhibition. Dubois-Pillet sends regards to Emile Verhaeren (1855-1916) and Les Vingtistes.

II. Books

2023. BAZALGETTE, LILY. *Albert Dubois-Pillet, sa vie et son œuvre (1846-1890).* Paris: Gründ Diffusion, 1976. 183 p., illus.

Scholarly monograph on Dubois-Pillet's life and works. Includes salons where the artists exhibited (pp. 161-5), exhibitions (p. 166), illustrations and publications (p. 167), museums

that hold his works (pp. 168-9), group exhibitions (pp. 170-71), public auctions of his works (p. 172), collections that hold his work (p. 173), and a bibliography (pp. 174-6).
Review: P.,G., *Gazette des Beaux-arts*, ser. 6, 89(May-June 1977):25.

2024. DORRA, HENRI and JOHN REWALD. *Seurat: l'œuvre peint, biographie et catalogue antique.* Paris: Bibliothèque des Arts, 1959. 311 p., illus., 3 col. (L'Art français)

Cites three letters regarding Dubois-Pillet dated 1886-87 from Seurat to Signac, pages 49-51.

2025. PISSARRO, CAMILLE. *Lettres à son fils Lucien.* Paris: Albin Michel, 1950. 522 p., illus., 68 pl.

Includes letters from Pissarro that mention Dubois-Pillet.

2026. STOCK, PIERRE VICTOR. *Mémorandum d'un éditeur.* Paris: Stock, 1935.

Mentions Dubois-Pillet on page 300.

III. Articles

2027. ALEXANDRE, ARSENE. "Varia—Dubois-Pillet." *Paris* (Aug. 1890). Reprinted in *La Haute-Loire* (26 Aug. 1890).

Obituary and tribute to Dubois-Pillet published in various daily newspapers.

2028. ANTOINE, JULES. "Les Peintres néo-impressionnistes." *Art et critique* (16 Aug. 1890):524-6.

Exhibition review that critiques Dubois-Pillet's works.

2029. ANTOINE, JULES. "Dubois-Pillet." *La Plume* 3:56(1 Sept. 1891):299.

2030. BAZALGETTE, LILY. "Albert Dubois-Pillet" in *Les Néo-impressionnistes*, ed. by Jean Sutter (Paris; Neuchâtel: Editions Ides et Calendes, 1970):89-98.

2031. BEAUBOURG, MAURICE. "Les Indépendants: la mort de Dubois-Pillet et Vincent van Gogh." *La Revue indépendante* 47 (Sept. 1890):391⁺.
Obituaries and tributes to Dubois-Pillet and van Gogh.

2032. CHRISTOPHE, JULES. "Dubois-Pillet." *Les Hommes d'aujourd'hui* 370(May 1890).

Details Dubois-Pillet's experimental Neo-Impressionist *passage* color technique of mixing reds, greens, and violets.

2033. CHRISTOPHE, JULES. "Le Commandant Dubois." *Art et Critique* (30 Aug. 1890):155-6.

2034. COQUIOT, GUSTAVE. "Dubois-Pillet" in Coquiot's *Les Indépendants* (Paris:

Librairie Ollendorf, 1920): 49.

2035. COQUIOT, GUSTAVE. "De feu Dubois-Pillet" in Coquiot's *Georges Seurat* (Paris: Albin Michel, 1924):49-50.

2036. DAVRIGNY. "Dubois-Pillet." *Journal des arts* (24 Oct. 1890).

2037. DUBOIS-PILLET, ALBERT. *"Au bal de l'Hôtel de Ville: l'entrée par la porte du Préfet."* La Vie moderne (16 April 1887).

Pointillist pen drawing by Dubois-Pillet.

2038. DUBOIS-PILLET, ALBERT. *"Vapeur."* La Vie moderne (1887).

Pointillist pen drawing by Dubois-Pillet.

2039. DUBOIS-PILLET, ALBERT. *"Jules Christophe et Anatole Cerfberr."* Les Hommes d'aujourd'hui 308 (Sept. 1887).

Pointillist pen portrait by Dubois-Pillet.

2040. DUBOIS-PILLET, ALBERT. *"Grue à vapeur,"* in *Catalogue des XX, 1888*(Brussels, 1888).

Pointillist pen drawing by Dubois-Pillet.

2041. DUBOIS-PILLET, ALBERT. "Dubois-Pillet." *Les Hommes d'Aujourd'hui* 370 (1890): cover. Reproduced in *La Plume* (1891):191.

Self-portrait pen drawing printed in two colors by Dubois-Pillet.

2042. DUBOIS-PILLET, ALBERT. *"Still Life."* ARTnews 52(Dec. 1953):31.

2043. DUBOIS-PILLET, ALBERT. *"Seine at Paris."* Burlington Magazine 110(July 1968):428.

2044. DUBOIS-PILLET, ALBERT. *"Le Passeur."* Connaissance des arts 209(July 1969):93.

2045. DUBOIS-PILLET, ALBERT. *"Le Quai Saint-Michel et Notre-Dame."* Connaissance des arts 209(July 1969):93.

2046. DUBOIS-PILLET, ALBERT. *"Les Tours de Saint-Sulpice."* Connoisseur 172(Nov. 1969):27.

2047. DUBOIS-PILLET, ALBERT. *"Champs et usine."* Burlington Magazine 112(April 1970):4.

2048. DUBOIS-PILLET, ALBERT. *"Falaises à Yport (1888)."* ARTnews 82(Oct. 1983):18; Art in America 71(Nov. 1983):60; Burlington Magazine 129(Nov. 1987):18.

2049. "Dubois-Pillet" in *Petit bottin des lettres et des arts* (Paris: Grand et Cie., 1886):37.

Unsigned article, perhaps contributed by Paul Adam, Félix Fénéon, Jean Moréas, and Oscar Méténier.

2050. "Dubois-Pillet." *La Haute-Loire* (18 Aug. 1890); (20 Aug. 1890).

2051. "Echo sur Dubois-Pillet." *Art et critique* (20 Sept. 1890):605.

2052. FENEON, FELIX. "IIe exposition de la Société des artistes Indépendants" in Fénéon's *Les Impressionnistes en 1886* (Paris: Giraud, 1886). Reprinted in Fénéon's *Oeuvres* (Paris: Gallimard, 1948) and *Oeuvres plus que complètes* (Paris; Geneva: Librairie Droz, 1970).

2053. FENEON, FELIX. "Le Néo-impressionnisme aux Indépendants—M. Albert Dubois-Pillet." *L'Art moderne* (15 April 1888).

2054. FENEON, FELIX. "Treize toiles et quatre dessins de M. Albert Dubois-Pillet." *La Revue Indépendante* 9:24 (Oct. 1888):134-7.

2055. FENEON, FELIX. "Albert Dubois-Pillet mort." *L'Art moderne de Bruxelles* (24 Aug. 1890).

Tribute and obituary.

2056. GOUNOT, ROGER. "Le Peintre Dubois-Pillet." *Cahiers de la Haute-Loire* (1969):99-131.

Catalogue raisonné of extant works.

2057. KAHN, GUSTAVE. "Au temps du pointillisme." *Mercure de France* 171: 619(April 1924):5-22.

2058. KUNKEL, PAUL. "For Collectors: The Rediscovered Neo-Impressionists." *Architectural Digest* 40:4(April 1983):68-76.

2059. LECOMTE, GEORGES CHARLES. "L'Exposition des néo-impressionnistes." *Art et critique* (9 Aug. 1890):203-5.
Exhibition review that discusses Dubois-Pillet's works.

2060. MAJOLA, J. "Albert Dubois-Pillet." *La Haute-Loire* (27 Aug. 1890).

Tribute to Dubois-Pillet by a fellow painter in a daily newspaper.

2061. PIZON, PIERRE. "Dubois-Pillet, 1846-1890: essai biographique." *Peintre* 487(15 June 1974):3-7.

Biographical account of Dubois-Pillet's life and military and artistic careers that emphasizes his role as a founding member of the Société des Artistes Indépendants, including the Société's seventh exhibition (1891) that paid homage to him after his death from smallpox

in 1890. Concludes with observations about his contributions to Neo-Impressionism.

2062. TAYLOR, J. R. "Post-Impressionism." *Royal Academy of Arts Yearbook* (1980):9-34. 31 illus.

Review of an exhibition entitled "Post-Impressionism" held at the Royal Academy of Arts, London in 1980 that mentions lesser-known painters worthy of critical attention including Dubois-Pillet.

2063. ZEVACO, MICHEL. "Indépendants et impressionnistes: Dubois-Pillet." *L'Egalité* 210(5 Sept. 1889):1-2.

IV. Individual Exhibitions

1888, September-October	Paris, *La Revue indépendante*, 11, Chaussée d'Antin. *Exposition Albert Dubois-Pillet*. 13 canvases, 4 drawings.
1891, 20 March -27 April	Paris, Pavillon de la Ville de Paris. Septième exposition de La Société des Artistes Indépendants. *Rétrospective Dubois-Pillet*. 63 works.

V. Group Exhibitions

1877, 1 May	Paris, Palais des Champs-Elysées. 1 canvas, no. 745 *Un coin de table*.
1879, 12 May	Paris, Palais des Champs-Elysées. 1 canvas, no. 1057 *Chrysanthèmes*.
1884, 15 May-16 June	Paris, Baraquement des Tuileries. *Salon des Indépendants*. 5 works, including no. 32 and 278.
1884, 10 December	Paris, Pavillon de la Ville de Paris-Champs-Elysées. *Première exposition de la Société des Artistes Indépendants, Salon d'hiver*. 7 works, no. 68-74, including 2 painted fans, and 1 pastel.
1886, 21 August-21 September	Paris, rue des Tuileries. *Deuxième exposition de La Société des Artistes Indépendants*. 10 works, no. 153-62.
1886-87, 10 October-15 January	Nantes, Exposition des Beaux-arts de la Ville de Nantes. 1 work, supplément au catalogue no. 1725, *L'Embarcadère*.
1887, 26 March-3 May	Paris, Pavillon de la Ville de Paris. *Troisième exposition de La Société des Artistes Indépendants*. 10 works, no. 144-53.
1888, 4 February-4 March	Brussels, V^ième Salon des XX. 13 works.

1888, 2 March	Paris, Hôtel Drouot. 1 work, no. 17 *Paysage*. Sold for 120 French francs to the Baron Edmond de Rothschild.
1888, 22 March-3 May	Paris, Pavillon de la Ville de Paris. *Quatrième exposition de La Société des Artistes Indépendants*. 10 works, no. 240-9.
1889, 3 September-4 October	Saint-Germain, Salle de la Société d'horticulture. *Cinquième exposition de La Société des Artistes Indépendants*. 3 works, no. 95-7.
1890, 18 January	Brussels, VIIième Salon des XX. 9 works.
1890, 20 March-27 April	Paris, Pavillon de la Ville de Paris. *Sixième exposition de La Société des Artistes Indépendants*. 8 works, no. 315-22.
1932, 25 February-17 March	Paris, Galerie Braun. *Le Néo-impressionnisme*. Préface de Paul Signac. 1 work, no. 11 *Paysage*.
1933-34, December-January	Paris, Galeries des *Beaux-arts* et de *La Gazette des Beaux-arts*. *Seurat et ses amis (Le Néo-impressionnisme)*. Documents par Paul Signac. 2 works, no. 29-30.
1941-42, 12 December-15 January	Paris, Galerie de France. *Les Néo-impressionnistes*. Préface de Paul Signac. 1 work, no. 34 *Bords de la Seine*.
1953	Venice, Biennale. Works by Dubois-Pillet from the Musée Crozatier, Le Puy and the Musée d'Art et d'industrie, Saint-Etienne (Loire).
1954, 1-30 June	Paris, Galerie L.-G. Baugin. *Autour de Seurat*. 1 work, no. 15, *Nature morte aux poissons*.
1961, 6 June-7 July	Paris, Galerie Jean-Claude et Jacques Bellier. *Les Néo-impressionnistes*. 1 painting, no. 11, *Bords de rivière*.
1965, 20 January-14 March	New Haven, Yale University Art Gallery. *Neo-Impressionists and Nabis in the Collection of Arthur G. Altschul*. 2 works, no. 1-2.
1965, 23 April-16 May	Paris, 76ieme exposition de La Société des Artistes Indépendants. *Les Premiers indépendants, rétrospective 1884-1894*. Préface de R. Yan, R. Charmet, J. Fouquet. 8 works, no. 57-64.
1966, 7-25 June	London, Arthur Tooth and Sons. *Pointillisme: A Loan Exhibition of Paintings by Angrand, Cross, Dubois-Pillet* [et al.]. 10 p., 26 pl.
1967, 24 May-27 June	Paris, Galerie Hervé. *Quelques tableaux de maîtres néo-impressionnistes*. 2 works, no. 14-5.
1968, February-April	NY, Solomon R. Guggenheim Museum. *Neo-Impressionism*. 4 works, no. 25-8.

1980 London, Royal Academy of Arts. *Post-Impressionism.*

Review: J. Taylor, *Royal Academy of Arts Yearbook* (1980):9-34.

Art Works Index

Includes the titles of art works by individual Neo-Impressionist artists in all media, as referred to in the entries and annotations. By entry number.

Charles Angrand
Paysage aux environs de Paris 1936

Henri Edmond Cross
L'air du soir 341, 1904
Arbres (1909) 1910
La chevelure 1895-6
Femme lisant sous la lampe 1904
Les Haleurs de filet (1892) 1899
Les Iles d'or 1896
Le Naufrage 341, 1904
Portrait de Mme Henry Edmond Cross
 1901

Albert Dubois-Pillet
*Au bal de l'Hôtel de Ville: l'entrée par
 la porte du Préfet* 2037
Autoportrait 2041
Champs et usine 2047
Falaises à Yport (1888) 2048
Grue à vapeur 2040
Jules Christophe et Anatole Cerfberr
 2039
Le Passeur 2044
Le Quai Saint-Michel et Notre-Dame
 2045
La Seine à Paris 2043
Still Life 2042
Les Tours de Saint-Sulpice 2046
Vapeur 2038

Maximilien Luce
Les Chaouchs s'amusent 2014
Comment on entraîne les marins russes
 2014
Filles à soldats 2014
Notre-Dame 1988, 1990
Paysage, dans l'Yonne 2004
Pissaro (portrait) 1515
Pissaro (portrait assis) 1516
Quai à Camevert-Finistère 1992
Vache à lait 2014
Vue de Dordrecht 2004

Camille Pissarro
Autoportrait 1341, 1560-1
L'avenue de l'Opéra 1482, 1506
Le Barrage (1872) 1579
Bathers in the Woods 1328
La Bergère 1600
Black Crayon Drawing of a Cowherdess
 1349
The Cabbage gatherer 1580
La Cueillette de pommes 1226
La Charrue 1437
Chrysanthèmes dans un vase chinois (ca.
 1870) 1450
A Climbing Path at the Hermitage
 1550
Côte des Grouettes, près de Pontoise
 1606

Personal Names Index

Names of the Neo-Impressionist painters covered in this sourcebook appear in bold type.
By entry number.

Abbott, Jere 670, 671
Abdy, Jane 486
Abel, Lionel 197, 1073
Abramowicz, Janet 672
Adam, Paul 194, 450, 654, 1010, 1234-
 5, 1572, 1931, 2049
Adams, Brooks 1841
Adhémar, Hélène 281, 673, 1236
Adhémar, Jean 1081
Adler, Kathleen 176, 650, 1082-3,
 1158, 1192, 1237-8, 1294
Adlow, Dorothy 1239
Af Buren, Jan 1240
Agamemnon, Jean 1959, 1977
Aichele, K. Porter 675
Aiguier, Auguste 483, 1070, 1635,
 1954
Ajalbert, Jean 7, 247, 654
Akinari, Takahashi 487
Albert, Charles 282, 488
Alexandre, Arsène 8, 283-4, 1066,
 1241-3, 1642, 1704, 1807, 1952,
 1978, 2027
Alexandrian, Sarane 489
Allan, Blaise 625
Allrich, Steve 1559
Alma-Tameda 1352
Alzate Cuervo, Gastón 676
Aman-Jean, Edmond 608, 714, 885
Aman-Jean, François 9
Amaral, Cis 285

Amir, Aharon 547
André, Albert 109, 1763, 1967
Andre, Carl 1510
Andrews, Keith 880
Andry-Bourgeois, C. 10, 379
Angelov, I. 679
Angrand, Charles 113, 1636, 1812,
 1888, 1925-46, 1950
Angrand, Pierre 11, 250, 490, 1812,
 1927, 1933, 1946
Annenberg, Walter 1027
Anquetin 1951
Antoine, D. 1934
Antoine, Jules 286, 677, 2028-9
Anzani, Giovanni 1244
Apollinaire, Guillaume 12, 287, 491,
 711, 1705, 1889
Apollonio, Umbro 492, 678
Appelbaum, Stanley 573
Aquilino, Marie-Jeannine 288
Aragon 1763
Archer, Jeffrey 1476, 1773
Argüelles, José A. 13, 1707
Arnold, Matthias 289
Arwas, Victor 494
Ashbery, John 302
Ashworth, Mark 1124
Askin, Sheila C. 749
Astley, Philip 906
Astruc, Gabriel 495
Atsushi, Miekawa 642

About the Authors

RUSSELL T. CLEMENT is Reference Services Coordinator, Humanities, John C. Hodges Library, The University of Tennessee, Knoxville. His previous Greenwood books include *Four French Symbolists: A Sourcebook on Pierre Puvis de Chavannes, Gustave Moreau, Odilon Redon, and Maurice Denis* (1996), *Georges Braque: A Bio-Bibliography* (1994), *Les Fauves: A Sourcebook* (1994), *Henri Matisse: A Bio-Bibliography* (1993), and *Paul Gaugin: A Bio-Bibliography* (1991).

ANNICK HOUZÉ is the French Cataloger at the Harold B. Lee Library, Brigham Young University, Provo, Utah.

ISBN 0-313-30382-7

HARDCOVER BAR CODE